Dreamworld Tibet

'If my next book is a flop, I'll start a Tibet project!'

Dreamworld Tibet
Western Illusions

Martin Brauen

In collaboration with
Renate Koller and Markus Vock

Translated by Martin Willson

Orchid Press
Bangkok 2004

Martin Brauen
DREAMWORLD TIBET—Western Illusions

First published as 'Traumwelt Tibet: Westliche Trugbilder' by Verlag Paul Haupt,
Berne 2000.

First English edition.

ORCHID PRESS
P.O. Box 19,
Yuttitham Post Office,
Bangkok 10907, Thailand
www.orchidbooks.com

Cover illustrations:
Front: 'Shangri-la' by Leland Klanderman. © Conrad Represents/ Leland Klanderman.
Back: Line drawing of Manjusri, bearing the symbols of wisdom, the book and the sword.

The English translation, and thus this English edition, was made possible by the financial
support of the 'Swiss Aid to Tibetans' Foundation and by a group of young, engaged,
Tibetans and Swiss, who have formed an association called 'Changing Movement'.
The author is very grateful for these financial contributions.

Printed and bound in Thailand

ISBN 974-524-051-6

Table of Contents

Part 3. In Search of 'Shangri-La' and the White Lamas 83
The image of Tibet in literature, comics and films

Part 4. In Search of 'Dharma-la' and the Tibetan Lamas 163
The image of Tibet in feature films of the '90s, advertising and commerce

List of Illustrations

Introduction

The inadequacies and imperfections of human existence receive their often enough laborious explanation and justification in myths, religion and philosophy, but they nevertheless also always require comforting and hopeful counter-images, which in a concrete and even a blatant manner make separation from happiness and fear of an uncertain end bearable. One of these central dreams of mankind is the dream of an earthly paradise, of a place on this Earth that promises absolute happiness and supreme bliss. (Klaus H. Börner)

Tibet, however wonderful, is a dream; whether of a long-lost golden age or millenarian fantasy, it is still merely a dream. (Jamyang Norbu)

For around four hundred years, Tibet has been the goal of a body of Western pilgrims, who to start with consisted mainly of missionaries, joined in due course by explorers, political officers, spies, travel writers, esotericists and adventurers. Many of them did not travel to Tibet in reality, but only in their fantasies, hallucinations and dreams. Some endeavoured to paint as objective a picture of Tibet as possible; others, however, constructed a Tibet that arose from their fantasies and had little or nothing to do with the real Tibet. The present book is concerned with these fantastical legends and fictions and with the stereotypes revealed in them. The book makes no claim of portraying Tibet as it used to exist and does exist, but is a compendium of all the strange fictions that have developed about Tibet. Each of their creators, almost exclusively men, drew a very personal picture of Tibet. Thus there arose over the centuries a whole gallery of Tibet pictures, allowing one to recognize certain periods by specific characteristics of style as soon as one starts to analyze them in more detail. In this book we call the periods 'Utopia', 'Shambha-La', 'Shangri-La' and 'Dharma-La'. Utopia was the age of the early missionaries and explorers, who sometimes at least were in search of the kingdom of the fabled priest-king Prester John or of similar social-utopian areas. 'Shambha-La' with its 'Aryan lamas', a period that was rung in by the Theosophist Helena Petrovna Blavatsky, reached its high point in the first quarter of the twentieth century, and led on to the 'Shangri-La' period, an age in which 'white lamas' living somewhere in Tibet stimulated westerners' imagination. Today we find ourselves in 'Dharma-La': sacred Tibet has

shifted from the Roof of the World to India and into the West, the Tibetan lamas—and with them, naturally, the Dalai Lama—have become leading protagonists in the Western dreams of Tibet and have left Tibet. At the same time the Buddhist Teaching, the Dharma, is degenerating more and more into a commodity: sacred Tibet is coming to be for sale. Of course, the transitions between the individual periods are fluid and certain dream motifs are to be found in all of them. These are to be explained systematically in Part 5.

As mentioned, the aim of this book is to discover and describe the fictional Tibet—not the real Tibet. This has already been described in numerous books and articles, which for the most part portray parts of Tibetan life. But besides these there exist almost as many reports of a fictional Tibet, which often displays absurd features. If these absurdities are described in such detail, it is by no means to make fun of the Tibetans, but to expose how grotesque and peculiar Western thought can be. Dreamworld Tibet was not, however, created out of complete nothingness, but was based on roots that reach far back in European thought and on certain Tibetan ideas, as will be shown likewise in Part 5.

I make no claim to have worked through all the evidence of fictional Tibet. Some categories of sources indeed are deliberately mentioned only in passing, whether because their treatment would each require a long treatise (for example, the no longer surveyable flood of documentary films on Tibet, the many, sometimes dubious, books and articles on Tibetan medicine and Tibetan art[1], and the scientific perception of Tibet[2]), or because the material is very cursory (for example, travel brochures). But of course we shall also fall back upon this material where it appears necessary.

It is not simple to draw a clear boundary between the fictional and realistic Tibet sources. This distinction, it cannot be said clearly enough, is dependent on the author's personal image of Tibet, which also reflects his own prejudices; it is therefore subjective and to a certain extent arbitrary. Also, to borrow a metaphor from Donald Lopez, I as author am a 'prisoner of Shangri-La'. In fact, with many sources their fictional character is obvious, while with others we move in an uncertain border region between fiction and reality.[3]

I must right from the outset counter the possible objection that this book is destructive. 'Tibetophiles' and 'Tibetomaniacs' want to ask themselves why, from novels, legends, stories, comics, films and the like, pieces of a jigsaw have been collected here that in their entirety reveal a caricature of Tibet. If the author's concern was the objective depiction of Tibet, he would have had to strive for the most accurate possible portrayal of Tibet's history, society and culture, instead of troubling his readers with all these strange, abstruse and not infrequently crass descriptions. And does Tibet not suffer harm when these absurdities and banalities are published? Does this not mean more grist to the mill of those who, like many Chinese for example, see in Tibet a medieval hell realm?

I should like to reply to such critics that the absurd descriptions and images of Tibet have taken on such proportions that they must not be concealed. All of us who are interested in some way or other in Tibet—or in foreign societies and cultures in general—should be aware of these 'slanted' images. In this way we shall be able to construct a more objective image of Tibet—a basic prerequisite for a true dialogue and exchange with the Tibetans—and at the same time learn something about ourselves. For the Western images represented here express a great deal more about Westerners—their yearnings, needs, desires, hopes and dreams—than about Tibet and its inhabitants themselves. The dream reveals a lot about the dreamers.

Such a demythologizing of Tibet, by the way, is being demanded increasingly urgently by Tibetan intellectuals. To represent them all, I cite here Tsering Shakya:

> We need to look to some extent at the way in which the West perceives Tibet and, more importantly, interprets the Tibetan political struggle. The Western perception of Tibet and the images which have clustered around Tibet have hampered the Tibetan political cause. The constant mythologisation of Tibet has obscured and confused the real nature of the Tibetan political struggle.[4]

There is nothing to add to this.

In the present book, source material will predominantly be used that one might label as trivial. If one considers many such documents, one could expect a trivial result, so the Zürcher Goethe-Stiftung für Kunst und Wissenschaft informed me in reply to a request for financial support for the research project. Without doubt, this represents a widespread view. But why should a careful investigation into so-called trivialities actually lead to a trivial result? And what does 'trivial' mean anyway? Is the term accepted as so negative because 'trivial', which it is known can mean commonplace, also means many negative things such as hackneyed, inane, mindless, banal and insignificant? Is the commonplace so negative and the study of the commonplace therefore wrong? That I have taken such 'trivial' material into consideration in the present book shows my response clearly: I am convinced that not only the analysis of conventional sources such as mission and travel reports and scientific books is legitimate, but also that of the 'commonplace' such as comics, novels, feature films, advertising and everyday objects, and I hope to be able to demonstrate the meaningfulness of such material here.

Such a compendium of Tibet fictions could never have been collected by one person. Many helpers were necessary. I should like especially to mention by way of thanks two of them, who because of their exceptional investment of labour must basically be cited as co-authors. One is Renate Koller, who with unbelievable zest and success ransacked libraries, catalogues, fairs and shops for years for usable material, worked on the sources found and reappraised them for me, wrote synopses, looked into questions of detail and read through texts. The other is Markus Vock, who with equally great commitment sought out and procured pictorial material and objects, sought and found unexpected sources in the limitless world of the Internet, read through the book manuscript and drew my attention to certain facts I did not know.

My two collaborators and I could fortunately enlist the help of many, who are listed here in alphabetical order:

Jan Andersson, Münster; Joss Bachofer, Munich; Manuel Bauer, Winterthur; Harald Bechteler, Munich; Eberhard Berg, Lucerne; Dorothee Berger, San Diego; Sönam Dolma, Yangzom and Taschi Brauen, Bern; Andreas Brodbeck, Zollikerberg; Katia Buffetrille, Paris; Esther Bühlmann, Zurich; Jeff Cobb, Beavercreek; Loten Dahortsang, Rikon; Hubert Decleer, Kathmandu; Hervé Dumont, Lausanne; Heidi Ebertshäuser, Munich; Angelika Eder, Paros;

Michel Egger, Pully; Isrun Engelhardt, Icking; Zara Fleming, Ruthin, Denbighshire; Erich Frei, Zürich; John Halpern, New York; Wolfgang Hellrigl, Bozen; Michael Henss, Zürich; Peter Horemans, Brussels; Peter Iseli, Bern; Martin Kämpf, Zürich; Marietta Kind, Zürich; Frank Korom, Santa Fe; Douglas Kremer, New York; Roland Kübler, Bern/Shanghai; Dieter Kuhn, Burgdorf; Elsbeth Lauber, Feldmeilen; Frank Lenz, Zürich; Donald Lopez Jr., Ann Arbor; Stefanie Lotter, Heidelberg/Kathmandu; Mingyur Rinpoche, Taipei; Peter Nebel, Zürich; Anna Nippa, Dresden; Tsewang Norbu, Berlin; Braham Norwick, New York; Mark Oppitz, Zürich; Françoise Pommaret, Paris; Ramon Prats, Barcelona; Hanna Rauber, Unterstammheim; Roswita Reinhard, Rikon; Veronika Ronge, Bonn; Verena Rongger, Bern; Hans Roth, Bad Münstereifel; Hansjörg Sahli, Solothurn; Luc Schädler, Zürich; Silvia Schneider, Bern; Randy Scott, East Lansing, Michigan; Elliot Sperling, Bloomington; Roland Stutz, Bern; Sophie Tchang, Brussels; David Templeman, Melbourne; Gvido Trepsa, New York; Eduard Troxler, Basle; Peter van Ham, Wiesbaden; Martin Weber, Bern; Paola von Wyss-Giacosa, Zürich.

Financial support was provided by the Völkerkundemuseum der Universität Zürich, the Zürcher Hochschul-Verein and the Cassinelli-Vogel-Stiftung in Zürich. I emphatically thank these institutions and their committees of management, the above-mentioned informants and helpers, the publisher of the German edition, Paul Haupt (especially Frau Regine Balmer), and the publisher of the English edition, mainly Chris Frape. Special thanks go to the translator, Dr Martin Willson. He not only translated my text very accurately, but he also added data, analysed references in the notes, checked many of them, inserted some new entries and proposed certain corrections.

The English translation could only be done thanks to financial support by the Foundation 'Swiss Aid to Tibetans' and by a group of young, engaged Tibetans and Swiss, who have formed an association called 'Changing Movement'. This association has set itself the goal of facilitating financial and cultural support for aid organizations all over the world, by means of events of many different kinds. I give heartfelt thanks to all these helpers, and especially the donors, for their support.

Part 1

In Search of Utopia?

The Tibet images of missionaries, travellers, scholars and colonial officials

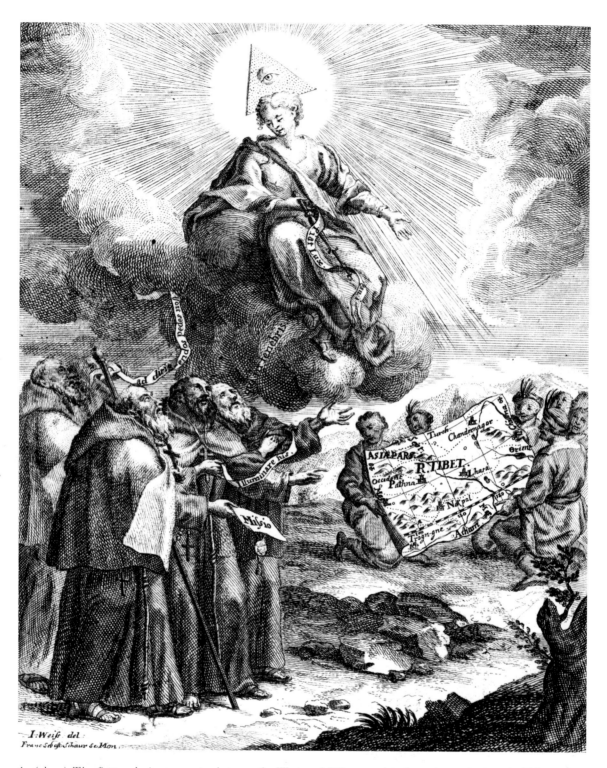

1. (above) The first enduring encounter between the West and Tibet was based on the myth that the Tibetans were Christians—descendants of the Nestorians, followers of Prester John or even inhabitants of the earthly paradise. If this rumour of supposed Tibetan Christians had not been in circulation, Tibet would not have been sought out by missionaries so early and would have remained a blank on the map for longer.

2. (right) The legendary Prester John, whose kingdom was conjectured to lie somewhere between China, India, Central Asia and Ethiopia. The first accounts go back to the chronicler Otto von Freising, whom a Syrian bishop reputedly told about the priest-king John in 1145. In 1165 a letter of Prester John's turned up, in which his kingdom is described as an earthly paradise, with the typical paradise themes such as the fountain of youth, unbelievable wealth, abundance of food and so forth. Some travellers went in search of this Utopia, which one theory located in the region of present-day Tibet.

First myths

> I would like to ascertain whether it is true, as I have heard, that he (the king of the western Tibetan kingdom of Guge) and his subjects are bound to Christ and the true law of God. But should it not be so, may I come to clear up the errors and faults in his faith, if he consents … He should perceive the opportunity that through God's will is now offered him; this would be a grace that for centuries his forefathers had not had; he would want to prove himself worthy of this grace.[1]

That is how on 8th November 1624 the Jesuit Father António de Andrade (1580–1634) described the reasons why he and his companion Father Manuel Marques travelled to the kingdom of Guge in Western Tibet.

The first enduring encounter between the West and Tibet was therefore based on a myth, to wit, the myth that the Tibetans were Christians. Had this rumour of supposed Tibetan Christians not circulated, Tibet would no doubt have remained for some time a blank on the map.[2] How did this rumour arise? Were the Muslims, strongly represented in India, responsible for it, with whom de Andrade was in close contact and who saw in Buddhism a Christian sect?[3] Did it go back to the tidings of Nestorians allegedly living in Tibetan-Chinese territory,[4] or to the legend of the redeemer and priest-king Prester John, that all-powerful, all-knowing Christian, living in abundance, who in the 12th century supposedly ruled over a paradisal realm in central Asia, flowing with milk and honey? Or did de Andrade believe he could play an important part in the history of God's work of salvation, seeing that he imagined himself in search of a paradise supposed to be somewhere in the East, which it was believed lay between high mountains and had four great rivers running through it?[5] A document in the archive of the Society of Jesus in Rome in fact indicates that de Andrade's journey was perceived as the fulfilment of a biblical prophecy, that the people surviving the apocalypse would live on a mountain towering above everything.[6] Can we find in this biblical prophecy, which appears to have inspired de Andrade's journey to Tibet, the origin of all those legends that arose principally in the 19th century and suggested that Tibet, lying in the high Himalaya, was the promised land where the highest knowledge of wise men was

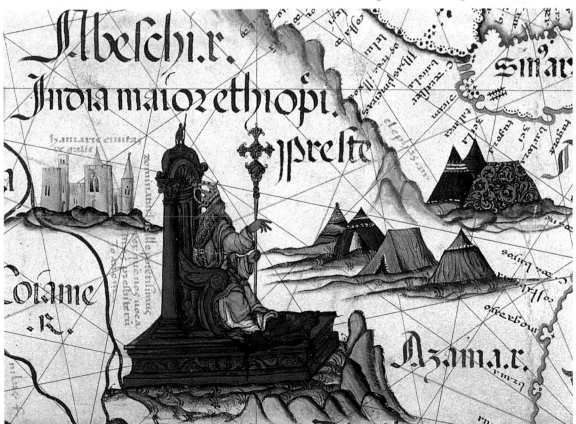

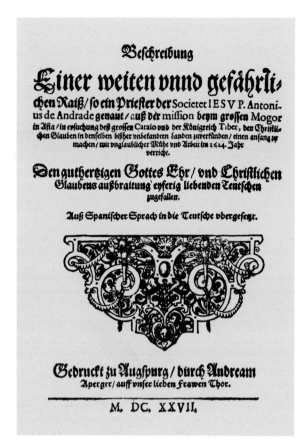

3 (above), 4 (p. 5). *The first enduring encounter between the West and Tibet was based on the myth that the Tibetans were Christians. It was António de Andrade (1580–1634) who first investigated the true content of this myth: 'I would like to ascertain whether it is true, as I have heard, that he (the king of the western Tibetan kingdom of Guge) and his subjects are bound to Christ and the true law of God. But should it not be so, may I come to clear up the errors and faults in his faith, if he consents … He should perceive the opportunity that through God's will is now offered him; this would be a grace that for centuries his forefathers had not had; he would want to prove himself worthy of this grace.'*

stored? The fact that de Andrade's journey was indeed related to Isaiah's prophecy of the last days now makes this interpretation seem plausible.

Even if we must start from the assumption that the mission report drawn up by de Andrade is a text distorted by self-censorship,[7] and take into account that de Andrade scarcely mastered the Tibetan language, as he himself regrets time after time, we do learn from it some valuable things about the way of life of the Tibetans living in the west Tibetan kingdom of Guge and about the way one of the earliest Tibet travellers perceived Tibet as alien. De Andrade undertook the arduous journey from India to Guge twice, the first time

in Summer 1624, the second in Summer 1625, to stay there for five years. Soon after his arrival in 1624, de Andrade must already have realized that one myth had come to grief: the Western Tibetans were not Christians, despite the supposed similarities. Even so, de Andrade must have thought that once, perhaps, close affinities between Buddhism and Christianity were recognizable there. Of all the religions he knew, Buddhism seemed the nearest to Christianity, thought de Andrade, followed by Islam and—at the bottom of the hierarchy—Hinduism. One must suspect that the high estimation of Buddhist Tibetans is based upon the 'religious racism' here hinted at. As will be shown in the final chapter, it was to remain in existence for four hundred years.

In his reports, translated into several European languages, which aroused the interest of a wide readership, de Andrade described the benevolent Tibetans with the words:

> The people of the country are mostly kind, brave and pious, and love combat, which they practise all the time. In addition these people are compassionate and inclined towards worship. … Amongst the worldly population one seldom hears a presumptuous or even an angry word. They seem to be quite a peaceable people.[8]

This description contains a contradiction that will occupy us in connection with thee Tibetans again and again: are they a peaceful people or one that loves and all the time practises combat, 'a people bold and experienced in war', as is said in other places. The myth of a peace-loving, pacifist people appears to have its origin in the first description of Tibet. It arose even though the author demonstrably knew that it was false. De Andrade had directly experienced how much the West Tibetans were embroiled in war, such that the king of Guge was constantly at war with armies from the South (Garhwal) and the West (Ladakh). He describes how in the summer the men took part in a war expedition and how, after returning home, they spent the whole day practising archery, the use of weapons and breaking lances.[9] And yet he called them peace-loving! Was it their 'piety and their affection for the things of religion, innate in them', that allowed de Andrade to forget time after time that these folk were violent and aggressive? This proverbial religiousness of the Tibetans is at least a possible explanation why the myth of the peace-loving Tibetans has been

maintained up to the present day—as if religiousness and violence were inevitably mutually exclusive.

De Andrade's description of Tibetan religiosity is quite pejorative, in accordance with the circumstances and the spirit of the times, but constantly betrays the author's critical discernment, something often lacking in later descriptions, especially those of the 19th and 20th centuries. Thus de Andrade doubts if there is anything miraculous when lamas remain sitting on the bed after the moment of death, and mentions instead some possible natural reasons for the seated posture of a dead lama.[10] He mentions some arguments well worth considering against 'migration of souls', without being aware that the term 'migration of souls' is fundamentally false,[11] and puts the obvious question, why the lamas advise a layman wrestling with death to give plenty of alms so as to win salvation, if everything is really predetermined.[12] He cannot understand either why reciting sufficiently the words 'Om mani patmeonri' (Om mani peme hung hri) after a sin, one should again be blessed with the grace of God. 'If that is so,' argues de Andrade,

> then if you take a dagger and promptly stab the first person who comes along in the heart, and steal from the king the pearls he is wearing, then speak the words 'Om mani patmeonri', at once you will be redeemed. Does it really seem to you that this is reasonable?[13]

Other things de Andrade describes without comment, from which we can infer respect, perhaps even high esteem. These include mention of wind instruments, rosaries and drinking cups of human bones, whose use serves to keep death and the impermanence of pleasure vividly before one's eyes. De Andrade was the first, but by no means the only one, to look into the Tibetans' attitude towards death. After him the Tibetan *ars moriendi* was taken up by countless authors and in the 20th century experienced an almost inflationary high regard.

De Andrade attempted, by making the alien understandable to himself and his readership, to bring it into relationship with their own familiar culture. Thus he saw in a deity who held a sword in his hand the Archangel Michael, although he lacked scales and wings. That the method of comparison was a hopeless undertaking when a complicated interrelation was involved is clearly shown when de Andrade discusses the trinity of 'Lama (Buddha), Dharma and Community of Monks' and wants to equate it with the Holy Trinity of Christianity (Father, Son and Holy Ghost). This was despite the fact that he lacked the necessary linguistic competence for such a comparison and was unable to find various words in Tibetan 'that are absolutely essential … for the explanation of such a great mystery', as de Andrade himself had to conclude.[14] This, however, did not deter de Andrade from believing that the commonest, crassest and most trivial arguments were the most effective for convincing the lamas of the Christian faith, so ignorant were they.[15] Lack of linguistic ability and faulty communication were at the root of so many misunderstandings and misjudgements in the early history of the discovery of Tibet! Were they also the cause of many stereotypes and myths of the present?

If one can give credence to de Andrade's words, he stood close to the king, indeed the king seems to have treated the Jesuit as a high lama, which if need be can be put down to misleading behaviour by de Andrade. It can indeed be assumed that he never clearly expressed in front of the Tibetans the fact that he and his companion were not Buddhists.[16] The father was allowed to go in and out of the king's palace unhindered, to debate with

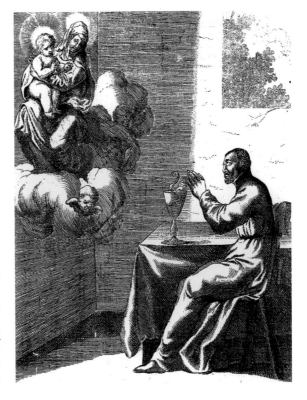

the monks, to distribute amulets, crosses and holy images, and even to build a place of worship (Our Lady of Hope) and a house for the missionaries, for which the houses of some local inhabitants had to be pulled down. Obviously this did not suit many of the locals, notably the king's brother and the monks, which however did not stop the sovereign carrying on treating the missionaries extremely kindly. De Andrade felt 'a strong inclination towards the reception of holy baptism', a moment for which, he found, the royal family and many other Tibetans too were waiting impatiently. History teaches us that this was a misjudgement. After de Andrade's departure in 1630, more Christian missionaries came in the following period seeking conversions, but exceedingly few Tibetans converted to Christianity. Instead, some 250 to 300 years later, there was to be a reverse proselytization. The peaceful, naive and strange folk chosen for conversion, with their 'wrong views', became gurus for tens of thousands of Westerners. At first they were simply imaginary creations (like the Aryan Mahatmas of the Theosophists or the Westerner Lobsang Rampa), but later they were to become real gurus of flesh and blood, countless Tibetan monks working in the West. In the late 19th and the 20th centuries, the missionized became missionaries.

Although de Andrade conveys to us by and large a sympathetic picture of the Tibetans, he leaves no doubt as to the backwardness of Tibetan belief. Nevertheless he seems to have been positively moved by the faith and religious devotion. Praise and criticism are both found in his reports, and we shall meet just this ambivalence many times when we analyze the West's image of Tibet. It will be shown from de Andrade and one of his successors how different points of view can be, even within a group of like thinkers. While de Andrade describes the Tibetans quite positively, Nuño Coresma, who arrived at Tsaparang some five years after him, could find only negative words. He is of the opinion that the people are incapable of understanding the mysteries of Christianity, and are very poor, uncivilized and coarse to an extent he had never himself seen or heard of before ... There is not even a shadow of religious feeling, and the people visit the temple only as a place to eat and drink.[17] When reading these negative judgements it must be borne in mind that the missionaries who arrived at Tsaparang after de Andrade were no longer treated courteously. They were at times under house arrest and had in the end to leave the country, which is certainly a reason for the later missionaries' negative judgements on the Tibetans. This raises the question why opinion swung against the missionaries. Had the Tibetans realized they would have to be baptized and converted to Christians? Had the latest political events something to do with this change? Or did the opinion swing reflect the fact that the new missionaries did not have the same capacity for understanding and the same sympathy with the Tibetans as de Andrade did? In other words: was de Andrade's positive reception connected with his positive attitude towards the inhabitants?

Other clerics followed de Andrade in the 17th and 18th centuries, such as the Jesuits Estevão Cacella and João Cabral (arrived in Shigatse end of February 1630); Johannes Grueber (1623-1680) and Albert d'Orville (1621-1662), who while searching for a shorter land route from Rome to China became the first Europeans to reach Lhasa (on 6th October 1661; altogether they were on the way for eight years!); and Ippolito Desideri and Manuel Freyre (arrived in Lhasa 1716). After them, several Capuchins journeyed to Tibet, among whom the best known is no doubt Francesco Orazio della Penna (arrived in Lhasa 1st October 1716). The accounts of the Capuchins, in particular those of Orazio della Penna and Cassianus Maceratensis, were published in 1762-3 by Agostino António Giorgi (Georgius) (1711-1797) in his *Alphabetum Tibetanum* and enriched with all kinds of syncretistic theories. The foundation was thereby laid for the idea of Tibet as the mysterious treasure-house of a luxuriantly proliferating syncretism.[18]

There is no doubt that most of the negative images that shaped the Tibet image of European philosophers in the 18th and 19th centuries and can be detected in the negative judgements on Tibet in the 1930s, go back to the Capuchins. Some of the Capuchins were indeed of the view that Tibetan Buddhism was the work of Satan: only he could create a religion in so perfidious a fashion, outwardly so similar to Catholicism.[19]

White-headed Lama Ippolito

We wish to concern ourselves below with one of the most interesting missionaries, the Jesuit Ippolito Desideri (1684-1733). As the following quotation indicates, he was one of the first to lay bare and refute the myths springing up about Tibet. He was to remain for a long time the only one.

> Some people have a craving for publishing accounts of various countries and of the religion and habits of divers peoples in large prolix volumes, and they sometimes get more credit than they merit. When an author writes about a country he does not know and the language of which he does not understand, his information is of no value for me. For instance, either by word of mouth or in print it has been stated that the people of Thibet venerate the Cross and often wear it on their clothes or on their caps. This is absolutely untrue …

Others have declared that [the Tibetans] believe in fate and therefore are atheists.

> … whereas the Thibettans … assert that all who believe in destiny are infidels, and that good or evil are solely the results of good or evil deeds of men. Others again when arriving in Europe from Thibet have informed our Congregation of Propaganda,

5. António Agostino Giorgi (Georgius) (1711–1797) in his Alphabetum Tibetanum *laid the foundation for the idea that Tibet was a mysterious treasure-house of luxuriantly proliferating syncretism.*

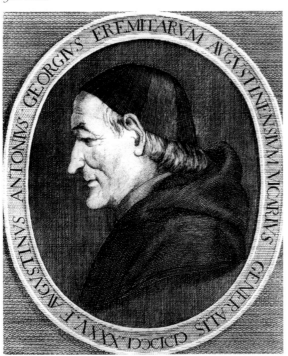

and the Pope that the words Sang-ghiêe-Kon-cciôâ means the first Person of the Trinity, or God the Father, Ccioo-Kon-cciôâ the Son, and Ke-n-dùn-Kon-cciôâ the Holy Ghost.[20] What I have said about these matters is not by way of censure or to contradict others, but to beg any who may read these pages to believe what I have written, as I have travelled in the three Thibets, spent some years in those countries, learnt the languages, and read a number of the principal and most abstruse books of those peoples.[21]

Desideri wrote these wise, critical words as early as the first quarter of the 18th century. It was, however, to be around two hundred years before his account was published, and several decades more before its valuable contents were taken note of. Instead the Tibet stereotypes began to proliferate.

Desideri had reached Lhasa with Emanuel Freyre on 18th March 1716, after an exhausting journey that had begun seven months earlier in Leh (Ladakh). He spent five years in Tibet, initially in Lhasa and in Sera Monastery and later, because of political turmoil, in the Dhakpo district. It was an extremely busy and productive period, in which he studied every day from morning till evening, as he mentions once. He concerned himself so earnestly, intensively and minutely with Tibetan culture, he trained himself so much in Tibetan religion, and his reports are so accurate and full of fascinating details, that he can be seen as the founder of western Tibetology, if one disregards the places where, in arrogant missionary fashion, he criticizes the Tibetans and chosen aspects of their faith. Under the pseudonym Gokar gyi Lama Ipolido (White-headed Lama Ippolito) he wrote four documents in Tibetan, in which he expounded to his Tibetan readers his own 'holy faith' and attempted to refute some central Tibetan articles of faith, such as for example the 'abominable belief in metapsychosis, or transmigration of souls'[22] or the 'capital error, source of all the false dogmas believed in by this people', namely 'the absolute and positive denial of the existence of any God or of any uncreate and independent Being.'[23] At the same time, like de Andrade before, but much more ably, he produces comparisons between the Tibetan faith and his own, for example when he comes to speak

of the style of religious argument and debate, the Tibetan way of contemplation and the Tibetan 'trinity'. He recognizes the last correctly as a trinity of Buddha, Doctrine and Community of Monks, which are not perceived as 'divine' in the Christian sense and are completely different from the three persons of the Holy Trinity.[24]

It can be shown exemplarily from Desideri how prejudices and misjudgements can arise, and how hard it is to correct them: as Desideri self-critically admits in his large work,[25] in a letter he wrote on 10th April 1716 to Father Grassi he made two capital errors. Namely, he had asserted that the Tibetans did not believe in the migration of souls, but in attaining either hell or heaven after the moment of death. He had also recorded that they

had certain knowledge of God and the Holy Trinity. These assertions, wrote Desideri later, had been a gross error. There were also a lot of serious consequences: the letter and its erroneous contents were published without Desideri's knowledge or indeed consent, and subsequently cited again and again, while Desideri's contrite correction was first published around two hundred years later. Once put into the world, the error was continually reincarnated in new variants through the cheerful plagiarism of later pen-pushers.

Like de Andrade, Desideri tried to track down contradictions in the Tibetans' faith. Thus he found it inconsistent that normal dead bodies were presented to the birds as food—as a good deed, so to speak—while deceased lamas and nobles were

6. The copperplate engravings in China Illustrata *(1667) in which Tibetan scenes are shown betray in many details that their producer had never been in Tibet, and could have based his representations chiefly on Grueber's sketches. The deity 'Manipe' seen here undoubtedly indicates Avalokita, about whom Kircher says: 'The foolish people worship this idol by making unusual gestures and performing rites, while constantly reciting "O Manipe mi hum," which amounts to "Manipe, save us!" ... Figure XVII shows the figure as our forebears saw it. But they also transmitted it to me in the form shown in Figure XXI.' It is particularly striking that in the nine-headed form only the upper body of the Bodhisattva is depicted, standing on a pedestal—like a Greek or Roman bust. Nothing indicates the interior of a Tibetan place of worship, neither the arched entrance, nor the curtains, the hanging lamps or the position of the two figures, which would never be placed in the temple with their backs to the door.*

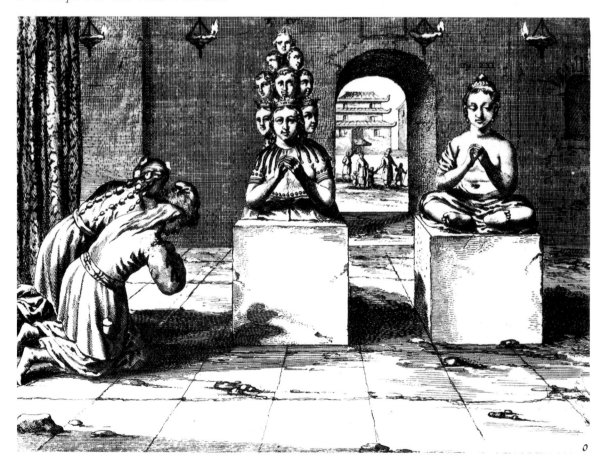

cremated.[26] But Desideri also critically examined Western authors and thereby clearly stood out from others. Thus he contradicted Athanasius Kircher, the genius of compilation, who asserted in his illustrated work with the abbreviated title *China Illustrata* that the Great Lama (Dalai Lama) could be seen only by certain close friends[27] and that the Tibetans worshipped a god named Manipe, to whom they recited 'O manipe mi hum'![28] If he conceded that in fact Athanasius Kircher also disseminated some truths, he refuted Tavernier completely. Tavernier wrote about a land in which he had never set foot, because of which everything he wrote about it was without truth, pure fantastic invention and valueless.[29] Consequently Desideri is the first to have tried systematically to expose and refute the prejudices and misjudgements concerning Tibet and the first 'Tibet myths'. For a long time he was to remain the only one.

In fact even Desideri fell victim to one 'myth', the one of the peace-loving Tibetans. He was of the opinion that Tibet was a peaceful country,[30] but on the other hand reported in great detail on wars and extremely cruel civil-war-like battles. Thus he describes how between 1717 and 1720 the 'Yellow-cap' monks tortured and even killed the 'Red-cap' monks, plundered and destroyed monasteries, turned temples into stables, destroyed statues, burnt books, and forbade anyone to pray to Urgyen (Padmasambhava) or even mention his name, so that Desideri found himself compelled to help a reincarnate 'Red-cap' monk thus persecuted.[31]

Desideri's notes went missing for a long time. They were first discovered in 1875, but another twenty-nine years passed before they were published in an abridged form by Puini.[32] But even after their publication, Desideri's texts did not receive the attention they deserved.

Many misunderstandings and many Tibet myths would not have arisen if Ippolito Desideri's writings had been published in his lifetime. Instead, the compilers of reference books and other authors had to fall back on considerably less reliable sources, and worse still, they even spread many untruths about Desideri himself.[33]

Why did highly interesting texts, by a scholar who had lived for five years in Tibet and mastered the language himself, disappear into a drawer? It

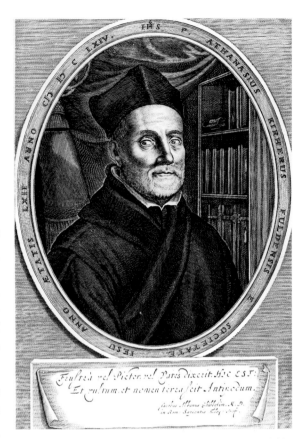

7. *Athanasius Kircher, a genius of compilation, was never in Tibet himself. In his illustrated work with the abbreviated title* China Illustrata *(1667) he used ten detailed letters of Grueber and had some copperplate engravings of scenes prepared.*

appears that Desideri was far ahead of his time in his sophisticated way of looking at things. Apparently there was no demand for learned explanations with complex ideas, such as 'Emptiness', nor for his astonishingly brilliant attempt at translating the mantra 'Om mani padme hum'. It also remains open why Desideri himself was still unrecognized after the discovery of his texts, for example, by the later Theosophists, who constantly referred to Tibetan wisdom but expounded instead many banalities and untruths;[34] or even by Sir Charles Bell and David Macdonald, two Britons who lived a long time in Tibet. We can only conjecture, and after all the assumption cannot be denied, that the Tibet image drawn by Desideri was too subtle and, in the 20th century as two hundred years before, did not fit the current ideas and stereotypes. It appears that the image of Tibet is oriented towards the needs of the public and not to knowledge actually available. This raises the question whether the same still applies today.

The strange other

Particular problems regularly arose, due to practices that stood opposed to our own conception of the world. Thus for example, the question was considered as to whether in fact, as Grueber had claimed,

> the great ones of the kingdom were very eager to be given the feculence (=excrement) of this deity (the Great Lama, Dalai Lama or heavenly father), which they wore neatly around the neck as relics. He said elsewhere that the lamas had great advantage from these important gifts, which the great ones gave them, helping themselves to such excrement or urine. For by wearing the former round their necks, and mixing the latter with their food ... they imagined that they were protecting themselves from all diseases.[35]

The philosopher Immanuel Kant also took up the theme and mentioned in one of his writings:

What certain travellers pretend, that the followers of this faith carry with them the excrement of the lama as a fine powder and sprinkle some of it on their food, may well be merely a libel.[35]

In other places, however, he wonders whether the inhabitants of Tibet perhaps really did consume the great Dalai Lama's bowel movements, as Pallas had confirmed that they sprinkled their food with them and that they complained to him (Pallas) that there was so little of them to have and that little was very costly.[37]

Many authors also commented in detail on the belief in rebirth and 'migration of souls'—as a rule, negatively. Orazio della Penna spoke of a 'foolish notion of the Tibetans';[38] Grueber calls the incarnation of the Great Lama 'a cunning deceit' and 'a deception of the dull minds of the barbarians, who are blinded by this devilish illusion.'[39] In the *General History of Travels on*

8 (below). The Capuchin Francesco Orazio della Penna, who reached Lhasa on 1 October 1716. Orazio della Penna described in detail the religious customs and ideas of the Tibetans, which he often passed judgement on—some positively, others negatively. For example, he found words of praise for the fasting, the great respect and reverence, the 'spiritual exercises' and 'spiritual gathering of the mind', by which he probably meant meditation. However, he felt the 'bizarre worship' was 'horrible and senseless', as the Tibetans offered sacrifices to 'graven images' and 'with this gave their diabolical adulation'.

9 (right). Tibetan Table of Transmigration, from Orazio della Penna's work: 'The places of transmigration, to which (according to their false law) Tibetan souls have to cross over after their departure from life.
A. A loathsome monster, which according to the Tibetan view is a symbol for human deeds ...
B. shows their false god, who is a ghostly emanation from all the Tibetan pseudo-saints together and is supposed to have a material body of nothing but precious gems ...
C. Here is represented the last reformer and re-completer of the Tibetan pseudo-religion, called Sciachia tupha (Buddha Shakyamuni) ...
D. The mother of the aforementioned reformer ...'

In the following passage the six worlds in which a being can be reborn according to the Buddhist view are quite correctly described:
'1. is the first place, to which the Lha ... are translated and dwell for a certain time.
2. The second place, for the Lhamain or demigods, who ... continually have to fight with these Lha ... over the fruit of the Zambú tree.
3. The third place of transmigration, wherein souls live as different animals or beasts in accordance with the form of their crimes ...
4. The fourth is a place of torment for the Ità or tantalized, who suffer pitiful hunger and thirst ...
5. The fifth is Hell; and this consists of eight places of fire and eight of cold; there stands the ruler ... with a mirror, in which the good and evil deeds of every soul are to be seen, and also with a pair of scales likewise ...
6. The sixth and last, also the best place of translation is this world occupied by us, along with the sea and the fishes.'

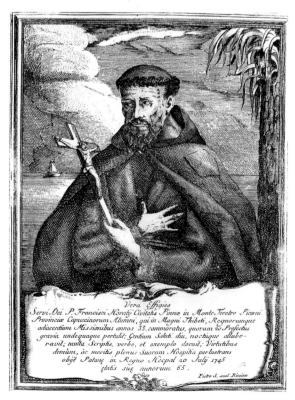

Vera Effigies
Servi Dei P. Francisci Horatij Civitatis Pinnæ in Monte Feretro Picæni
Provinciæ Capuccinorum Alumni, qui in Magni Thibeti, Regnorumque
adiacentium Missionibus annos 33. commoratus, quorum 20 Præfectus
gravia undequaque pertulit; Gentium Saluti diu, noctuque allabo-
ravit; multa Scriptis, verbo, et exemplo docuit; Virtutibus
demùm, ac meritis plenus Suarum Hospitia perlustrans
obijt Patanę in Regno Necpal 20 July 1745
ætatis suæ annorum 65.
Pietro S. scul Rimino

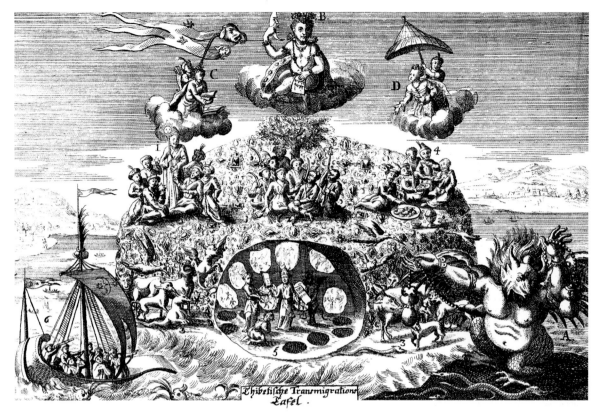

Water and Land the belief in incarnation is called 'superstition' and deceit, against which the 'missionaries' rail vehemently.[40]

Although these reports speak (falsely) of migration of souls, references are in fact found to a subtler and more correct evaluation. Thus Bentink, for example, had already established that 'anyone under the lamas who wants to know better than the others does not believe that souls actually move from one body to another, but only their *capabilities*,' a term that comes much nearer to the Tibetan 'consciousness' than the word 'soul'.[41]

Comparisons and contradictions

One of the first non-clerical Tibet travellers was George Bogle (1746-1781). He was engaged by Warren Hastings, Governor of Bengal, to undertake a journey to Tibet as an agent of the British East India Company, which he began in 1774 at just twenty-eight years of age. Hastings, perhaps the first modern 'Tibetophile' (Bishop), had previously received a letter and presents from the Third Panchen Rinpoche, which he interpreted as a request for a visit. Hastings was interested above all in the question of how trade with Tibet might be promoted. He wanted plant seeds and some animals, and in addition all possible 'wonders' from Tibet, such as natural products, manufactures or art for English 'persons of taste', and information about the people, the land, the climate, the routes for travelling, customs and usages, buildings and cooking; but also about the lands lying between Siberia and Lhasa and between China and Kashmir. Bogle was to keep a record of all this. In preparation he drew up a short summary of the knowledge of Tibet of the time. This document dealt with several topics that we shall encounter again below: comparison with religious practices of the South American Indians of the valley of Quito, 'the highest country in the new continent' (for example, the use of the Dalai Lama's excrement as valuable amulets, probably borrowed from Grueber's report), and a longer note on polyandry. Bogle also treated in advance in his report

> most of the themes that were to fascinate Europeans for the next hundred and fifty years—funerals, dogs, diplomacy, bureaucracy, religion, polyandry, national character, dirt, landscape views and lamaistic power.[42]

From all the wealth of sights he had seen, Bogle—and Turner, who travelled to Tibet eight years later—selected and commented on the things that appeared significant to them personally, on the basis of their own knowledge and interests. They invented a Tibet; they did not actually discover it. Their images of Tibet reflect their own background, their interests and the expectations of their readership. Almost all authors belonged to the same social class, the upper middle class, or were of aristocratic origin, and had far more in common than their different national origins would lead one to suppose. In addition, the fact that as a rule travellers were acquainted with the writings of their predecessors impeded an open, objective encounter with Tibet and its inhabitants.

However, prejudices also seem to have existed on the Tibetan side. Thus the Panchen Rinpoche, who was friends with Bogle, admitted once in a conversation that he had heard much about the foreigners' power. The East India Company was capable of waging war and conquering lands. So it was his task to pray to God, if he were afraid, for the foreigners in his country to leave. But now he had learned that the foreigners were fair and honest people.[43]

The early descriptions of Tibet are marked by a feature we also encounter repeatedly in descriptions of other countries: comparison with the already familiar. The strange and partially inexplicable must be 'translated' into the familiar. So the Tibetans were related to the Egyptians, the Incas, the Indians and Gnostics, and Tibetan Buddhism to Catholicism—comparisons which, as we have already seen, the early missionaries had drawn and which were refined by the Theosophists in the last third of the nineteenth century and applied again and again right up to the present day. Typical examples of the

10 (below), 11 (p. 13). The partly incomprehensible unknown that the missionaries encountered in Tibet had to be 'translated' into the familiar. They compared Tibetan Buddhism with Catholicism and thought they found traces of the Christian religion in it. Among other things, they were of the opinion that the clothing of the Apostles in old paintings was not dissimilar to that of the lamas. This overlooked two points: that the depiction of both the Apostles' clothing and the lamas' arose from the artists' imagination. This is confirmed, for example, by the depiction of lamas (Fig. 10) and that of the Tibetan Regent and his followers (Fig. 11). The cut and pattern of the robes, as well as the hats, reveal plainly the European origin of the artist.

comparison of Tibetan religion with Catholicism are found in the *General History of Travels on Water and Land*:

> Various missionaries have imagined that in the old books of the lamas were traces remaining of the Christian religion, which they believe was preached here in the times of the apostles. Their conjecture is based on the following.
>
> (1) The clothing of the apostles in old paintings is not dissimilar to that of the lamas. (2) They stand one beneath the other in a way quite similar to the holy rule of the church. (3) Some of their ceremonies are similar to Roman ones. (4) They have a concept of incarnation; and (5) certain principles of ethics similar to Christianity. And nothing certain can be said of this, if one does not know well their old books, where only are obtained accounts according to the most learned lamas on the migration of souls. ... Grueber goes much farther. He claims, 'Although no European or Christian had been with them before; yet so agrees their religion in all essential parts with the Roman. They held the sacrifice of the Mass with bread and wine, gave the last rites, consecrated those who wished to marry, prayed over the sick, made circumambulations, honoured the remains of idols [he should have said, of saints], had monks and nuns, sang in choirs like monks, observed various fasts in the year, submitted to very strong penances, and

among others whips, consecrated bishops, and sent forth missionaries who lived in the utmost poverty and travelled the wastes barefoot as far as China. Of all these things,' said Gruber, 'I am an eye-witness.'[44]

Others were obviously moved to disown any similarities between the Tibetan faith and Christianity, because they were of the opinion that it would bring no honour to their own religion to be so closely related to another that

> commits such idolatry, which the Protestant accusation of idolatry against the 'papist religion' would help confirm.[45]

Protestant thinking was not only negative in the face of the 'papist religion', but also had trouble with the 'idol-worship' of the Tibetans. To the most violent critics of the 'religion of the lamas' belonged various philosophers such as Rousseau, Kant, Herder and Nietzsche,[46] all of Protestant background.

These differing judgements mirror the dilemma in which the travellers, researchers and thinkers of that time found themselves: on the one hand, they recognized similarities with Christianity, which they commented on very positively;[47] on the other hand, they were surprised at so much

REGGENTE DEL TIBET.

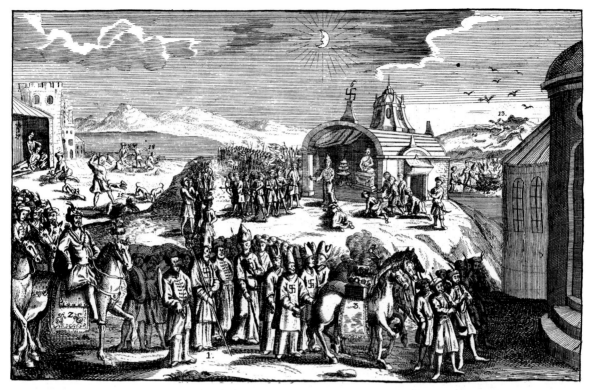

12. Customs of Tibetan Religion. *This picture shows in exemplary fashion the kind of 'customs' the Western public was most interested in and how they were shown in surroundings comprehensible to a Western public. The architecture is Western—a tower with battlements, a vaulted roof that one would never find in Tibet, a church-like building with a suggestion of church windows—as well as the clothing, which in general, apart from small details, is not reminiscent of Asiatic dress. It is striking in how much detail the Tibetan treatment of corpses is portrayed: dismemberment (15), a kind of river burial (18), the cremation of exalted persons (the king and the highest great lamas) (12), 'air burial', the offering of corpses to the birds (13), and the symbolic opening of a dead person's skull so that the consciousness can leave the body ('A cleric pulls out a few hairs from the dying person, to let the soul out.')(14). It is also striking how frequently the swastika ('their cross form') is shown, both on clothing and as an architectural element. Although the Christian background of the artist is discernible in this depiction, for example in the architecture and dress, it is nonetheless evident that the individual scenes are based on observation on the spot—unlike many other early representations of Tibet.*

idolatry, wildly proliferating demonology, occultism and 'law arising out of the priestly religion incompatible with society' (Rousseau). The complexity expressed in the various documents and the contradictions partly showing through, however, accord with the Tibetan reality better than many later reports, especially those of the twentieth century, which, as we shall see, often gush over Tibetan religion without differentiation.

After Bogle and Turner, more than a century passed before another Briton reached Tibet on an official mission. Before this, in 1811, the rather eccentric Thomas Manning had visited Lhasa on a private basis. At that time the image of Tibet was still contradictory: sympathy for the Dalai Lama, the Tibetans in general and the landscape—aversion to the clergy, the dirtiness of the people and the seclusion. The capital, Lhasa, was far from living up to its Tibetan name (City of Gods). Thomas Manning had a particularly negative impression of the city. He found nothing striking there, nothing pleasing, the habitations he found dirty, the streets were full of annoying dogs, stinking, hungry, ill … in short, everything seemed miserable and pathetic.[48] But on the other hand, he was so impressed by his meeting with the seven-year-old Ninth Dalai Lama that he 'could have wept through strangeness of sensation'. Indeed, after the visit Manning even tried to draw the boy.[49]

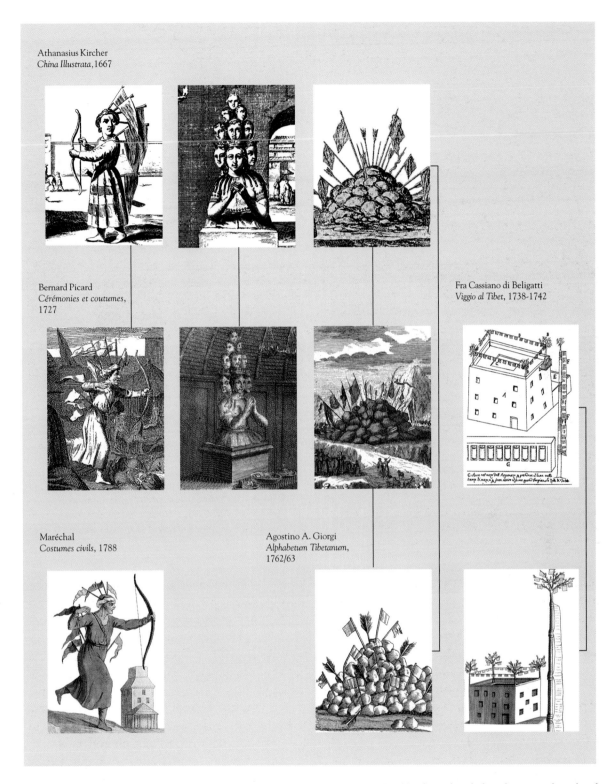

Athanasius Kircher
China Illustrata, 1667

Bernard Picard
Cérémonies et coutumes,
1727

Fra Cassiano di Beligatti
Viggio al Tibet, 1738-1742

Maréchal
Costumes civils, 1788

Agostino A. Giorgi
Alphabetum Tibetanum,
1762/63

13. Pictorial plagiarism: Kircher's China Illustrata *contains an illustration of 'Buth', who is described in the text as brutal and terrible (on certain days he is supposed to kill every person he meets), although his pictorial representation looks quite peaceful. In* Cérémonies et coutumes *by Picard with illustrations by Herrliberger, Buth is found again, this time aggressive and wrathful. This portrayal is copied, relatively faithfully to detail, by Maréchal in his book* Costumes civils, *but with the description generalized to 'homme du Tibet'.*

Kircher's incomplete depiction of an Avalokita (or rather, of a torso of this Bodhisattva) and his picture of a cairn with prayer-flags also found their imitators (Picard/Herrliberger and Giorgi). The last also copied some pictures by a missionary who had actually stayed in the Himalaya and made sketches there, Cassiano di Beligatti (see the illustrations of a house and a large prayer flag).

The search for the source

Around the middle of the nineteenth century, people appear to have been

> obsessed with 'blank spots' or 'gaps' on the map. [They] wanted a world in which everything fitted and had its place, but the plan seemed constantly in danger of being overwhelmed by the plenitude of new discoveries.[50]

To these efforts to get to know the last blank spaces also belonged the search for the source region of every great river, including the Sutlej, Brahmaputra, Ganges and Indus, which rise in Tibet. In addition there was intensive search for the origin of races and peoples.

Csoma de Körösi (1784-1842), who is accounted the founder of European Tibetology, reached West Tibet about 1825 in search of the origin of the Hungarians and their language, and in dictionaries the opinion was put forward that the human race came from Tibet.[51] The Theosophists suspected the area of origin of the Aryans was in Central Asia. The view that Tibet was an important country of origin, however, goes back to at least the eighteenth century.

Kant already said in his geography lectures, written essentially before 1760:

> The discovery of Tybet or Tueb-eth was important. For then we had the key to the ancient history of

the human race. It is the highest land, consequently probably Nature's first workshop, the nursery of creation, the cradle of the human race ... All this appears to prove that the high expanses of the western land, the fatherland of so many animals, were also the first fatherland of human beings ... China, Persia and India got their first inhabitants there. Here or nowhere must one seek the original roots of all the proto-languages of Asia and Europe. From there came the Indian and all of our religion, learning, agriculture, figures, the game of chess, etc.

Kant cited as his principal reason (besides the height), that pilgrimages were always followed in the lands from which the religion in question came. As the Indians went on pilgrimage to Tibet, to the temple in the middle of the city of Lhasa, the origin of their religion was clear.[52] Kant perhaps referred in part to the *Histoire de l'Astronomie Ancienne*, 1775, by Jean S. Bailly,[53] which supported the view that after the outbreak of the Flood some men fled to the high mountains of Asia, whence 'after it was over they were scattered to China, India, Phoenicia, Chaldea, Ethiopia, Northern Europe and so on.' We shall see that the myth that Tibet is the country of origin of certain beings has survived up to the present day via the Theosophists and is today being partially revived in neo-Nazi literature.

Solitude and gold

In the middle of the nineteenth century Tibet for the first time moved clearly into the awareness of a wider public, when in 1851 the account of the two Lazarist priests Huc and Gabet was published in Paris. This book had such great success that the first edition was sold out in a very short time and was immediately translated into English and German.

In the last quarter of the nineteenth century, in non-missionary literature Tibet was able more and more to signify a mountain towering above the sorrows and problems of the world, an island of seekers.

> Lhasa ... would become an *axis mundi*, an opening to the transcendent at the very centre of the world.[54]

Tibet was a dreamland floating above the clouds, in which, in the opinion of many, ancient knowledge was preserved. Helena Blavatsky, the principal founder of Theosophy, and her followers

and admirers have shaped this image of Tibet quite decisively. They gained their knowledge not through their own experience on travels, although they repeatedly claimed so, but through the reading of accounts of travels, compilations and commentaries (among others, Huc and Gabet, Orazio della Penna, Kircher and probably Rousseau, Herder and Kant also), and through the alleged inspirations of Mahatmas, masters living in Tibet. The Theosophists approached Tibetan Buddhism by comparing it with Christianity, but they also recognized its own inherent value. This, however, was conveyed in part in a very corrupted way, as almost any source was employed uncritically. Since these esotericists, such as Blavatsky, Gurdjieff, Trebitsch-Lincoln and others, quite decisively shaped the Western image of Tibet, we shall come back to them again after

Genef: VI. Cap.
Das Schifflin der Kirchen erhalten.

Got his inn Kasten Noe tretten/
Mit seim Geschlecht/vnd was sie hetten/
Von allen Thiren auch ain par/
Das für der Sündflut ers bewar.
Gots Kirch vnd Schar/pleibt jmerdar.

14. After the outbreak of the Flood, in the view of certain European thinkers, survivors fled to the high mountains of Asia, to the Himalaya and into Tibet, whence after the Flood was over they spread into China, India, Phoenicia, Chaldea, Ethiopia, Northern Europe and so on. Some missionaries and later travellers were inspired by the idea that such 'primeval humans' were still living in Tibet, and went in search of them. The myth that Tibet is the country of origin of ancient human races was fostered again by the Theosophists and is today being revived afresh in certain neo-Nazi books.

this general history of the discovery of Tibet and look into their images of Tibet more thoroughly. They also deserve this special attention because two mental currents of the twentieth century that have a particular affinity with Tibet are based in part on Theosophy: National-socialist esotericism on the one hand and the New Age movement on the other.

Before this longer excursion into Theosophy we should like to follow further the later development of the image of Tibet outside Theosophy. After Britons especially had begun to reconnoitre and travel the Alps, the solitude,

wildness and pure air of the Himalaya and Tibet lured mountain climbers and adventurers all the more. The travellers were overwhelmed—with the mountains, with the climatic and geographical extremes of Tibet, and with the timelessness.

The ancient myth of gold enhanced the attraction of Tibet additionally. Herodotus had already written in the fifth century BCE of 'ant-gold', which inhabitants of the northern Indus valley brought down from a sandy plateau in the far north-east. In fact it can be plausibly shown that the 'gold that is dug up by ants' constitutes a fable, which came about through a reinterpretation of the Sanskrit adjective *pipîlika*, whose meaning amounts to 'ant-like [gold]'.[55] Whoever brought the gold to the surface of the Earth, Western Tibet, which with great probability is identical to the western Tibetan land of Shang-

15. The legend that in Tibet ants mine gold and bring it to the Earth's surface goes back to Herodotus (5th century BCE). Whoever brought the gold to the surface of the Earth, Western Tibet, which with great probability is identical to the western Tibetan land of Shang-shung, was regarded as the rich 'Gold-land', in which Britons, Russians, traders and scientists were interested.

shung, was regarded as the rich 'Gold-land', in which Britons, Russians, traders and scientists were interested. Thus in 1867 the British sent the Indian Pandit Nain Singh to the Roof of the World to reconnoitre the largest goldfield, and the Younghusband Expedition (1904) had instructions to follow up any indications of gold deposits.

Lhasa had in the meantime become more and more attractive and developed into a kind of Rome or Mecca of Asia. The city, however, had one great disadvantage: for the British and other Western travellers it remained almost completely closed, while citizens of neighbouring countries were allowed to visit it. Moreover, there were signs that the Russians were gaining the upper hand in the 'Great Game': the Buryat Agwan Dorjieff, who had contact with the Tsar, had become the closest of friends with the Thirteenth Dalai Lama and was in the legendary city of Lhasa. Owing to the unapproachability of the city and the threat looming from the North, the British felt compelled to conquer it. In 1904 they dispatched the Younghusband Expedition to Tibet, which got as far as Lhasa. That the British withdrew again straight after their victory, whereupon the Tibetan government once more cut off their land from outside, reinforced the city's allure. According to Bishop, relations with Tibet and above all Lhasa had something of the erotic about them:[56] Lhasa was a kind of virgin city, and anyone who was able to catch a glimpse of her, even if it was only for a short time and as it were through a keyhole, had the sense of having made a conquest and was deeply satisfied.

The image of Tibet in the missionary literature in the late nineteenth and early twentieth centuries was more obviously sceptical and often emphasized the exotic, strange, eccentric aspects of Tibetan life. The missionaries were obliged for ideological reasons to be critical towards the Tibetan religion, but as we have already seen in the case of Desideri, the critical attitude also has an advantage. Through it aspects of Tibetan culture were revealed that would otherwise have been ignored or that other authors described in fanciful transfigurations. Like the first missionaries, these later missionaries too lived with the local population for a long time, often decades, and many a missionary experienced in that way what 'going native' meant.[57]

Forbidden land of mysteries: antithesis of the West

In the last fifty years of its independence, especially after 1920, Tibet, which despite its attempt at isolation was visited by considerably more people than ever before, became the spiritual refuge for many weary of civilization, critics of materialism, and those who had lost confidence in Western civilization after the two World Wars. A striking alteration in the perception of Tibet took place. Tibet was now the wholly other,

> the most spiritual and inspiring country on this globe …
> perhaps the only light which can guide mankind out of the dark ages of our modern world …
> this forbidden land of mystery, the only place on Earth where wisdom and happiness seemed to be a reality.[58]

Tibet became

> a symbol of all that has been lost to present-day humanity and that threatens to disappear for ever …: the security and stability of a tradition that had its roots not merely in a historical or cultural past but in the innermost being of man,

as Lama Anagarika Govinda (alias Ernst Lothar Hoffmann) wrote.[59] What was going on in Tibet was symbolic of the fate of the entire world. A battle was being played out there between two worlds, a

> battle between man and machine, spiritual freedom and material power, the wisdom of the heart and the intellectual knowledge of the head, between the dignity of the human individual and the herd instinct of the mass, between faith in the higher destiny of man through inner development and faith in material prosperity and an ever-increasing production capacity for worldly goods.[60]

Before this, in 1933, without ever having been in Tibet himself, the novelist James Hilton had already cleverly taken up this yearning for peace and spirituality and given it a home: Shangri-la. He also subtly detected the need of his Western readers for an aged spiritual leader, and bestowed this ideal upon the character Father Perrault. Since the West had been in contact with Tibet, these wise men at the top of the hierarchy had been a source of fascination—the Panchen Rinpoches, the Dalai Lamas or, at the time of the Theosophists, the Masters/Mahatmas or other invented sages. James Hilton incorporated the yearning for a wise guru in a skilful way in his fictional creation.

Tibet was felt as never before to be the positive antithesis of the West, a land with spiritual, moral and peace-loving people, to which Western technology and the associated industrial revolution had not yet been able to spread—and a good thing too, in the eyes of many. Tibet had never opened itself to the West as had, for example, China or Japan. On the contrary, it had defended itself successfully against any influence from outside. For example, the English school that the Thirteenth Dalai Lama opened at Gyantse in 1923 had to be closed again in 1924, a fate shared by Tibet's second English school, opened in October 1944. They had to preserve this place, a place that was actually a non-place (*ou topos*—, lit. 'no place'; Greek, from which Thomas Moore coined the term 'Utopia', in 1516), as obviously quite different laws of space and time applied within it. Utopia had been found and must be saved, and its inhabitants too. Disregarding the few negative portrayals of the bandits to be found in Tibet (interestingly, these are generally identified with the Kham-pas, coming from East Tibet), in the travel literature of the twentieth century the Tibetans have developed into supermen. They are one of the happiest, most cheerful nations on Earth, laughing, always courteous, always honest. Scarcely a word is wasted on the inhuman punishments, the rivalry between the different religious schools, the excesses of the theocratic system, the social injustices, the poor education of most of the Tibetans, or the rites of exorcism, which often served very worldly goals. In short,

> generally the sort of image that we might have expected if the Tibetans had hired a modern American public relations firm!

says Alex C. McKay in his analysis of the British construction of an image of Tibet.[61]

This markedly positive image was lastingly shaped by a small group of around twenty members of the British officer class, who were stationed in Sikkim and Tibet between 1904 and 1949 and were all of similar family background, upbringing and education. They were loyal to the colonial administration of India, which for political reasons wanted to convey a positive image of Tibet: the British were interested in a strong, forward-looking ally and in the development of a Tibetan

national consciousness that fully accorded with the views of the Tibetan government. Such a Tibet must have no weaknesses. Even if a particular British official was not especially taken with Tibet, his negative evaluation would not get out officially.[62] To maintain the positive Tibet image they even resorted to measures of censorship, after William McGovern published some unfavourable comments about Tibet in the 1920s. Foreign travellers to Tibet had to certify in writing that their planned publications would be submitted to the Indian government for censorship,[63] a censorship that the British officials also had to undergo. The person mainly responsible for building a positive image was Sir Charles Bell, who was political officer in Sikkim from 1908 to 1921 and supported the Thirteenth Dalai Lama's conversion of his territory into an independent state.

In the twentieth century the ambivalent evaluation of Tibet finally gave way to a euphoric interest in Tibetan religiousness or in certain of its aspects, if one disregards certain predominantly German-speaking authors in the 1920s and '30s. Besides the interest in the incarnate monks at the top of the Tibetan hierarchy (especially the Panchen Rinpoches and the Dalai Lamas), which was established very early on, this was displayed in the intensive preoccupation with the Tibetan

presentation of after-death experience. The first translation of the Bardo Thödol appeared in 1927 under the title *The Tibetan Book of the Dead*; many more were to follow.

This mystical image came at just the right time for the British officer establishment, reinforcing the positive perception and the intention to stress the autonomy of Tibet. 'Mysticism', said McKay,

added to the positive awareness of Tibet and its unique culture, and the cadre implicitly encouraged it in their writings. ... In the absence of a viable alternative, the image of Tibet they constructed became the dominant historical image followed by Western academics.[64]

This image was maintained for a long time by scientists, and only in recent years did Tibetologists and ethnologists also concern themselves with other aspects of Tibetan culture besides those such as meditation, visualization, ethics and philosophy that are included in Tibetan 'high religion'.

Although in this overview we have already reached the twentieth century, in the next part we shall flash back some eighty years and turn to the Theosophists and their images of Tibet. For a great deal that was said about the reception of Tibet in the twentieth century is only understandable when the Theosophical sources are familiar.

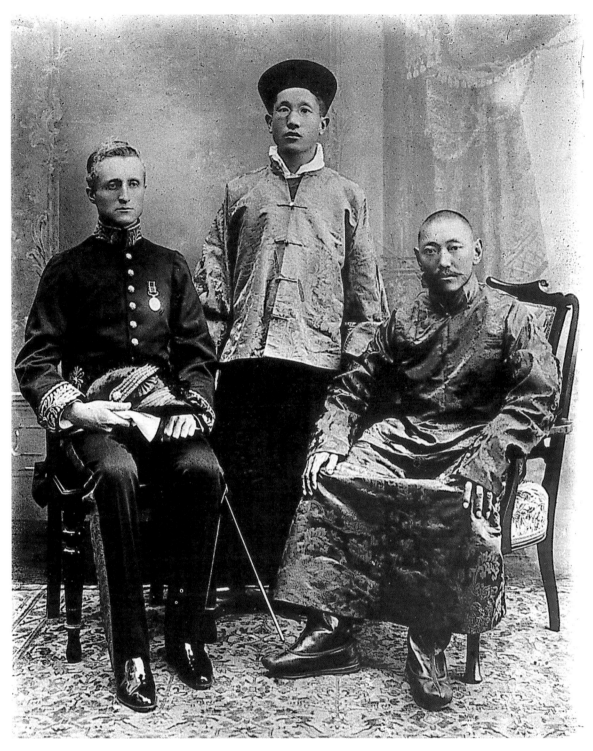

16. *In the first half of the 20th century, a small group of around twenty members of the British officer class, stationed in Sikkim and Tibet between 1904 and 1949, shaped a markedly positive image of Tibet. The British were interested in a strong, forward-looking ally and in the development of a Tibetan national consciousness, which also fully accorded with the views of the Tibetan government. The person mainly responsible for building a positive image was Sir Charles Bell (left), political officer in Sikkim from 1908 to 1921, who supported the Thirteenth Dalai Lama's (right) conversion of his territory into an independent state.*

Part 2

In Search of 'Shambha-la' and the Aryan Lamas

The Tibet images of the Theosophists, occultists, Nazis and neo-Nazis

A. The Theosophists and some of their followers

An Aryan brotherhood

> For centuries we have had in Thibet a moral, pure hearted, simple people, unblest with civilization, hence—untainted by its vices. For ages has been Thibet the last corner of the globe not so entirely corrupted as to preclude the mingling together of the two atmospheres—the physical and the spiritual.[1]

These lines were ascribed to Koot Hoomi, who was said to have belonged to a secret brotherhood in Tibet. Like other supposed 'brothers' in Tibet, he was most closely linked with Helena Petrovna Blavatsky (1831–1891), the founder of Theosophy. The first meeting of HPB (we shall frequently use this abbreviation for Helena Petrovna Blavatsky below) with her 'Master' goes back to the year 1851, but as so often in Blavatsky's biography, there exist various accounts, sometimes contradictory, of this first meeting. Her Master,

17. Master Koot Hoomi Lal Singh, who was said to have been Pythagoras in a previous incarnation and to have lived in Shigatse during Helena Blavatsky's lifetime. Many of the mysterious letters that Helena Blavatsky and other Theosophists received by miraculous means are supposed to originate from him.

called Morya, was a member of an Indian or Nepalese delegation that stayed for some time in London. When she met him, 'a tall Hindu', in London—or according to another version, in Ramsgate—she immediately recognized in him the person who had often appeared to her 'in the Astral', that is to say, in her astral, non-corporeal form. The very next day she met him again in Hyde Park. In the course of this he is supposed to have disclosed to her that he had come to London on an important mission with some Indian princes and wanted to meet her personally, because he needed her co-operation for a task he wished to tackle. He told her at this meeting how the Theosophical Society was to be formed and that he wished HPB to found the Society. Morya also asked her to travel to Tibet and live there for three years, to prepare herself for her important task.[2]

In 1856 HPB travelled to India, because she longed for the Master she assumed was in Tibet. She risked everything to cross the Tibetan border—apparently first from Darjeeling, then also from North-west India via Leh (Ladakh). The attempts were unsuccessful—even if, as some Theosophists were to claim, Blavatsky reached Leh and at best even Mongolia.

In 1868, after Master Morya had again appeared to her in Florence, HPB tried once more to reach Tibet, and in the view of her supporters her efforts were definitely crowned with success, for from the autumn of 1868 until the end of 1870 she lived in the neighbourhood of Tashi Lhunpo Monastery in Southern Tibet. There Blavatsky was received by her Master Morya and one of his friends, Koot Hoomi. According to Blavatsky these two were not Tibetans, but Indians, who knew Europe and spoke English, and Koot Hoomi even French. Morya was a Rajput by birth,

> one of the old warrior race of the Indian desert, the finest and handsomest nation in the world ... a giant, six feet height, and splendidly built; a superb type of manly beauty.[3]

Koot Hoomi, a Kashmiri Brahmin, who had studied in Leipzig, welcomed to his house Tibetan scholars 'who wore the yellow cap of the Gelugpas'. The most advanced scholar was Djwal

Khool, who later achieved fame as 'the Tibetan' at the time of Alice Bailey.

HPB was regarded as the chosen one who was to carry to Europe and the USA the secret knowledge of the sages living the other side of the Himalaya, in Tibet, 'to gradually prepare the way for others'. In a letter ascribed to Koot Hoomi appears:

> This state of hers [Blavatsky's] is intimately connected with her occult training in Tibet, and due to her being sent out alone into the world to gradually prepare the way for others. After nearly a century of fruitless search, our chiefs had to avail themselves of the only opportunity to send out a European *body* upon European soil to serve as a connecting link between that country and our own [Tibet].[4]

In other words, the Masters living in Tibet, 'the custodians of the Ancient Wisdom', had recognized HPB's special abilities and wished to appoint her as an intermediary between Tibet and Europe, just as they had already done before with certain chosen Western men, such as Robert Fludd (Rosicrucian, spiritual father of Freemasonry, 1574–1637), Thomas Vaughan (physician and alchemist, 1622–1666), Paracelsus (1493–1541), Pico della Mirandola (Italian humanist and philosopher, 1463–1494) and Count Saint Germain (occultist and alchemist, 1685–1784). They, like the other chosen, were so-called 'chelas' [Skt/Hindi: servants, disciples], who had declared themselves ready 'to learn practically the "hidden mysteries of Nature and the psychical powers latent in man."' For this a chela needed a guru,

> an Adept in the Occult Science. A man of profound knowledge, exoteric and esoteric, especially the latter;[5]

to whom he had to be totally devoted. In the view of the Theosophists, these 'Masters' or 'Mahatmas' are not gods but simply links with the divine plane. At the top of this strictly hierarchical system reigns 'The Lord of the World', who lives in Shamballa in the Gobi Desert. Under him are his helpers, such as Buddha, Manu and Maitreya, each of whom has a Master as assistant. These Masters are simple, saintly mortals,

> nonetheless morally, intellectually and spiritually higher than all others in this world. However saintly and developed they are, … they are still men, members of a brotherhood that goes back to pre-Buddhist times …,

that is, ascetics who had 'the good Doctrine even before the days of [the Buddha] Sakya-muni' and have lived for time immemorial on the other side of the Himalaya [Tibet]. In prehistoric times they

18. *Master Morya—allegedly a Rajput prince, and in an earlier incarnation Akbar, the great Mogul of India in the 16th century—is supposed to have lived in Shigatse. According to her own statements, Helena Blavatsky met her Master for the first time in 1851. He was a member of an Indian or Nepalese delegation that stayed for some time in London. When she saw him, 'a tall Hindu', she immediately recognized him as the person who had often appeared to her 'in the Astral', that is to say, in her astral, non-corporeal form. Morya revealed to her that she was to found the Theosophical Society, and asked her to travel to Tibet to prepare herself for the important task.*

preferred to remain in their inaccessible and unidentified hiding places, instead of migrating to the South (i.e., India) like others of them. The adepts living in Tibet are linked with those in Egypt, Syria and Europe,[6] and are

> beings who have at their disposal powers far surpassing human measure, and for whom time and space play only a limited role.[7]

The Masters are also supposed to have the ability to materialize themselves, i.e., to 'condense' themselves in a temporary body in far-distant places for a short or a longer time, and then 'evaporate' again. It seems the Masters are exclusively men, although Colonel Olcott, who was very close to HPB, once conceded that there were also women in Tibet with remarkable powers—he had even communicated with them—but he could not say whether they were Mahatmas.[8]

The (fictitious) Tibet journeys of Helena Blavatsky

Although the Theosophists have tried time and again to provide evidence for a long stay by HPB in Tibet—altogether she is supposed to have spent seven years there—it remains beyond doubt, not only that she never lived in the neighbourhood of Tashi Lhünpo, but even that she probably never trod on actual Tibetan soil. There are certain indications that HPB stayed in the region of Darjeeling and reached as far as Sikkim, where she met Tibetans and Bhutanese. From here no doubt came also her evident aversion to the Dukpa[9] and the 'Shammars'—by which she surely meant the Sha-mar-pa, a subgroup of the Ka-gyüdpa. Blavatsky calls them 'the Red Capped Brothers of the Shadow',[10] adherents of the Bön religion, 'a religion entirely based on necromancy, sorcery and sooth-saying'.[11] They would also 'lead Europe's best minds into the most insane and fatal of

19. Helena Petrovna Blavatsky (1831–1891), co-founder of Theosophy, described herself as a 'Thibetan Buddhist', who had already as a child been quite familiar with the 'Lamaism of the Tibetan Buddhists'. She was regarded as a chosen one, who was supposed to carry the secret knowledge of the sages living the other side of the Himalaya in Tibet to Europe and the USA. She was called by her admirers 'the white yogini of the West', 'a messenger of the light' or 'the most remarkable woman of our century'.

superstitions—Spiritualism'.[12] She accused the 'Dugpa' of being sorcerers and damage-causers and of fighting the Gelukpa (the reformed school within Tibetan Buddhism). One of their infamous methods involved leaving at dangerous points of paths 'bits of old rag … impregnated with their evil magnetism' by the Dugpa. When a wayfarer stepped on one, it could communicate to him an enormous psychic shock, so that he might lose his footing and fall down the precipice.[13]

There are many reasons to suppose that HPB did not 'arrive in the forbidden land of Tibet hidden in a hay-cart', to learn Sanskrit from the Masters there and be initiated into occult knowledge. For one thing, there is the fact that none of the quite numerous people who to travelled Tibet had heard of the Indian Masters in the region of Tashi Lhünpo, or indeed seen them. In addition, Blavatsky's descriptions of Tibet are exceedingly rare and superficial, and—the most important argument—the explanations presented as Tibetan by the Masters and HPB are at best reminiscent of Tibetan wise sayings, but are mostly a matter of gross distortions or 'teachings' that have next to nothing in common with Tibetan Buddhism. HPB, who herself claimed that she was a 'Thibetan Buddhist',[14] evaded authentic ancient knowledge without a qualm, when it did not suit her. In Blavatsky's numerology the number seven has quite a special meaning. In Tibetan Buddhism, however, groups of five frequently occur. No problem for HPB: in the case of the five 'Dhyani-buddhas' (actually Tathagatas), she claimed that in esoteric Buddhism there were seven of them. But as she could not deny the existence of five Tathagatas, she explained that this grouping belonged to 'exoteric' (i.e., outer or ordinary) Buddhism.[15] She got round the Buddhist theory of five human 'components' (heaps, Skt *skandha*) similarly: for her the human being was made up of seven constituents or principles,[16] a transitory tetrad and an intransitory triad—a theory she probably borrowed from the medieval secret teachings of Agrippa of Nettesheim and Paracelsus.[17] As evidence that the Tibetan Buddhists also supported this theory, she promptly provided Tibetan and Sanskrit names for the seven

20. *Although the Theosophists have repeatedly tried to produce evidence that Helena Blavatsky stayed for a long time in Tibet, it remains beyond doubt that she never trod on actual Tibetan soil. This is also indicated by this picture, which is supposed to depict the valley in which HPB visited the Masters. The arched gateways on the left of the picture are extremely untypical of Tibet, and the vegetation too—especially the palm-like tree in the bottom right-hand corner—in no way fits Tibet. The prayer-flags typical of Tibetan dwellings are missing, and nowhere can one see a stupa or any other distinctive Buddhist feature, such as a Wheel of the Doctrine flanked by two deer or a mani-wall, as one would expect in a Tibetan Buddhist area.*

constituents, but thereby drew criticism from Indologists, who pointed out discrepancies and errors.[18]

The interpretation of the Master's name also gave considerable difficulty: it suggested neither a Tibetan nor any other Buddhist origin. Morya could if need be be related to (Chandragupta) Maurya, as HPB seems to have suggested, a ruler who was in fact not Buddhist but Jaina. But why should Morya, who Blavatsky said was a Rajput and Sikh, have had a Jain name?

The valley too, in which the Masters or Brothers supposedly lived, is to be found in China rather than in Tibet. There exists a picture of it, which Djwal Khool is supposed to have painted. The style of painting and the architecture recall China, the arched gateways on the left of the picture are extremely untypical of Tibet, and the vegetation too, especially the palm-like tree in the bottom right-hand corner, in no way fits Tibet.

The prayer-flags typical of Tibetan dwellings are missing (a single flag can indeed be made out on the roof of the left-hand house, but it has nothing in common with a Tibetan prayer-flag), and nowhere can one see a stupa (a typical Buddhist religious structure) or any other distinctive Buddhist feature, such as a Wheel of the Doctrine flanked by two deer or a mani-wall, as one would expect in a Tibetan Buddhist area.

One must have a certain sympathy with HPB's position, that the Masters had non-Tibetan names because they were Indians living in Tibet. But what about the teachings transmitted by the sages? If one analyses the letters ascribed to the Masters, as well as some writings by HPB in which she refers to Tibet, the yield is extremely meagre. There is hardly one Tibetan term correctly interpreted, and only a little of the essential content of Tibetan Buddhism is explained. Amongst the allegedly Tibetan terms mentioned now and then are in

21 (above), 22 (p. 29). Helena Blavatsky often lived in her own world, mysterious to those outside, and had trouble distinguishing between reality and her own subjective perceptions. What she experienced in her imagination she interpreted as reality—and this laid the foundation for many Tibet stereotypes of the present day.

particular 'Chohan Lama', the superior of Koot Hoomi, and the books *Kiu-te* and *Dzyan*. Neither *Chohan* nor *Dzyan* is demonstrably a Tibetan word. By *Kiu-te* HPB surely means *rGyud-sde*, the Tantric texts within the *bKa'-'gyur* text collection. She had probably read the term in a text by the Capuchin Orazio della Penna, in which some books called *Khiute* are mentioned. Della Penna said they gave instructions for magical practices and other harmful things and set out the shortest, but rugged and unsafe, way to holiness. The book *Dzyan*, supposed to have been written in the unknown language 'Senzar', was spelled by HPB in the most varied ways (*Dan, Jan-na, Dzan, Djan, Dzyn* or *Dzen*), and the translation of the book title comes out similarly vague also: 'Mystical meditation' or 'Occult (divine) Knowledge'. According to Blavatsky the first volume concerns the 'incredibly ancient commentaries of the seven secret books of the *Kiu-te*', which contained

archaic doctrines concerning the origin and construction of worlds and races. The book, which HPB had allegedly seen in an underground monastery in the Himalaya,[19] forms the basis of her great work, *The Secret Doctrine*, but it has not yet been possible to find and identify it either inside or outside Tibet.[20] As far as the secret language 'Senzar' is concerned, this is supposed to be used by all adepts the world over as a language of mysteries—however, since Helena Blavatsky it has never come to light either in Tibet or anywhere else.

HPB calls the Chohan Lama
the chief of the Archive-registrars of the libraries containing manuscripts on esoteric doctrines belonging to the Dalai and Tashi-lhunpo Lamas ... than whom no one in Tibet is more deeply versed in the science of esoteric and exoteric Buddhism,[21]
truly the Tibetan authority! But where we would expect some clarification about the Chohan Lama, we find instead mystification and obfuscation.

For Blavatsky, 'the Lamaism of Tartary, Mongolia, and Tibet' was the purest Buddhism;[22] in fact, her readers learn about it little that is concrete, and a great deal that is false. Thus in her *Collected Writings* one finds completely untenable interpretations of the word 'Lama' —
'Lama' means path or road in the vulgar Tibetan language
— and the name 'Tibet' —
the land of the Wisdom Deity, or of the incarnations of Wisdom.[23]

In her *Tibetan Teachings* one finds more Buddhist terms, such as Ho-pahme (Öpame = Amitâbha), Bodhisattwa, Alaya Vijnâna and Kwan-yin, but one cannot avoid the impression that they have been noted down by free association and without a plan. And *Tibetan Teachings* is especially concerned with a petty settling of scores with two authors: Arthur Lillie (*Buddha and Early Buddhism*) and Orazio della Penna.[24] If one remembers that in the *Tibetan Teachings* HPB professes to be proclaiming not her own opinion, but that of the venerable Tibetan Chohan Lama, then one inevitably asks oneself whether this most erudite lama had nothing better to do than keep struggling with publications appearing in Europe, and how it came about that he had a good command of a European language.

Evidently HPB settled scores in this way with authors she did not like. That is, she let other

authorities, Tibetan or Indian, speak, so as to feign substance and credibility. Basically it is a matter of HPB's thoughts and words. Was HPB conscious of this? Was she, as has repeatedly been claimed, a confidence trickster? Or was she convinced that others—in this case the Chohan Lama, one of the Mahatmas—were proclaiming their views and using her as a medium to do so? This is a hard question to answer, but there are some indications that HPB suffered from a split personality, of which she was probably not aware. HPB often lived in her own world, mysterious to those outside; had trouble distinguishing between reality and her own subjective perceptions; heard voices; felt she was the object of plots and conspiracies: in short, she had symptoms that are typical of schizophrenia. These schizoid characteristics of HPB's may explain the following passage from a letter from her sister Vera:

> Madame Blavatsky was taken very ill … It was one of those mysterious nervous diseases … Soon after the commencement of that illness, she began—as she repeatedly told her friends—to 'lead a double life'. … This is how she herself describes that state:
>
> 'Whenever I was called by name, I opened my eyes upon hearing it, and was myself, my own personality in every particular. As soon as I was left alone, however, I relapsed into my usual, half-dreamy condition, and became *somebody else* … When somebody else, i.e., the personage I had become, I know I had no idea of who was H.P. Blavatsky! I was in another far-off country, a totally different individuality from myself, and had no connection at all with my actual life.'[25]

In other places HPB describes rather unclearly an 'operation' by which apparently the soul of a living being was released from its body. This operation was carried out by the 'Brothers'— likewise a reference to her split personality:

> They have operated on me, and I once slept for eleven weeks, believing myself to be awake the whole time and walking around like a ghost … without being able to understand why no one appeared to see me and to answer me. I was entirely unaware that I was liberated from my old carcase which, at that time, however, was a little younger. That was at the beginning of my studies.[26]

This could have been an account of the grave illness that HPB suffered in the period of her life about which we possess the most contradictory or very inaccurate information, and in which she was allegedly living in Tibet. Even an author favourably disposed towards her thinks:

> There is a hiatus [in knowledge] between the years following her marriage (July 7, 1849) up to the date of her coming to America to commence her work in the world (July 7, 1873).[27]

This is a period of over twenty years and, note well, the period in which among other things Blavatsky is alleged to have been in Tibet! The first letter from the Masters, a letter addressed to HPB's aunt, Mme de Fadeyev, spoke of her grave illness and at the same time announced that HPB, believed missing, would soon turn up again. In other words: thanks to the Masters, in Tibet HPB became a new person, learnt the ancient knowledge preserved there and was now bringing it to the West. Blavatsky's recovery, Blavatsky's cure, came (allegedly) from Tibet.

The mysterious letters

It is a particularly interesting question how, in the view of the Theosophists, the letters from the Masters reached their recipients, as the mode of transmission provides information on the powers and abilities the Theosophists attribute to the Masters from Tibet. As so often, the Theosophists' answer is nebulous and complex. One theory started from the assumption that the Masters made the letters they had written disintegrate into tiny particles, which joined together into the original document again at the destination. Letters from the sages of Tibet are supposed often to have arrived on HPB's desk overnight by this means, and in many cases the letters allegedly dropped onto the table beside the recipient, 'as it were "out of nothing"'.[28] There is also mention of 'photographic reproduction from one's head',[29] or that the document was moved by the 'transmitter' line by line via the stars, holding his breath until a ringing made it known that the letter had been read and noted down at its destination. According to another view, to be rematerialized in another place the letter had to be burned in a 'virgin flame', lit not by a match, sulphur or any preparation, but by rubbing with a small, resinous, translucent stone, which no bare hand must

touch. As if these interpretations were not enough, in *The Theosophist* in 1893 HPB described the transmission of the letters as:

> a sort of psychological telegraphy … An electromagnetic connection, so to say, exists on the psychological plane between a Mahatma (Master) and his chelas (disciples), one of whom acts as his amanuensis. When the Master wants a letter to be written in this way, he draws the attention of the chela, whom he selects for the task, by causing an astral bell to be rung near him … The thoughts arising in the mind of the Mahatma are then clothed in words, pronounced mentally and forced along the astral currents he sends towards the pupil to impinge upon the brain of the latter. Thence they are borne by the nerve-currents to the palms of his hands and the tips of his fingers, which rest on a piece of magnetically prepared paper. As the thought-waves are thus impressed on the tissue, materials are drawn to it from the ocean of *akasha* (permeating every atom of the sensuous universe) by an occult process … and permanent marks are left.[30]

This description of 'psychic telegraphy' leads us back to HPB's early youth. Every night for six years, from about the ninth to the fifteenth year of her life, the spirit of a Mrs T.L. came to write through HPB in the presence of her father, her aunts and many other people,

> in clear, old-fashioned, curious handwriting and grammar, in German (a language which I had never learned and could not even speak well) and in Russian.

As HPB emphasized, T.L. was not a dead person, as was initially suspected, but was living in Norway. HPB understood herself as a medium not for the spirits of the dead but for the living. The

23. *Helena Blavatsky claimed she was in continual contact with her Masters, living in Tibet. She or other Theosophists, she said, received letters from the Masters, whom she also called Brothers. These letters did not arrive at their destination by normal post, but by supernatural means. One theory assumes that the Masters got their letters to disintegrate into tiny particles, whereupon they reunited into the original document at the destination. Other letters were moved by the 'transmitter' line by line via the stars, until a ringing made it known that the letter had been read and noted down at the destination. On another view, the letter was burned in a 'virgin flame', and rematerialized at the destination. As if these interpretations were not enough, Helena Blavatsky described the transmission of the letters as 'a sort of psychological telegraphy': the Master clothes his thoughts in words and transmits them mentally along astral currents to the receiving pupil. From the latter's brain the thoughts are carried by his nerves to his fingertips, which are resting on some magnetically prepared paper, on which the thoughts are then noted down.*

origins of the mediumistic letter-writing of the 'Brothers' working in Tibet are therefore to be found in HPB's younger days. And it is to be assumed that most of the letters of the 'Brothers' were written by HPB herself. In the view of the Theosophists, however, it was a matter of 'psychic telegraphy', an occult action that the (Indian) sages in Tibet have mastered.

The following passage from a letter to her sister Vera demonstrates what probably 'happened' with HPB when she wrote her letters, or the Mahatmas' letters:

> *Someone* comes and envelops me as a misty cloud and all at once pushes me out of myself, and then I am not 'I' any more—Helena Petrovna Blavatsky—but someone else. Someone strong and powerful, born in a totally different region of the world; and as to myself it is almost as if I were asleep, or lying by not quite conscious,—not in my own body but close by, held only by a thread which ties me to it.[31] However, at times I see and hear everything quite clearly: I am perfectly conscious of what my body is saying and doing—or at least its new possessor. I even understand and remember it all so well that afterwards I can repeat it and even write down *his* words …[32]

We can assume that the Mahatma letters render what HPB saw and heard in moments in which she was—as described above—'outside herself', was someone else, and apparently that 'someone' was one of the Masters. HPB in fact wrote to her aunt:

> It seems strange to you that a Hindu Sahib comes like an intruder … into my house [body] … When his double, or the real Sahib leaves temporarily his vehicle, the body is left in a similar state to that we can observe in a calm idiot. He orders it either to sleep or it is guarded by his men. At first it seemed to me that he pushed me out of my body, but soon I

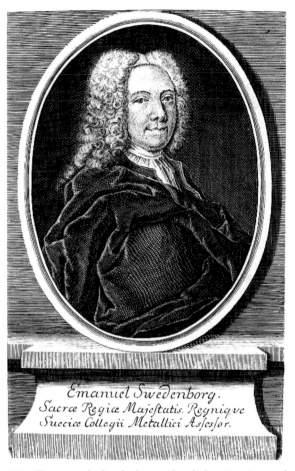

Emanuel Swedenborg.
Sacræ Regiæ Majestatis. Regnique
Sueciæ Collegii Metallici Asfesfor.

24. *Emmanuel Swedenborg (Swedish scientist and mystic, 1688–1772). His writings, in which he claimed that the ancient teaching existed in Great Tartary (Tibet?), also influenced Helena Blavatsky.*

seemed to become accustomed to it, and now during the moments of his presence in me, it only seems (to me) that I am living a double life. I am learning only now to leave my body; to do it alone I am afraid, but with him I am afraid of nothing.[33]

Fascination with Tibet

Why did Blavatsky feel so drawn by Tibet and India? What fascinated her so much? HPB wrote that as a child she was already well acquainted with the 'Lamaism of the Tibetan Buddhists'.

> I spent months and years of my childhood among the Lamaist Kalmucks of Astrakhan and with their high priests … With an uncle of mine … I had visited Semipalatinsk and the Urals, on the border of the Mongolian lands where the 'Terakhan Lama' resided, and made numerous excursions beyond the border and known all about lamas and Tibetans, before I was fifteen.[34]

Apart from this direct contact with 'Lamaists', HPB was undoubtedly strongly influenced by the body of thought of the so-called Rosicrucians, a mysterious secret brotherhood whose supposed founder, Christian Rosenkreutz, is a fictitious character, invented like HPB's Tibetan Brothers.

But where should a brotherhood be established, whose existence began to be doubted when no one ever managed to see them? Sensibly, in a completely isolated, inaccessible place. Tibet seemed suitable, for Heinrich Neuhaus, one of the

25. Although some Theosophical circles disapproved of pictures of the Masters, since they were only interpretations by the relevant artist and in no way lifelike portraits, there do exist some depictions of them. This portrait shows the Tibetan Chohan Lama, Koot Hoomi's superior and another Master who here looks more like an Indian priest than a Tibetan one.

original Rosicrucian pamphleteers, suggested that the Brothers had settled in India and Tibet.[35] Emanuel Swedenborg also (Swedish scientist and mystic, 1688–1772), told his disciples that the ancient teaching was in Great Tartary, where perhaps it could still be found. It is debatable, however, whether Great Tartary actually meant Tibet, or more likely Outer Mongolia.[36]

Blavatsky must have taken up and extended these theories. She was certainly also strongly influenced by English occult novels, especially by Edward Bulwer-Lytton (English novelist, 1803–1873), whose work she knew well, and by Eliphas Lévi (Alphonse-Louis Constant, well-known French occultist and esoteric writer, 1810–1875). W.E. Coleman was able to prove that HPB copied from around a hundred books, which mainly had as their subject ancient and exotic religions, teachings on demons, Freemasonry and spiritualism.[37]

'Ever on the lookout for occult phenomena,

hungering after sights,'[38] Blavatsky was extremely fascinated by the marvels that were attributed to the Tibetans among others. Thus, for example, she was familiar with the account of Huc and Gabet (whom she seems otherwise not to have liked very much) that in the monastery of Kumbum in North-eastern Tibet there stands a legendary tree that goes back to the year the reformer Tsong-kha-pa first had his head shaved, at the age of three, and displays a Tibetan letter on every one of its leaves. She sharply dismissed the critics of this legend—without having seen the tree or its leaves herself.[39]

Blavatsky also wrote with pleasure of the child prodigy, a claimed incarnation whom she is supposed to have met 'about four days journey from Islamabad,' apparently in Ladakh. This infant of three or four months, who was placed on a bit of carpet in the middle of the floor, suddenly jerked upright and then stood on his feet 'erect and firm as a man', and spoke the words: 'I am Buddha; I am the old Lama; I am his spirit in a new body.'[40] Even a perpetually carping and doubting sceptic, a positivist, learned better through this experience …

HPB believed the ability to undertake aerial journeys in one's own 'astral body' was particularly developed in Tibet; she was convinced of the phenomenon of levitation, the neutralization of gravity and as a result of this the floating of the body, and wrote of the proverbial longevity of many lamas, which was put down to their using a chemical compound that 'renews the old blood', as the lamas themselves put it.[41] We shall see that all these occult abilities that Blavatsky attributed to the Tibetans belong even today to the stock caricature of Tibet. They have survived up to the present and been 'reincarnated' in, for example, comics, feature films, novels and advertising.

Blavatsky's familiarity with 'Lamaism',[42] going back to her childhood, the theory already current of a brotherhood living in Tibet and India, and the Tibetan legends, which contain much that is occult and mystical, may explain why HPB was so interested in Tibet and described it as the place of origin of the ancient wisdom. In the face of this enormous interest in Tibet it is astonishing that only three or four Tibetans actually appear in Blavatsky's writings: the Chohan Lama, Tendup Ughien, Djwal Khool (whose nationality is

in fact disputed) and, in the inaccessible distance, the Panchen Lama. This led Poul Pedersen to the conclusion:

> that there were no Tibetans on the global religious and spiritual scene where the Theosophists were acting ... Tibet and the Tibetans were, in the Theosophical teaching, purely imaginary objects, all made up from various sources ...[43]

Alice Bailey and 'the Tibetan'

Not only did H.P. Blavatsky refer to Tibet and Masters living in Tibet, but one of her female followers, Alice A. Bailey (1880–1949), also had contact with the Masters and after 1919 even had an allegedly genuine 'Tibetan' as a permanent companion in life.[44]

Bailey had her first meeting with a Master—at that time it was just the Indian Koot Hoomi—when she was fifteen.

> The door opened and in walked a tall man dressed in European clothes ... but with a turban on his head ...
>
> As the years went by I found that at seven years intervals (until I was thirty-five) I had indications of the supervision and interest of this individual. ... I found that this visitor was the Master K.H., the Master Koot Hoomi, a Master Who is very close to the Christ, Who is on the teaching line and Who is an outstanding exponent of the love-wisdom of which the Christ is the full expression.[45]

In November 1919 she came in contact for the first time with her personal Master. Bailey was sitting on a hill,

> and then suddenly I sat startled and attentive. I heard what I thought was a clear note of music which sounded from the sky, through the hill and in me. Then I heard a voice which said, 'There are some books which it is desired should be written for the public. You can write them. Will you do so?'[46]

Bailey declined. After three weeks she was spoken to again and let herself be persuaded to try for a few weeks. The few weeks turned into over twenty-five years.

Who her personal Master was remained for a long time a closely kept secret, until Bailey herself first published his name: it was Djwal Khool, 'the Tibetan', the former disciple of Koot Hoomi, who was supposed to have lived as his teacher near the monastery of Tashi Lhünpo in southern Tibet.

Bailey did not think of herself as the author of her books, but would simply 'register and write down the thoughts ... as He dropped them into my mind.' The protagonist was 'the Tibetan', and Bailey saw herself as his helper and secretary. As Bailey feared she could be injured through this activity, she turned to her Master K.H., who however reassured her: it had been he himself who had suggested Bailey to the Tibetan. Since her discussion with K.H., Bailey wrote many books for the Tibetan and over the years developed their own technique of—telepathic—communication. The final responsibility for the texts, however, as Bailey could not emphasize enough, lay with the Tibetan.

> After all, the books are His, not mine, and basically the responsibility is His ... I have published exactly what the Tibetan has said.[47]

Although Bailey called him Tibetan, what he allegedly dictated had little Tibetan about it. No work of Bailey contains Tibetan teachings or allows a Tibetan to be recognized as its author.

Who was Alice Bailey?

> A quite unimportant woman who was forced (usually against her will) by circumstances, by an actively intruding conscience, and by a knowledge of what her Master wanted done, to undertake certain tasks,[48]

Bailey once said of herself. Bailey was a victim of the strict Victorian age,

> a life of discipline, rhythm and obedience, varied occasionally by spurts of rebellion and consequent punishment.[49]

She suffered from the dogma that the world was divided into two parts,

> into those who were Christians and worked hard to save souls, and those who were heathen and bowed down to images of stone and worshipped them. The Buddha was a stone image; and it never dawned on me then that the images of the Buddha were on a par with the statues and images of the Christ in the Christian churches ... I was in a complete fog. And then—at the height of my unhappiness and in the very middle of my dilemma and questioning—one of the Masters of the Wisdom came to me.[50]

Bailey had found deliverance from 'the narrowest kind of Christianity' in the form of a Master from distant Tibet, who was later to be joined by a real Tibetan. Her deliverance came from Tibet.

The Theosophists' image of Tibet

Theosophy and Tibet are fatefully linked together: essential Theosophical teachings were supposed to have come from Tibet; Blavatsky claimed to have studied the occult knowledge of an age-old wisdom teaching in Tibet; she described herself as a Tibetan Buddhist; the Mahatma letters, so important for the development of Theosophy, came from Tibet (in fact, most were written by non-Tibetans); the book *Dzyan*, which formed the basis of *The Secret Doctrine*, was according to HPB a Tibetan book; and HPB's followers referred to Tibet again and again. Without Tibet Theosophy would scarcely be conceivable. But what sort of image of Tibet did the Theosophists have? It was a Tibet without beggars 'nor people dying from hunger', where 'drunkenness and crime are unknown, as well as immorality', a Tibet with 'a moral, pure hearted, simple people,' untainted by the 'vices of civilization'; a land where 'the two atmospheres, the physical and the spiritual,' still existed side by side and together; a land in which the people were so honest that the shopkeepers would return to their unlocked shops to find all their wares untouched—or money on the counter for articles taken.[51] Tibet, 'the very land of mystery, mysticism and seclusion',[52] occult, shrouded in mystery; where 'the custodians of the Ancient Wisdom' evoke 'powers and potencies which are at present not only unknown to the Western world, but are dormant as well';[53] a region where 'the atmosphere and human magnetism [are] absolutely pure and—no animal blood is spilt';[54] in short, an imaginary, transfigured, utopian and unreal Tibet, which HPB wished fate might protect from the charity of civilization and especially from missionaries. This Tibet, as we know today, had little in common with the actual Tibet.[55]

The special achievement of Theosophy did not, in today's view, lie in the transmission of detailed knowledge about Tibet or other countries and religious traditions, for 'such a mixture of unbelievable rubbish and inane esotericism' (Bharati) was not suited for that. Its value lay in demonstrating that there were entirely different and remarkable ways of living and thinking besides the puritanical Victorian lifestyle and Christianity—not only in Ancient Greece or Egypt, but also in Asia, in far-off Tibet among other places. Theosophy made it possible to break

out of the tight corset of the Victorian age. It demonstrated alternatives, for example in the field of ethics, that were taken up again around a hundred years later by the New Age movement and pursued further. Then all of a sudden, in place of far distant Masters telepathically imparting (allegedly) Tibetan knowledge to the West, there were real Tibetans standing in front of you. Now meeting a Master was no longer the exclusive privilege of a Helena Petrovna Blavatsky, but every Tom, Dick and Harry had the chance of hearing from an authentic mouth what HPB had transmitted in garbled fashion. The Masters now revealed themselves to every seeker.

Theosophy did not only demonstrate alternatives to Christianity, but was also a 'revolt against positivism'.[56] Not only what was scientifically secure should be valid, but also such 'self-evident truths' as rebirth and the theory of karma, a 'belief' also adopted by the New Age movement of the 20th century, which has many

26. The achievement of Theosophy did not lie in the transmission of detailed knowledge about Tibet. Rather, Theosophy demonstrated that there existed quite different ways of thinking that were worthy of consideration, besides Christianity—especially in Asia. Thus the social reformer Colonel Olcott helped Buddhism in Sri Lanka (Ceylon) get new blood and thereby strengthened the process of shaping a national identity.

similarities with Theosophy.

Another achievement of the Theosophists—particularly of the social reformer Colonel Olcott—that should not be underestimated was that in Sri Lanka (Ceylon) they helped Buddhism gain new blood and thereby strengthened the process of shaping a national identity. Olcott and Blavatsky's visit to Ceylon in 1880 thus became a significant event for the Buddhists of Ceylon. For the first time, members of the then ruling race came to the country, who were not spreading the Christian faith but wanted to promote the Buddhist religion. The ensuing foundation of the 'Buddhist Theosophical Society'—which actually had very little 'Theosophical' about it and stood instead for a new type of Buddhism—contributed considerably towards stemming the influx of Christian schools into Ceylon.[57]

In general, Theosophy knew how to break down prejudices with regard to Hindus and Buddhists in India and Ceylon and to demonstrate that there were also other religious options besides Christianity. Or, in the words of the Indologist Glasenapp:

> Despite all criticism of the frequently chaotic fantasy and the strange outward history of the Theosophical Society, it must on the other hand be granted that even with the imperfections attaching to them, they brought home to wider circles in the West, for the first time and with great success, Indian trains of thought and Indian books such as the Bhagavadgîtâ—circles that would never have been reached by more scientifically sound and less sensationally presented works and endeavours.[58]

And according to Pedersen, the Theosophists did not only strengthen the interest of the West in Asiatic religions and philosophies:

> Perhaps more important was their introduction of Western interpretations of Eastern traditions to the educated Asian élites.[59]

Roots of racism

Blavatsky, like other Theosophists also, encouraged a racist body of thought—connections that have scarcely been examined up to now.[60] The basis of this racist doctrine was a theory of evolution, getting its bearings from Hinduism and Buddhism, according to which living beings develop from a lower state to a higher (with temporary steps backwards being part of the norm), over extremely long periods of time, until the most highly developed state is reached, after which a cycle starts again from the beginning.

In this Theosophical evolutionary plan, the majority of human beings alive today—Chinese, Malayans, Mongolians, Tibetans, Hungarians, Finns and Eskimos—belong to the 'Fourth Root-Race'.[61] In this period of the fourth root race, in which the miraculous power 'vril' was developed, the islands of Atlantis and Lemuria were submerged, along with a great many living beings. A few chosen people, however, escaped this great catastrophe and reached a beautiful island in the Central Asian sea of that time, which lay where the Gobi Desert is today, and corresponded to 'the "fabled" Shambhallah'. The island could not be reached by sea, but there were underground passages, known only to the highest, that led in all directions. At the same time,

> some of their accursed races, separating from the main stock, now lived in the jungles and underground ('cave-men'), when the golden yellow race (the Fourth) became in its turn 'black with sin.' ... The demi-gods of the Third had made room for the semi-demons of the Fourth Race. ... the White Island had veiled her face. Her children now lived on the Black land ...[62]

During this 'degeneration of mankind' the nucleus of the fifth root race was formed in Shambhala (for around a million years). The first subrace of this fifth race was formed by the Indian Aryas, and the fifth and therefore higher subrace was the whites.

In the course of the degeneration of the fifth root race, which will begin in the middle of their cycle, will arise the sixth root race. They will live once more on Lemuria and Atlantis, which will have risen again, purified.[63]

> Each root-race reaches its evolutionary maximum at its midpoint, when a racial cataclysm occurs and the race begins to decline. At the same time the seeds of the succeeding root-race appear, and the new root-race in its infancy begins to run parallel with the race that is declining, so that there is continual overlapping.[64]

According to this theory, at the moment the Aryan whites and the Indian Aryas clearly stand at the highest point in the hierarchy of evolution. They are above the descendants of the fourth root race, who are apparently also subdivided into higher (Chinese, Tibetans, etc.) and lower spheres (who are 'black with sin'). This racism supported

by Theosophy still more clearly pervades the following passage from a letter, supposedly written by Koot Hoomi (but probably by Blavatsky):

> I told you before now, that the highest people now on earth (spiritually) … are the Aryan Asiatics; the highest race (physical intellectuality) is … yourselves the white conquerors. The majority of mankind belongs to … the fourth *Root race*,—the above mentioned Chinamen and their off-shoots and branchlets (Malayans, Mongolians, Tibetans, Javanese, etc., etc., etc.) …—and the seventh sub-race of the third race. All these, fallen, degraded semblances of humanity are the direct lineal descendants of highly civilized nations neither the names nor memory of which have survived …[65]

Among these 'inferior races', HPB also counted the Australian aborigines and some African and Oceanic tribes,[66] who were regarded as 'wild' in contrast to the highly cultivated and civilized. Her racial theory was somewhat qualified, in that even the Africans could 'form the bulk of the civilized nations', if Europe were to disappear and they gave up their isolation and were scattered on the face of the Earth.[67]

The doctrine of racial development sketched here, supported by HPB, was a strong impulse for Ariosophy, a kind of 'Germanized Theosophy, whose core is a dualistic doctrine of race'.[68] Thus for example, Guido von List (1848–1919), influenced by HPB's *The Secret Doctrine*, combined *völkisch* ideology with occultism and Theosophy.[69] Jörg Lanz von Liebenfels (1874–1954) too was intensely preoccupied with the Theosophist racial doctrine, which, he said, plausibly demonstrated that the heroic Aryas mistakenly got mixed up with animals, through which the original races, the Chandalas, arose,

> who are therefore so dangerous, because they have blond-blue blood in their veins, and that is why the Asiatic race became so dangerous an enemy.[70]

Pennick leads us to the topic of Tibet once more, when he mentions the reasons why, in his opinion, the Theosophical writings contain many seeds of the Nazis' racist ideology:

> Both the Theosophists and the Nazis had connections with Tibetan esoteric schools, so it is not surprising that we find similar themes in both systems.[71]

Tibet therefore once again becomes the place of origin of an abstruse ideology, in this instance, indeed, an ideology contemptuous of mankind. The perfidy lies in the fact that this myth is disseminated in a book whose author claims in the introduction to belong to the guild of professional historians.[72]

But to return to the Nazis: we shall see below that some Nazis, prompted by the Theosophists, tracked down the origin of the Aryan race in Asia—whether actually or only in the fantasy of the neo-Nazis remains for the moment an open question—which will lead us into the undergrowth of the legends about Thule, Atlantis and Shambhala.

We shall also pursue the question of whether an (ultimately) racist theory of evolution does not lie at the bottom of the positive image of Tibet so widespread today, assigning Tibetan culture to the so-called high cultures and thereby to a supposedly higher stage of human development.

And if the Theosophical influence on the precursors of National Socialism is a fact, should Blavatsky's writings not be condemned here in their entirety? It should simply be shown how HPB's Theosophy influenced National Socialist esotericism, *völkisch* occultism and likewise National Socialism's racial theory. We can also not hide the fact that in later documents of Theosophy it says their goal is to form a universal brotherhood of mankind, without distinction of race, faith, sex, social stratum or skin colour, but this formulation dates from the year 1896,[73] that is to say, it was written down five years after Blavatsky's death. It is not included in the original code of rules from the time of the foundation of the Theosophical Society in 1875.[74]

As already mentioned, Jörg Lanz von Liebenfels also allowed himself to be demonstrably influenced by Blavatsky in his 'sexo-racist gnosis'.[75] In one important point, however, Blavatsky differs from Lanz von Liebenfels: Blavatsky also dreamed of a new race, but she saw its source not in Germany, nor in an 'Aryo-Christian area', but in America. 'When shall this be?' she asks in *The Secret Doctrine*:

> Who knows save the great Masters of Wisdom, perchance, and they are as silent upon the subject as the snow-capped peaks that tower above them.[76]

The Tibetan sages also apparently know more than anyone else about this secret.

Helena Petrovna Blavatsky, who was called by her admirers 'the white yoginî of the West', 'a messenger of the light', or 'the most remarkable woman of our century',[77] influenced not only

National Socialist occultists but also a number of personalities seriously interested in religion, and left her mark on their Tibet images: Alexandra David-Neel, W.Y. Evans-Wentz, Lama Anagarika Govinda and, in particular, Nicholas Roerich. Donald Lopez said of them that:

> First, they mystified Tibet, embellishing the realities of Tibet with their own mystical fancies, and, second, they mystified their readers, playing on the credulity of the reading public.[78]

When Lopez speaks of playing with the public, he is suggesting that the authors in question deliberately sought to deceive their readers, an assessment that will not be shared here. However, I am in agreement with Lopez that these authors did introduce their own mystical fantasies (also) into their works and drew, at least in places, a greatly transfigured image of Tibet. This can be shown clearly from Nicholas Roerich.

Nicholas Roerich: dualistic Tibet

Nicholas Roerich (1874–1947) who was a painter, created original stage properties and wrote books on art, culture and philosophy. He also undertook extended expeditions to Russia and Central Asia, including Tibet. Roerich initiated a pact for the world-wide protection of cultural assets, especially in wartime, which served as the foundation for the 'Hague Convention of UNESCO for the Protection of Cultural Assets in the Event of Armed Conflict' (1954). Like his wife Helena, he had a great interest in Theosophy—and just as great in Tibet, as is confirmed (in place of other statements) by the following passage from a letter that Roerich wrote in 1939 from the Kulu valley, India, to Boris de Zirkoff, Blavatsky's great-nephew:

> While I write these lines to you, before my eyes out there in the distance tower the snow-covered peaks and the high pass to Tibet, as mute witnesses to those eternal truths that spiritual renewal shelters within itself and with them the possibility of the highest perfection of the human race. The Great Masters are always ready to help. But as so often, men turn away from this help.[79]

Roerich accordingly suspected, like Blavatsky, that there were 'eternal truths' to be found in Tibet, secret teachings which were waiting to be discovered and translated. He was also convinced of the existence of great masters residing in Tibet, with whom he was in contact, and who—by using Roerich—intervened in the fate of the world. They supposedly wanted to unite Buddhism and Communism in a new system and on this basis form a great oriental federation, and Roerich was to help them with this. The bearer of hope for this pan-Asiatic vision was the Ninth Panchen Lama, who according to Roerich was the spiritual

27. Blavatsky left her mark on the Tibet images of several personalities seriously interested in religion, for example on that of Nicholas Roerich (depicted here), who felt the Shambhala myth particularly spoke to him. Nicholas Roerich (1874–1947) was an artist, writer and explorer. Like Blavatsky, he suspected there were 'eternal truths', secret teachings, to be found in Tibet. He was also convinced of the existence of great Masters, residing in Tibet, who intervened in the fate of the world. They supposedly wanted to unite Buddhism and Communism into a new system and to build on this foundation a great oriental federation, and Roerich was to be of assistance to them in this. Hope for this pan-Asian vision rested on the Ninth Panchen Lama, who was—according to Roerich—the spiritual leader of the Tibetans, and after his return from Inner Mongolia would be the sole ruler of Tibet, ousting the then Thirteenth Dalai Lama.

leader of Tibet and after his return from Inner Mongolia would be the sole ruler of Tibet, which meant the then Thirteenth Dalai Lama was to be ousted.

The antipathy towards the Dalai Lama had substantial grounds: in 1927, Roerich had tried to reach Lhasa from Nagchuka, with his wife Helena and their son George. He and his people had to overwinter in Nagchuka for around five months, under unspeakably harsh conditions, to receive in the end in March 1928 the order to travel direct to Sikkim. This ruling was no doubt pronounced only after consultations with the British, who had built up good relations with the Dalai Lama and his government and were extremely sceptical towards Roerich.

Roerich's pan-Asiatic vision probably had its roots in the Shambhala myth, which he had possibly become acquainted with through Agwan Dorjieff (c. 1850–1938). The latter was one of the Thirteenth Dalai Lama's close Buryat Mongol friends sympathetic to Theosophy, who also had relations with Tsar Nicholas II. During a visit to the Ninth Panchen Lama, Dorjieff had received a copy of one of the Shambhala texts going back to the Third Panchen Lama and since then was convinced by the idea that the age of Shambhala

was just round the corner.[80] This opinion was obviously Roerich's also. What he reported in his book *Shambhala—The Secret World Centre in the Heart of Asia*, about that hidden realm lying somewhere in Central Asia, must have been told him by a lama. The tale is much more reminiscent, however, of a tall story that at best shows the hand of Dorjieff. According to Roerich, the king of Shambhala is portrayed as always vigilant, all-seeing, all-knowing, helpful and immensely rich, his thoughts extend to far-off regions and his brightness eliminates all darkness.[81] In glaring contradiction with the traditional Tibetan view, the people of Shambhala occasionally go out into the world to meet Shambhala's earthly collaborators—as a rule, unknown to 'normal' people. Even the king is supposed to appear sometimes in human form, especially in holy places such as monasteries. The messengers of Shambhala travelling in the world and the location of its 'ashram' in the neighbourhood of the Tibetan city of Shigatse clearly reveal Blavatsky's hand. It gets quite confused when in Roerich's story the lama connects 'the teaching of the Great Fire (Agni)' with the Shambhala myth. In thoroughly Theosophical style, Hindu, Manichaean and Tibetan Buddhist bodies of

28. Path to Shambhala, *a painting by Nicholas Roerich. For Roerich, the world was divided into two, light and darkness, enlightenment and superstition. The embodiment of the light world was for him Shambhala, which he supposed lay behind the high mountains of Tibet. There dwelt an ever-watchful, all-seeing, all-knowing, helpful and immensely wealthy king, whose power of light annihilated all darkness.*

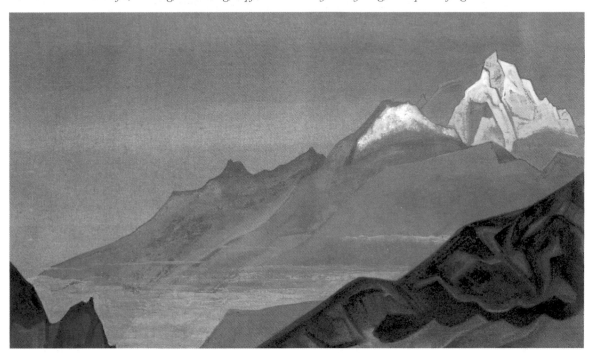

thought are here blended together: the lama refers to Moses and the Kabbalah as if Tibetan monks were universal scholars.

To conclude from these accounts that for Roerich Tibet was nothing but brightness and light would be a misapprehension. For him the world was dualistic and polar:

> As in any country, so too in Tibet there are undoubtedly two kinds of consciousness: one enlightened, developing—the other dark, prejudiced, hostile towards the light.[82]

Of the latter, Roerich is unsparing of criticism. He speaks of low shamanistic practices, of lethargic pilgrims who free themselves from any expenditure of energy thanks to their prayer wheels. He criticizes that the monasteries' storerooms are stacked to the rafters with the corpses of sheep and yaks slaughtered for the monks.[83] He gets worked up about the dirtiness of monks and monasteries, so-called miracles, deceptions, lies, betrayal, superstitions and loathsome deeds—constantly asking what this has to do with Buddhism. Roerich sees clearly that what he criticizes so much in Tibet belongs to Tibetan life just as much as the so-called light sides—knowledge, truth, fearlessness and compassion. Like so many Tibetophiles and Tibetomaniacs, he holds an evolutionary world-view. He distinguishes those with whom he 'can meet in trust and friendship and speak of the most exalted subjects in the peace of the evening twilight in the mountains' from the godless, the superstitious, shamans and Bönpos.

In Roerich it is shown in exemplary fashion how subjectively Western man encounters Tibet: before the first meeting with Tibetans, he already forms an image of the 'true' and 'correct' Buddhist. When it then comes to an actual meeting, he will try to make the real Tibet agree with the imaginary one. If he succeeds, the person in question is superior and enlightened; if not, he is ignorant and has not taken part in evolution. One's own ideal as the yardstick for the other's development!

From a present-day point of view, many of the exuberant statements of Blavatsky's followers seem unbelievable, or often even amusing. Their theosophically moulded interpretations are for the most part outdated, and sometimes altogether false. Tibet was never the land of Shambhala, as it was painted by the Theosophists, their followers, and later the neo-Nazis also. No Aryan lamas lived in Tibet.

Was Jesus in Tibet?

Helena Blavatsky still has followers today, over a hundred years after her death. For example, Benjamin Creme, to whom—so his disciples relate—one January night in 1959, as he was getting out of the bath, spoke an inner voice of a Master living in the Himalaya. After several weeks' training in telepathy, Creme was spoken to by the Master of all the Masters, Maitreya Himself, the Christ and World Teacher, who told him:

> I Myself am coming, in about twenty years, and you may play a role in My Coming if you so choose.

Creme inwardly consented to this proposal, but was not concerned about the prophecy for many years. His training continued under his master's direction until the early '70s, when he was preaching to a sceptical world the return of Christ one day. Creme was now a 'window on the world' for his master. As he explained:

> Everything I see and hear, he sees and hears. When he wishes, a look from me can be a look from him; my touch, his. So … he has a window on the world, an outpost of his consciousness; he can heal and teach. He himself remains, in a fully physical body, thousands of miles away.

Christ began his Descent on 7th July 1977, not from 'heaven' but from the heights of the Himalaya. As Creme put it:

> At the end of the world, when the whole world is disintegrating, [Christians] expect [the Christ] to come down on a cloud into Jerusalem. They think He is sitting up in heaven but the Christ has been no nearer 'heaven' than the high Himalayas, 17,500 feet [5330 metres] up, for the last thousands of years. And it is from there that He comes into the world, not from this mythical heaven.[84]

After a few days of acclimatization on the plains of Pakistan, the World Teacher boarded a flight to Heathrow, and on 19th July 1977 began living as a perfectly ordinary man in the Indo-Pakistani community of London. Since then he has devoted himself—incognito, i.e., without making known his true nature—to political, social and ecological problems.[85]

The Masters from Tibet seem to be adaptable

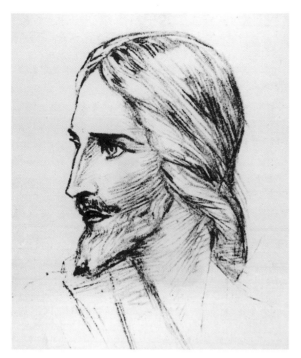

29. A Theosophical portrayal of Christ. According to Benjamin Creme, after his death Christ did not live in heaven but in the Himalaya, at an altitude of 5330 metres. After coming down from the Himalaya in July 1977, he boarded a flight from Pakistan to Heathrow. On 19th July 1977 he began living as a perfectly ordinary man in the Indo-Pakistani community of London, and since then has devoted himself—incognito, i.e., without making known his true nature—to political, social and ecological problems.

(or idle?): at the time of Helena Blavatsky, and again eighty years later when Lobsang Rampa was working, they acted only 'astrally', from one place to another; today they use any practical means of locomotion that the modern world they reject has to offer. Nevertheless they appear not to have lost their superhuman powers: according to Creme, Maitreya-Christ, coming from the Himalaya, is supposed through his positive energies to

> stand behind the apparently sudden changes of the day, from the fall of the Berlin Wall to the massive disclosures of scandal in the West

(Creme leaves it open what he understands by that). In addition he devotes himself to social and ecological problems—well lobbied by an international organization, the Share International Foundation in Los Angeles.[86]

When Creme relates Tibet to Christ, he is by no means alone in this. About a hundred years before, someone claimed that Christ had already been in Tibet: Nicolas Notovitch (1858–?), a contemporary of Helena Blavatsky. His book *La vie inconnue de Jésus-Christ* appeared in 1894, in which he explained that Christ had lived for about

fifteen years in the East.[87] Notovitch had allegedly heard in 1887, on his journey to India and Ladakh, that in the archives of Lhasa there lay an ancient document about the life of Jesus Christ, of which there were copies at great Tibetan monasteries, including Hemis Monastery in Ladakh. After some toing and froing, Notovitch said, the head of Hemis brought out the Tibetan text and read out to him the passages that were about the life of Christ and let him translate. All the high religious dignitaries to whom the Russian read the translation—the Metropolitan of Kiev, two cardinals and a well-known philosopher—advised him against publishing this supposedly sensational 'discovery'. But Notovitch would not be stopped and published his text first in French and then, reworked, in English.

Notovitch claimed, very wisely referring always to the lama he had allegedly met at Hemis Monastery, that the texts in which the life and works of Issa (Jesus) were described reached Tibet from India and Nepal. According to these texts, Jesus left Jerusalem when he was about fourteen years old and travelled with merchants in the region of the Indus (Sindh), where he settled down among the Aryas with the intention of perfecting himself in the laws of the great Buddha. After that Jesus crossed India and arrived in the Himalayas, in the region of present-day Nepal, where he devoted himself to the study of Buddhist texts. Eventually as an itinerant preacher he made his way back to the West via Kashmir, in the direction of Jerusalem, which he reached at the age of twenty-nine.[88]

Many authors, especially J. Archibald Douglas and Günter Grönbold, have demonstrated convincingly the 'mental leaps' (Grönbold) of Notovitch and his followers. Douglas visited Hemis Monastery eight years after Notovitch, and after meticulous questioning established that Mr Notovitch's conversations with the Ladakhi monks originated simply in Mr Notovitch's productive head and the whole thing was a literary fraud.[89] Nevertheless the book was a best-seller. The French edition reached eleven impressions within two years.[90]

Some authors go so far as to claim that Christ also spent several years in Tibet, where he studied at the 'master temple' in Lhasa—although Lhasa did not even exist at that time.[91] They like to try and corroborate Jesus's alleged stay in Tibet by

pointing out striking correspondences between the practices of the early Christians and the Tibetan Buddhists, overlooking the fact that the supposed instances cannot by any means go back to early Christianity, as the following passage indicates:

> Catholic scholars were astounded on first noting the extraordinary similarity between the rituals and teachings of Tibetan Buddhism and those of the Catholic Church. The costume of the Tibetan lamas is virtually identical not only with the vestments worn by Catholic priests, but also with the clothing of the apostles and the first Christians, as depicted in contemporary frescoes, right down to the details. The hierarchical organization of the Tibetan and Roman Catholic monastic orders exhibit quite astounding similarities. Like the Catholics, the Buddhists say prayers of intercession and praise, and give alms and offerings; and in both religions the monks take vows of poverty, chastity and obedience. Buddhists use consecrated water and raise their voices in the celebration of a religious service in which the liturgy is very close indeed to that of the Eastern Christian Church ...[92]

In fact, as we have already explained, early Christian travellers in Tibet repeatedly pointed out (outward) similarities between Catholicism and Tibetan Buddhism, but under no circumstances do these necessarily presuppose direct contact of the early Christians and the Tibetans and still less are they evidence for Jesus having stayed on the Roof of the World.

With these stories we have definitely arrived in the realm of fiction, dreams and fantasies. At best they can be ascribed to a genre of narrative fiction, the novel. In later chapters, which are concerned with such Tibet novels, we shall see how attempts have repeatedly been made to confer a fabricated authenticity by supplying facts and circumstances that on closer examination turn out to be half-truths or even deceptions. In Western stories of Tibet, fact and fiction are especially hard to tell apart.

Georgei Ivanovitch Gurdjieff and the 'seven Tibetan beings'

Georgei Ivanovitch Gurdjieff (1866 or 1877–1949) was another enigmatic personality, who like Blavatsky claimed to have lived in Tibet, and like her too was extremely controversial: some saw in Gurdjieff a prophet, the greatest mystical teacher, esotericist, healer and 'man of the fourth dimension'; others a confidence trickster or megalomaniac.[93]

Gurdjieff supposedly came upon a dervish in New Bokhara, who for his part claimed to have met an old man who was said to be a member of a brotherhood known to the dervishes by the name of Sarmun (sometimes also called Sarmung). To this brotherhood belonged four monasteries, one in the Pamir, one in India, one in Kafiristan (the Afghan-Pakistan border area west of Chitral) and one, the chief monastery, in Tibet.[94] After Gurdjieff had met the old man in person and promised him never to reveal the location of the monastery to anyone, he and his (probably fictitious) friend Soloviev[95] were blindfolded, put on horses and led to the monastery, which they reached after twelve days. Gurdjieff describes it as follows:

> At last, when at the end of the twelfth day our eyes were uncovered, we found ourselves in a narrow gorge through which flowed a small stream whose banks were covered with a rich vegetation. ...

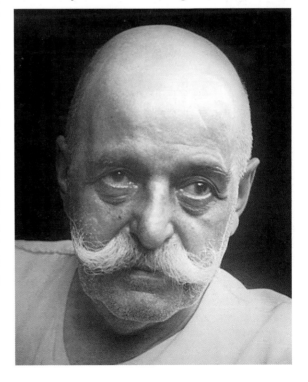

30. An important teacher of Pauwels: Georgei Ivanovitch Gurdjieff (1866 or 1877–1949). He was an enigmatic personality, who like Helena Blavatsky claimed that he had lived in Tibet, and like her too was extremely controversial. Some saw in Gurdjieff a prophet, the greatest mystical teacher, esotericist, healer and 'man of the fourth dimension', others a confidence trickster or megalomaniac.

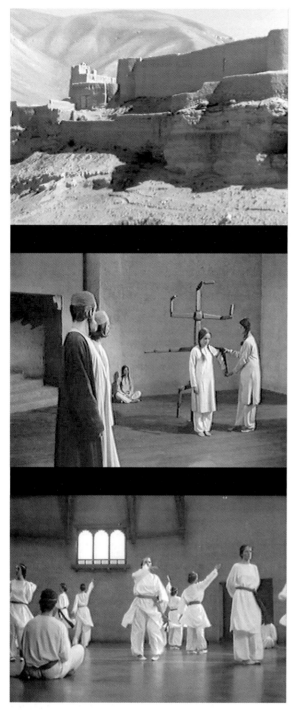

31. *Scenes from the film* Meetings with Remarkable Men *by Peter Brook. Gurdjieff claimed to have visited personally in 1898 a monastery in Tibet by the name of Sarmun. The sparse descriptions and the extremely vague geographical localization seem to agree with those who maintain that the monastery story is to be interpreted only symbolically, that the description is an allegory.*

We rode on asses up the stream, and after we had ridden half an hour through the gorge, a small valley opened up in front of us surrounded by high mountains. On our right, and in front of us, but a little to the left, we could see snow-capped peaks. While crossing the valley, after a bend in the road, we saw some buildings in the distance on the slope to our left. As we came nearer we were able to make out something like a fortress ...[96]

The sparse descriptions and the extremely vague geographical localization seem to agree with those who maintain that the monastery story is to be interpreted only symbolically, that the description is an allegory, even if Gurdjieff names a year for the visit, to wit, 1898. The story remains nebulous, as Gurdjieff never got round to describing the details of the monastery in a special book, as he had planned. In 1935 he broke off his work on *The outer and inner world of man*, and with it his revelations about the Sarmun monastery, provoked by a flying accident to a patron who had expressed his readiness to support Gurdjieff financially. From that moment on, Gurdjieff never wrote another book.[97]

The clearest account of the chief monastery, which today is regarded among Gurdjieff's disciples as the place of origin of his most profound realizations, is found in *Meetings with Remarkable Men*, and this is enough to establish with certainty that this monastery cannot have been a Tibetan one. Its occupants spoke Turkish and '*Pshenzis*', the head of the monastery was not an abbot, Rinpoche or Tulku (as one would expect for a Tibetan monastery) but a sheikh, and men and women lived in the same building complex— apart from one another, admittedly—which is altogether unthinkable for a Tibetan Buddhist institution. In no Tibetan monastery are there 'priestess-dancers', and the peculiar apparatus described by Gurdjieff with which the dancers learned their art does not reveal a Tibetan origin.[98]

Interestingly, the description of the monastery—its geographical situation and surroundings—is strongly reminiscent of Shangri-La, 'somewhere in Tibet', which James Hilton evoked in his novel. But the correspondences go further: like Conway and his friends in Shangri-La, Gurdjieff in the Sarmun monastery met some exceedingly old men. One of the oldest monks, an aged man looking like an icon, was 275 years old. Also when Gurdjieff later went to another of the four monasteries of the Sarmun brotherhood, the one in Kafiristan, he got to know there Father Giovanni, who lived among other Christians, Jews, Mohammedans, Buddhists, Lamaists and a shaman in that monastery. Giovanni, previously a Catholic priest, had reached the monastery by a roundabout route and was now joined to the 'inner life' there. The Father reminds us strongly

of the Capuchin monk Perrault, likewise radiating kindness and wisdom, in Hilton's novel, so that one may reasonably ask whether Hilton was inspired not only by the Shambhala myth but also by Gurdjieff's legend, which might have come to his ears through Gurdjieff followers. Or was Hilton himself perhaps a student of Gurdjieff some time?

It is highly questionable not only whether Gurdjieff was actually in the monasteries he describes but also whether he subsequently travelled (again) to the real Tibet in 1901 or 1902 and with what intention. Did he have a secret mission to carry out as a spy for Tsar Nicholas II; was he actually a pawn in that game of chess between pan-Russian imperialists and the British viceroy, 'equipped with roubles, porters and false papers'?[99] He is supposed to have hung around for about a year in 'Upper Tibet' (it is unclear what that means), 'where he mainly took an interest in the red-cap lamas'. He supposedly studied Tibetan language, ritual, dance, medicine and especially 'body techniques', the meaning of which term remains unexplained. Many years later he spread the rumour that he had got married in Tibet and fathered two children there.[100] According to Gurdjieff's statements, the Tibet idyll was shattered already in 1902, when, hit by a stray bullet, he was taken to an oasis on the western edge of the Taklamakan desert, where in his life and death struggle he had an important mystical experience. In that time of convalescence and 'physical strain and unusual wealth of psychic experience', he heard about the British campaign against Tibet (the Younghusband Expedition of 1904), which upset him deeply and which he went into in more detail in *Beelzebub's Tales to his Grandson*. Here he did not take the facts seriously, but in the style typical of him made up a new esoteric story that represents another piece of the jigsaw of the comical caricature of Tibet. According to that, in the 'high country' of Tibet

> there also existed a small group of seven beings who, according to the rule established from the very beginning, were the guardians of the most secret instructions and counsels of Saint Lama.
>
> This 'group of seven' had followed the indications of Saint Lama for freeing themselves from the consequences of the properties of the organ kundabuffer,[101] and had brought their self-perfecting up to the final degree.[102]

When the 'seven beings' heard about the military

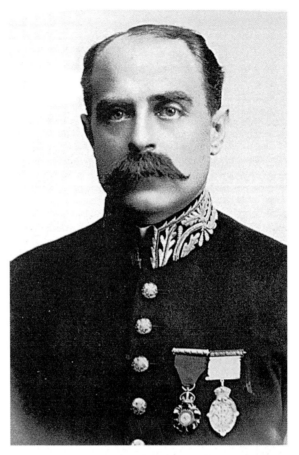

32. *Colonel Francis Younghusband, leader of the British military expedition against the Tibetans in 1904, which so shocked Gurdjieff that he took it as a central theme in his book* Beelzebub's Tales to his Grandson *and worked it into a fantastical esoteric story about seven powerful beings working in Tibet. Another piece of the jigsaw of the comical caricature of Tibet.*

expedition planned by the Europeans (the British military expedition against Tibet under the leadership of Colonel Francis Younghusband), they decided to send their leader to confer with the chiefs of the whole country. In the course of this conference, when the others already wanted to respond to the intruders with violence, the head of the 'seven beings' advised them not to do what they intended, on the following grounds:

> 'The existence of every being is equally precious and dear to God, our Common Creator, so the destruction of these beings, especially of so many of them, would give no small grief to That One Who, even without this, is overburdened with care and sorrow for everything that exists among us on Earth.'[103]

All Tibetan chiefs present refrained from taking any action against the European intruders. Indeed, it was decided to order the population not to hinder the passage of the foreigners under any circumstances. As the leader of the seven 'nearly

perfected brethren' was carrying out his duty of informing the population accordingly, he was hit by a stray bullet and killed on the spot. The six remaining brothers were horrified, for their leader had been unable to pass on to them certain secret instructions of 'Saint Lama', and with the destruction of him, the sole initiate of that time, the possibility of being initiated into 'Saint Lama's' most secret instructions was lost to them for ever.

For Gurdjieff, the religion of the Tibetans, which he called the Lamaist religion, was one of the five great religions of Earth, beside Buddhism, Judaism, Christianity and Islam. Each of these religions went back to its own 'true saint', Lamaism to 'Saint Lama', whose followers the 'group of seven beings', already existing since long before, became. Gurdjieff remains silent as to who this Saint Lama was. Did he mean Padmasambhava, the reformer Tsong-kha-pa, or one of the Dalai Lamas?

It is certain that Gurdjieff attributed supernatural powers to the most perfect followers of this Lama, such as the 'sacred process' he called 'almtznoshinoo'. This is the ability to

> intentionally bring about the coating or, as is otherwise said, the 'materialization' of the 'kesdjan body' of a being whose planetary body has ceased to exist, up to such a density that this second body regains for a limited time the possibility of manifesting through certain functions proper to its former planetary body.

This is possible as long as there is still a threadlike connection between the 'kesdjan body' (or astral body) and the 'planetary body', the physical body or corpse, an idea reminiscent of the 'silver cord' of the Theosophists and Rosicrucians.[104]

The six remaining beings attempted to use 'almtznoshinoo' on their deceased leader, so that in his materialized form he could pass on to them the secret wisdom not yet transmitted. As, however, the six had not been initiated into the secret of this process, and consequently were not perfect saints, their attempt at materializing their master failed. A catastrophe occurred, an explosion, in the course of which the six beings, their leader and their books as well were completely annihilated. The military expedition of the British under the leadership of Colonel Francis Younghusband was therefore, in Gurdjieff's eyes, a great misfortune not only for

the people of Tibet but for everyone on the whole planet Earth.

The little that Gurdjieff said about Tibetan religion accords so poorly with the actual religiosity of the Tibetans that it must be assumed Gurdjieff was not really trying to draw a real picture of Tibetan Buddhism. It seems rather that Tibet was a screen for the projection of Gurdjieff's fantasies and surreal teachings. This is indicated, for example, by his invented names ('Sincratortsa' for Tibet, 'Orthodoxhaidooraki' and 'Katoshkihaidooraki' for two Tibetan sects, and so on) or by his exaggerated description of the three-year meditation, which he degraded into a fanatical, self-destructive preoccupation with emotions and thoughts up to 'the total destruction of planetary existence':

> As soon as the companions of the immured learned that one of them had ceased to exist, his planetary body was removed from the improvised sepulchre and at once, in place of the being who had thus destroyed himself, another unfortunate fanatic of that maleficent religious teaching was walled up. And the ranks of these fanatical monks were always being filled with other members of that peculiar sect constantly coming from Pearl-land (India).[105]

Stereotypes that we encounter in the study of the various Tibet caricatures are found again clearly in Gurdjieff. Thus he relates certain secret mystical abilities to Tibet when he writes

> they become so skillful at wiseacring and making a 'mystery' of something, and then so thoroughly concealing this 'mystery' by all sorts of means, that even beings with Pure Reason cannot penetrate to the heart of it.[106]

The 'group of seven beings' also, which is called in another place a 'group of nearly perfected brethren' and is supposed to have existed for a very long time in Tibet, recalls the Brothers, Masters or Mahatmas of Helena Blavatsky, whose work he certainly knew. And like HPB's Mahatmas, the 'group of seven beings' is also hierarchically constructed, with a 'near-saint' as leader.

Finally Gurdjieff fosters the myth of peace-loving Tibet when he claims that the 'heads of the Tibetan beings' had decided to request the British who had forced their way into the country 'to be good enough to return whence they had come, and to leave undisturbed both themselves and their peaceful country that was doing no harm to anyone,' and had decided to treat them in a

kind and friendly manner and offer no resistance to them, since 'The existence of every being is equally precious and dear to God, our Common Creator.'[107]

That this war against the British, in consequence of which the seven brethren, their books and other important things were destroyed, is described as a kind of apocalypse is a new element: the mystical kingdom on the Roof of the World can guard its secrets only as long as it is uninfluenced by other nations and trends of thought. With the incursion of foreigners, in this case the British, Tibet lost its mystical virginity.

Gurdjieff is also said to have been the teacher of the Thirteenth Dalai Lama. In this he is obviously being confused with Agwan Dorjieff, already mentioned, the Thirteenth Dalai Lama's Buryat Mongol friend who was sympathetic to Theosophy. The first allusion to Gurdjieff's employment as a tutor of the Dalai Lama occurs in 1936 in a book by Rom Landau.[108] This cites a certain Ahmed Abdullah from New York, a writer and adventurer, who met Gurdjieff at a meal and 'identified' him as Lama 'Dorzhiew' (Dorjieff), which Gurdjieff answered with a wink. Since then, Gurdjieff has been accepted as Dorjieff. Pauwels accepted the myth without checking, and after him further authors, who dealt with sources with the same lack of concern as he. According to Suster, Gurdjieff played an important role in the major powers' 'Great Game' for Central Asia as a Tibetan lama and professor of metaphysics at Drepung Monastery. Under the name of Dorjieff, he tried to form an alliance between Tibet and Russia, to convert the Tsar to Buddhism and bring Russia more strongly under Tibetan influence.[109] Also according to Suster, Gurdjieff was the Nazis' most important contact in Tibet (Agarthi and Shambhala), the 'king of fear'. Initiates were in contact with him by means of an electronic transmitter, and also with the help of a special game.[110] Bronder has Gurdjieff living for ten years in Tibet as the chief agent for Russian intelligence, where he was tutor to the Thirteenth Dalai Lama and fled with him when the English marched in.[111] Landau and Pauwels seem to be the forces behind these legends also.[112] As if Gurdjieff were not already enigmatic enough, Webb gives him yet another colour when he tries to demonstrate that in all probability Gurdjieff and the Russian Ushe Narzunoff were one and the same person![113]

Whether Gurdjieff was actually in Tibet and in the so-called chief monastery of Sarmun can never be conclusively answered. That taking into consideration all the data at our disposal, the answer must turn out negative, is not so relevant here, where we are concerned with the Tibet image of the West.[114] The reasons why Gurdjieff is supposed to have lived in Tibet carry little conviction. Thus one author writes:

> Gurdjieff has also said he had been in Tibet sometime around the turn of the century. I assume this is accurate, because I am sure he speaks considerably more than a few scraps of Tibetan.[115]

As the author, J.G. Bennett, obviously does not speak Tibetan himself (otherwise how could he claim that colloquial Tibetan is not hard to learn, that one has merely to know the vocabulary, then the grammar is quite simple), it remains a mystery how he could have verified Gurdjieff's supposed knowledge of Tibetan.

Another author mentions 'circumstantial evidence' that confirmed that Gurdjieff had been in Tibet. Gurdjieff had known, for example, that

33. The Thirteenth Dalai Lama, of whom Gurdjieff is also said to have been a teacher. In this, Gurdjieff is obviously being confused with Agwan Dorjieff, already mentioned, the Thirteenth Dalai Lama's Buryat Mongol friend who was sympathetic to Theosophy.

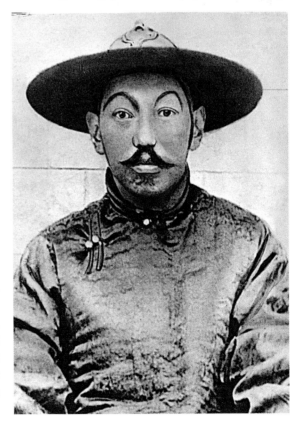

in Tibet sheep were used as beasts of burden; moreover his teachings certainly contained Tibetan elements, and many of his earliest followers had been convinced that he had lived in Tibet.[116] On closer examination, the circumstantial evidence turns out to be of the most questionable, illusory sort.

There remains the interesting fact that a remote spiritual place somewhere in Tibet, accessible only with extreme difficulty, is accepted as the source of the deepest knowledge—as by Helena Petrovna Blavatsky (an area in the neighbourhood of Tashi Lhünpo) and, as we shall see, by other authors such as James Hilton (a place by the name of Shangri-La), Lobsang Rampa, alias Cyril Hoskins (caves underneath the Potala) and so on. Interestingly, the belief in a remote, secret spiritual centre has its counterpart in Tibet itself. This is the so-called Bä-yul (sbas yul), the 'hidden countries' in Tibetan frontier areas and inside Tibet, one of which in particular has attained great significance: Shambhala, which we have already become acquainted with and which we shall study more intensively later, when we look into the the Tibet literature of the neo-Nazis and again in the last part of the book when we shall turn to the traditional Tibetan picture of Shambhala.

Karl Haushofer: intermediary between Tibetan 'Yellow-caps' and Nazis?

Gurdjieff is said in the neo-Nazi literature to have been particularly close to Karl Haushofer (1869–1946), a Nazi who is credited with the closest contacts with Tibetans. According to these sources, Gurdjieff and Haushofer are supposed to have been in Tibet together five times between 1903 and 1908,[117] where Gurdjieff allegedly initiated Karl Haushofer into the mystery of the 'state of awakening', 'with all the magical powers that this mystery brings with it'.[118] It is also asserted that through his closeness to his supposed disciple Haushofer, Gurdjieff played a decisive role in the formulation of the Nazi ideology and even suggested the use of the reversed swastika.[119]

Haushofer is characterized by neo-Nazis as 'one of the most important men of the Third Reich'. For Carmin, he was 'one of those figures who are among the essential links between the occult-esoteric movements of the turn of the century and the Third Reich'.[120] And according to Pauwels & Bergier, Haushofer made the Thule Society into 'the magical focal point of National Socialism, whose members are in touch with the invisible'.[121]

In the novel Die schwarze Sonne von Tashi Lhunpo by Russell McCloud (see below), the handwriting of Pauwels & Bergier is not hard to recognize when it is claimed that during the First World War Haushofer struck up contact with initiates of the 'Yellow-caps' (an unfortunate name for the Gelukpa school). These contacts between

34. Karl Haushofer (1869–1946). From 1904 to 1907 he taught modern military history at a German military academy. In 1909 and 1910 he was a military attaché in Japan, in the First World War a major general, then Professor of Geopolitics at the University of Munich. One of his assistants was Rudolf Hess, later Hitler's deputy. Haushofer is credited with the closest contacts with Tibetans, although he probably never met a Tibetan or travelled to Tibet. Haushofer's alleged closeness to Tibet is a figment of neo-Nazis' imagination. The latter claim that Haushofer established contact with Tibetan 'Yellow-caps', Gelukpas, with the result that Tibetan communities were formed in Germany in the 1920s, which had contacts with Nazis. There are also supposed to have been Tibetan lamas in the head office of a secret lodge where Haushofer was a leading figure. The sole aim of the lodge was to pursue researches into the origin of the Aryan race and to find out how the magical capabilities that lay dormant in the Aryan blood might be reactivated, to become the tool of superhuman powers.

Haushofer and the 'Yellow-caps' are supposed to have led to some Tibetan communities being set up in Germany in the 1920s and many of them maintaining contact with important personalities in the NSDAP (National Socialist German Workers' Party), which was then becoming stronger all the time.[122]

The mystification of Haushofer goes further still. Thus it is claimed[123] that Haushofer introduced as an esoteric centrepiece of the Thule Order the Tibetan book *Dzyan*, so shrouded in mystery, which no one apart from Madame Blavatsky had seen. He is also supposed to have been substantially responsible for the dispatch of research teams to Tibet[124] and to have acted as a leading personality in a secret society that was founded in Berlin, called the 'Vril Society' or the 'Shining Lodge'. Members of this Lodge inevitably included initiates from Tibet, and in the head office in Berlin Tibetan lamas would rub shoulders with Japanese Buddhists and members of oriental sects. The sole aim of the Lodge was to pursue further researches into the origin of the Aryan race and to find out how the magical capabilities that lay dormant in the Aryan blood might be reactivated, to become the tool of superhuman powers.[125]

The term 'vril' leads us to Louis Jacolliot (1837–1890) and Edward Bulwer-Lytton (1803–1873). Jacolliot, a convicted swindler,[126] took the view in his books that a particular energy, 'vril', lies dormant in every human being, but he employs only a fraction of it usefully. Whoever mastered 'vril' could master mankind. The successful writer, member of parliament and colonial minister, Bulwer-Lytton, who seems to have been close to the Rosicrucians and Freemasons and knew personally the French magician and occultist Eliphas Lévi (Alphonse-Louis Constant), understood by 'vril':

> I should call it electricity, except that it comprehends in its manifold branches other forces of nature, to which, in our scientific nomenclature, differing names are assigned, such as magnetism, galvanism, &c. These people consider that in vril they have arrived at the unity in natural energic agencies, ... which Faraday thus intimates: '... that the various forms under which the forces of matter are made manifest have one common origin.'[127]

'Vril' was discovered and cultivated by the so-called Vril-ya, those who managed to escape the submergence of Atlantis in caves, and according to the conception of Bulwer-Lytton's novel still

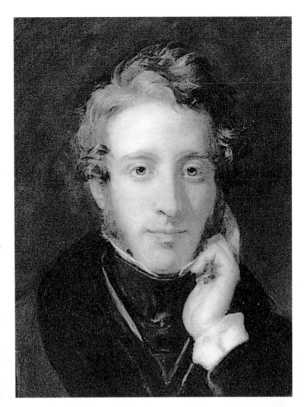

35. Edward Bulwer-Lytton (1803–1873), a British novelist, MP and colonial secretary, who substantially influenced both Theosophists and neo-Nazis. He writes of the existence of an elemental force called 'vril', which was discovered and cultivated by those who managed to escape the submergence of Atlantis in caves. This idea was borrowed from Louis Jacolliot (1837–1890). Jacolliot, a convicted swindler, took the view in his books that 'vril' lay dormant in every human being, but that he only employed a fraction of it usefully. Whoever mastered 'vril' could master mankind. In the neo-Nazi literature this elemental force is connected with Tibet: it is said that 'vril' is a Tibetan word and that there is a Tibetan character for it.

lived there in the present. When one understands and handles this fluid in the right way, says Bulwer-Lytton, it 'is capable of being raised and disciplined into the mightiest agency over all forms of matter, animate or inanimate.' To know this is of a significance not to be underestimated, as according to Bulwer-Lytton there is the danger that the Vril-ya, the coming generation, may find their way into the world of men.[128] No wonder the Nazis (at least in neo-Nazi literature) were interested in this elemental force—and among them in the first rank the magician, Haushofer. And no wonder that recently in the same literature 'vril' is connected with Tibet: it is said that 'vril' is a Tibetan word and that there is a Tibetan character for it. But as it is not a matter of an everyday term but of one directed at initiates,

one should not expect a professor specializing in Sino-Tibetan studies to be able to lay bare its deeper meaning ...[129]

But to return to Haushofer. In the neo-Nazi literature, he was not only a magician, a man with 'mediumistic abilities and other extraordinary talents',[130] but also a power-obsessed geo-politician: he was convinced of the necessity of conquering the whole of Eastern Europe, Turkestan, the Pamir, the Gobi Desert and Tibet, for these countries were the 'heart region' and whoever controlled that region would control the world.[131]

Haushofer, the so-called 'greatest magician of the German Reich', was supposed to have lived in Tibet long before a certain Adolf Hitler appeared on the political stage in Germany;[132] but what connection did he really have with Asia or indeed Tibet? Karl Haushofer taught from 1904 to 1907 as an instructor in modern military history at a German military academy.[133] In 1909 and 1910 he was a military attaché in Japan, in the First World War a major general, and afterwards Professor of Geopolitics at the University of Munich. One of his assistants and friends was Rudolf Hess, later Hitler's Deputy, but there can be 'no question of any crucial influence by Karl Haushofer on Hitler's political behaviour up to 1941.'[134]

There is not the slightest reference to a stay in Tibet by Haushofer either on his return journey from Japan to Germany or afterwards.[135] All the claims of the neo-Nazis that credit Haushofer with the closest contact with Tibet are based on dubious sources, which are uncheckable or in many cases are described as rumour in the relevant texts. Both Haushofer's biographer, Hans-Adolf Jacobsen, and Haushofer's son Heinz have clearly rejected the abstruse claims.[136] Haushofer's supposed closeness to Tibet is a figment of the neo-Nazis' imagination.

The numerous legends growing up around Karl Haushofer are mentioned here because they belong to the deviant Tibet image with which we are dealing, just as much as the Tibet descriptions of Helena Blavatsky, Gurdjieff or Trebitsch-Lincoln, whom we are going to look at rather more closely in the next section.

Trebitsch-Lincoln, Hitler and the three wise Tibetans

Trebitsch-Lincoln (1879–1943) is another of those enigmatic people who, like Gurdjieff and Ossendowski (to be described later), are hard to pin down and have been connected with Central Asia and especially Tibet. Trebitsch-Lincoln was a member of the British parliament, spied for Germany and Britain, was convicted of serious frauds and forgeries, worked for the German counter-intelligence (Abwehr), spent three years in prison, studied Buddhism in Ceylon (Sri Lanka), was ordained as a Buddhist monk in China, and gathered round himself a little group of Western Buddhists, containing thirteen persons, of which he called himself abbot. Trebitsch lived for a long time in China, in Shanghai and elsewhere, where he lent his support to the revival of Buddhism, winning recognition among Chinese Buddhists. At the same time he seems to have been working for the German counter-intelligence and was involved in fantastical Tibet plots.[137] Before, in winter 1939, he had asked the governments of Britain, France, Germany and the Soviet Union to resign. On non-compliance with this demand,

> the Tibetan Buddhist Supreme Masters, without prejudice, pre-direction or favour will unchain forces and powers whose very existence is unknown and against whose operations one is consequently helpless.[138]

Trebitsch did not identify these Tibetan masters more precisely. He explained, however, that while statesmen were normal mortals with human faults and limitations, the Buddhist masters,

> by their unlimited and unbounded knowledge of nature's secrets and their ability to use certain powers, have broken through those limitations.[139]

With these masters, one inevitably thinks of Helena Blavatsky's Mahatmas. But possibly Trebitsch-Lincoln would have had in mind the Panchen Lama, who had died in 1937, and whom he greatly admired and looked upon as his spiritual teacher, even though (despite his claim to the contrary) they had never met.

Trebitsch had already long cherished the wish to travel in Tibet, but no opportunity had ever presented itself. Now, at the beginning of 1941, he saw his chance come at last. He would travel

to Tibet on the orders of the Nazi secret service, bring the Tibetan government under German influence and set up a German radio station to broadcast anti-British propaganda from the Roof of the World. Lhasa, the seat of the Dalai Lama, was perceived as pro-British, and Tashi Lhünpo, the seat of the Panchen Lama, as anti-British. Given Trebitsch's hostility towards Britain, this explains his sympathies for the Panchen Lama. The wording of a telegram to Berlin from the German consul general in Shanghai is instructive: in it Trebitsch is characterized as:

> Abbot Chaokung, for many years member of the Grand Council of Yellow Cap Lamas who possess special influence in Tibet and India.[140]

Perhaps because Berlin did not react to this plan, Trebitsch tried to win over to his plan Police Colonel Joseph Meisinger, who was stationed in Tokyo but was staying temporarily in Shanghai, with a fantastic story. Clearly he succeeded initially, although Meisinger was regarded as a coarse, extremely mistrustful Gestapo man. Trebitsch explained to Meisinger that the sages of Tibet, forming a kind of unofficial world government, were of the opinion that the time had come for Germany to make peace. He, Trebitsch, had been authorised by his Tibetan masters to undertake the necessary steps. He therefore wished to travel to Berlin to meet Hitler there. As evidence that he was speaking the truth, he said, as soon as he was alone with Hitler three of the Tibetan sages would step out of a wall.

Meisinger telegraphed the plans Trebitsch had worked out to Himmler, who got in touch with Ribbentrop about them. The latter was so outraged by Meisinger's meddling in politics that he strictly forbade him to have any further contact with Trebitsch-Lincoln.[141] The abrupt refusal may have had something to do with Rudolf Hess's spectacular flight to Scotland (10th May 1941), as the close contacts of Hess with astrologers, mediums and so forth were well-known. From then on, Hitler harboured an even greater mistrust of astrology and esotericism[142]—a mistrust that Himmler, Meisinger's supreme commander, did not in fact share, though he had to submit to it.

His chameleon-like adaptability, his tendency towards exaggeration, his sense of mission in both the religious and the political spheres and his thirst for oriental wisdom made Trebitsch-Lincoln, alias Moses Pinkeles, alias Ignaz

Trebitsch, alias Thimotheus Lincoln, alias Dr Leo Tandler,[143] with the Buddhist name Chao Kung, a mysterious figure, whom different authors have tended to use for their own purposes. Thus Trebitsch-Lincoln is connected with occult, secret knowledge of Central Asia, especially Tibet, and

> it is not unthinkable [one observes the vague formulation] that Trebitsch-Lincoln, like Gurdjieff, Crowley[144] or Haushofer, acquired supersensory cognitions in a Tibetan monastery.[145]

There would also have been contacts between Karl Haushofer and Trebitsch-Lincoln.[146] For one author, he was even accepted as a friend of Hitler's, whom he informed about Buddhism. He is supposed to have been a member of 'the Tibetan

36. Trebitsch-Lincoln (1879–1943), another enigmatic and mysterious person connected with Tibet. Trebitsch-Lincoln was a member of the British parliament, spied for Germany and Britain, was convicted of serious frauds, worked for US counter-intelligence, spent three years in prison, studied Buddhism in Ceylon (Sri Lanka), was ordained as a Buddhist monk in China, and gathered round himself there a little group of Western Buddhists. At the same time he seems to have been working for the German counter-intelligence and was involved in fantastical Tibet plots. Like Blavatsky, Gurdjieff and Roerich, he was convinced of the existence of powerful Tibetan masters, who had superhuman powers at their disposal. He saw himself as a long-standing member of 'the Great Council of the Yellow-cap lamas, who have a particular influence in Tibet and India'. Trebitsch-Lincoln was connected with occult, secret knowledge of Tibet, which he is supposed to have picked up in a Tibetan monastery—although it is certain that he never stayed in Tibet. He is even said to have had contacts with Hitler, whom he allegedly informed about Buddhism.

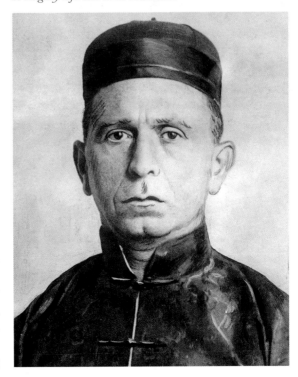

Agartha, that is, the priestly rule of the lamas',[147] and spoke in front of a reporter the following enigmatic sentences:

> It is not Stalin, Hitler and Roosevelt who are leading the present war, but a handful of men who live in Tibet or at least were engendered there and are now stationed in different parts of the world. We [Trebitsch also counted himself as one of these wise men from Tibet] could stop the war, but like God, who allows bad things to happen, we do not intervene too soon. But one day, when the time is ripe, we shall save mankind from this catastrophe.[148]

Trebitsch-Lincoln felt he was a chosen one, one born to higher things, 'the greatest adventurer of the twentieth century', as he suggested in an autobiography that appeared in 1931. Another claim that fits this picture of a divine or at least prophetic and superhuman Trebitsch-Lincoln is that he once described himself as a reincarnation of both the late Thirteenth Dalai Lama and the late 'Tashi' or Panchen Lama,[149] and saw himself as a Tibetan lama who bore the name of Lama Djordni Den.[150] Even if these two stories must for lack of checkability be assigned to the realm of fantasy, it is a fact that Trebitsch-Lincoln was initiated in China as a 'Bodhisattva', which certainly confirmed him in his 'Messiah-complex' (Wasserstein).

> Trebitsch was an extreme, but in a sense a characteristic product of the era of political messianism when madness gained an ascendancy over large portions of humanity.[151]

And Tibet was a part of this insane history.

B. The neo-Nazis and Tibet

What has Hitler to do with Tibet?

> Once upon a time there was a cremation. It took place in the afternoon of 30th April 1945. There were two corpses burnt, which rumour said belonged to two prominent suicides, who had departed this life voluntarily a little before ... Today we are far enough removed from the events of that April evening to be able to take note impartially of the contents of a diary brought to Europe from India in 1961. It says that the corpses burnt at that time belonged to anonymous victims of the war around Berlin. Those who had seemingly been burnt then died not in Central Europe but in inhospitable Tibet ...

This is the blurb to the book *Mönch-Story* ('Monk Story') by Albert Wallner. Right from the first page of the story it is clear that one of the supposed suicides, who had not in fact died and been cremated in 1945 but had chosen Tibet for their old age, is a prominent Nazi politician. Even though no surnames appear in the text—supposedly a diary—'after reading the first lines, it is no secret who is being referred to': Adolf (Dolph) Hitler and his mistress Eva Braun. According to the story, as they recognized the hopelessness of their situation they had recalled an invitation a Tibetan 'high lama' had given them when he visited Germany. With the help of the very experienced pilot Walter they flew towards Tibet, where they jumped from the plane with parachutes ... and were received in the high lama's monastery. There they lived, dressed as clerics,

> quiet and withdrawn, fellow citizens who did not want to attract attention. Neither in the good nor the bad sense.

As the Communist Chinese forced their way into Tibet in 1951, Eva and Walter—Dolph had already died—decided to flee to India, but they never arrived. They had previously handed over to a monk a package, with the request to give it to a professor living in Munich. The package contained the diary of Hitler's wife, which is printed in *Mönch-Story*.

This cliché-ridden tale is mentioned here for several reasons: in it Tibet is portrayed once again as the far-off, isolated retreat where those coming from the far West find admission to a monastery—similar to the Shangri-La of Conway and his companions, which we shall get to know in more detail later on. For another thing, because not so much as a hint occurs in this novel of the theme so dominant in the National Socialist literature on Tibet: the search for the origin of the Aryas, for Agarthi and Shambhala. The author of *Mönch-Story* does not credit Hitler with the slightest interest in eastern occultism or eastern esotericism—and in this, as we shall see, he is very close to the facts, though not in accord with the trend of the neo-Nazi literature.

It is not easy to find a collective term for the literature we are going to analyze below. We speak here mainly of 'neo-Nazi literature', well aware that one or other author would not give agreement to this classification. Detlev Rose uses the term 'irrational literature', which he contrasts with 'scientific literature', thus quite rightly emphasizing that there are also titles that draw from both sources and thereby cause serious confusion.

As already mentioned, the doctrine of racial evolution upheld by Helena Petrovna Blavatsky influenced Ariosophy and its advocates, and some Nazis—prompted by the Theosophists—allegedly wanted to track down the origin of the Aryas in Asia. Nothing about this is included in *Mönch-Story*, unlike many other novels, such as *Der Schneemensch* ('The Snowman') by Jens Sparschuh and *Die schwarze Sonne von Tashi Lhunpo* ('The Black Sun of Tashi Lhunpo') by Russell McCloud (probably the pseudonym of an Austrian author),[152] to name but two examples. But the idea is also spread under the guise of (popular) science that influential Nazis had quite a special interest in Tibet, since they expected to find ancestors of the Aryas and occult knowledge there.

In *Die schwarze Sonne von Tashi Lhunpo*, the Austrian Hans Weigert, a reporter on the Viennese newspaper *Blatt*, writes an exclusive about the murdered president of the European Central Bank. On the dead man's forehead was carved a twelve-spoked sun symbol. Weigert's investigations lead him to a French amateur historian Martin, who has written a book about the Wefelsburg (the SS School for Leaders of the Reich (*Reichsführerschule*) during the Nazi period, under the direction of Himmler), in which the sign of the Black Sun is depicted as a floor ornament in one of the rooms of this castle. Martin presents him, shortly before his murder by Freemasons, with two CD-ROMs and sends him to Tibet to a German called Karl Steiner.

In a hermitage above Tashi Lhunpo Monastery he finds the man he was looking for. He is wrapped in a thin yellow robe in the icy cold, clairvoyant—he seems already to know the seeker by name—and of youthful appearance, though in reality he is more than ninety years old. He explains to the disbelieving journalist that he came to Tibet in July 1942 as a member of the last SS expedition organized by Himmler and Haushofer. The expedition's task was to find the beings from Thule. These descendants of the gods had survived the downfall of Thule and on their journey had come into contact with the first human beings. After this they had fallen out among themselves over whether or not they ought now to share their divine knowledge with the humans, and split into two groups: Shambhallah, the knowledge-keepers, and Agarthi, the knowledge-brokers. The Agarthi had retired to the Himalayas so that they could keep their knowledge pure for longer. Since this disagreement, war has been going on between the two estranged groups. In more recent times, the members of Shamballah have organized in the lodges of the Freemasons, while the Agarthi initiates have founded the Thule Society and were also members of Himmler's black SS order. Steiner dismisses Weigert with the comment that the Agarthi members are now (in the 1990s) about to be resurrected after the defeat in the Second World War and seize power once more.

Having returned to Europe, Weigert negotiates in Rome with a representative of the Shamballa Freemasons, the American Beckett, about the CD-ROMs, which have in the meantime been decoded and contain the current membership lists of the 'Sleepers of Agarthi'. Beckett also tells Weigert that the previous night, Agarthi agents had stolen from the Hofburg in Vienna the Holy Lance, the spear that according to the legend came into contact with the blood of Christ on the cross and confers on its possessor power for good or evil. Hitler is supposed to have brought this spearhead from Vienna to Nuremberg once before.

The encounter of Agarthi initiates, Shamballah-UNO agents and the journalist at the Wefelsburg ends in a wild, James-Bond-style shoot-out. But Weigert escapes and sends the holy lance to the bottom of an unknown Austrian

mountain lake.[153]

In this book, historical data and fiction are subtly interwoven, a skilful way of phrasing is employed such that compromising or risky statements are often placed in the mouth of a third party. A superficial reading, moreover, gives the impression that the author is a neutral narrator with no particular sympathy for either the Freemasons or the SS. In fact, however, it is the Freemasons who torture and murder, while Hitler and the SS are merely executive tools of a higher power.[154]

The lama with green gloves

Writers on neo-Nazism are constantly claiming that certain esotericists and occultists had a very great influence on leading Nazis such as Hitler, Himmler and Hess. In this connection the names of Dietrich Eckart (1868–1923) and Karl Haushofer (1869–1946) turn up regularly. The latter, as we shall see, is also said to have had the closest links with Tibet.

Jointly responsible, or perhaps even chiefly responsible for the creation of this 'Tibet connection' of the Nazis were Pauwels and Bergier, who in 1960 put forward in their best-seller *Le matin des magiciens* (UK title: *The Dawn of Magic*; US: *The Morning of the Magicians*) the unsubstantiated and so also uncheckable assertion that in Berlin in the 1920s there had been a Tibetan monk

> nicknamed 'the man with green gloves', who forecast three times in the press, with exactitude, the number of National Socialist representatives who would take their seats in the Reichstag.[155]

This man had regular meetings with Hitler. He was, so the initiates said, 'the keeper of the keys that open the kingdom of Agarthi' (which we shall go into, in more detail, later). Carmin[156] imputes the function of key-keeper of Agarthi to the enigmatic Trebitsch-Lincoln. In 1926, according to Pauwels & Bergier, a small Hindu and Tibetan colony formed in Berlin and Munich. After the Russians entered Berlin,

> a thousand volunteers for death were found among the corpses, in German uniforms, without papers or insignia, and of Himalayan race.[157]

Since the chief exponents of this legend, Pauwels & Bergier, were demonstrably not very particular about truth, as they themselves attest in their book ('fairy tale and truth, rash speculation and exact vision are mingled in it'),[158] and since they seldom name checkable sources, we must assume until we have evidence to the contrary that the 'Tibet connection' of the Nazis that they claim is complete fiction and shows another piece of the jigsaw of the picture entitled 'Dreamworld Tibet'. What is so treacherous about it is that the legends that Pauwels & Bergier brought into the world have been taken up by many later authors and described as facts, which has led in the end to such outrageous assertions as:

> Yet to the SS men, their actions were perfectly

37. Jacques Bergier published in 1960, in his bestseller Le matin des magiciens, *co-written with Pauwels, a popular version of the Shambhala legend, continually quoted ever since. According to it, three or four thousand years ago a people with a very high culture lived in the area of the present-day Gobi Desert. As a result of a catastrophe, the land was turned into a desert, and the survivors emigrated: some to Northern Europe, others to the Caucasus … Certain Nazis—said Pauwels & Bergier—were convinced that the emigrants from the Gobi land formed the basic race of humanity, the Aryan stock. Some great sages of this high culture settled in a vast realm of caves beneath the Himalaya and split into two groups. One followed the right-hand path with Agarthi as its focus, the other the left-hand path, which ran via Shambhala (Shampullah), the city of might and power. This myth of origin had strongly moulded the founders of the National Socialist Party—given them strength, thought Pauwels & Bergier.*

comprehensible. They were the warrior élite of a new civilisation immeasurably superior to the old, the high priesthood of the New Age, the standard bearers of the coming Superman. Their leaders were magicians who had formed alliances with the mystic Tibetan cities of Agarthi and Shamballah, and had mastered the forces of the living universe.[159]

The Tibetans are here made into allies of the Nazis, on the road paved with millions of corpses to the new humanity, the future superman of the thousand-year Reich.

Tibet-occultism and the Thule Society

Among historians it has not been settled how great the influence of occultism was on people like Hitler, Himmler (Reichsführer SS and from 1943 Minister of the Interior) and Hess (SS General (*Obergruppenführer*), Reichsminister and Deputy to Hitler). Goodrick-Clarke, in his book *The Occult Roots of Nazism*, takes the view that with the widespread aversion to Catholicism among the *völkisch* nationalists and pan-Germanists in Austria, Theosophy virtually imposed itself as an alternative creed:

> Theosophy commended itself as a scheme of religious beliefs which ignored Christianity in favour of a mélange of mythical traditions and pseudo-scientific hypotheses consonant with contemporary anthropology, etymology, and the history of ancient cultures. Furthermore, the very structure of theosophical thought lent itself to *völkisch* adoption. The implicit élitism of the hidden mahatmas with superhuman wisdom was in tune with the longing for a hierarchical social order based on the racial mystique of the *Volk*.[160]

However, that Hitler might have been interested in eastern esotericism or indeed Tibet can be ruled out. Nevertheless, he is connected with Tibet again and again by neo-Nazi authors. Thus Ravenscroft includes in *The Spear of Destiny* something fitting the fiction that Pauwels & Bergier created, when he claims that Hitler had spoken regularly with the 'Tibetan leader' in Berlin, a man with proven clairvoyant abilities, who could look into the future. There were rumours in circulation, he says, that he had predicted the exact days on which Hitler would become German Chancellor and the Second World War would begin.[161] Another writer says Hitler, a fanatical supporter of occultism, had the intention of resolving the fate of Europe at the astrological moment that had been transmitted to him by pseudo-initiates in Lhasa. These

> personalities surrounded with an aura of the picturesque ... were playing a double game: they were leading the credulous Hitler into catastrophe ... through bad advice and betrayal.

The conspiracy theory goes still further:

> The lama priests were working on a plan to exercise control of the world that was fully the match of the Germans'.[162]

It is in fact proven that Rudolf Hess and Haushofer knew each other well and that Hess introduced Hitler to his friend. But to conclude from this that Karl Haushofer had a decisive influence on Hitler and his conception of leadership and had transmitted to Hitler parts of the 'Secret Doctrine', particularly concerning the origin of the different races of men,[163] is by no means to be verified. It cannot be proved either that Haushofer's 'theses' (which ones?) reached Hitler via Hess, as Hitler was serving a sentence in the Landsberg fortress and working on his book *Mein Kampf*.[164]

Perhaps the most eccentric claim comes from the Chilean Fascist Miguel Serrano (b. 1917), according to whom Hitler was an Avatar (a divine incarnation), a Bodhisattva(!) or a Tulku (reincarnated spiritual teacher), who was able to duplicate himself and to be incarnated in several persons, for example in Mussolini and the Indian Subhash Chandra Bose.[165] According to Serrano, 'esoteric Hitlerism is Tantric' and Hitler was a Tantric Master from Shambhala who, like the esoteric SS personnel, practised rites of sexual magic. Serrano also fosters the myth that Hitler did not die. Although he is living in his previous homeland, the kingdom of Shambhala, one can (no longer) meet Hitler in Tibet. Since the Second World War, the entrance to Shambhala between Shigatse and Gyantse has been closed and Shambhala is now at the South Pole, in the Antarctic. There 'Tulku Hitler' waits to attack and overcome the powers of darkness one day in an apocalyptic war and then to establish the 'Fourth Reich'.[166]

At the instigation of the occultist Rudolf Freiherr von Sebottendorff (1875–1945), in November 1918 the Thule Society, a *völkisch* and

38. The Chilean Fascist Miguel Serrano (b. 1917) is one of the main proponents of the thesis that leading Nazis such as Hitler were and still are closely linked to Tibet. According to Serrano, Hitler is an Avatar (a divine incarnation), a Bodhisattva or a Tulku (a reincarnated spiritual teacher). He is also a Tantric Master from Shambhala who, like the esoteric SS personnel, practised rites of sexual magic. As the entrance to Shambhala is not in Tibet any more, according to Serrano, one can (no longer) meet 'Tulku Hitler' there. But he is waiting in the Antarctic for the day when he will attack and overcome the powers of darkness in an apocalyptic war, so as then to establish the 'Fourth Reich'.

antisemitic lodge, was founded. There is no evidence that Hitler ever attended the Thule Society.[167] On the other hand, it is considered certain that Rudolf Hess, later Hitler's Deputy, was a member of it. Although it cannot be confirmed that Thule people or the Thule ideology ever played a substantial role in the National Socialist movement—only a small part of the Thule membership took an active part in building up the DAP and NSDAP[168]— nevertheless some authors assume that during the emergence phase of the NSDAP, Hitler and his close friends assimilated important subject matter from the Thule Society.[169] As expected, the neo-Nazi writers evaluate this influence as considerably stronger.

What is the position regarding the moulding

of the Thule Society by 'the ancient teachings from Tibet and India, in part secret and in part simply made up,' as some authors have claimed?[170] Sebottendorff personally declared himself unambiguously against it:

> It was attempted to persuade us, and the world still believes today, that the original homeland of the nations was the East Asian highlands or Mesopotamia. Light is supposed to have come from the East. Recent research has demonstrated that this assumption is false. Northern Europe, North Germany is the ancestral seat of the bearers of culture; from here, from the dim and distant past until now, streams of fecundating German blood have poured forth.[171]

This clear rejection by Sebottendorff, founder of the Thule Society, of the theory that Central Asia and Tibet were the retreat area of the ancient Aryas, did not stop the neo-Nazis connecting the Thule Society closely with Tibet. Thus in 1928 the Thule Society is supposed to have taken up the connections via the strong Tibetan colony in Berlin with the monastic secret societies of Tibet, which were never broken off during the Second World War. For the radio messages exchanged in this period between Berlin and Lhasa, the book *Dzyan*, 'a secret magic book of Tibetan sages', allegedly served as a key.[172] We recall that this is the book that on the view of the Theosophist Helena Blavatsky served as the basis of *The Secret Doctrine*.

According to van Helsing (alias Jan Udo Holey), whose conspiracy theories read like a mixture of *Mein Kampf*, wild science fiction and black magic,[173] Tibetan monks also helped in the background, together with the Knights Templar ('Marcionite Order') and the 'Lords of the Black Stone', in the establishment of the Third Reich, the foundation of the 'Thule Society' and the supreme 'Black Sun' lodge. In other words, a 'Tibetan black magic order'[174] was substantially involved in the genesis and shaping of the Third Reich. That agrees with the statement that Hitler and the Thule Order were the external tool of a group of Tibetan black magicians.[175] But it gets more eccentric yet. In the view of the neo-fascists, the 'Black Sun' has underground bases all over the world, occupied by millions of Germans of the Reich. There is a gigantic base in the Himalaya, 'at an altitude of well over 5,000 metres', and the only reason why the Chinese attacked Tibet and tortured and killed the monks

lies in the fact that the Chinese had to track down and slaughter the Germans of the Reich, on the orders of the Masonic Illuminati, so as to prevent the new kingdom of light being established in Germany. However, the Chinese had no success, as the Germans lived in hidden valleys where no Chinese ever went. Whatever they were able to do, the Germans of the Reich were under the protection of the highest Tibetan lodge, the Geluk-pa or 'Yellow-caps', who also protected the Ariannis, the occupants of the underground kingdom and descendants of extraterrestrials![176]

Tibet as a sanctuary for Germans of the Reich, allied with the Geluk-pas against the Chinese— and waiting for the day when they can build a new Reich on Earth! Comment is superfluous.

The beginnings of the Agarthi myth

This strange picture is part of a myth used by the neo-Nazis in various books, which is closely linked to Tibet. We wish to take a closer look below at the different forms of this myth, as it involves another important piece of the jigsaw that, together with the many others, reveals our present-day caricature of Tibet.

An early version of the myth is found in *The Secret Doctrine*, by the Theosophist Helena Petrovna Blavatsky. This is the account, already presented above, of the submergence of Lemuria and Atlantis and the ensuing deliverance of certain chosen people on an island in the Central Asian sea that lay at that time where the Gobi Desert is today, and is equated with Shambhala.[177] In Shambhala, the nucleus of the 'fifth root race' was formed, whose first sub-race formed the Indian Aryas and whose fifth and consequently higher sub-race is the whites. According to this Theosophical theory, Atlantis is the motherland of the high-bred races.

We know today that in recounting this legend, Blavatsky was influenced by Bulwer-Lytton, who in his book *The Coming Race* did not, however, locate the underground realm precisely and did not relate it to the Himalaya or Tibet. This still did not stop one author claiming that Bulwer-Lytton's novel had 'combined an ancient Tibetan creation myth with a message full of hope'.[178]

Another source that nurtured the myth of an underground realm is Ferdinand Ossendowski's (1876–1945) book *Beasts, Men and Gods*, in which he portrays Tibet as a land of mystery, supernatural powers and secret knowledge. Ossendowski reports among other things on 'Agharti', an underground kingdom. According to an old legend, a certain Mongolian tribe hid in the underground country, the 'mystery of mysteries', to escape the demands of Genghis Khan. A monk allegedly told Ossendowski that a holy man with a whole tribe of people disappeared beneath the earth for more than 60,000 years, never to appear again on the surface. Many people, including even Buddha Sakyamuni, had visited this kingdom

39. Ferdinand Ossendowski (1878–1945) portrayed Tibet in his book Beasts, Men and Gods *as a land of mystery, supernatural powers and secret knowledge, and reported among other things on the land of Agharti, beneath Central Asia. Its ruler, the 'King of the World', knows all forces and can read in men's souls and in the book of their destiny. One day the people of Agarthi will come to the surface of the Earth and build a new kingdom. What Ossendowski did not say was that these tangled tales of Agarthi go back not to an ancient local legend, but to a work by Saint-Yves d'Alveydre, published in 1910.*

since then. But nobody knew quite where it was. Within it people were protected from evil, there was no crime inside its borders. The underground people had attained supreme knowledge. Millions of people belonged to the kingdom, and its king was the 'king of the world', who also rules over people on the surface, knows all the forces of the world and can read in men's souls and the book of their fate. This kingdom, which extends over all the underground passages of the world, was called Agharti. The inhabitants of the two continents that sank beneath the surface of the water (Atlantis and Lemuria) dwelt in this kingdom of Agharti as well.[179]

Ossendowski continues with a detailed description of Agharti's capital city and the abilities of the country's residents, which we do not wish to go into further here. There is, however, an account of a strange procedure that is of some interest and should be mentioned here, as it incorporates a recurring Tibet myth.

> The highest Panditas place their hands on their eyes and at the base of the brain of younger ones and force them into a deep sleep, wash their bodies with an infusion of grass and make them immune to pain and harder than stones, wrap them in magic cloths, bind them and then pray to the Great God. The petrified youths lie with eyes and ears open and alert, seeing, hearing and remembering everything. Afterwards a Goro [apparently a synonym for Guru] approaches and fastens a long, steady gaze upon them. Very slowly the bodies lift themselves from the earth and disappear. The Goro sits and stares with fixed eyes to the place whither he has sent them. Invisible threads join them to his will.[180]

It is not hard to recognize here the description of levitation, which, as we shall see, seems to belong to the standard repertoire of a Tibetan priest—at least in the view of the 'Tibet occultists'. The 'invisible threads' too recall the 'silver cord' of the Theosophists and of Lobsang Rampa.

The 'king of the world' ruling in Agharti betakes himself occasionally to the temple cave in which the embalmed body of his predecessor lies in a coffin of black stone (obviously another source for Lobsang Rampa's The Third Eye). There the 'king of the world' is in contact with the thoughts of all men who influence the lot and life of mankind. When these are pleasing to God, the 'king of the world' encourages them, but when they displease God, he opposes them.[181]

In the not too distant future, after the whole Earth has become empty and there is only night

and death, a new people will begin a new life. After that will follow again years of war and devastation, until the people of Agharti come out of their underground caves onto the Earth's surface and build a new kingdom.

Although Ossendowski does not localize Agharti exactly, it can be assumed that its centre lies mainly underneath Central Asia, as the entrance to the kingdom is supposed to be somewhere in Mongolia. Central Asia—and in a narrower sense Tibet—is consequently the area from which the world's deliverance, a new, better kingdom, will one day come.

The esoteric writer René Guénon (1886–1951), who showed sophisticated judgement in his book Le Théosophisme, published in 1921, defended Ossendowksi's accounts of Agarthi in his posthumous work The Lord of the World (Le Roi du Monde). But his references to Tibet (and only these should concern us here) are so questionable and error-ridden that his book cannot in any way be adduced as evidence for the correctness of Ossendowski's writings. Thus for example, Guénon writes of a trinity in Lamaism, in which the Dalai Lama 'represents the holiness (or pure spirituality) of Buddha', the Tashi-Lama 'the (not magical, but rather theurgical) science', and the Mongolian Bodgo-Khan 'material and military power'. He also mentions a 'circular council' of the Dalai Lama, supposed to consist of twelve great 'namshans (or nomekhans)',[182] a description strongly reminiscent of d'Alveydre, according to whom twelve gurus constitute the innermost and highest circle of the Society of Agarthi.

Sven Hedin contested the accuracy of Ossendowski's accounts,[183] and Marco Pallis too has convincingly shown[184] that the story recounted by Ferdinand Ossendowski about Agharti and the King of the World does not in any case go back to a Mongolian legend, but represents a plagiarism or copy of a tale by Saint-Yves d'Alveydre (1842–1909) published in 1910.[185] Although Ossendowski altered certain central names (Agarttha to Agharti, Mahatma to Mahytma, etc.), everything can be put down to Saint-Yves d'Alveydre. D'Alveydre describes the location of 'Agarttha'—which appears to be a kingdom, a city and a university in one—only very vaguely, as somewhere in the Himalaya: beneath twenty-two temples scattered over the

Himalaya, Agarttha constitutes 'the mystical cipher, the unfindable'.[186] Tibet or Central Asia is not mentioned in this early version of the legend.

In Agarttha, says d'Alveydre, prisons, the death penalty, police and law courts are unknown, as are poverty, prostitution, alcoholism, cruelty and subversion. The innermost and highest circle of the strictly hierarchical society of Agarttha is made up of twelve supreme gurus (bagwandas), magicians above whom sit enthroned the pope-like high priest Brâhatma and his two assessors, the Mahatma and the Mâhânga. For the execution of certain mysteries, the twelve gurus raise themselves up in the air,[187] but d'Alveydre is not the only one, nor the first, to have reported flying gurus in the Himalaya region. As we have already seen, Blavatsky too, referring in this case to Huc, speaks of such levitations. We shall return again later to the subject of supernatural powers, as it has a special status in the stock Tibet image of the present.

Millions of 'twice-born' dwell in Agarttha, according to d'Alveydre, the vast majority of them in underground cities. Also underground are the enormous libraries, to which only one person has the key: the supreme high priest. This passage is strongly reminiscent of the 'man with green gloves' mentioned by Pauwels & Bergier, who was supposed to have regular meetings with Hitler and was regarded as 'the keeper of the keys that open the kingdom of Agarthi'. According to d'Alveydre, the libraries of Agarttha contain an immense knowledge about the cosmos, the divine, and also the arts and natural sciences, to know which would be extremely useful for Western men. In Agarttha, both the disciples of Moses and Jesus and the researchers of all universities would acquire new realizations. The result would be a peaceful coexistence of all religions and sciences in a so-called 'synarchy'. This is a patriarchal triarchy of teaching and culture, justice, and the economy.[188] But Agarttha would open itself to the West only if it were guaranteed that this realm would be able to carry on existing peaceably and independently.

It cannot be completely excluded that in spite of everything the Agarttha/Agarthi myth has a Tibetan or Mongolian core, as several details recall the Shambhala myth. Most probably d'Alveydre and Ossendowski took up fragments of that Shambhala myth and moulded them into a new myth.[189]

The Shambhala and Agarthi myths of the neo-Nazis

The various legends of the neo-Nazis, which we wish to look into thoroughly below, take up both the Theosophical Shambhala myth[190] and the Agarttha/Agharti myth created by Saint-Yves d'Alveydre and Ossendowski and weave both myths into new, confused legends, which display Tibet in an extremely strange light.[191]

Pauwels & Bergier published an early version of the legend, repeatedly quoted since, in their 1960 bestseller Le matin des magiciens. According to this myth, three or four thousand years ago a people with a very high civilization lived in the area of the present-day Gobi Desert. Following a catastrophe—possibly an atomic disaster—the Gobi region was transformed into a desert and the survivors emigrated, some to northern Europe and others to the Caucasus ... The 'initiates' of the Thule Society were convinced that these emigrants from the Gobi constituted the fundamental race of humanity, the Aryan stock. The great sages settled after the catastrophe in a vast system of caves beneath the Himalaya and split into two groups. One followed the right-hand path, centred on Agarthi, the other the left-hand path that led through Shambhala (Schamballah), the city of violence and power.[192] This myth of origins, which goes back to a Tibetan legend brought back from the East by Haushofer in 1905, had (claim Pauwels & Bergier) a strong formative influence on the founders of the National Socialist party, giving them strength, faith and confidence.

A Tibetan legend at the origin of the National Socialist party?

This version handed down by Pauwels & Bergier contains the most important elements of the myth, which were later taken up by others: the Aryan fundamental race living in the region of Central Asia, Shambhala, and Agarthi. In later embellishments of the myth, however, there are discrepancies concerning the meaning of Shambhala and Agarthi.

In Die schwarze Sonne von Tashi Lhunpo by

McCloud, Thule (which the author apparently equates with Atlantis) sank 12,000 years ago in a gigantic catastrophe. Thule was the realm of a race that was descended from the gods. They had at their disposal indescribable knowledge, far surpassing that known today. Some of the beings from Thule survived the catastrophe. They went into the world and there met the beginnings of the human race, who were just making their first steps in history and worshipped the Thule beings as gods.

Argument arose, says McCloud, over the question of what the Thule beings, worshipped as gods, should do with these humans. This led to the formation of two parties. One group wanted to let the humans share their divine knowledge, and make equals of them. They followed the 'left-hand path' and called themselves Agarthi. The others, who wanted to be worshipped as gods still, were the Shambhala (Shamballah), who followed the 'right-hand path'.[193] In the course of the millennia, both groups became mixed with humans, to whom they grew more and more alike.[194] The Agarthi supported the Thule Order and the Nazis in general, and the Shambhallah the Freemasons[195]—two hostile groups locked in conflict ever since their formation.

Tibet occupies a special place in this legend. To wit, one of the largest surviving Thule groups 12,000 years ago reached the Himalayan region. As these beings living in Tibet had no contact with human beings for a long time, they were able to preserve their knowledge and abilities for longer than Thule beings elsewhere. But the men of Agarthi do not live only in Tibet but also, since thousands of years ago, among human beings, and are constantly trying to overcome the power of Shambhala, for example as 'Men of Agarthi' (Nazis) in the Third Reich. But the Shambhala and Agarthi people are still among us today and their conflict is not by any means over.

In *The Spear of Destiny* by Ravenscroft, the Aryan nations are led out of Atlantis by 'the great Manu, the last of the sons of the gods or supermen'. The journey went straight through Europe and Asia to the Gobi Desert and from there to the Himalayan range and Tibet.[196] The light beings settled in the mountain shrine of the 'Sun Oracle', from where the higher initiates ruled by virtue of their wisdom. But there were also 'initiates of evil', who reached the area of present-day Tibet, where they settled in two huge caverns beneath the light world of the 'Sun Oracle'. One group (or order) dedicated itself to Lucifer. There were supposedly initiates of the Agarthi oracle (the left-hand path) in Germany, known as 'the Society of the Green Men'. The other group were the Ahriman (the right-hand path), adepts of the Shambhala oracle.[197]

A further variant of the myth was published by van Helsing (Jan Udo Holey) in *Geheimgesellschaften und ihre Macht im 20. Jahrhundert* ('Secret Societies and their Power in the Twentieth Century').[198] According to him, Thule, or Ultima Thule, was the capital of Hyperborea, the first continent settled by Aryas, older than Lemuria and Atlantis. The Hyperboreans were very advanced technically and flew so-called vrilya-missiles.[199] Hyperborea sank in the course of an ice age. At that time the Hyperboreans with great machines dug huge tunnels in the Earth's crust and established themselves under the Himalayan region. Their kingdom was called Agartha or Agarthi and their capital city Shamballah. Van Helsing therefore contradicts the version supported by McCloud, Ravenscroft and Pauwels & Bergier, in which the Thule-Atlanteans split up into two groups, the Agarthi (Thule Society or Nazis) and the Shamballah (Freemasons and Zionists).

The ruler of the underground kingdom, continues van Helsing, is 'Rigden Iyepo', the King of the World, with his representative on the earth's surface the Dalai Lama, who has allegedly confirmed that the people from Agarthi still exist today.[200] Although van Helsing cites Karl Haushofer, no footnote refers to him, but instead to other dubious sources such as Bronder and Carmin. In this way typical of him,

40. *The neo-Nazi occult literature on Tibet is growing unstoppably. One of the most recent examples is the book* The Black Sun, Montauk's Nazi-Tibetan Connection, *by Peter Moon. In this it is claimed that Tibet, 'the heart of Central Asia', is described in countless legends as the place of origin of the human race. Numerous initiates have wandered through this region on their way to spiritual enlightenment, such as Haushofer, Gurdjieff, Crowley and Ron Hubbard(!), the founder of Scientology. According to Moon, Bön meetings were held on Long Island, New York, in the 1950s and '60s, gatherings of Aryans, at which strange science was discussed. Of interest is the author's tendency to cast aspersions on Tibetan Buddhism and the Dalai Lama, 'an extremely tragic figure', and to favour the Bön faith strongly. The latter has been repressed by the Tibetan emphasis on Buddhism, and the point now is to help it get its ancient rights. Then Tibet will be given back to the true Tibetans.*

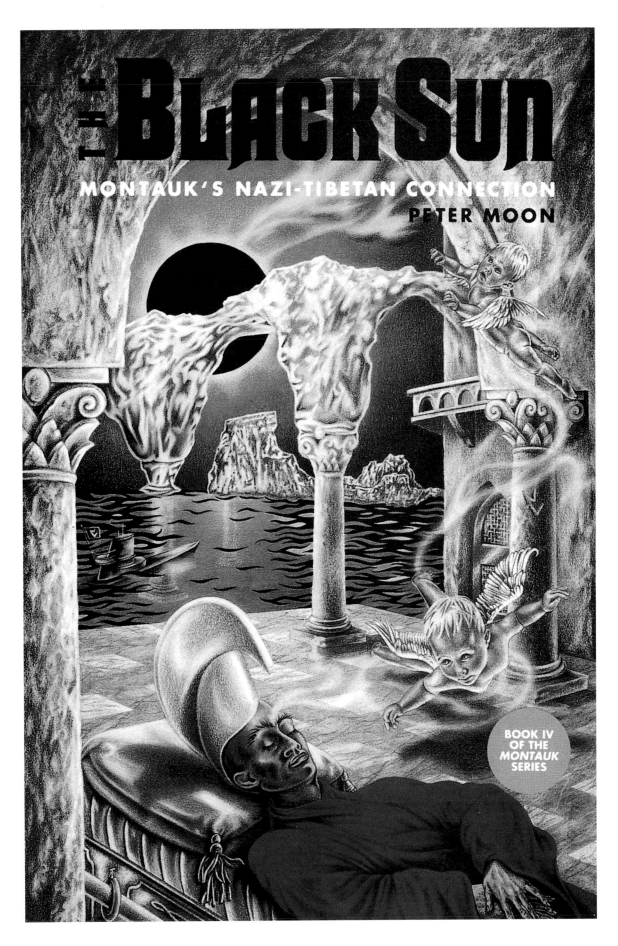

DISCOVER THE NAZI'S DEEPEST SECRET

THE BLACK SUN CONTINUES THE INTRIGUING REVELATIONS READERS HAVE COME TO EXPECT FROM PETER MOON AS HE DIGS DEEPER THAN EVER BEFORE INTO THE MYSTERIOUS SYNCHRONICITIES THAT HAVE MADE HIS WORK SO POPULAR.

THE BLACK SUN IS AN ADVENTURE IN CONSCIOUSNESS THAT REVEALS A VAST ARRAY OF NEW INFORMATION. FROM THE GERMAN FLYING SAUCER PROGRAM TO THE SS MISSION INTO TIBET, WE ARE LED ON A PATH THAT GIVES US THE MOST INSIGHTFUL LOOK EVER INTO THE THIRD REICH AND THE HOLY RELICS THEY SOUGHT IN THEIR ULTIMATE QUEST: THE ARK OF THE COVENANT AND THE HOLY GRAIL.

41. Peter Moon takes up once again the myth of the 'Vril Society' (Shining Lodge), supposed to have been under the direct influence of Tibetan lamas. The flag of this society, he says, includes in the centre a Tibetan character that means vril'. This is a deliberate misleading of the readership, for neither is the sign Tibetan, nor is there a concept known to Tibetans that could be equated with the 'vril' of Louis Jacolliot (1837–1890), Edward Bulwer-Lytton (1803–1873) or Peter Moon.

the New Right author disguises his ideological intentions with a skilful montage of facts, unverifiable testimonies, partial truths and factually untenable interpretations.[201]

Thus he claims it was Hitler's request to get in touch with the descendants of the Aryan god-men. To this end he sought entrances into the underground realm of Agarthi, and during the existence of the Third Reich two great SS expeditions to the Himalaya were undertaken in order to find them.[202] In short: according to van Helsing, Hitler was completely taken with the search for the realm beneath Tibet and the Thule-Aryan racial doctrine. But that was not all: during the Third Reich, countless young men are supposed to have been trained by the 'Black Sun', initiated in the Wefelsburg and sent to Tibet, to survive there and prepare themselves for the great final battle of the twentieth century.[203]

The neo-Nazi Tibet occult literature is growing inexorably. One of the latest examples is the book *The Black Sun: Montauk's Nazi-Tibetan Connection*, by Peter Moon, a friend of Jan van Helsing.[204] In it Moon claims that Tibet, 'the heart of Central Asia', was described in countless legends and actual histories as the place of origin of humanity. Numerous initiates passed through this area on their way to spiritual enlightenment, including Haushofer, Gurdjieff, Crowley and Ron Hubbard (!), the founder of Scientology. Even Joseph Stalin (!) was closely linked to the Central Asian tradition.[205]

Moon, who simulates seriousness and scientific character by concluding his book with a detailed index, is a striking example of the insolent style in which certain authors deal with information. In one brief section he manages to plant three basic falsehoods in the world, when he claims that Karl Haushofer was a member of the 'Yellow-caps', who were known in Tibet by the name of 'Dugphas', and therefore a member of the priesthood of the indigenous Bön religion. Apart from the fact that Haushofer was quite definitely not a 'Yellow-cap' monk, the Tibetan name of the school often called 'Yellow-caps' in the West is Gelug-pa (and not Dugphas, by which he no doubt means the Drug-pas), and neither Gelug-pa nor Drug-pa can be classed with the Bön faith.

Interestingly, Moon devotes a whole chapter to the Bön religion and so brings a new element into the occult literature on Tibet. According to Moon, on Long Island, New York in the 1950s and 1960s 'Bön meetings' were held, gatherings of Aryas, in which strange science was discussed. The name, says Moon, suggests that on the occasion of these meetings, reverence was shown towards the old Tibetan religion (Bön). There is no point in going into the conglomeration of idiocies that Moon presents us with. What is interesting is simply the author's tendency to discredit Tibetan Buddhism, and with it also the Dalai Lama, 'an extremely tragic figure', of whom it is expected that he (finally) teach real things, and to stand up for the Bön religion. The latter has been suppressed and masked by Tibetan Buddhism, and it is now a matter of helping it get its ancient rights—then Tibet would be given back to the real Tibetans.

We recognize without difficulty in these stories, in which the authors try hard to hush up the horrors of National Socialism, essential elements of the Tibet myths spread by the neo-Nazis: the mysterious kingdoms of original Aryas in and beneath Tibet (Shambhala and Agarthi), Hitler's interest in Tibet and the SS expeditions to the Roof of the World with occult purposes. We can

say with Hugo Stamm:

> The Nazi ideology was veiled in mystique and tendentiously interpreted.[206]

The latest, and very negative, interpretation of Shambhala comes from the Trimondi couple. For them, the Shambhala myth carries within it an exceedingly demonic potential, which could be activated at any moment, and there exists the danger that the 'Shambhala idea' might develop into a pan-Asiatic vision with Fascistic character. The Trimondis also point out—correctly—that the Shambhala myth was taken up by the Japanese leader of the Aum sect, Shoko Asahara, only their interpretation is completely erroneous. They accuse the Dalai Lama of having consciously initiated Asahara into the Shambhala myth, so as to use him as a pawn in his plans for world domination. They suggest that Asahara is the outwardly projected shadow of the Dalai Lama. He has taken upon himself the sins of the Dalai Lama, the actual string-puller. In the process the authors fail to notice that certain Japanese had already made use of the Shambhala idea much earlier, during their occupation of Manchuria, and

furthermore that in his teachings on the Kalachakra Tantra the Dalai Lama never mentions the warlike aspects of the Shambhala myth, which is tantamount to a perfidious misrepresentation when there is talk of a 'Shambhalization plan' of the Fourteenth Dalai Lama. The fact that the apocalyptic vision of the Shambhala myth has fascinated many people, such as for example the Buryat Lama Dorjieff, who identified Shambhala with Russia, cannot be made into a reproach against the Dalai Lama or the Tibetans in general. This apocalyptic part of the myth has a marginal significance within Tibetan society, but has attracted the attention of a considerable Western and Asian public. It also cannot be denied that many who have made use of this part of the Shambhala myth for themselves have a certain proximity to Fascism. But to conclude from that that the Tibetans sympathized with Fascism is a fallacy, just as inaccurate as if someone were to claim that all Indians sympathized with the Nazis, because the Nazis in India had used for their own purposes the widespread Indian swastika.

Sources of the neo-Nazi caricature of Tibet

Van Helsing holds the view that Hitler was inspired by Lord Bulwer-Lytton's book *The Coming Race* and also by Ossendowski's book *Beasts, Men and Gods*. This claim is in no way verifiable and is extremely improbable,[207] but the influence of both authors on the neo-Nazis is obvious. Their legends correspondingly borrow many passages from the books mentioned and from Theosophical sources, as the following examples demonstrate.

Ravenscroft speaks of 'secret teachings' that arose some 10,000 years ago among the initiates in ancient Tibet, which strongly recalls Helena Blavatsky's *The Secret Doctrine*, which is indeed supposed to be based in large part on the archaic Tibetan book *Dzyan*. Ravenscroft is of the opinion that at that time the initiates were able to think themselves back through immense periods of time into history, so that the spiritual origin of the Earth and the human race was obvious to them, and claims that this was possible thanks to the 'third eye', which could read in the 'Akashic Chronicle'.[208] Even Hitler is connected with this 'third eye': Haushofer, so it is suggested, activated Hitler's 'third eye', the chakra between and behind

42. The idea supported by Helena Blavatsky that all human beings once had a 'third eye' is also taken up in a comic from Japan. In this, Pai, who comes from Tibet, is the last survivor of the Triclopes.

the eyebrows, through his teachings,[209] and Hitler allegedly spoke of his 'Cyclops eye', an activation of the pineal gland (or epiphysis), which afforded a limited insight into time.[210] The source of this idea is evident: Blavatsky had already written of this 'third eye' in *The Secret Doctrine*. She there supported the view that the early Fourth Race could have been three-eyed 'without having necessarily a third eye in the middle of the brow'. This third eye allows a spiritual inner sight. For occultists, disciples of esoteric symbology, this is no conjecture or possibility but simply a phase of the law, of growth, in short, a proven fact. With time,

> their spiritual vision became dim; and coordinately the third eye commenced to lose its power. ... The third eye ... disappeared. ... The eye was drawn deep into the head and is now buried under the hair. During the activity of the inner man (during trances and spiritual visions) the eye swells and expands. ...
>
> The third eye is dead, and acts no longer; but it has left behind a witness to its existence. This witness is now the *pineal gland*.[211]

In the Ariosophical (e.g., Jörg Lanz von Liebenfels) and neo-Nazi literature these theories are taken up again, and once more it is a case of a concept referring to Tibet: three-eyed, exceptionally wise men are allegedly still living in the area of Tibet and the Himalaya. Lobsang Rampa (Cyril Hoskins) has cleverly taken up this theme in his novel *The Third Eye*, and it was also borrowed in the 1980s in a very successful series of Japanese comics. These are about a strange girl called Pai, who comes from Tibet. She is the last survivor of the Sanji Unkara or Triclopes, who have behind them a quite different evolution from that of the hominids and know the secret of eternal life.[212]

The theory of racial development upheld by Blavatsky was also, as already explained, a strong impulse for Ariosophy and its supporters, such as Guido von List and Jörg Lanz von Liebenfels. The root races appear likewise in Rudolf Steiner and turn up again more recently with Wilhelm Landig and Ravenscroft.[213]

The borrowing by neo-Nazism of the Shambhala myth described in detail by Helena Blavatsky has already been pointed out. According to the Theosophical view, beneath Tibet there were huge caverns with libraries (*Isis Unveiled*) and the wise men of the Third, Fourth and Fifth Root-races stayed in underground dwellings (*The Secret Doctrine*). Parallels are likewise found in the neo-Nazi literature: for example, the neo-Nazis sometimes located Agarthi and Shambhala in great caves beneath Tibet. This cave theme was borrowed by Lobsang Rampa/Cyril Hoskins as well, who allegedly experienced the 'Ceremony of the Little Death' in a temple deep below the Potala, and it also occurs in other Tibet stories, such as the film *The Golden Child*, and in 1980s comics.[214]

All these examples, which could be supplemented with others, confirm how much the authors presented here took inspiration from Theosophy. Some, especially Ravenscroft, also used Anthroposophical ideas.[215] It is hard to distinguish the two sources clearly, as it is known that Anthroposophy evolved out of Theosophy and there is much common ground between the two. The neo-Nazi authors also borrow heavily from Gurdjieff and Ossendowski, while d'Alveydre and Jacolliot are probably unknown to them as their books are scarcely obtainable any more today.

Arbitrary concoction of history

The story we gave an account of above that describes Hitler's escape begins with the sentence 'Once upon a time there was a cremation.' As we know, many fairy tales start like this, and so should most of the accounts of Tibet mentioned up to now—for they too belong in the category of fairy tales. There was no Tibetan living in Berlin nicknamed 'the man with green gloves', and as he did not exist, Hitler in turn could have got no advice from him. There was no Tibetan colony or indeed a Tibetan order of black magicians in

Germany. Based on information from the aliens branch of the police of the period, there was only one Tibetan in Germany at that time, namely a servant of the explorer Albert Tafel, who later married a German woman.[216] The supposed Tibetan Burang, who in 1947 published the book *Tibeter über das Abendland*, also turns out on more precise examination to have been a non-Tibetan: he was T. Illion, alias Nolling.[217] In short, there is no evidence for the existence of a single Tibetan monk living and working in the Third Reich,

never mind a whole group or even thousands of Tibetans!

There also exists no evidence that Gurdjieff and Trebitsch-Lincoln were in Tibet, disregarding their own assertions, which must, however, be strongly questioned in view of the unbelievable yarn-spinning of both men. In addition, many of their scraps of information make it appear extremely improbable that they stayed in Tibet. Karl Haushofer too, as his complete biography demonstrates, was never in Tibet, and could therefore have built up no contact with the 'Yellow-cap monks'. Moreover, he was certainly not initiated by Gurdjieff into the Tibetan mystery of the 'state of awakening', as he had no contact with Gurdjieff[218] and no initiation into the 'state of awakening' is known in the Tibetan tradition. It has also been proven that the Thule Society did not deal with Asian or Tibetan teachings.

Also in the realm of fairy tales belong the diverse versions of the Agarthi myth, which is not known either in Mongolia or Tibet. When Ernst Schäfer set off in 1938 with his expedition to Tibet, neither Hitler nor Himmler was interested in the discovery of Agarthi. Himmler's interest in Tibet is verifiable indirectly at best, based on notes by Ernst Schäfer, information from Bruno Beger and activities that Himmler clearly planned or supported (Tibet expedition, 'Ahnenerbe', etc.).

Only Shambhala has a Tibetan origin, at least so far as the name is concerned; but the legend as the Theosophists and neo-Nazi circles recount it is unknown in Tibet—as will be shown in Part 5.

From the many sources cited in this chapter, one thing is clear: the knowledge of the authors who have had a chance to speak about Tibet is shockingly poor. Obviously not one author has taken the trouble to refer to well-researched texts by Tibetologists and academics studying religion; instead, passages from dubious Theosophical texts or novels such as Bulwer-Lytton's are cited. A 'chaos of plagiarism' rules, everyone copies from everyone else, sometimes naming the sources (whereby the relevant publication is meant to be lent a touch of scientific respectability), but for the most part without precise identification of sources.[219] The fact remains that the sources drawn on are as a rule extremely dubious or—as one expert in the material puts it—

One proves the 'truth' of a lie with someone else's lie.[220]

Detlev Rose, who has worked intensively on the Thule Society and critically analysed the various sources, thinks:

The contents of 'occult' world views are not verifiable, not provable and not refutable,[221]

an opinion that is only accurate up to a point. There are many occult convictions that in fact one must simply believe or reject, but everywhere that occultism draws on other religious systems or borrows other religious ideas—which in occultism seems often to be the case—verification is possible. As has been shown in this chapter, a great many falsehoods, untruths and monstrous things about Tibet and Tibetan religion have been spread under the cloak of occultism; these can be refuted without further ado, provided one has the necessary basic knowledge about Tibet and uses the sources at one's disposal critically.

The slipshod way of using sources is characteristic of many of the publications presented here, as is the often tendentious bending of data to bring them into agreement with one's own preconceived opinions. Two examples must suffice for illustration, though numerous others could be added: Doucet claims in his book *Im Banne des Mythos* ('Under the Spell of the Myth')—which by numerous source references and footnotes tries to give the impression of a scientific study—that

the Upanishads are the foundation of the secret Buddhist teachings and the psycho-techniques of the abbots and monks in the lama-monasteries of Tibet, as were transmitted through Haushofer to the members of the Thule Society.[222]

Apart from the fact that the Hindu Upanishads are in no way the foundation of the Buddhist teachings (unless in the sense that Buddhism has developed out of Hinduism), several Tibet myths are implicitly transmitted in this one sentence: the 'secret' content of Buddhist teachings, the special 'psycho-techniques' that Buddhist monks are supposed to have at their disposal, and the myth already sufficiently familiar that Karl Haushofer transmitted Tibetan wisdom to the members of the Thule Society. A still more absurd conjecture is found a few pages further on in the same book, when Doucet writes:

Considering the demonstrable connections of the 'Thule Circle' with Tibet [connections that, as we have shown, cannot be proven] and the adoption of Tibetan secret teachings, the reversed swastika and also the colours of the party uniforms could have been taken over from the Yellow-cap sect.[223]

Not much more is needed to make the equation: German SS men (or their backers) = Tibetan Yellow-cap monks.

To label such literature irrational, as does Detlev Rose,[224] is indeed comprehensible on the basis of his own argumentation, but at least as far as the Tibet image drawn in it is concerned, too sweeping. This literature is tendentious, it is speculative (without declaring this clearly), it is neo-Nazi literature. It is literature that with the aid of arbitrary concoction of history resurrects Nazi ideology. Nor should one be misled by the fact that there are some among these authors who qualify their statements, as for example Bronder, who in the chapter on the occult roots of National Socialism writes that it should not be denied that fact and fiction are woven together in his accounts and what is quoted is in part unsatisfactory and not verifiable with certainty.[225] Despite this 'recognition', his book contains many untruths that could have been avoided with careful investigation.

To demonstrate that in the neo-Nazi literature Tibet is visibly gaining in importance and is increasingly 'misused' was the main aim of this last chapter.

As already mentioned, many data concerning Tibet from the Nazi and neo-Nazi area go back to the Theosophy of Helena Blavatsky, who herself in turn used those sources that suited her, without critically inspecting their truth content. Critique of sources was a foreign word for Blavatsky, as it is for the exponents of the new Tibet occult literature. It seems that for these authors it is not a matter of demonstrating facts but of presenting preconceived opinions: Tibet is the place of retreat for the inhabitants of Atlantis and thus of the early Aryas; these early Aryas knew wisdom that has been lost to other inhabitants of Earth; it is worthwhile—nay, obligatory—to get to know this wisdom, and therefore to get in contact with the Tibetan sages so as to establish a new, better régime on Earth. The question remains, why did the Theosophists (and their forerunners) create these Tibet myths and the neo-Nazis develop them further? Why Tibet? Why Tibetan monks? These are questions we should like to consider more deeply in Part 5.

C. The real 'Tibet-connection' of the Nazis

Himmler's interest in Tibet and the 'Ahnenerbe'

It would be equally tendentious and wrong to convey the impression that the Nazis displayed no interest in Tibet at all or that Himmler had no connection with Asia and Tibet. We should like to investigate below the factual 'Tibet connection', basing ourselves principally on the preliminary studies of Harald Bechteler and Reinhard Greve.[226] Where it seems useful, we shall also refer in this chapter to the neo-Nazi literature.

The focal point for preoccupation with Tibet in the Third Reich was the research and teaching group called the Ahnenerbe, 'Ancestral Heritage'. This institution, founded in 1935, was primarily due to Himmler's great mistrust of the 'journeymen of science'. He wanted to carry out in the Ahnenerbe 'fundamental and most valuable researches' that were in the national and National Socialist interest and were not accepted or pursued by official science.[227] In particular it was desired

'to explore space, spirit and action in the northern Indo-Teutonic world' and 'to impart the results to the German nation in a clear and simple form'.[228] The Ahnenerbe, which at times included from forty to around fifty scientific departments, was, however—as Heller & Maegerle correctly remark—by no means just an airy-fairy hobby of Himmler's, but was involved in the extermination of the Jews and was brought in, as justification of it. The Ahnenerbe was integrated into the SS, it was an office within the personal staff of the Reichsführer-SS Himmler, and its academics had SS ranks and wore SS uniforms.[229]

Himmler appears to have been interested in oriental wisdom teachings and occultism, and is supposed to have often carried with him a copy of the Bhagavad-Gîtâ. The belief of the Indo-Germans in rebirth and the law of karma appealed to him. Thus for example he spoke of 'the karma

of the Teutons', because of which it was predetermined that Hitler would save the Teutonic world. According to Himmler, in Hitler one of the light-beings had received incarnation.[230] Himmler evidently liked the Hindu caste system with its clear hierarchy and apportionment of tasks, and he blended it with his ideology of the master race. He was particularly taken with the aspect of Krishna, who—like the Führer Hitler—meddled in the fortunes of the world whenever injustice arose.[231]

But it also remains unclear regarding Himmler, how much he believed in the recondite myths of origin, according to which the Aryans lived in a place of retreat in or even beneath Tibet. Because of Himmler's conviction that positive qualities existed exclusively in 'Nordic blood' and that higher development of this Nordic race constituted an important goal, it can be assumed that his interest in the alleged Aryans of Central Asia was extremely limited, indeed probably non-existent. But this still does not deter the neo-fascists from connecting Himmler with Tibetan occult knowledge—that Tibet that the Nazi occultists turn into a projection-screen for their 'esoteric Hitlerism', the latter being an expression of the esoteric National Socialist Miguel Serrano. According to Ravenscroft, Himmler was so enthusiastic about the teachings of a Tibetan

group that had been set up on the suggestion of Professor Karl Haushofer that he established an occult school and detailed many members of the Death's-head SS, the Gestapo and so forth for 'courses in meditation, transcendentalism and magic'.[232] Even the world-ice theory of Hanns Hörbiger was connected with occult Tibet: it was claimed that the cosmology that was hidden behind the theory originated 9,000 years ago in ancient Tibet.[233]

Himmler's interest in Tibet can probably be put down in part to his adviser, Karl Maria Wiligut. This man, 'Himmler's Rasputin', claimed to have undertaken a journey to India and visited a Lamaist monastery there, a journey that cannot be accommodated in the uninterrupted curriculum vitae of the colonel which is available.[234] The tale recounted by Wiligut, however, with which he, as it were, sought to prove his journey, is again instructive. On leaving the monastery, he was led by the monks into a rich treasure-chamber and the holy men invited him to take as much of the treasure as he desired. The old man politely refused the offer and took none of the jewels.[235] Later it was claimed by his esoteric friends that the meeting had taken place

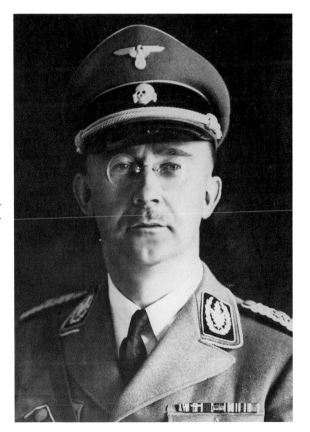

43. The focal point for preoccupation with Tibet in the Third Reich was the research and teaching group called the Ahnenerbe, 'Ancestral Heritage', which was an office within the personal staff of the Reichsführer-SS Himmler (1900– 1945). This institution, founded in 1935, was primarily due to Himmler's great mistrust of the 'journeymen of science'. Himmler appears to have been interested in oriental wisdom teachings and occultism, but not, as is claimed from time to time, in discovering Agarthi, which some supposed was in Tibet. He hardly believed at all in the recondite myths of origin, according to which the Aryans lived in a place of retreat in or even beneath Tibet. The claim that on the suggestion of Karl Haushofer he established an occult school and detailed many members of the Death's-head SS, the Gestapo and so forth for courses in meditation, transcendentalism and magic also lacks any foundation. It is, however, a fact that in 1938 Himmler took a lively interest in the Schäfer expedition to Tibet, which was under his patronage and in association with the Ahnenerbe. Himmler hoped for important data of military science from this expedition, as is shown, for example, by the fact that he gave Schäfer special orders to breed a 'super steppe horse' for war purposes. Himmler also supposed that 'remnants of the tertiary moon-men, the last witnesses of the lost, formerly worldwide Atlantis culture' were to be found in Tibet.

only on the astral plane (even if Wiligut was convinced the journey to India and the stay in the monastery had happened) and had been an initiation experience: by refusing the jewels, Wiligut passed an important test.

Wiligut was convinced that Lhasa, together with Urga (Ulan Bator), the Egyptian Pyramids and Vienna, formed a kind of geomantic quadrilateral, in the centre of which lay Utgard, a place already known in the Edda, which is supposed to be identical with the old Russian monastery of Gora Blagodaty and the 'Iron City' mentioned by the Persian poet Firdawsi in his *Book of Kings*. In this Asian primary order powerful energy beams are at work. Thus Vienna is supposed to be under the influence of beams from Utgard and Urga, while another energy current runs from the Pyramids via Iran, Afghanistan and Baluchistan to Lhasa.[236] Himmler apparently believed in this geomantic theory, and it cannot be ruled out that he was hoping for more accurate data on it from the Schäfer expedition.

Ernst Schäfer and his SS men

Ernst Schäfer (1910–1992) had already taken part, in 1931–32 and 1934–36, in two American-German expeditions to Eastern Tibet, together with the American Brooke Dolan, after which he was appointed SS 2nd lieutenant (*Untersturmführer*)

44. The British observed with great scepticism the members of the Schäfer Tibet expedition, who did not conceal their political origin in any way. This is confirmed, for example, by this dedication of Schäfer's in a book that Reginald Fox, radio operator in Tibet for the British Indian government, received as a gift: 'With best regards and in kind remembrance of the five SS men who visited Lhasa.'

by Himmler.[237] In 1938 he was to lead a separate German Tibet expedition 'under the patronage of Reichsführer-SS Himmler and in association with the Ahnenerbe'. Himmler therefore showed a lively interest in the Schäfer expedition to Tibet, was helpful in obtaining the necessary authorizations—among others, from the British-Indian authorities—and also paid for the last part of the expedition's return flights.[238] Apart from that Schäfer raised the money for the expedition personally, because of which he had great independence in planning and implementation. This led to Schäfer himself largely defining the areas of research, so that the Ahnenerbe saw itself compelled to distance itself from the undertaking, as under the prevailing conditions it could not be reckoned that 'the cultural-scientific purposes of the Reichsführer-SS' were being served.[239] Nevertheless, this did not stop Himmler inviting all the participants in the Tibet expedition to an audience before departure, presenting each one with an angora-wool pullover, promoting them all at Winter Solstice 1938—Schäfer became a captain (*Hauptsturmführer*)—and on their arrival in Germany in August 1939 greeting them in front of the media after having them picked up in Athens by Himmler's private plane. Schäfer, who was fêted like a hero, received from Himmler a death's-head ring signed by the Reichsführer and an SS sword of honour.[240]

The Schäfer Tibet expedition again demonstrates in exemplary fashion how subtly neo-Nazi authors blend fiction with history and disguise their ideology. In *Die schwarze Sonne von Tashi Lhunpo* the expedition had the task of tracking down the Thule legend, and in *The Spear*

of Destiny the German expeditions, which Ravenscroft claims set out annually between 1926 and 1942, were trying to establish contact with the cave communities of adepts of Agarthi and Shambhala. They were supposed to persuade these to place the Luciferian and Ahrimanic powers at the service of National Socialism and to support the planned mutation that should signal the birth of the new race of supermen.

Wilhelm Landig in his Thule trilogy likewise mentions Schäfer's expedition to Tibet, which is supposed to have served esoteric purposes.[241] For Tibet, according to Landig, is

> the realm of the Black Sun! It is the focus of the esoteric circles of the SS, whose knowledge even Herr Himmler suspected, but was not party to.[242]

Carmin too tries to suggest to his readers that Himmler was interested in the expeditions to Tibet because he believed in the real existence of the kingdom of Agarthi.[243] Finally, Bronder claims that the Schäfer expedition was under the leadership of Eva Speimüller and Karo Nichi, 'an envoy of the Tibetan Agartha in Berlin'. It

brought the Dalai Lama radio equipment for the reception of communications between Lhasa and Berlin.[244]

> Schäfer's SS men [where was Eva Speimüller then?] were allowed to enter holy Lhasa, usually closed to Europeans and Christians—indeed, even the magnificent Lamaist temple that contained just one gigantic symbol, the holiest in the Mongol world: the swastika.[245]

The swastika there becomes the uniting symbol between the German Reich and Tibet, which is not altogether unfounded when one reads what Schäfer said on the occasion of a presentation of gifts to the Tibetan regent:

> As the swastika represents for us Germans too the highest and most holy of symbols, so may our visit stand beneath the motto: meeting of the western and eastern swastikas in friendship and peace …[246]

Despite this supposed swastika affinity we have still to emphasize that the swastika in Tibet never took on the central status that the stories mentioned above would lead us to believe. The magnificent Lamaist temple that is supposed to contain only a swastika does not exist; it is a fairy tale.

45. Members of the Schäfer expedition on a visit to the Tibetan ministerial council. The expedition, carried out in 1938–39, led to much speculation. Among other things, it was supposed that with this journey to Tibet, the Nazis had wanted to prove the existence of cave communities from Agarthi and Shambhala and to pursue esoteric aims. Nothing, however, bears out these hypotheses. The principal goal of the Schäfer expedition was gathering geophysical, zoological, botanical, geological, ethnological and anthropological—hence racial studies—data.

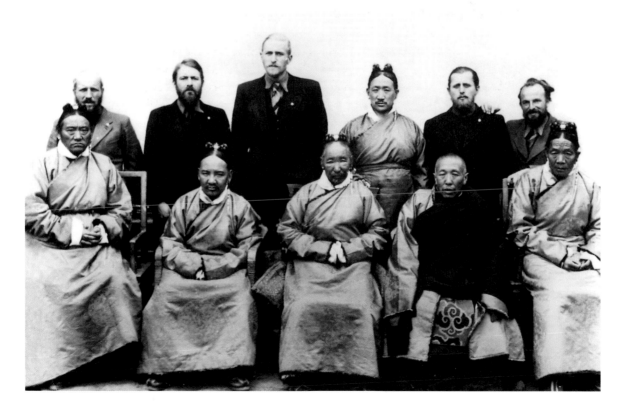

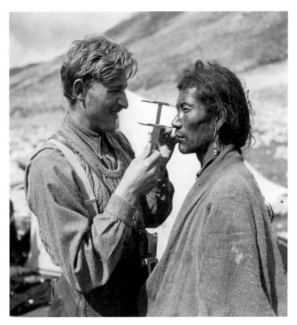

46. The man in charge of collecting anthropological data on the Schäfer expedition was Bruno Beger, a student of Hans Friedrich Karl Günther, a leading ideologue of Nazi racism. Beger paid particular attention to the Tibetan nobility, as like his teacher Günther he assumed that Nordic or Caucasian racial elements must be preserved above all in the leading stratum and the nobility. Although only non-nobles made themselves available for anthropological measurements—Beger recorded 376 persons anthropo-metrically and photographed approximately 2000 Tibetans—Beger later claimed that his hypothesis had been confirmed.

According to present-day knowledge, the previously mentioned occult objectives and background of Ernst Schäfer's Tibet expedition are taken from thin air. The principal goal of the Schäfer expedition consisted of the collection of geophysical, meteorological, zoological, botanical, geological, ethnological and anthropological data—including data concerned with the study of race:

> a synopsis of his research area, Inner Asia: earth—plants—animals—and people, synthesis in the Goethean and Humboldtian sense.[247]

In addition he was also supposed to be on the look-out for Germanic remnants in Tibet and conduct research to substantiate the so-called world-ice theory.[248] The world-ice theory developed by Hanns Hörbiger, of which even Adolf Hitler was a convinced supporter,[249] attempted to explain catastrophes such as the Flood and the end of Atlantis and postulated a continual battle between ice and heat in the universe. In this battle the driving force of all cosmic events was to be sought.[250] From the experiments to be carried out in Tibet and elsewhere, Himmler was hoping for

a significant contribution towards reliable weather forecasts, so as to be independent of foreign meteorological services in the event of war. He was therefore interested above all in military-scientific data, which is shown for example in Himmler's having given Schäfer special orders to breed a 'super steppe horse' for war purposes. He also instructed the Ahnenerbe to work on the cultivated plants collected during the Tibet expedition, among other things, to breed hardy cereals, with which Germany might become economically self-sufficient. This kind of research was in accord with Schäfer's interests: he saw himself as an applied scientist and never took to any occult theories about Tibet.[251]

There is also nothing to confirm that Schäfer acted in any way as a political intermediary between the German Reich and Tibet. We know only of one courtesy document from the Tibetan regent to Hitler, which Schäfer brought back to Germany together with a present, with which Hitler is supposed to have been disappointed.[252] The document gives expression, completely non-committally, to the wish

> to intensify the at present friendly relations between our two capitals. I believe that you, exalted king, Herr Hitler, in agreement with me on this matter, consider this, as previously, essential, and not unimportant.[253]

The person principally responsible for collecting anthropological data in the Schäfer expedition was Bruno Beger. Beger was a student of Hans Friedrich Karl Günther, a leading ideologist of National Socialist racism, who held that:

> The valuable race, the constructive, creative, structuring [race], the fair, heroic race, is the Nordic.[254]

Professor of Racial Studies' Günther was interested in particular in the nobility, that part of the nation in whom the will to create exemplary stocks is inherent. The original racial characteristic of the Indo-germans, he said, had been best preserved in the nobility of the peoples of Indo-germanic speech.[255] This preference of Günther's for the nobility was shared by his student Beger, who wanted to pay special attention to the Tibetan nobility, because like his teacher Günther he assumed that the Nordic or Caucasian racial elements must be preserved above all in the leading stratum and the nobility. This, said Beger in his lecture *The Racial Character of the Tibetans*, had in fact been confirmed on his

Tibetan journey.[256] As nobles never made themselves available for anthropological measurements, it remains open how Beger arrived at this conclusion.

In addition, Beger wanted to search in Tibet for skeletal remains of earlier Nordic immigrants and investigate the Nordic race among the Tibetan population,[257] because—as he wrote in a memorandum, in which he criticized Schäfer—a National Socialist expedition must have only one research goal: the investigation of the 'Nordic race' in Asia. Thus he recorded 376 persons in Tibet anthropometrically and photographed approximately 2,000 Tibetans. However, because of the reservations of the local people, he was able to take only a very few head casts.[258]

In 1939 Schäfer was entrusted with a 'special political order'. He and a few other selected men were to incite the Tibetan army, with weapons and other gifts, against the British-Indian troops. In 1940, however, the expedition had to be called off on the orders of Himmler's rival Alfred Rosenberg, with Hitler's blessing.

In January 1940 Schäfer became leader of the 'Research Centre (Forschungsstätte) for Inner Asia and Expeditions', which developed into the most important department within the Ahnenerbe. Tibet was now unambiguously an object of 'purposeful research important for the war': with the extension of the Third Reich towards the East and the advance of the Japanese against the West the question arose of what should happen with Tibet, which lay in between, the only state in the region not involved in the war. Could the Tibetans as an 'allied race' play a significant role in a pan-Mongolian federation under the aegis of Germany and Japan?

A clear expression of the great interest in Tibet was an order of Himmler's in Spring 1942, 'that the Tibetan and all the Asian research should be very strongly reinforced'.[259] Another Tibet expedition was planned, which, however, had to give way to 'total investigation of the Caucasus' when German troops reached the Caucasus in August 1942. Nevertheless, the Tibetan research was intensified: in 1943 the 'Sven Hedin Institute for Central Asia' was founded, whose purpose was 'the total investigation of the Central Asian living space'.[260] With this, Beger's research in racial studies enjoyed its terrible culmination. Also after the Tibet expedition, Beger had devoted himself intensively to racial questions and had become a leading race expert in the Ahnenerbe, in which he devoted himself more and more to 'checking races for their usability'. Of all Schäfer's colleagues, Beger stood closest to National Socialism. Certain clues indicate that within the framework of his 'Mongol research' he procured for anthropological investigation 115 skeletons of prisoners from the Auschwitz concentration camp. He was interested above all in Mongoloid types, but there were only four of these in Auschwitz, so he extended his 'research' to Jews.

The skeleton collection and the data belonging to it no longer exist today, as the order was given to destroy everything completely.[261] Would this 'great scientific loss of this unique collection'[262] not be a possible subject for a future neo-Nazi Tibet novel, in which the kinship of the Germans with the Tibetans is demonstrated once and for all?

Threatening Tibet

The literature cited up to now partly goes back to neo-Nazi authors, who refer continually to prominent representatives of the Third Reich—without naming checkable sources. In the National Socialist literature of the 1930s and '40s only a few references to Tibet are found, and these voices feel Tibet is more of a dangerous threat than a Promised Land. Buddhism is seen as a 'sign of decay of the spirit of the Nordic race'.[263] It is claimed of 'Lamaism' that with its allies, the Jewish Freemasons and the Roman papacy, it threatens the peoples of Europe.

Similarly negative assessments of Tibet, especially of its religion, are already found at the beginning of the twentieth century. Thus the lyricist and narrative writer Max Dauthendey (1867–1918) in his story Himalayafinsternis ('Himalayan Darkness') describes a Tibetan temple as

> a kind of dark stable with gods—not a single peaceful one among them—who were standing or squatting in wild, contorted positions. A few Tibetan priests in dirty yellow habits were sitting around on the floor, smoking and drinking. Behind the feeling of dull stupidity that squatted in this stable-like temple room there lay at the same time a cold-blooded cruelty. It glanced almost

mischievously from the blank eyes of the bald-headed Tibetan priests and grinned in grotesque friendliness from the laughing mouths of the face masks of the god figures squatting in the semi-darkness.[264]

Another early negative evaluation of the 'Lamaist theocracy' came from S. Ipares—influenced at all events by the orientalist Albert Grünwedel (1856–1935), whose publications became more and more confused during the 1920s. Ipares wrote in his book *Geheime Weltmächte* ('Secret World Powers') that the eastern world had already been preparing for some time for an undreamt-of, large-scale defence against the white nations' plans for world domination. But behind these masses of nations of the near and far East pushing into and entering major world politics, said Ipares, the occult *hierarchia ordinis* of the Lamaist theocracy

47. In Zu Juda und Rom—Tibet, *J. Strunk portrayed Tibet as part of a global conspiracy. According to Strunk, the priestly caste in Tibet observed the machinations of their representatives, active everywhere, like a spider whose threads spanned the whole world. Strunk said the nations should recognize the great danger that threatened them from the 'Roof of the World', all the more so seeing that the Tibetan priestly caste was even endeavouring to lay claim to the symbols of the German nation, such as the swastika.*

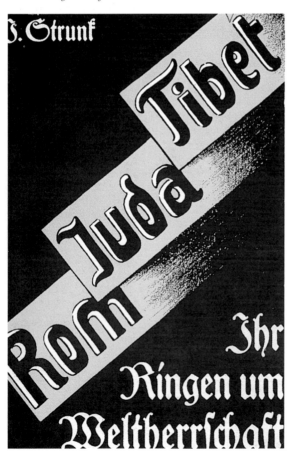

was keeping watch, invisibly influencing and guiding the East.[265]

J. Strunk also argued quite similarly in *Zu Juda und Rom—Tibet* ('On Judah and Rome—Tibet: their struggle for world domination'), which speaks of a secret world leadership, by which he understands

> all the organizations that resist the natural development of a nation and want to bring the nations into their absolute power. ... Like a spider's web they encompass all states and nations of the Earth.

Among these organizations Strunk counts all world religions, but Buddhism is leading together with Judaism, Christianity and 'Mohammedanism'. Typical of these religions is strong binding by oath, the foundation of the priestly castes, of which the Buddhist claims to be the oldest. This believes itself to be in possession of the most secret knowledge. Its visible head is the living Buddha, the Dalai Lama in Lhasa.[266] According to Strunk, the priestly caste sits in Tibet and observes the work of its representatives all over the world—like a spider whose threads are spread out over the whole world.

> What goes on at organizations and in new spiritual currents, simultaneously and confused, almost always ends up on the 'Roof of the World', in a Lama temple, after one has proceeded through Jewish or Christian lodges.[267]

Strunk writes in his 'first attempt at a history of the development of the secret world leadership' that the work of the eastern priestly caste was scarcely discernible until the middle of the 19th century, but since then it had displayed lively activity, because of which the situation of the nations was becoming more difficult. The eastern priestly caste wanted to drive out Judaism and Christianity and step into their place. It even appeared to be endeavouring

> to lay claim to the very symbol of the German nation for themselves, so as to lend their work a national touch. So we must, for example, resolutely reject that the 'Buddhist Association' of Berlin introduces the swastika into its occult symbols.[268]

Whoever thinks it is ridiculous

> to pay so much attention to these dirty, ragged and foolish lama-priests, need only look round his circle of acquaintances once and he will be shaken by how many occult ideas he finds there. But they are all preparers of the way for the rule of the eastern priestly caste, which wants to step into the place of the Judeo-Christian one.[269]

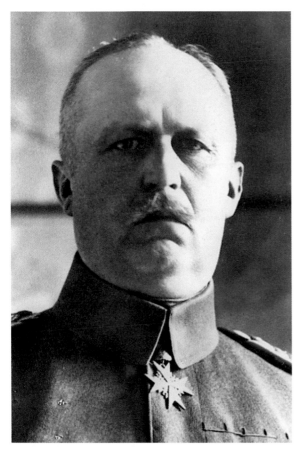

48. General Ludendorff wrote with his wife in 1941 the book Europa den Asiatenpriestern? *('Europe for the Asian Priests?'), in which he depicted the Buddhists as a danger to the West, not least because they had set themselves at the top of many secret orders. This assessment contradicts the neo-Nazi claim that leading Nazis had taken the most thorough interest in secret Buddhist teachings.*

It is, however, no less pernicious, and the 'Lamaist-Buddhist collective', which is to be put in the place of the Judeo-Christian one, is no less terrible for the nations.

> As the Jew or the Jesuit endeavours to penetrate all expressions of life with his mind and make them usable for himself, so does the Eastern priestly caste. May the nations recognize the great danger that is threatening them more than ever from the 'Roof of the World'. May they take care that their national aspiration for freedom is not abused by it, for the spirit of Asia is already right in their midst.[270]

When Strunk speaks of the secret work of the priestly castes destroying nations and states, and of supranational powers, this recalls General Ludendorff and his wife, who with similar arguments led a battle against Freemasonry and Christianity, which later—presumably influenced by Strunk—extended to the 'Asian priests' as well,[271] who had supposedly succeeded in placing

themselves at the head of many secret orders. Like Strunk before, Ludendorff too connected Buddhism with Judaism and Christianity (by which he of course meant Catholicism): Judaism had drawn from Egypt and Babylon and the mysteries there and trimmed them to its own requirements, and then from Buddhism and 'Krishnaism' with Jewish ingredients had fabricated the Christian doctrine.

In the field of Ipares, Strunk and Ludendorff there also belongs Wilhelmy, who wrote about a 'crusade of the mendicant monks'. The teaching of Buddha,

> that last and greatest miasma of Asia, is intended for us, so as to make us poor in defence, to eradicate us finally from the face of the earth as a nation of the Germanic high race with creative abilities, to silence our experience of God that is rooted in the purity of the breed!

49. Wilhelmy also wrote of a threatening global conspiracy and a crusade of Buddhist mendicant monks, who intended to eradicate 'the nation of the Germanic high race' from the face of the Earth. He located the centre of this conspiracy in Tibet, 'with its two million withered and famished souls governed by brats of the devil'. In Tibet sit the wire-pullers, who turn 'the almost attained closeness to God of the German nation' into distance from God and threaten to crucify the Germans. Only one thing can help: the mendicant monks must be vanquished with the spiritual weapons of enlightenment so abundantly available.

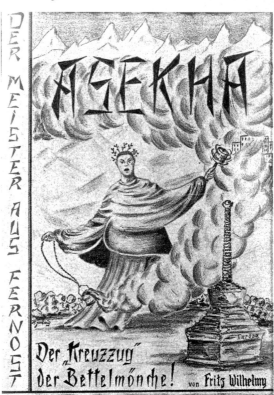

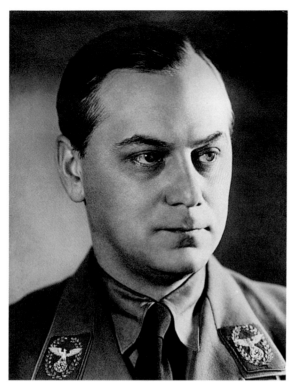

50. *Alfred Rosenberg (1893–1946) also adopted a clearly anti-Asiatic position. According to him, Tibetan Lamaism—besides other places of the racial enemy such as Syria, Etruria and especially Jerusalem—had influenced Roman Catholicism negatively. But happily, says Rosenberg, Martin Luther opposed that enchanting, terrible state of affairs, which had come from Asia. Had this not happened, Europe would have been completely stultified and stuck in the most dreadful superstition, poverty and squalor. Rosenberg thus saw Lhasa, Jerusalem and Rome as places of the enemy opposing the Aryan-Nordic race.*

As centre of this conspiracy he specified Tibet,

> with its two million withered and famished souls governed by brats of the devil, who even consider it a high honour when they pass away for their corpses to be cut up by their priests and thrown down as food for the vultures … Tibetan Buddhism … is apparently called to play a more than mysterious role in the great world-gearbox of the supranational wire-pullers,

among whom Wilhelmy counts the imperialists in London, the Buddhists in Tokyo, the Muslims in Mecca, the anticapitalists in Moscow, the big capitalists in New York and the Catholics in Rome.[272] All the 'mysteries' of the Jesuit order, Freemasonry, the Theo-, Anthropo- and Ariosophists, the Mazdaznan, New Spirit, Buddha and Eranos movements, the 'pure Aryan' religious cults of the racial metaphysicists—they all somehow flow spiritually into the mysticism of Tibetan monasteries.

The mendicant monks from the East threaten to turn 'the almost attained closeness to God of the German nation' into distance from God. Just one thing could help:

> Either we crucify the mendicant monks, i.e., we nail them firmly with their occult, zombifying false science (*Afterwissenschaft*), before they have reached Europe's borders, with our so abundantly available spiritual weapons of enlightenment; or the mendicant monks crucify us.[273]

Alfred Rosenberg (1893–1946) also adopted a clearly anti-Asiatic position. According to him, Tibetan Lamaism—besides other places of the racial enemy such as Syria, Etruria and especially Jerusalem—had influenced Roman Catholicism negatively. He included in this the use of the rosary, 'whose mechanism has reached its perfection in the prayer wheel', and the Papal foot kiss, which he says the Dalai Lama also requires.[274] But happily, says Rosenberg, Martin Luther opposed the advance of that enchanting nuisance, which had come from Asia. Had this not happened,

> Europe today would have reached the condition of the holy men of India and Tibet, thick with dirt, a condition of the most complete stultification, of the most dreadful superstition, poverty and squalor—with continual enrichment of the priestly caste.

The priestly societies of Asia, which had influenced the magically powerful priesthood in Rome, were warded off by Martin Luther! But, Rosenberg warned, one must not forget,

> should the Protestant spirit no longer be there, the Tibetan-Etruscan world would reveal itself once more.[275]

Rosenberg thus saw Lhasa, Jerusalem and Rome as places of the enemy opposing the Aryan-Nordic race. The question remains open, why the neo-Nazi authors did not take note of this extremely negative evaluation of Lhasa and Tibet by one of the important National Socialist ideologues, 'the originator of racial hatred' (International Military Tribunal in Nuremberg), and instead portrayed Tibet as the stronghold of the Germans of the Reich. Why did the same neo-Nazi authors refer to the Führer in their occult theories, when really the dictator railed against the occult leanings of party members in 1938 with the words:

> The slipping in of mystically inclined, occult explorers of the other side cannot be tolerated in the Movement?[276]

D. Negative assessments of Tibet

Possible borrowings from critical philosophy

How did the negative assessment of Tibet and the 'Asiatic priestly caste' by Ipares, Strunk, Wilhelmy, Ludendorff and Rosenberg come about? What were their sources? Most probably, the philosophers Rousseau, Kant, Herder and Nietzsche, who for their part relied on missionaries such as Grueber, della Penna and other Capuchins, without making their sources known.

Kant (1724–1804) thought that the religion of 'the Mongolian Tartars', by which he meant the Tibetans, was 'a Catholic Christianity degenerated into the blindest heathenism'.[277] In the one as in the other there is the 'statutory walk to church', pilgrimages, the recitation of prayer formulas (offering of the lips), the offering of natural goods, and indeed self-offering of one's own person by becoming lost to the world as a hermit, fakir or monk. For Kant, this was 'false service (*Afterdienst*) of God', i.e., superstition, in which he also counted the Tibetans' prayer wheels and hanging up of prayer flags. Such 'pious games and idleness', such 'creeping religious mania', Kant compared with the 'ethos of virtue' (*Tugendgesinnung*), which apparently he found neither in Catholicism nor in the religion of the lamas.[278]

To the more temperate critics belonged the philosopher Johann Gottfried Herder (1744–1803):

> To the highest degree unnatural is the condition for which His Holiness [the great Lama = Dalai Lama] strives. It is disembodied calm, superstitious lack of thought and cloistered chastity. And yet there is scarcely an idolatry on Earth so widespread as this one.[279]

But fortunately, said Herder, not all Tibetans would obey the laws of the lamas, not every foolishness, otherwise the race of men would come to an end.
The Tibetan married, though he sinned thereby,

> and the industrious Tibetan woman, who even takes more than one husband and works by herself more diligently than the men, willingly renounces the higher grades of paradise so as to preserve this world. If there is one religion of Earth that is monstrous and unfavourable, it is the religion in Tibet …[280]

Nevertheless, Herder did see one benefit in this religion: the repulsive rule of the lamas had raised a rough, heathen people, who themselves thought they were the descendants of an ape, into a well-mannered, indeed in many things a fine people. Herder saw benefit even in the belief in migration of souls, as this belief made them sympathetic towards living Creation, so that

> these rough men of the mountains and rocks could perhaps be tamed with no gentler bridle than with this delusion.

This Tibetan religion, 'a kind of papistical

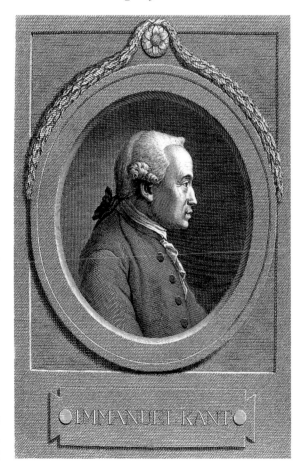

51. Kant (1724–1804) thought that the religion of 'the Mongolian Tartars', by which he meant the Tibetans, was 'a Catholic Christianity degenerated into the blindest heathenism'. In the one as in the other there is the 'statutory walk to church', pilgrimages, the recitation of prayer formulas (offering of the lips), the offering of natural goods, and indeed self-offering of one's own person by becoming lost to the world as a hermit, fakir or monk. For Kant, this was 'false service of God', i.e., superstition, in which he also counted the Tibetans' prayer wheels and hanging up of prayer flags. Such 'pious games and idleness', such 'creeping religious mania', Kant compared with the 'ethos of virtue', which he found neither in Catholicism nor in the religion of the lamas.

IMMANUEL KANT

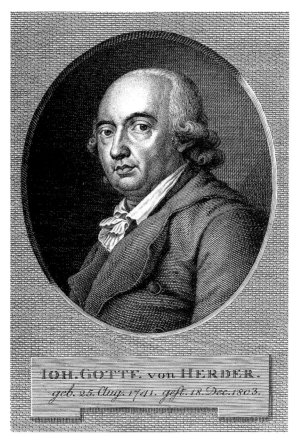

IOH. GOTTF. von HERDER.
geb. 25. Aug. 1744. gest. 18 Dec. 1803.

52. To the more temperate critics of Tibetan religion belonged the philosopher Johann Gottfried Herder (1744–1803). He did indeed feel the religion of the Tibetans was the most monstrous and unfavourable one in the world, but on the other hand he realized that fortunately, not all Tibetans obeyed the laws of the lamas. Moreover, the 'repulsive rule of the lamas' had raised a rough, heathen people, who themselves thought they were the descendants of an ape, into a well-mannered, indeed in many things a fine people, who thanks to this religion were acquainted with a kind of learning and written language.

religion ... This third [kind of religion] is so obviously bad that it would be a waste of time to play around proving it such.[282]

For Rousseau, uniting worldly and spiritual-religious power in one person was completely unthinkable, and conferring the sovereignty of the nation on a ruler like the Dalai Lama was for him an abomination. Understandably so: after all, the rigid, hierarchical 'Lamaist' system stood diametrically opposed to the freedom of the people propagated by Rousseau, which was to find its realization in the French Revolution.

That a man should now be honoured as a god, especially a living man, has in it something conflicting and outrageous,

said also another philosopher, Georg Wilhelm Friedrich Hegel (1770–1831); but he then immediately qualified his criticism by emphasizing

53. Jean-Jacques Rousseau (1712–1778) supported in his Contrat social *a negative evaluation of Tibetan religion. For him, the 'religion of the lamas' was a 'bizarre kind of religion', comparable with the religion of the Japanese and of Roman Christianity. In particular, uniting worldly and spiritual-religious power in one person, the Dalai Lama, was for Rousseau altogether a mistake; the rigid 'Lamaist' system stood diametrically opposed to the freedom of the people propagated by Rousseau, which was to find its realization in the French Revolution.*

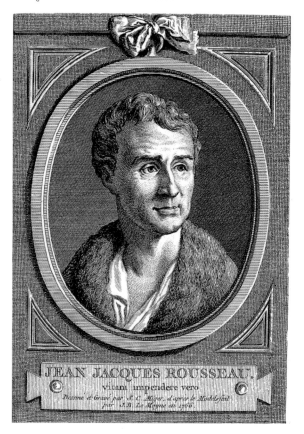

JEAN JACQUES ROUSSEAU,
vitam impendere vero

religion', had indeed brought a kind of learning and written language among this mountain race and furthermore among the Mongolians, which was a service to humanity.[281]

Shortly before, in 1762, Jean-Jacques Rousseau (1712–1778) had supported in his *Contrat social* a far more negative evaluation of Tibetan religion. He divided religions into three classes and wrote about the third:

There is a third, more bizarre kind of religion, which by giving men two legislative codes, two rulers and two countries subjects them to contradictory duties and prevents them from being able to be at the same time devout and a citizen. Such is the religion of the lamas, such that of the Japanese, and such is Roman Christianity. One could call it priestly

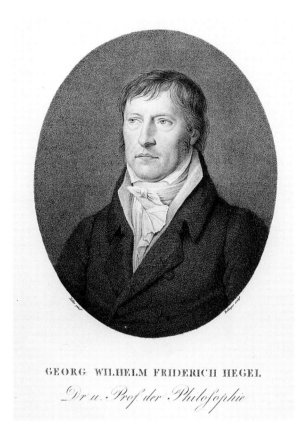

GEORG WILHELM FRIDERICH HEGEL

Dr u. Prof der Philosophie

54. Georg Wilhelm Friedrich Hegel (1770–1831): although Hegel found it outrageous that a man should be honoured as a living god, he seems to have had a certain sympathy for the Tibetan lamas. They were nothing but the forms in which the spirit manifested itself, and did not consider it their property. The spirit was 'a generality in itself', which the Tibetans, the Indians and Asians in general considered 'as the all-pervading'. For Hegel, the lamas were thus completely spiritualized beings: they did no magic, performed no miracle, 'for of him whom they call god, they [the lama-servants] want only spiritual deeds and granting of spiritual favours.'

that it lay in the concept of the spirit to be a generality in itself, which the Tibetans, Indians and Asians in general considered 'as the all-pervading'. And just this substantial unity of the spirit,

> it is thought, comes into view in the lama, who is nothing but the form in which the spirit manifests itself, and has this spirituality not as his own particular property, but only as sharing in the same.

For Hegel, the lamas were completely spiritualized beings, who appear to have nothing in common with the lamas of later authors: they do no magic, perform no miracle,

> for of him whom they call god, they [the lama-servants] want only spiritual deeds and granting of spiritual favours.[283]

Friedrich Wilhelm Nietzsche (1844–1900) also

did not spare the Tibetans with his critique, when he labelled them, along with others who prayed, as the 'poor in spirit', who actually never had a thought off their own bat. 'That way at least they are not a nuisance,' said Nietzsche,

> the wisdom of all founders of religions, large and small alike, has commended to them the formula of prayer, as a long, mechanical work of the lips, combined with effort of the memory and with a similarly set posture of the hands, feet and eyes! So now they want to ruminate countless times on their 'om mane padme hum' like the Tibetans … or they may use prayer wheels and rosaries—the main thing is that with this work they are tied up for a time and afford a tolerable sight … those poor in spirit know not how to help themselves, and forbidding them the clattering of prayer means to take away their religion from them.[284]

55. Friedrich Nietzsche (1844–1900) did not spare the religious Tibetans with his critique. For him they were the 'poor in spirit', who actually never had a thought off their own bat. But their prayers had at least one benefit: 'So now they want to ruminate countless times on their "om mane padme hum" … or they may use prayer wheels and rosaries—the main thing is that with this work they are tied up for a time and afford a tolerable sight … those poor in spirit know not how to help themselves, and forbidding them the clattering of prayer means to take away their religion from them.'

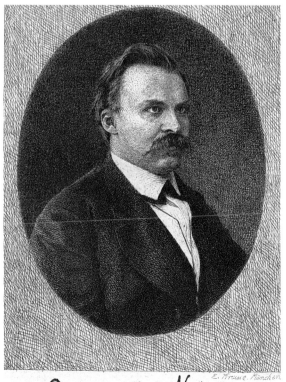

E. Krause. München

Professor Dr. Fried Nietzsche

Against the 'Red-caps': Gustav Meyrink

A generation later, Gustav Meyrink (1868–1932) drew a similarly negative picture of the Tibetans in some of his stories, especially of the so-called 'Red-caps', which in turn probably influenced the Nazis' negative images. But Meyrink was hardly the inventor of this specific negative image of the 'Red-caps'. It appears to go back to Helena Blavatsky, who for her part relied on the reports of early missionaries and on her own 'intuition'.

The West's Tibet image has in part very deeply-lying, strongly branched roots.

In Meyrink's *Der violette Tod* (*The Violet Death*), which appeared in his first volume of stories *Der*

56. Gustav Meyrink (1868–1932) drew a very negative picture of the Tibetans in some of his stories, especially of the so-called 'Red-caps', whom he called Dugpas. But Meyrink was hardly the inventor of this specific negative image, which appears to go back to Helena P. Blavatsky; Meyrink was in fact very close to the Theosophists for a while. On one occasion Meyrink depicted the Tibetans as guardians of magical secrets. Another time he described the Dugpas as the direct tool of the destructive, 'diabolical' powers in the cosmos. The Dugpas are beings whom one must no longer call by the name of man. They use the path of the left hand, a spiritual path full of horror and dreadfulness, while others walk the path of 'the Light'—becoming one with Buddha.

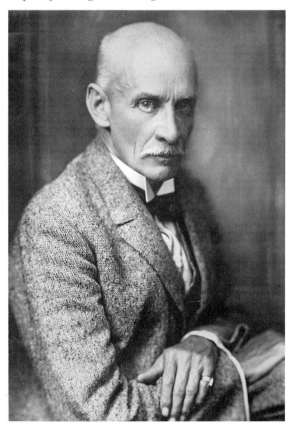

heiße Soldat und andere Geschichten (1903), the Tibetans were portrayed as custodians of magical secrets, with which they hope to destroy 'the arrogant strangers' when the great day dawns. Sir Hannibal Roger Thornton is one of these strangers, who wants to see with his own eyes whether these curious people, the Tibetans, really do possess occult powers. He has heard that in a valley in the Himalaya there is a rather peculiar piece of ground—with vertical rock faces on three sides, the sole entrance blocked by poisonous gases. In the ravine lives all alone—right in the middle of the lushest vegetation—a small tribe, who belong to the Tibetan race, wear red, pointed caps, and worship a malicious, satanic being in the form of a peacock. Over the centuries this devilish being has taught the inhabitants black magic and revealed mysteries to them, which one day are to alter the whole world. He has even taught them a kind of melody that can destroy the strongest man in an instant.

Sir Roger, who wants to explore this ravine, with his deaf assistant Pompey, passes through the barrier of poisonous gases with the aid of diving helmets and in a meadow bumps into about a hundred Tibetans wearing red, pointed caps. The Tibetans are clothed in sheepskins, but scarcely look like human beings,

> so repulsively ugly and misshapen were their faces, in which lay an expression of terrifying and superhuman malice.

They let the two approach closely, then—suddenly—they seal their ears with their hands and scream something at the top of their lungs. Deaf Pompey hears nothing, and looks towards his master, but what he now sees makes his blood run cold: first a layer of gas forms around his master, then Sir Roger's form loses its contours, his head becomes pointed, his whole body melts together, and what is left is a pale purple cone of the size and shape of a sugarloaf. Pompey is spared this fate, and just manages to escape and have his story put on record, before dying of a wound he had received in the fight with the Tibetans. Although deaf, because of his talent for lip-reading he has found out what the Tibetans had screamed at him and his master, who was melted down into a sugarloaf: *Ämälän*, a word whose meaning he

did not find out.

As soon as the incredible story of Pompey and his master is published in the *Indian Gazette*, reports of strange deaths start to accumulate: in dozens, men reading newspapers vanish in front of the eyes of the horrified crowd and turn into little purple pyramids. From every country horrifying news messages announce that the 'purple death' has broken out everywhere almost at the same time and the Earth is in danger of being depopulated. A German scholar finds the solution to the riddle: as only the deaf and deaf-mutes remain exempt from the epidemic, he correctly concludes that they are dealing with 'a purely acoustical phenomenon'. The word *Ämälän* is a secret Tibetan word that one must not hear, otherwise one degenerates into a purple cone. The quintessence of his instruction:

> 'Go to the ear specialist, he should make you deaf, and keep yourself from pronouncing the word *Ämälän*!'

—whereupon he and his hearers turned into lifeless cones of slime … The men still surviving have found his manuscript and followed his advice: a deaf and dumb generation of men now inhabits the globe, ruled by an ear specialist. To blame for this are the red-capped Tibetans from the strange ravine on the Roof of the World.[285]

In *Das Grillenspiel* ('The Crickets' Play'), a story from his volume *Die Fledermäuse* ('The Bats', 1916), Meyrink speaks of a 'Tibetan-Chinese sect—called Dugpas'. These are to be regarded as the direct tool of the destructive, 'diabolical' powers in the cosmos.[286] In this novel, the West European scientist Johannes Skoper calls on a Dugpa monk in Tibet, one of

> those devil-priests feared all over Tibet, recognizable by their scarlet caps, who claim to be direct descendants of the Demon of the Fly-sponges (sic: *Fliegenschwämme*). Anyhow, the Dugpas are supposed to belong to the ancient Tibetan religion of the Bhons, of which we know as good as nothing.

This Dugpa was a

> being whom one must no longer call by the name of man, and for whom … owing to his ability to see through space and time as delusions, nothing is impossible to accomplish on Earth.

In Tibet there are two ways, Skoper learns, to climb those steps that lead above humanity. One is that of 'the Light'—becoming one with Buddha. The other, set against it, is the 'path of the left hand', to which only a Dugpa knows the entrance

gate—a spiritual way full of horror and dreadfulness.

As Johannes Skoper finally sits opposite him, the Dugpa miraculously makes many strange crickets crawl out from their hiding places in the ground. At first they run about at random on a map of Europe that Skoper has spread out in front of him and the Dugpa. But when the monk projects a spot of light onto the map with a glass prism, the crickets begin to fight, and the peaceful crickets turn into a clump of insect bodies tearing each other to pieces in the most ghastly way.

Disgusted by this horrible spectacle, Johannes Skoper suddenly recognizes in the twitching pile of crickets a million dying soldiers, and feels a terrible sense of responsibility mounting within him. He no longer knows whether it is reality, fantasy or vision, truth or appearance. He sees in his mind how from the heap of dead crickets there rises a reddish haze, which becomes cloud shapes, which, darkening the sky like the nightmares of the monsoon, roll towards the west. Meyrink appears to be suggesting in this story that the Drugpa monks of Tibet bore the responsibility for a reddish threat of war rolling from east to west.

With the negative characterization of the Red-caps or Drugpas, we inevitably feel reminded of Helena Blavatsky, who allows them not one shred of goodness, apparently influenced by a passage in Orazio della Penna's report.[287] The equation of the Red-caps with the Bhons (which of course means the Bön-pos) also goes back to Blavatsky, who, as we have already mentioned, falsely described the 'Red Capped Brothers of the Shadow' as adherents of the Bön religion, 'a religion entirely based on necromancy, sorcery and sooth-saying'.[288] Meyrink was in fact close to the Theosophists for a brief period—for some time the members of the Prague Theosophical lodge used to come together regularly in Meyrink's home. Previously he had wanted to put an end to his life, whose features were 'love affairs, chess and rowing'. At the moment when he was intending to kill himself, however, he caught sight of a booklet about spiritualism, reports of ghosts and witchcraft.

> This topic, until then known to me only by hearsay, aroused my interest so much that I locked the revolver in the drawer for a later, more favourable opportunity …

wrote Meyrink. Consequently he sought

admission to various circles and groups, among them the Theosophists:

> Mysterious and mysteriously behaving old and new 'occultist lodges' were opened to me. And once again it took years until I left them again unscathed with the experiential knowledge: nothing here

either! Empty straw! Parroting of inaccurate knowledge.[289]

Thus he distanced himself also from Blavatsky and her teaching, from 'present-day Theosophical occultism', as he later wrote.

The Dalai Lama as 'Antibuddha'

A negative assessment of Tibet and its inhabitants also comes from the pen of the prolific writer J. van Rijckenborgh, founder of the Lectorium Rosicrucianum. In his booklet *Light over Tibet* (*Licht over Tibet*) he says that on the Roof of the World, out of universal Buddhism there developed a natural-magical, oriental caricature of church Christianity, Lamaism. But besides this there is another brotherhood active,

> a brotherhood that had its settlements in many other places in this world and is linked to all its ramifications—in unity, freedom and love. It is a brotherhood that accepts only one hierarchy, namely the divine hierarchy of the original realm, the Kingdom that is not of this world. It has only one goal: to lead the whole of fallen humanity … back into the Imperturbable Kingdom.

These brothers, who are called Lohan, are masters of the recitation of mantras, 'the songs of the true gods'. The representatives of Lamaism, however, imitate the sweet songs of the Lohans in a repulsive way in order to put the world and mankind in fetters, which van Rijckenborgh calls 'Tibet's magic hold on humanity'.[290] Lamaism is an anti-brotherhood, which

> has at its disposal thousands of focal points [monasteries] established by it and millions of priests. It behaves in accordance with an immense plan and exerts its influence to the farthest corners of the Earth. It is completely in the picture about everything that happens in this world. Nothing escapes its attention.[291]

From their mighty centres on the Roof of the World, the Lamaist brothers transmit bundles of thought rays to humankind, which 'contribute to the maintenance of this ungodly order of nature.'[292] While the evil brothers of Lamaism gag humanity, the Lohans, the good brothers, sacrifice themselves for the freeing of humanity, trapped in sorrow and darkness. But—a ray of hope for the author—the Lamaist brotherhood is filled with mortal fear of a mysterious counterforce, which interestingly seems not to come from the Lohans and about which we learn nothing more

precise. At all events, it involves the 'Inner School', which the Lectorium Rosicrucianum equates with Shambhala, which lies 'in the heart of the Gobi desert, somewhere in Central Asia' and is accessible only through seven secret underground passages.

In *Light over Tibet*, Theosophical Mahatma beliefs are thus blended with conspiracy theories like those we are acquainted with from various Nazi literature. The product is a highly ambivalent Tibet: the Roof of the World shelters the Lohans, 'servants of exalted nature', but at the same time the repulsive throngs of nature-magician priests, who want to master the world by 'pulling the strings behind the scenes'. Although van Rijckenborgh does not express it explicitly, it is clear in his book that according to him even the Tibetan leadership reflects this twofold division: the Tescho-Lama (no doubt meaning the Panchen Rinpoche), who works hidden away as a more active, greater ruler of Tibet, and the less powerful Dalai Lama, who is, however, better known because he appears in public. He is the chief of Lamaism's throngs of priests, that 'dialectical distortion of original Buddhism'. Again, and not for the last time, we here run into the phenomenon that the normally highly venerated Dalai Lama is also now and then perceived as an 'Antibuddha'.[293]

In one case, a curser of the Dalai Lama was indeed once an admirer: namely, the Surrealist, actor, poet and director Antonin Artaud (1896–1948), who in 1925 addressed the following euphoric message to the Thirteenth Dalai Lama:

> We are your most faithful servants, O Grand Lama. Grant us, grace us with your wisdoms in a language our contaminated European minds can understand. And, if necessary, transform our Minds, make our minds wholly oriented towards those perfect summits where the Human Mind no longer suffers. …
>
> We are surrounded by roughneck popes, scribblers, critics and dogs …

Teach us physical levitation of the body, O Lama, and how we may no longer remain earthbound!

For you well know what transparent liberations of the soul we are referring to, what freedom of Mind in the Mind, O acceptable Pope, O true Pope in the Mind!

I behold you in my inner eye, O Pope, on my inward summit. I resemble you, inwardly I, impetus, idea, lip, levitation, dream, cry, renunciation of idea, hovering among all forms and hoping only for the wind.[294]

After this, Artaud expected of the Dalai Lama deliverance from his suffering, which Europe with its pope and its literary figures could no longer give him. The Dalai Lama should teach him levitation, the cancellation of the Earth's gravitational force, floating, in short, everything that Europe, with its 'language games', its 'juggling with formulas', its logic and its 'mineral staves closing upon the frozen mind' could not offer him. It was necessary 'to find the great law of the heart', to get further than science would ever be able to reach.[295] Salvation lay in Tibet. The sages living there, the Dalai Lamas, had apparently already found what the Surrealists were looking for: the devaluation of values, the undermining of the intellect, the dissolution of evidence, the new division of things, and the breaking up and disqualification of logic.[296]

In this assessment Artaud deceived himself tremendously, and with him hosts of those weary of civilization. For intellect and logic are in no way denied in Tibetan Buddhism, and even in Tibetan Buddhism there are counterparts to the 'roughneck popes, scribblers, critics and dogs'. Artaud had also evidently overlooked the fact that in the person of the Dalai Lama he was writing and paying homage to one of those father figures against whom the Surrealist movement was basically rebelling. Artaud obviously realized this many years later, for his second letter to the Dalai Lama in 1946 was a diatribe in which he suddenly called the lamas swine, vile idiots, the cause of the syllogism, logic (!), hysterical mysticism and dialectics, and condemned them for living in Lhasa unaffected by the war, without having to give up any pleasure, be it of a sexual or a culinary kind. These lamas, who called storehouses 'full of opium, heroin, morphine, hashish, nard, nutmeg and other poisons' their own, were now suddenly the centre of the global conspiracy.[297]

Artaud's negative evaluation seems to be based

on a great disappointment. As the East and the Dalai Lama could not satisfy his longing, Artaud felt betrayed, hurt, humiliated. Hate and contempt were the result. Interestingly, we come across this 'Artaud syndrome' again and again, the hate-filled separation of fanatical dogmatists from their gurus. The most conspicuous example in the present is the Dorje Shugden affair, and here too the Dalai Lama, the figure symbolizing Tibetan wisdom as such, is not exempt—quite the reverse. All of a sudden it is claimed that 'the highly revered' is not even the correct Dalai Lama— otherwise how could it be explained that things have gone so badly for Tibet and its inhabitants since he took over?

57. Dalai-Lama-admirer and Dalai-Lama-curser in one: the Surrealist, actor, poet and director Antonin Artaud (1896–1948). In 1925 he beseeched the Thirteenth Dalai Lama to send his enlightened insights to the Europeans, transform their minds if need be and teach them levitation. For Artaud, salvation lay in Tibet; the sages living there, the Dalai Lamas, had apparently already found what the Surrealists were looking for. But a second letter to the Dalai Lama in 1946 was a diatribe, in which Artaud now called the lamas swine, vile idiots, the cause of the syllogism, logic, hysterical mysticism and dialectics, and condemned them for living in Lhasa unaffected by the war, without having to give up any pleasure, be it of a sexual or a culinary kind. These lamas, who called storehouses 'full of opium, heroin, morphine, hashish, nard, nutmeg and other poisons' their own, were now suddenly the centre of the global conspiracy.

Demythologizing or new myths?

The latest anti-Dalai-Lama and anti-Tibet campaign also stems from two former Tibet enthusiasts, who claim to have contributed strongly to shaping the 'Tibet myth': Herbert and Mariana Röttgen, who under the significant pseudonym Victor and Victoria Trimondi (roughly translatable as 'Conquerors of the Three Worlds', i.e. of the Universe) have written the weighty tome *Der Schatten des Dalai Lama* (*The Shadow of the Dalai Lama*). It is not worth going into individual claims of the countless ones made by the two authors, as most are extremely absurd and confused. If a few are mentioned here even so, it is to show how old negative myths are brought to life again.

The book is structured as an indictment by a public prosecutor, and is supposed to be 'a spectacular criminal history of Tibetan Buddhism', with 'charges, circumstantial evidence, a body of spiritual evidence and incriminating material' against guilty parties and wire-pullers.[298] But the 'circumstantial evidence' very quickly proves to consist of fallacies and false conclusions. Many exceedingly questionable Western sources are consulted, for example, Grünwedel, whom the Röttgens themselves describe as insane and paranoid, Sierksma, Evola, Serrano and a great many anonymous addresses from the Internet. Traditional texts over a thousand years old are taken word for word, without taking into account in the slightest the exegesis and development followed since they were written down. A further omission of the Röttgens consists in their not finding it necessary to be introduced to the mysteries of the texts by Tibetan masters. Most perfidious are the innumerable suggestive questions, subtle insinuations and speculations, and the continual citing of alleged experts whose names the reader never finds out.

The authors convict both the Fourteenth Dalai Lama and the whole of Tibetan Buddhism and its followers. The Dalai Lama is suggestively accused of association with the Japanese poison-gas guru Asahara, the forcible suppression of the free practice of religion, involvement in a ritual murder and connections with National Socialism.[299] He is a 'brilliant exponent of the double game': outwardly he is an apostle of peace, but in the nature of ritual he concentrates on the aggressive Time Tantra (Kalachakra-tantra), in which the scenario is supposedly dominated by fantasies of destruction, dreams of omnipotence, desires for conquest, outbursts of rage, pyromaniac obsessions, pitilessness, hate, homicidal mania and apocalypses.[300] The Dalai Lama is further characterized as an oriental despot, magician, manipulator and Trojan horse, who wants to cause the downfall of Western culture. He practises techniques of sexual magic, is indeed the supreme master of sexual magic rites, and there are rumours and insinuations (one observes the vague formulation, unconfirmed by any source!) that give rise to the suspicion that the Fourteenth Dalai Lama is deliberately carrying out, or has carried out, tantric rites of killing.[301]

Like Ipares, Strunk, Ludendorff, Wilhelmy and Rosenberg some sixty years earlier, the Röttgens construct a conspiracy theory, according to which the Dalai Lama is a world ruler and wants to establish a global 'Buddhocracy' by infiltrating the West with his 'omnipotent lamas'—one is immediately reminded of the 'crusade of the Buddhist mendicant monks' evoked by Wilhelmy—and in a sublime way making Western people, especially women and great film stars, part of his world-wide Kalachakra project. The persons controlled by the Dalai Lama are supposed to include among others the Green politician Petra Kelly, who has died in the meantime, and the pop singer Patty Smith.[302]

After this it is not surprising that the religion the Dalai Lama is accepted as head of is also discredited in the most unpleasant way, with the authors not even trying any more to give the impression that they want to do justice to the complexity of Tibetan religion. Tibetan Buddhism is subsumed under Tibetan tantrism, and by that the Röttgens understand nothing good: erotic cult, energetic vampirism, ritualized sacrifice of women, the vilest abuse of women, necrophilia, ritual murder, child sacrifice, sadomasochistic gratifications and the like. They also say there is a deep inner kinship between the tantric world view and modern Fascism. Even though the Dalai

Lama explains again and again that he is not interested in the political right, the authors say that

> ideologists and theoreticians of Fascism have examined Tibet, its culture and the ritual life of the lamas in detail, and indeed almost obsessively.[303]

The best-known example, say the Trimondis, is the Italian Julius Evola (1898–1974). According to them the latter has outlined an ingenious portrayal of sexuality, which supposedly stems from criteria from Vajrayana, that is, from Tibetan tantrism—which is however highly questionable, there being after all no reference to Buddhist Tantras in his publications. Another modern Fascist who has found a home and a predecessor in the Shambhala myth and in tantrism is Miguel Serrano, already mentioned above. Once again, therefore, a bridge is built between 'Lamaism' and Fascism, and it remains unclear on which side the sympathies of the authors lie, on that of the Fascists or of their opponents. In any event, the two neo-fascists Evola and Serrano are quoted for

pages and there is nothing to indicate that the authors distance themselves from them. On the contrary, Evola's view of tantrism seems to correspond to the Röttgens'. They also say it would be thoughtless to dismiss Serrano as a regrettable, isolated case, as he has a notable influence in the international Nazi scene and is frequently taken seriously because of his social standing as a diplomat.[304] That his sources are extremely suspect the Trimondis/Röttgens do not mention.

Even if the alleged intimate friendship between Serrano and the Dalai Lama belongs in the land of fables, the question poses itself with ever greater intensity: why does Tibet excite so much interest on the part of the neo-fascists? What makes Tibet so attractive to them? What is so fascinating about the Shambhala myth, that both those who foster it and those who fight vehemently against it are drawn under its spell? This is a question that we should like to turn to again in Part 5 of this book, as the answer will at all events help to unveil the mysterious appeal of Tibet.

Part 3

In Search of 'Shangri-La' and the White Lamas

The image of Tibet in literature, comics and films

A. Literature

Where all is guided in wisdom, while the storm rages without

'We do not follow an idle experiment, a mere whimsy. We have a dream and a vision. It is a vision that first appeared to old Perrault when he lay dying in this room in the year 1789. He looked back then on his long life ... He saw the nations strengthening, not in wisdom, but in vulgar passions and the will to destroy; he saw their machine power multiplying until a single weaponed man might have matched a whole army of the Grand Monarque. ... He foresaw a time when men, exultant in the technique of homicide, would rage so hotly over the world that every precious thing would be in danger, every book and picture and harmony, every treasure garnered through two millenniums, the small, the delicate, the defenceless—all would be lost ...

'And that, my son, is why *I* am here, and why *you* are here, and why we may pray to outlive the doom that gathers around on every side. ... There is a chance. It will all come to pass before you are as old as I am.'

'And you think that [we shall] escape?'

'Perhaps. We may expect no mercy, but we may faintly hope for neglect. Here we shall stay with our books and our music and our meditations, conserving the frail elegancies of a dying age, and seeking such wisdom as men will need when their passions are all spent. We have a heritage to cherish and bequeath. Let us take what pleasure we may until that time comes.'

'And then?'

'Then, my son, when the strong have devoured each other, the Christian ethic may at last be fulfilled, and the meek shall inherit the earth.'[1]

What has this vision got to do with the West's image of Tibet? What links it to Tibet?

Shangri-La! That place where 'the frail elegancies of a dying age' and 'the riches of the mind' are conserved. Shangri-La, where they 'preside in wisdom and secrecy while the storm rages without'.[2] As to precisely where Shangri-La lies and what it is, there has already been much speculation. Is the 'lamasery' a Tibetan monastery or rather the centre of some Western esoteric society? Appearances point more to Tibet as the geographical location—somewhere in the area between Baskul, Bangkok, Chung-Kiang and Kashgar[3]—and the population—Chinese and Tibetan—living in the valley below the monastery, the Western origin of the High 'Lamas' (the former Capuchin friar from Luxembourg,

Perrault, and the Austrian Henschell), the library with 'the world's best literature' in the most varied Western languages, besides Chinese and other oriental manuscripts, as well as the interior furnishings—central heating and luxurious baths of delicate green porcelain that come from the USA.[4] The central ideas of this unique institution can also not be clearly assigned to Tibetan Buddhism, even though certain similarities with the Buddhist 'Middle Way' come to light when Chang, a Chinese lama, says:

'If I were to put it into a very few words, my dear sir, I should say that our prevalent belief is in moderation. We inculcate the virtue of avoiding excess of all kinds—even including, if you will pardon the paradox, excess of virtue itself. ... We rule with moderate strictness, and in return we are satisfied with moderate obedience. And I think I can claim that our people are moderately sober, moderately chaste, and moderately honest.'[5]

The inhabitants of Shangri-La are neither lechers nor ascetics, they are allowed to eat and drink with pleasure and also do not have to be completely chaste.

James Hilton (1900–1954), the author of the Shangri-La novel *Lost Horizon*, in 1933 skilfully picked up the thread that Helena Petrovna Blavatsky had begun to spin some sixty years before. A brotherhood—whose chief spokesmen are, for HPB also, not Tibetans—is based somewhere in Tibet and is distinguished by its exceptional wisdom. With their help the rest of the world, which is disastrously embroiled in war, will one day experience a renaissance,

a new world stirring in the ruins, stirring clumsily but in hopefulness, seeking its lost and legendary treasures,

which will be preserved, hidden behind bleak, impenetrable mountains, in Shangri-La.[6] These treasures of wisdom appear not to be the property of a particular religion, but display a syncretism, combining the wisdoms of the most varied schools of belief, especially Christian and Buddhist. Helena Blavatsky's Theosophical legacy is similar, only she calls the land behind the mountains Shambhala, and its sages, who syncretically mix religious ideas from all over the place, are almost exclusively Indian. For Blavatsky, all this was

58. James Hilton (1900–1954), author of the Shangri-La novel Lost Horizon, *in 1933 skilfully picked up the thread that Helena Petrovna Blavatsky had begun to spin some sixty years before. A brotherhood, to which mainly whites belong, is based in Shangri-La, somewhere in Tibet, and is distinguished by its exceptional wisdom. With their help the rest of the world, which is disastrously embroiled in war, will one day experience a renaissance. The treasures of wisdom preserved in Shangri-La appear not to be the property of a particular religion, but combine the wisdoms of the most varied schools of belief. Helena Blavatsky's Theosophical legacy was similar, only she called the land behind the mountains Shambhala, and its sages, who syncretically mixed religious ideas from all over the place, were almost exclusively Indian. For Blavatsky, all this was irrefutable certainty; James Hilton, however, made from the material a novel, a dreamlike, modern fairy tale, sold in several million copies.*

short, Shangri-La belongs today to the international vocabulary.

Hilton took up in his novel several themes that we have already encountered in connection with Tibet myths, confirming his erudition. He was aware, for example, of the Christian missionaries, especially the Capuchins stationed in Lhasa in the eighteenth century, and their search for possible Nestorian Christian descendants in Tibet. The most important old reports were also known to him, at least by their titles, as well as those on the enormous gold reserves stored in Tibet, which—according to Hilton—were also supposed to lie in the ground in the valley below Shangri-La.

Hilton also took up the myth of the peace-

59. Its seclusion and difficulty of access are certainly one reason why Tibet is regarded as a mysterious fairy-tale land. The author James Hilton cultivated the idea of a Tibet lying 'behind the seven mountains' with his masterly account of the abduction of four Westerners to Shangri-La. Not by a journey of several years, as in the time of the early missionaries, but by a daring flight over the highest summits on Earth, the abductees arrive at Shangri-La, somewhere at the end of the world. Hilton was perhaps the first to portray the remoteness of Tibet through the image of a seemingly endless flight—but he was not to remain the only one.

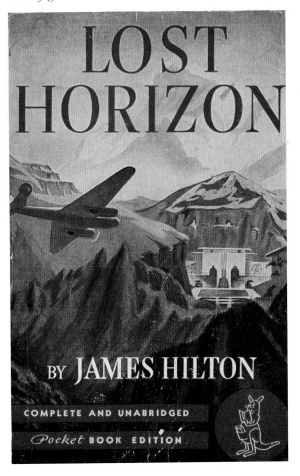

irrefutable certainty; James Hilton, however, made from the material a novel, a modern fairy tale, which became incomparably more successful than Blavatsky's writings. His book came out in several million copies all over the world. Hilton's Tibetan utopia is so successful that many believed, and still believe today, in the existence of Shangri-La. In the meantime a large chain of hotels has been named after the lamasery invented by Hilton, and in 1942 President Franklin D. Roosevelt called his holiday home in rural Maryland after it because, as he once told his colleagues, like Shangri-La it was so remote in the mountains.[7] The U.S. navy gave one of its aircraft carriers the name Shangri-La; numerous pieces of music and a pinball machine of 1967 from the Williams company bear the name.[8] In

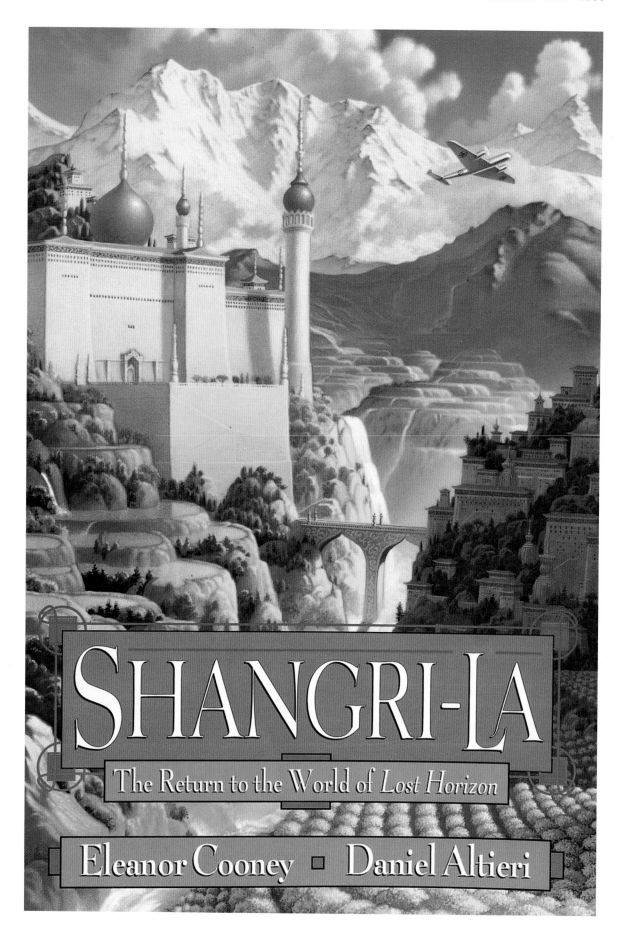

loving Tibetans living in a paradise, for Shangri-La and the valley lying beneath it are an island of peace around which war, power and base passions surge. They are an antithesis to the 'exulting in the technique of homicide', in destruction, dynamite and steel. In Shangri-La and its valley are neither military nor police, crimes are very rare, and there is hardly any quarrelling even over women. The valley is described as 'an enclosed paradise of amazing fertility', in which 'crops of unusual diversity grew in profusion and contiguity.'[9]

Hilton took up yet another theme, which goes back at least to Blavatsky: that of the fountain of youth. Whoever gains admission to Shangri-La ages far more slowly than elsewhere, so that at eighty, one can still climb to the pass with a young man's gait. Not through the practice of particular yoga exercises,[10] and not through a special elixir,[11] but apparently with the aid of methods that are as simple in Shangri-La as they are impossible elsewhere, about which the reader is, however, always left in the dark.[12] Apparently different laws of time operate in Shangri-La, for the lamas 'had time on their hands, but time that was scarcely a feather-weight', so that they succeeded in 'slackening the tempo of this brief interval that is called life', as the High Lama Perrault, himself 250 years old, once told the hero of the novel, Conway, whom he appointed his successor.[13]

The theme of autocracy and patriarchy familiar from the early Western myths of Shambhala and Agarthi is also not absent in *Lost Horizon*.[14] These and other correspondences can hardly be coincidental. It seems that Hilton knew the Shambhala myth very well and adapted it. Shambhala turned into Shangri-La, from which a 'loose and elastic autocracy' operated over the valley population, who would—according to Chang—have been 'quite shocked' at democratic institutions.[15] For many people, a strict hierarchy

seems to be a typical characteristic of the Tibetan paradise, which is comprehensible in view of the autocracy in fact practised in old Tibet. When Hilton suggests that this 'Shangri-La-Tibet' will one day rescue the ailing world, he turns Tibet into an island of peace and the site of a renaissance—but not of a revolution. Values such as unhurriedness, moderation and autocracy, says Hilton, will come into their own again and save the world. Tibet, the dreamland of a protecting conservatism, which upholds patriarchal theocracy.

Its seclusion and difficulty of access are certainly one reason why Tibet is regarded as a mysterious fairy-tale land. Hilton cultivated the idea of a Tibet lying 'behind the seven mountains' with his masterly account of the abduction of four Britons and Americans to Shangri-La. Not by a journey of several years, as in the time of the early missionaries, but by a daring flight over the highest summits on Earth, which appears to have no end, the abductees eventually arrive somewhere at the end of the world, in Tibet. Hilton was perhaps the first to portray the remoteness of Tibet through this image of a seemingly endless flight—but he was not to remain the only one. After Conway and his companions, many others reached fairy-land Tibet by flying, a theme that is, as we shall see, taken up repeatedly, especially in comics.

There is one Tibet stereotype that Hilton deals with more cautiously than other authors. Thus the High Lama Perrault is indeed supposed to have made many experiments to try and raise himself in the air (levitation), but was obliged to attest soberly that he had been granted no success in this regard. On the other hand, he acquired skill in telepathy and seemed to have some powers of healing at his disposal:

> there was a quality in his mere presence that was helpful in certain cases.[16]

The image of the Tibetan lama experienced in the art of self-defence is likewise unknown to Hilton, indeed 'the mimic warfare of the playing-field' is seen as barbarous and as 'a wanton stimulation of all the lower instincts'.[17] We shall see that the martial-arts lama is only invented later—probably by Lobsang Rampa, alias Cyril Hoskins, in the 1950s.

Shangri-La too displays two sides—like Tibet, which exerts a special fascination over many, but affects a small band extremely negatively. For the

60. *Although the 'lamasery' of Shangri-La appears to lie somewhere in Tibet, it has hardly anything Tibetan about it: the architecture, its inhabitants' way of life, the wisdom preserved and handed down and the inhabitants themselves are of Western origin; the lamasery is much more like a centre of a Western esoteric society than a Tibetan monastery, the 'lamas' are whites and not Tibetans. Nevertheless, Shangri-la has become a metaphor for sacred Tibet, as it has several characteristics that the West has imputed to sacred Tibet for centuries: Shangri-La is an island of peace around which war, power and base passions surge, where a hierachically organized brotherhood exercises a loose and elastic autocracy over the valley population, and the people attain a very great age.*

majority it is a remarkable region, a paradise. Others, however, such as Mallinson for example, experience it as a hellish place, with something dark and evil about it.[18] They do not believe in its special qualities, in the lamas' age of a few hundred years.

61. Hilton's Tibetan Utopia is so successful that many have believed, and still believe to this day, in the existence of Shangri-La. Today Shangri-La belongs to the international vocabulary, a large hotel chain has been named after the 'lamasery' invented by Hilton, in 1942 President Franklin D. Roosevelt called his holiday home in rural Maryland after it, and shops, restaurants and even a Nepalese brand of cigarettes use the name Hilton invented.

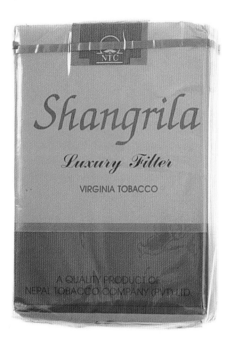

'But, my God, I'd give a good deal to fly over with a load of bombs!'

says Mallinson to Conway at one point,

'Because the place wants smashing up, whatever it is. It's unhealthy and unclean—and for that matter, if your impossible yarn were true, it would be more hateful still! A lot of wizened old men crouching here like spiders for anyone who comes near ... it's filthy ... who'd want to live to an age like that anyhow?'[19]

It is not hard to recognize here a theme we have already encountered: Tibet as the site of a global conspiracy, where the lamas dwell, self-satisfied and parasitical, with their spider's threads spun everywhere.

Hilton did indeed locate Shangri-La somewhere in Tibet, but he never—and this is for the most part overlooked—equated it with Tibet. On the contrary, he painted quite a negative picture of the actual Tibet. He says at one point that Tibetan lamaseries were not beautiful places and the monks were generally corrupt and dirty. The legends of extreme longevity among monks were 'stock yarns you hear everywhere, but you can't verify them.' A lot of very curious knowledge and ways for prolonging life were attributed to the lamas, but these reports turned out to be the same as the Indian rope trick—it was 'always something that somebody else had seen'. At the same time, however, the lamas had eccentric tastes for self-discipline, by sitting stark naked on the edge of a frozen lake and winding ice-cold sheets round their bodies.[20]

In this Hilton is very close to the traditional Tibetan Shambhala myth. For Shambhala too, as we shall see in due course, does not lie in Tibet proper, but beyond the Tibet lived in by ordinary mortals. Somewhere beyond mountain ranges and rivers ...

Hilton's Shangri-La is a place of men. Apart from the shy, non-English-speaking Manchu Lo-Tsen and the sanctimonious Miss Brinklow, no women are found there, even though Chang, when asked whether they also have women lamas, replies that they make no sex distinctions there.[21] In any case, sex seems to be a foreign word in Shangri-La, where not even lascivious insinuations are made.

Tibet is also similarly male-dominated in another extremely popular novel: *The Third Eye*, by Lobsang Rampa.

The third eye

The 'Lobsang Rampa' story

I am a Tibetan.

So begins the first book of Lobsang Rampa (1910–1981), which was published in London in 1956 by Secker & Warburg under the name of *The Third Eye* and soon became a best-seller. The book described in the form of an autobiography the life of Tuesday Lobsang Rampa, the son of one of the leading men in the Tibetan government, a nobleman of high rank, a multimillionaire, who possessed enormous wealth in land, jewels and a great deal of gold.

Lobsang went to school in Tibet, where he learned among other things Tibetan, Chinese, arithmetic and the carving of wooden printing blocks. At seven—after a very strict and harsh upbringing—he had to enter a 'lamasery' and be trained there as a priest physician. Entrance into the school of medicine on Chagpori at Lhasa was hard: Lobsang had to pass tests, take blows, but eventually he was able to win out against the others, as he had learned a kind of judo from an old police monk. The superiors had investigated Lobsang's previous incarnations and thereby found

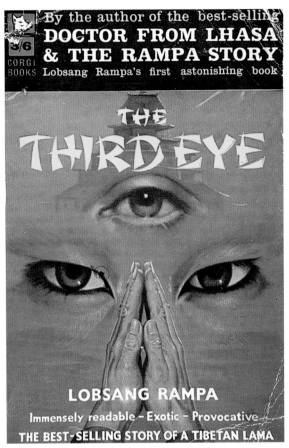

63. Lobsang Rampa claimed that on his eighth birthday an operation was performed on his head. Since this opening of the 'third eye', which provided the title for his first book, he saw people as they actually were—he had a new sense organ, or rather had a sense organ, that all human beings used to possess, reactivated.

62. Lobsang Rampa (1910–1981), the author of the book The Third Eye, *published in 1956. The book described in the form of an autobiography the life of Tuesday Lobsang Rampa, the son of one of the leading men in the Tibetan government. Research by a private detective established, however, that the mysterious Tibetan was not called Rampa but Cyril Henry Hoskins, and that he was not a Tibetan but a Briton. This did not stop some publishers speaking of an authentic autobiography of a Tibetan monk, and it seems many people still believe today in Rampa's authenticity.*

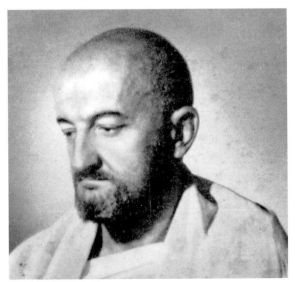

out that he had certain powers and abilities within him, which they now proposed to develop again. Thus they wanted to teach him to be clairvoyant and to travel on the astral planes, and to train him in esoteric sciences, metaphysics and medicine. But in order to develop clairvoyance, on Rampa's eighth birthday a small operation had to be performed on his head. This 'opening of the Third Eye' was supposed to enable Lobsang Rampa to see people as they actually were, and also to recognize the aura that surrounds every person, the 'reflection of the Life Force burning within'. This operation proved to be a bigger intervention than supposed: with a kind of toothed bradawl, Lama Mingyar bored a hole in his forehead bone while he was fully conscious, until suddenly a blinding flash flared up. Now Lobsang Rampa was someone who could see people as they were, not as they pretended to be: he had a new sense organ.

He learned to recognize people's state of health
in the colour and intensity of their auras, and he
saw from the way the colours fluctuated whether
someone was telling the truth or not. A long time
ago, all human beings possessed the third eye, but
they wanted to get rid of the gods and tried to kill
them, whereupon the gods closed the third eye of
humans as a punishment.

Lobsang was not an ordinary monk, but one
chosen very personally by the Thirteenth Dalai
Lama for important tasks. Thus for example, he
had to 'read' the aura and thereby the intentions
of the British diplomat Charles Bell when he
visited the Dalai Lama, and learned the diagnosis
of disease based on the patients' auras. He also
had to pass hard tests, among other things in judo,
in which Lobsang was always the best. But
Lobsang Rampa was selected for still higher
things: he had to learn under hypnosis all the

*64. Lobsang Rampa's books—19 in all—found a devoted
following and were mostly received extremely positively. Nevertheless,
from his first book to his last, Lobsang Rampa was always fleeing
before media people, who mainly wanted evidence of what was
already clear, that he was not a Tibetan.*

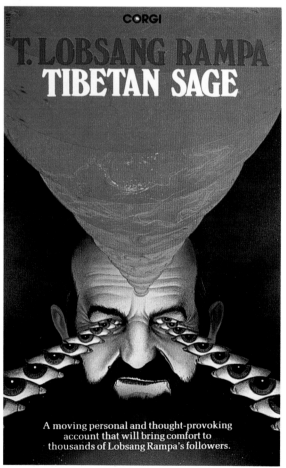

CORGI

T. LOBSANG RAMPA
TIBETAN SAGE

A moving personal and thought-provoking
account that will bring comfort to
thousands of Lobsang Rampa's followers.

64a

knowledge at his teachers' disposal and then go
abroad. He was also given a training in 'astral
travelling', in which the spirit or the ego leaves
the body. But this was not enough. He was also
instructed in the art of telepathy, hypnosis,
levitation and yoga.

For Lobsang Rampa, Tibet was the land of
occult powers and esoteric knowledge:

> Our physical world had proceeded at a leisurely
> pace, so that our esoteric knowledge could grow,
> and expand. We have for thousands of years known
> the truth of clairvoyance, telepathy, and other
> branches of metaphysics. It is quite true that many
> lamas can sit naked in the snow, and by thought
> alone melt the snow around them … Some lamas,
> who are masters of the occult, definitely can levitate
> … Those powers are in no way magical, they are
> merely the outcome of using natural laws.[22]

Simpler and less awkward than levitation,
however, according to Lobsang Rampa, is
travelling of the astral body, in which the spirit
or ego leaves the body and is linked to the earthly
life only by a 'silver cord'. Most lamas, like himself,
are familiar with it, and anyone who has a little
patience can learn this useful and pleasant skill.[23]
Astral journeys, writes Lobsang Rampa in his third
book, are just as natural as breathing, everyone
travels astrally in sleep.[24] Another ability, of which
one can say it is good that only exceedingly few
men possess it (he himself is not among them), is
making oneself invisible:

> There are men in Tibet who can become invisible
> at will, but they are able to shield their brain
> waves.[25]

Telekinesis too is an ability that can be learnt in
Tibetan monasteries, for

> Thoughts, as we in Tibet well know, are waves of
> energy. Matter is energy condensed. It is thought,
> carefully directed and partly condensed, which can
> cause an object to move 'by thought'.[26]

The Dalai Lama was very happy with a lama so
knowledgeable and capable, but wanted Lobsang
to train yet more before he left Tibet. So he studied
anatomy in the places where bodies were cut up.
A high point in Lobsang Rampa's development
was the 'Ceremony of the Little Death', which
took place deep below the Potala in a golden cave
temple, in the centre of which stood a shining
black house in which there were three black stone
coffins with a golden body in each. He was
initiated by 'three old men, perhaps the greatest
metaphysicians in the whole of the world'.
Between the coffins he experienced the little

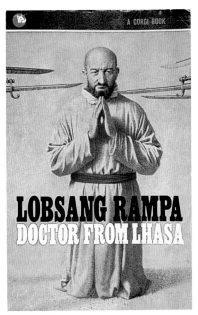

death, an anticipation of natural death: his astral body separated from his flesh body, linked only by a silver-blue cord, and experienced in time-lapse tempo the evolution of the Earth from chaos to the final state.

A short time after this initiation, Lobsang Rampa received the order to travel to China as a doctor. As we are interested here in the Tibet image, and especially the Tibet caricature, of the West, we shall follow no further Lobsang Rampa's life in China, where he studied medicine at Chungking University, in Japan, where he experienced the explosion of the first atom bomb, and in Korea.

The book *The Third Eye* proved finally and

unambiguously that Helena Petrovna Blavatsky had been right eighty years before: they did exist, this rare species of Tibetan lamas, who possess occult abilities, who are masters of the art of levitation, telepathy and astral travel of the ego. In the days of Helena Blavatsky, the masters from Tibet showed themselves in the West only on extremely rare occasions and generally made use of a medium to transmit their messages. They were moreover mainly Indian Aryans. Now at last one of these sages from Tibet was turning directly towards Western men and was right in their midst: he lived in London—and he was a Tibetan! A hundred years after Morya had appeared for the first time to Helena Blavatsky in this metropolis,

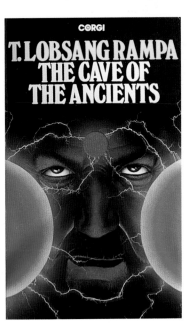

one of the Brothers had chosen this very city as his place of residence. At last the time was ripe … if only there had not been some sceptics, as already in Helena Petrovna Blavatsky's time, who sought to demonstrate that Lobsang Rampa's life story was a fraud and that Lobsang Rampa was in fact a non-Tibetan. One of these sceptics was Marco Pallis. After consulting the Tibetologist Hugh Richardson, formerly stationed in Lhasa as a diplomat, and Heinrich Harrer, who had lived in Tibet between 1943 and 1950, he employed the respected private detective Clifford Burgess from Liverpool. At the end of January 1958, Burgess published the results of the investigations he had carried out in England and sometimes in Scotland. He established that the author of *The Third Eye* was not called Lobsang Rampa but Cyril Henry

65. Lobsang Rampa/Cyril Hoskins loved cats and claimed that Tibetan monasteries were guarded by Siamese cats. Two Siamese cats, with his wife and a family friend, made up his 'four-woman household': Miss Cleo Rampa and Miss Tady Rampa, with whom—according to his own statement—he conversed very well, with one of them verbally and with the other telepathically, as she was deaf …

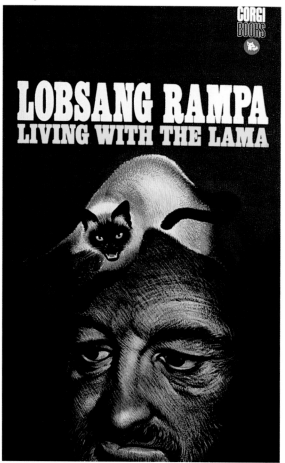

Hoskins,[27] and he was not a Tibetan but a Briton.

Immediately after this, on 1 February 1958, an article was published in the *Daily Mail* about the Bogus Lama, with the principal message:

> The man accepted by thousands as the Lama of (sic) the Third Eye has been exposed as a brilliant hoaxer.

Hoskins was besieged by journalists in his house in Dublin. At first he refused any interviews, on the pretext that he was very ill; later, however, he gave one journalist a brief interview and gave him a tape on which he confirmed that he was in fact Cyril Henry Hoskins but that a Tibetan lama had taken possession of him. This 'transformation' was announced to him when he was about thirty-four years old, and the lama had actually forced his way into him on 13 June 1949. That day Hoskins was climbing a tree, where he wanted to photograph an owl. But the branch he was sitting on broke and he fell down. The next thing he remembered was finding himself outside his body and seeing his body lying below him. A lama in saffron robes approached him and said 'I want your body.' 'Why?', replied Hoskins. 'Because I possess no passport and would otherwise be deported,' answered the lama. When Hoskins realized that this was the predicted taking of possession of him, he accepted and the lama entered Hoskins' body, and from that moment on Hoskins was the Tibetan lama and Hoskins no longer existed.[28] In *The Rampa Story*, Hoskins' third book, the motivation of the yellow-robed lama was portrayed altruistically: because he wanted to take a stand against poverty, lack of understanding, lack of faith and the deepest hatred, in short the power of evil, he was prepared to take over another's body.

Who was Cyril Henry Hoskins before Lama Lobsang Rampa (allegedly) took him over? Hoskins was born in Plympton, England, on 8 April 1910 as the son of Joseph Henry Hoskins, a master-plumber by trade, and Eva Hoskins-Martin, and went to school until he was fifteen years old. As a child Cyril Hoskins already had a striking character: he was a loner, had no friends, and was regarded as a strange, extremely odd and spoilt child. Apart from often carrying out experiments with electricity and insects, he hardly exerted himself at all. As a teenager he did indeed help his—apparently strict—father in the shop from time to time, but he often lay in bed for days

and was regarded as lazy.

When his father died in 1937, he moved with his mother to his sister's in Nottinghamshire and then to London, where Hoskins worked in a firm that produced surgical instruments. In London Hoskins experienced the horrors of the Second World War and became unemployed; one firm after another declined to take him on.[29] Eventually he was employed by a commercial college that offered correspondence courses, but there he had to carry out work he felt was boring.[30] In the same year, 1940, he married Sarah Anne Pattinson, a nurse. In the succeeding years he became more and more peculiar. He used to take his cat for walks on a lead and called himself Carl KuonSuo or Carl Ku'an,[31] a change of name that was officially recognized in 1948. After he left his job at the correspondence-course institute in 1948 and broke off all contact with his former life, his trail becomes blurred. Apparently he was not well, he had hallucinations—possibly the result of a minor accident in Summer 1949—and he seems to have been at odds with life and to have had the feeling of always being on the losing side. He did not feel happy as an Englishman; instead he took more and more interest in Tibet and the countries of the Far East, which he saw in his dreams,[32] and now dressed in 'oriental' style.[33] From time to time, according to his wife, he would fall into a trance and speak in an unknown language, 'surely an eastern one'.[34] For a short time he apparently worked in a photographic laboratory and as a casual photographer, became unemployed again … and emerged in 1954 as Dr Carl Ku'an in Bayswater, London. There, weakened again and again by phases of illness, he wrote *The Third Eye*, surrounded by his wife and his two beloved Siamese cats. In the meantime he had got himself a new name as the outward sign of his new identity: Tuesday Lobsang Rampa.[35]

In 1958 he was living together with his wife and a friend of the family, Shellagh Rouse, an insurance broker's wife, in Howth near Dublin, where according to his own statement he was having the time of his life. There is no reference to his having left the British Isles up to this moment. When because of the constant criticism of the media people and problems with the tax authorities, the Hoskins couple with Shellagh Rouse and their two Siamese cats left Ireland, their journey went not towards the Orient but to the 'land of the Indians', to New York and then Canada, where the five stayed in Montreal, Vancouver and elsewhere. It is by no means erroneous to speak of five family members, for Lobsang Rampa treated the family friend Shellagh Rouse, who dealt with the secretarial work, as his adoptive daughter, and the two cats as 'two more women in my household', to whom he could talk very well according to his own statement, to one of them indeed not verbally, but simply by telepathy, as she was deaf. He called one Miss Cleopatra (Cleo) Rampa, the other Miss Tadalinka (Tady) Rampa.[36] Lobsang Rampa lived very withdrawn, like a hermit, and claimed not to have any sex life.[37]

Innumerable people wrote to Lobsang Rampa and wanted to meet him, but almost nobody was able to. Only extremely few letter-writers saw him as a fraud, most were enthusiastic about him and found through his books hope, consolation and new courage, as the following lines from a letter—representative of countless others—confirm:

> I am twenty years old. You are for me the purest man anywhere. I was really disappointed with life … but when I read your books, I regained my self-confidence and the strength to endure life.[38]

From his first book to his last,[39] Lobsang Rampa was constantly fleeing before hostile and sensation-hungry media people. After Montreal, further stages in his life were Vancouver and Winnipeg. Rampa died in Calgary in 1981.

66. His great respect for his two Siamese cats is expressed in a kind of 'family coat of arms': the cats hold the light (candle) that Tuesday Lobsang Rampa (TLR) had lit with his books (lower left). Rampa's alleged Tibetan background is recalled by the Potala (upper left) and a prayer wheel. The whole thing is framed in a rosary of 108 beads..

Rampa's Tibet image

The picture that Lama Lobsang Rampa, alias Dr Ku'an-Suo, alias Henry Hoskins, paints of Tibet strongly resembles that of Helena Petrovna Blavatsky:

> Tibet was a theocratic country. We had no desire for the 'progress' of the outside world. We wanted only to be able to meditate and to overcome the limitations of the flesh. Our Wise Men had long realized that the West had coveted the riches of Tibet, and knew that when the foreigners came in, peace went out. Now the arrival of the Communists in Tibet has proved that to be correct.[40]

Both Blavatsky and Hoskins recounted unbelievable grotesqueries about supposed life in Tibet—and both had an enormously large following, who gave credence to these stories and

ICH FLIEGE!, DAS IST PHANTASTISCH!

their creators.[41] The interest in Blavatsky's and Rampa's books is still respectable today. This is indicated, for example, by the facts that their books are still read and that several home pages on Theosophy and Lobsang Rampa can be found on the Internet.[42]

It would be taking things much too far to enumerate all the fabrications, lies and errors in *The Third Eye*, but some should nevertheless be mentioned here—for readers' amusement, but also because we shall thereby find out still more about the Tibet caricature that so many Westerners make or believe in.

According to Rampa there were lamaist savings banks in the monasteries[43]—as if the monks had earned money; the temple treasures, 'masses of uncut gems strewn around the holy figures,' were guarded by temple cats, nearly black Siamese cats[44]—the famous fierce dogs, which were kept in the monasteries as guard beasts, appear not to have existed in Rampa's time; the monks used to soar into the air on kites they had built themselves[45]—although the Tibetan clergy took strict care that no technical devices were allowed into Tibet, and certainly none that could have aroused the wrath of the gods and local spirits, quite apart from the fact that it would have been impossible to build such kites with the materials available in Tibet; butter-lamps, according to Lobsang Rampa, used to hang down from the branches of trees, swing from the projecting eaves of houses and float on the still waters of lakes[46]— in actual fact, butter-lamps were exclusively set up by the Tibetans in front of altars; deity statues were of jade, gold or cloisonné enamel[47]—but not of bronze, out of which by far the majority of Tibetan statues are made.

As far as Tibetan cooking habits were concerned, Hoskins no doubt projected his own experiences into his stories when he claimed that in Tibet only the men saw to the cooking, women were no good at stirring the tsampa or producing the right mixtures … women were simply suitable 'for dusting (sic!), talking and, of course, for a few

67. *Rampa/Hoskins may have been a crafty novelist, but he had scarcely any idea of Tibet. His books are full of inventions and errors, some of them borrowed from others, only to be imitated themselves by later authors, a* perpetuum mobile *of Tibet absurdities. One of these imitators is the comic-book artist Jodorowsky, in whose series* The White Lama, *for example, monks soar into the air on homemade kites, as in Rampa's* The Third Eye.

other things';[48] that pickled rhododendron flowers (found mainly in the southern valleys) and shark fins should be delicacies for the Tibetans is impossible, as Tibetans like neither raw plants nor fish and anyway they regard rhododendrons as poisonous; and that butter churns are cylinders of wood or bamboo and not goatskin bags[49] is known by anyone who has ever been in Tibet, northern Nepal or Bhutan.

The catalogue of absurdities could be prolonged at will—that the Tibetans dipped new-born infants in icy streams to test whether they were strong enough to be allowed to live;[50] that corpse-dissectors ('Body Breakers') examined all the internal organs to establish the cause of death[51]—but let us content ourselves with this, for the doubts turn into the irrefutable certainty that Hoskins might have been a good novelist, but he had scarcely any idea of Tibet, and the little he did know he had scribbled down from the literature—like Blavatsky in her time.[52] Hoskins made active use of Blavatsky's writings, something he himself denied in an interview with his Canadian publisher Stanké, although in the foreword to the second English edition of *The Third Eye* he had acknowledged that he was acquainted with the Theosophical literature. His works are thus in great part plagiarism of plagiarism. In part, however, Hoskins assumed different main emphases than the old lady of Theosophy. He revalued some details described by HPB and made them out to be authentic components of Tibetan teachings and conception of life. These include without doubt the 'third eye', which Blavatsky had already discussed in *The Secret Doctrine*. With the third eye it can be demonstrated how skilfully Rampa mixed authentic Tibetan ideas with pseudo-Tibetan ones. The idea of a third eye is in fact not unfamiliar in Tibet: some portraits of Tibetan deities and gods show a third eye on the forehead, and in certain meditations particular attention is paid to the place between the eyebrows, but not a single Tibetan ritual is known that even remotely resembles the initiation procedure described by Hoskins. The effects ascribed to the third eye— such as recognizing what illness someone has, whether someone is speaking the truth, and so forth—are also devoid of any Tibetan foundation.

Some other images created by Hoskins were taken up into the repertoire of Tibet stereotypes and have survived up till today, as for example the image of monks trained in hand-to-hand combat. For according to Hoskins, contrary to Blavatsky, monks were not only tranquil meditators living in solitude, but were masters of judo.[50] Since his invention by Rampa, the fighting Tibetan monk has surfaced here and there in comics, films of the 1980s and '90s, or articles. Thus one author claimed that during the Tibetan-British war in 1904 (the Younghusband Expedition), the Tibetans had put to the proof the effectiveness of the Tibetan art of war. That they were defeated, he omitted to mention. The Tibetan monks were also supposed to be trained in martial arts,

> the higher the rank of the monk, the tougher and more brutal the training, so as to teach morality and humility.[54]

Among the allegedly Tibetan ideas revalued by Rampa, we should also mention the 'silver cord', which in Blavatsky's writings is found only on the

68. Other images created by Rampa have also been adopted into the repertoire of Tibet stereotypes and survived until the present day, such as the image of the monk trained in hand-to-hand combat. Unlike in Blavatsky, according to Hoskins the monks were not only tranquil meditators living in solitude, but masters of judo. The fighting Tibetan monk turns up here and there ever since his invention by Rampa, both in comics and in feature films of the '80s and '90s.

68a

68b

69. Rampa/Hoskins—influenced by Helena Blavatsky and the Rosicrucians—was convinced that any human being's astral body could leave the earthly body, linked with it only by a 'silver cord'. Most lamas were able to use this technique consciously, and anyone with a little patience could learn it. The comic artist Jodorowsky also portrayed the silver cord, which by the way lacks any Tibetan foundation, in artistic pictures—evidently inspired by Rampa's novel.

> Above the still body the life-force gathered in a cloud-like mass, swirling and twisting as if in confusion, then forming into a smoke-like duplicate of the body to which it was still attached by the silver cord. Gradually … the cord thinned, became a mere wisp, and parted. Slowly, like a drifting cloud in the sky, or incense smoke in a temple, the form glided off.[57]

The silver cord was also the sole link between Lobsang Rampa's astral body and his lifeless body when, in the three-day initiation described above, Rampa became an 'initiate' with the ability to see the past and to know the future.[58]

The silver cord, which by the way lacks any Tibetan foundation, was taken up more recently and portrayed artistically in pictures by the comic artist Jodorowsky in the series *Le lama blanc* (*The White Lama*)—clearly inspired by Rampa's novel, whose 'autobiography', as we shall see, had strongly influenced the creators of *The White Lama*.

Critique of Rampa

Whether Lobsang Rampa was really convinced of his episodes and accounts of occult occurrences cannot be answered conclusively; it is, however,

margins. By the 'odic or magnetic cord' Blavatsky understood a connecting string between the head of the astral and that of the physical body, which she equated with the silver cord in the Old Testament (Ecclesiastes 12.6).[55] The Rosicrucian tradition also recognizes such a silver cord, a thin, shining, silvery cord, which at the time of death links the 'higher supports' (the life body, feeling body and intellect) with the dense (physical) body that they have left. In *The Third Eye* Rampa often makes reference to this silver cord,[56] and even gives a description of what a Tibetan lama who was carrying out a death ritual (supposedly) came to see:

probable that he was. With the greatest likelihood, Rampa, similarly to Blavatsky, split and slipped from one personality—Hoskins—into another—Dr KuonSuo or Dr Ku'an—and then even into a third—Lobsang Rampa.

Rampa shared an additional character trait with Blavatsky: like Blavatsky, Rampa/Hoskins impressed the people around him by his outward appearance. Particularly striking were his 'piercing eyes', as Frederic J. Warburg, his English publisher, attested; Warburg was won over by Hoskins, even though he knew that Hoskins had taken him for a ride:

> The lama impressed me, he really appealed to me,
> … he was an extremely unusual figure.

Rampa's Canadian publisher, friend of many years' standing and agent against his will, Alain Stanké, also felt Lobsang Rampa was an impressive personality:

> When one is in his house, one has the impression of being in a great realm full of peace that nothing can disturb,[59]

an impression that Stanké had to revise somewhat in the course of his friendship with Rampa, Rampa proving to be really a difficult, demanding and overbearing opponent.

Indisputably, Hoskins was enormously successful with his books: *The Third Eye* especially received a series of positive reviews.[60] Rampa's books are still read with pleasure today and have a faithful following, as the following quotation from a letter to the author of the present book confirms:

> Well, it seems that you don't know all the Tibetan culture and the inner workings of monasteries of the east! This is the single most 'worse' problem, when western authors criticize eastern culture and religion or books. I am not pointing a finger at you but I have seen people do that. A lot of them. What you must have read from books by authors who have done this or that research, is just the little top parts of what the monks actually do. The tradition is, all the inner workings of the monks are kept away from the westerners' eyes since there are more moronic sceptics who have nothing better to do and cannot do what the monks can! … The inner workings are not revealed since many people in the world just cannot believe it. So the ones who know these things exist, have the information. … What Rampa has done, has provided the inner workings of Lamas of very high orders and what part they play in a monastery. You could say that they are researchers of the occult which is the mystic part of the Buddhist way of life, not the mystical.[61]

This assessment is not unacknowledged by the highest Tibetan authority. Thus a secretary of

70. *Lobsang Rampa's 'third eye' goes back at least as far as Helena Blavatsky, who described it in* The Secret Doctrine. *According to Blavatsky, early human beings were three-eyed. This third eye permitted a spiritual inner vision, but with time it grew dull and atrophied into the pineal body. In trance states and visions, however, it can swell up again. This idea of the third eye inspired not only Lobsang Rampa, but also several comic artists.*

H.H. the Dalai Lama informed the Canadian publisher and writer Alain Stanké in October 1972 that the works of Dr T. Lobsang Rampa were 'highly imaginary and of a fictitious nature'.[62] Rampa himself rebutted this criticism in the adroit way typical of him: the letter had been written not by the Dalai Lama himself but by a subordinate secretary, who had written what seemed to him opportune. What excuse would Rampa possibly have had if *Freedom in Exile* had already been published at the time, in which the Dalai Lama writes that Rampa's books sprang from the author's creative imagination?[63]

One of the clearest critiques of Rampa comes from the ethnologist Agehananda Bharati, who called Lobsang Rampa an esoteric arch-deceiver and master-swindler[64] and emphasized in an article entitled *Fictitious Tibet: the origin and persistence of Rampaism*:

> Every page bespeaks the utter ignorance of the author of anything that has to do with Buddhism as practiced and Buddhism as a belief system in Tibet or elsewhere. But the book also shows a shrewd intuition into what millions of people want to hear. Monks and neophytes flying through the mysterious breeze on enormous kites; golden images in hidden cells, representing earlier incarnations of the man

who views them; arcane surgery in the skull to open up the eye of wisdom.

He formulated the quintessence of his analysis in the phrase:

'esoteric knowledge cannot be had from esoteric lies.'[65]

The Tibetologist Donald S. Lopez treats Hoskins (whom he calls Hoskin) less severely when he writes:

> The representation of Tibetan Buddhism historically has been and continues to be situated in a domain where the scholarly and the popular co-mingle, a domain that is neither exclusively one or the other. The confluence of the scholarly and the popular is strikingly evident in *The Third Eye* where Rampa draws on the accounts of travellers and amateur scholars (themselves sites of the admixture of the popular and scholarly) and combines them with standard occult elements (astral travel, rites from ancient Egypt, etc.) into a work that is neither wholly fact nor wholly fiction. It is evident that by the time Rampa wrote his 'memoir' there was ample material available from scholars, travellers, and Theosophists to enable him to paint a portrait of Tibet in which his own contributions seemed entirely plausible. Furthermore, he was able to represent the Tibet of Western fantasies in such a way that he himself could be embodied within it.[66]

Donald Lopez used *The Third Eye* in a seminar for beginning students, with whom he did not discuss further details. Interestingly, the budding academics, who had already read standard works on Tibetan history and religion, felt *The Third Eye* was credible and compelling, indeed they even found it more realistic than everything else they had read on Tibet.[67] Bharati also told of a historian who enthused about Rampa's wisdom. When Bharati explained the facts to him, he was visibly shaken, but said that though Rampa might not actually have been a Tibetan, he still grasped the truths of Buddhism. When, however, Bharati replied to him that it just was not so, the 'historian with perfectly respectable academic credentials' would not be convinced—he carried on believing in Master Rampa.

When I read about Lopez's 'experiment' and Bharati's story, I could not help thinking of the woman who once told me she had flown over Shangri-La on a Pakistan Airways flight. She had not the slightest doubt in the existence of Shangri-La, for at one point between Pakistan and Central Asia the pilot had announced over the loudspeaker that they were flying right over the legendary land. Should one, *could* one doubt the truth content of the statements of a person in authority, as a pilot appears to her? To return to Rampa, can one put the statements of a lama into question?

We shall see that our Tibet images and Tibet caricatures and thus also stereotypes have a great deal to do with authority and charisma. Why did Helena Blavatsky refer constantly to the 'Masters' living in Tibet? Why did Gurdjieff use a group of 'seven wise brothers'? Why do Tibetan clergy more and more play a prominent role in present-day advertising? Evidently since Blavatsky's 'Masters' the clergy from the Roof of the World have attained such authority and charisma that what they maintain is regarded as credible—more than that, as sacrosanct. We are not in the habit of analyzing the sacrosanct, and if one should nevertheless do so, one is considered an 'imbecilic sceptic', an 'idiot', an 'embittered earthling with mocking tongue', a 'malicious man who spreads lying stories'[68] or an 'academic aristocrat', 'gross materialist' and 'positivist'.[69]

Sex-obsessed female incarnations

We have seen that according to Hilton and Rampa the sages in Shangri-La or Tibet are (almost) all of the male sex. Quite the contrary in *The Rose of Tibet* by Lionel Davidson, who tells us the following story. In January 1950, Charles Houston goes in search of his stepbrother, who is missing with a film unit in the Tibetan highlands. Enquiries reveal that he has been received in the nuns' monastery of Yamdring. Houston asks the help of the regional authorities in vain, because they are afraid. The female oracle of Yamdring has prophesied that the monastery will soon be visited by a guest who comes 'from beyond the sunset'. He would be a past conqueror of the country, who would take away with him the abbess and the monastery treasure, numerous emeralds.

The unsuspecting Houston nevertheless reaches Tibet in an adventurous way and arrives at the women's monastery, where little by little he finds out about the ghastly mysteries. It is the

time of the spring festival. On the last day all the faithful flock to the abbess, to receive her blessing. She is the eighteenth incarnation of the she-devil who in her first incarnation gave birth to the first men, fathered by a monkey. Houston too takes his place in the line of those seeking blessing, but when he calls his name he is knocked unconscious and carried into the monastery. It is suspected he is the rebirth of the lecher Hu-Tzung, who had caused havoc in the region about two hundred years before. Whether he is actually so is to be found out by a kind of test: the abbot of the monastery lays down some objects from the estate of the late Hu-Tzung—three silk jackets, three pairs of boots, three daggers and three rings—and Houston has to choose one object from each set … and he chooses correctly, that is to say, the objects that belonged to his predecessor! Houston is therefore obviously the rebirth of Hu-Tzung.

The Yamdring oracle had predicted Houston's arrival accurately many years before. It can be no coincidence: the agreement of the names (Hu-Tzung or Houston), the exact time, the origin in the West and the correct choice of objects when he was put to the test. Nevertheless doubts arise. Is he actually the contrary of the lecher Hu-Tzung, a tulku, an incarnate monk?

The governor responsible for the choice decides for the tulku option: Houston is regarded as the incarnation of a helpful lama who has been sent to protect the Mother, the abbess. From then on he is treated with the greatest respect, with particular attention paid—contrary to every Tibetan tradition—to his feet: everyone tries to kiss them, and each morning his feet are caressed by a woman. They all want to touch him and kiss him … Eventually the wily Houston manages to meet the abbess and experiences some unforgettable nights with her. Soon he becomes conscious that he must free the abbess, 'the Rose', and bring her to safety, together with her treasure of emeralds, an escape that only he accomplishes. The abbess stays behind in Tibet, whether voluntarily or by force remains unclear.

By introducing historical facts, Davidson lends his novel an insidious authenticity. A female incarnation did in fact live in Tibet in a monastery by a lake. Up to 1950, however, when the novel is set, the line of incarnation did not show eighteen incarnations but only six. The monastery was called Samding (not Yamdring), and the lake,

the Yamdrok Tso, is not oval but has, according to Tibetan opinion, the shape of a scorpion. Tibetan legend also informs us that in 1717 one of the Samding incarnations was able to drive away the Dzungar Mongols. The references to the looming Chinese invasion, at the time when the story is set—the beginning of the 1950s —as well as the mention of some concrete historical details, likewise give rise to the impression of serious research by the author.

Apart from a few historical facts, however, Davidson's book abounds in stereotypes. The nuns' monastery turns out to be a vast brothel: the thousand priestesses 'do it like rattlesnakes! They do it whenever they can!' explains Houston's Tibetan companion on his arrival in Yamdring.

> [They are] not allowed [to do it]. But they do it. They can't help themselves, sir. All the young ones do it. … It's the only pleasure they have. They live in stone cells. They sleep on stone shelves. They have a hard life, sir. It's no wonder they love to do it so much. … They're locked in, but the monks unlock the doors. There are only one hundred monks for all those women. … Some of the women can do it ten times in one night.

The abbess too is insatiable. Her maid has to bring men to her each time, blindfolded, their hands tied behind their backs, sometimes four or five in one night. Once a year, at the second great monastic festival, the abbot has the privilege of having the abbess all to himself for three days and nights—an imitation of the union of the monkey with the she-devil that took place 700 years before, repeated every year since then. This legend is, by the way, another borrowing from an actual Tibetan myth, which describes the origin of the human race.[70] The latter, however, is set in a much earlier epoch than the legend Davidson would have us believe.

On account of so much promiscuity, such abandoned sex-life, there naturally ensue problems, which are however eliminated by three women supposed to be continually occupied with abortions … Evidently Davidson has not heard of the Tibetan Buddhist law of not killing! And why the Tibetan women would submit to abortion, if they are so 'crazy about babies, no matter whose', as Davidson writes once, is not altogether understandable.

Besides sex, Davidson seems to delight in the demonic and devilish, which is allegedly a feature of Tibetan religiosity. Thus he describes how in a

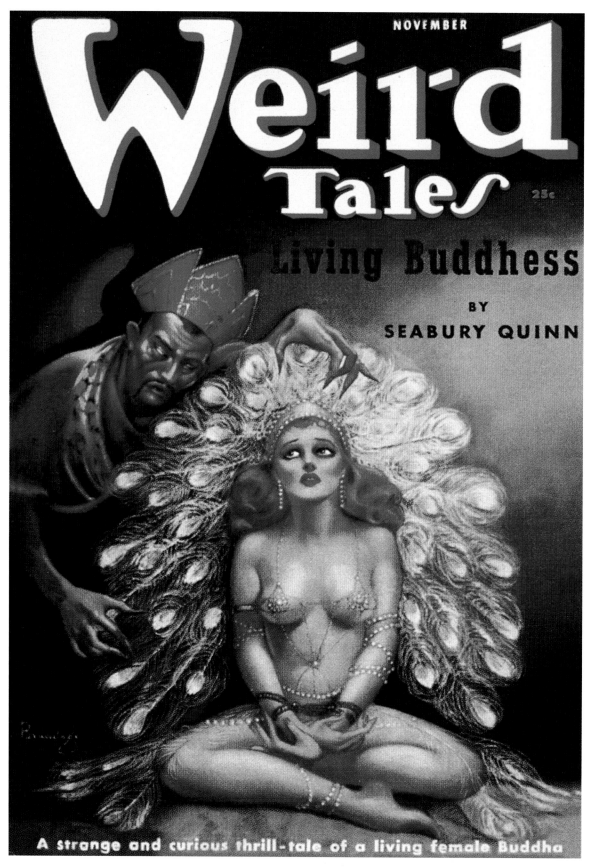

71. *Sacred Tibet seems to be inhabited almost exclusively by monks. Nuns scarcely occur at all, except as sex-obsessed ones incapable—unlike the monks—of keeping the vow of chastity. In* The Rose of Tibet, *a nuns' monastery turns out to be a vast brothel, in which the abbess seems to be the most insatiable of them all.*

chapel, the monastery's holy of holies, sit seventeen life-size 'idols', the 'seventeen Former Bodies' of the present abbess. Davidson calls them 'devil-headed' and 'she-devils'. They are unclothed and support their breasts with their hands. Obviously Davidson has got his inspiration for this and other similar descriptions from wrathful depictions of Tibetan deities and from the so-called Yab-yum images, Father-Mother representations, without understanding their meaning even approximately. In Yab-yum representations, a male deity holds a female deity in an embrace, a representation of the union of Method (*yab*) and Wisdom (*yum*) striven for in meditation. It has nothing to do with veneration of the phallus, 'this symbol ... this key to so many Tibetan mysteries'.[71]

Besides the massive distortions described here—mass sex and satanic traditions in a nuns' monastery—the numerous other stereotypes seem almost harmless, such as the claim that the nuns among other things wore green habits and ornamental gold jewellery piled high on their heads, held silk banners in one hand and prayer wheels in the other in processions (once more prayer wheels have to be dragged in), fastened butter lamps to walls with some mounting, kissed the feet of saints ... descriptions that sometimes display striking similarities with those of the earliest missionaries. What must serve the missionaries as an excuse, namely their ignorance, is no longer valid in Davidson's case.

A female incarnation is likewise at the centre of the novel *Frost of Heaven* by Junius Podrug. Like Lionel Davidson's novel, it is at first about the search for a missing person, a Scottish pilot in the Royal Air Force, who has crashed in the Himalaya during a reconnaissance flight. In the course of the novel it emerges that the pilot, McKinzie, has been found by Tashivaana and brought to her monastery, which lies in Shambhala. Tashivaana is the 32nd incarnation of a female demon and progenetrix of mankind, who tends the grave of the monkey king, the progenitor, until his eventual return. When the affair between Tashivaana and the pilot is discovered, the female incarnation has to leave Shambhala and soon dies, while the ex-pilot is blinded by the monks and stuck in a dungeon. No one must know the secret of Shambhala. Three years later the rebirth of Tashivaana is

found and grows up in the lamasery in Shambhala. In the woods outside Shambhala she is initiated by an ascetic and magician into certain Tantric techniques, such as lung-gom (*rlung sgom*; effortless, very rapid walking) and tumo (*gtum-mo* or *gtum-po*; development of the inner heat). It is recounted that her teacher can send messages by the wind, take on any form, kill with words alone and send his spirit anywhere. Tashi, the 33rd incarnation, however, is overtaken by a similar fate to her predecessor: she has to leave Shambhala and flee before Mongolian horsemen, is picked up by Tibetan nomads, sold as a slave and ends up in a brothel. In the end, having escaped from all these horrors, she decides not to return to Shambhala but to seek her lover's bliss in the West. First she returns with Peter in search of his father to Tibetan Shambhala. But in Shambhala a war flares up because of greedy intruders, which leads to the destruction of this green paradise. The ice halls surrounding the monkey king's sarcophagus start to cave in, a volcano erupts and everyone dies, except Peter. Whoever enters the Shambhala paradise without permission desecrates it, and does not come out unscathed: he must die.

Both stories, *The Rose of Tibet* and *Frost of Heaven*, take up a theme that is remarkably rare, that of the female sacred person. We do not find her, the strong Tibetan nun, the female guru, the female incarnation, in any other story, in any feature film or promotional film, or in any comic. An indication of the emancipation of woman, at least in the imaginations of the two male authors? Only at first glance, for on closer analysis one notices that in both the stories in which female incarnations appear, conduct is ascribed to them that none of their countless male colleagues share: they both behave only superficially as would be expected of a sacred person. To wit, they are incapable of keeping the vow of chastity, which their male colleagues apparently manage to do without further ado. For it says about Tashi, for example:

> She had discovered in Sinkiang [in the brothel] that she was a woman of flesh and blood, not a religious relic. She could not return to Shambhala and become the object of worship for many and love for none.[72]

Male saints seem to be above such sexual needs and surpass the female incarnations considerably.

Where extraterrestrials, apes and demons begot humans

One cannot avoid the impression that in writing his novel *Frost of Heaven*, Junius Podrug drew strong inspiration from Davidson's *The Rose of Tibet*. As mentioned, this too is about the search for a missing person, and here too the hero falls in love with a female incarnation, who is likewise the descendant of a demoness and a monkey king.[73] At the same time, Shambhala turns out to be a melting pot of many themes that we have already become partially acquainted with: it shelters a powerful energy source (one recalls the force 'vril'), control of which would make possible world domination, and it is regarded as the place of the origin and emergence of the human race, which is verified by an abstruse theory: as the monkey king put in a coffin in Shambhala is basically Cain, says the priest in the novel, then if the grave were opened, looking at the body would be as it were to look upon the face of God, for Cain (= the monkey king) was created in the image of God. Here, then, the myth that Tibet is the place of origin of mankind is revived in an excessive way, a theory that—and this is new—is here related to the contents of Christian belief.[74] One of the protagonists, however, goes still further: he is convinced that the monkey-king progenitor was an ancient astronaut, an extraterrestrial, whose spaceship possessed an inconceivably powerful driving force, which is still effective today, an energy source stronger than any on Earth. A sign of this energy is the mist over the valley, which brings about great fertility amidst the icy waste.[75]

Extraterrestrials are also found in the novel *Le tigre et le lama* ('The tiger and the the lama', by Erik Allgöwer), in which extraterrestrials on their

72. Tibet is not only the retreat of wise Mahatmas, but the (involuntary) place of refuge of extraterrestrials. The theme of extraterrestrials living and working in Tibet is found in novels and comics, such as Hamilton's Creature ...

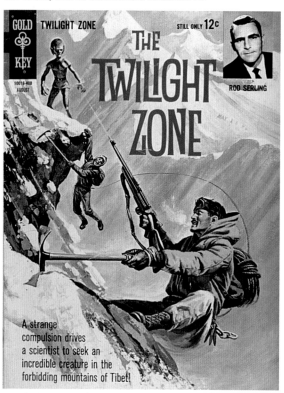

72a

72b

72c

journeys through the solar system have established contact with Tibetans. In the novel *Endstation Tibet* ('Terminus Tibet', by C.C. Bergius) also, extraterrestrials appear to be operating out of Tibet, but it turns out in the end that the beings, who are demanding over the television immediate and complete global disarmament and immediate measures to combat unemployment, to compensate for war damage and to end the Chinese occupation of Tibet, are scientists who have devoted themselves to the saving of humanity. The hero, the journalist Pierre Massol, finds out that the home aerodrome of an aircraft he is able to follow lies in a tunnel in the heart of the mountains of Tibet. Over three hundred renowned international scientists have sequestered themselves there in order to enforce with the most modern technical means a global improvement in living conditions. The 'World Improvement Experiment' goes wrong, the media report an atomic explosion in a supposedly uninhabited region of Tibet, after Pierre Massol has let the American secret service have his information for ten million dollars. For a short time the scientists had tried to turn the Earth into a paradise from Tibet, but, just as it says in the Old Testament, man banishes himself from Paradise.

The theme of extraterrestrials living in Tibet is also found elsewhere, for example in a comic (*Hamilton's Creature*) and in accounts that seek to evoke the impression of scientific respectability but which, for reasons that very soon become apparent, can likewise be counted in the category of science fiction novels. We should like to deal in more detail with one of these stories, as because of its popularity it has substantially influenced the Tibet dream image:

> In 1938 high in the mountains of Bayan-Kara-Ula, on the borders of China and Tibet a team of archaeologists was conducting a very detailed routine survey of a series of interlocking caves.

This is the beginning of an account entitled *Tibetan Stone Disks*, which has also been published, the same or similarly, under other titles.[76]

> Their interests had been excited by the discovery of a line of graves which contained the skeletons of human-like creatures, apparently with spindly bodies and oversized heads.
>
> At first it was assumed that a hitherto unknown species of ape had found refuge in the caves. But as the species seemed to bury its dead

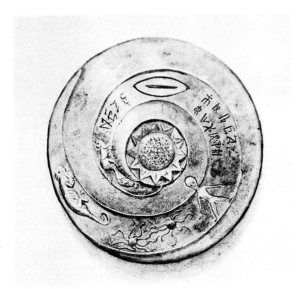

73. ... *and in strange 'factual reports', which actually belong in the category of science-fiction novels. One such story is the 'Stone Disk Report', a classic of the pre-astronautical literature. In one variant of this story, somewhere in north-eastern Tibet there live a people called Dropa or Dzopa, who have noted their story down on twelve peculiar disks. In 1947, Robin-Evans set out for the land of the Dzopa. He learned in the process that about 20000 years ago the inhabitants of Sirius undertook their first expedition to Earth, where they copulated with apes; this led to the emergence of the first humans. On a second visit the extraterrestrials were unable to leave Earth, and they have lived ever since in eastern Tibet, as the Dzopa.*

this idea was rejected.

One day a member of the expedition stumbled on a large round stone disk half buried in the mud on the floor of the cave. The disk looked like an object from the Stone Age. There was a hole in the center of it and a spiralling line of closely written characters, but no one could understand the meaning of this script. The disk, around 30 cm in diameter and 2 cm thick, was kept for the time being in a storeroom with other finds from the area, continues the *Stone Disk Report*, one of the classics of the pre-astronautic literature.

For twenty years experts in Peking tried to decipher the script on the disk, to which another 716 similar disks were added in the course of time. Finally Dr. Tsum Um Nui managed to translate some of the characters carved on the stone. At first the Chinese Academy of Prehistory forbade the scientist to publish his findings, then he was allowed to.

According to them, 12,000 years ago beings from outer space (according to one version of the story they are supposed to have been called Dropa) had made an emergency landing on Earth. They had been unable to leave our planet again as their aircraft no longer had sufficient power. They tried to make friends with the population living in the region of the crash, Dropas and Khams, but were hunted down and systematically exterminated until

the last of these extraterrestrials was dead.

What had this event got to do with Tibet? Not a lot, had there been no mention of 'Tibetan stone discs' and of the 'Dropa' and 'Kham', names that clearly connect the story with Eastern Tibet, where Drogpas and Khampas still live today.

Since D. Agamon has published in the book *Sungods in Exile* the account of a certain Robin-Evans,[77] the Tibetan origin of the stone plates has been still more obvious for the ufologists, although some confusion arose when he wrote about 'Dzopa' instead of 'Dropa'. But such trivialities need not be studied here, especially seeing that Agamon himself seems to be unclear whether Dropa or Dzopa is the correct spelling. What is important is the fundamental message: somewhere in north-eastern Tibet lives a people called Dropa or Dzopa,

74. To give his book an air of authenticity and respectability, Agamon printed a photograph of the ruling couple of the former inhabitants of Sirius, who are supposed to live somewhere in eastern Tibet. The fraud is obvious: it is a (lightly retouched) picture of a well-to-do married couple from Central Tibet, recognizable by the woman's typical headdress, worn only in the Tsang region.

who keep eleven rare disks in a secret temple deep underground (actually twelve, but one was stolen and brought to India), which seems to be the link to the stone plates of the extraterrestrials mentioned above. In 1947 Robin-Evans set out clandestinely for the sinister land of the Dzopa, after a Professor Sergei Lolladoff, Professor of Anthropology and Ethnology, had shown him a curious stone disk (the stolen twelfth one!), which on the basis of several indications appeared to come from Tibet. Thus he travelled via Lhasa, where he met the twelve-year-old Dalai Lama, into the region of the Bayan-Kara-Ula mountains (called the Bayankala Mountains on recent maps). On the way, in the inaccessible high mountain region north-east of the Himalaya, some disquieting incidents occurred. Just before the goal, the Englishman's bearers, hired in Tibet, abandoned him, as they had a panic fear of the realm of the Dzopa. Eventually, with great difficulty the explorer reached his goal, and once he had overcome the local inhabitants' mistrust, a female language teacher was assigned to him, who imparted to him a basic knowledge of the Dzopa language.

To give his book an air of authenticity and respectability, Agamon printed a photograph of the ruling couple Hueypah-La (1.20 m tall) and Veez-La (1.07 m tall). But the author would have done better to leave it out. No sooner do you look at this photo than the fraud becomes obvious. Anyone who knows their way around the ethnography of Tibet a little will realize that it is a lightly retouched photograph of a well-to-do married couple from Central Tibet, recognizable by the woman's typical head-dress, worn only in the Tsang region. But the text also quickly proves to be a clumsy fake. Dr Robin-Evans learned from Lurgan-La, the Dzopa's religious guardian, that the Dzopa's original home was the star Sirius. Some 20,000 years ago and then again in the year 1014 of our era, said Lurgan-La, the inhabitants of Sirius undertook two expeditions to Earth. During their first visit, the extraterrestrials copulated with some earthly monkeys living in trees, which led to the emergence of the first 'sons of the gods'. These founders of civilization, of whom quite ancient legend tells, because of their extraterrestrial intelligence were soon ruling over the other living beings on Earth. When they visited the planet

Earth the second time, the beings from outer space could no longer leave it, as the gravity of the high mountains of Tibet was too strong. To begin with, the extraterrestrials who had survived the crash of their spaceship had trouble finding their way in Tibet. But with time they learned from the population round about how they clothed themselves and tilled their fields, while they made a name for themselves through their methods of healing. The direct descendants of these alien beings from outer space, who never mixed with the surrounding Tibetan population, are the roughly 10,500 Dzopa whom Robin-Evans visited in East Tibet in 1947, while humans go back to the first visit of the extraterrestrials, when the denizens of Sirius copulated with the tree monkeys.

> Your next-door neighbour, the President of the United States, the Emperor of Japan, you and me, all of us who call ourselves humans, are in reality half descendants of these rapists born in outer space,

wrote Robin-Evans on the last page of his manuscript, though not without adding correctly an 'if the story is true' … Incidentally, that Robin-Evans had to leave the endearing direct descendants of the denizens of space living in East Tibet, the Dzopa, again is not to be put down to hostility, but simply to the fact that he had a child by one of the Dzopa …

It will probably not be long before an expedition sets off to find out how this new being, the cross between a man and a female descendant of the Sirians, is getting on in Tibet.

The strange stories show that Tibet is not only the retreat of the Mahatmas, but also the (involuntary) place of refuge of extraterrestrials, whose descendants are still living somewhere in Eastern Tibet. For the 'UFO pope' Erich von Däniken (b. 1935), such links between Tibet and extraterrestrials are already proven fact and one more example for his theory that the Earth received visits in prehistoric times from unknown beings from outer space. As 'evidence', von Däniken cites again and again the same two examples: the genealogy of the early kings of Tibet, and a scene from the life story of the saint Padmasambhava. According to Tibetan legend, seven heavenly kings descended the ladder of heaven a very long time ago. According to von Däniken, they were declared to be gods of light, who at the end of their earthly activity once more

75(above), 76 (p. 106). For two well-known 'ufologists' also there are close connections between Tibet and extraterrestrials: Erich von Däniken (above) asserts that the first kings of Tibet, who each, according to Tibetan legend, descended from heaven and reascended there on dying, were extraterrestrials. George Adamski (p. 106) allegedly learned 'the universal, true principles' in a school deep beneath the Himalaya, and at the same time found out important things about extraterrestrial life.

disappeared whence they had come—into outer space.[78] In the Padmasambhava hagiography, a scene appealed to von Däniken in which it is described how the great teacher once rode away on a steed of gold and silver. For von Däniken, proof that this scene did not simply spring from the imagination of an inspired cleric but represents 'a splendid report' of a journey into space actually carried out is to be found in the following description of the flight, from an early translation of a Tibetan text:

> When they looked, they saw Padmasambhava the size of a raven; when they looked again, they saw him the size of a thrush; and then again he was like a fly, and then again he appeared unclear and indistinct, the size of a louse egg. And as they continued to watch, they saw him no more.[79]

Truly an incontrovertible proof that Padmasambhava—whose biography, by the way, still poses a great many riddles—was an extraterrestrial!

Von Däniken found further 'proof' in Helena Blavatsky and the book *Dzyan* she supposedly discovered. It is known today that *Dzyan* is 'the phonetic total description of ancient Tibetan writings', claims von Däniken, without revealing how he knows it is known. Von Däniken simply knows! So he can without more ado relate the book *Dzyan* to the latest space technology and even suggests that the essentials for space exploration are in the book, for example in the form of the future habitat in outer space, on the manner of the habitat-occupants' long journey, on new manners of bearing fertilized eggs in outer space ...[80]

Another famous ufologist, George Adamski (1891–1965), also allegedly had a hot line to Tibet. His disciples assure us that he was introduced to secret Tibetan knowledge just like Helena Blavatsky in her day.[81] According to these informants, at the age of thirteen, accompanied by a family friend, he travelled in the Far East. There he gained admission to a remarkable school hidden deep beneath the Himalaya, where chosen students went through a rigorous syllabus. The extraordinarily carefully selected students were taught universal mathematics, molecular science, religion and philosophy, the science of thought

transference (telepathy) and much else. Adamski's training in this school, whose exact position is not published because of the code of honour of the Adamski disciples, lasted five years. It was not a Tibetan school or a school connected with any Tibetan religious organization. Rather, there were preserved there unadulterated the 'universal, millennia-old and true principles', which are included in the different religious systems only partially and when there at all are unfortunately heavily distorted. One informant, however, contradicts this view when he says that Adamski studied for six years at 'the highest school of Cosmic Law at a monastery in Tibet', and there attained a degree that enabled him from then on to teach himself.[82] Although the location of this school in the region of Tibet is, viewed historically, not altogether accidental, the Adamski followers inform us, it depends above all on the vastness and isolation of that mountainous region, and this extreme seclusion is the reason why it is not possible even today to bump into it inadvertently. One can also not expect in any event to meet a teacher or student of that school and coax the exact location out of him, for in the meantime they have all died. So you cannot believe anyone who pretends to have been connected once with this school in Tibet.

During the 1920s and '30s, Adamski added to his knowledge collected (supposedly) in the Himalaya and in 1936, with the help of some friends, he opened a school in Laguna Beach, California, at which the explanations and instructions he had enjoyed before in Tibet were passed on. At this school—sometimes also called a monastery—known as 'The Royal Order of Tibet', little that was 'Tibetan' was apparently taught, but instead a lot of theory about extraterrestrial life and visits from outer space. Or is this a fallacy? Have we not learnt from Agamon and Robin-Evans that because of the extraterrestrials from Sirius, who sexually assaulted the monkeys of our planet, Tibet is the country of origin of humanity, and from von Däniken that the saint Padmasambhava was basically an extraterrestrial? Accordingly reports about extraterrestrials also say a great deal about the Tibetans—and reports about Tibetans a lot about extraterrestrials. From this point of view, was it wrong to subsume UFO reports under novels?

Secret knowledge

The *Eternal Enemies* is a work by the author Leonard Sanders from a series about the superhero Loomis. The episode, an action thriller with a lot of deaths and not a single woman in the whole book, takes place in Nepal and Tibet and is knitted from a very simple pattern: the Muslims (= holy war) are baddies, as are the Chinese (= Communism), while the Tibetans, whose Buddhism and wisdom are of benefit to the world, and the Americans (= Democracy) are goodies.

The plot summarized: Owenby undertakes the task of bringing Loomis and a load of rifles to an underground monastery in Western Tibet, 600 km north of the Nepalese border. Before the adventurous journey, Loomis does not know what awaits him; not until he is at the monastery does he find out about the threat to it from the Muslims from Turhan. These, under the leadership of Oztrak, have allied themselves with Peking against Tibet. Their goal is holy war, 'jihad', plotted together with Peking for the destruction of the Tibetans.

After the hero has learnt the significance of the monastery—it houses irreplaceable ancient manuscripts—everything is tried to save at least these manuscripts and also the monks. At the end, after endless slaughter and a bitter bloodbath, the fleeing monks and the unique library are saved and the army beaten, and Loomis has successfully fulfilled his commission. The ancient knowledge that had been preserved away in Tibet for centuries is to be brought to a new monastery in India for the benefit of Buddhists, Christians, Jews, Hindus and Taoists.[83] One wonders, though, what about Muslims? Whether they come under 'other religions' is rather unlikely.

But the book also contains numerous current Tibet stereotypes: Tibet is a place where ancient wisdom is kept safe, for the monastery whose treasures must be saved is the richest storehouse of old manuscripts in the world.

> 'We are the custodians of some of the earliest and most valuable books mankind possesses … the direct words of the Buddha … early texts of the Old Testament … the oldest versions of many books of the New Testament, including portions of the so-called Q document containing many direct quotations from Jesus Christ expurgated at the earliest church councils and now unknown to modern Christian scholars,'

Lhalde tells Loomis.[84] Tibet as a stronghold of ancient knowledge, an image for which, as we have already shown, we have the Theosophists principally to thank. At the same time, the myth is fostered that Jesus was in India during his 'lost years', between the ages of twelve and thirty, which can be read in an early version of Luke's Gospel that is also to be found in this Tibetan monastery.[85] Leonard Sanders thus incorporates the old myth already mentioned, according to which there is supposed to be a special connection between Jesus and the Tibetan cultural sphere.

The peace-loving, non-killing Tibetans must also not be left out: Buddhists are pacifists, who would not once kill even if they had to defend themselves. However, the author gets into a dilemma when the peace-loving monks suddenly face the bloodthirsty, fanatical, kamikaze-like Muslims who are waging a holy war against the Tibetans.

The theme of the all-knowing, all-seeing lama who foresees that the enemies will get into the monastery is encountered, as well as that of rebirth: Loomis, the hero, is suddenly made aware that the enemies he is about to confront are old acquaintances: one more battle in a long string of battles with 'the eternal enemies':

> 'You have met this foe many times in the past,'

the Kamala Lama meaningfully tells Loomis. When Loomis' head is touched by the lama, a pleasant warmth spreads through his body and he feels a profound calmness and a peace he had never experienced before. With his Lama Kamala, the author is undoubtedly borrowing from the High Lama Perrault in *Lost Horizon*, but one cannot escape the impression that it is but a feeble imitation of him.

All the same, the novel does take as its central theme an interesting subject: the dilemma that ensues from an inwardly directed contemplation orientated towards renunciation and the daily struggle for survival of a community of monks. This struggle can go so far that the same monastery has to defend itself against enemies, thereby saddling itself with bad karma. This recalls the self-sacrifice of a Bodhisattva:

> A good man turns bad to make the bad man good.

By making central the theme of monks fighting and defending themselves, the author does away

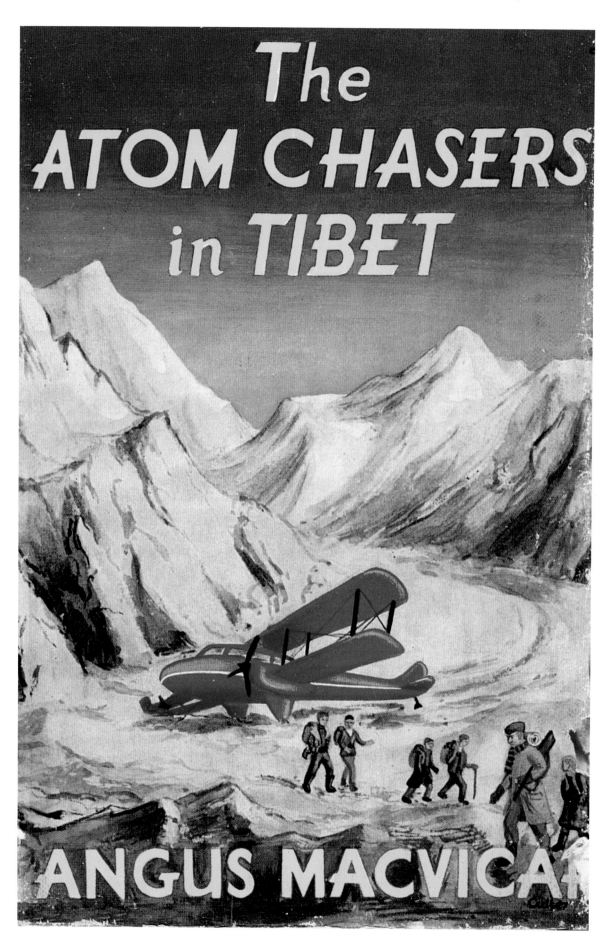

with one stereotype that history has long since refuted: that of the ever peaceable Tibetan monk. It remains up in the air whether at the end of the novel there is really a transformation in the Buddhist sense, for the foes, the Muslims, remain 'eternal enemies'. At least on this point an old stereotype endures, though one that—at first sight—appears to have nothing to do with our Tibet stereotypes. But even the view that the Muslims are evil and nasty has on closer examination a connection with our Tibet myths: for many Westerners, the Tibetan Buddhist culture is superior to the cultures shaped by Islam or Hinduism. This view, based on evolution, represents a not to be underestimated basis for many positive Tibet stereotypes, as will be shown in Part 5.

The secret knowledge hoarded in Tibet is a subject frequently encountered in fiction. Thus for example, in the novel *Le tigre et le lama* a statue at the Tang monastery in Bhutan contains documents, which say amazing things about quantum theory and relativity and the origin of the physical world. This knowledge comes from extraterrestrials from the Large Magellanic Cloud, who by dint of a tireless spiritual search succeeded in attaining incredible physical knowledge and insights, such as how the energy of black holes can be used. The extraterrestrials have transmitted this knowledge to the Tibetans, who have written it down and hidden it in the statue.

In a novel for younger readers, *The Atom Chasers in Tibet*, a mission is looking for an old manuscript, the 'Book of Wisdom', which is supposed to be in a hidden monastery in eastern Tibet. After an adventurous journey—emergency landing, attack by bandits and an encounter with yetis—the expedition reaches a hidden, extraordinarily mild valley, where they are received in a friendly way by the monastic community. After a further incident— appendicitis of the ten-year-old(!) abbot of the monastery and an emergency operation—the seekers are finally led into the library for the Book of Wisdom, which the monks regard as their most valuable text. But what a surprise and disappointment! The book is the Greek text and Tibetan translation of I. Corinthians 13, in which love is praised as the supreme gift of mercy …

Instant practices for attaining the fountain of youth: the 'Five Tibetans'

'For the first two weeks after I arrived,' said the Colonel, 'I was like a fish out of water, I marveled at everything I saw, and at times could hardly believe what was before my eyes. Soon, my health began to improve, I was able to sleep soundly at night, and every morning I awoke feeling more and more refreshed and energetic. Before long, I found that I needed my cane only when hiking in the mountains.

'One morning after I arrived, I got the biggest surprise of my life. I had entered for the first time a large well ordered room in the monastery, one that was used as a kind of library for ancient manuscripts. At one end of the room was a full length mirror. Because I had traveled for the past two years in this remoter and primitive region, I had not in all that time seen my reflection in a mirror. So with some curiosity I stepped before the glass.

'I stared at the image in front of me in disbelief. My physical appearance had changed so dramatically that I looked fully 15 years younger

77. *In the novel for younger readers,* The Atom Chasers in Tibet, *a mission is looking for an old manuscript, the 'Book of Wisdom', which is supposed to be in a hidden monastery in eastern Tibet. But what a surprise and disappointment! The book is the Greek text and Tibetan translation of 1 Corinthians 13, in which love is praised as the supreme gift of mercy …*

than my age. For so many years I had dared hope that the "Fountain of Youth" might truly exist. Now, before my very eyes was physical proof of its reality.'

Colonel Bradford describes here how after a long and perilous expedition in remote areas of the Himalaya he eventually found the monastery which according to legend sheltered the secret of eternal youth and rejuvenation: the 'Five Tibetans'. As with Blavatsky, Gurdjieff and like-minded authors, information about this supposed monastery is exceedingly sparse, so that even the author of the framework story, Peter Kelder, admits that a lot of it sounds more like fantasy than fact, a view we can entirely agree with. Whether the lamas' interesting way of life, their culture and their complete detachment from the outside world are really as hard for Western people to understand as the author tries to make us believe may, however, be questioned.[86]

But what does the secret of youth and rejuvenation of this monastery in the Himalaya consist of? It is the activation of the seven

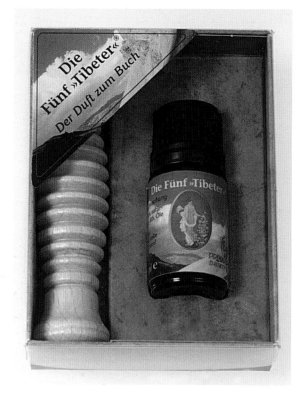

78. *Although it is claimed that to attain the fountain of youth the correct practice of the 'Five Tibetans' is sufficient, shrewd business people are forever inventing new products, which the faithful Tibetan gymnastics community seem to fall for: supplementary books (the 'Five Tibetans' for children, the 'Five Tibetans' gourmet cookbook and so forth), audio and video cassettes, courses and even a perfume of '100% natural etheric oils': 'The scent for the book'.*

energy centres,

> powerful electric fields, invisible to the eye, but
> quite real nonetheless,

which in turn have a positive effect on the 'seven ductless glands in the body's endocrine system'. The quickest way of regaining youth, health and vitality therefore consists of getting the energy centres to turn normal again, for which one uses five simple exercises, which are actually 'rites'. The result of these rites is striking, this at any rate is what Kelder in his framework story would have us believe: the seventy-three-year-old Colonel Bradford was judged by the members of the 'Himalaya Club' on his return from the mysterious monastery to be about thirty years younger. Apparently he had also practised thoroughly the sixth rite, for only this guarantees a complete restoration of health and youth. The sixth rite should only be practised by those who have a surplus of sexual energy. Fortunately it is also an 'instant' practice: the rite is so simple that one can perform it anywhere and at any time,

whenever one feels the need. The practice, the crowning of the whole, is in fact extremely banal. The sole requirement: one must experience a sexual urge, feel sexually fulfilled and be correctly motivated, then by means of the sixth practice one can transform this urge and 'lift it upward' into the higher chakras. So one simply becomes a 'superman or superwoman', grows younger every day and every moment and produces within oneself 'the true "Elixir of Life"'.

In the foreword, a certain Harry R. Lynn writes that it is impossible to say whether Peter Kelder's (framework) story of Colonel Bradford is based on fact, fantasy or a mixture of the two, a typical qualification that we find again and again in made-up stories whose authenticity is not supposed to be doubted. Credibility is faked by purported openness and qualification. At the same time, it is not open to any doubt that the framing story can be described at best as a short novel and at worst as a cock-and-bull story. It is in fact claimed that the monastery with the secret of the 'fountain of youth' is so remote and isolated that its monks are practically cut off from the outside world—which is supposed to mean that the truth of the story can be neither proved nor disproved. A potential critic can simply be made aware that the right monastery has not yet been found … The non-existence of the (almost) secret monastery cannot be proved.

The falsity of the story can nevertheless be proved, on the basis of many false 'clues', of which only a few are mentioned: there is certainly no remote Tibetan monastery where there is a monastery library with a large mirror reaching right down to the floor; in Tibetan Buddhism, five, six or eight energy centres (chakras) are spoken

79. *In rare cases, Tibetans do practise physical exercises, but they are quite a different kind of exercises from the 'Five Tibetans'. Paradoxically, the book written by long-standing practitioners of the so-called Yantra Yoga, with reference to original Tibetan texts and after in-depth discussions with a Tibetan master, is largely unknown, while the phoney book by Peter Kelder enjoys a circulation of around two million. The world wants to be duped!*

of, but not seven; only in the rarest cases do monks produce themselves what they need for food; Tibetan monks are as a rule not vegetarians and just do not practise a kind of segregated diet (not mixing food classes, e.g. meat and carbohydrate, in the same meal) as Kelder would have us believe. A meal that consisted only of bread or vegetables is quite inconceivable in Tibet. And it gets thoroughly absurd when Kelder fails to mention at all the healthy staple food of every Tibetan, young or old, rich or poor: tsampa.

In one point the author is right. Although it is little known, in rare cases physical exercises were practised in Tibet, the so-called 'Yantra Yoga' or yoga of movements. But they were quite a different kind of practice from those Kelder describes in his book. Only the fourth 'Tibetan' has a certain similarity with one of the traditional Tibetan exercises, but on closer examination this turns out to be only superficial: the initial position as well as the position of the chin are entirely different. While Kelder claims that when raising the body one must let the head fall to the back, the Tibetan exercise stipulates that the chin absolutely must be pressed against the chest![87]

In one considerably more important point, a further discrepancy is detectable: Kelder assumes that the 'Five Tibetans' can be learnt alone just by reading his book, as it were 'unencumbered by difficult disciplines and dogmas'. But a Tibetan master of traditional Yantra Yoga, Namkhai Norbu, stresses that it is in no way sufficient simply to read a book and start practising the exercises on one's own. One definitely needs direct transmission, i.e., an experienced teacher. Practising Yantra Yoga means working with energy, and this work with energy is not a game.

> One must work together with a teacher, as the experience of this practice and the clearing up of all doubts ... constitutes the sole possibility for really learning Yantra Yoga.[88]

Paradoxically, the book that disseminates Tibetan pseudo-yoga has been reprinted more than thirty times and had around two million copies published. But the book written by long-standing practitioners of Yantra Yoga from all over the world, with reference to original Tibetan texts and after in-depth discussions with a Tibetan master, is known only to a few initiates ... The world wants to be duped!

Many of the themes outlined here recur in countless other novels—for example, lamas who practise astral travel, move at very great speed, are clairvoyant, have other supernatural powers and guard secret, ancient texts—but one basic theme of many stories is not mentioned: the quest. In almost every novel someone is searching for people—missing family members, friends or scholars—yetis, old texts, plants or even the origin of humanity. Tibet seems to be the land of missing people and of strange treasures that it is necessary to discover. The quest, moreover, always comes from whites, sometimes even white lamas,[89] who determine the course of the story.

In all these novels the white Westerner brings sacred Tibet and the lamas under his control. There is nothing the Tibetan lamas do that whites cannot do better. 'Tibet facsimiles' are created, rational and intellectual whites, who supersede the Tibetans so that the world should be saved from the villains— Nazis, Chinese or other 'baddies' such as Muslims or Japanese.[90] As we shall see later, similar things also happen in most feature films.[91]

80. In Kelder's book it is claimed that the secret of youth and rejuvenation is preserved in a Tibetan monastery. It consists of the activation of the seven energy centres (here the seven chakras are depicted on a record sleeve that has no reference to the 'Five Tibetans'), which has a positive effect on the seven endocrine glands of the body. The quickest way to win back youth, health and vitality is to get the energy centres turning normally again, for which one may use five simple exercises, types of yoga exercises. These exercises, it seems, were once learned by a British colonel in a remote Tibetan monastery, whose exact location, however, is not divulged. Instead, some clever Westerners marketed the spiritual knowledge of Tibet—despite the spiritual copyright, which ought to belong to the Tibetans, if the story is true ...

B. Comics

Tibet in comic books

Lamas, monks and tulkus …

Since the 1950s a remarkable number of comics have appeared that in one way or another are set in Tibet or at least have a close connection with it.[92] It is one of the characteristics of comics that they often seek to depict a different reality, where the irrational, the comical, the unusual, the threatening, the unconscious and the fabulous predominate. It would therefore not be fair to comics to dispute all the Tibet curiosa and absurdities contained in them or to want to 'prove' their non-existence. It would mean robbing the comics of their essence. It is consequently not a matter of valuation here, but of demonstrating which Tibet images predominate in comics, and which 'original images' and which possible sources lie behind particular images. A critical distance is, however, appropriate where bogged-down stereotypes that are bigoted, racist or otherwise discriminatory are perpetuated.

A prime example of such a comic is *Der Lama von Lhasa* ('The Lama from Lhasa', 1979), a conglomeration of alleged ethnographic facts: he is greeted with stuck-out tongue ('the Tibetan welcoming custom'), the natives cannot pronounce the letter 'r', are always smiling, a wooden collar is worn for punishment and hundred-year-old yak cheese, bird's nests and rotten eggs are eaten. We learn the same sort of thing from the comic *Mickey Mouse In High Tibet* (1952), in which Mickey is likewise greeted with stuck-out tongue and filled with tea made from six-year-old yak butter.

> 'You must know, noble stranger, that many things occur here in Tibet which seem unbelievable to you men of the West,'

says the abbot of a Tibetan monastery once to Captain Haddock in *Tintin in Tibet*, stating something that is expressed in a very large number of Tibet comics: Tibet is the land of the wonder-

81. The monks, lamas and tulkus living in sacred Tibet can disappear into thin air … they are masters of the art of levitation, floating in the air; or they can deliberately bring about death and shrivel up …

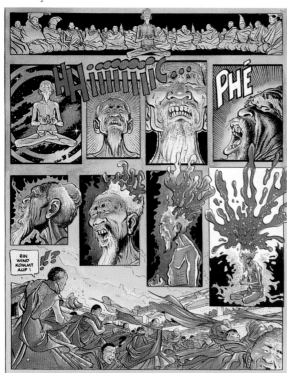

81a-c

81d

working monks. Indeed, when one reads the Tibet comics one gets the impression that Tibet and the Himalaya are inhabited almost exclusively by such monks. There do not appear to be any lay people, or if there are, they are no more than extras without major roles.

The monks, lamas and tulkus (the terms are used as synonyms) are frequently all-comprehending and all-knowing. They can disappear into the air and reach 'the state of the fourth dimension'[93] and are masters of the art of levitation, or floating in the air.[94] As a rule they are friendly and courteous; only in *The White Lama* (*Le lama blanc*, 1988–92) some monks are

81e

extremely brutal—critical monks are killed or walled up alive in underground cellars, and in the same comic series the Bönpos do not even shrink from human sacrifice. In some other comics also, the monks unexpectedly take on very destructive characteristics, when for example in a completely unBuddhist fashion they sentence persons lacking in understanding to death.[95]

There seem to be no nuns in Tibet, with one great exception: in *Jonathan* there occurs Miyma, the all-knowing sorceress of the white mountain. Otherwise the world of religion portrayed in most comics is reserved for men.

Quite a few comics anticipate a phenomenon that was only later to become relevant in the everyday life of Tibetan Buddhism, but which we already know from some novels: a Westerner too can become a monk in the Tibetan tradition, and can even be a reincarnate monk (tulku). The forerunner for this idea was probably Lobsang Rampa/Hoskins in *The Third Eye*. Very clearly, Rampaesque myths and stereotypes were rendered in *The White Lama*. In this there is no lack of monks flying on kites, and the way a novice is received in Chakpori Monastery is thoroughly unusual—Gabriel has to sit in the monastery courtyard for three days and must not move; after his reception he wins the respect of the novice

82. ... *and frequently they are all-seeing and all-knowing. As a rule monks are friendly and courteous, but sometimes they are extremely brutal and do not even stop at human sacrifice (82g–j).*

82a-e

82g

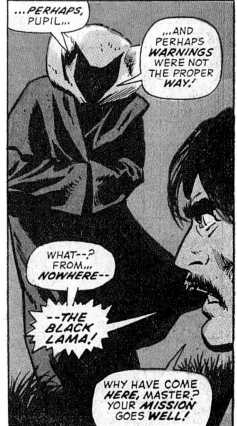

82h

82f

82i

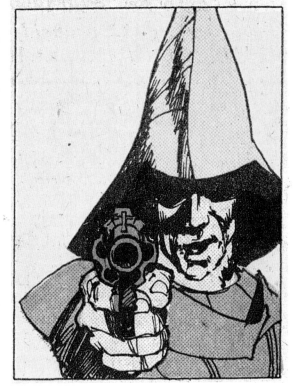

82j

83a

83. Sacred Tibet and the Himalaya, if one is to believe novels and comics, are almost exclusively inhabited by monks. There seem to be no lay people, and when there are, they are at best extras without significant parts. But whoever thinks the chief protagonists in sacred Tibet must be Tibetan *monks is mistaken: in many novels and comics white monks play the main parts.*

83b

master by defeating the most battle-tried monk in the monastery. Idolized watchcats also appear, which guard the monastery's treasures and—in not very Buddhist style—are kept happy by the monks with white mice![96] Instead of the chiseling in of the 'third eye', in the third volume of *The White Lama* the 'third ear' is opened, with which Gabriel can perceive all molecular vibrations as acoustic signals and convert them into mental images by way of the pineal gland. From this moment on, very much like Lobsang Rampa after the opening of the third eye, Gabriel is in a position to see the hues, thoughts and auras of other people. And like Rampa, Gabriel undertakes astral journeys, during which his astral body remains linked to the physical body by a fine cord—the silver cord of Rampa, the Theosophists and the Rosicrucians.

After Jerry Siegel and Joe Shuster had published the first Superman story in 1938, triggering a kind of revolution in comics, there came a flood of similar series. The heroes of some of these series also rush to help the Tibetans and protect them from evil. One of the first such stories is *Trouble in Tibet* (1941), in which Steve Conrad saves the High Lama, abbot of a Tibetan monastery, who has been deposed by a Chinese and put in prison, and so helps him back to office and honour. Shortly after that appeared *At the Top of the World* (1942), in which rescue comes from Ted Crane, who thwarts the plans of the Japanese to drive the British back 'to the other side of Suez'. He also prevents the abduction of the young Dalai Lama, who invites him to stay in Lhasa and become 'Head Lama'—probably the first time that a Western man almost becomes a lama. The Japanese are also portrayed in *Treachery in Tibet* (1946) as enemies of India—the painful aftermath of the Second World War. But the 'superman' Spy Smasher overcomes the Japanese who has risen from the grave, disguised himself as a Tukul (*sic*!) and is trying to win over the inhabitants of Aki Rema, a small kingdom in Tibet, to the Japanese military action against India. Spy Smasher does not lead this fight alone, but with the inhabitants of Aki Rema, who from 'peaceful sheep change to raging rams' when the war trumpet is sounded.[97] A kind of Western superman also rushes to the aid of the Tibetans in *Quisling Quest in Tibet* (1946), in this case of an unsuspecting abbot who without realizing it is sheltering Nazi war

83c

83d

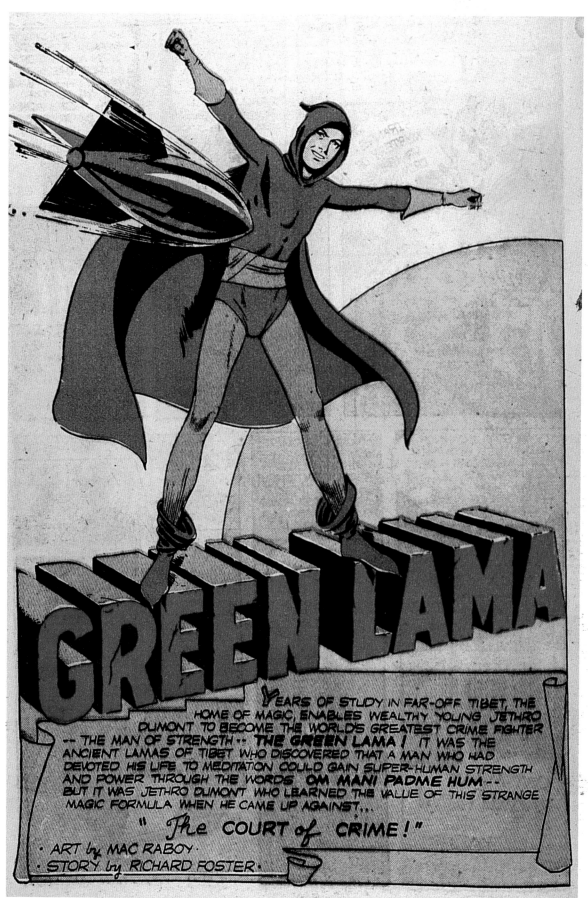

criminals—'the arm of the Nazi underground reaches far, even to Tibet!'. In all these comics the Tibetan lamas are by no means all-knowing—on the contrary, they are credulous and let themselves be duped by the baddies. Deliverance definitely comes just from Western men.

In other comics in which non-Tibetan white monks or lamas appear, they have to fulfil a mission in the West—always in New York, the symbol for the decadent world. There they fight, partly supported from Tibet,[98] against the evil in man that makes him sick,[99] or against professional criminals.

84. Non-Tibetan, white monks, who have acquired their knowledge and skills in Tibet, often have to carry out a mission in the West—always in New York, symbol of the decadent world. There they fight, sometimes supported from Tibet, against the evil in men, which makes them ill, or against professional criminals. In The Green Lama, Dumont decides to compete against the entire New York crime scene with his supernatural powers learned and acquired through meditation in Tibet. With the words 'Om mani padme hum,' which are answered in mysterious fashion from a faraway temple in Tibet, Dumont transforms himself into the 'Green Lama', who, however, looks from outside more like a superman than a Tibetan monk.

The comics *The Origin of an Avenger* (1966) and *The Court of Crime* (1944) were evidently godparents to the film *The Shadow*, which we shall present in more detail below. In *The Court of Crime*, the rich young American Jethro Dumont returns to New York as a tulku, together with his servant Tsarong, after familiarizing himself for many years in a Tibetan monastery with the 'peaceful ideas of Lamaism', which he will now spread in America. Dumont has scarcely arrived in America when a stray bullet from an unknown culprit hits an innocent little girl. Dumont decides to compete against the entire criminal fraternity of New York with his supernatural powers learnt in Tibet and acquired through meditation. With the words 'Om mani padme hum,' mysteriously answered from a far-off temple in Tibet, Dumont transforms himself into the 'Green Lama', who has however no resemblance to a lama at all, but looks like a superman. Made up and thus no longer recognizable as Dumont, he investigates a criminal group, but when he falls into the water he is discovered and recognized. In extreme need

84b

he is saved by the words 'Om mani padme hum' and their echo from far Tibet. Dumont nevertheless is taken prisoner by the gangsters and is going to be killed, but he is invulnerable: bullets bounce off his steel-hard muscles, an axe splits, chains break, the Green Lama is even able to stop a projectile from a ship's gun with his chest. Finally he halts the criminal gang's ship with his bare hands, swimming, lets it run aground, and hands over the crew to the police. Pronouncing the magic formula backwards ('Hum padme mani om') allows Dumont to become the rich young playboy once more.

In the comic *The Origin of an Avenger* (1966), we find the theme of a crate arriving at a New York museum with no clear sender, harbouring alarming contents, a subject that we likewise encounter in the film *The Shadow*. In the film, in the sarcophagus is found the villain Shiwan Khan, the last descendant of Genghis Khan; in the comic, dinosaur eggs millions of years old come to light, from which hatch gigantic prehistoric creatures, which threaten to destroy New York— a 'gift' from 'the Masked One' living in a cave in the Himalaya, the personification of evil, but the Lone Avenger overcomes him. In each of these comics in which a Western tulku is active in New York, the hero looks like a mixture of Robin Hood and Superman. They are white heroes, who have, however, acquired knowledge and abilities in Tibet, with which they are still linked.

… Shangri-la and yetis …

Comics are present-day fairy tales and testify a great deal about the anxieties and longings of the age that produced them. In the comics of the 1940s, '50s and '60s, another object of human comic-book longing is the land of Shangri-La, which is also given other names such as Tralla-La, Shangreet-Lo or simply 'the valley of eternal youth'.

Of the comics to hand, one from 1946—*Bugs Bunny's Dangerous Venture*—mentions Shangri-La or a similar name for the first time: Shangreet-Lo, which is supposed to lie in the forbidden mountains of Tibet. Its inhabitants are civilized, but visitors are not infrequently killed.

In the 1950s Uncle Scrooge too hears of a valley of eternal youth in the Himalaya, which he goes to, in order to become as old as its oldest inhabitant, who has after all kept going for 700 years. Soon afterwards, in 1954, a Shangri-La-style valley appears in another comic by Carl Barks: *Uncle Scrooge in Tralla-La*. Uncle Scrooge, overtaxed by the management of his wealth and

85. In the comics of the 1940s, '50s and '60s, another object of human comic-book longing is the land of Shangri-La, which is also given other names such as Tralla-La, Shangreet-Lo or simply 'the valley of eternal youth'. In the comic Bugs Bunny's Dangerous Venture, *from 1946, Shangri-La, or rather the similar-sounding Shangreet-Lo, which is supposed to lie in the forbidden mountains of Tibet, is mentioned for the first time. Its inhabitants are civilized, but visitors are not infrequently killed.*

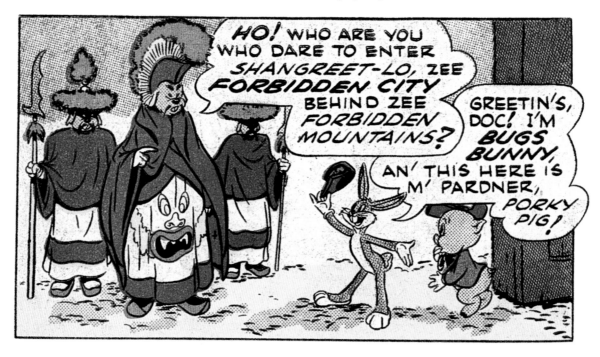

all kinds of petitioners, suffers a nervous breakdown and dreams of a place where money and wealth play no part. His doctor knows of a mysterious valley by the name of Tralla-La in the Himalaya, and the overworked duck in need of a rest decides to fly there with Donald and his nephews. Nobody knows the way to Tralla-La, but a pilot signed up by Uncle Scrooge succeeds in locating the round valley by radar and Uncle Scrooge and his companions jump out over it with parachutes—a theme also frequently met with in other Tibet comics. The inhabitants of the valley know no avarice and regard friendship as the highest value, until one of them finds a bottletop thrown by Scrooge from the aircraft. The chaos unleashed by this—the top becomes an extraordinarily coveted object of value—leads to the expulsion of the strangers, and Tralla-La sinks back into its slumber. Later, Uncle Scrooge, his nephews and Donald reach the secret valley again by accident while in search of the state treasure of Kublai Khan (*Return to Xanadu*, 1991), but once again they are flushed out of it without having achieved anything. Shangri-La is a secret region that only gives shelter to those who submit to its laws—this is also conveyed by the other Shangri-La comics, such as *Bugs Bunny's Dangerous Venture* (1946).

In *The Man Who Found Shangri-La* (1964), in

86. In 1964 a comic appeared that made direct reference to Hilton's Shangri-La: The Man Who Found Shangri-La. As in Hilton's novel, the good think Shangri-La is a perfect land of inconceivable beauty, where all live in peace, happiness and contentment. To bad men, however, Shangri-La appears as a horror scenario, a field of ruins with wild, down-at-heel, menacing people: to each the Shangri-La he deserves.

86a

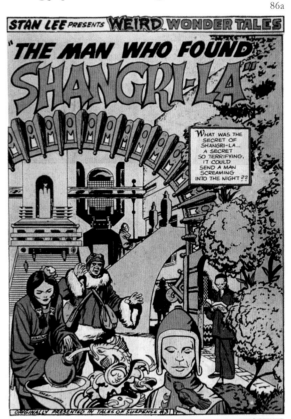

86b

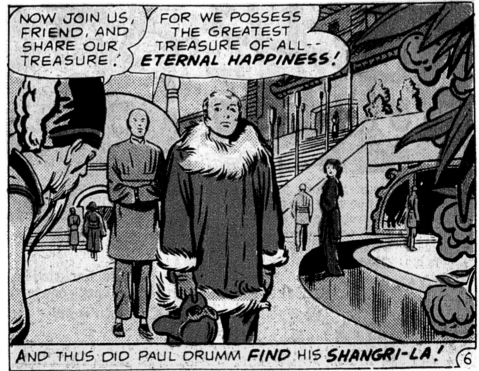

87a

87b

87c

87. A basic theme of many Tibet novels and comic books is the search—often the search for yetis, those mystery-scented snowmen. They are always about the first discovery of the yeti—in spite of insistent warnings by the natives. And every time the Western hunters are punished for their greed. The mysterious ideal world of Tibet must be left in peace; one is not allowed to intrude and explore it without paying the price.

this perfect land of incredible beauty good men encounter wealthy, contented and peaceful inhabitants, but to the bad Shangri-La appears as a horror scenario, a field of ruins with wild, down-at-heel, menacing people: to each the Shangri-La he deserves.

It is typical of all these Shangri-Las that admission is extremely difficult, only a few manage to get in—just as James Hilton's Shangri-La was only open to quite a small band. The theme of the arduous air journey and the crash-landing, as described in the book *Lost Horizon*, is also repeated in a substantial number of comics not belonging to the Shangri-La type:[100] a metaphor for Tibet's seclusion and inaccessibility.

Somewhat later than the first Shangri-La comics, the first yeti stories appeared, which went on until the 1970s. They are always about the first

discovery of the yeti—in spite of insistent warnings by the natives. And every time the Western hunters are punished for their greed, whether by natural forces, by the yeti itself, or by a kind of karma, as in *Ich fand den schrecklichen Schneemenschen* ('I Found the Abominable Snowman', 1968). In this comic, the unteachable yeti-seeker is transformed into the yeti by an old lama, and retains this form until another greedy yeti-seeker turns up. The mysterious ideal world of Tibet must be left in peace; one is not allowed—as we have already seen above—to intrude and explore it without paying the price.

Only in a few cases do the two species, men

88a

88. Only in a few cases do human and yeti live in peace, as for example in Tintin in Tibet *(© Hergé/Moulinsart 1999) and* The White Lama. *There the yeti does not turn out to be an abominable snowman, but a sympathetic, almost human, being.*

and yetis, live in peace, as for example in *Tintin in Tibet*. There the yeti does not turn out to be an abominable snowman, but a sympathetic, almost human, being, who cries heart-rendingly when he realizes that Chang, whom he has grown fond of, is leaving him forever.

After flourishing for twenty years, the yeti or snowman now turns up only occasionally, as one cliché among many.[101] Instead, Tibet becomes the site of global conspiracy. In this way an old theme from the 1930s has been enjoying a revival in the '80s and '90s. But whereas in the 1930s danger threatened from 'the crusade of the mendicant monks' (Wilhelmy) and 'the occult *hierarchia ordinis* of the Lamaist theocracy' (Ipares), in the comics there is a strange new formulation of a global threat coming from Tibet, which seems to have its roots in neo-Nazi literature.

88b

... Nazis, Agartha, theosophists and Rampa

In a lot of comics, Tibet is simply a place where things happen over which the Tibetans can exert scarcely any influence: a secluded, empty space, which sometimes serves as a place of retreat for crazy beings. The two most typical stories of this genre, *Le cerveau de glace* (1988) and *Le signe de Shiva* (1985), are about a fight between evil world-conquerors who live beneath Tibet in caves and the world of light. In *Le cerveau de glace*, the baddies are ancient SS thugs who had been sent to Tibet by Hitler in 1943 with orders to gather political and esoteric information for his race doctrines, which recalls the Schäfer expedition and its alleged secret orders. In Tibet they are stationed at the monastery of Peng-boche (reminiscent of Pangboche in Khumbu, Nepal), in which at first live monks who have been initiated into the secrets of magic. War materials needed are flown in by air freight and the soldiers build an underground bunker and wait for instructions—in vain, for after the war they are forgotten. Years later a former SS camp commandant, Zimmermann, becomes aware of the forgotten Nazi base and the last active bastion of National Socialism and converts the monastery and the bunker underneath into the headquarters and high-tech centre of his SS organization 'Anti'. From there, with a supercomputer Zimmermann is able to get hold of information worldwide from all the data networks and to manipulate people with transmitters planted or hidden in clothing and train them as weak-minded collaborators. Thus, for example, he has Tibetan monks burn themselves in a ritual called 'Tcheud'. 'Tcheud' certainly means the Tibetan ritual of self-offering called gCod, which appears in this comic as a hideous, crazed and frenzied orgy.

The superagent Pharaon eventually succeds in destroying the computer system, killing Zimmermann and the Tibetan collaborator Obersturmführer Tsering and freeing the manipulated collaborators. The system is left to the perpetual ice and the deadly cold. To the world of light, besides Pharaon and his companion Chrystal, there belongs a Tibetan monk who—how could he not?—has supersensory powers at his disposal. He tells of the 'Seven Wise Men' (a

89. *Tibet as a place of global conspiracy. In the 1980s and '90s a theme from the 1930s experienced a renaissance. At that time danger threatened from the occult lamaist theocracy; in the comic books there is a revival of the idea of a global threat coming from Tibet, based on Nazi literature. In* Le cerveau de glace *(1988) and* Le signe de Shiva *(1985), there is a fight between evil world-conquerors who live beneath Tibet in caves and the world of light. Whereas in neo-Nazi literature a close collaboration between Tibetans and Nazis is often suggested—Tibet being portrayed as a place of retreat for Germans of the Reich, allied with the Gelugpas against the Chinese and awaiting the day when they can create a new Reich on Earth—in these two comics the Tibetans act as opponents of the Nazis, with the exception of Obersturmführer Tsering in* Le cerveau de glace. *In this comic the baddies are ancient SS thugs, who had been sent to Tibet by Hitler in 1943 with orders to gather political and esoteric information for his race doctrines.*

homage to Gurdjieff) who would hold the world in balance until they were defeated by an 'Eighth'.

It is instructive how authenticity is faked, how a seal of credibility is stamped on a comic despite a ludicrous course of events: at the end of the story alleged testimonies are referred to, which bear out connections between the Waffen-SS and Tibetan magicians. After the entry of the Russian troops

90a

90b

into Berlin in May 1945, more than a thousand corpses of volunteers are supposed to have been found, who wore German uniforms but had neither identity documents nor insignia on them. All these soldiers came from the Himalaya. We recall that these alleged facts were first published by Pauwels and Bergier at the beginning of the 1960s. They were never verified, but nevertheless found their way again and again into novels, so-called reference books … and now, at the end of the 1980s, into this comic.

The comic *Le signe de Shiva* too is about Nazi survivors in a secret base under the Himalaya, who want to rule the world and create an ideal society in which men are for ever equal and in which the individual no longer has any will of his own. Here too there is a war between goodies—in this case in the form of 'the Dalai Lama Sakyamuni Padma Vajrasattva' (an entirely made-up name) and his allies—and the baddy. The latter is called Dr Wreibritisch-Lincorn (a parody on Trebitsch-Lincoln, with whom we have already become

90. In Le signe de Shiva, *the embodiment of evil is a former Nazi, who has highly complex technologies at his disposal and is a demonic rebirth of 'Shiva'. He takes up the fight against the Dalai Lama, who lives in the Agartha monastery.*

90c

acquainted), a former Nazi, who has at his disposal highly complex technologies and is apparently a demonic rebirth of 'Shiva', who has recreated the hell 'Avici' beneath 'Sumeu'. One is led to believe in the authenticity of this comic by the frequent use of Tibetan and Indian terms such as Sumeu (properly the world-mountain Sumeru), Avici (a Buddhist hell), Shiva, Dalai Lama, Sakyamuni, Padma and Vajrasattva and Agartha, the supposed monastery of the Dalai Lama. The last-mentioned name brings us back to van Helsing's book *Geheimgesellschaften* ('Secret Societies'), according to which the Hyperboreans in fact inhabited Agartha, though their representative on Earth was the Dalai Lama. Both the comics discussed here take up the Nazi-Tibet connection postulated by van Helsing, but differ from van Helsing's theory in one important point: while he suggests a close collaboration of Tibetans and Nazis—he describes Tibet as a place of retreat for Germans of the Reich, who have allied themselves with the Gelugpas against the Chinese and are waiting for the day when they can create a new Reich on Earth—in the two comics the Tibetans clearly appear as opponents of the Nazis, with the

91. In the global conspiracy story Le secret de l'espadon, *the villain who wants to achieve world power is the Tibetan emperor Basam-Damdu, whose details mark him as a Nazi-like despot. He and the rocket base he has built underneath Lhasa are destroyed by the two heroes, Blake and Mortimer.*

exception of Obersturmführer Tsering in *Le cerveau de glace*.

Another story of global conspiracy, *Le secret de l'espadon*, is also about a kingdom reminiscent of Agartha, but whose name is not mentioned. In this story, published as early as 1946 by the well-known comic artist Edgar P. Jacobs, weapons, including atomic bombs, are produced on a vast scale in underground factories beneath Lhasa, in preparation for a third World War. The villain in this case is the Tibetan emperor Basam-Damdu, whose details mark him as a Nazi-like despot and who wants to achieve world power and the suppression of other nations. The unscrupulous Colonel Olrik stands by his side. The story ends with the emperor's death and the destruction of the rocket bases in Tibet and the emperor's palace by the two heroes, Blake and Mortimer, who use an aircraft of versatile application (Espadon = 'Swordfish'). Only the architecture is reminiscent of Tibet in this story. The emperor's palace was certainly modeled on the Potala, a large stupa looks similar to the Kumbum Stupa at Gyantse and several other stupas are likewise of Tibetan provenance. Details of the scenes set in 'Tibet', however, such as facial features, clothing, interior architecture and writing, recall China. Thus even in the French edition, 'Lhassa' is labeled 'the new capital of the great Yellow world empire', and Basam-Damdu is called the ruler of 'the Yellows', a mixing of Tibet myths and the fear of the 'Yellow Peril'.

Agartha and neo-Theosophical and 'Rampaesque' ideas appear also in a comic of another genre, namely, in a yeti comic. In this story, *The Snowman* (*L'uomo delle nevi*, 1978),[102] a reporter in search of yetis in the Everest region is received into a Tibetan monastery, where he is tormented by a strange nightmare. In this he discovers, in an ancestral gallery of mummified and gold-coated monks, his own image, which begins to live again. A voice welcomes him as Brother Yza Migdama Lah-Lu (allegedly a Tibetan name!) to the Union of Agartha. He sees himself rushing naked through the library of the paradise, in which the entire past, present and future, everything living and non-living, are stored. The reporter later realizes that he has returned into the Brotherhood of Agartha. In the thoroughly secluded Tibetan monastery, this brotherhood has devoted itself for ages to peace and research, under

the leadership of the high priest Mahatma. So that no unauthorized person enters the monastery, the monks surround it with an hypnotic field that arouses travellers' 'atavistic fears'. Instead of the monks, they then see snowmen, are frightened and run away. From time to time, Agartha disciples go out into the world from this monastery and other similar centres to mingle with men, so as to spread their knowledge of awakened consciousness and the superego and to impart advice. Several typical Theosophical and Rampaesque themes can easily be recognized here: the allegedly Tibetan name Yza Migdama Lah-Lu is an almost word-for-word plagiarism from Rampa's *The Third Eye*, which is naturally mentioned in the comic also.[103] The Agartha 'library' containing all knowledge, rather like a universal memory, recalls the Akashic Chronicle; and the Brotherhood and its leader Mahatma the Theosophical Mahatmas, who indeed according to both the Theosophists and the 'Rampasophists' go out into the wide world from time to time to transmit their knowledge to others. For the Brotherhood, which has been devoting itself to peace and research for an unimaginable time, has in its keeping an all-embracing knowledge.

The ancient secret knowledge stored in Tibet is a motif that also turns up in other comics: in *The Origin of an Avenger*, old scrolls contain instructions on how the unused potential of the brain can be harnessed; *Minuit à Rhodes* ('Midnight in Rhodes') is about a library of valuable old Tibetan texts that contain the entire knowledge of the Tibetan people, as well as information on Chinese military operations and the locations of nuclear weapons in Tibet; in *The White Lama* the Chinese are looking for the entrance to a secret archive that is supposed to contain the essence of the knowledge of an ancient civilization. Prayer wheels also sometimes contain written secrets, as in *Le cerveau de glace*— a piece of paper with the name of an important monastery—and in *Top Secret*, where news of a missing German atomic physicist held prisoner in Tibet comes to light in a prayer wheel. Amongst the secret texts is also the formula 'Om mani padme hum', which is recited now and then in comics.[104]

It is of some interest which 'ethnographic' details the comic-book artists, very few of whom

certainly have ever been in Tibet or the Himalaya, select to try and create a Tibetan ambience. They give us information about their Tibet stereotypes—and in a certain sense ours as well. Frequent themes are Tibetan palaces, whether the Potala Palace with its golden roofs[105] or the old royal palace of Leh,[106] as well as other well-known buildings such as the Bhutanese monasteries Taktsang[107] or Tongsa.[108] The stupa too is a construction often encountered, both in the form of the famous stupas of Swayambunath and Bodhnath and in simpler form, as found in Ladakh, northern Nepal and Tibet.[109] Wrathful

92. As only in the rarest cases have the comic-book artists been in Tibet themselves, they have often used as models photographs from well-known books. (92a)

Especially in cheap comics, details from different regions and even from different cultures are indiscriminately mixed. Thus the artist Ertugrul puts in front of a Potala-like building a stupa that he turns into a kind of minaret. (92b)

92a

92b

deities, who sometimes come to life, appear disproportionately often,[110] and the Dalai Lama too is a relatively popular theme.[111] For some authors a special mode of punishment also seems to belong to the Tibetan ambience: the wooden collars put on certain prisoners in Tibet.[112]

As only in the rarest cases have the artists been in Tibet themselves, they often use as models photographs from well-known books. Thus Hergé, for example, demonstrably drew from photographs by Giuseppe Tucci, Heinrich Harrer, Lowell and Ernst Krause (Schäfer expedition) for *Tintin in Tibet*, and in the process had—with few exceptions—a lucky touch, which cannot always be said of other authors.[113] Especially in cheap

comics (for example the *Gespenstergeschichten* ('Ghost Stories') series), details from different regions and even from different cultures are indiscriminately juxtaposed. Thus for the first picture in *Das Rätsel der Dämonenglocken*, the Potala is used as a pattern, while a few pictures further on the same monastery building is copied from the 'Tiger's Nest' (Taktsang) in Bhutan. For a stupa, the artist Ertugrul draws a tower like a minaret, in which a 'heavenly bell' is supposed to be kept; once for a scene of a religious dance (*'cham*) he uses as a model a stupa from Ladakh. For a stone guardian, he draws the head of a Thai statue; and his abbot looks more like a magician from a European book of fairy tales than a Tibetan monk.

Remember ...

Two comic-book stories stand out for their careful research and consequently great fidelity of detail: *Tintin in Tibet* and *Jonathan*. Interestingly, both stories spring from the same theme: both Hergé (Georges Rémi, 1907–1983), the creator of *Tintin in Tibet*, and Cosey, who created *Jonathan*, project into their comics their search for, or recollection of a real person from their life who had meant a lot to them. In *Tintin in Tibet* the hero and his dog, Snowy, are searching for the Chinese Chang,

whom everyone assumes to have died in a plane crash in the Himalaya, with the exception of Tintin, who is firmly convinced that he is still alive. With this central subject of his Tibet comic, Hergé was treating his own quest for the Chinese Chang Chong-Chen, who had advised him in

93. Tintin in Tibet (© Hergé/Moulinsart 1999). In this comic book, Tintin ('Tim' in the German edition) is looking for his lost Chinese friend Chang, whom he eventually finds in a cave. In this, the most personal of his stories and the one he thought of most highly, Hergé, the creator of Tintin and Snowy, lets himself be guided by dreams. Is this the influence of Tibet, where—so Hergé allows his readers to believe—certain monks, such as 'Blessed Lightning' with his talent for clairvoyance, possess supernatural powers?

93a

93b

93c

great detail during the creation of the comic *Blue Lotus*. This had saved Hergé from creating a colonialist, racist and stereotyped comic similar, for example, to the previously published *Tintin in the Congo*, moreover he had found a good friend. This friendship did not break even when Chang returned to China in 1935. However, all trace of him was lost there because of the political upheavals. More than twenty years after his friend's disappearance, Hergé still did not believe in his death, and in 1977 he was actually to succeed in finding his Chinese friend Chang Chong-Chen

and in 1981 in getting him out of China.

In a deep life crisis and in the face of a psychiatrist's advice to give up drawing, some thirty years after inventing Tintin, Hergé created *Tintin in Tibet* [begun in 1958]. With this comic Hergé was battling against hopelessness … and created a comic of hope, self-sacrifice and friendship: after repeatedly risking his life, Tintin finds his missing friend Chang—and his creator Hergé, himself. It is instructive how much, in this the most personal of his stories and the one he thought of most highly, Hergé lets himself be

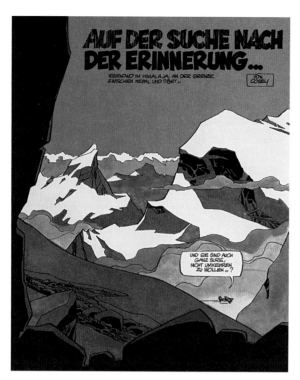

94. At first only a few—at any rate, in the time of the missionaries the journey sometimes took years—then many, and today legions have set out, in actuality or fiction, on the way to Tibet, driven on by the hope of finding a paradise on the Roof of the World. Almost every one of the Tibet stories presented here describes such a search. This theme is particularly marked in the comic books Remember Jonathan … *and* Tintin in Tibet.

guided by dreams and apportions such a central role to the supernatural. The influence of Tibet? Of that Tibet in which—so Hergé allows his readers to believe—certain monks in spite of everything have supernatural powers; for example, 'Blessed Lightning' with his talent for levitation and clairvoyance.

With *Jonathan*, especially with the first of the thirteen volumes that have appeared so far, *Remember Jonathan …* (*Souviens-toi, Jonathan…*, 1977), Cosey too created a graphic novel with which he was trying to deal with the loss of his friend, Jonathan. In their youth, Cosey and Jonathan skied and motorcycled together in the Swiss Alps, with the Vedas, the Bhagavad Gîtâ, comics, C.G. Jung or Woody Allen in their pockets for reading. In real life just as in the comic, Jonathan was strange and eccentric. He wanted to ride his motorbike on Kilimanjaro, and eventually went away to Nepal, where he ended up in a psychiatric clinic after being found half dead on the Tibetan-Nepalese border. Jonathan did not remain in the clinic. He ran away in the

direction of the Himalaya and Tibet, Cosey is convinced. And that is where his story, an eleven-part series,[114] begins. From this point of view the comic is not complete fiction, but perhaps contains more autobiographical material than other comics. Cosey reported with a great deal of empathy, on the basis of personal experiences of real people and events. Here and there, indeed, current themes are portrayed, such as the search for a new Dalai Lama or that for the snowmen, and he is also noticeably fascinated by Tibetan mysticism. The crude stereotypes of other comics are absent, however, so that it may be regarded as a remarkable comic series, which, as the blurb says,

> does not display its quality in the plot alone, but densely, atmospherically conveys fascinating experiences in a foreign culture.

To sum up, it may be stressed: in comics also themes are repeated that we have already become acquainted with in Tibet novels: all-knowing, sometimes ancient monks, lamas or tulkus endowed with supernatural powers—no nuns; Tibet as the realm of peace, long life and secret knowledge, which could bring salvation to Planet Earth; but also Tibet as a place where there exist dreadful and manipulative powers, portrayed on the one hand as evil clerics who use black magic (*Le lama blanc* and *The Black Lama*), and on the other by modern technology, mostly controlled by Westerners, which awaits its deployment in vast, mysterious, underground caverns. The light, ultra-bright world of Tibet draws strong shadow pictures. Settled somewhere between these light and dark worlds is the snowman, the yeti, who seems to reflect the ambivalence that clings to Tibet: one time he is a peaceful, wise being, another he is dreadful, dangerous and wild. In *L'uomo delle nevi* his appearance depends on the attitude of the people who meet him.

> 'We appear to you large or small, hairy or bare, menacing or sad … just as your personal fear inspires you,'

says a lama to a reporter who has ended up in an Agartha monastery, a subjectivity that, it is becoming increasingly clear, applies to our Tibet images also. These are indeed shaped only very rarely by fear, but by personal emotions, feelings, needs and dreams, which are taken up and used in comics and increasingly also in advertising and by business quite generally. In what way is to be investigated in the next chapter.

C. Films

First documentary films

From the first British films on Tibet produced in the 1920s, it can be demonstrated how much the production of such documentary films was from the outset a dialectical process, which those filmed influenced just as much as those filming. Some scenes from the film *Epic of Everest* (1924), as well as the public appearance of dancing Tibetan monks before the film's presentation in London, upset the Tibetan government to a high degree. The greatest stumbling block was a film sequence in which a Tibetan man was delousing a small boy and appeared to eat the captured lice, a scene that had to be removed from the film on account of the protest. The film and the performance of the monks had political consequences in Tibet and led to a dispute between traditionalists and modernists, in which the latter were defeated. Another Everest expedition was called off, Tibetan officials were demoted, and in consequence only a very few films could be shot in Tibet. We can therefore conclude with Peter Hansen that

> Tibetans as well as the British contributed to the construction of cinematic myths of Tibet,

and that the films that originated at that time were 'examples of the intercultural construction of Tibet'.[115] The Tibetans, who were in no way averse to being filmed, made it known right from the start what images they would tolerate and what not, and they let all concerned know the possible sanctions, namely withdrawal of permission for entry or at least for filming. Each of the British political envoys stationed in Sikkim in the late 1920s and early '30s did indeed shoot films in Tibet, but

> These films incorporated *both* British projections of their myths about Tibet and Tibetan assumptions about what was worth filming in Tibet.[116]

An important interchange and a kind of voluntary censorship of contents occurred on the occasion of showings in Lhasa, at which the new films were shown to the filmed—primarily the Tibetan upper strata.

> British film parties showed Tibetans the images of Tibet that the Tibetans wanted to see … The images that Tibetan and British audiences were *not* shown

are also significant. They were not shown images of everyday life in Tibet such as those that offended the Tibetans in the Everest film. Even the anodyne scenes of Tibetan farming in F.M. Bailey's films were absent.[117]

What is said here, which would probably not apply so unreservedly to non-British film directors such as Filchner, points to one thing: the image that the West creates for itself of the East—in this case Tibet—is not exclusively determined by the West, as E. Said says in his famous book *Orientalism*. The Tibetans, or rather the Tibetan élite in Lhasa, helped influence the Tibet images expressed in Western films. This applies at least to the time before the occupation of Tibet by China and the ensuing flight. It was only in films made after 1959 that the Tibetans became 'victims', who could have scarcely any influence on the content any longer, so that it can be said with Lorenz Schaedler:

> Tibet has no voice, it is represented … Tibet as a subject does not exist, only the film-maker who is looking for something—and usually finds it too.[118]

It is noticeable, says the author, that Buddhism is portrayed in some form or other in each of these films, including those that do not primarily have Tibetan religiosity as a theme, and that a fascination with the omnipresence of Buddhism manifests itself in their commentaries, whereas more deeply grasped religious understanding is lacking.

The heavy weighting of the religious is shown, for example, by the fact that by far the majority of Tibet documentary films portray religious themes, especially unique, spectacular, secret rites such as monastic dances and initiations. Many are devoted to the phenomenon of reincarnation or to the sexual symbolism of Tantric Buddhism[119]—both themes that, as we shall see later, are also portrayed in feature films. But these later documentary films are also the product of a reciprocal process: Tibetan clergy tolerate, indeed encourage films on religious topics because through them are reported the aspects of the Tibetan way of life that they consider the most valuable. On the other hand, these religious films

meet the needs of numerous people interested in Buddhism—earlier only Westerners, but today increasingly Asians as well. And they seem to comply with the desire of many to be able to 'discover' exotic, unique rites voyeuristically.

More recently, Tibetans have increasingly taken the camera into their own hands—as a rule in cooperation with a non-Tibetan person. Let us recall Tenzing Sonam and Ritu Sarin (*The Reincarnation of Khensur Rinpoche*, 1991), Lobsang and Sylvia Sensiper (*Films are Dreams that Wander in the Light of Day*, 1991), Tashi Tsering and Vadim Jendreyko (*Exiltibeter zwischen zwei Kulturen*, 1985), Tsering Rhitar (*The Spirit Doesn't Come Anymore*, 1997) or the monk Khyentse Norbu in a feature film (*Phörpa/The Cup*, 1999), which a film expert commented on as follows:

> There is no (more) need for commentary by a self-appointed specialist, for the first time it is the Tibetans who actually get to speak. It was high time![120]

That the films made by Tibetans are only an extremely modest beginning is shown by the flood of films coming onto the market at the moment: as a rule, Tibetans are to be found in them as advisers at best.

Let us be content with these comments on the image of Tibet painted in documentary films. The number of Tibet films produced in past years is so enormously great that it makes it exceedingly hard to keep an overall view and to do justice to the manifold currents (television films of the most variable quality; full-length documentary films; scholarly films; films shot by Chinese and Tibetan documentary-film makers, and so forth).

We should like next to have a detailed look at a genre of films that conveys current Tibet images still more than documentary films, and has hardly been analysed as yet: Western feature films in which Tibet is depicted.[121] Films will also be introduced here of which only short scenes refer to Tibet, because these sequences also give information on the way Tibet has been perceived and is perceived today.

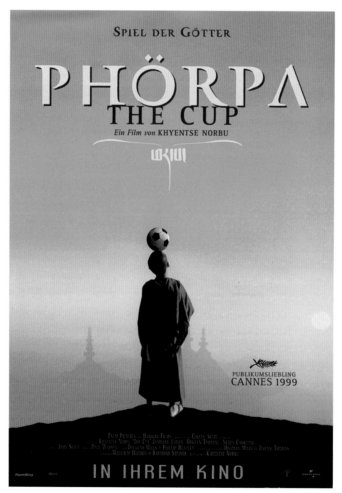

95a

95b-d

95. Film-making as a spiritual exercise: in 1999 the monk and tulku Dzongsar Khyentse Rinpoche (Khyentse Norbu) shot the film Phörpa. The film does away with several Tibet stereotypes. It shows that tradition and worldliness can meet one another in a perfectly conciliatory way (Neue Zürcher Zeitung), that the Tibetans cannot stop e-mail, faxes and the Internet, but must adapt to the modern world and at the same time preserve their ancient tradition and culture with their values (Khyentse Norbu). Finally, this charming, happy film is proof that the Tibetans themselves are well capable of portraying themselves and their way of life. There is no (more) need for commentary by a self-appointed specialist, for the first time it is the Tibetans who actually get to speak. It was high time!

Early feature films referring to Tibet

In 1928 the film *Potomok Chingis-Khana* (*The Heir to Jenghis Khan* or *Storm over Asia*) was produced in Russia under the direction of Vsevolod Ilarionovich Pudovkin. Although a film about Mongolia, it can nevertheless be described as the first feature film concerning Tibet, as Mongolian culture was very strongly shaped by Tibet from the 16th century and a clerical system arose in Mongolia that is very similar to the Tibetan one. In the film, the magnificent Mongolian-Tibetan clergy is primarily portrayed in the first part, with elements that appear to belong to the repertoire of Tibet stereotypes: 'Lamaism' is seen as the mirror image of Catholicism (in one conversation between a British colonel and his wife, a monastery's 'wild abbot, reeking of garlic, with matted [hair]' is called a Buddhist version of the Pope), the obligatory religious dances (*'cham*) are performed, and a young incarnation also appears in the film, who despite his tender age 'understands everything', as one of the monks tells the visitors.

The undamaged life in the monastery stands in stark contrast to the struggle for survival of the partisans, avaricious merchants and foreign imperialists and to the Bolsheviks' revolution. The film takes the side of a nation that—according to the film—is exploited and treated like a puppet, symbolically portrayed by the hero Lubsang, who transforms himself from a poor, small fur trader into a revolutionary who challenges his people to rise up. Full of critical contemporary references, it displays a film aesthetic the like of which we shall scarcely come across again in later Tibet films. The impressive authenticity, among other things, contributes to this aesthetic: Mongols were played by real Mongols, and monastery scenes were filmed in an actual monastery, in which the ritual instruments, the over-life-size Buddha and the ritual music were all genuine. This in turn allowed the camera to take impressive close-ups without running the danger that behind the picture an illusion could suddenly be discerned. One would have thought that such authenticity went without saying, but we shall discover that it was not until some sixty years after this Russian film that Hollywood recognized its necessity and its appeal, with the film *Kundun*.

Undoubtedly the best-known feature film in

96. Although a film about Mongolia, The Heir to Jenghis Khan *(or* Storm over Asia*) can be described as the first feature film concerning Tibet, as Mongolian culture was very strongly shaped by Tibet from the 16th century. The film does indeed contain elements that belong to the repertoire of Tibet stereotypes—'Lamaism' is portrayed as the mirror image of Catholicism —but the document, full of contemporary references, displays impressive authenticity: Mongols were played by real Mongols, and monastery scenes were filmed in an actual monastery, in which the ritual instruments, the over-life-size Buddha and the ritual music were all genuine. It was not until some sixty years later that Hollywood recognized—in* Kundun—*the value and appeal of authentic actors and scenery.*

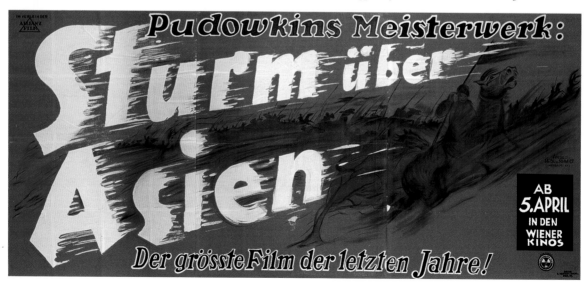

96a

96b

the Tibet films category was Frank Capra's film adaptation of the bestseller *Lost Horizon* in 1937. The film only departs in details from the novel, which we have already gone into.[122] As we are concerned here above all with our images of Tibet, it is of interest to us how Frank Capra portrays Shangri-La visually. Are Tibetan elements recognizable, for example in the architecture, the dress or the material culture in general? The answer, bluntly, is 'no'. Apart from a few clothes and musical instruments, the only thing that recalls Tibetan living space is some copies of stupas, which indeed have a few yaks passing in front of them on one occasion. Despite their realism, however, the stupas are of no consequence beside the rest of the architecture of Shangri-La, which clearly displays features of Western architecture of the 1930s. Except for this, with the best will in the world nothing Tibetan can be recognized—no Buddha statues, Tibetan ritual implements, prayer wheels or long trumpets, no Tibetan prayers or ritual music.

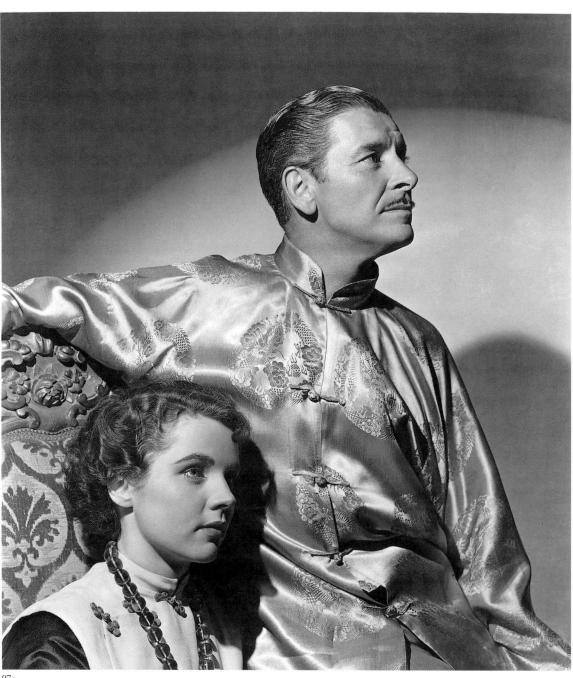

97a

As in the novel, it is whites who play the principal parts, but where in the film have the Tibetan and Chinese inhabitants of the 'Blue Valley' below Shangri-La gone? Instead of flat-roofed houses a settlement somewhere in the Alps is shown, a craftsman is pulling candles (which are unknown in Central Asia and Tibet) and the children, the sole people of clearly Asiatic origin apart from a few porters, sing 'Good evening, good night' …

97b

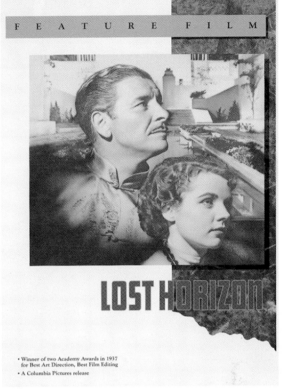

• Winner of two Academy Awards in 1937 for Best Art Direction, Best Film Editing
• A Columbia Pictures release

97c

97. The remoteness and inaccessibility of Tibet—not its own religion and wisdom—made it the ideal place for the Utopian refuge of James Hilton (author of the bestseller Lost Horizon) *and Frank Capra (director of the first film version). Tibet as such did not interest them. One can make out some phoney Tibetan touches in the film—clothes like those worn by the Tibetan nobility, a handful of yaks, stupas—but otherwise the story seems to take place in a luxury hotel, whose architecture and interior furnishings are Western.*

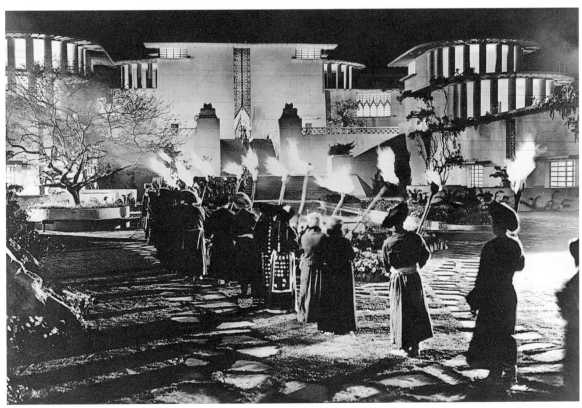

97d

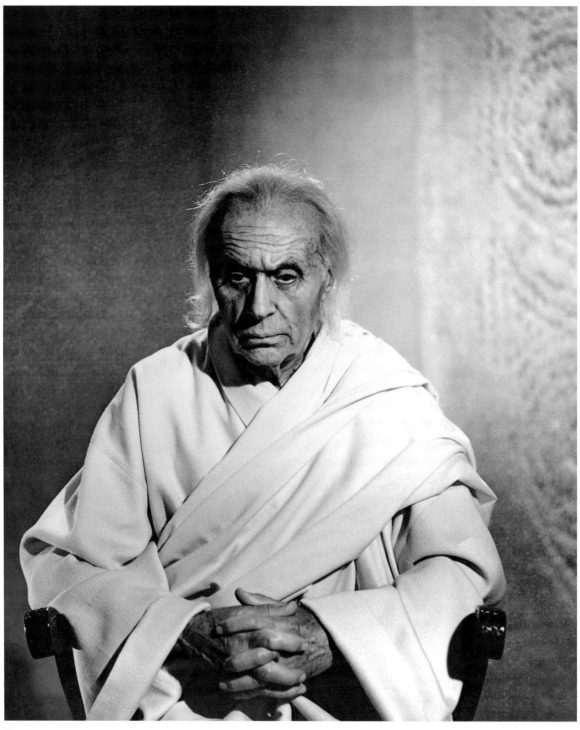

98a

98. As in the novel, in both of the film adaptations of Lost Horizon *(here, scenes from the 1973 version) whites play the major roles, Tibetans do not occur in that respect. We should not be misled in this regard by the fact that Father Perrault, at the top of the Shangri-La hierarchy, is called 'High Lama'. In his background, his outward appearance and also his conversation he resembles less a Tibetan 'high guru' than the Jewish elder Nathan the Wise in Lessing's play of that name.*

These remarks should not be taken as criticism of the whole film, which went down exceptionally well with critics and the public, but simply point out that the director found it hard to make anything look Tibetan, if not Shangri-La itself (which has hardly anything Tibetan about it even

98b

in the novel) then at least the surroundings. Here it is expressed still more clearly than in the novel that neither for Frank Capra nor for the public was Tibet a real place. James Hilton chose Tibet as the location for Shangri-La because, on account of its great seclusion, it was suited for catching all the dreams that Western people had in the 1930s after the great economic crisis and in the face of the looming war. Thus the film begins with an introductory paragraph that poses the suggestive question:

> In these days of wars and rumors of wars—haven't you dreamed of a place where there was peace and security, where living was not a struggle but a lasting delight ?
>
> Of course you have. So has every man since Time began. Always the same dream. Sometimes he calls it Utopia—sometimes the Fountain of Youth— sometimes merely 'that little chickenfarm'.

The remoteness and inaccessibility of Tibet—not its own religion and wisdom—made it the ideal place for the Utopian refuge of James Hilton and Frank Capra. Tibet as such did not interest them. We should not be misled in this regard by the fact that Father Perrault, at the top of the Shangri-La hierarchy, is called 'High Lama'. In his background, his outward appearance and also his

conversation he resembles less a Tibetan 'high guru' than the eponymous hero of Lessing's *Nathan the Wise*.

In 1972 there was a remake of the film, which because of its dreadfully kitsch song-and-dance interludes, as well as its atrocious dramatization and lack of poetry, became a massive flop. This 'warmed-up film dish', as one critic called it, also had nothing in it that recalled the Tibetan location of Shangri-La: the architecture is a mishmash of neoclassicism and Moorish style, the monks' robes remind one of Tibetan monks' clothing mainly by their red colour, and nowhere

98c

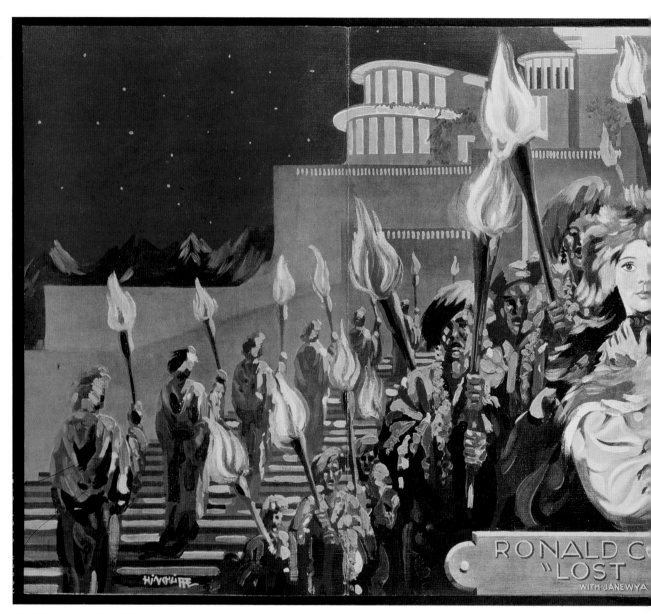

99. Film poster for Lost Horizon.

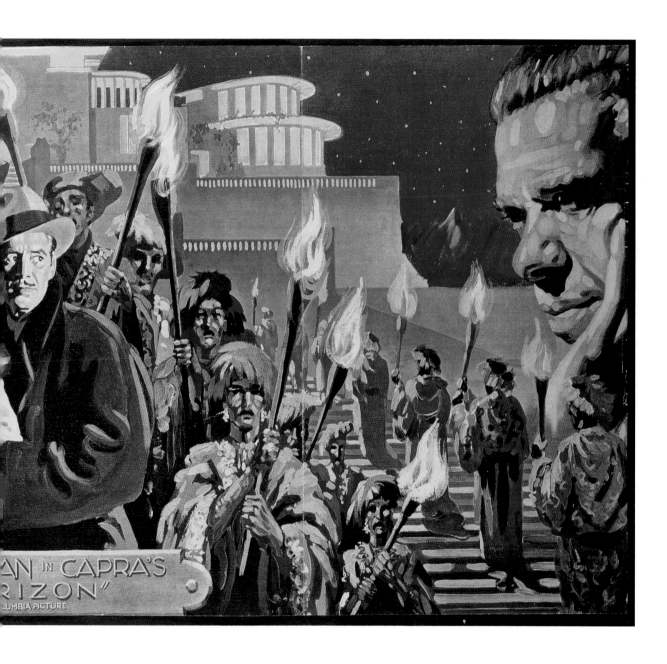

100a

100. *Das verlorene Gesicht (1948) recounts the enigmatic story of a young woman who for a long time takes on a second personality, which, it emerges in the course of the film, appears to be that of a Tibetan woman. When a plaster cast is taken of her face, the Asiatic features disappear, and the woman apparently becomes again the one she was before. 'Perhaps we actually have people at the ends of the Earth, Tibetan priests or Indian holy men, with such powers that they can take hold of another person and make them truly possessed,' one character says of this story in the film.*

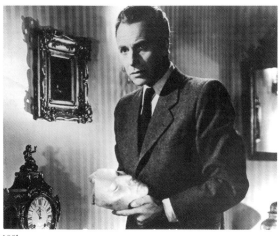

100b

is a Tibetan object to be made out, whether a ritual object, a musical instrument or an everyday object. Nothing can represent the mindlessness and triviality of the film better than the closing song, a hymn of praise to Shangri-La in distant Tibet:

> Far from the earthly zone waits a world where the cannon has never boomed!
> There the shouts of war don't ring in your ear anymore.[123]

Some more feature films on Tibet followed in the late '40s and the '50s, though they never achieved the fame of the first filming of *Lost Horizon*: *Black Narcissus* (1947),[124] *Das verlorene Gesicht* (1948), *Storm over Tibet* (1952)[125] and *The Abominable Snowman* (1957).

Das verlorene Gesicht (1948) recounts the enigmatic story of a young woman who for some time takes on a second personality, which, it emerges in the course of the film, appears to be that of a Tibetan woman.

In Stuttgart, an apparently white woman with Asiatic facial features is picked up and admitted to a psychiatric clinic. There she recovers the power of speech, but nobody can understand her. The strange woman is called Luscha and is employed in the institute's kitchen, where Verena von A.,[126] the leader of the Theosophical Society in Stuttgart, soon visits her, in the company of two linguists. The latter come to the conclusion that Luscha originates from Tibet, for when she is shown a Buddha statue she takes it in her hands, places it on a windowsill and bows down in front of it, on which the professor present comments with the sentence:

> One could think, a Buddhist of strict observance— Tibet, typical Tibet!

This impression is soon strengthened when Luscha gathers up all the knives nearby and puts them to one side, which the assistant interprets as further evidence for Luscha's Tibetan origin. According to the assistant, near a Buddha image there should be no objects with which one could kill.

With the words

> Perhaps she has been sent to us, perhaps she has a task to carry out on us,

Frau von A. demonstrates her Theosophical background and that she believes in the girl's sincerity. Luscha is received by Frau von A. and subjected to several experiments, but her precise

origin is not worked out. When a plaster cast is taken of her face, the Asiatic features disappear, Luscha no longer recognizes those present, and she apparently becomes again the woman she was before: Johanna, who had previously escaped from a reformatory, had an accident and was then found, with a new personality, by the Stuttgart police.

At a Theosophical Society conference, the speakers and audience puzzle over the strange phenomenon of a supposed splitting of the consciousness or change of personality. Where did the foreign speech come from, how did Luscha come to know how to behave as a Buddhist, how could it all be explained? The professor's answer is of some interest, as it expresses an idea we already know from Theosophy, as well as from Lobsang Rampa:

> 'Perhaps there really are secret powers in humans that can leap over great timespans and great distances to another person and change them. Perhaps we actually have people at the ends of the Earth, Tibetan priests or Indian holy men, with such powers that they can take hold of another person and make them truly possessed.'

And when a man from the audience retorts that in science one should not work with suppositions, riddles and mysteries, the professor answers:

> 'We do not work with them, but have to be prepared for them. And I find that that's good. It is good

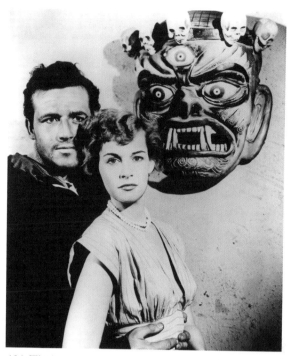

101. *The fascination of the mysterious demonic and the all-knowing lama: the film* Storm over Tibet *(1952) is about a mask of the god of death, 'Sindja', stolen from a Tibetan temple by Bill March, which brings him bad luck: his plane crashes in the region of Tibet and he is thought to be missing ... until his former friend David Simms in Los Angeles receives the mask by post.*

that there are still mysteries in our explored world.'

The professor therefore does not want to bring science and religion together in Theosophical

102. *Convinced that Bill is still alive, David sets off in search of the missing man. Although a monk warns him that the mountain will be against him, he looks for his friend in a foolhardy expedition. David is almost killed and returns to the monastery without having achieved anything. There he hears that Bill March has already died, shortly after the crash. The highly dangerous expedition nevertheless had a point: by it, says the monk who seems omniscient, David's guilt, which was written in his face, is supposed to have been expiated.*

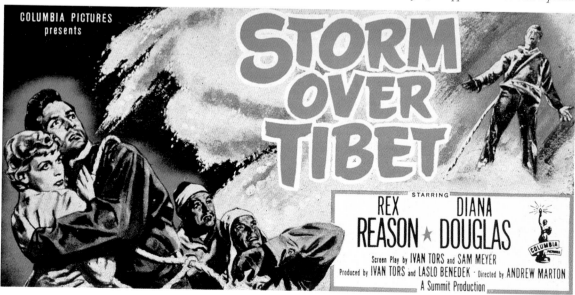

103a

103. In the film Storm over Tibet, *several shots were used that had been filmed by Prof. G.O. Dyhrenfurt in the Karakorum and in Ladakh (Lamayuru Monastery) for his film* Der Dämon des Himalaya *(1935).This film too is about a mountaineering expedition, which turns out to be extremely dangerous, as a powerful demon living on the mountain, represented by a Tibetan dance mask, is trying to thwart the expedition.*

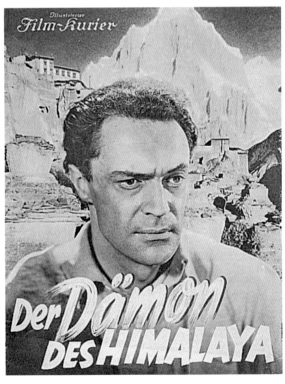

103b

fashion but simply wants a science that has deep respect for the mysterious and enigmatic, a science for which superhuman powers of Tibetan lamas or Indian yogins lie in principle within the realm of the possible. The supernatural powers of the Tibetan 'Brothers' are not made out to be self-evident in the manner of the Theosophists and esotericists. They are merely treated as a possibility, which remains as long as their non-existence has not been proven. But can the non-existence of a phenomenon be proven, even if it seems so unfounded and improbable? This is a question that we deal with in connection with the Tibet myths again and again and will be discussed in detail in Part 5.

The film *Storm over Tibet* (1952) is about a mask. This mask of the god of death, Sindja (*gShin-rje*; Yama), has been stolen from a Tibetan temple by Bill March, which brings him bad luck: his plane crashes in the region of Tibet and he is thought to be missing … until his former friend David Simms in Los Angeles receives a package from Bill, in which is the mask. With Bill March's wife, David sets out for an area of the Himalaya not marked on any map, to discover the secret of Sindja.[127] He is convinced that Bill is still alive, for who else would have sent him the mask? Before

he goes in search on Amne Mandu, he visits a high monk, who predicts to him that the mountain will be against him, which does indeed come true. David is almost killed and returns to the monastery without having achieved anything. There the monk reveals to him that after the crash, his friend was cared for in the monastery, but unfortunately died. He had been unable to tell David this because he 'had seen guilt in David's face', which he had to atone for with his life-threatening quest. Now he had been freed from his guilt.

A 'Tibet mystery' that was on people's minds at the time was the 'Loch Ness monster of the Himalaya', the yeti, a phenomenon that the film *The Abominable Snowman* (1957) took up. Dr John Rollason, his wife and an assistant are in Tibet collecting medicinal herbs and rare plants for a botanical establishment. But Rollason secretly has something quite different in mind. With other expedition members who are to join the group later, he wants to go in search of the snowman.

The expedition members are guests of the Hon-yuk monastery, whose 'lama' astonishes the foreigners with his clairvoyant abilities. Thus he is able to predict the arrival of people he knew nothing about. Asked how this could be possible, the monk replies that here one develops all the senses one has, and has the time to become aware of many things.

Apart from this well-known theme of the all-knowing, telepathically gifted Tibetan cleric, the film also shows the constantly ascertainable, opposing views of the Westerners regarding Tibet and the Tibetans: one either loves them or despises them, there seems to be nothing in between. Rollason, who obviously knows more about the area and its inhabitants than the others, finds the country attractive and treats the inmates of the monastery with fairness and respect. Other expedition members would like to get away as quickly as possible from this dreadful land with its cold, its terrible superstition and its frightful smells, for in this land dripping with filth there are only rocky tracks [and] greedy, uneducated people who call an abominable cuisine their own; abominable too is the yeti they are in search of. The lama hints that he does not believe in the existence of the yeti, this creature exists only in

the strangers' heads. He also counsels the expedition members in sibylline fashion to be humble during the quest. Man is on the brink of destroying himself; instead of enlarging his territory, he should think about who should succeed him as heir.

The search for the yeti develops into a disaster. The Tibetan leader takes to his heels when a yeti hand appears under the tarpaulin, a yeti is bagged, the sensitive photographer cracks up because he cannot stand the yeti's howling any longer, one of them dies of a heart attack, and another sets off an avalanche with a revolver shot, which buries them. Only Rollason survives the encounter with the yetis, but after returning to the monastery he claims that what he was looking for does not exist. Loss of memory or deliberate withholding of the truth? Probably the latter, for high up in the mountains Rollason had spoken to his companions, then still living, the following cryptic words:

> 'The yetis are not violent creatures … They are waiting until mankind dies out. Perhaps we are the wild ones, we are the middle ages for them. Perhaps we are not *Homo sapiens*, thinking men, for where have our thoughts got us? Certainly not to wisdom, rather to destruction. If the world learns of these creatures, they will be destroyed … If the yetis finish us off, their secret has been kept. Their only chance of survival … perhaps until their time has come.'[128]

The yetis are therefore wise, mysterious beings, who are waiting until the time is ripe. As they are in danger of being eradicated by men, it is better to deny their existence. Everything indicates that Rollason has survived because he has not given away the secret of the yetis. He thus comes close to the lama, who, as the film leaves no doubt, knew everything right from the start—once again confirming the image of the all-knowing Tibetan lama.

Let us throw a quick glance at the way Tibetan culture is depicted in the film *The Abominable Snowman*. The first takes already reveal that those responsible for the shooting had never looked round a Tibetan monastery. In the monastery courtyard one can recognize on a pillar a demon mask that comes from South-East Asia; the altar stands half in the open air, with the result that the monks sit outside to pray, even when it is snowing. Pictures of dragons are painted on the

104. *In 1984 John Byrum shot the film* The Razor's Edge, *based on the well-known novel of the same name by W. Somerset Maugham, which was filmed the first time as long ago as 1946. It is instructive that John Byrum does not establish the priest who helps Larry in his search for the meaning of life in India, as in the novel, but somewhere in Tibet. This shifting of the redeeming, sacred place from India to Tibet is probably a consequence of the demystification of India between the appearance of the novel (1944) and that of the second film adaptation (1984), as well as the politically caused isolation of Tibet in the same period, which may have strengthened the mystification of that country.* The Razor's Edge *is one of the few Hollywood films produced before the 1990s whose Tibet scenes were filmed at original locations and in which the indigenous characters were played by Tibetans, or rather Ladakhis.*

walls in a way that one would never encounter in a Tibetan temple, and the peal of bells arouses associations with a Western church, but not with a Tibetan monastery. The abbot is played by a white man, who does not manage to stay in yoga posture like a Buddhist monk. Around his neck hangs an amulet box such as women are in the habit of wearing. But the most peculiar thing is undoubtedly the portrayal of the masked dances ('*cham*), in which neither the masks nor the music nor the musical instruments (with one exception) are Tibetan. One is happily fiddling on a Tibetan stringed instrument, although such instruments are never employed for religious purposes ...

In 1984 John Byrum shot the film *The Razor's Edge*, based on the well-known novel of the same name by W. Somerset Maugham, which was filmed the first time as long ago as 1946. Larry Darell, unable to cope with either America or France after the First World War, is looking for the meaning of life in Asia. He is doing this on the advice of a pal who gives him as a present a translation of the Upanishads, but at the same time says one can find no answer in books but must set out on the Way oneself. In the film, unlike in the novel, Larry ends up not in the

Indian ashram of a yogin, a holy man, but in a Tibetan monastery in the mountains, somewhere in the Himalaya or Tibet.[129] The abbot of the monastery, who had already been expecting Larry thanks to his telepathic abilities (yet again a clairvoyant monk!), sends the seeking Westerner to a hut on the peak of a snow-covered mountain. Having reached it, Larry meditates and reads from a bound book, which is no doubt the copy of the Upanishads he was given. After reading, Larry burns the book, an action that is hard to interpret: has the meditation high up in the Tibetan mountains shown him the meaning of life, so that he can from now on do without religious texts?

Secluded Tibet is compared in an intercut sequence with the decadent world of Western high society: in one is silence, spirituality and warmheartedness, in the other, glamour, unemployment, economic crisis, alcoholism and depressions. However, after his meditation on the Tibetan peak Larry is ready to return to this degenerate world. Back in the monastery he takes his leave of the abbot, who is sorry that Larry is going away. The latter replies that it is easy to be a saint on the summit of a mountain, to which the monk retorts that Larry is already near, but the path to salvation is so narrow that walking on it is as hard as walking on the edge of a razor (hence the title).

The rest of the course of the story has no more connection with Tibet, or at best an indirect one: after his stay in a Tibetan monastery, Larry is more balanced and tries to help others by giving them confidence and pleasure. In one of the concluding sentences he admits he had tried to be a good man, but one must expect no reward, at least not immediately. Whether this is an allusion to the belief in karma remains open. After his long odyssey, during which his stay in Tibet has undoubtedly brought about decisive change, Larry wants to go home to America. The final image is optimistic: Larry is climbing the steps of a long, solid, stone staircase ...

It is instructive that John Byrum does not establish the concerned priest in India, as in the novel, but somewhere in Tibet. This shifting of the redeeming, sacred place from India to Tibet is probably a consequence of the demystification of India between the appearance of the novel (1944) and that of the second film adaptation

(1984), as well as the politically caused isolation of Tibet in the same period, which may have strengthened the mystification of that country.

The Razor's Edge is one of the few films produced before the 1990s whose Tibet scenes were filmed at original locations and in which the indigenous characters were played by Tibetans, or rather Ladakhis. For this reason the scenes are much more authentic than in most other Tibet feature films.

Even in the mid-1980s it was by no means self-evident that Asians should play Asians, as is shown by the 1984 film version of another well-known novel, Rudyard Kipling's *Kim*.[130] The film sticks quite closely to the novel, disregarding the sequence in which the Russian secret agents try to divert the Jamuna river by an explosion and so cut off Delhi's water supply.

Against the background of the Tibet image with which we are concerned here, it is particularly interesting how the lama is portrayed in the film. The first thing that leaps to the eye is that, as in other comparable films, a white man plays the holy man, so that the contrast Kipling deliberately brought out in his novel between the old, wise Asian lama and the young, lively Western Kim does not show to advantage. The lama is indeed wrapped in Asiatic-looking yellow clothing, but neither in cut nor in colour does it resemble the robes of a Tibetan monk. Around his neck hangs an amulet box as worn by women and he has a peculiar red hat on—breathing new life into the ancient myth of Tibetan red-capped monks worn out by Blavatsky. Finally, the lama has long, white hair, hanging down uncombed—ignoring the fact that with very few exceptions, Tibetan monks are bald-headed, and the few clerics who do have long hair tie it together in a knot. All this makes the lama look absurd, to which his silly recitation of the well-known mantra 'Om mani padme hum' also contributes—Tibetans pronounce it 'Om mani peme hung'. It gets completely ridiculous when, sitting in the train, the lama playfully alters the mantra into 'Om mani padme locomotive hum'.

In the first film version of *Kim*, of 1950, the lama plays a rather peripheral role, as the secret service scenes clearly predominate. Here too a white plays the lama, but his clothing is more convincing than in the 1984 version. He wears

105. In most Hollywood films that appeared before the 1990s, Asians were played by whites; so too in the two film versions of Rudyard Kipling's novel Kim. *Nor is there any striving for authenticity in costume or accessories. In the second film adaptation (1984), the 'lama' wears yellow clothing, which does not resemble the robes of a Tibetan monk in either cut or colour. Round his neck hangs an amulet box, normally worn by women.*

robes quite similar to a Tibetan monk's, at least in colour, with a rosary instead of an ornamental chain. However, in this earlier version too, his long, white, hanging-down hair is covered with a strange red hat, in shape more like a cowboy hat than the head-covering of a Tibetan monk.

106. In the first film version of Kim, *of 1950, the lama does wear robes quite similar to a Tibetan monk's, at least in colour, as well as a rosary. But his long, white, hanging-down hair is covered with a strange red hat, in shape more like a cowboy hat than the head-covering of a Tibetan monk.*

Magical religious objects, reincarnations and superhuman powers

From the mid-eighties, various films reached the screen that could be subsumed under the title of 'zany and/or martial-arts movies'. They will be described here in relative detail, despite or rather because of their triviality and although Tibet is sometimes not at the centre of the action in them, as they show some facets of the Tibet caricature that are already familiar, as well as some new ones, and

because some of these films are exceedingly popular.

In the first scenes of *The Golden Child* (1986), we see a young monk in a monastery in north-eastern Tibet. Apparently he is the incarnation of a deceased monk, for to the amazement and delight of the monks present, he picks out the right one from many rosaries, which recalls similar tests at the discovery of Tibetan incarnations. Thanks to his superhuman powers the boy also performs miracles, for example he can bring a dead parrot back to life. The happy and joyful life of the young monk does not last long, for the embodiment of evil, Sardo Numspa, abducts the child and brings him to Los Angeles. In this city, there also lives Chandler Jarrell, a committed, slightly eccentric social worker, whose job is finding missing children. A Tibetan woman (who actually looks more like a Nepalese) becomes aware of Jarrell when he appears in a television programme, as she too is looking for a missing child, namely the 'golden child' kidnapped from Tibet.

Jarrell learns that the Tibetan child, whose destiny is to save the world, could become lost to humanity. This would represent an enormous loss, after all, such a perfect child, a golden child, is born only every thousand generations. This 'messenger of mercy' has come to save humanity. If he dies, compassion will disappear as well, and the world will turn into Hell. But all is not yet lost: the Nechung oracle has predicted that the golden child will be brought to 'the City of Angels' (Los Angeles) and rescued by a man who is no angel—Jarrell.

Jarrell is torn between scepticism and sense of duty, but finally he consents to look for the golden child, after the child has appeared to him in a vision and he has realized that Sardo Numspa will stop at nothing. For the moment it seems no danger threatens the child, as he is still in possession of his superhuman powers: sitting in the centre of a mandala, by holding out his hand he can turn aside stones hurled at him, by

107. The first scenes of the film The Golden Child *(1986) already convey typical Western images of sacred Tibet: praying monks in front of an over-lifesize Buddha statue—from the style, by the way, not a Tibetan statue; a young monk who reveals himself to be an incarnation and possesses supernatural powers: he is able to revive a parrot believed to be dead.*

concentration he distorts a Pepsi-Cola carton into a dancing manikin, he overturns the bowl of porridge and blood without moving, and feeds himself only on a few leaves.

Jarrell learns that he must acquire in Tibet a mysterious ritual dagger, which can have very ambivalent effects: in the hands of an evil person it enables him to kill the golden child, but in the hands of a 'superman' it becomes an instrument of salvation. So Jarrell and his female friend Kee Nang travel to Tibet to pick up the dagger in a remote monastery. After they have arrived, Jarrell must prove that he is 'pure in heart', by passing a test that risks his life. He is required to pick up the dagger at the end of an underground room and in the process to pass a test of agility, leaping from pillar to pillar, in which he succeeds, so that he is able to seize hold of the dagger.

Back in Los Angeles the final battle comes: Jarrell manages to stab Sardo Numspa to death.

108. A Tibetan ritual dagger (phurbu) as the miraculous weapon of a Western superman: Jarrell, who wants to rush to the aid of the Tibetan incarnate monk living in captivity, the Golden Child, has to gain possession of a mysterious ritual dagger in Tibet. With this, after lengthy battles, Jarrell is eventually able to stab to death the embodiment of evil, Sardo Numspa.

108a

108b

109. A Tibetan ritual dagger also plays a central part in the film The Shadow *(1994), and becomes the all-powerful miracle tool that defeats the villain Cranston, alias Ying Po. Thereupon the reformed villian sets himself up as 'the Shadow' in the service of the good Tulku (incarnate monk) and goes on the hunt for criminals in New York. His greatest opponent is Shiwan Khan (still, left), who has taken possession of the tulku's ritual dagger. Initially Shiwan Khan appears to have the upper hand, but in the final battle Cranston is victorious, not least because of the Tibetan ritual dagger, which aids the good with its beneficial power.*

The golden child from Tibet, who has previously put his superhuman powers to the test again and again, restores to life Jarrell's woman friend whom the villain had murdered, and she takes him back to Tibet.

Even if Jarrell stands as a hero at the end, it becomes clear that he would never have done it on his own: the golden child from Tibet was always standing helpfully by his side—not by physical strength, but by the power of his thoughts. In addition, Jarrell needed the mysterious ritual dagger from Tibet.

In a later film, *The Shadow* (1994), a Tibetan ritual dagger becomes an all-powerful miracle tool. The story begins in Tibet, where the murderous drugs boss Ying Po, known as the Butcher of Lhasa, rules

over an opium kingdom. But one day he is kidnapped by a Tibetan spiritual master, 'the Tulku' (which is the Tibetan term for an incarnate monk), and brought to his monastery, produced from the Void. The Tulku tells Ying Po that he knows him very well and is aware that his real name is Lamont Cranston and that he is basically an American. He, Tulku, would like to be his teacher from now on and save him, for he knows that the beast within Ying Po is constantly breaking through. But for the time being, Ying Po does not want to be saved. Cranston, *alias* Ying Po, seizes a Tibetan ritual dagger, a phurbu, and leaps upon the Tulku with it, who escapes from the attacker by 'beaming' himself out of range. The ritual dagger floats away from Cranston, points itself towards him, bores its way into his thigh and finally, after its stiff face has come to life, bites him in the hand. Cranston is defeated—and at the same time, saved. As a service in return, he must take up the fight against evil. To this end, the Tulku has taught him to darken the minds of men, to obscure their vision by the power of concentration, in such a way that they see only what cannot be concealed, his own shadow. With this ability, Cranston returns to his homeland, 'that most wretched lair of villainy, which we know as …' New York City.

Seven years later, we see how Cranston is on the hunt for criminals in New York, by means of telepathic abilities and the capability of making himself invisible right down to his shadow. He is leading a double life: when he is saving people from death, whom he afterwards uses as agents of good, and when he is fighting against evil, he is the black-clad Shadow with his typical big hat and scarf hiding his face; in everyday life he is a perfectly normal, upper-middle-class citizen.[131]

His greatest opponent is Shiwan Khan, who emerges from a silver sarcophagus, which is delivered to the Museum of Natural History. Shiwan Khan, who according to the museum curator is the last descendant of Genghis Khan, is like Cranston a master of the art of mental concentration. He wants to subjugate the entire world, and the only person who can prevent him is Cranston's alter ego, the Shadow. Khan attempts to seize for himself a terrible new weapon. For this purpose, he meditates in front of a large mandala, which by virtue of his thoughts disintegrates into separate pieces; this allows him

to establish telepathic contact with a scientist who is building an extremely dangerous bomb in a laboratory of the American War Department. Thanks to this telepathic contact, Khan succeeds in abducting the scientist together with his bomb. Shadow puts himself in the way of Shiwan Khan and his Mongol warriors; the two fight, with physical force and mental powers. Initially Shiwan Khan seems to emerge victorious from the battle, as before his journey to New York he had murdered the Tulku and taken possession of the Tibetan ritual dagger. In the final battle, the ritual dagger almost bores into Cranston's throat, but thanks to his enormous mental power he pacifies it and in the end defeats Shiwan Khan.

In the film *Vice Versa* (1988)[132] also, a Tibetan ritual implement plays a central role—this time a skull-cup. A Tibetan skull-cup, richly embellished with gold and silver, is stolen from a monastery in Thailand and ends up by mistake with an American businessman who is in Thailand on a buying tour. Back at home, the father has an argument with his son, in the course of which the two express the wish to exchange identities, so that the father becomes the son and the son the father. When both of them at the same time wish this and by chance touch the vessel from Tibet, a 'transmogrification' occurs: the father actually turns outwardly into the son and goes back to school, while the son turns into the father and works as vice-president in the store. The process of transformation is accompanied by a spectacular performance that underlines its supernatural nature: the eye and mouth apertures of the skull-cup begin to glow palely and smoke escapes from the skull.

After a varied story with many odd experiences, father and son seek advice from a professor at the Natural History Museum, without disclosing to him exactly what has happened. He explains that for Tibetan lamas, the skull is a symbol of transitoriness.

> To the Lamas this skull symbolizes the inpermanence of the body. They view it as one of the many houses inhabited of the spirit on its ceaseless journey of reincarnation.

The professor does not think much of transmogrification, which belongs to the realm

110. A pseudo-Tibetan ritual device, a skull-cup, performs a 'transmogrification' in the film Vice Versa *(1988): when father and son touch the skull-cup simultaneously, the father outwardly turns into the son, while the son appears to slip into the body of the father and works as vice-president in the department store. The process of transformation is accompanied by a spectacular performance: the eye and mouth apertures of the skull-cup begin to glow palely and smoke escapes from the skull.*

of superstition. Instead, he displays great interest in the Tibetan skull object, and would like to show it to a Tibetan lama. The father and son hope for help from this lama, but are not certain whether he is

> probably one of those spaced out weirdos who tries
> to sell you coloring books at the airport and tells
> you your life is a tulip!

But the lama, who in the film has nothing in common with a Tibetan lama, as he wears a black robe and his face is more like a Confucian priest's, seems to give them the right advice: at home, when they wish for the reverse transformation and touch the skull, the father and son regain their own bodies.

In these three films, one thing becomes clear: Tibetan ritual implements are miracle tools, the Tibetan version of a magic wand. True reincarnations, however, because of their inner powers, do not have to rely on such aids, as the film *Prince of the Sun* (1991) shows. In this, the respected abbot of an old Tibetan monastery, close to death, has two monks come to him and explains to them how, after his death, his reincarnation can be found again in the form of a small boy, a 'living Buddha'. He will bring peace and harmony into the world. The master falls silent and concentrates for a short time, and a yellow swastika moves in a spiral pattern over his body, which catches fire and completely disappears. A small stone remains behind, but this is snatched away by the villain, Khentse. His opponent, the good Khenlun, escapes and after a fierce battle with his pursuers reaches Hong Kong.

Five years later, Khenlun wants to accompany the abbot's incarnation, who has been found in the meantime, to Tibet, but as the two of them cross the Chinese border Khenlun is killed. The little boy escapes and eventually finds lodging, where the spirit of Khenlun teaches the incarnate child the techniques of self-defence. Khenlun also appears to his female disciple Bencheuk, whom he instructs to track down the boy and bring him

111. The film Prince of the Sun (1991) *combines in exemplary fashion the best-known Tibet stereotypes: monks are masters of the arts of telekinesis, levitation, dematerialization, astral travel and the purely mental conquest of evil, supported by wondrous manifestations of light and magical hand movements. But the myth of Tibetan clergy experienced in martial arts is also fostered in the film: in front of a Buddha statue the nun Benchenk fights with a monk and defeats him.*

111a

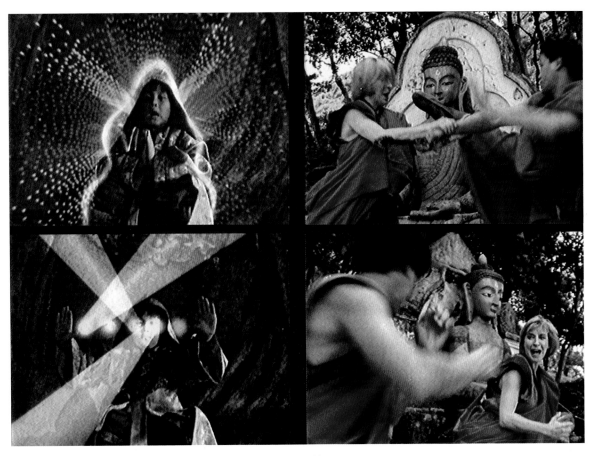

111b

111c

to Nepal. One night, Khenlun speaks to the young monk—as a speaker in monk's clothing on the television—and tells him that he has indeed sent someone for his protection, but would also like to teach him personally to defend himself, through the ability to read the thoughts of others and develop superhuman powers. In addition he demonstrates his own superhuman powers by making objects fly through the air by use of his ability of concentration, an ability he would also like to teach the young incarnate monk:

> You have to concentrate all your power and focus. Once you do that you will be able to move all objects at will and change reality according to your own wishes. And with practice you can do this even when you are miles away.

And as a proof of his supernatural powers, he makes the boy float up into the air.

The evil monk finds the child, who with the aid of his protectress, however, defeats the foe. After more battles and a flight to a pilgrimage place, the child's spiritual power is 'ignited': by reflection, beams of sunlight fall on the young incarnate monk, charging him with so much

energy that he rises from the ground and is transformed into the 'Prince of the Sun'. With some nimble hand movements, he fights Khentse and his lamas with flashes of flame and coloured energy fields. By invocation of the thousand Buddhas, the villain reaches the underworld in a meteoric dive and shortly afterwards the 'living Buddha' is enthroned in a solemn ceremony.

The film combines several typical Tibet clichés we have already encountered: the power of a tulku to dematerialize himself (the old tulku transforms himself into a small stone) and travel 'astrally'; the ability to transcend natural laws and, for example, make objects fly through the air; and levitation and magical 'peaceful battle' simply through hand movements and invocations.

We also get a conglomeration of Tibet clichés in the film *Ace Ventura—When Nature Calls* (1995). In this, the chief protagonist, Ace, after an unsuccessful attempt at rescuing a racoon, retires to a monastery high up in the mountains of Tibet, where he is recovering his strength and 'finding his peace'. He meditates in Tibetan monk's robes

in the lotus position, butterflies flutter about his head (on which he wears a Tibetan monk's hat), and animals, wild and domesticated, lie peacefully side by side around him. In this 'enlightened' state he is discovered by the Briton Fulton Greenwall, who has to persuade him to recover for an African nation a stolen, sacred, white bat. Ace, who claims that in the Tibetan monastery he has become a 'child of light', at first refuses to leave Tibet, as he has not yet attained 'omnipresent supergalactic oneness' (apparently the goal of Buddhist meditation?). For the Tibetan abbot, this presents

no problem: with an incantatory movement of the arms he brings it about that Ace attains this peculiar state of oneness with everything and hands over to him an Egyptian(!) amulet, a 'medallion of spiritual accomplishment'. When Ace leaves the monastery, the monks celebrate the parting with an orgy, in which champagne(!) flows generously, prompting the monks to acrobatic leaps—all this in the temple, before the eyes of an over-life-size seated Buddha.

Much later, when Ace is staying in Africa and making no headway with the solution of the case

112. We also get a conglomeration of Tibet clichés in the film Ace Ventura—When Nature Calls *(1995). In this, Ace retires to a monastery high up in the mountains of Tibet, where he is 'finding his peace' and meditating in Tibetan monk's robes, while butterflies flutter about his head, on which he wears a Tibetan monk's hat. In this 'enlightened' state he is discovered by the Briton Fulton Greenwall, who persuades him to solve a difficult problem in Africa. When Ace is making no headway with the solution of the case assigned to him, he recalls the Tibetan abbot. Sinking into meditation, he, or rather his 'aura', rushes at great speed to Tibet. Floating in the air, Ace asks the abbot for advice; he seems to know everything, as befits a Tibetan monk.*

assigned to him, he recalls the abbot in far-off Tibet. Sinking into meditation, he, or rather his 'aura', rushing through the air at great speed until it reaches the monastery in Tibet, establishes telepathic contact with the abbot, who is just reciting 'Om ni padme', by himself. Floating in the air in front of the abbot, Ace asks him for advice and the abbot has, in the process, to establish once again that he knows everything, as befits a Tibetan monk. It goes without saying that he is in a position to help Ace out of his fix.

One wonders how this stupid movie could have cost forty-four million dollars. At any rate the director, Steve Oedekerk, pulled off a brilliant achievement by managing to combine several very central Tibet clichés in a few metres of film: the all-knowing monk possessed of superhuman powers, levitation, the ability to 'beam' oneself to any place, the recitation of the (garbled) mantra 'Om mani padme hum' and the magic of Tibetan amulets. That it is not a Tibetan but an Egyptian amulet is no longer of consequence in the face of so many banalities.

The image of Tibet depicted in the films presented is alarmingly sketchy. None of the films was shot in the Tibetan area or in regions resembling Tibet. Only in rare cases is the architecture Tibetan;[133] the actors are not Tibetans, they hardly ever wear Tibetan clothing, and even the names given them in the films do not reveal their (allegedly) Tibetan origin. About the culture one learns nothing typical, but at best the 'stereotypical': in Tibet live lamas ('lama' is erroneously used as a synonym for 'monk') who are distinguished by superhuman skills—for example levitation—knowledge and special ritual practices. One of the chief preoccupations of these lamas/monks, moreover, appears to be the practice of martial arts. In almost all these films reincarnation, or a process very similar to reincarnation, emerges as an important theme.[134]

Tibetan ritual objects—ritual daggers, mandalas, skull-cups and amulets—seem to have

113. Tibetan ritual objects, such as ritual daggers, mandalas, skull-cups and amulets, seem to have appealed particularly to the film-makers of Hollywood. They are represented as magical objects, which becomes especially clear in The Shadow, *where the ritual dagger comes to life. It tears through the air, opens its mouth and reveals hideous, pointed teeth, with which it bites its enemy in the hand.*

appealed particularly to the film-makers and are represented as magical objects with a life of their own. This is especially clear in *The Shadow*, where the ritual dagger comes to life. Its eyes start to move, its mouth opens and hideous, pointed teeth come into view. In addition, the dagger (*phurbu*) races around in the room, forces its way into its victim, writhes when the wrong person holds it in their hands and once even turns into a scorpion-like creature. The ritual dagger in *The Golden Child* symbolizes power and superiority. Whoever takes possession of the dagger after a harsh ordeal is ruler. The skull-cup in *Vice Versa* allegedly refers to the idea of rebirth. According to the professor, the Tibetans are supposed to regard the skull as a residence of the soul travelling from rebirth to rebirth, which explains why the 'time limited rebirth' portrayed came about, in which the father slipped into the body of his son and vice versa. Even the amulet in *Ace Ventura* occupies a central position, as Ace does not want to leave the monastery without the amulet, which was wise, after all it helps him 'out of the shit' at the end of the film.

The use of mandalas in two of these films is also instructive. In *The Golden Child* the child, when a prisoner of the demonic Sardo Numspa, sits in the centre of a mandala painted on the floor, which apparently has the purpose of averting the child's superhuman powers. A warding-off function is also ascribed to another mandala construction occurring in the same film: in a room in which the golden child is held prisoner, Jarrell discovers spells painted on the four walls, which are supposed to overcome the child's powers. That the characters—both Tibetan and Nepalese—make no sense does not worry the director. The 'Tibetan' scenes of this film were shot in Nepal anyway.

Conclusion: the Tibetan ritual implements are completely misused in the films. They are objects of a sacral technology that are being used to attain superficial ends and robbed of their true spiritual and ritual meaning. Tibetan religion is thereby given the air of a mechanistic magical cult.

This is underlined by the frequent depiction in the films of the use of prayer wheels. There is hardly a single film in which such prayer wheels fail to appear, from the colossal down to the tiny, either turned correctly—from the Buddhist point of view—in the clockwise direction, or the reverse.

In all the films belonging to these categories, initiates turn up, be they Western scholars or Tibetan or white 'lamas', again underlining their fairy-tale-like plots. Through their insight and training the initiates recognize connections and expose the deeper meaning of a particular phenomenon. In *The Shadow*, a museum curator assigns the sarcophagus to Genghis Khan, and in *Vice Versa* also the significance of the skull-cup in the Tibetan religion is pointed out by a museum curator. The Tibetan Buddhist monks or tulkus all possess superhuman powers and always give the correct advice. They are all-knowing. Even in the martial arts movie *The Quest* (1996), the chief monk assumes a function similar to those of the initiates in the other films, by inviting the combatants and being in charge of them. In the centre of events is a secret meeting of the best and most famous exponents of martial arts in the world. A Tibetan monk, who appears to belong to a secret brotherhood, presents each of these fighters with a scroll, not in the least Tibetan-looking, which besides the invitation also contains a map. The hero of the film, Chris Dubois, after many detours and after having shown himself worthy of the competition in Tibet, likewise arrives at the 'lost city'—in the company of some bandits, who want to steal the competition trophy, a large gold dragon. You only know that the main part of the film is set in Tibet by an inserted caption. If this was not there, you would assume the secret city was somewhere in South China or North Thailand: the chief monk resembles a Confucian priest, the monks wear robes reminiscent of those of Thai monks, the architecture and the gold dragon offered as the main prize are of Chinese style, and both at the city gate and in the fighting room stand oversized Chinese statues.

The theme of the experienced, all-knowing master, who often changes the course of the story, is also central to later feature films: in *The Razor's Edge* and *The Abominable Snowman*, the visitors to the monastery are already expected by the clairvoyant abbot, and in *Kim* the lama, who is in search of the River, has the role of the enlightened initiate, who transmits the wisdom of life to the young Kim.

The surreal deconstruction of search for meaning

Ab nach Tibet! ('*Off to Tibet!*', 1993), by Herbert Achternbusch, constitutes a special kind of zany comedy movie, in which the principal character Hick is not actually a clown or comedian, but uses 'the mask of fooling around'.[135] The film is divided into two parts. The first is set in Munich in 1993, which proves to be a hotbed of samsara, life's endless cycle of suffering. Hick tries to escape this by dying and is transformed (back) into an incarnation living in Tibet in 1662, as whom he appears in the second part, entitled 'The Last Illusion': the monk 'Laughing River'. In Munich he is a kind of clown; in Tibet he appears as a person somewhere between active monk and guru, who seems in fact to be closer to Zen than to Tibetan Buddhism—at least as far as his meagre 'instructions' are concerned, which recall koans or surreal nonsense:

> 'Nothing is better than nothing at all;'
> 'Whoever believes in God will be caught by the Devil;'
> 'In the end I would prefer that when you speak to me you are silent.'

The film blurs the boundaries between space and time, between banality and wisdom, between samsara and liberation—a Buddhist film? Buddhism has demonstrably left its marks on Achternbusch, indeed he has painted on the walls of a room in his apartment the Buddhist Path to Enlightenment—a black elephant (mind), who walks along a path upwards, getting ever whiter in the process—a painting that is also to be seen in the film. Achternbusch also tells an (invented?) story to the effect that when he was young he had to kill chickens. Each time he would hold the eyes of the 'condemned' shut and hack off its head with the cleaver, shouting 'Off to Tibet!' Why was this? asks Achternbusch:

114. The starting point for the dream-story Ab nach Tibet! *by Herbert Aschenbusch is the city of Munich, of which a woman courier says: 'Only for the Jewish and Tibetan cultures does there seem to be no need of accommodation in this city. But now, according to a prophecy of Nostradamus, Tibetan culture will be given a triumphant procession in our city.'*

Despite this prophecy, Hicks and Sue (or the audience?) set out for Tibet, where Hicks is seen as a monk. But he seems to be living not in the twentieth century, but in the year 1622—as a wise man or a madman?

It seemed to me the only possible country for a rebirth of the cocks. It just occurs to me that when I was nineteen I had a vision in the commuter train as it was waiting in the deathly dreary station of Planegg: it was night, I was dancing round a wood fire. It was in Tibet. I was holding my mother's pelvic bones around my head and dancing. There is certainly a connection there.[136]

Why Tibet seemed to him the only possible country for a rebirth, Achternbusch does not reveal to us. His short story *Tibet*[137] cannnot help us either; in this, by the way, he was already reflecting on a journey to Tibet and having a 'memory', seeing himself in Tibet seven hundred years before …

Perhaps Tibet fascinates simply because of its remoteness, its oppositeness, its difference? At all events, also because of the death practices cultivated in Tibet and the intensive preoccupation with death, a topic with which Achternbusch has always been preoccupied? Or because (Tibetan) Buddhists have always looked intensively at the problem of the naming and labelling of things? This is evidently a theme that Achternbusch is concerned with, when he says in the film:

It is not good when one gives things names. You know everything and say no more,

or when Hicks, asked by his beloved (or daughter? or both?) what life is, replies:

Pheasants and ducks.

The film raises many questions. Is the white sheet of paper that Laughing River/Hicks has as a heart a metaphor for the Buddhist Emptiness? Is *Ab nach Tibet!* a somnambulistic lark with pictures of a skewed alpine Absurdistan (*Berliner Morgenpost*), a documentary film of Achternbusch's dreams (Luisa Francia), or a feature film that has more to do with Buddhist insights than any other film discussed here? 'Om mani peme hum, it just knocks me out,' Hicks would probably reply.

Tibet as a store of miraculous herbal essences

In the Woody Allen film *Alice* (1990), Tibet is scarcely mentioned, but even so it plays more than a merely peripheral role, as Tibet and the Himalaya are connected with a central theme of the film, the potent herbal preparations that Alice gets administered in this modern fairy tale. Alice is a neurotic, rich housewife from Manhattan, who has fallen in love with a musician, but dares not put her sixteen-year marriage in danger by having a bit on the side. She is suffering from various physical and emotional problems and therefore goes to a Chinese herbal doctor. The first herbal pill makes Alice lose her inhibitions and talk about her secret passion. The second medicine is herbs that make Alice invisible. The third consists of herbs that she has to burn, after which the spirit of a dead friend of her youth appears to her and gives her advice on her love affairs. One can deduce indirectly that the herbs administered come from Tibet, as the following scene shows:

Dr Yang: 'Mrs Tate, come in. Er, please excuse appearance, er, Dr Yang leaving.'
Alice: 'You are going away?'
Dr Yang: 'Er, yes, must go to Tibet for period of time. Ancient scrolls discovered—new remedies—er, Dr Yang must always continue education, er, good for my patients and, er, keeps Dr Yang young …'

One gets the impression that this journey of Dr Yang's to Tibet is not his first to the Roof of the World, and that consequently these remedies that make people forget their inhibitions, make them invisible and even bring the dead to life all come from that region of the world. This becomes quite clear when Dr Yang again administers herbs that are only found in the Himalaya. They are herbs that when dissolved in liquid produce a strong love potion.

'Herb is potent—choice is yours—use wisely,'

says Dr Yang. Shortly afterwards, the medicine proves its efficacy: a cook mistakes it for nutmeg and mixes it into an egg-nog that is served at a party, with the result that all the men present declare their love and passion for Alice.

Once again Tibet and the wider Himalayan area are connected with something miraculous. This time it is herbal medicines that are able to heal not physical diseases but emotional deficiencies. In the end, the herbal medicines are so powerful that Alice gives up her old lifestyle and—quite in the spirit of Buddhist compassion, though this is not explicitly stated—places herself at the service of the poor. Here as in other films with Tibet themes, the turn in the story takes place

115. In the film Alice *(1990) Tibet and the wider Himalayan area are connected with miraculous herbs. Some are able to cure emotional deficiencies, others make one invisible (illustration), bring the dead back to life or with liquid yield a strong love potion. Alice, a neurotic, rich housewife from Manhattan, experiences all of these. In the end—not least because of these herbs from Tibet—she gives up her old lifestyle and places herself at the service of the poor.*

not through an internal process but through mysterious healing objects. Of Buddhism, which underlies Tibetan medicine, the viewer learns just as little from *Alice* as from the other films, though this comparison should by no means give rise to the impression that the quality of *Alice* is in any other way on a par with the mediocre zany and martial-arts movies discussed above.

Plant essences originating from Tibet also crop up in the soft-porn movie *Emmanuelle in Tibet* (1993). At the beginning of the film, a voice says:

> In the sacred mountains of Tibet, a mysterious power has been granted to Emmanuelle, a power that makes her irresistible to all men. A single drop of a thousand-year-old plant essence is enough, and she becomes younger, or it becomes possible for her to get into the soul of another woman.[138]

No wonder Emmanuelle promises to go back to the high mountains of Tibet one day. Since she was there, she says, her life has changed.

> 'I have learned a lot—been through highs and lows of my feelings. But I had to seek my way, find my truth.'

Later, she asks:

> 'Why did I choose this monastery? I don't know. Call it higher providence or fate. I wanted to find my inner centre, my peace of mind, or what the Buddhists understand by harmony. These people teach a religion there that grants one inner peace. They teach one everything about God, but they give Him other names, to be more precise, they give Him no name, because He is in them.'

Emmanuelle continues:

> 'I was not in the temple for long—after a few weeks of spiritual exercises I was initiated. I began to like this style of life. It seemed to me as if the Tibetans could stop time and turn over the years like the pages of a book. At that time … I did not know

what I wanted, where my path was leading me, what the meaning of my life was meant to be. But then I was called to the Master—I had never seen him before …'

The monk tells her a grace has been granted her, because she has been chosen to take a place among the immortals, and she has been chosen to become the incarnation of any woman on Earth. With these words the monk gives her a plant essence, which is supposed to possess a magical power. Emmanuelle has to put just a few drops of this essence between her breasts, then she will be able to get into the soul of any woman, and all her wishes will be fulfilled. This substance is the essence of life, it is knowledge and truth, it is the eternal source of youth. When one's own soul is suffering and one's heart is bleeding, the substance will help one find supreme harmony, will heal wounds and bring peace.

After he has said this, first the Master and then Emmanuelle are rejuvenated, amid thunder and lightning, whereupon the two unite.

Besides the theme of the magical Tibetan essence that allows the person who uses this preparation to slip into other persons (which once again suggests a kind of incarnation), brings harmony and—last but not least—acts like water from the fountain of youth, the theme of tantric sex is also present in *Emmanuelle in Tibet*. For example, the scene in which the rejuvenated couple, the Master and Emmanuelle, unite, but also shortly before the end of the film, when Jenny has a conversation with a Tibetan monk about sex in his system of belief. The monk is of the opinion that the vow of chastity in force in his religion leaves the responsibility to the individual.

'Our religion has no objection to the sexual act as such, it is a lower level of spirituality,'
whereupon Jenny thinks that this is a wonderful religion, in fact in her opinion this is *the* shape of spirituality. Tibet not only as a stronghold of magical and esoteric miraculous powers and rites, but also as a place where corporeal well-being (health, sex, age) can be brought to perfection.

116 *(left). Plant essences originating from Tibet also crop up in the soft-porn movie* Emmanuelle in Tibet *(1993). In the sacred mountains of Tibet, Emmanuelle is looking for her inner centre and peace of mind, but finds a mysterious plant essence thousands of years old, which makes her irresistible to all men—even to the aged master who provides her with the essence. Besides the theme of the magical Tibetan essence, which acts like water from the fountain of youth, the film also reaffirms the theme of tantric sex, when the Master and Emmanuelle, both rejuvenated thanks to the plant essence, unite in love.*

117 *(right). Even detectives find inspiration in the Tibetan way of life. In the TV series* Twin Peaks, *Detective Dale Cooper uses among others 'the Tibetan method', namely, intuition, visions and dreams, solving criminal cases with the aid of the Dharma (the Buddhist teaching)!*

Twin Peaks: the Tibetan method

The mysteries hidden in Tibet are inexhaustible. It is not only martial arts practitioners, believers in reincarnation and those interested in potency-enhancing drugs who get their money's worth in Tibet, but even detectives find inspiration in the Tibetan way of life. In *Twin Peaks*, a very popular TV series from the USA, the hero, Detective Dale Cooper, distinguishes himself by a special mode of investigation. Besides the conventional style of investigation, in which great store is set by logical thought, securing of evidence and physical strength, he uses intuition, visions and dreams. No wonder he calls this irrational method 'the Tibetan method', which was given to him in his sleep. Cooper tells a policeman,

> 'Following a dream I had three years ago, I have become deeply moved by the plight of the Tibetan people and filled with a desire to help them. I also awoke from the same dream realizing that I had subconsciously gained knowledge of a deductive technique involving mind-body coordination operating hand in hand with the deepest level of intuition.'[139]

In another place Detective Cooper relates the Tibetan historical past just as vaguely to the current criminal case he is working on, when he says:

> 'Buddhist tradition first came to the Land of Snow in the fifth century AD. The first Tibetan king to be touched by the Dharma was King Hop-thong-thor-bu-nam-bu-tsang [a completely distorted name]. He and succeeding kings were collectively known as "the happy generations". Now some historians place them in a Water Snake year, AD 213 . Others in a year of a Water Ox, AD 173. Amazing, isn't it? "The happy generations".'

To this Agent Rosenfeld replies:

> 'Agent Cooper, I am thrilled to pieces that the Dharma came to King Ho-ho-ho, I really am. But right now I am trying hard to focus on the more immediate problems of our century right here in Twin Peaks.'

And Agent Cooper meaningfully responds:

> 'Albert, you'd be surprised at the connections between the two.'[140]

The Tibetan Dharma (the Buddhist Teaching) takes over Hollywood, Hollywood takes over the Dharma.

Part 4

In Search of 'Dharma-la' and the Tibetan Lamas

The image of Tibet in feature films of the '90s, advertising and commerce

A. Films

The Tibetan 'Brothers' are discovered

While in previous films Tibetans had been played by non-Tibetans, i.e., the idea of 'white lamas' had still not been grown out of, in the 1990s films at last reached the market in which Tibetans themselves had to play their own parts. Sacral Tibet was still depicted in them as a top priority, but now it was no longer inhabited by 'white lamas' but by Tibetan monks and the Dalai Lama. Helena Blavatsky's 'Brothers' had finally—after more than 120 years—become real Tibetans. Sometimes they still live in faraway, mystical Tibet, but in one film, *Little Buddha*, they have already made the leap into the Western world. This film belongs to a new phase in the reception of Tibet: the phase of 'Dharma-la' has begun, the portrayal of Tibetan Buddhism and its supposedly only positive effects on Western people.

The first film of this (unplanned) 'trilogy', *Little Buddha* (1993), was not conceived as a Tibet film,

but was first and foremost a film on the life of the historical Buddha, Shakyamuni. However, the director, Bernardo Bertolucci, skilfully combined the historical part with a framework story from the present, which takes reincarnation as its central theme. In strands of this narrative played in the USA, Nepal and Bhutan, Tibetan monks play an important role, and the film concerns a theme that has recently been mentioned repeatedly in connection with Tibetan Buddhism, the question of reincarnation; it is therefore natural for us to go into the film in more detail here, where we are concerned with our present-day images and caricatures of Tibet. We shall not deal with its portrayal of early Buddhism—from the life of the Buddha—despite the stereotypes and embarrassments it contains, but shall confine ourselves to the scenes in which explicit reference is made to Tibetan Buddhism.

118 (below), 119 (p. 165). In the film Little Buddha, *Hollywood appears to be slowly and hesitantly discovering Tibetan culture's own values. It is true that yet again the historical Buddha is played by a white man, and as an incarnation of Lama Dorje we have Jesse, the son of an American family, in the centre of events. But both the other incarnations are Asian children, and the scenes in Tibetan monasteries were shot at original locations. Tibetan Buddhism, however, still appears in the film as a magical vehicle that involves little more than an unusual form of transmigration of souls.*

As we said, the story with the Tibetan monks forms the framework story, which is interrupted again and again so as to present the life of Gautama Buddha in flashback. Some Tibetan monks, who since the occupation of their country have been living in Bhutan, are looking for the reincarnation of Lama Dorje. Various signs indicate that the revered monk has been reborn in Seattle (USA). There, thanks to a vision, the monks from Tibet find the Conrad family, whose son Jesse they recognize as the incarnation of the deceased lama. Jesse's parents, not Buddhists themselves, are torn this way and that, not knowing what to make of the matter, until the father agrees to travel with the Tibetan monks and Jesse to Nepal, where the boy is to undergo some final tests, just like another candidate, who has been found in Kathmandu. When they arrive in the capital of Nepal, they learn from those in charge of the search that yet another candidate, a girl, has been discovered in the south of Nepal. When all three pass the tests—principally a matter of choosing from several hats that of their late predecessor—they are all recognized as incarnations of Lama Dorje. It often happens, a monk says, that there are three reincarnations of one lama, three distinct manifestations of his Body, Speech and Mind.

The belief typical of Tibetan Buddhism in the reincarnation of the deceased monk is the central theme of the film's framework story. Apart from this, mainly external characteristics of Tibetan Buddhism are depicted, such as the production of a mandala, an oracle's trance and—completely shorn of context—sacred dances ('cham). About Buddhist teaching and its rendering in everyday life one learns practically nothing.

The emphasis on the belief in reincarnation holds a certain danger (which obviously does not apply only to this film): those unfamiliar with Buddhism could get the impression that the belief in reincarnation is actually a very practical affair: without having to contribute anything much, anyone can be the reincarnation of a monk, be it as in the film a child from a well-to-do family in the USA, a street kid from Kathmandu or a girl from the south of Nepal. The belief in the law of karma (the law of the effects of actions) is scarcely mentioned, and thereby a most central tenet of Buddhist belief is withheld from the audience,

namely, that the form of one's rebirth depends purely and solely on earlier thoughts, words and deeds. One also hears hardly anything of what thoughts, words and deeds are regarded as beneficial according to Buddhist belief, and what are regarded as harmful.

The film is also dishonest and mystifying inasmuch as one of Lama Dorje's three incarnations is a girl. It is true that in principle nothing stands in the way of a female incarnation of a monk, but throughout the long Tibetan tradition, not a single reincarnation combination is known that matches the one shown in the film.

> By this token, *Little Buddha* is a particularly sad loss, since it transforms Buddhism into a kind of magic vehicle that involves little more than the fancy transmigration of souls.

concludes Pico Iyer in *Tricycle*,[1] continuing:

> In its way, it performs an even greater disservice to the discipline than simply disparaging it; it romanticizes it out of existence, turning it into a kind of special effect with no apparent application in the here and now. It makes Buddhism not closer to our daily lives, but more remote. And instead of providing a simple primer to some of the precepts of the Buddha—an A-B-C of Buddhism, as it were—it provides an A-L-I-E-N.[2]

It is particularly obtrusive that Buddha is played in this film by a white, i.e., the idea of the 'white guru' has still not been overcome. It is quite otherwise in the next two films, in which—at last—the people in question get to play their own roles.

Seven Years in Tibet and *Kundun*, which reached the cinemas in 1997, are concerned with Tibet immediately before and during the Chinese invasion. In *Seven Years in Tibet*, up to the scenes with the Chinese invaders, a very idyllic Tibet is depicted—uncritically, innocently, naively. There is no reference to the sometimes-unjust social and economic conditions or to the legal system with its often-cruel methods of punishment.

Kundun is more honest about this. The audience sees, if only briefly, one of these cruel methods of punishment, a prisoner with shackles, and learns something about the Reting affair that shook Tibet severely in the '40s and brought it close to civil war. In another respect also it is more honest than *Seven Years in Tibet*: it does not commit the error of dramatizing in Hollywood style the life story of the central figure, in this case the Dalai Lama. In *Seven Years in Tibet*, on the other hand, the director makes Heinrich

Harrer into a hero, a comic-book superman. He credits him with an inward purification ('Harrer returns without possessions, apart from his purified ego, and he has been fortunate.'), supposedly brought about through his contact with the Dalai Lama, as the following conversation between the Dalai Lama and Harrer confirms. When the film Dalai Lama asks Harrer what fascinates him about mountaineering, he replies:

> 'You are filled with the deep, powerful presence of life. I've only felt that way one other time.'
> Dalai Lama: 'When?'
> Harrer: 'In your presence, Kündün.'

Jean-Jacques Annaud is here reviving the old, already well-known idea that no one can escape the positive, spiritually-minded aura of Tibet and especially of the Dalai Lama. Undoubtedly in the last period of his stay in Tibet Harrer had close contact with the Dalai Lama, marked by friendship and intimacy. It was, however, a one-sided give and take and not a 'reciprocal learning and maturation': often against the resistance of the officials responsible for the well-being of the Dalai Lama, Harrer brought the young ruler closer to the outside world, but in the process Harrer hardly picked up anything of the mental and spiritual world of the Dalai Lama. He was not interested in Tibetan Buddhism—this was apparent in his book *Seven Years in Tibet* and he confirmed it in conversation with the author—nor in Buddhist ethics, nor in the Buddhist process of purification of the mind. Interestingly, however, a great many film critics now single out the demonstration of this alleged process of reciprocal learning and maturation as Annaud's special achievement. There is mention of Harrer's 'cathartic development' and 'self-discovery', of a 'process of becoming a man' and of the 'sensitivity with which Jean-Jacques Annaud portrays this lengthy process, so difficult and plagued with relapses'.[3]

There seems to have been, as Annaud and the media wanted, an (additional) reason why a former Nazi should get to be portrayed as a hero in a full-length film. After the German newspaper *Stern* had revealed at the end of 1997 that Harrer was a declared Nazi, it had to be shown why the film still made sense, or had all along: an SS *Oberscharführer*—through his contact with Tibetans—became a reformed, selfless man! This put in place another piece of the jigsaw of the Tibet caricature.

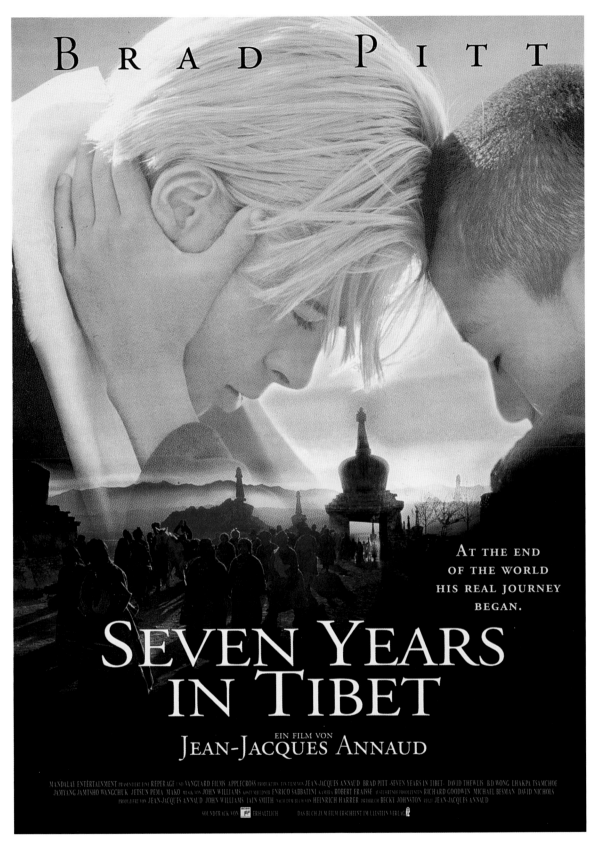

120. More Hollywood stereotypes: in Seven Years in Tibet, *except for a few scenes a very idyllic Tibet is depicted, and the main character, the Westerner Heinrich Harrer, appears in comic-book style as someone who is changed by a difficult process of inward enlightenment from a Nazi villain into a superman.*

The narcissistic loner Heinrich Harrer was still a loner after his stay in Tibet, and did not develop there into the caring father or the noble idealist who committed himself to the political future of the Tibetans by rebelling against the traitor Ngapö Ngawang Jigme. But nor was he the Nazi villain or 'bastard' that some of the media made him into after the *Stern* exposé. Both before and after Tibet, Harrer was undoubtedly an opportunist, who wrongly concealed his Nazi party membership and for a long time denied and glossed over it, but he never demonstrably took part in any of the atrocities of the Nazi régime and to this day neither anti-Semitism nor racism can be laid at his door. Nowhere in his diary, unpublished but available to the author, is there a passage that reveals Harrer as a National Socialist. This is not to gloss over Harrer's proven closeness to Nazism, but simply to put it in the proper light. It remains a fact that in 1938 Heinrich Harrer became a member of the NSDAP (National Socialist German Workers Party) and of the SS, with the rank of *Oberscharführer* (a kind of sergeant), and that from 1933 he was a member of the NS-Lehrerbund (National Socialist Teachers Association), illegal until 1938, in Graz. It is disputed whether he joined the SA (the Nazi Storm Troopers) in 1933. Harrer himself denies this, but says he pretended to have had such early membership on an application form so as to get quicker authorization for his marriage with his first wife.[4]

Characteristically, some media people took advantage of the opportunity of the *Stern* revelations to impute once again to the Nazis mysterious occult researches in Tibet and the building of a German-Tibetan alliance, and one even asked speculatively whether Harrer's and Aufschnaiter's escape to Tibet was not part of this Nazi plan. For, so this journalist argued, Tsarong, a good friend of Harrer and Aufschnaiter, had been some years earlier a close confidant of Bruno Beger, whom we have already got to know as a convinced race theorist. Why, the writer asks, did Harrer not mention in his book that some years before, Beger had come and gone in the very house where he was staying? With this question he seems to be trying to suggest that there was a connection between Harrer and Schäfer's SS expedition.[5] It's so simple concocting history.

In comparison with *Seven Years in Tibet*, *Kundun* conveys a more authentic image of Tibet. For one reason, because the principal actors and actresses were all lay Tibetans in exile and the director, Martin Scorsese, endeavoured at unbelievable expense to play individual scenes correctly down to the smallest details, and spared no effort or outlay to reproduce the buildings, interiors, clothing and equipment both ritual and profane in a masterly manner. For a second reason, because as already mentioned some of the dark side of Tibetan life was also portrayed; and finally, because in this quiet, calm film, historical events are shown both factually and in their correct temporal sequence—in total contrast to *Seven Years in Tibet*, where Harrer, who had already left Central Tibet in 1950, experiences the entry of Chinese troops to Lhasa as well as the signing of the Seventeen-Point Agreement (1951). In *Seven Years in Tibet*, the first important meeting between the Dalai Lama and Chinese envoys also takes place in Lhasa instead of in the Chumbi valley, Southern Tibet, and the Dalai Lama's flight to the south of the country follows Harrer's advice—all 'facts' that are incorrect.

Kundun also conveys more authentic information on Tibetan religion, not only the countless, sometimes pompous ceremonies (such as, for example, the impressive entrance of the state oracle), but also the special method of 'burial' of corpses[6] and the Buddhist teaching. Whereas in *Kundun* the Four Noble Truths, central for every Buddhist, and the problem of the origin of suffering are discussed, *Seven Years in Tibet* delivers platitudes regarding Tibetan religion, as for example when the tailor Pema, arguing with Harrer about the point and pointlessness of mountaineering, says:

> 'Then this is another great difference between our civilization and yours: you admire the man who pushes his way to the top in any walk of life; while we admire the man who abandons his ego. The average Tibetan wouldn't think to thrust himself forward this way.'

As if every Tibetan were a little Dalai Lama or Milarepa!

Kundun too displays a blind spot, typically enough where the portrayal of Heinrich Harrer is involved: in *Kundun* 'Henrig' (as the Dalai Lama

called Harrer) is not found at all—presumably because of Harrer's National Socialist past, which became known during filming. This cutting out of a person who after all had an intimate relationship with the young Dalai Lama for almost a year does not match the concern for authenticity that is otherwise a feature of the film. Yet the portrayal of this unusual relationship could have been so delightful, for it would have allowed a side of Kundun's life unknown up till now to be demonstrated; for example, that the Dalai Lama and Heinrich Harrer corresponded by secret letters because of the distrustful clergy, or hatched plans how the Dalai Lama might have flown out of Tibet.

We should like to turn briefly to one theme, firstly because it appears in both films, and secondly because in at least one of them, *Kundun*,

it becomes a leitmotif. This is the process of making and destroying a sand mandala. As we have seen, mandalas or mandala-like structures did appear in earlier films, but there they were more magical objects, useful for the attainment of a particular goal. In *Kundun*, however, the creation and subsequent destruction of a sand mandala forms a kind of framework story, barely noticeable, inserted at the beginning and ending of the film, subtly expressing a Buddhist wisdom: everything is composite, exists in dependence on something else, is subject to continual change and is therefore transitory. A mandala as a symbol for the transitoriness of the land of Tibet. In *Seven Years in Tibet* too a sand mandala is sprinkled, conveying despite the brevity of the scene a central message: the brutal destruction of the

121. In comparison with Seven Years in Tibet, Kundun *conveys a more authentic image of Tibet, for one reason, because the principal actors and actresses were all lay Tibetans in exile and the director, Martin Scorsese, endeavoured at unbelievable expense to play individual scenes correctly down to the smallest details, for another reason, because some of the dark side of Tibetan life was also portrayed; and finally, because in this quiet, calm film, historical events are shown both factually and in their correct temporal sequence.*

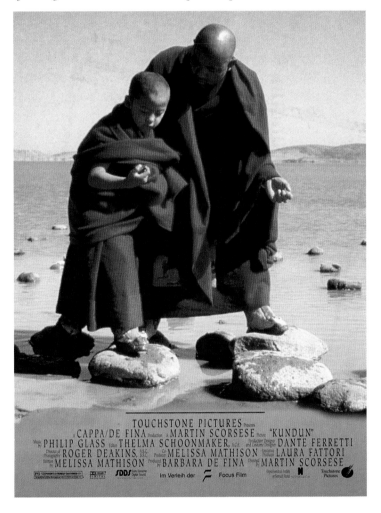

mandala sprinkled on the ground by a Chinese general stands for the destruction of the entire Tibetan culture by the Chinese.

On one point both films are taken in by the same myth: both suggest long-standing pacifism in Tibet. In *Kundun* the audience reads in the opening credits the sentence:

> In a wartorn Asia, Tibetans have practised non-violence for over a thousand years,

and in *Seven Years in Tibet* the young Dalai Lama explains to the Chinese general sitting opposite him that the Tibetans are a peace-loving nation who absolutely reject violence.

Both films, *Kundun* and *Seven Years in Tibet*, undoubtedly have a merit that should not be underestimated: they make a large audience aware of Tibet and its most recent history. Through them, people who hardly knew where Tibet was learn for the first time about the Chinese occupation of Tibet, which was indeed no paradise, as Harrer's companion Peter Aufschnaiter suggests once in *Seven Years in Tibet*, but also not the hell on Earth that Chinese propaganda would have us believe.[7]

The jet set goes (Tibet) mad

> It is the Tibetans who for the first time actually get to speak. It was high time!

This sentence, applied to recent documentary film production, is also valid for the feature films produced at the end of the 1990s. Hollywood has at last discovered that Tibetan culture does not exist only in fantasy, but is a reality lived by actual people—Tibetan women and men.

But please, not goddesses and gods! For at the moment the pendulum seems to be swinging in the other direction: while for a long time, Tibetans were portrayed in the film world as faceless, incomprehensible, alien and sometimes even rather stupid, today they are becoming more and more godlike. Something special does indeed cling to them and their culture, something supernatural, but which at the same time hides within itself something magical, ambiguous and dangerous. Magical ritual daggers and skull-cups, levitating monks, miraculous mixtures, all these are outward signs of this esoteric side of Tibet in many early films. More recently a new dimension has arrived: the divinizing of Tibet, in which certain spokesmen of the Hollywood establishment are involved, for example Martin Scorsese, when he describes Tibet as 'this very special country which was based on non-violence' and the Tibetans as not going out but going in ... centering in themselves, in their lives.[8]

Richard Gere also divinizes Tibet, when he says:

> Tibet exists on many levels. All of them heartbreakingly real. It is the pure land dreamscape of gods and goddesses. It is our last living link to the ancient wisdom civilizations and their hard won knowledge of the vast and profound secrets of the human heart and mind ...

When discussing Tibet, cultural and sociological facts must of course also be taken into account, but we must not let ourselves be guided by a (hidden) progressionism. What is meant by that? It is any theory according to which humanity develops from a simple, primitive, barbaric state into a complex, superior existence. This progressionism also underlies the idea that the development of humanity can be equated with the development of a child into an adult, with the development of reason from irrationality and of psychically highly developed, civilized, people from savages. The progressionism that appeared with the French Enlightenment is one of those fateful myths of our society that may not be officially taught and supported any more but is nevertheless still smouldering more or less unconsciously, in the heads of many Tibet-enthusiasts, among others. For them the ideal state aspired to is not Western civilization with its technical, social and political achievements, but Tibetan civilization.

One of the clearest representatives of the 'Tibetan-civilized' (who plainly likes to distinguish himself from the 'Western-civilized') is not in fact a great film star but a man who is very close to show business and readily moves in the glamour world of the media. This is Robert (Bob) Thurman, sometimes also affectionately called 'Buddha Bob', of whom Erik Davis writes in *The Village Voice*:[9]

> No contemporary Western Buddhist fuses scholarship and popular desire with the panache of Robert Thurman. Ex-monk, Columbia prof, *Tricycle* magazine honcho, Tibet House president, father of Uma (actress), and American point man for the

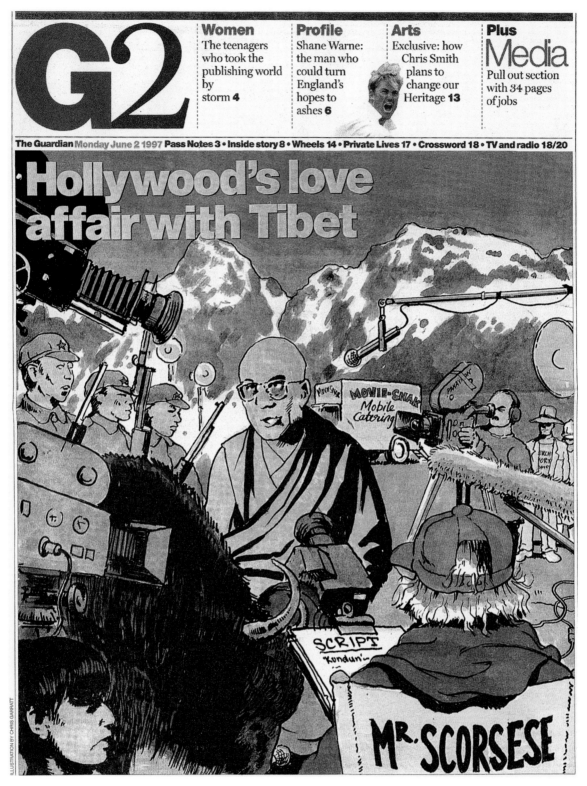

122. *Hollywood's love affair with Tibet:* 'From Hollywood's Himalayan eye candy to the Dalai Lama's elfish Macintosh grin, from Beastie Boys Buddhism to the proliferation of "Free Tibet!" bumper stickers—it's clear that Tibet has captured the pop mind ... But Tibet remains a hybrid, half-imagined landscape, a curious commingling of reality and fantasy, scholarship and popular desire.' (Erik Davis in *The Village Voice, August 19–25, 1998*)

Dalai Lama, Thurman plays the Orientalist scholar as Buddhist impresario. He hobnobs with movie stars, writes books, and lectures with a charismatic fire that have led some to dub him the Billy Graham of Buddhism.

Because of Thurman's closeness to the jet set and thus to the American film world and the not unimportant role he plays in the American media, we should like to look into his Tibet image rather more closely. Thurman is convinced that it is not only the Buddhist movement that needs Tibet, a kind of Tibetan Salvation Army, but all human beings, so that they can really know themselves.

> It is time we took action before another holocaust happens. Tibet is the last bastion of Buddha's army of peace. If Tibet's ecology, if Tibet's society, if Tibet's Dharma is crushed and destroyed finally by the external-reality-modernizing-militarizing army, the planet is lost. The experiment has failed. …
>
> Tibet is an alternative direction for the entire planet, a peace direction that the planet could have gone in four hundred years ago. Tibet is a manifestation of the fact that we can have paradise, we can have Shambhala, we can have Eden again. Easily. But not through 'business as usual'. … The zone of peace which should be the whole planet will begin in Tibet.[10]

Once again we recognize the theme of a Tibet dedicated to peace and pacifism. For Thurman, the Tibetans did not become pacifists only in the last fifty years, but had been ever since Buddhism found its way into Tibet in the seventh century. At that time, Thurman says, the terrible, savage Tibetans, who were constantly clashing, realized that there was something else, namely meditation and logic, and from world-conquerors they became self-conquerors.[11]

> The emperors were meditating, and everyone was reeducated, and the Tibetans became tame and peaceful. Their enemies were so far away, they were able to do that. And finally, the monasteries took over the country. Not like the Protestants. The Protestant ethic destroyed monasticism and created the Industrial Revolution. But in Tibet, it was the opposite: monasticism made an industrial revolution itself.

By this 'revolution', Thurman obviously means what he calls 'Enlightenment-industry', which he clarifies somewhat with examples. (Why he speaks of an 'industrial' revolution is not quite clear.) He sees a country in which the government and all the taxes are there to support anyone to become selflessly enlightened. That is, any person could withdraw for meditation when required and would be given free food in the process. He

suggests to the reader that this was the case in Tibet, but overlooks the facts that for economic reasons not everyone in old Tibet who wanted to was able to go on retreat for an 'Enlightenment trip' and that many who had decided on the path to Enlightenment and found admission to a monastery had to work hard without much chance of devoting themselves to their own path to Enlightenment. Many monks, moreover, in no way lived 'tame, full of love, selfless, friendly, free of jealousy and greed,' but sometimes beat each other up—in the name of religion.

The old system of rule, which the present, Fourteenth Dalai Lama wanted to see abolished, Thurman deifies when he says:

> Tibet has developed a different sense of responsibility. The Dalai Lama is the head of *state*. We think that's weird. We expect an enlightened, holy person to be *powerless*; we almost suspect that if they're not powerless, there's something wrong with them. But the enlightened person has to take responsibility, take power, in fact. And Tibet is the only place on this planet where political power and enlightenment became the same thing.

Bob Thurman would like to apply the Tibetan model to the whole world—even with the help of the Chinese:

> If Deng Xiaoping (the article comes from a time when Deng was still alive) were smart, he would say, with the whole world, 'Liberate the Tibetans! Train up ten million Dalai Lamas, send 500 to Iowa, Kansas, Moscow, Paris, Tokyo, Washington D.C., and teach those people to pray and be tamed before they drop neutron bombs on us.' The world should be praying to Tibet to come over here and get us to cool out,[12]

… for the Buddhist agents of a 'cool revolution' to lead the nihilistic civilization of the West to an about-turn. For Thurman, the evidence that such an 'inner revolution' can succeed is Tibet, that demilitarized and socially harmonious 'enlightenment factory' with its monasteries, which he sometimes calls 'bliss factories'.[13] Erik Davis again:

> … But one can't escape the sense that Thurman is consciously creating a romanticized image that serves the West's own contradictory need to both escape and fulfill modernity.[14]

The world need no longer pray for Tibet to come to us, for it is already in our midst. In films, as well as in novels, comics and advertising, and—the latest development—Tibet more and more degenerated into a commercial product, with its marketing taking on strongly American characteristics: the Americanization of the Tibet image.

B. Advertising

Tibetan monks as 'regular guys' in advertising

You can't have a TV commercial referring to Tibet without monks! In no other 'medium' investigated in this book is Tibet so exclusively associated with the 'occupational group' monk as in TV advertising and in advertising in general.[15] Advertising has found in monks new 'regular guys', trendy people:[16] in sixteen of a total of seventeen TV commercials known to us, monks play a central role; in twelve, monks appear exclusively.[17]

Although in three ads monks are shown who cannot be unambiguously assigned to the Tibetan tradition, they are included for consideration here, as only the expert can recognize this, on the basis of details of the clothing.[18] In all probability, when producing the ads the film team would not have been aware of the differences in the robes and wanted—on account of the popularity of Tibetan monks—to convey to the viewer the impression that it was a representative of Tibetan Buddhism. This is indicated, for example, by the advertising for *Danka* fax machines. From his robes, the monk appearing in it is in fact clearly not a Tibetan monk, but still the ad bears the name 'Dalai Lama'; the association with Tibetan monks, and even with the Dalai Lama, is therefore intended. The *Danka* representative in the film even calls the monk 'Dali', which underlines what was said before: when the layman catches sight of the monk for the first time and hears the form of address, he thinks momentarily of the 'Dalai', i.e., the Dalai Lama, or a representative of the Tibetan clergy. The monk advertising in a commercial for *Königspilsner* is also, according to his robes, not a Tibetan monk. In the *Xtreme Information Ltd* archive (an archive of advertising films), however, the ad goes under the headword 'Tibetan monk'.[19]

As far as authenticity is concerned, exactitude is not striven for in the commercials anyway—with one exception (*Xsara Coupé*). In two ads, Tibetan monks are praying in a supposedly Tibetan monastery, but for the exterior shots of it Newari architecture had to serve (*Renault Clio* and *Sampo*). In the *Biogran* ad, one learns that Tibetan monks would live up to 120 years old. In the *Tchaé* film, in which Liptons are advertising green tea, a monk in Tibetan robes serves tea in a room

reminiscent of Japan. In the *Baygon* film, a meditating (and levitating) monk sprays mosquito-killer, an unforgivable error if one recalls the Buddhist precept of not killing. This error becomes bad taste when the client, the Bayer concern, writes apologetically:

> This film was produced with purely positive intentions. The Buddhist monk, symbol of peace of mind, helped us to convey the calm that the products of Baygon bring with them. We never had the intention to offend in any way against Buddhist principles and especially not to treat them with prejudice. Quite the contrary: we simply showed positive values in this film: peaceful images, children, calm and peace of mind.

For all that, it remains open what analogy exists between the peace of mind of a meditator and the peace of death in which a Baygon product results by the killing of troublesome mosquitoes.[20]

123. In Tibetan monks, advertising has discovered new 'regular guys', trendy people. In almost all TV ads referring to Tibet, monks play a central role, and in many [magazine] ads too Tibetan monks advertise consumer goods—often modern technology such as computers, television sets or cars.

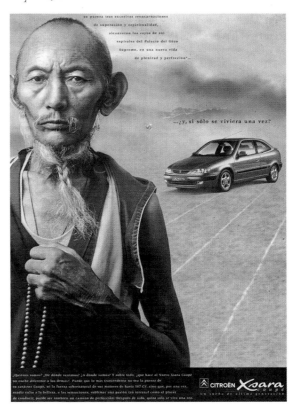

Interestingly, the majority of the commercials are for modern Western technology: cars, computers, televisions, office equipment—especially fax machines—and a vacuum cleaner. One is advertising a mosquito spray, and the rest are for products in the groceries sector: tea, beer, cheese, a bar, pastilles and a pick-me-up. Many of these products are such as go down well with the upper middle class, which may partly explain why Tibetan monks were used as transmitters of advertising: for the upper middle class, monks and Tibetan Buddhism, which they embody, are chic and 'in', while lower classes would have difficulty identifying with Tibetan monks.

Fountain of youth and levitation

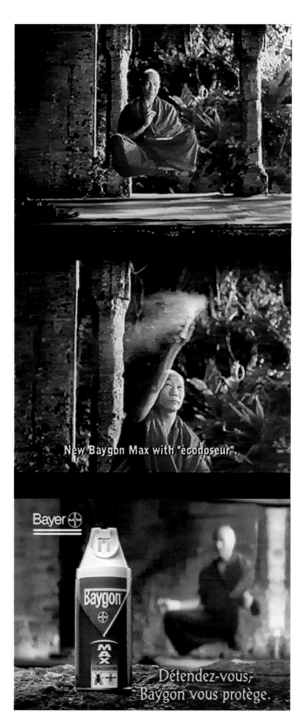

Only one commercial, the one for the pick-me-up Biogran, takes up the stereotype of the Tibetan fountain of youth, and three the phenomenon of levitation (*Electrolux*, *Leerdammer* and *Baygon*).

At the beginning of the unspectacular *Biogran* ad,[21] one sees images of praying Tibetan monks, which by their grey-brown colour give the impression of having been filmed in old Tibet. The first sentence also refers to good old Tibet:

> Tibetan monks live up to 120 years, without drinking, smoking and, of course, without sex.

Now follows a leap in image and text into the viewer's world: on a table top stands a jug full of milk. From the right a can labelled *Biogran* is put down. Commentary:

> If you want to live longer, but don't have the vocation to be a monk, drink *Biogran*. *Biogran*–retaaaaards aging.
>
> If you can't change your lifestyle, change to *Biogran*. There is still time.

The myth that in Tibet, as in Shangri-La, people grew to be very old, is reactivated in this advertising. The reason for the (alleged) great age of the Tibetans is not an elixir, but —much as in the Shangri-La novel by James Hilton—a moderate lifestyle: a life without alcohol, smoking or sex. This way cannot be expected of the Western viewer. Instead *Biogran* offers him an 'instant' way: the viewer too can enjoy the advantage of Shangri-La/Tibet, a great age, without having to give up his lifestyle, i.e., all the large and small departures from moderation. The elixir permits a life as long as the moderately living, always praying Tibetan monk's, who is to be seen again right at the end of the commercial.

Not long life, but coping with stress in a big

124. Advertising by dishonest methods: a (supposedly) Buddhist monk advertises a Bayer *mosquito-killing product. Meditative levitation—thanks to death-spraying* Baygon Max!

city is what Lipton's advertisement for green tea (*Tchaé*) promises. The film works by an opposition: first, images of the alarming, aggressive big-city chaos, portrayed through cars, hectic people 'hurled out' from a revolving door, in the background the wailing of a siren. These scenes, all in grey tones, are suddenly pushed from the screen by a Tibetan monk, in colour; at the same time a deep 'OM' sounds, and the monk turns towards the audience with the following words:

> I allow myself to interrupt all stress. I have brought you a cup of *Tchaé*.

The monk goes into a bright, unfurnished room, in which there are only two cushions lying on the floor (association: Japanese tea house), up to some objects standing on the floor: two drinking bowls, a teapot (all non-Tibetan, but rather Japanese) and a packet of *Tchaé*.

> I have brought you a cup of *Tchaé* … for only the green leaf calms the mountain. If you take the time to appreciate this fresh taste, it wakes up the mind and revives the body.

With these words, the monk moves both his hands from his breast above his head and down again in a circle.

> I invite you to make your acquaintance with the mysteries of the Orient.

The monk brings in, on a tray covered with a white cloth, a drinking bowl full of tea. The last but one image displays a symmetrical construction: a *Tchaé* can in the centre, others to left and right, on the far left a black teapot and in front of it a *Tchaé* tea bag, on the far right a drinking bowl and in front of that the label *Lipton*.

The last scene harks back to the first: relaxed, i.e., without signs of stress, the monk rides between two stationary columns of cars, cheekily ringing his bicycle bell a couple of times … Thanks to *Tchaé*, he has brought stress—represented by the stationary vehicles—to a halt and can move effortlessly and without problems.

We notice in this ad the confusing of two Asian cultures. In this scenery one would expect a Japanese, perhaps a Zen monk. Instead, a Tibetan-looking monk appears, recognizable as such only by his robes. In his behaviour, manner of walking, and gestures, he again resembles more a Japanese than a Tibetan. As already mentioned,

ethnographic exactitude is of no concern. Any current positive Asian images—Zen, Japanese tea ceremony, mantra (Om), Tibetan monk, mudra (gestures)—are cobbled together without a qualm into new images.

Of the three 'levitation ads' we should like to confine ourselves to one, that for an *Electrolux* vacuum cleaner.[22] A monk opens a door and looks into a temple-like room, recognizable by the (non-Tibetan) columns and the predominant dark red

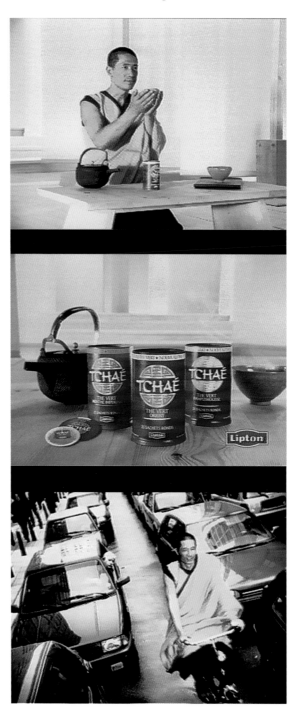

125. A Tibetan-looking monk in a Japanese ambience. Green tea versus big-city stress.

colour. In the room nine monks are sitting in meditation position, eight of them floating in the air about a metre away from the floor. The ninth, middle monk slowly floats to the same height.

New take: the monk who previously looked in at the door moves about with a vacuum cleaner over the large (non-Tibetan) carpet that lines the temple, and cleans the carpet beneath the central monks. When he finishes this, the meditating monk abruptly moves downward and lands—quite audibly—back on the floor. The same thing happens, only quicker, with the other levitating monks. Commentary:

> When you need to get the cleaning done fast
> Get the *Electrolux Wide Track*.
> It is 25 per cent wider than most of the vacuum cleaners.

When all the monks are sitting on the floor again, a strongly symmetrical group picture results: in the background, arranged centrally in the middle of the picture, four columns can be seen, which divide the image into five parts, an ordering to which the monks sitting in front appear to submit: in the centre and closest to the camera the chief monk, to left and right four monks each, each one farther back in the room the farther from the central monk he is.

After close-ups of the vacuum cleaner, the meditating monks open their eyes. Final image (freeze frame): vacuum cleaner and text:

> The *Wide Track*, intelligent design from Electrolux.

Of particular interest in this advertisement—apart from the fact that the levitation myth is adopted in it—is the iconic group picture of the nine monks. We shall see that in the Tibet advertising under discussion here, this iconic structure is used again and again.

126. *Cleanliness in a Tibetan monastery, thanks to levitation and the* Electrolux Widetrack.

The fraternization of modern technology with traditional religion

As already mentioned, Tibet-related TV advertising uses almost exclusively Tibetan monks and the majority of it advertises modern Western technology. If we also consider product advertisements that make reference to Tibet, the same thing stands out: an old and a young monk advertise a climbing rope (*Beal*), a monk encourages the purchase of a camcorder (*JVC*), the Dalai Lama advertises *Apple*, the Tibetologist Glenn Mullin and four monks from the Tibetan Drepung Monastery advertise an *Apple* laptop, the monk Lobsang Namgyal advertises a fashionable range of glasses (*Silhouette*) and so on. What might the reasons be why more and more advertising people are discovering Tibet and using and misusing it for their own purposes? To answer this question we should like to analyse in more detail the pictorial and verbal language of some of this advertising.

A barren, rocky landscape; in a cleft forming a valley the point of a stupa can be seen. Around twenty monks are sitting on a clifftop. One after the other, close-ups of individual monks with the following text dubbed on:

> It's a beautiful thing.
> You can say that again.
> *IBM* and *Lotus* in spiritual harmony.
> Just imagine ... Notes workgroups by the thousand..
> Collaborating all over the universe.
> On just about any platform they like.
> Cosmic.
> Hey, keep it down!
> Some people want to be alone with their thoughts.

Freeze frame:

> IBM—solutions for a small planet.

The monks leave over the cliff in single file, the image is frozen.

In the whole ad, no computer is shown and the word 'computer' is not used. That it is a computer advertisement the viewer learns only through individual words of the dubbed-on text: *IBM*, *Lotus*, *Notes* workgroups, platform. In a play on words, some contrasts are subtly mentioned that— according to the advertisement—are nothing and do not need to be anything: '*IBM* and *Lotus* in spiritual harmony.' *Lotus* can indeed be understood as the name of the software company now owned by IBM ('the superhuman software'), but in this advertisement Lotus undoubtedly has a second meaning: lotus, the sacred flower of

Buddhism, is here a symbol for the Buddhist religion.[23]

In other words: between *IBM* and *Lotus*, between the modern computer world and the traditional world of Buddhism, there is no dissonance, but both are 'in spiritual harmony'. They fit so well together that one or other monk even imagines already that this technology could be used with profit for the entire universe. A religion embracing the entire universe supports itself on a technology embracing the entire universe. Both—Buddhism and IBM—are cosmic, universal ... are of equal birth! Computer technology a kind of universal religion? What Helena Petrovna Blavatsky and many other Theosophists with and after her postulated, the unity and universal brotherhood of the great religions (especially Christianity and Buddhism), is propagated today under new auspices: not Buddhism and Christianity, but Buddhism and information technology should become allies. The belief in the universality of modern technology gives it the characteristics of a religion. What could be more natural than getting in contact with brothers of another universal religion—with monks in Tibet, the descendants of the Blavatskyan Mahatmas?

Then as now, the partners addressed in Tibet were 'brothers', not sisters. Tibet advertising is entirely male-centred. In all the commercials, it is exclusively men who are found in the main roles—monks. Women are no more than extras.

127. Tibetan monks advertising for IBM *in front of a Himalayan backdrop.* IBM *and Buddhism in spiritual harmony.*

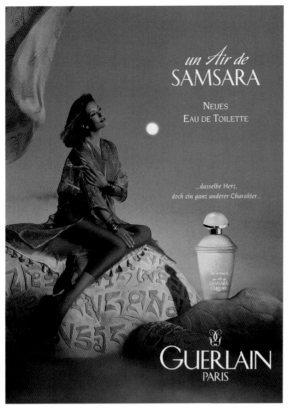

128a

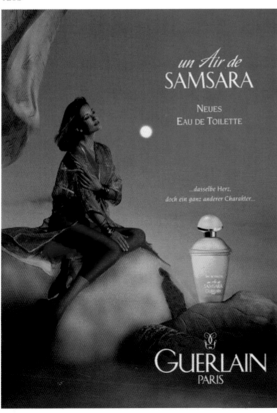

128b

The male-dominated world of traditional Tibetan knowledge is indeed not so remote from the male-dominated world of Western technological knowledge. Is it a matter of a 'fraternization' of the (male) knowledge-holders on both sides, in traditional Tibet and in the modern West?[24]

In one of the few Tibet-related advertisements in which a woman is at the centre—not indeed a Tibetan, but a Western woman—it caused a major row, as the advertisers committed a sacrilege. In an ad for the perfume *Un Air de Samsara* (*Guerlain*), they put a woman sitting on a rock, into the side of which were amateurishly chiselled a kind of Tibetan characters, similar to a Tibetan mani-stone. The ad led to protest by French Buddhists and academics, as the script is regarded by the Tibetans as sacred and like anything sacred should not be touched either with the feet or with the backside. Guerlain were obliged to amend the image: after that the woman was sitting on a bare rock, from which the Tibetan characters had been touched out. Only a prayer flag fluttering in the wind then allowed one to guess that she could have been somewhere in Tibet or the Himalaya.

A message similar to that of the above-mentioned IBM commercial is conveyed in a Taiwanese ad. In this the viewer is transferred with a few images into the world of a monastery somewhere in the Himalaya or Tibet: a praying Tibetan monk, mountains, a large rotating prayer wheel, monks outside a Nepalese temple (evidently the temple stands for the outside of a Tibetan monastery), and monks playing Tibetan ritual instruments.

The next take shows from above the central hallway of a temple, with monks sitting on the floor to left and right, facing the centre of the hall. Slowly a monk approaches the 'apse' in the hall, that is to say, the place where there is normally an altar with deities and offerings, but in the film there is a large television set on it. The sacredness of the 'Buddha-technology' is emphasized by three monks sitting near the TV monitor lowering their heads as if they were bowing to the 'TV Buddha'.

Suddenly a young monk reaches into his robes,

128. A lapse by Guerlain: *a model sat on a pseudo-mani-stone, so profaning the (pseudo)-Tibetan inscription. Protests by Buddhists and Tibetologists led to a correction—and an indirect confession of the mistake: the characters were removed (bottom picture).*

takes out a remote control and switches the television on with it; a football match is being transmitted just then. At that moment, some monks who were standing outside the temple turn on their own axes and run inside the temple, where there is already a disorderly crowd of monks sitting side by side and looking spellbound at the TV, now laughing, now howling. Then an older monk comes up from behind and resolutely turns the TV off with the remote control. The monks look back, some astonished, some horrified.

The next take shows the old monk in his beautifully furnished cell—apparently he is a clerical person in authority. The old man is holding in his hand the remote control of a games console for—the next take makes it clear—a *Nintendo* game, which he plays with great pleasure. The TV he is using for his game is identical to the one from the temple, so that it can be assumed that the old man had it transported from the temple to his own room. As previously in the temple, the TV here occupies a most sacred position: it stands instead of a statue in the centre of the room's altar, raised slightly on a pedestal wrapped in the holy colours yellow and red, with rows of offering bowls in front. From the back a young monk with a beaming face approaches and says:

> Let me go on the Internet, then I can find out something about the news in the stars,

whereupon some astrology web pages appear on the screen and then a page in the centre of which is 'TV' surrounded by the words 'Computer', 'Game', 'Net'. The TV set is framed by red temple pillars to the left and right: the TV monitor as a modern shrine.

In the closing scene, the high-tech world is no longer remembered. The two monks are sitting in seclusion on a rock and seem to be meditating, until the older one says to the younger:

> Living Buddha (Rinpoche), Bill Clinton has sent you an e-mail.

Final freeze frame: *Sampo.*

Many of these (TV) advertisements offend against the perceptive expectations of consumers. They work with the contrast between two worlds, with paradox. It is suggested that what is being

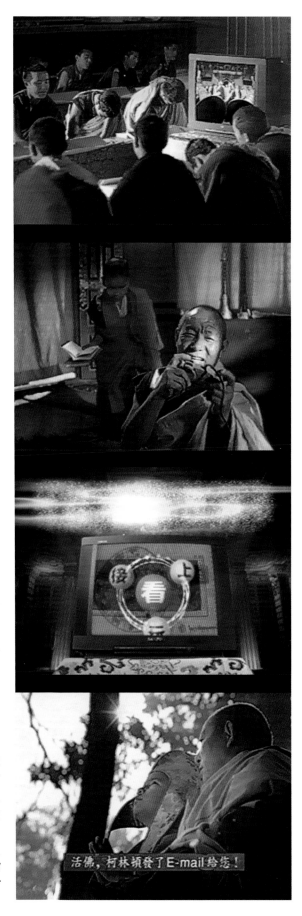

129. A Sampo *television has displaced Buddha from the altar— both in the monastic assembly hall and on the Abbot's altar. Instead of prayer, a football match; instead of reading books, a computer game and an e-mail from Clinton …*

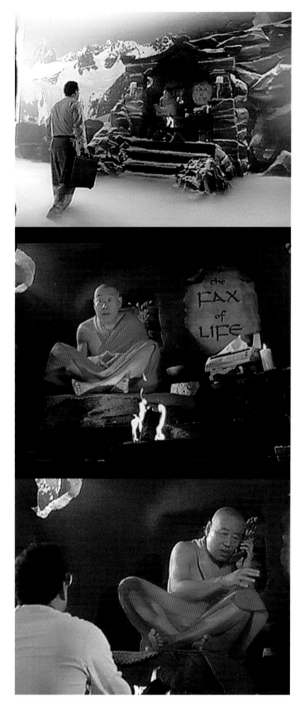

130. 'Dali' as a transmitter of the facts of life and 'the fax of life'—thanks to the Danka fax machine.

to the strange world of the spirit, can use this modern technology just like Western people, indeed they are fascinated by it and want to use it, like the old monk playing a video game with a young one, or as we shall see, the young monk driving up and away again in a Renault Clio. Even people of modest needs (is there anyone of more modest needs than a Buddhist monk?) have a yearning for modern technology, and even those who must be technical wash-outs know how to handle this technology. For example, the printed ad for a *Macintosh* laptop with Buddhist monks implicitly contains the message: these monks come from a completely non-materialistic, non-technical world, but computer technology helps even them. Or in the case of an ad for a fax machine: even a monk working in far-off Tibet can no longer carry out his work of spiritual welfare without a fax machine (and mobile phone), as the following *Danka* commercial shows.

A man with a white shirt and a tie drives in a jeep marked *Danka* up a steep mountain road, with snow-covered rocks on either side. In the next scene the Danka man, clutching an attaché case in his right hand, climbs round a projecting rock edge, over snow and—with his last strength as it were—over a cliff. Spoken text to this:

> If your office equipment ever breaks down, call Danka. No matter where you are in the business world, we will be there in two hours or less.

The Danka man arrives on a small, snow-covered plateau, where there is a little cave-like temple; in this sits a Buddhist monk with reddish robes.

> Monk: 'Welcome, my son.'
> Danka man: 'Hallo Dali.'
> Monk, called Dali: 'Everyone wants to know the facts of life.'

At the same time the camera shows a poster hanging to the monk's left, with the words *The fax of life.*

> 'But look at the jam.'

The monk points to a fax machine beneath the poster, in which a paper jam has occurred.

> Danka man: 'I can fix that.'

Open-plan office with a lot of equipment, dubbed on: '2-hour service guarantee'. As spoken text:

> Only Danka offers copiers, fax machines and digital systems with this world-class service guarantee.

The Danka man in the mountains again with Dali, who says:

> 'You are wise beyond your age, Danka man.'

Dali receives a call on his mobile, listens and says:

advertised basically does not fit in the world of the Tibetans. Here in the West we use ingenious technology, there in Tibet they have fascinating spirituality and superhuman powers. But—and this is the pattern behind many of these advertisements—the paradox or dilemma exists in appearance only. The Tibetans too, who belong

'Maureen, not now, I have a customer.'

Turning to the Danka man:

'They don't let you live.'

Spoken text:

Danka—world-class products, world-class service.[24]

Many commercials, however, are about more than proof that the right machine can be used even by someone who has dedicated himself to the spiritual life. Many of them offer a far more complex paradox, which the product being advertised can resolve. An early advertisement of this kind is the printed ad already mentioned for a *Macintosh* laptop, which appeared in many magazines in summer 1992.

A symmetrical image: in the centre is a Westerner, holding a laptop in front of him, its screen turned towards the viewer; he is surrounded by four monks, two standing to his left and right and two farther back, a little raised up, also to his

left and right. One feels reminded of the basic construction of a mandala, with one deity in the centre and four more deities in the four cardinal directions. The four Tibetan monks, all wearing yellow hats, are grinning, and the white man is simply smiling. On the screen a document is visible that refers to the four monks and the reason for their presence. On the right-hand side of the picture is advertising text for the Macintosh the white man is holding in his hands. The text on the screen, under the title 'The Tradition of Drepung Loseling', describes the Drepung Monastery and one of its departments, Loseling, which after the events in Tibet in the 1950s was moved to South India. A small group of monks are working there for the preservation of the cultural heritage of this spiritual institution. Further on in the text, it says that in 1988 Loseling carried out its first tour of America and Europe

131. Advertisements related to Tibet are often constructed with strict symmetry and reminiscent of icons. In this case the advertisement displays furthermore a mandala-like structure: a central figure in the middle, with four more monks arranged about him in the four cardinal directions. Just as an authentic mandala expresses not only symmetry, but also a clear hierarchy, so also in this 'advertising mandala' the central figure clearly appears to stand higher than the others. For it is this person—remarkably, a Westerner—who is holding the object that is advertised by the text in exuberant tones on the right—an Apple laptop.

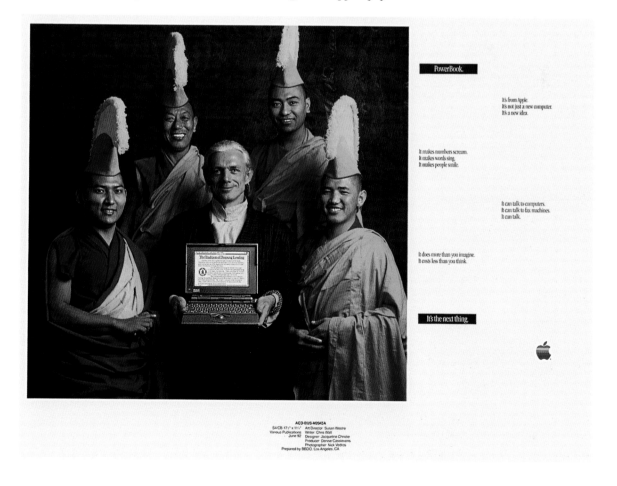

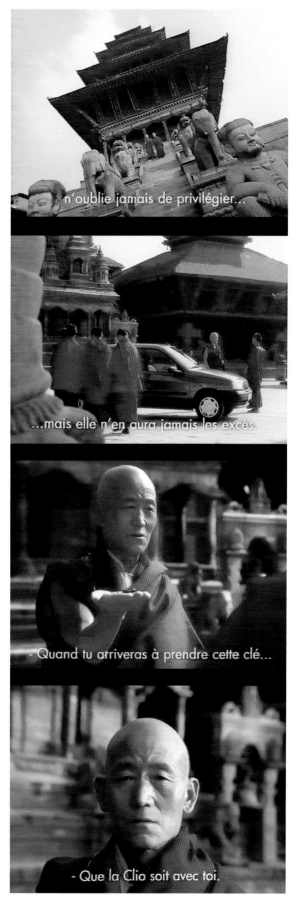

and performed sacred music and dances for world peace. On the present tour, traditional Tibetan practices would be used for the purification and healing of our troubled planet.

This text, transmitted with the aid of a hypermodern medium, therefore states as its main point that the ancient spirituality of Tibet is to help the sick planet Earth, tradition cures the ailing modern age. But in the centre of the ad is neither a Tibetan sacred object nor a Tibetan, but a computer and a Westerner, whose yellow shirt with stand-up collar is the only thing Tibetan about him. An object is being advertised from this very non-traditional, modern world that is evidently in need of healing. A paradox? Only partly! The planet may need help, but not Macintosh. Macintosh—and here we come to the text on the right, formulated in haiku style— provides the solution! *Apple*'s laptop

> is a new idea … It can talk to computers. It can talk to fax machines. It can talk.

This means it can communicate even with the seemingly so incompatible world of traditional, spiritual Tibet, which—thanks to modern technology—can widely disseminate its practices for the saving of the planet.[26]

Another example of a commercial that plays with paradox is one for a *Renault Clio*. On a monastery roof, two Tibetan monks with yellow caps are playing long trumpets. Large prayer flags are fluttering in the wind, there are mountains in the background: evidently we are somewhere in the Himalaya or Tibet. In one of the next scenes we see praying monks in a Tibetan temple. Some of the monks are playing oboes, whose tone slowly changes into European music. A monk opens the temple door. From a new viewpoint the camera reveals how from above two monks are walking down the steps of a—now all of a sudden Newar— temple. The old monk says to the younger one:

132. Even people of modest needs (is there anyone of more modest needs than a Buddhist monk?) have a yearning for modern technology, and even those who must be technical wash-outs know how to handle this technology. Especially when it comes to a Renault Clio, *a car that travels on the Buddhist Middle Way, of right measure. 'Never forget to give precedence to personal values over material values' … 'And here's the car you want for that. It costs only 51600 francs and contains all the riches of big cars, but will never have their excesses.'—'When you manage to take this key, you will be able to go back into the world.'—'May the* Clio *be with you!'*

Never forget to give precedence to personal values
over material values.

Medium-sized prayer wheels turning; the two traverse a spacious Newar square and approach a car parked there. The old monk says, while approaching the car with the younger one:

And here's the car you want for that.
It costs only 51,600 francs
and contains all the riches of big cars,
but will never have their excesses.

When the two monks have reached the car, the old one holds a car-key in his out-stretched right hand and says:

When you manage to take this key,
you will be able to go back into the world.

The young monk moves his hand like lightning against the old one's hand, who closes it into a fist just as quickly, draws back the closed hand, opens it and is visibly astonished to find it empty. The young man was quicker.

The young monk climbs into the car—merely represented by a close-up of the front door, behind which a corner of the monk's robe disappears before the door shuts.

The car turns round the corner of a house; the old man's face, which initially filled the screen, gets farther away (as if the camera were filming through the rear window of the moving car), and we hear what the old monk is thinking:

May the Clio be with you!

Closing image: filmed from behind, the *Renault Clio* moves quickly away past a Newar temple on the large square. Text:

Clio, à partir de F51600;
mais que reste-t-il aux grandes?

[= Clio, from 51,600 francs; but what's left for big cars?]

As mentioned, this commercial too plays with paradox. The first paradox is the older monk's exhortation to the young one:

Never forget to give precedence to personal values
over material values.

It is not *spiritual* values to which the young monk is to give precedence, as would basically be expected of a Buddhist monk, but personal ones. What this means remains at first unclear, until the old man says:

And here's the car you want for that. It costs only
51,600 francs …

A second paradox: what applies to other cars apparently does not apply to the Renault Clio: the Renault Clio does not belong to material values. Perhaps because it offers all the riches of its bigger brothers—in moderation? Is it supposed to be being suggested here that it is a 'Buddhist' moderate-sized car, that travels on the Buddhist Middle Way, of right measure?

Also unusual is the test to which the young monk is subjected, and the reward he is offered for passing it:

When you manage to take this key, you will be able
to go back into the world.

This too is a paradox, after all the goal of a Buddhist monk does not involve going back into the world, never mind that one of his own teachers invites him to and even wishes 'May the Clio be with you!' This amounts to equating a Western consumer good with the Buddha, for should not a monk's wish far rather be 'May Buddha be with you!'? The car as Buddha, as God![27]

Rein-Car-nation

The equation of a car with the supreme Buddhist state also occurs in another ad for a French car—*Citroën Xsara Coupé*—entitled 'Reincarnation'.

Distant view of a mountainside, on which people are moving in single file, forming a fine, slowly moving line. We hear prayers and see mani stones in a mysterious light. The people are going towards a monastery. In its courtyard a dead body has been laid out, apparently a high monk. An incarnation? His head is covered with a cloth. Spoken text:

The spirit of the great lama was so pure
that when he left his body

it chose a simple waterdrop
in which to seek its next incarnation.

A younger monk looks up at a bell, from whose clapper a drop of water is detaching itself. At the same time a vibrating tone rings out. Commentary:

Having rejected wealth and all earthly pleasures
its reincarnation will shine like a diamond.

Close-up of the face of an old Ladakhi layman, in front of whom the drop falls down.

High above the monastery roof, the camera looks at the plain in front of the monastery. There many people have gathered for the cremation of

the corpse, which the next scenes show.
Commentary:

> Having slipped the bonds of human form,
> its reincarnation will fly like the wind.

Picture of a monk who is looking upwards and
holding his hands in front of him so as to catch
something falling from above. The water-drop falls
down and between the hands of the monk, who
gazes after it.

> Exactly a thousand moons later ... fate led him to
> the perfect reincarnation. A Xsara Coupé.

In a close-up, bird's-eye view, we see the drop
making its way at high speed from the camera to
a street, which crosses the screen from top to
bottom—clearly not a street in the arid Himalaya,
as it is covered with many leaves. Along the street
a car is driving—evidently 'the reincarnation'.
Change of camera angle: car from in front, from
behind; it is clear that the car is moving in an
avenue.

Back to the bird's-eye view of the falling drop
rapidly approaching the car. Various close-ups of
passing cars from the side. Closing scene: car from
behind, retreating along the tree-lined street.
Behind the car is a puddle, in which the drop falls.
Apparently it has just missed its new incarnation
... Commentary:

> Oh shit!

In this film a car, the Xsara Coupé, is (almost)
the reincarnation of a deceased tulku. More, of a
tulku liberated from the fetters of human form,
that is to say, a tulku who because of his perfection
will not be reborn again, i.e., who has attained
Buddhahood. Let us recall what was said about
the future reincarnation of the high lama: that it
is immaculately pure, is as radiant as a diamond
(likewise a symbol of purity and perfection), and
flies like the wind. Exactly a thousand months
later the lama seems to have chosen a car as his
place of reincarnation, suggesting that this is
the diamond among cars, car perfection. Perfect
spirit and perfect material are (almost) one.

*133. Perfect mind and perfect matter are (almost) one: the mind of
a perfect Tibetan sage (nearly) embodies itself in the highest
'autoperfection'—a Citroën Xsara Coupé. 'The spirit of
the great lama was so pure that when he left his body it
chose a simple waterdrop in which to seek its next
incarnation.' ... 'Having rejected wealth and all earthly
pleasures, its reincarnation will shine like a diamond.'
... 'Having slipped the bonds of human form, its reincarnation
will fly like the wind.' ... 'Exactly a thousand moons later ... fate
led him to the perfect reincarnation. A Xsara Coupé.'*

Another paradox.

The filming of this commercial is quite superb, masterly. The producers, Michel Rivière and Partho Sen Gupta of *IF Productions*, paid heed to ethnographic authenticity and never resorted to lazy compromises. Nevertheless there remains a feeling of unease, for with its principal message the ad offends fundamental religious feelings. Those offended, however, cannot defend themselves. What would happen if the Xsara Coupé were portrayed as a resurrected Christ?[28]

The commercial for a *Thomson* television set also plays with the frugality, remoteness and spiritual world of Tibetan Buddhism. Much as in the other films in which Tibetan monks take the principal parts, the viewer is got in the mood by several short scenes: a metallic, gleaming gold, honorific umbrella on a monastery roof, in the background a beautiful mountain landscape, a gong is heard, a young Tibetan monk (or perhaps a young nun?) looks out of a window. A child's voice says:

> One day one will sit down on the edge of the world,
> to be able to see all the planets at the same time.

Young monks or nuns leap over the monastery yard and through a gate into the open air. They run up a slope, along a large crevice, past a mani stone, and on up. Man's voice:

> Because children are the heralds of the future, we
> have a lot to learn from them.

When they have arrived at the top of the mountain their faces are shown in close-up. To these extreme close-ups—we see only details of the children's heads—the wide-angle shot that follows forms a sharp contrast: the children, previously shown oversized, almost disappear in the next scene, where we see from behind three monks sitting close to each other, side by side, as little dark silhouettes in front of a magnificent mountain panorama, which they are looking at. Commentary:

> For example, such views deserve to be seen in their
> full extension.

Another abrupt cut: insert of a television set.

> Your Thomson TV … Thomson autant voir grand.
> [= Thomson, it's as well to see big.]

This ad too works with contrasts: the spiritual world of Tibetan Buddhism is confronted with the communication technology of the Western, material world; the small person with the gigantic universe. The Thomson TV set, it is suggested, is the right device to show all aspects, to make every

134. Young Tibetan monks and the magnificent landscape of the Roof of the World here serve as synonyms for humanity and universe, future and infinity, which only one device can reproduce properly, a Thomson *television.*

viewpoint possible.

The seemingly incompatible can be surmounted! Whoever does not believe it should look around for the Tibetan 'Mahatmas', the lamas. They levitate, play basketball, cope with big-city stress, design vodka bottles, make computers into

Buddhas, travel without car problems, and even reincarnate themselves as a car. Matter and spirit, technology and religion, big city and monastery are only apparently opposed, contradictory and

incompatible—as the Theosophist Blavatsky already recognised in her book *The Secret Doctrine*, which after all bore the subtitle *The Synthesis of Science, Religion and Philosophy* ...

Advertising icons

We have already pointed out several times the markedly symmetrical construction of individual 'key images' in various commercials and printed advertisements. Both the (printed) ad for a Macintosh laptop and a TV commercial for tea from Taiwan display the basic structure of a mandala, the embodiment of symmetry: a central figure in the middle, around which four more monks are arranged in the four cardinal directions.[29]

A mandala does not express only symmetry, but also hierarchy. The central figure is clearly superior to the others. In the Apple advertisement, the central person is holding in his hands the product the advertisement is about, a laptop, and in the tea advertisement from

Taiwan the central monk is the announcer of the advertising message while the monks surrounding him remain silent. Hierarchy and thus authority is also displayed in some other ads presented here, such as the TV commercial for a Sampo TV and the one for a Renault Clio. In the latter, the teacher's authority is emphasized by his transmitting (supposedly Tibetan) wisdom to his disciple. This also occurs in the printed ad for a *Beal* climbing rope: the old monk visible in the background appears to give the novice sitting in front of him in a dignified posture—and so also the reader—again the supposedly Tibetan wisdom on the way:

> When your soul and your body are intimately linked, then and only then will you form a whole

135. More icon-style Tibet advertising: monks advertise a Tibetan tea—meditative calm ...

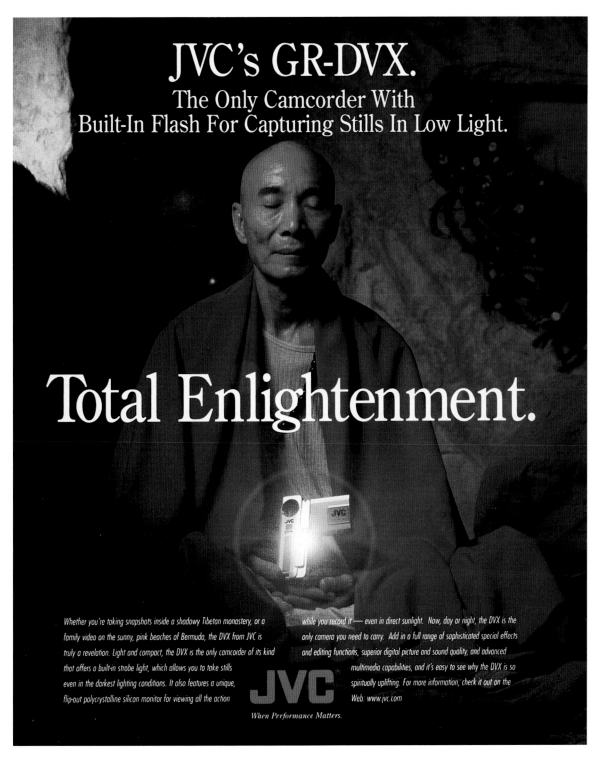

136. ... a camcorder—total Enlightenment.

capable of standing up to the vertical world. We have seen how much the male 'Lamaist' hierarchy has fascinated the West for centuries. Dalai Lamas, Panchen Lamas, tulkus, obscure clergy such as the Mahatmas or the 'Seven Beings' and other questionable monks have stimulated the Western imagination again and again. The advertisements that emphasize hierarchy, order and spiritual authority appear to take up once again this interest, which is probably rather more

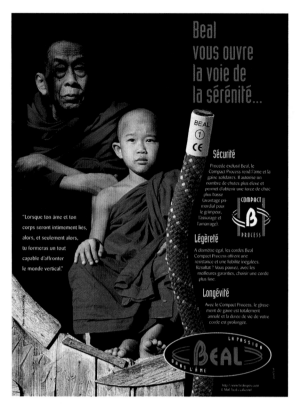

137. ... a climbing rope—security ...

that divides the screen into two exactly equal parts.

Many advertisements fall back on authentic Tibetan religious images, which reinforces the icon effect. For example, in a *Swissair* ad (Austria operational campaign), which shows a detail from a Tibetan scroll painting—the historical Buddha sitting on a lion throne. The relaxed meditation posture of the Buddha arouses associations that are amplified by the text beneath—relaxed, easy, comfortable, spoiled, hospitality, floating and travel to the Far East are the associative words that seek to establish a connection between the 'Buddha' icon and the service being sold—quick and easy journeys from Austria to Asia via Zürich.

An advertisement for the holiday airline *Condor* aims at something similar. This shows, full-frame, the Tibetan bronze statue of a monk, who is sitting in meditation posture on a comfortable, three-layered throne cushion and is apparently 'perfectly happy'. This is indicated by the thought-bubble left empty and the text

than that, in fact a deep-seated need. A further indication of this is the fact, already mentioned, that Tibetan women do not appear in a single commercial or advertisement. To look at the Tibet image of advertising, only monks live in Tibet. No laymen, no women, no nuns.[30]

Besides the advertisements or advertisement elements clearly constructed in mandala style, there are other symmetrical images recognizable, which can best be described with the term 'icon'— a term that of course includes the advertising images here labeled 'mandalas': images clearly arranged about a central axis, in the centre of which is the sacred object or the product stylized as sacred. Besides the 'mandala images' already mentioned, such icons are included in the Electrolux, Sampo, Xsara and Tchaé commercials. In the Electrolux commercial, the eight monks arranged either side of the central monk; in the Sampo one, the 'iconoscope' (TV set) framed by two pillars that appears as an altar; in the Tchaé ad, the centre-accenting arrangement of three cans and other objects; and finally, in the Xsara ad, the back of the car, seen right in the middle of the screen, which is moving away along a street

138.(a) Advertising with Buddha Shakyamuni for Swissair. *(b) Fly with* Condor *like a perfectly happy Tibetan lama. (c) Buddhist statue as a symbol of the journey inwards.*

Je weiter man fliegt, desto entspannter sollte man ankommen. Die Swissair bringt Sie schnell und bequem von Österreich in die Schweiz und von da schnell und bequem nach Bangkok, Beijing, Bombay, Hong Kong, Jakarta, Karachi, Manila, Seoul, Singapur oder Tokio. Ab Genf oder Zürich reisen Sie ausschliesslich in Grossraumflugzeugen mit allem erdenklichen Komfort. Wie immer verwöhnt von unserer sprichwörtlichen Gastfreundschaft. Welche Fluggesellschaft schwebt Ihnen nun für Ihre nächste Fernostreise vor? **swissair**

138a

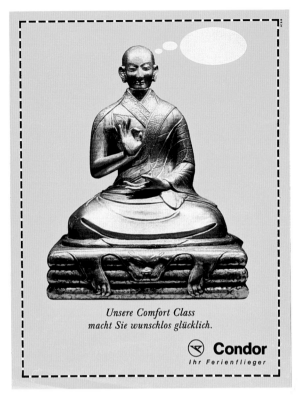

*Unsere Comfort Class
macht Sie wunschlos glücklich.*

Condor
Ihr Ferienflieger

138b

directly at the viewer, with a slight smile, holding his hands clasped in front of his chest. At top right is the only spot of colour, the nibbled-apple logo of Apple; beneath this, the message: 'Think different'. At lower right, as if in answer to the question that may be intended by this message, is Apple's internet address: www.apple.com. The Dalai Lama as an exemplar of different, divergent, out of the ordinary, exceptional thinking, precisely, 'Apple thinking'. Perfect spirituality and perfect computer technology (from Apple of course) are compatible, indeed one: perfect universal knowledge! However, the message has one flaw: like all the advertising messages shown here, it is not universally valid, even if it seeks to give that impression. It is dependent on the Tibet image of the consumer. The message of the Apple ad did not mean anything to a different ideology, that of the market-economy socialism of China; the consequence of this was that Apple were unable to deploy it in Asia. Asians—especially Chinese living in the People's Republic of China—have their own Tibet images and stereotypes.[32]

beneath the statue:

Our Comfort Class makes you perfectly happy.

A similar advertisement comes from the *Lotus Travel Service* in Munich. With a postcard, on which one can see Buddha Amitayus on a background of palm trees, this service advertises 'Travel to self and others'.

In 1998, activities marking the first anniversary of the death of Diana, Princess of Wales were advertised with a light blue poster, in the centre of which sits a large Buddha Vajradhara; this too is an 'icon ad'.

How problematic the use of religious symbols and icons in advertising can be is shown, apart from the examples already mentioned (*Un Air de Samsara*; Baygon's mosquito-killer), by an advertisement that unites in exemplary fashion paradox and iconolatry, the worship of images. In addition, it is a good example of the so-called reductionist or minimalist style, the reduction of the advertising message to one central idea. It is an *Apple* advertisement, which was to be seen among other things as a large poster in American cities. On it is seen a black and white portrait shot of the Fourteenth Dalai Lama.[31] He is looking

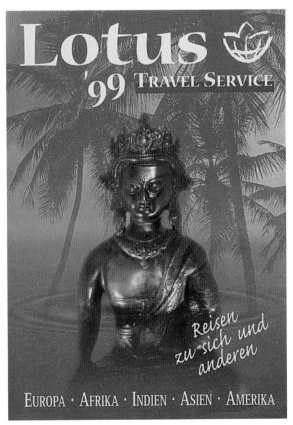

138c

139. What Tibetan Buddhas and deities all have to suffer: Poster with Buddha Vajradhara, referring to events in Zürich on the occasion of the first anniversary of Princess Diana's death. ...

140. ... The historical Buddha with a chef's hat: advertising a Zen cookbook with a Tibetan statue.

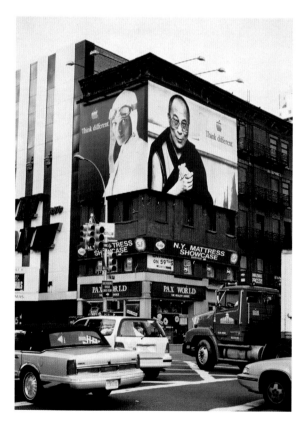

141. Thus Tibet grows ever more fashionable as a nation, and six million Tibetans, draw ever closer to extinction. To dramatize the plight, the Dalai Lama is forced to cooperate with pop culture that brings down everything it exalts. ... If the Tibetans encourage such projects (Apple advertising with the Dalai Lama), they risk the distortion of their culture. If not, they face its destruction. ... ' (Pico Iyer, The New York Times, 24 April, 1998)

C. Commerce

The commercialization and trivialization of Tibet

It's official. Crystals are out, Tibetan Buddhism is in.
(From a J. Peterman catalogue, USA.)

Commerce has discovered Tibet. In recent years, Tibet has been strongly present in advertising, especially—as we have already seen—Tibetan monks. But there are also more and more products that could be described as 'Tibet products'. Well-known firms are creating a kind of 'Tibetiana', Tibet collections, or at least give their ranges a Tibet touch. Thus *Hermes* created a silk scarf on which Tibetan pilgrims move round a stupa, resembling the one at Bodhnath. *Swatch* produced a watch with the name 'Lama', on whose dial a Tibetan good-luck knot is to be seen.[33] *Silhouette* issued a range of glasses under the title 'Tibet Collection'; *Mephisto* did an advertising campaign for their shoes entitled 'Tibet'. Tibet—for the most part sacred Tibet—is also represented in games, whether it be in the *Shangri-La* pinball machine of 1967 from the W. Williams company, in dice games (*Mo*), card games (*Secret Dakini Oracle*) and parlour games (e.g. *Samsara*) or modern computer games in which individual scenes deal with Tibet, such as *Tomb Raider II*, *Hexen*, *Megarace* and *Tintin in Tibet*. Finally, for the sake of completeness, let us mention once again the comics, novels and especially the feature films that are riding the wave of Tibet commerce.

A relatively new group of objects is comprised of Tibetan Dharma products, that is, objects that purport to be related to Tibetan Buddhism and for that reason are supposed to be particularly beneficial and salutary. We wish to deal in more detail below with certain of these products from the 'spiritual supermarket', as they too give

142. Some well-known firms have recently been creating a kind of 'Tibetiana': a Hermes *scarf, on which sacred Tibet is for once not reserved for monks. Among the pilgrims circumambulating the great stupa of Bodhnath, many lay people can also be made out, some of whom are holding prayer wheels in their hands.*

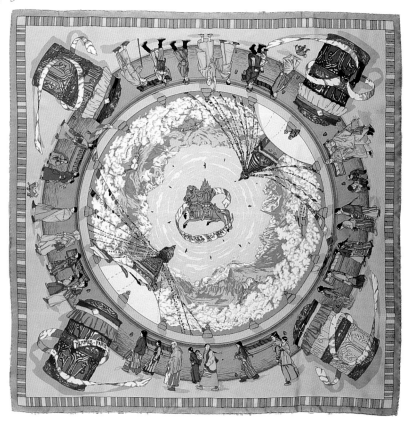

143 144

143–146. Tibet—for the most part sacred Tibet—is also represented in games, whether it be in the Shangri-La *pinball machine of 1967 from the W.Williams company (145), in astrological games (*Mo *and* Secret Dakini Oracle, *146) and parlour games (e.g.* Samsara, *144), or in modern computer games in which individual scenes deal with Tibet, such as* Tomb Raider II *(143),* Hexen, Megarace *and* Tintin in Tibet. *On closer inspection, however, it is revealed that many elements and motifs of the allegedly Tibetan games have no connection with Tibet: most of the cards of the astrological games recall tarot cards or show Hindu deities and symbols, and the architecture in the computer games and the pinball machine displays more Nepalese, Chinese and Japanese characteristics than Tibetan ones.*

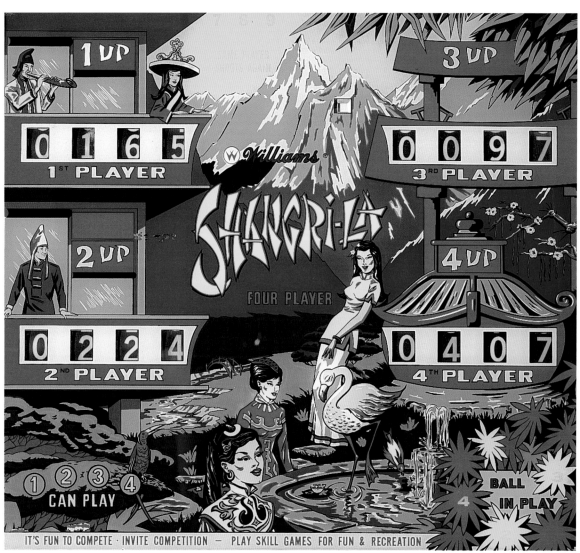

145

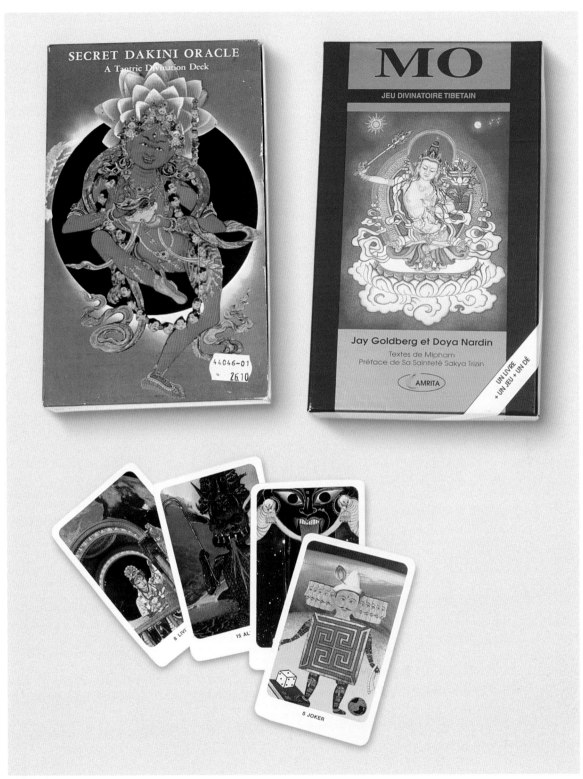

information about the Western stereotypes of Tibet.

> Haven't you wanted for a long time to do something for yourself? To be fitter; to feel happier; … to feel younger; … to cope better with stress; to cut down better on nervous tension, anxiety and worry; … to be more successful; to remain physically and mentally agile; to alleviate physical complaints; to be better prepared for the daily struggle for existence; … without great expenditure of time? without great effort? without costly equipment? Then 'The Five Tibetans' are just the right five exercises for you!

This is a passage from a prospectus in which one of the most successful 'Tibetan' Dharma products is advertised: *The Five Tibetans*, with which we have already become acquainted. Here it is argued exclusively egocentrically that the satisfaction of one's own needs is the goal. There is not a single attempt to mention higher, altruistic aims.

> Likewise with the following product:
> The fragrance of juniper, sandalwood, cardamom, black pepper, black mustard seed and an aphrodisiac mixture of 16 herbs prepared according to an age-old recipe handed down by Tibetan doctors creates the best conditions for romance and love …
>
> The Tibetan love cushion perfumes the bed and creates the best conditions for romance and love. The ideal wedding, St Valentine's day or birthday gift.

With these words *The Body Shop* advertised an inconspicuous cushion of red, shiny material, which according to the product information was manufactured by deaf women in Kathmandu. Thus the Tibet Eros myth, fostered in popular books on so-called Tibetan Tantra, is cultivated once again.[34] The authenticity of the product is guaranteed by Tibetan doctors and an age-old recipe.

Such a centuries-old recipe also serves as a guarantee of success with the *Precious Gem Formulas of the Himalayas Golden Dragon Series*. This is a bottle filled with eau de toilette, the front of which is adorned with a colour picture of a Tibetan holy man—apparently Tsong-kha-pa— and on the back of which the following information is found:

> From finely ground precious stones. Manufactured in the U.S.A. … This is the most powerful recipe, used for centuries, for winning love and a companion for life. You will immediately realize (on applying it) how people treat you with love,

friendliness, patience and respect. Fills your aura with 'attractive energy'. Great success with your employment discussions; helps against shyness in public speaking; generates a diamond-like light in the aura. To be sprayed and rubbed in on heart and head as often as necessary.

A typical example of an 'own-benefit Dharma article', which by its labelling arouses associations with Tibetan Buddhism and the Himalaya and in the product information connects these with wondrous effects.

One 'own-benefit Dharma article', the 'shaman jacket', is even granted magical powers:

> Now it's official: crystals are out, Tibetan Buddhism is in.
>
> In America, monasteries are shooting up like mushrooms from the soil. Hollywood, rock and Wall-Street stars sing 'Om mani padme hum'. But why run along behind, when you can overtake them all straight away?
>
> Long before Buddhism set foot in Tibet, the indigenous Bön shamans there got along quite well, without having to do without the belief in a personal existence (as is required of good Buddhists).
>
> Inspired by their ceremonial jackets, they devoted themselves entirely to everyday things such as relieving toothache and made sure that their stock never got too low with the common herd. They could fly through the air, communicate by telepathy and inflict interesting problems on their enemies.
>
> Surely you too would like to torment someone, for example by setting nine different kinds of destructive hailstorms on them?
>
> Authentic Bön shaman's jacket, hand-sewn in North India by Tibetan refugees, who know what matters. Wool with woollen dorjes (stylized lightning) embroidered on … Flush-seamed pockets

147. Cultivation of the Tibet Eros myth with the 'Tibetan love cushion' from Body Shop*; the authenticity of the product is guaranteed by Tibetan doctors and an age-old recipe.*

A typical 'own-benefit Dharma article': Precious Gem Formulas of the Himalayas eau de toilette. 'This is the most powerful recipe, used for centuries, for winning love and a companion for life. You will immediately realize (on applying it) how people treat you with love, friendliness, patience and respect. Fills your aura with "attractive energy". Great success with your employment discussions; helps against shyness in public speaking; generates a diamond-like light in the aura. To be sprayed and rubbed in on heart and head as often as necessary.' Fit und jung ein Leben lang *('Fit and young your whole life'): the almost unbelievable is made possible by the 'Tibetans', banal gymnastic exercises that originated in the imagination of business-minded Westerners.*

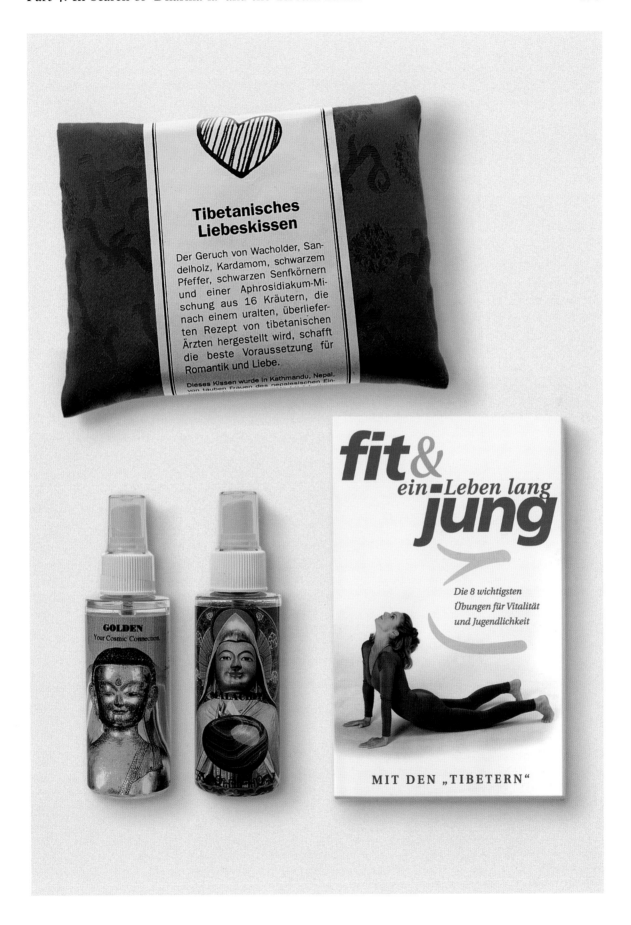

for magical herbs. Pearl-studded tassles for drawing off surplus energies ... (But you're sure to get the table you want when you're wearing it).

This product information subtly incorporates some current stereotypes: Bönpos, unlike Buddhists, do not renounce personal existence (self), are healers, fly through the air, are telepathically gifted and inflict bad things on their enemies. Their equipment: a shaman jacket, manufactured by knowledgeable Tibetan refugees. What could be better for the struggle for survival in the USA?

Basically, Buddhist products should not be acquired for one's own benefit, but for the good of all suffering, living beings. With certain Dharma articles, altruism is in fact appealed to, as in the case of pendants in the form of tiny prayer wheels, which contain a great many mantras on microfilm and can be turned in spite of their small size:

> Dharma-wheels, mantras on microfilm. Beautifully made prayer-wheel pendants of sterling silver; three thousand to a hundred thousand mantras in each wheel. Our intention is that the rotating prayer

wheels embrace all sentient beings in the blessings going out from them, open their hearts and minds to the Dharma and hasten their attainment of Liberation. For information and orders call us or send an e-mail. Please visit our website; we accept Visa/Mastercard and Amex; ten per cent of our sales is transferred to Dharma projects and activities all over the world.

On closer inspection, altruism often emerges as hidden self-interest, as in the following case:

> The Wheel of Time ... Kalachakra—Be a Warrior for World Peace! The designer's watch, whose creation is inspired by Tibetan sacred art and endorsed by His Holiness the Fourteenth Dalai Lama, is dedicated to the pursuit of enlightenment, world peace and a free Tibet. ... The central emblem embodies the entire essence of the Kalachakra teaching. Tibetan Buddhists believe in its protective power and its blessing. It is believed that coming into constant contact with the emblem by seeing, touching or wearing it would create causes for one to attain the basis for liberation from samsara in this life or in a near future life.

This is what it says in an advertisement for a watch, on the side of which it reads 'Kalachakra' and whose dial is adorned with a circle of stylized lotus petals surrounding the Mighty Ten Syllables of Kalachakra. The attainment of world peace, a free Tibet and liberation from the suffering cycle of existence—what more could one wish for from a watch? Except that it is 'Swiss made'—which is also attested by its being a dearer model. A technically perfect instant Dharma object has its price!

148 (left). Gilded 'treasure vase' made of clay, filled with many ingredients in accordance with traditional Tibetan practice: 'This Treasure Vase is an ancient remedy that can replenish vitality and balance to the essence of the elements. It has the power to magnetize wealth and abundance, improve health, remove obstacles to long life, pacify anger and warfare and increase wisdom and compassion for all ...'

149 (right). Sacred Tibet on one's own wristwatch: watch with lucky knot (Swatch); watch (Swiss made) with the Mighty Ten Syllables of Kalachakra: dedicated to the aspiration to Enlightenment, world peace and a free Tibet; watch with pseudo-mandala.

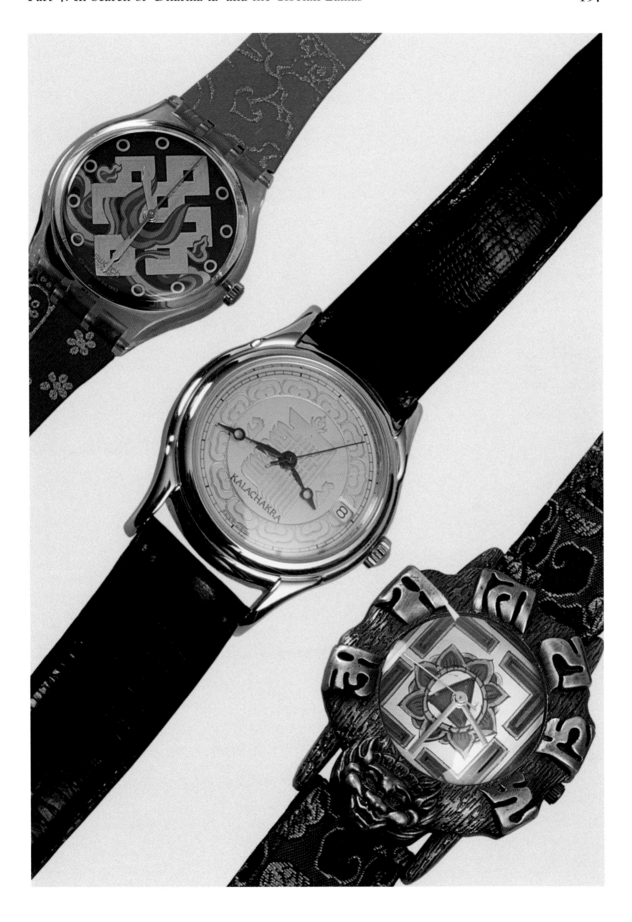

Legitimization through history ...

Frequently, as evidence alike for the significance and the efficacy of the object, its sacred history and context are recounted. Thus in the case of this Kalachakra watch, in its one-page advertisement the origin of the Kalachakra teaching, going back to Gautama Buddha, the Shambhala legend, and the apocalypse in the year 2327 CE predicted in the Kalachakra Tantra are described in detail.

Historical anchoring is also important in the extolling of the 'treasure vase', a vase made of clay, whose gilded interior is filled with many ingredients in accordance with traditional Tibetan practice:

> The Buddha Padmasambhava established Buddhism in Tibet in the ninth century. He prophesied a time of degeneration evident by decreased human vitality, incurable diseases, inescapable weapons of mass destruction and a weakening of the elements of the earth, depleted by pollutants and poisons in the environment. Through his compassion he gave specific instructions for healing our environment and restoring the energy of many beings and realms. This Treasure Vase is an ancient remedy that can replenish vitality and balance to the essence of the elements. It has the power to magnetize wealth and abundance, improve health, remove obstacles to long life, pacify anger and warfare and increase wisdom and compassion for all ...

There are overtones here of some well-known themes: a Tibetan object that lengthens life and fosters peace. Tibet as the place in which the secrets of the fountain of youth and of eternal peace are (just) known. Interestingly, in the present case this image is transmitted not by Westerners alone, but by a Tibetan religious centre whose leader is a Tibetan lama. Some of our

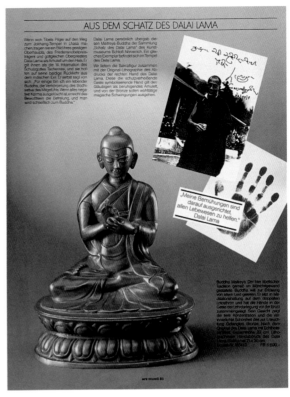

150. Buddha statue 'with beneficial magical vibrations' from the Ars Mundi collection: 'We deliver the sacred figure together with the original lithograph of the imprint of the Dalai Lama's right hand. This hand, symbolizing the gesture of promising protection, is regarded by the faithful as a calming amulet.'

Western myths of Tibet are not snatched out of thin air but are based on Tibetan legends and ideas and actively promoted by Tibetans. We shall be speaking in more detail of this fact in Part 5, as its significance for the understanding of Western images of Tibet is not to be underestimated.

... and exemplars

That the treasure vase is connected with a high lama of the present day is another characteristic of many Dharma products. In this case, Lama Tharchin Rinpoche has shaped and consecrated the vase; with other products, the Fourteenth Dalai Lama is often named as guarantor for the authenticity and efficacy of the object—probably without his knowing about it. For example, with the Kalachakra watch mentioned above, or in the case of a Buddha statue from the Ars Mundi collection:

From the treasure of the Dalai Lama. Dalai Lama personally presented this Maitreya Buddha to the 'Treasure of the Dalai Lama' collection of the Schloss Nörvenich Art Museum. A similar copy exists in the Dalai Lama's temple. We deliver the sacred figure together with the original lithograph of the imprint of the Dalai Lama's right hand. This hand, symbolizing the gesture of promising protection, is regarded by the faithful as a calming amulet, and beneficial magical vibrations are supposed to be emitted from the bronze.

Beside this advertising text from Ars Mundi are

seen a signed photo of the Dalai Lama and a picture of a handprint, with the text superimposed:

'My efforts are orientated towards helping all living beings.' Dalai Lama,

and beneath these a Buddha statue, which contrary to the advertising text does not show Buddha Maitreya. The boundaries of the 'permitted lie' in advertising were clearly overstepped once again in this case—and a Tibet myth received new impetus, for with the product and its advertising, magical Tibet was evoked: the imprint of the Dalai Lama's right hand is supposed to bring protection and have a calming effect, while the statue emits beneficial magical vibrations. Finally, the signed photograph of the Dalai Lama gives the impression that the Dalai Lama is personally behind this deal—which is hardly the case, as the photo reproduced was signed as long ago as 1973, but the *Ars Mundi* catalogue was only published about twenty years later.

It is not only the Dalai Lama or an incarnate monk who exudes authenticity and thereby trust. A quite 'normal' Tibetan monk does it too, as the *Silhouette* company's advertising for their Tibet Collection of glasses shows: two pictures portray

the same monk, once with his eyes covered by a light-coloured bar on which are the words, [in lettering skilfully designed to suggest Tibetan script:]

All light is within you.

On the other photo, the bar has been removed and one can see that the monk is wearing a pair of glasses. Beneath the second picture is a caption in small print:

Lobsang Namgyäl, Tibetan monk (Gelong), and his *Silhouette*, Tibet Collection.

In this newspaper advertisement for a range of glasses, the paradox theme, with which we have already become acquainted, appears once again: the first picture recalls Buddhist wisdom, which is 'the light' in every living being, i.e., Enlightenment and Buddhahood. To behold it needs no eyes, no glasses (except a third eye …). Gelong Lobsang Namgyäl may be able to see as well as this within himself, but now and then he also has to observe the outer, relative world—and then he is happy to be able to call a pair of Silhouette glasses his own. Here the two levels of truth that Buddhism postulates are cleverly worked with: absolute truth—on this level the Tibetans are perfect masters—and relative truth—there Silhouette is leading.

151/152. Advertising for Silhouette *glasses, with pseudo-Tibetan aphorisms such as: 'Be one. All is part of the Whole. … Be brightly radiant. All light is in you. … Be reflective. All is important, all is transitory.'*

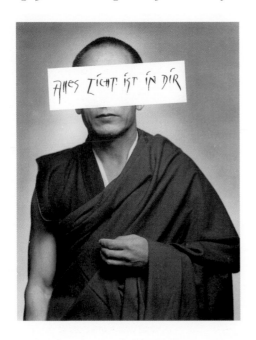

For me it must be a Silhouette

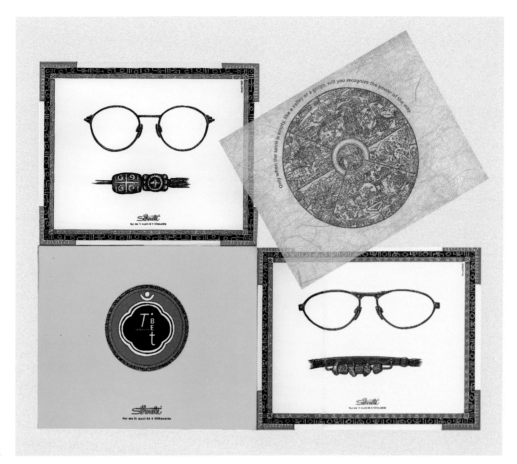

152a

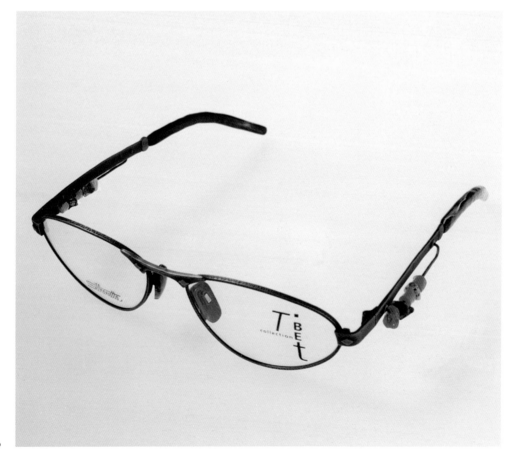

152b

It is worthwhile looking rather more closely at the rest of the advertising material for this 'Tibetan' range of glasses: in a beautifully designed, folding brochure, three of the eight lucky symbols of Tibetan art are drawn, surrounded by pseudo-Buddhist and non-Tibetan texts, reminiscent of the daily mottoes in many Christian calendars:

> Be one. All is part of the Whole. You are like the raindrop entering the river. May the sun raise it to the heavens.

> Be brightly radiant. All light is in you. You are like a star in the twilight, a flickering lantern, a gleaming flash of lightning from a summer cloud.

> Be reflective. All is important, all is transitory. You are like the cloud that tirelessly gathers itself, knowing that the wind will drive it apart again.

Also in the brochure as a loose sheet, without any obvious connection with the range of glasses, is a Wheel of Life print. A further component of the advertising material is a long wire with little coloured pennants that recall Tibetan prayer flags, a pictorial motif that like the prayer wheel appears to belong to the fixed repertoire of the Tibet dreamworld.

Misused ritual objects

Tibetan ritual instruments are increasingly offered on the market, such as for example a ritual dagger (*phurbu*) that resembles the one in the feaure film *The Shadow*. (Text on the packaging:

> The two faces adorning the handle represent the good and the evil, that lurks in the hearts of men.)

There are also phurbu earrings, phurbus are sold as letter-openers and are even stocked by knife shops. This completely disregards the fact that the Tibetan ritual dagger, like the ritual knife available on the market, is a secret, seldom-used object that is only employed in certain rites. It does not form part of the normal equipment of a Tibetan monk, let alone that of a lay person. In one case the secret character of a ritual knife is mentioned, but only by way of a selling point:

> This wonderful, handmade phurba (an incorrect term for the object being sold) is a ritual instrument of Tibetan Buddhism. It comes from Nepal, where it is manufactured only for use in temples. We were permitted to acquire this object because we are exporting it. Ritual instruments that are manufactured for Tantric Buddhist ceremonies must be made very exactly and are not intended for public sale. This maintains sacred art and prevents the artist from simply manufacturing copies and mass-produced articles. At the moment we possess only a very limited number of them … Each one is unique and is a work of devotion. An investment like no other.
> (*Mystic Trader* on the internet, price $129)

Secret, unique and valuable (also financially): these are the emotive words with which potential customers are swindled here. In actual fact, however, the ritual knife spoken of is indeed a cheap, mass-produced article, which is certainly not made for ritual use, and about which *Mystic Trader* can have meant only one thing: an investment as bad as no other.

Another object that has evidently still not lost the fascination it already exerted on the earliest missionaries is the Tibetan prayer wheel. Besides the prayer-wheel pendants already mentioned, earrings in prayer-wheel form are also sold and

153. Imitation of the ritual dagger (phurbu) *that the Shadow and the embodiment of evil, Shiwan Khan, fight over in the film* The Shadow. *'The two faces adorning the handle represent the good and the evil, that lurks in the hearts of men.' (Text on the packaging)*

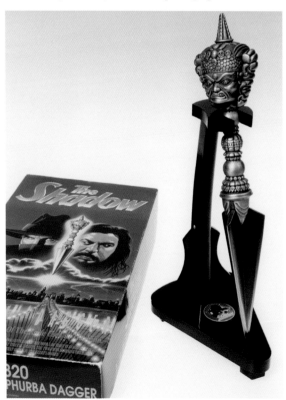

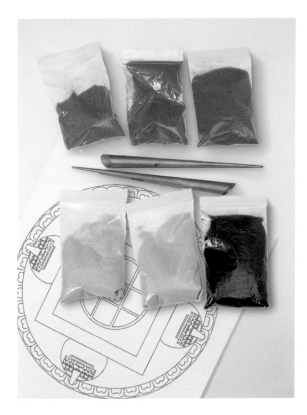

154. What was hitherto reserved for trained monks can now be produced by every Tom, Dick and Harry: a personal sand mandala.

battery-driven prayer wheels are offered. These last, according to the manufacturer's product information, have effects extremely rich in blessings:

> The mantras contained in the wheel are activated as the wheel turns, the seed syllables transforming into deities generating great blessings that can be directed for precise purposes depending on which mantras are selected, (for example) the prevention of natural disasters, promoting world peace, healing disease, the longevity of the Dharma, clearing inner and outer obstacles and removing negativities …
> The average size prayer wheel from *Mandallum Instruments* contains 8000 mani mantras and turns at 30 rpm, generating 240000 repetitions (of the mantra) a minute. A person can chant 100 a minute. Therefore this wheel is similar to having 2,400 people chanting in your home 24 hours a day! As you can see, these small religious objects generate a fantastic amount of blessings, that have the power to clear away obstacles to enlightenment and to harmonize the natural environment, bringing peace and joy to the beings who dwell nearby.

The industrialization of the Dharma has actually begun.

And the commercialization of the Dharma goes on: aprons that the clerical dancers use in the 'Cham performances are nowadays offered as wall hangings. Anyone can acquire funnels, coloured powder and patterns to sprinkle their own sand mandala. Ever more frequently one sees articles of clothing—especially T-shirts—with Tibetan religious motifs. That they bear symbols that until recently were regarded as secret and worthy of protection seems not to concern anyone. Used as decoration in this way are the Mighty Ten Syllables of Kalachakra, entire mandalas, *Om mani padme hum*, 'the mantra of the Western bourgeoisie' (Shakya), and even deity T-shirts. In one case, deities that obviously come from Tibetan scroll paintings are arranged entirely arbitrarily, i.e., side by side and one above the other incoherently: a tumult-of-deities T-shirt.

Since the opening of the Kalachakra initiation, practised above all by the Dalai Lama, there has been a veritable Kalachakra boom: reproductions of the sand-sprinkled mandala adorn jigsaw puzzles, wall clocks, badges for clothing, fridge magnets and T-shirts. As we mentioned, there are Kalachakra watches (for which the translation of Kalachakra—Wheel of Time—is not ill-suited), and the Kalachakra sand mandala also comes in useful as a computer screensaver.

A special category of such Dharma products is

155b

155a

155. Although according to Tibetan belief sacred symbols should never be made dirty, today they adorn more and more articles of clothing, which after one wearing will end up in the laundry basket with other washing. Divine blessings for underpants and socks. In this category of objects belongs also the pair of shoes (155c) with the mantra Om mani padme hum *produced by Alain Tribeaudot in Paris. For Tibetans it is a big sacrilege to touch holy things (to which also belongs the Tibetan writing) with the feet.*

constituted by the allegedly Tibetan 'singing bowls', which have nothing to do with Tibet. They are metal bowls from North India or Nepal, originally food bowls, which have a beautiful tone but are no more sacred objects than Western crystal glasses are musical instruments—despite the beautiful tone one can elicit from them by proper treatment.

155c

We have seen that commerce has discovered Tibet. But the reverse is also valid: Tibet has discovered commerce. So even monasteries offer T-shirts printed with sacred motifs, the treasure vase mentioned can be obtained by mail order from a Tibetan centre, monks carry out religious rites in both possible and ridiculous places, and even pray on theatre stages and let themselves be gawped at by audiences at these 'lama peepshows'—generally, of course, to the clink of coins, even though it is stressed again and again that no payment must be asked for religious actions. In recent years a radical change has been taking place: secret sacred rites are becoming public secular performances—'Tibetan roadshows',[35] which have used heavily symbolic venues such as the IBM Gallery and the World Trade Center in New York.[36]

All of a sudden we have thus arrived at the question, how much do the Tibetans really influence the image Westerners form of them? How much do they encourage the dream image of Tibet and how far do they at all events hinder a more objective contemplation of the Tibetan reality? We should like to deal more thoroughly with these questions, among others, in Part 5, next.

156. Sacred doormat, so that Buddha can be trodden on with the feet: a faux pas *of an exceptional kind.*

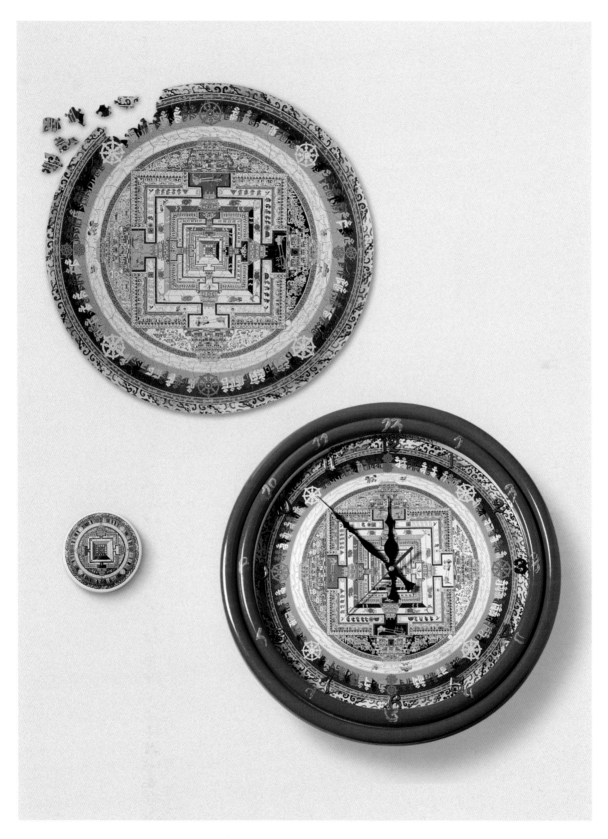

157. Since the Dalai Lama especially has been practising the opening up and popularization of the Kalachakra initiation, with the aid of the mandala of the same name, there has been a veritable Kalachakra boom: there is a Kalachakra mandala available on the market that is assembled from 440 jigsaw pieces. Whoever wants to be reminded constantly that Kalachakra means 'Wheel of Time' can buy himself a Kalachakra wall clock. It's quite 'in' to wear a Kalachakra button or to decorate your fridge with a Kalachakra magnet.

Part 5

The Foundations of the Dream

A. Introduction

Why are Tibetan saints credited with superhuman abilities, what is the explanation for the 'third eye', why are Tibetan monks regarded as guardians of ancient knowledge, and why are peaceableness and—rather more rarely—promiscuity repeatedly mentioned in connection with Tibet? Until recently, the numerous strange descriptions of Tibet were left undiscussed, and even academics did not find it necessary to examine anything so trivial as the countless Tibet stereotypes. But since a few years ago, a hint of a change of thinking has been detectable: at conferences, in books and in individual articles, people are beginning to consider why the West creates for itself such a one-sided image of Tibet.[1]

On the basis of what has been conveyed up till now, we understand that no easy answer can be expected to the question of the reasons for these dream images and stereotypes. The images are not uniform, they are complex and sometimes have a long history. On closer examination, however, we can recognize certain recurrent themes and characteristics, which we wish to turn to below. In this way we gradually get closer to an answer to the question of what the more deep-seated causes of the Western dreams of Tibet could be.

Basically two modes of examination present themselves: 'gallery contemplation' and the 'jigsaw view'. In this book we have been witness to how, over almost 400 years, a whole gallery of Tibet images arose, which revealed certain periods with specific stylistic features: Utopia, 'Shambha-la', 'Shangri-La' and 'Dharma-la'. This is the historical way of looking, in which attention lies mainly on the development of and change in Tibet images.

We can also, however, compare the many individual stories and images in this book to the innumerable pieces of a jigsaw puzzle. When we lay them side by side and view them correctly arranged from a certain distance, the individual pieces become indistinct and outlines, forms and structures become recognizable—the themes of Dreamworld Tibet.

We wish to make use below of both modes of examination—first the historical, then the 'structuralist', with the intention also of looking for the possible origins of individual themes. In the process we shall do something we have deliberately avoided up until now, because till now it has primarily been a matter of demonstrating the Western images of Tibet: where the interpretation of the Tibet images is concerned, we shall, from time to time, go back to Tibetan sources also. For although the Dreamworld Tibet here demonstrated is a product of Western man,

158

159. *Authentic Tibetan legends have also contributed and are contributing to the Tibetan dreamworld, such as, for example, the life story of the saint Milarepa, who lived and worked in Tibet in the 11th–12th century. This yogi is supposed to have mastered the art of flying, as he proved on the occasion of a competition with a Bönpo: one full-moon day the two held a race to the summit of Mount Kailas, which Milarepa won, thus achieving sovereignty over the entire Kailas range.*

some of its elements—or sub-dreams—are based on Tibetan ideas. Dreamworld Tibet, as will be shown later, likewise has Tibetan roots, thus like any dream it can be not only be interpreted as out of the dreamer's subjectivity, but is also a mirror image of what he faces, the outside world: there is an interrelation between the dream world and the outside world.

B. The individual periods

From Utopia via 'Shambha-la' and 'Shangri-La' to 'Dharma-la'

We meet people, weigh them up and assess them regardless of whether they come from a strange or a familiar background. Obviously we seek the standards necessary for this in the world of our own experience—we compare the foreign with our own by trying to recognize similarities and differences. From the very beginning this assessment runs like a thread through the history of the Western discovery of Tibet. Many writings of early missionaries deal with supposed correspondences between Catholicism and 'Lamaism': both appear to believe in the Trinity, both recognize similar ceremonies such as baptism and similar principles employed in ethics, and in both belief systems there is singing in the choir, fasting, and doing penance. Furthermore, correspondences also appear in the moral evaluation of Muslims, with regard to whom the Buddhists too appeared sceptical to disapproving. This position is to be put down in particular to negative experiences in connection with the Moghul invasion of North India, in the wake of which the Muslims drove the Buddhists out of

the Indian tribal areas. These many putative and actual correspondences between Christianity and the religion of the Tibetans created a good ground for well-disposed reporting, in accordance with the motto: our own is good; the foreign that is the same or at least similar is likewise good—provided the Devil did not create it to deceive us, a view that is also sometimes held.

The missionaries were not content with comparisons, but also sought reasons for the similarities: were the Tibetan monks in any event descendants of the legendary priest-king Prester John, who was presumed to have lived somewhere in Central Asia in the twelfth century? Were they descendants of the Nestorians, those Christians of the early Middle Ages who spread the message of Jesus in the Near East and Central Asia as well as in China? Were they people who escaped the last flood and found refuge on the 'Roof of the World'? Or were they even inhabitants of the biblical Garden of Eden, which since ancient times had been assumed to be somewhere in that region of planet Earth?

Apart from the bonds of kinship thought possible between the still largely unknown people living in the region and Europeans, the remoteness of the region could have been a reason for its fascination. The far away and hard to reach, the non-place—which is what Utopia means—has always fascinated.

But this positive evaluation of Tibet—to be more precise, of sacred Tibet (we have still to go

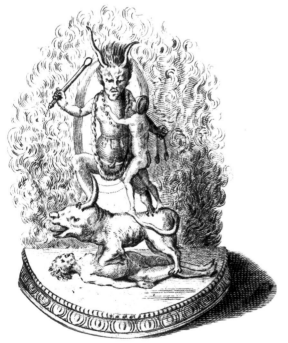

160

160–162. The positive evaluation of sacred Tibet was not altogether undivided. From time to time, benevolent sympathy gave way to unconcealed rejection, whether because the commentators were Protestants, who felt the similarity between Catholicism and 'Lamaism' to be more of an added danger than a blessing, or because certain practices seemed so aberrant even to Catholics that with the best will in the world they could not bring them into accord with their own conception of the world. Thus Yama, the god of death, became a Christian devil (160), the peaceful Bodhisattva Avalokita became a bloodthirsty god who delighted in human flesh (161), or the so-called yab-yum (Father-Mother) representations were interpreted as religious whoring (162)
(162 dialogue: 'Lord! How abominable! A graven image of stone!—A repulsive idol of whoring!').

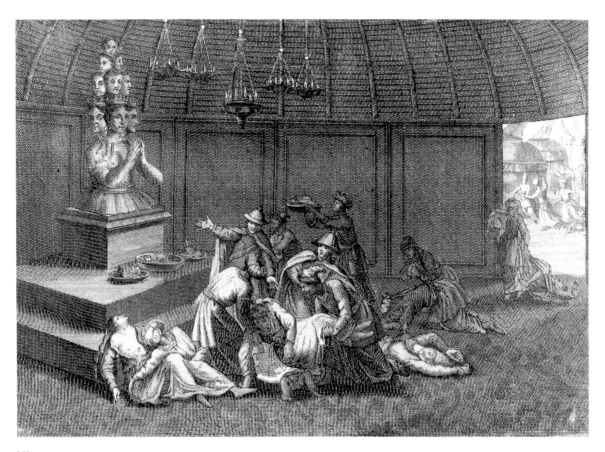

161

into the difference)—was not undivided. From time to time, benevolent sympathy gave way to unconcealed rejection, whether because the commentators were Protestants, who felt the similarity between Catholicism and 'Lamaism' to be more of an added danger than a blessing, or because certain practices seemed so aberrant even to Catholics that with the best will in the world they could not bring them into accord with their own conception of the world. To these belonged among others the belief in reincarnation, and the worship of the Dalai Lama, for instance, by the religious practice of prostrating oneself, which the Jesuits maintained must have been taught to the Tibetans by the Devil; as for believing Catholics this manner of worship was to be shown exclusively to the Roman Pope as Vicar of Christ.[2] The worship of wrathful deities and what was generally identified in the Christian West with superstition and magic, but would be better labelled 'popular Buddhism', also met again and again with clear rejection.[3]

Tibetan religion, as we have seen, was also

162

assessed negatively by famous philosophers of the European Enlightenment and the nineteenth century, such as Kant, Herder, Rousseau and Nietzsche. There was mention of a 'Christianity degenerated into the blindest heathenism', of 'creeping religious mania' (Kant), 'monstrous and unfavourable religion' and 'idolatry' (Herder), and 'those poor in spirit' (Nietzsche). But sometimes there was also a positive undertone, for example when Herder said the belief in migration of souls made the Tibetans sympathetic towards living Creation and had perhaps tamed these 'rough men of the mountains and rocks', which could scarcely have been contrived in any other way. Often travellers and commentators were shocked at the lack of hygiene and the supposedly immoral sexuality, which for them manifested itself in polygamy (both polygyny and polyandry). In short, until the middle of the nineteenth century, Tibet was encountered with a mixture of benevolence and reserve, of interest and disapproval, often accompanied by a feeling of respect or at least of muted sympathy.

The Theosophist Helena Petrovna Blavatsky brought about a change: the age of fervour, enthusiasm and adoration began. In this phase of the Tibet dream, which I call the 'Shambha-la'

phase, the Tibetan myth of the legendary Shambhala was 'discovered', picked up, shamelessly reinterpreted and mixed syncretically with ideas of Western magicians, occultists and esotericists, which already showed itself in the fact that hardly a single Tibetan was given the privilege of membership in the chosen circle of exalted 'Brothers' or 'Mahatmas'. That honour was bestowed almost exclusively on Indian Aryans.

This was the period in which certain 'Tibetan' ideas were either fabricated or underwent an obligatory 'codification', were completely overrated and in many cases were simply wrongly interpreted, such as for instance the 'third eye', the 'silver cord', the 'astral body' and the like. It was also the period in which Tibet became integrated into an extremely peculiar-seeming racialistically framed theory of human evolution. Tibet, it was said, was the country of origin of the Aryans. In actual fact this myth hardly influenced the Nazis, even if, as demonstrated here, the opposite is claimed in a literature that is becoming increasingly hard to overlook, but to make up for that it influences the neo-Nazis and their sympathizers all the more.

Today the 'Shambha-la' phase has passed its peak. But it still continues to have an effect, on the one hand in neo-Nazi circles, on the other in certain occult-esoteric circles that are sympathetic to Theosophy.

James Hilton in his book *Lost Horizon* ushered in another phase in the European view of sacred Tibet: 'Shangri-La'. Yet this too was not Tibet, but a sacred place 'somewhere in Tibet'. Still non-Tibetans, now unambiguously Westerners, were the 'High Lamas': in this case Father Perrault and Conway, who succeeded him. Lobsang Rampa heralded a further change: outwardly, Rampa was the Englishman Cyril Hoskins, but his 'soul' was that of a Tibetan, and the sacred place was now situated in Tibet proper—but just as inaccessible as the sites of the paradises of Utopia and Shambhala had been before, for Tibet had in the interim been occupied by the Chinese and entry

163. Until the second half of the 20th century, hardly a single Tibetan is given the honour of belonging to the circle of the exalted 'Brothers' or sages. Instead, the 'Tulkus' are of Aryan or white origin and often have a mission to carry out in, or at least for, the West, whether in novels, feature films or comic books.

was entirely denied to foreigners. Since then, the white Tulku with a mission to fulfil—for the most part in the West—has been a constantly recurring motif in novels, films and comics.

The actual emancipation of the Tibetan lama, which went along with a sacralization of the whole of Tibet, first occurred in the 1970s and '80s: 'Shambha-la' and 'Shangri-La' gave way to the sacred 'Great Tibet', whose deliverers, as prophesied by many, began to spread over the entire globe. Westerners met real Tibetan lamas, the age of 'Dharma-la' dawned, with hundreds of Dharma centres and a multiplicity of lamas. Tibetan monks—still no nuns—were finally regarded as autonomous personalities, who had brought their knowledge to the West and with their 'Enlightenment industry' were showing the 'alternative for the whole planet' and at the same time the way to the 'buddhaverse' (Thurman)—

in advertising, commerce, the media, books and above all in feature films of the '90s. The West went lama-crazy!

In this phase, here called 'Dharma-la', it is characteristic that the Dharma, the Buddhist teaching, increasingly becomes a commodity: with sufficient finances, one can afford a trip into Dharma-land—to the 'power places' of sacred Tibet such as places of pilgrimage, holy mountains (first of them all Kailas[4]) and monasteries, or—if less well-to-do—one can at least treat oneself to a 'Five Tibetans' course or a visit to an event with praying monks. And those quite comfortable are satisfied with a Tibetan love cushion or a Kalachakra watch—for the sake of world peace. As in the preceding phases, therefore, the adoption of Tibet is concerned not with the real Tibet, but simply with sacred Tibet, which has come to be for sale.

164. The 'Dharma-la' phase has begun. Westerners are encountering real Tibetan lamas, who outside monasteries and meditation centres are showing them the way to the 'buddhaverse'—in advertising, commerce, the media, books and movies. 'The best part of us hopes, perhaps, that the Dalai Lama may be able to use the mass media to promote spiritual values more than the mass media use him to advance their less exalted aims. Yet the tightrope walk is treacherous: the medium itself, after all, imperils the message ...' (Pico Iyer, The New York Times, *April 24, 1998)*

C. Solving the puzzle of Tibet: the place, the characteristics, the gurus, their knowledge and their mission

The place

Since its actual 'discovery' by missionaries in the 17th century, Tibet seems always to have been perceived as a sacred place, as Peter Bishop has already established in his book *The Myth of Shangri-La*. But if we pass in review the many Tibet images collected in this book, we realize it would be an undue simplification to describe the whole of Tibet as a sacred place. The geographical area of Tibet is for many authors divided into two: an outer, apparently 'normal' Tibet and an inner, secret, mysterious and sacred place that is clearly different from outer Tibet. In most cases the sources analysed here deal with this 'inner' Tibet, this 'heart region', even though this is not always so explicitly stated.

As a rule it is overlooked that even for the Theosophists Tibet as a sacred place did not coincide with the actual, geographical Tibet. Shambhala, situated within Tibet, was regarded as sacred, but not the whole of Tibet; Aryan Mahatmas, living in a quite specific place, were honoured above all, and not all Tibetan monks. Thus for Blavatsky and her followers, the sacred place Tibet was reduced to certain regions—a locality in the neighbourhood of Shigatse, underground caves and an underground Shambhala, which appears to have lain not beneath Tibet but beneath the Gobi Desert. This identification of certain sacred places within Tibet, however, did not prevent Blavatsky from ascribing positive characteristics to 'outer' Tibet too and sacralizing it as well to a certain extent. Tibet was for her a land without beggars or people dying from hunger, consequently a land where drunkenness, crime and immorality were unknown. In other words, for Blavatsky the whole of Tibet seemed to be pure, but in addition she identified certain regions that she considered more sacred than the rest and to which she directed special attention.

Others distinguished a lot more clearly between the geographical and the sacred Tibet; for example, d'Alveydre and his numerous followers, such as the neo-Nazi authors, for whom the underground Agartha did indeed lie in the region of Tibet, although it was not identical to it.

Roerich too made a distinction between Shambhala and the rest of Tibet, which he in no way saw as an earthly embodiment of paradise. He criticised the monasteries and the monks, and got worked up about their 'so-called miracles, ... superstitions and loathsome deeds'.

Something often overlooked is that even James Hilton distinguishes between the real and the sacred Tibet. He paints a rather negative picture of a Tibet inhabited by dissolute, dirty monks who have an eccentric taste for self-discipline. This Tibet contrasts with Shangri-La and the valley beneath it, an island of peace, an antithesis to the world of homicide, destruction, dynamite and steel.

Thus the European construction of Shambhala or Shangri-La often has an interesting double function: on the one hand it is an image in contrast to the West, with positive connotations; on the other an image of an ideal, Utopian Tibet as opposed to a real, rather run-down Tibet.

Sacred Tibet, whether as a Utopia, 'Shambhala', 'Shangri-La' or 'Dharma-la', is unimaginable without mighty mountains. The idea that Tibet could have been the place to which people escaped at the time of the Flood presupposes the existence of high, indeed very high mountains. Also, the idea that Tibet could have been that Eden in which the four great rivers mentioned in the Bible arose is clearly to be put down to its topographical situation and the high mountains of the region. In Tibetan accounts, Shambhala is a region enclosed by a high mountain rampart, with a magnificent, white, shining crystal mountain, a description that has undoubtedly moulded Western images of Shambhala. And Shangri-La too lies amid a magnificent mountain-scape, from which juts out the mountain of Karakal, over 8,500 metres high, 'a sensational peak, by any standards'. Even in the current phase, which I call 'Dharma-la', a mountain has become an exceedingly popular goal for Western pilgrims: Mount Kailas in south-western Tibet. The mountains not only provide security and refuge, but also frequently appear as terrifying and dangerous, as the abode of mighty demons or

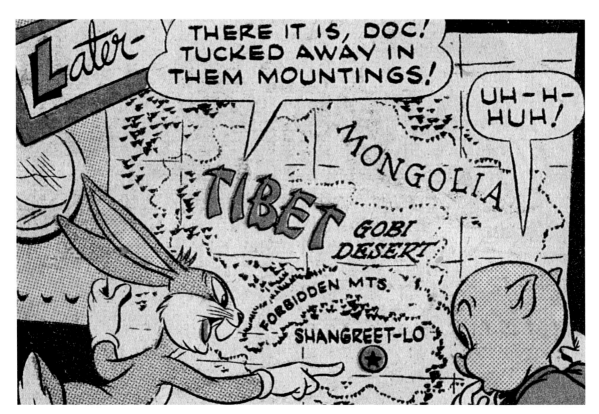

165. Tibet is for many authors divided into two: an outer, apparently 'normal' Tibet and an inner, secret, mysterious and sacred place that is clearly different from outer Tibet. In most cases the sources analysed here deal with this 'inner' Tibet, the 'heart region', even though this is not always explicitly stated.

dreadful creatures such as the snowmen, who defend the place against intruders.[5]

Interestingly, very frequently the sacred place lies not on the mountains of Tibet, but in underground passages and caves, a theme that was probably invented by Bulwer-Lytton and taken up by Blavatsky and d'Alveydre and has survived up to the present day via Ossendowski, Adamski and neo-Nazi authors (Germans of the Reich under the protection of the Gelukpas, supposed to live in underground bases beneath the Himalaya). It is found again in comics, especially those whose theme is global conspiracy, but also turns up in feature films, as in *The Golden Child*, where the hero has to undergo a test in an underground cave, or in *Prince of the Sun*, where the wise abbot dies in a cave at the start of the film. With the story *Der Winterkrieg in Tibet*, subterranean Tibet even found its way into world literature, thanks to Friedrich Dürrenmatt—not indeed as a sacred or Utopian place, but as a dystopia, a place where the gruesome, terrible last days are happening after the Third World War. The story describes how the Swiss government, which has retreated into the hollowed-out mountain massif of the Blümlisalp, sends a soldier to Tibet in the 'Winter War', where in the labyrinthine mine galleries of the Himalaya he becomes the chronicler of the last days and eventually kills himself.[6]

The characteristics

Through Tibet's seventeen-hundred-year association with the Buddha reality, the entire land of Tibet has become the closest place on Earth to an actual Pure Land [paradise],

says a Western dreamer of Tibet.[7] In fact, according to many people's view, Tibet, or the part of Tibet regarded as sacred, has similarities with a paradise: no prisons, no death penalty, police or law courts, no evil, no crime—only peace, an astonishing fruitfulness and in some cases mastery over an immense power (vril), and further, highly developed saints and supreme knowledge. Let's get to know some of the themes of this Tibet paradise in more detail.

The Tibet of secret wisdom

Sacred Tibet is a 'supermarket', in which any Westerner can grab titbits of knowledge and wisdom according to his taste. It holds knowledge about the origins of humanity, extraterrestrial visitors, the yeti, the spiritual powers of human beings, other religions, possibilities for the prolongation of life, the maintenance of peace and even military, political and scientific, but especially philosophical and spiritual secrets. This knowledge is secret and difficult of access, often stored in underground libraries that only the chosen are allowed to enter. These are, in the first place, the spiritual knowledge-holders living in sacred Tibet—Mahatmas, tulkus, gurus and the like—as well as some few Westerners, who have devoted themselves to the goal of finding hidden knowledge. That this search is no picnic, but amounts to a difficult test or initiation, is guaranteed by the special location of the treasuries of knowledge, which stand in solitary splendour at well-nigh unattainable heights behind many mountain walls—as it were, behind the seven mountains.

But there is another reason why the search for the secret knowledge in Tibet turns out to be problematical. For a stranger's visit to paradise can have grave consequences: the storehouses of wisdom in Tibet are in serious jeopardy, which is why sinners must be deported or punished in some other way. The mysterious wisdom world of Tibet wants to be left in peace. The country must keep itself free from the influence of Western nations, otherwise their primitive ideas confuse and derange the followers of the Good Teaching. Then Tibet would no longer be able to accomplish its mission of spreading wisdom over the entire world.

The Tibet of peace

> If 80% of the world population were Tibetans, there would be no problems, it would be wonderful, there would be peace ...,

an acquaintance once said to my Tibetan wife, expressing an idea that is very widespread: that the Tibetans are peace-loving, abhor fighting with weapons, are pacifists. As early as the beginning of the 18th century, the Jesuit Desideri was of the opinion that Tibet was a peaceful country, an idea that in recent times has found new adherents, as is shown, for instance, in novels and films and in the commercialization of Tibet. This message is also strongly supported by members of American high society such as Bob Thurman.

But this peace of Tibet is not everlasting. It is threatened when foreigners enter the sacred precinct and pollute it with their presence. So the Tibetans knew—according to Rampa—that peace would desert the land when foreigners entered it, and Gurdjieff was convinced that the 'military expedition' of the British in 1904 had brought about the destruction of the 'seven beings' and their books and therefore of their peaceful coexistence.

Tibet the fountain of youth

Although Blavatsky had already reported the proverbial longevity of many lamas, who renewed old blood with the help of an elixir, it was probably James Hilton who helped the fountain of youth motif on its way to real success: Father Perrault was 250 years old, because like the other lamas in that region, where time weighed scarcely so much as a feather, he had

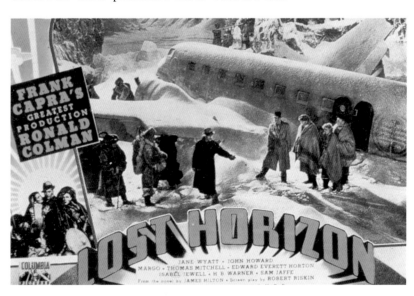

166. Sacred Tibet hides special knowledge, which is, however, very secret. It reveals itself only after initiation-like trials—for example, a long, adventurous flight and a crash landing, as in Lost Horizon.

succeeded in 'slackening the tempo of this brief life'. Since then, sacred Tibet has been regarded, at least unspokenly, as a fountain of youth: Gurdjieff met extremely old men in the Sarmun monastery; in *Ancient Secret of the Fountain of Youth* Colonel Bradford found a Tibetan monastery somewhere in the Himalaya that sheltered the secret of eternal youth; Karl Steiner, in *Die schwarze Sonne von Tashi Lhunpo*, looked young although he was ninety years old; in *Emmanuelle in Tibet*, in the mountains of Tibet the soft-porn queen Emmanuelle was given a centuries-old plant essence, the essence of life, the eternal source of youth, and it seemed to her that the Tibetans could stop time. The pick-me-up Biogran is extolled as a comparable modern essence ('Tibetan monks live up to 120 years, without drinking, smoking and, of course, without sex' … 'If you want to live longer, but don't have the vocation to be a monk, drink Biogran.'), and modern Dharma products also promise, among other things, prolongation of life.

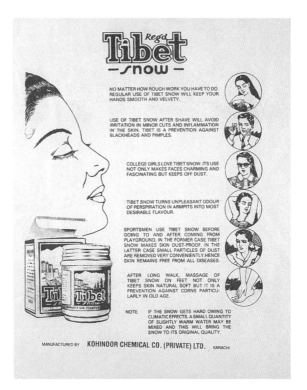

167a

Tibet as a power place

Behind the descriptions of sacred Tibet presented in this book, the idea is often hiding that Tibet is a 'power place'[8]—even though authors only rarely state this explicitly and the 'vril' power of earlier generations of Tibet enthusiasts is hardly ever related directly to Tibet any more. The special power of Tibet is mainly expressed indirectly— through the saints, who have special powers at their disposal, but also through special effects such as the retarded operation of the aging process and the creation of peaceful surroundings. The fact that Tibet is regarded as the landing site of extraterrestrials and escaped Atlanteans, as a temporary place of residence of Jesus or as the area of origin of superior Aryan men also bestows on it a special power.

More recently, further attempts at the elucidation of 'power-place Tibet' have come along. One theory speaks of cosmic-terrestrial energies, which among other places are particularly strong in Tibet, especially in its monasteries—so

167. A Tibetan 'fountain of youth' preparation, which for once does not come from the West: Tibet Snow*, which keeps the skin young and smooth and velvety, and counteracts pimples, perspiration odour, skin diseases and corns.*

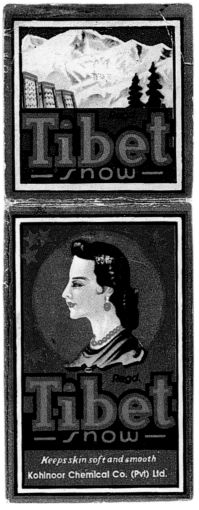

167b

168a 168b

168. Tibetan ritual instruments such as prayer wheels are reproduced in the West as objects of a sacred 'power technology', which serves for the attainment of external goals.

strong that practically untrained monks

> can suddenly speak several modern languages or read fluently ancient Latin and Greek texts.[9]

According to another theory, Tibet—and the Colorado plateau in North America—are at the centres of 'solar energetic magnetic fields', while Hawaii, Jerusalem and Giza lie at the centres of lunar energetic fields, all of them fields that are supposed to influence the well-being of plants, animals and people worldwide. But the highest energy concentration clearly lies in the land of the Hopi and in Tibet, homeland of the Dalai Lama.[10] Thanks to their location on our planet, the Colorado plateau, Tibet, Giza, Jerusalem and Hawaii are therefore power places, sacred places, which have brought forth special human beings. The Egyptian-Indian-Tibet connection suggested here is postulated primarily by adherents of the New Age, who never tire of discovering supposed parallels and common causes of Indian, Tibetan, Ancient Chinese and Ancient Egyptian wisdom.[11] The power place of Tibet—one of just a few power places on Earth.

A special power appears to be peculiar to various Tibetan ritual objects. For the pictorial representation of Tibetan religion, the same objects and themes have been employed almost unchanged from the first missionaries up to the present day: statues of saints and deities—among them, relatively frequently, wrathful deities—prayer wheels, prayer flags, the mantra 'Om mani padme hum' and the Wheel of Life. More recently these have been joined by the mandala, and since

the 1920s the so-called *Tibetan Book of the Dead*.[12] However, Tibetan funeral customs attracted the attention of Western authors much earlier, for example, George Bogle in 1774.

Particularly popular is the prayer wheel, already illustrated and described by the missionaries, which is hardly missing from a single film relating to Tibet, comes up here and there in comics, and is today ubiquitous in commerce—as a battery-driven table model, virtually on various internet sites or as a pendant for the ear or the neck. More recently another ritual object has somewhat superseded the prayer wheel: the ritual dagger (*phurbu*), which is given an important role in at least two films, *The Golden Child* and *The Shadow*, but is also available commercially every now and then—as a letter opener, good-luck charm or magic weapon.

To sum up, it can be said of the Western use of Tibetan ritual objects what we have already established in the chapter on feature films: Tibetan ritual objects become objects of a sacred 'power technology', which serves for the attainment of external goals. But they are robbed of their true spiritual and ritual meaning. Tibetan religion is thereby given the air of a mechanistic magical cult.

Tibet as a retreat area

Tibet is the retreat area par excellence. Hitler, surviving inhabitants of Atlantis, Buddhists (Mahatmas) coming from India, Prester John, Christ, Blavatsky, extraterrestrials, scientists, Nazis, survivors of the Flood, yetis, the Nestorians, Sherlock Holmes (after his faked death at the Reichenbach Falls)[13]—all these and many more besides are supposed to have found refuge and protection in Tibet for a shorter or a longer time. Tibet as the country of asylum for deportees, refugees, the marginalized, seekers, those in danger, and saviours or conquerors of the world.

But Tibet also appears remarkably often as a place to which missing people go, who are supposed to be searched for and rescued by their relatives, journalists, scientists or other heroes—a theme found above all in comics and novels.[14] In recent decades, Tibet has also increasingly been perceived as a refuge for animals and plants,[15] and in this way stylized as the ecological Tibet.[16]

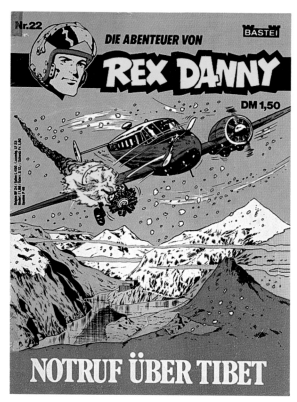

169. Tibet often appears as a retreat area and a place to which missing people go, so that they can then be rescued in adventurous expeditions.

170a

The (almost) asexual Tibet

An earthly paradise is often portrayed as a secret garden of desire, a *paradiso amoroso*, but in sacred Tibet the people are neither hetero- nor homosexual but quite simply asexual. As already mentioned, it seems that almost no one but men lives there, sacred men—monks, lamas and tulkus. The other sex appears, if at all, only right on the margin. Sex is a foreign word for Blavatsky's Mahatmas, and sexuality also appears not to exist in Shangri-La or in Lobsang Rampa's Tibet.

The sexual life of the Tibetans is also not a theme in old accounts. Only Marco Polo writes that a woman in Tibet is not ready for marriage until she has slept with a lot of men. When a caravan passed through the land, young women would be offered to the male strangers and live with them as long as they stayed there.[17]

More recently, however, Tibet has sometimes been depicted as a 'tantric brothel', a place in which the monks carry on particularly wildly with certain nuns. This theme of the erotic-lascivious Tibet is most conspicuous in the novel *The Rose of Tibet*, in which a sex-obsessed abbess plays the

170b

170. Western dream: Yab-yum *(Father-Mother) representations as symbols of free and unrestricted sexual intercourse, with which Tibetan Buddhism is credited.*

principal part—energetically supported by equally sex-mad nuns. However, it also occurs in the film *Emmanuelle in Tibet* and in the numerous so-called 'reference books' on Tantrism, which have flooded the book market in recent times; these, as a rule, do not distinguish between Buddhist and Hindu Tantra.

The loathsome, macabre Tibet

For many, sacred Tibet—which, as we have seen, coincides only very rarely with geographical Tibet—is a paradisal dream world, but for a few it is a nightmare. This negative evaluation by a throng of missionaries, philosophers, Nazis and certain other authors obviously has different reasons. Some are afraid of the macabre Tibet, with its implements of bone, wrathful deities, corpse symbolism and 'demon dances'; others recoil from the 'priestly caste' and their power, which they also used for domination of the world. Here too, however, we encounter the typical ambivalence we have already met several times: phenomena that repel one captivate another. Thus the theme of world domination is by no means seen only as something negative. The neo-Nazis mentioned in

this book seem to see something extremely positive in the Tibetan monks' supposed potential for world domination. The 'bone cult' too is here and there interpreted positively as an *ars moriendi*, the art of thinking about death in one's lifetime and preparing oneself for it. Others describe the bone implements as comical objects, such as Dauthendey, who claims that the Tibetan hourglass drum made of two skulls was made from the skull of a faithless man and that of a faithless woman and was beaten daily at the hour of prayer, for the faithless pair, bound together eternally, should have no peace in death.[18]

A horrific, macabre picture of Tibetan religion was also painted in a number of novels. So a young novice has to lie upon a 'demon', the corpse of a murdered criminal, and recite mantras continually, otherwise the demon will force its way into his body and kill him. And at the very moment when the demon opens its mouth and its tongue appears, the monk must bite the tongue off. This is then dried and becomes a fiercely coveted amulet.[19] Also amongst the macabre scenes are descriptions of religious dances in the course of which someone is killed—a frequently occurring theme in more recent novels.[20]

171. For many, sacred Tibet is a paradisal dream world, but for a few it is a nightmare, as the engraving reproduced here shows. It illustrates 'Buth, who is a young Tartar traveller who kills everyone he bumps into.' According to the original commentary, persons killed by Buth should be offered to Manipa, a deity of Lassa (see Fig. 161). 'By this kind of violent offering, it is sought to make this deity agreeable in the kingdom of Tanchuth.'

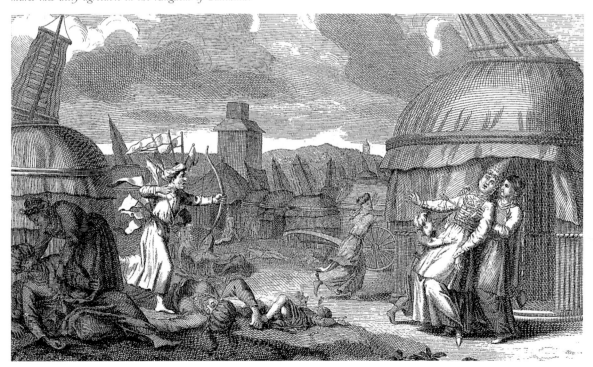

The gurus

The division of geographical Tibet into 'normal' and sacred regions is naturally reflected also in its society, which consists of saints and normal human beings; the latter—like 'normal' Tibet—one is hardly aware of. Sacred Tibet, or what is thought of as sacred Tibet, is almost exclusively inhabited by male saints, who almost without exception are Aryans or whites. Not until the last quarter of the twentieth century, as shown, did a gradual emancipation of the Tibetan knowledge-holders come about in popular culture, demonstrated to us in exemplary fashion by the feature films *The Golden Child*, *Prince of the Sun* and *Kundun*.

In many stories, the non-Aryan—Tibetan—clergy do not escape as favourably as one might suppose. They are judged very ambivalently. For Blavatsky, for example, opposite the bad and infamous Red-cap monks and Bönpos stand the good Yellow-caps (Gelukpas), a twofold division that many others have adopted also. Interestingly, however, a reversal soon comes about: in one book by a neo-Nazi, the Bönpos are all of a sudden revalued and the Dalai Lama devalued. This is in any case connected with the ambivalent stance that is generally taken towards the Dalai Lama, for the (Yellow-capped) Dalai Lama is not seen by everyone as a positive personality. Sometimes he is a negative counterforce to the likewise

172a

172a–e. The figure of the guru is omnipresent, it seems to occur as a stock character in every story and picture recounted here. The Dalai Lamas have exerted a particular fascination. Missionaries and early travellers were already impressed by them (172a). Cartoonists and graphic artists have elevated the present Dalai Lama into a Buddhist superstar (172b–e).

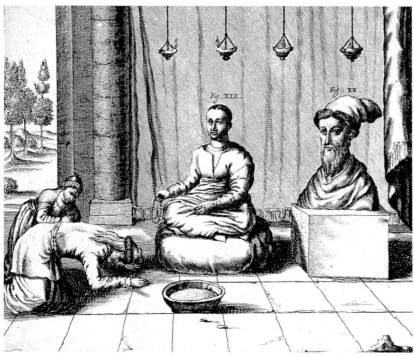

172b

172c

172d

Yellow-capped Panchen Lama,[21] or as in the case of the neo-Nazi book mentioned, to the Bönpos.[22]

In some sources the image of the always peaceful, high-minded lama is placed in question. According to them, martial arts form part of the normal training of a Tibetan monk—a stereotype that probably goes back to Lobsang Rampa, who very likely got his inspiration from the heavily-

172e

built dopdop monks (*ldob-ldob*, monastic policemen).

Nicholas Roerich too was in the habit of a pronounced dualism when he distinguished between the Tibet of the godless, the superstitious, the shamans and the Bönpos and the enlightened Tibet with its profound knowledge, truth, fearlessness and compassion, which showed itself in holy places such as certain monasteries as a manifestation of the secret world centre in the heart of Asia—Shambhala. That both Blavatsky and Roerich let the Red-caps and Bönpos appear in a bad light can only be explained by their, or their informants', being sympathetic to the Gelukpas (Yellow-caps), who were often inclined to be sceptical or even hostile towards those of other denominations. This aversion also shows through with other authors, such as Meyrink.

A theme that runs through from the early missionaries right up to the present day is the reincarnate monks, the tulkus. The belief in reincarnation was commented on by the missionaries with great scepticism; Blavatsky made it socially acceptable. But even before this, individual tulkus had made an extremely positive impression on travellers, who then reported effusively on their meetings. Also closely connected to the idea of the incarnate monk is the veneration of the guru (lama). The figure of the guru is omnipresent, it seems to appear as a stock character in every story and picture recounted here—with different labels: once he is called Lama or High Lama, then Goro, another time High Priest; often he does not have any name but is simply recognizable as a lama by his outward appearance.

Marco Polo already claimed that in Tibet there were masters of the black arts, who performed extraordinary and deceptive magic,[23] and the early missionaries reported on the omniscience that was attributed to high lamas. But it was the Theosophists who first made their 'Brothers' living in Tibet into miracle-working saints who, for example, had mastered the art of dematerialization and materialization and were able to transmit letters over long distances by telepathic and other means. Since then, in novels, comics, films and advertising, lamas—whether Westerners or Tibetans—float in the air, travel through the neighbourhood astrally, are

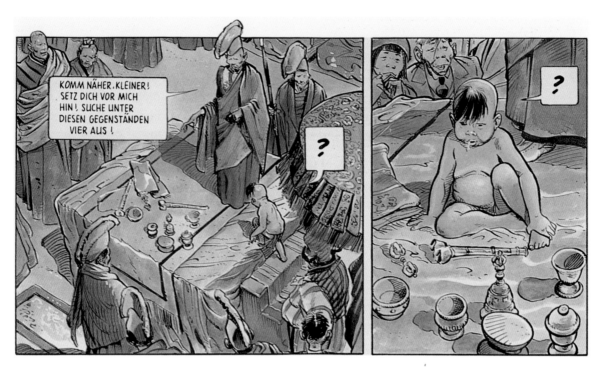

173. A particular spell is also cast by the concept of incarnation, so hard to understand from the Western rationalist viewpoint, and the procedure for selecting new incarnations. In countless reports, stories, films and comics, the always identical sequence is repeated, regarded as decisive for the choice: the child candidate chooses from various objects put in front of him the ones that belonged to his predecessor, which is regarded as proof that he is the genuine reincarnation.

ominiscient, and understand how to turn the laws of nature upside down. With astonishing persistence, this image of the miracle-working magical monks from Tibet managed to endure and is today experiencing a revival.

Typical of the dreamworld of the Tibetan or pseudo-Tibetan gurus is their strict hierarchy in the style of a theocracy. Since the West has been in contact with Tibet, the wise men at the top of this sacred hierarchy—the Dalai Lamas, the Panchen Rinpoches, and at the time of the Theosophists, the Masters, Mahatmas and other imaginary bearers of wisdom—have exerted a particular fascination. Bulwer-Lytton, who did not explicitly name Tibet, but whose mythical realm must be assumed to be in the Tibetan region, already described the corresponding social system as markedly hierarchical. The Theosophists' 'pantheon' also displays a strict structuring by rank. At the top reigns 'The Lord of the World', who lives in Shambhala in the Gobi Desert and transcends the geographical Roof of the World for the political one: Tibet becomes the seat of an imaginary or future world government, an idea that was taken up and further embellished by Trebitsch-Lincoln, people who saw themselves

threatened by Tibet, and neo-Nazis.

Beneath the supreme ruler stand his helpers such as Buddha, Manu and Maitreya, who have Masters or Mahatmas as assistants, and these in turn are surrounded by 'chelas', disciples. Let us also recall the twelve supreme magical gurus of d'Alveydre, in whose work Theocracy appears as a leitmotif, and Gurdjieff's 'seven beings', among whom one was the leader. Hilton, too, subtly detected the need of his Western readers for an aged spiritual leader and presented this ideal in the person of the Father Perrault character. Hilton likewise took up the autocracy theme: according to him, a 'loose and elastic autocracy' operated in Shangri-La, certainly no democracy, at which the valley population would have been 'quite shocked'. In other Tibet novels also it became clear that our images and caricatures—and hence also our stereotypes—of Tibet had a lot to do with authority and charisma. Since Blavatsky, the clergy of the Roof of the World have attained such authority that what they maintain is regarded as credible, indeed more than that, as sacrosanct. Among advertising films also, we bumped into several in which monastic hierarchy and authority constituted a central theme.

A particular spell is also cast by the concept of incarnation, so hard to understand from the Western rationalist viewpoint, and the procedure for selecting new incarnations. In countless reports, stories, films and comics, the always identical sequence is repeated, regarded as decisive for the choice: the child candidate chooses from various objects put in front of him the ones that belonged to his predecessor, which is regarded as proof that he is the genuine reincarnation.

Anyone can in principle become recognized as a tulku, anyone can hope to win in the 'tulku lottery'. This is shown in novels such as *The Third Eye*, *Tulku* or *Samsara*, in comics and in the film *Little Buddha*, but for the last few years people like you and me have also been able to win the 'tulku ticket'—like the film actor Steven Seagal or a

woman from Brooklyn known today as Jetsunma Ahkön Lhamo, who were both recognized as incarnations by Penor Rinpoche.[24] To these modern Western lamas, the embodiment of Western lamas in the Dharma-la phase, also belongs the Dane Ole Nydahl, who proselytizes for Tibetan Buddhism 'with worldly charm and business sense,'

> a fisher of men, part Paul, part Schwarzenegger, Buddha's most active man in the West, always ready with a provocative quip. A nice little smutty joke, some stupidity about poor countries ...tittle-tattle from the regulars' table.[25]

The idea of incarnation has even inspired Herbert Achternbusch, who once wrote:

> When I was in Tibet seven hundred years ago, I dreamt the people from Lhasa came and made my son Dalai Lama ...[26]

Tibetan knowledge

The difficulty of access to Tibet for Western people—Asian travellers could travel the country much more easily than was generally assumed—fired the imagination of Western authors. Tibet is not only a retreat area for the most varied creatures, but as we have already seen, a treasury of ancient knowledge that can bring help to Planet Earth. But however hard one tries to squeeze out from the countless stories represented here the profound knowledge of Tibet, highly praised time after time, one will be unable to gain more than a few pitiful drops of Tibet elixir—mostly platitudes. Blavatsky may have written countless pages about the allegedly Tibetan book *Dzyan* that only she had seen, and the eternal verities it contained, Gurdjieff about the knowledge of the 'seven beings', Nicholas Roerich about the 'eternal truths'—but all these teachings and secret

doctrines have practically nothing to do with Tibetan wisdom, are insubstantial and fall apart as soon as one begins to analyze them in more detail. They should not be denied any meaning or value because of that. Gurdjieff's abstruse stories can perfectly well convey insight to his followers—by, for example, demonstrating the relativity of all knowledge and the difficulty of imparting profound religious truths—but his teaching reflects Tibetan wisdom neither in form nor in content. The same also applies to the explanations of Madame Blavatsky: on closer examination they turn out to be non-Tibetan, which does not mean that they failed to meet a need many people had for an alternative to Christianity, Positivism and Victorian morals. Even today they seem to fulfil some people's needs, after all there are still numerous branches of the

174. An old theme from the time of the early missionaries is revived by commerce. The Catholic and Buddhist brothers are close to each other—no longer because of the similarities of religious customs and views supposed by the missionaries, but thanks to the most modern computer technology.

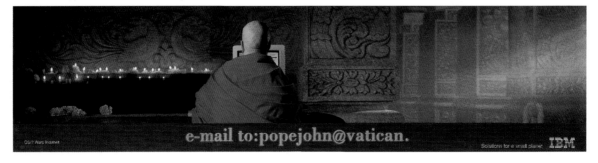

Theosophical Society, which has fallen apart into factions.

To sum up, then, just as sacred Tibet does not coincide with the real geographical Tibet, so supposedly Tibetan wisdom has little or nothing to do with Tibetan knowledge, but more with Western occultism, esotericism, spiritualism and rubbish. From the start there was a mixing of Tibetan ideas—often pseudo-Tibetan or very marginal ideas—with a Western body of thought. In the reports of the early missionaries, Buddhist, Christian and Manichaean ideas were often thrown into a single pot. The Theosophists carried this syncretism to an extreme by mixing wisdom teachings of differing provenance and shaping something new, Theosophy; and in novels, comics, feature films and advertising this syncretism is further cultivated, up to the alliance of Western and Tibetan knowledge-holders in advertising: scientists/technocrats and lamas are the guardians of the highest knowledge, they are perfection incarnate.

The mission: the new man

Sacredness does not exist for its own sake. Sacredness is created—for the benefit of human beings. So too in the case of Tibet. In the opinion of those who believe in its sacredness, sacred Tibet has a mission: from it comes salvation. Thus Blavatsky (allegedly) received inspiration and leadership from Tibet, likewise Bailey and their Theosophical followers—all of them not for their own benefit but for the entire world. According to Ossendowski, in Agarthi, which seems to lie somewhere underneath Tibet or Mongolia, a new nation is developing, that will form a new and better kingdom. Hilton suggests that Shangri-La is guarding its heritage until the strong have consumed one another, the Christian (sic!) teaching is fulfilled and the meek are guiding the Earth. For many neo-Nazis, help in the formation of the new superman, the new man, comes from the Tibet region, as can be shown from many examples, and help also comes from Tibet in the present—in novels, films, and advertising—now after the occupation and violation by the Chinese, no longer from Tibet the sacred place so much as from its sacred inhabitants.

In one genre of literature, comics, an original theme emerged in the 1940s—as a result of the Superman stories, published for the first time in 1938—Western supermen rushing to the aid of Tibetan lamas. Although the theme is most clearly recognizable in the '40s, it is also found later here and there in novels, feature films or comics.[27]

In summary, it can be said that on closer analysis of the numerous sources presented here the supposed Tibet turns out to be non-Tibet, the supposed message not Tibetan, the proselytizing sages non-Tibetan; or in the words of one Tibetan,

> In nearly all works of imagination about Tibet, the country and people come across merely as the *mise en scène* for the personal drama of white people,[28]

using, one might add, individual props (mostly certain ritual objects), scenery (monasteries) and actors (monks) arbitrarily torn from the whole context, without recognizing their traditional Tibetan significance.

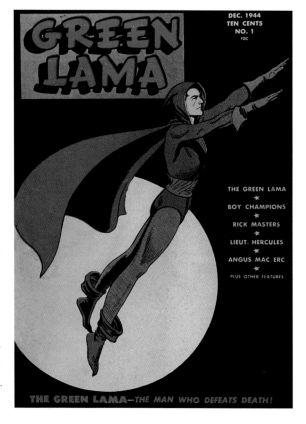

175. The sage of many Tibet dream stories is a kind of harbinger of the new man, the superman. That these sages are more often than not non-Tibetan 'lamas' shows that sacred Tibet and its inhabitants serve primarily as a setting for the personal dramas of white men.

D. The search for the foundations of the Tibetan dreamworld

Now that we have discussed in detail what images the West has constructed of Tibet over the centuries, we should like finally to turn to the question of what are their causes, a question that has been gone into only cursorily in the literature on Western Tibet images available up to now.

The satisfaction of deep-seated needs

Many of the dreams that make up Dreamworld Tibet seem to speak to yearnings in a Western clientele that are ancient and occur in many ideas of paradise: peace, wisdom, a long, carefree life, sexual fulfilment, harmony and an order that assigns to everyone his or her place. Let us think, for example, of Arcadia, that shepherds' Utopia where music, love and nature are enjoyed in harmonious peace, or of another part of the world that was regarded as an earthly paradise, especially in the 18th and 19th centuries—the South Sea island Tahiti.

To discern yearnings for paradise in the dreams of Tibet is sensible inasmuch as a further characteristic that is typical of earthly paradises applies to Tibet, too: it

> is so much of this world that it propels one on the way, in search.[29]

It is sought—as a geographical place—again and again.

> Hope's image is always hope's goal also

(Börner), towards which one moves, seeking—so too in the case of Tibet, as the numerous examples presented here confirm. At first only a few—after all, in the time of the missionaries, the journey sometimes took several years[30]—then many, today legions have set out for Tibet, in real life or fiction, driven on by the 'hope principle' (Ernst Bloch), in the expectation of finding, on the Roof of the World, Utopia, 'Shambha-la', 'Shangri-La' or 'Dharma-La'. Almost all the stories presented here describe such a search.

A common attempted explanation starts from the assumption that the need encountered everywhere for a paradise on Earth is so much the greater the more uncertain or meaningless present-day life is felt to be. Thus Utopian desires were already being projected onto peoples at the margins of the known geographical world in the age of Greek and Roman antiquity, because people weary of cultural development that they felt problematic longed for a simple, natural, country life. This theory might also explain why in the mid-nineteenth century, for example, Theosophy was so successful, with its search for a new spirituality: people were uncertain about the industrial revolution with its shift and assembly-line work, and about the downgrading of religious and moral values by a spreading rationalism and science-trusting positivism. Today—according to the champions of this theory—advancing mechanization, increasing

176-177 (p. 227). Many of the dreams that make up Dreamworld Tibet seem to speak to yearnings in a Western clientele that occur in many ideas of paradise: peace, wisdom, a long, carefree life, sexual fulfilment, harmony and an order that assigns to everyone his or her place. Let us think, for example, of Arcadia, that shepherds' Utopia where music, love and nature are enjoyed in harmonious peace, or of another part of the world that was regarded as an earthly paradise, especially in the 18th and 19th centuries—the South Sea island Tahiti.

unemployment, technology experienced as a threat and a general crisis of meaning cause uncertainties, which for their part result in a yearning for new purpose in life. Thus for example the ethnologist Bharati says:

> The radical, omnipresent alienation of Euro-America from the religious themes of the Western world, general dissatisfaction, the superficial religiosity of the established churches, antipathy towards scientific models, seem to bring forth war and destruction, and since recently, a growing fascination with the exotic for its own sake ... all that leads to a desperate search for ideas, rituals and promises that differ from those of the West, that lie as far as possible from the West, but are nonetheless easily attainable without intellectual effort or discursive input.[31]

In the fascination with the exotic mentioned by Bharati, Mario Erdheim sees an escapist theme: one hopes in foreign parts to get away from the problems that cannot be resolved at home.

> Exoticism does indeed draw young people to foreign parts, in this sense it stimulates separation from the family and its values, but preserves the old ties in the background,

says Erdheim, and he continues:

> One is drawn into the exotic in foreign parts, and therefore does not have to change anything at home.[32]

The examination of one's own history and present is replaced by the exotic idealization of the foreign. One gives oneself up and seeks salvation in the exotic, the foreign, the other and often also in the irrational.[33]

The above attempt at an explanation may make the need for a paradise-like state understandable, but it still does not explain adequately why Tibet in particular is regarded by many as a place of compensation and escape, why so many people have prejudices in favour of the Tibetans. Certainly a part has been and is still being played today by the view deeply rooted in Western thinking that simple societies—such as that of the Tibetans—live more harmoniously and better adapted than the larger, urbanized societies and ought therefore to be emulated, an opinion that has assumed the quality of a myth.[34] Tibet's remoteness may also have helped it to become a place of longing and escape—in accordance with the principle 'the more remote, the more fascinating'. But there are other societies just as simple and living in equally remote places about which no such myth has developed. The reasons must lie deeper.

If we start from the conclusion expressed previously that yearnings of Western man are expressed in Utopias, it must be accepted that Dreamworld Tibet also took up certain of these yearnings and promised to satisfy them. This means that the elements of Dreamworld Tibet encountered before are the reason for the special fascination of Tibet. For example, as a 'guru land'

> where there still dwell mystical men close to nature, who are above our school wisdom,[35]

fictional Tibet appeals to those for whom turning away from religion has brought about a crisis of meaning and uncertainty and who therefore yearn for a perfect way of life in which 'school wisdom' plays only a peripheral role. Tibetan religion, it is presumed, has something to offer in this regard: a rapid realization of perfection (for which neither reason nor intellect or logic is supposedly required), the attainment of superhuman powers, and a theory of fate as a valid alternative to Christian, materialist or existentialist theories, namely the belief in karma. This has fascinated such different people as the Nazi Himmler, the Theosophist Blavatsky, the adventurer and con-man Trebitsch-Lincoln, the author Davidson, the film-maker Herbert Achternbusch and many more, and still today draws many under its spell.

But Tibet satisfies still more concrete longings, for example with its belief in incarnation, based on the karma belief, which leads to the conclusion that saints can reincarnate in any being. Is there a better method for satisfying the human need for self-aggrandisement? Secret, strange, miracle-working, magical Tibet is within us!

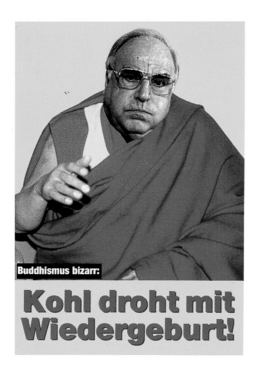

Buddhismus bizarr:

Kohl droht mit Wiedergeburt!

178. 'Kohl threatens to be reborn!'—Tibet satisfies still more concrete longings, for example with its belief in incarnation. Is there a better method for satisfying the human need for self-aggrandisement? Secret, strange, miracle-working, magical Tibet is within us!

The belief in karma and, so closely linked to it, reincarnation is of course shared in India, but the Indian caste system does not correspond to the European idea of equality and moreover India lost its sacredness the more it was explored, just as Egypt had lost its own to India before. Tibet presented itself as an alternative. The remote location was not as such the principal reason for the formation of the Tibet dreamworld, but merely one of the important prerequisites for it. For on account of its distance and inaccessibility, the characteristics imputed to Tibet could be neither verified nor disproved.

Finally, Tibet also answers yet other yearnings: we have established that in the view of many, there seems to be no change or indeed revolution in sacred Tibet, no assumption of autonomy. Instead, conservative values are fostered, such as the upholding of a hierarchical governmental structure and adherence to what has been handed down, e.g., ancient wisdom. Tibet stands for continuity, it is the antithesis of the ever faster change we experience. The mystification of Tibet is for many an expression of this longing for the preservation and restoration of old values and practices, for holding on to theocratic order and hierarchy. In a world experienced as ever more confused, challenging and dangerous, many seem to be fascinated by the belief in a charismatic, omnipotent ruler, a perfect monarch, who guarantees safety and security and leads his subordinates justly without their having to take care of political affairs. But we have established that these supposed perfect rulers in Tibet are only in the rarest cases Tibetans. Why?

The ladder of nature

It is comprehensible that the men living in dreamland Tibet were for a long time not Tibetans but Aryans and whites, if one keeps in mind how the West has encountered strangers over the centuries, how it has taken them and constructed 'the alien'. This always starts from a dichotomy, distinguishing between the home group, the us-group, and the others, the foreigners. The home group had a highly developed state and likewise a highly developed society, culture and religion—these were called 'civilized'—while the others managed without all this and were primitive and little developed. This idea was expressed in writings on theories of social evolution in the nineteenth century, but was already widespread before and survives to this day—sometimes only subliminally—in the heads of Western people.

Despite supposed perfection and a life of plenty,

Western man has constantly felt and still feels his existence to be unsatisfactory. The discrepancy between claim and reality is too obvious. Therefore he posits a place somewhere where all ideals are actually realized—an earthly paradise. Such paradise ideas reflect the central values not current (any longer) in the relevant society, for the paradise is the storehouse of the characteristic supreme values and people, the high civilization in absolute perfection. If many Westerners now feel Tibet to be paradisiacal, according to what has been said above this must mean that Western man is of the view that values are to be found in sacred Tibet that are very close to his own. And indeed we have seen again and again how there have been and still are attempts to demonstrate such (alleged) similarities, for example, correspondences in religious ideas and practices,

similar conceptions of the world and ways of life. The 'settling' of Aryans in Tibet also served to substantiate and confirm the closeness. For others, the closeness resulted from the fact that the cradle of humanity and thus of their own forefathers was supposed to be in the Himalaya.

On the basis of certain similarities defined by Western man, the Tibetans therefore belonged to the 'highly developed races', as, representative of many, the Australian missionary J.H. Edgar, active in Tibet in the first quarter of the twentieth century, once wrote.[36] The assessment of foreign human beings on the basis of a 'ladder of nature' theory was quite usual since the second half of the nineteenth century. What was new was that a scarcely known foreign group, the Tibetans, or at least the sacred Tibetans, was considered highly developed. This was a consequence, among other things, of the Theosophical racial theory. As we have seen, the Theosophists were probably the first to grant the Tibetans a high place in their evolutionary chart—and thereby encouraged the admiration of them that continues to this day.

Early travellers' reports already depicted Tibetan men and women as cheerful, constantly laughing and good-natured, whereas the negative voices, though not entirely absent, were clearly in the minority. This image survived for 300 years: at the beginning of the 1960s, when the first Tibetan refugees were received in Switzerland, they were still being described as the happiest, friendliest and most honest of people. To this was added a further characteristic, highly regarded in Swiss society: the Tibetans were described as able workers, eager to learn, they were 'like the Swiss', whose men went to work each day while the women and girls worked in the home and at the looms.[37] In other words: because the Tibetans shared with the Swiss a central virtue, namely a high work ethic, the Swiss took a liking to them. The Tibetans living in Switzerland are well aware of this bonus and behave accordingly. Thus some have gone over to giving away their Tibetan origin to an unknown opposite number right from the start, as they have established that they then encounter great sympathy,[38] whereas they are conscious of rejection or at least scepticism as long as it is suspected that they came from another Asian country such as the Philippines or Thailand. Inhabitants of these countries do not enjoy the privilege of ranking as high as Tibetans in the Western 'evolutionary scale'.[39] Interestingly, Blavatsky already placed these Asians lower than the Tibetans on her evolutionary scale.[40]

179. Many (alleged) similarities were found in sacred Tibet and interpreted as signs of the closeness and affinity of cultures so far apart. This endeavour to make visible what they have in common is recognizable, for example, in this coloured engraving: the Dalai Lama has long hair and clothes whose pattern is not at all Tibetan, and is sitting on an apparently European cushion. The eight-armed Avalokita (lower centre) is wearing a woman's dress of Western cut and has on the head some indefinable ornament instead of additional heads, and the head covering of the upper right figure is reminiscent of that of a Western nun. In fact the figure is probably supposed to depict a Tibetan monk with a hat.

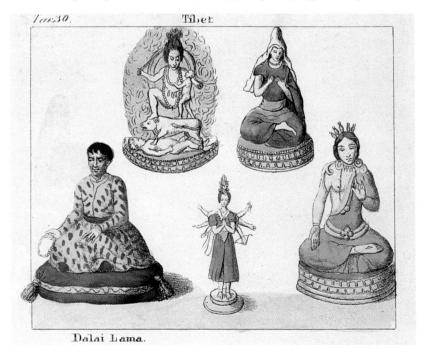

The fascination of David in the mountains

From the mid-eighteenth century the beauty and idyllicism of the mountains drew people enthusiastic for nature under their spell, which in Europe, for example, led to Switzerland, discovered as a travel destination in the eighteenth century and henceforth much praised, being felt to be 'holy', a 'mountain-enclosed Elysium', a paradise or even the Garden of Eden being seen in it. This represented an enormous reversal of opinion; after all the Swiss had been regarded previously as the scum of the earth, as godless, murderous barbarians, boundlessly compulsive and stupid. In the mid-eighteenth century an idealizing stereotype of Switzerland formed. This idyllizing was probably inaugurated by Albrecht von Haller with his didactic poem *Die Alpen* (1732), was continued by Salomon Gessner in his *Idyllen* (1756), and reached its apogee in Schiller's *Wilhelm Tell* (1804).[41] Human ideality and magnificent mountain nature were inseparably linked therein: ideal man in ideal nature. Something similar is reflected in the Tibet myths. In these too, ideal nature on the Roof of the World provides living space for ideal humans—especially clergy.[42]

Tibet, however, is not only a remote highland, the Roof of the World, but is regarded—despite its vast extent—as small and vulnerable, an image no doubt formed because of its two powerful neighbours, India and China. That the ideal men living in sacred Tibet are threatened, and even driven from Paradise, brings to life the myth of David and Goliath: in early newspaper articles on the reception of Tibetans in Switzerland there are allusions to this myth, when for example the Tibetans are compared with the ancient Swiss or there is mention of a 'brave little mountain nation who for the sake of freedom have taken upon themselves the bitterness of exile.'[43] Many Swiss are proud of their forefathers' resistance to

180. From the mid-eighteenth century the beauty and idyllicism of the mountains drew people enthusiastic for nature under their spell. Human ideality and magnificent mountain nature were inseparably linked therein: ideal man in ideal nature. Something similar is reflected in the Tibet myths. In these too, ideal nature on the Roof of the World provides living space for ideal humans—especially clergy.

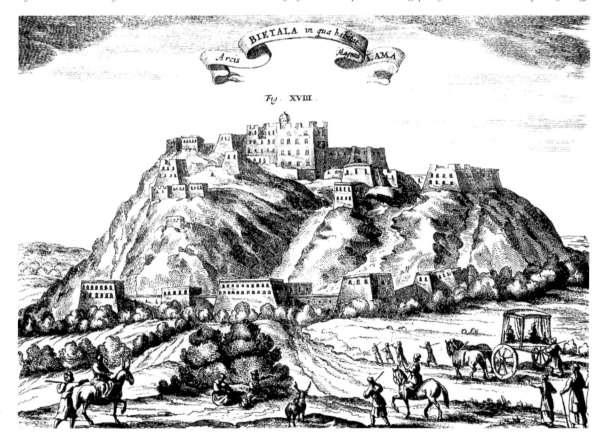

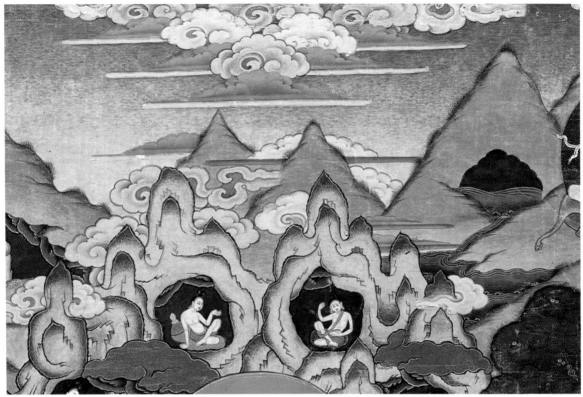

181a

181. The ideal Tibet images of the West are based in part on Tibetan ideas. The view, for example, that the ideal nature of Tibet provided the spiritual with suitable opportunities for living and development is also deeply rooted in the Tibetan tradition, as pictures of monks and yogins meditating in nature confirm (181a). There are also constant mentions in Tibetan legends of spiritual masters levitating or performing other miraculous deeds, including for example the Mahâsiddhas Virûpa (181b) and Bhinnapâda (181c).

mighty enemies and of their state that emerged from this. This common (or supposedly common) history is one of the central elements in the Swiss feeling of solidarity. Rebellion against unruly masters, against foreign powers, is familiar to the Swiss from hearsay and its reception is not unsympathetic—especially not when it is a matter of a powerful aggressor, representing an alien ideology, which he wants to force upon the little David. This sympathy for 'David' came to fruition in the cases of Hungary, Czechoslovakia and Tibet, but not with the Chilean, Kurdish and Tamil refugees. Strikingly, it was precisely the latter who always had the most trouble getting recognized as refugees. Many people seem to expect of a genuine refugee that he is running away from a powerful, foreign—that is, not identical ethnically or politically—cruel Goliath. If the latter is wanting to impose on the poor and—as shown above—conservative David a Communist ideology, for some the sentiment for the little guy is all the more sympathetic.

Orville Schell explains very similarly the present wave of sympathy that is greeting Tibetans in the USA:

> There is the little guy, even though Tibet is as large as western Europe, being kicked around by the big guy, namely China. And that is a very American theme, to root for the underdog, so on top of all the old fascinations with mystery, mountains, remoteness, roof of the world, forbidden kingdom, et cetera, we've added this new dimension, which I think makes it a very compelling subject for Americans.[44]

That Tibet is felt to be a plucky, independent David despite its geographical extent, is probably connected with the fact that it was never a colony. It was the last unconquered and unsullied land, an anachronism in the age of imperialism.[45] Perhaps because of that also, Tibet was largely spared criticism, a negative portrayal by the West. For did not Edward Said say that the negative portrayal of the Orient by the Occident was founded on hegemonic thinking and imperialistic control and exploitation? Where no imperialistic exploitation took place, it could be concluded on the basis of Said's form of argument, there also existed no reason for a negative portrayal.

Tibetan models as a kernel of truth

Until now we have assumed that all the Tibet stories and images presented in this book arose out of the imaginations of Western people and express something about their needs, fears and hopes. In the following section it is to be shown that the Tibet image of the West has also been influenced in part by actual Tibetan ideas and practices.

Let us take for example the theme of the levitating, astral-travelling and all-knowing Tibetan monk, which we have encountered again and again in Western stories of Tibet. This actually exists—in countless oral and written accounts of the Tibetans. Let us, for example, recall here the 84 Mahâsiddhas, who according to Buddhist ideas had at their disposal supernatural powers such as the power of passing through matter, materializing and dematerializing things, moving extremely

181b

181c

quickly and making themselves immortal. In addition they possessed spiritual powers such as mind-reading, the recollection of past lives, clairaudience (the ability to understand all languages, including those of animals), clairvoyance, the manipulation of the elements (e.g., flying, walking on water) and so forth.

Some concrete examples may elucidate what has just been said. The Mahâsiddha Virûpa walked across a lake. To a six-month journey on foot, Kotâlipa preferred reaching his goal in a single instant in his 'Awareness-body'. Nâgârjuna transformed a mountain first into iron and then into copper, and would without more ado have gone on to turn it into gold, had not the Bodhisattva Manjushri warned him that to do this would bring about a great quarrel among people. Nâgârjuna was also capable of flying in the air. Kânhapa floated a cubit above the ground after deep meditation, Kalapa managed a height of seven palm trees. Kapâlapa worked for other living beings for five hundred years until he eventually went to 'the realm of the Dâkas'; Sakara compelled the nâga-kings to let it rain; Nâgârjuna read the thoughts of a thief.[46]

Many of the miraculous feats represented in this book, which Western authors have credited Tibetan monks with, also appear in the biography of Padmasambhava, in that of the Yogi Milarepa, and in innumerable other hagiographies—even those of the present day.[47] They are true and at the same time false. They are true in the sense that they are found in Tibetan accounts and many Tibetans have believed in them and still believe in them today. They may also describe psychological states and processes, but not actual events in the outside world. Our European fairy tales are also full of miraculous deeds, and yet scarcely anyone would call them true, in the sense that the supernatural deeds described in them were actually performed or indeed are still performed today.

As has been repeatedly pointed out in the present book, the Western stories of Tibet presented here, abstruse for the most part, are at variance with each other and contain contradictions and errors. Fragments of Tibetan stories and ideas—for example, the legends

182. The 'third eye' is not a complete invention by the Theosophists and Lobsang Rampa. Many Tibetan depictions of deities show a third eye on the forehead between the two eyes. This is in fact a 'wisdom-eye', which enables the realization of Emptiness and together with the two 'normal' eyes makes it possible to discern and perceive the Three Times. But this third eye is never proper to a human being, and can accordingly never be chiselled in by means of an operation as Lobsang Rampa/Cyril Hoskins claimed.

describing anthropogenesis—are augmented with strange fantasies. The result is a dreamworld, a phantom world, an illusory Tibet.

But we come back again to the Tibetan sources: even the 'third eye' is not a complete invention by the Theosophists and Lobsang Rampa. Many Tibetan depictions of deities show a third eye on the forehead between the two eyes. This is in fact a 'wisdom-eye', which enables the realization of Emptiness and together with the two 'normal' eyes makes it possible to discern and perceive the Three Times (past, present and future).[48] But this third eye is never proper to a human being, even to a lama, and can accordingly never be chiselled in by means of an operation as Lobsang Rampa/ Cyril Hoskins claimed.[49]

Tibet, the fountain of youth, likewise is not altogether snatched out of thin air, but has parallels in Tibetan tradition. Once again the example of a Mahâsiddha will do to demonstrate this: the senile Râhula, who was no longer able to control his body and was abused and maltreated by his relatives, transformed himself by a special meditational practice into the body of a sixteen-year-old youth. Dharmapa even transformed himself into an eight-year-old boy.

The Tibet of miracles and the fountain of youth, as we have explained, has its counterpart in Tibetan hagiographies of the Mahâsiddhas, Padmasambhava and Milarepa, but is also found in the—genuine—Shambhala myth. For this too exists, though quite different from the way

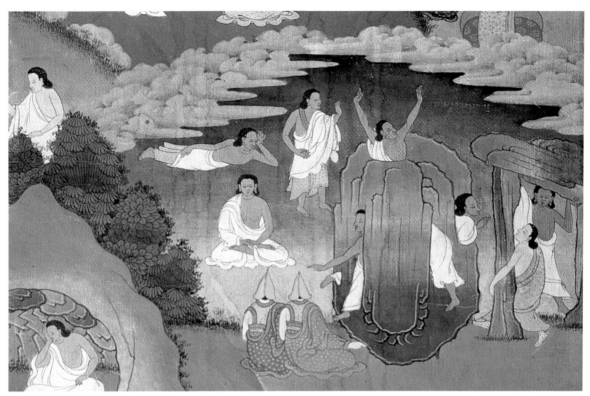

183. An example of mastery of the material world by a Tibetan saint: the yogi Milarepa—according to the relevant Tibetan hagiography—made a rock permeable by a special meditation, so that he could pass through it. Subsequently he threw the rock into the air and let it fall down on him, without suffering the slightest injury.

Blavatsky and her Theosophical and Ariosophical disciples told it.

> … In Jambudvîpa, in the Kailas region, in the right-hand half, between the World-mountain and the Śitâ river (the Tarim river in East Turkestan), lies the great land of Shambhala.
>
> Shambhala is completely circular, surrounded by snow mountains, which encircle the land like a garland. There are streets leading to the South, the West and the East. Inside the snow mountains the circular land is surrounded by dense forests of *śâl* trees … As if on fertile soil, a lotus flower rises at the focal point in the centre of the Kalâpa Palace … The palace is built of various precious stones. Its light shines over a distance of one *yojana* and combines with light coming from the outer snow mountains. This lights up the night as bright as day, (bright) enough to read the smallest writing. If one looks at the Moon at the same time, that appears only as a palely glimmering disk.
>
> The rooms in the palace that the King of Shambhala lives in are of emerald, crystal and diamond. The light of the precious stones turns night into day. The precious thrones are of the finest gold, gold from the Jambu River. On the sides of the thrones, which are like mirrors of costly glass, appear images of all living creatures within a radius of fifty *yojanas*, even the fish in the water.
>
> The round window disks are of glass; when one looks through them, one sees the palaces on the Sun, Moon and stars. Furthermore the gods, magnificent gardens, the Milky Way and the twelve signs of the

184 (right). Shambhala was first mentioned—as Xembala—in letters of the two Jesuits Estevao Cacella and Joao Cabral in 1627. They had heard the name during a stay in Bhutan, but identified the country not with Central Asia, but with Cathay, China. Ever since then the concept of Shambhala has stimulated the imagination of Western men.

The first mention of Shambhala in an English text is found in an article by Alexander Csoma de Körös from 1833. The Shambhala myth was especially fostered in the West by Helena Blavatsky. After a long interruption, Nicholas Roerich followed in the 1930s, and from the 1960s came the authors who have built up the legend of a Nazi-Tibet connection, such as Pauwels & Bergier, Ravenscroft, Suster, Serrano and McCloud.

Western scholars have speculated on conceivable geographical locations and the history of Shambhala. Was it identical with the kingdom of Kushan, the Uighur kingdom of Khocho or the Buddhist realm of Khotan? In favour of an equivalence of Shambhala with Khotan there is the fact that around 1000CE Khotan was the most influential Buddhist kingdom. Some researchers, however, establish Shambhala farther north. In any case, the correct location of Shambhala has been hushed up, as the mysteries supposed to be there should not be made accessible to everyone.

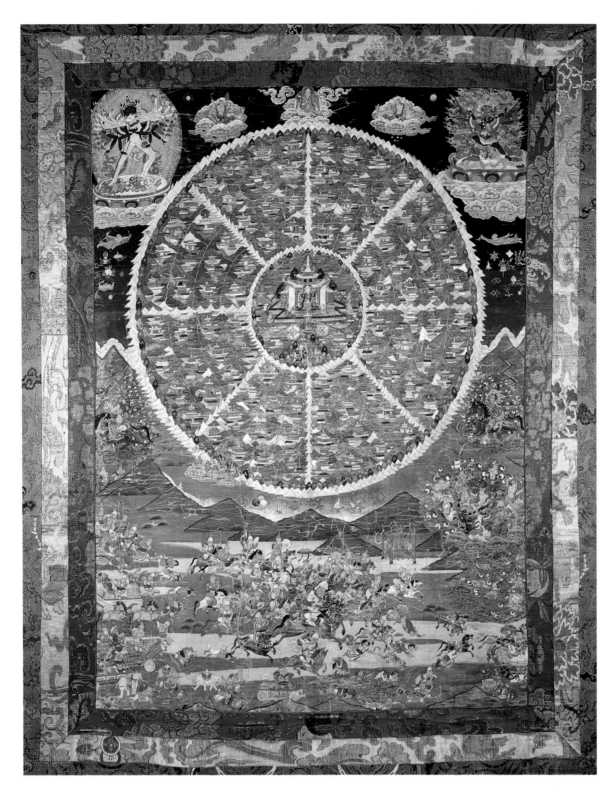

Zodiac appear to be just in front of one's eyes …

Not to speak of the most precious materials worth billions and more, of which the curtains and cushions are made. As for the value of a single one of these rooms in the palace, it amounts to a whole city of stacked up bars of gold, to say nothing of everything else. For example, the jewellery of the King of Shambhala consists of a crown whose peak is woven of coloured snow-lion hair and whose clasp is of gold from the Jambu River; the rings on his arms and ankles are studded with jewels each of which is worth several million gold pieces. Their light combines with the light of the king's body and shines so far that not even Indra, King of the Gods, can bear this radiance. In addition the king of Shambhala possesses ministers, generals, a great host

of queens and an infinite number of different vehicles, on which he travels: *śarabha*s, elephants, winged elephants, heavenly steeds, carriages and palanquins. Indra, King of the Gods himself is no match for his natural wealth, the power of the Tantras, and the pleasures and costly dishes his people bring him. ...

To the south of the palace lies the Malaya Park. In the centre of this park stands the three-dimensional Kâlachakra mandala built by King Suchandra. Other mandalas are found there as well, erected by other Kulika kings of later periods. In the east of this park is the Lake of Wishes, in the west the Lake of the White Lotus. ...

The land has the form of eight lotus petals, separated from each other by rivers and snow. On each petal live a hundred and twenty million families. Each ten million families have a king, who teaches the Kâlachakra Tantra. All the inhabitants speak Sanskrit and wear white clothing and turbans. Even the poorest own a hundred sackfuls of gold.

Most practise the Tantras that deal with the eight *siddhi*s, and many of them attain *samâdhi* according to the *Perfection of Wisdom* Sutras. Their way of life is gentle; they are completely free of any kind of use of force and from famine and disease. With the most profound reverence they make offerings to the several tens of millions of disciples of the Buddha.

As most of them have attained tantric power, the *nâga*s and titans appear as their obedient servants.[50]

It is not difficult to recognize in this description of Shambhala some central themes that we have encountered in our study of Western images of Tibet: a king who, if one is to believe the description of his palace, must be the Lord of the World;[51] people who practise the use of the eight *siddhi*s (superhuman powers) and who know no poverty, hunger or disease but who live gently and without violence. That there are nevertheless generals standing at the king's side and that in other places in the rest of the Shambhala myth there is mention of an apocalyptic battle in the last days, in which the enemies are brutally crushed, seems to do no damage to this image of peaceful Shambhala. This is a discrepancy that we have repeatedly noticed when contemplating the Western dream images of Tibet: although it is known perfectly well that murder, civil war and indeed external wars have happened in Tibet, the Tibetans are portrayed as extremely peace-loving, just as the inhabitants of Shambhala are regarded as peaceful although they have a considerable war machine at their disposal and are waiting for the day of the apocalyptic battle. In particular, the Shambhala myth describes a kind of final war

between Buddhists and Muslims. With this myth, the Buddhists of North India, humiliated, driven out and decimated by pillaging Muslims, gave expression to their hope of vanquishing the victors at a precisely determined time and helping Buddhism to a new blossoming. Were there overtones here of the idea of a Buddhist holy war, which is a peaceable and righteous war as long as it serves for the defence of one's religion? Is this antipathy towards the Muslims one of the reasons why some Christians feel linked to the Tibetans? It is not only common values that unite, but common images of the enemy.

The above description of Shambhala also reveals that its society is hierarchically organized: right at the top, the king of Shambhala; under him, kings, ministers and generals. Thus the hierarchy of sacred Tibet, which we have recognized as a typical theme of the Western dreams and myths of Tibet, is also not entirely invented, but based on a markedly hierarchical ideal image of the state found in many Tibetan descriptions.

This conception of the world also manifests itself in the hierarchy of the Tibetan pantheon and of the Tibetan clergy. There is a widespread type of scroll painting called the 'collection field' (*tshogs-zhing*), which shows a tree on whose branches sit the various categories of lamas, deities and buddhas—the less important ones lower down and the most important at the top. The entire Tibetan clergy is hierarchically structured. Let us recall the Dalai Lama, the Panchen Lama, the incarnations presiding over the important religious schools, the countless other incarnations,[52] the abbots and the monks subordinate to them, who likewise belong to

185. Since the West has been in contact with Tibet, the wise men at the top of its sacred hierarchy—the Dalai Lamas, the Panchen Rinpoches, and at the time of the Theosophists, the Masters, Mahatmas and other imaginary bearers of wisdom—have exerted a particular fascination. The mystification of Tibet is for many an expression of a longing for the preservation and restoration of old values and practices, for holding on to theocratic order and hierarchy.

This hierarchy of sacred Tibet, which we have recognized as a typical theme of the West's Tibet dreams and myths, is not wholly invented, but is based on a markedly hierarchical ideal image of the state found in many Tibetan accounts. This conception of the world also manifests itself in the strict hierarchy of the Tibetan pantheon and the Tibetan clergy. Tangka paintings of the so-called 'Field of Collection (of Merit)' (tshogs zhing) are widely disseminated, which show a tree on whose branches sit the various categories of lamas, deities and Buddhas, with the less important on the lower branches and the more important above.

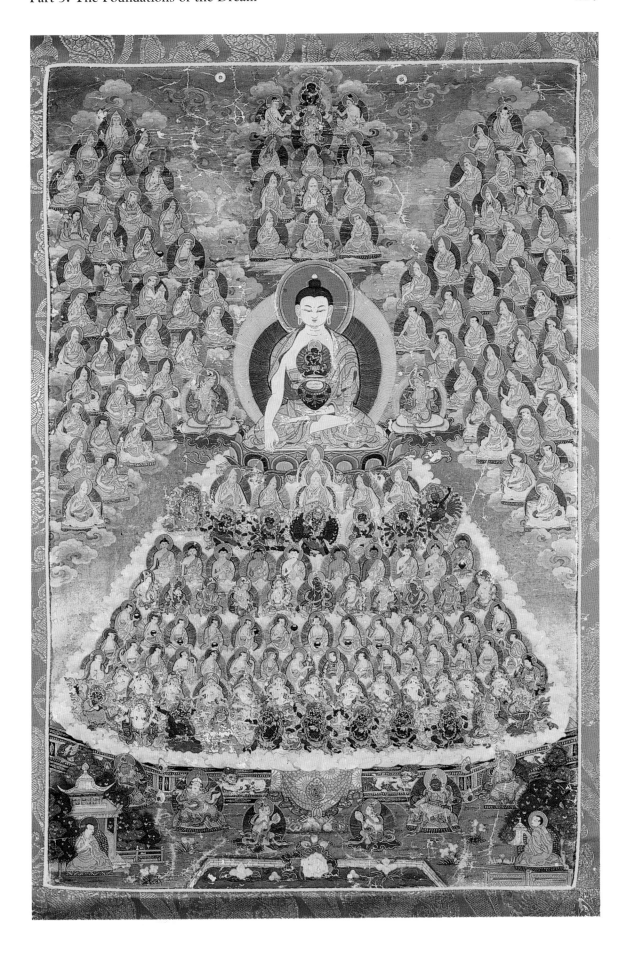

categories of differing rank—a system that, as Bishop points out, can be called either 'paternal and benign' or a 'divine tyranny', depending on one's point of view.[53] Blavatsky, Hilton, Gurdjieff and all their followers and imitators recognized the deep-seated need many people have for such a well-ordered clerical regime and for a wise and venerable father figure and took inspiration from comparable Tibetan models.

Even the lascivious, sexual scenes we have met in certain novels and in one feature film did not arise entirely from the imagination of Western authors. At first glance, Tibetan Buddhism does indeed look like a purely male preserve and asexual, if one ignores the symbolism of Tantra with its so-called *yab-yum* (Father-Mother) images and the corresponding, mostly secret, Tantric texts. But at the same time there exists a largely unknown erotic underground literature about the 'lower door', as the female organ is called. To this category of literature belong the erotic poetry of the Sixth Dalai Lama, the treatise on passion by the Buddhist master Mipham Jamyang Namgyal and a similar work by Gendün Chöpel, works that as a rule used to circulate in secret. Gendün Chöpel did not only write about sex and women, he was himself a fiery lover, but he warned monks and spiritual persons about reading his texts. On this point Gendün Chöpel tends to be misunderstood by some Western interpreters, who want to see him as a prototypical tantric sex guru. The Sixth Dalai Lama also suffers mystification in a similar manner: although his songs are simple love songs, they are seen as accounts of Tantric experiences.[54] To lay people, these writings and their heroes are barely known, with the exception of the tales of Aku Tonpa, who mainly carried on with nuns, and Drukpa Kunle, who primarily pestered Tibetan and Bhutanese virgins.

Even the union of a demoness with a monkey, taken as a theme in two novels, which inspired the authors to portray female incarnations, descendants of the demoness, as sex-crazy, goes back to a most central ancient Tibetan legend, which, however—in contrast to the novels—has nothing lascivious or sexually erotic about it:

> Then Buddha Amitâbha said to the Bodhisattva Avalokita: 'Buddha Shâkyamuni has not been into Tibet, the Land of Snows; his Word has not been spread there and his Mind has not blessed it. So you, Bodhisattva, should take this land into your care.

> First you should let men spread in the Land of Snows, then gratify them with material and spiritual gifts.'

> Then Avalokita betook himself to the room built of different precious stones in the palace on the Potala mountain. He bent his gaze upon the sentient beings in Tibet and saw the suffering beings, caught as if in an iron jar. From his left palm he shone a beam of light, which transformed into a monkey-bodhisattva. The monkey remained in the forest in the meditative absorption known as concentration meditation.

> At this time the Buddha Târâ also incarnated herself, as a rock-demoness, with the intention of spreading human beings in Tibet. At that time Upper Tibet, which consisted of snow and moraines, was inhabited by beasts of prey and game animals; Middle Tibet, consisting of rocks and forest, by monkeys and rock-demons; and Lower Tibet, consisting of plains and water, by elephants and various kinds of birds. Human beings were unknown.

> One day the rock-demoness, overcome with great desire, came to the monkey in the shape of a she-monkey … and intimated to him that he should couple with her. The monkey did not let himself be conquered by desire. The she-monkey came to him again and said 'I want to couple with you,' (but) the he-monkey replied 'I do not want to couple with you.' The she-monkey said: 'Listen and reflect, O King of the Monkeys! For reasons of karma, I have been born as a demoness. Out of desire I craved you, out of desire I sought to be near you. If you do not couple with me, then I shall couple with a demon. (Then) innumerable demon-children will be born, and they will eat thousands of sentient beings every night and kill tens of thousands every day. All other sentient beings will be eaten by the demons and the Land of Snows will become a land of demons. After my death, because of their negative actions, my children will be reborn in the underworld, full of suffering. Therefore I beg you to reflect upon my situation.'

> Then the monkey felt great compassion without desire and prayed to Avalokita in the following words: 'O kind Lord of the World, a lustful demoness has disturbed me. How should I react?'

> Avalokita answered: 'Unite with the rock-demoness. Your children will multiply and eventually become human beings. They will receive the teaching of the Buddha.' The monkey took this to heart, and later six children came into the world … As the children's father was a monkey, they had hair all over their bodies and red faces. As their mother was a rock-demoness, the children had no tails, but long hair (on the head). They liked eating flesh and drinking blood and were able to speak …[55]

This account inevitably makes one think of the yetis, which we have encountered now and then in this book. Here too it is valid: yetis did not

arise entirely out of the imagination of Westerners. The Tibetans, and especially members of Tibetan-speaking peoples to the south of Tibet, believe in their existence, but name them differently: drema, chuti, miti, midre or migu.[56]

Ritual instruments, which we have met again and again in the present book, also belong inseparably to the religious life of Tibet. Their actual role and use, however, are generally depicted in a distorted way in Western products. Thus hand prayer wheels are used by lay people rather than by monks, while ritual instruments such as daggers, knives and the like are not to be found in the hands of lay people. Ritual daggers (*phurbu*) are in fact weapons that should never be employed against humans. What is destroyed in the Phurbu cult is primarily the evil qualities of hindering beings, not so much the beings themselves. But there also exist practices in which hostile, hindering creatures are attacked in ritual: those within the meditator's mind, others that threaten the health and life of a monk, and those that wish to destroy Buddhism. These ritual 'killings' are permissible according to Buddhist views if carried out with the correct attitude, that is, with the feeling of compassion, because they achieve the destruction of evil and the furtherance of good. Regarded in this way, the films in which Tibetan ritual daggers appear are not as un-Buddhist as they might appear at first sight, as the daggers used in them help good succeed in quite a Buddhist spirit.[57]

The electrification of the prayer wheel is also founded on preliminary work by the Tibetans; for they are not acquainted only with hand-driven prayer wheels, but also with ones set in motion by water or wind power or by rising hot air. The 'industrialization' of Tibetan Buddhism had already begun a long time ago.

To sum up, it can be said: there are levitating and age-old holy men of Tibet who even have sex from time to time; there are ingredients, rites and implements that effect miracles; there are regions of the Shangri-La type, called Shambhala and 'hidden valleys'. All these phenomena exist—in legends, in fairy tales, in sacred texts, in the oral traditions of Tibet. The images, demonstrated in

186a

186b

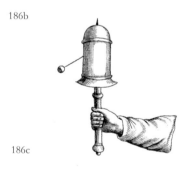

186c

186d

186. One Tibetan ritual instrument has been able to stimulate the imagination of Westerners—early missionaries, philosophers, novelists and comic-book artists—again and again: the prayer wheel.

this book, that the West has created of Tibet for hundreds of years are therefore not entirely snatched out of thin air, but are based—partly—on Tibetan models. But only partly. Many, as has been described here, have been constructed by Westerners, have arisen out of the longings and needs of Western society, and have scarcely anything to do with Tibet. Moreover, borrowings from Tibetan material are always done in a biased way: only the men are of interest, not the women; the clergy, not the laity; the strange, not the everyday; the exceptional, not the ordinary. In short, Tibet stereotypes have been created by selective awareness, simplification and schematic reduction of complex circumstances.

In our attempts at interpretation up to now, one category of Tibet caricatures has been left out of consideration: the depiction of the macabre, evil Tibet, which we have come across a few times, especially in accounts from the 1930s, in some novels and comics. Behind certain of these nightmare images there seems to be a failed hope, a disappointed love, as with Antonin Artaud and

Mr and Mrs Röttgen/Trimondi: at first they are themselves involved in the dream image of Tibet, then all of a sudden they see through the illusion and turn away from it, without realizing that they themselves had created it. For others, all of Tibet or a particular Tibetan theme seems to serve as a reflection of their own enemy image—Tibet as a kind of scapegoat. Why it should be Tibet that these people use as a whipping boy, one can only speculate. The reasons seem to be at least partly of a religious nature: for a number of Protestant critics in particular, Tibetan 'Lamaism' forms with Judaism and Catholicism a conspiratorial secret society, which results in fear and aversion. That Tibet is for some the threatening country of origin of world-conquerors can perhaps be traced back to the fact that, as shown in the present book, it is regarded in neo-Nazi literature as an area of retreat and activity of Nazis. The illusion of Nazi Tibet maintains its own dynamic, becoming increasingly considered as real. In this it shares the fate of many myths and dreams, which prove to be resistant and virulent, once lodged in the head.

187. A 'Tibetan ritual instrument' that is neither Tibetan nor ritual in origin: the 'singing bowl'. This was originally a food bowl from Nepal or India, whose beautiful tone was recognized one day by a clever businessman. Since then the bowls have been marketed as Tibetan ritual instruments.

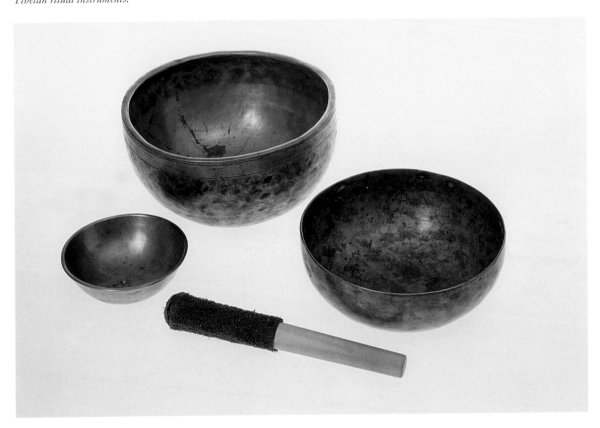

The cunning methods of creators of the Tibet dream, or:
The axiom of the irrefutability of the absurd

Gurdjieff claimed to have lived in the Sarmun Monastery; Agamon and Robin-Evans were of the opinion that descendants of beings from outer space were still living in Tibet; Lobsang Rampa would have us believe he was 'possessed' by a Tibetan. They all owe us proof that they were speaking the truth. But we sceptics and doubters have a problem too, which the inventors of the stories that by and large make up the Western dream of Tibet make full use of: it is also hard to furnish proof of the opposite, that many of these stories were invented and arose from the human imagination. Intensive study of strange images of Tibet has made one thing clear: the impossibility of refuting absurdities beyond doubt. Irrationality evades rational analysis and refutation. When Agamon and Robin-Evans claim that descendants of beings from outer space are living in Tibet, we can deny this with almost absolute certainty, but the non-existence of these beings cannot be proven. The claim that there are yetis living in Tibet and the Himalaya today can also be shown to be extremely improbable on the basis of our present knowledge, but it must be impossible to prove that there actually are no yetis. And how can it be verified that Cyril Hoskins was not possessed by a Tibetan?

Most of the stories that have been presented here play with this impossibility of proving the non-existence of something absurd. Helena Blavatsky claimed she received letters from her Masters by supernatural means. As long as no one caught her or one of her assistants writing the letters, this deception remained unproven.[58] Even when the Coulomb couple, who had worked together with HPB for a long time, claimed that HPB was a cheat, the attack could be cleverly warded off by making the Coulombs out to be liars and fakers. Absurdity cannot be disproven, and the creators of Dreamworld Tibet profit from this. Blavatsky, Gurdjieff, Trebitsch-Lincoln, van Helsing, Lobsang Rampa, von Däniken … they all made use of what we call here 'the axiom of the unprovability of the non-existence of an absurdity'. One consequence of the fact that the irrational evades reasoned analysis is that the prejudices and stereotypes arising out of

irrationality are very rigid, which may explain their long life. 'Prejudices are among the most durable things in human history,' Alexander Mitscherlich once said.[59]

To make matters worse, we have what has been dubbed a 'chaos of plagiarism'. Stereotype images obtain more credibility if many corroborate them, an effect that can be achieved, among other ways, by copying from each other like mad without naming sources or examining their credibility. If the same state of affairs is mentioned in several books, it appears (more) likely—fallaciously so, especially when all the statements go back to one and the same source and this proves to be unreliable. It has been possible to demonstrate this occurrence repeatedly. How often has it been claimed in the literature that Hitler was advised by 'the lama with green gloves' or that beside Hitler's corpse lay a thousand dead men from the Himalaya! It has been possible to show that all these claims go back to a single source, without this being clearly stated and without heed to the original authors' warning that 'fairy tale and truth, rash speculation and exact vision are mingled' in their book.[60]

Other authors attempt to lend authenticity to their tales by feigning a scholarly approach. They refer to the exact text passages they have supposedly used, without, however, examining the truthfulness of these sources. Many a reliable-looking source has been unmasked in this book as a tissue of lies—despite footnotes, bibliography, photographs and first-hand accounts. 'Eye-witness reports' are a frequently-used trick. With them it is sought to prove the veracity of a particular phenomenenon by someone's attesting to having observed the phenomenon themselves, on the principle that 'If someone has seen something, it must be true.' The question of whether this 'someone' is a fictitious or a real person and of whether the person in question could actually have been in the area at the given time is entirely irrelevant. All this can be observed in Kelder's book, in Gurdjieff's tales, in the works of Blavatsky, in Haushofer's 'biographies' and so on. After all, it is a trick often used, subtly to blend truth, half-truth and invention, for example, by

working into the text certain historical, geographical or ethnographical data. If some of this information is true, it all is—that is the impression that is supposed to be conveyed.[61]

The encouragement of the Tibet myths by those concerned

'We enjoy the Tibet myths and the Western dreams of Tibet,' a Tibetan woman once said when I told her about my book project. In this she was expressing that Tibetan women and men also participate in the Western dream. They tolerate it, even encourage it, something that one Tibetan explained to me in the following words:

> Thanks to this nice gift-wrapping, we are conscious of a lot of affection for Tibet, and I hope this image remains in existence.

Nothing wrong with nice gift-wrapping, but—as we have shown in this book—it can quickly turn into deceptive packaging. And once the deceptive packaging put round Tibet is recognized as such, the disappointed recipient turns away from Tibet. Examples mentioned in this book such as the Surrealist Artaud and the Trimondis or Röttgens, as well as numerous former Dharma-worshippers who have turned away from Tibetan Buddhism in disillusion, confirm this.

188. The Tibetans are often unaware of the misuse of their culture, or are not clear where they should set the limits of tolerance. In the present case the limits have evidently been overstepped: smoking is after all regarded as a vice in Tibetan Buddhism, all the more so when cigarette ash is sprinkled over the head of the Buddha ...

The Tibetans are in a dilemma: they want to draw attention to their fate and win over other people to their cause, but they want to and ought to use only peaceful means to do so. The power of commerce is just what they wanted. Who can blame them? But where should the boundaries be set so that, as a Tibetan woman once said to me, the Tibetans are not prostituting themselves, Tibet does not become a whore? And how, asked the same woman, should the Tibetans handle the pride they feel when they are promised so much? Does pride not make one blind?

Prestige and pride are not the only reasons for the spontaneous and unchallenged acceptance of the mostly positive Tibet myths by those actually concerned. Another motive is Buddhism, which strongly influences the life of the Tibetans, with its commandment to practise a generous tolerance and so to accept other opinions. The unexpressed view is that it is fine for Westerners to have strange ideas about Tibet and its inhabitants, as long as they are happy and contented. But this attitude is dangerous, for the almost boundless tolerance can also do damage, on both sides: those receiving the 'gift' realize all of a sudden that Tibetan culture and society also possess clearly defined values, which it is not permissible to disregard. This may lead to disappointment and frustration, which once again react negatively upon the Tibetans, the 'givers'.

A further problem consists of the fact that the Tibetans are unaware, and cannot be aware, of the use and misuse of their culture, as they are unacquainted with the sources and examples gathered in this book. What Tibetans yet know that the neo-Nazis are misusing them in their stories? Who is aware that there are so many novels, comics and advertising films that use Tibet for quite definite messages? Who is acquainted with the Tibet images of Blavatsky, von Däniken and Gurdjieff? Positive prejudices make life sweeter and attract much less attention than negative ones, which as a rule result in bad treatment and even sanctions.

Beginnings of criticism and the lack of heed to it

Even if most Tibetans try to paint as positive an image of themselves as possible, which is generally human and quite understandable in view of their existence as refugees, it should not be overlooked that within Tibetan society there are also attempts at a critical analysis of their own culture and society. Interestingly, this is scarcely noticed in the West—further evidence of the extremely selective perception of Tibet by the West. We should like to clarify this with an example.

In the Western 'stories' described here, Tibetan monks, disregarding a few exceptions, appear as wise, all-knowing, peaceful and introverted. If, however, one reads books and articles written by Tibetans in recent decades, a far more differentiated picture comes to light. One of the

first to dare to criticize Tibetan religion was Chögyam Trungpa, who criticized the Tibetan Buddhism of the nineteenth century as sharply as practically anyone else:

> Abbots and great teachers were more concerned with the construction of massive gold roofs on their temples and huge Buddha statues, as well as the improvement and outward impression of their temples, than with the actual practice of their lineages of transmission. They sat in meditation less and did business more. This was the turning point of Buddhism in Tibet. It began to lose its connection with the Dharma and started to change, slowly, most infuriatingly and dreadfully into ugly spiritual materialism.[62]

Another cleric, Chagdud Tulku, likewise qualified the Western image of the Tibetan monk when he

189. In the West's Tibet-dream stories, the Tibetans appear almost without exception as peaceful. But recently this image of the peaceful Tibetan has been increasingly put into question—not least by Tibetans, who point out that even Dalai Lamas, for example the 'Great Fifth', have resorted to military force now and then. Force is also discussed in the Shambhala myth, according to which in the distant future Shambhala's enormous companies of warriors will do battle against demons and the unbelievers of this world. This will be the beginning of the Age of Perfection, of Paradise on Earth.

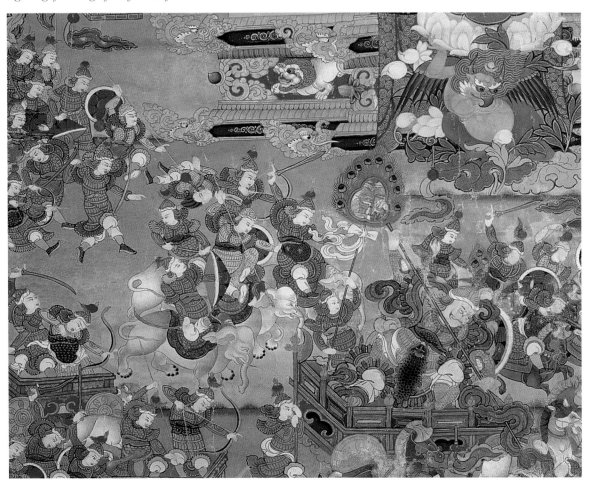

wrote in his autobiography that in Tibet the monks were not particularly docile, they would get aggressive if one refused to give them something, and behaved immorally again and again, whether they stole or had secret sexual relations.[63] Dawa Norbu also called most of the monks 'mediocre': only a few lived in accordance with their ideals, while others used to exploit the masses under the guise of religion. The learning of the monks—according to Norbu—benefited hardly anyone apart from themselves, and most of the monks were possessive and materialistic.[64] The Dalai Lama's sister, Jetsün Pema, herself wrote that there were monks among the religious orders who no longer followed their moral code, but occupied themselves with profiteering, developed greed for profit and preferred everything else you can think of to their spiritual contemplations.

> Quite a peculiar kind of people seemed to have usurped power, without consideration for morality or the nature of our culture.[65]

The very opposite of peaceful or even enlightened monks was to be found in the so-called 'dopdops' (Tib. *ldob-ldob*), who probably shaped the Western image of the fighting Tibetan monk. They are portrayed by almost every Tibetan author as brutal and stupid. For Tsewang Pemba, the dopdops, who each used their excessively large keys as weapons, were mindless monks, who shamelessly kept on

190. A prominent Tibetan critic was Gendün Chöphel, who was regarded by some as a lunatic, by others as a visionary. His protest stance cost him dearly: he was taken captive and died prematurely after leaving prison.

fighting and drinking,

> dirty, greasy fellows … more rogues than monks … They were the scourge of the streets in Lhasa, stole just what tempted them from shops, ate their fill free of charge in the pub and went after women with rude jokes and impudent looks.[66]

Tashi Tsering described how the dopdops would be on the hunt for youths and schoolchildren,[67] and Dawa Norbu too tore them to shreds.[68]

Tibetan authors by no means portray their homeland as purely peaceloving and pacifist, as the West has done repeatedly—more insistently in recent times. A young Tibetan says about this:

> One might believe that the principle of non-violence was something typically Buddhist, but one would be wrong. The Thirteenth Dalai Lama (1876–1933) and above all the 'Great Fifth' (1617–1682), who founded the Tibetan state in the form that remained in force until 1950, made use of military force time and time again, to defend the power of their government against foreign invaders or indigenous rivals (mostly religious leaders).[69]

In the twentieth century, according to Dawa Norbu, there was 'a cold war between the progressive and the reactionary elements of the government,' in which the reactionaries won 'because they claimed to be the vanguard of Lamaism'.[70] Someone like Tsipön Lungshar, who harshly criticized the Tibetan regime, formed a patriotic reform movement and tried to push through reforms, was miserably defeated, arrested, and convicted of attempted murder and instigating a plot aimed at taking over power. As punishment, his eyes were put out and he was thrown into prison for four years.[71]

Another, Gendün Chöpel (1905–1951), already mentioned above, a brilliant historian, philosopher, artist, poet and political activist, was for some a lunatic and for others a visionary. He was a member of the 'West Tibetan Reform Party', which wanted to create an independent democratic republic of Tibet, he opposed corruption and political power-games in the big monasteries and criticized various forms of behaviour of the monks; in short, he tore apart almost everything and everyone that had rank, name and power. When he returned to Tibet after a long stay in India, because of his reformist views, his protest stance and his harsh criticism of traditional ways of thinking and living he was thrown into prison. After leaving prison, he died prematurely, a disappointed, broken and sick man.[72]

The few who have tried to bring about reforms

were defeated by the Tibetan regime, which

> was decadent, inefficient and feudal. It stubbornly
> believed that its basic duty was to work for the
> collective Buddhahood of Tibetans,

as Dawa Norbu bitingly put it.[73] Similar criticisms of the regime were voiced by Shuguba[74] and other Tibetan authors, such as, for example, the Dalai Lama, who spoke of a system of government permeated by corruption.[75]

The peaceableness and non-violence of the Tibetans is also qualified by the so-called Reting Disturbances, on which several Tibetans have likewise reported in detail—but which the community of Tibet dreamers likewise seems not to have noticed. It was a time of 'endless intrigues and counter-intrigues',[76] with 'selfish pursuit of personal interest amongst those in high office',[77] in the course of which many monks and soldiers were killed and the Reting Monastery was totally destroyed. The former Regent Reting Rinpoche, who had been put in prison in the course of the disturbances, was found dead in his cell on 8 May 1947—probably killed by the administration of a poison pill.[78]

This brings us to the traditional Tibetan system of justice, going back to the seventh century, of which Tsewang Norbu says:

> As in many societies at a comparable stage of
> development, the Tibetan state had at its disposal
> archaic legal standards and practices, which from a
> present-day point of view would be characterized
> as inhumane and barbaric … This legal practice
> remained in effect in Tibet right into the twentieth
> century. Fortunately, the application of such
> methods of punishment was the exception rather
> than the rule.[79]

But—according to Tsewang Norbu—critics of this system ought first to take a glance at the history of the European Middle Ages and note that the nineteenth and twentieth centuries were no tale of glory for Europe either. Thus the author holds a mirror up to Westerners for them to look at themselves—a new, exciting element in the encounter between the West and Tibet.[80]

The criticism we have been referring to, raised on the Tibetan side, appears harsher here than it does in the publications cited, as it is nowhere formulated so compactly, but is simply scattered here and there in the texts. The clearest critique seems to come from Tibetans who, whether of their own free will or of necessity, have withdrawn to some extent from their own society and culture. They may have spent many years in Chinese

prisons (Shuguba, Tashi Tsering), joined another religious community (Sherab Paul), or pursued a Western academic career or lived and taught in the West (Dawa Norbu, Chögyam Trungpa, Tsewang Pemba, Tsering Shakya, etc.). But even the Tibetans most closely connected with Tibet do not draw an entirely rosy picture of Tibet. As representative of all of these we may cite the Fourteenth Dalai Lama, who in his first autobiography criticized the isolationist policy of his country; pointed out the unequal distribution of prosperity between the land-owning aristocracy and the small farmers, in no way consistent with the Buddha's teaching; denied that every Tibetan was a gentle, peace-loving person; and said that even in Tibet there were criminals and sinners, for example, robber tribes who constituted a great danger for travellers.[81] The Dalai Lama describes as particularly in need of reform the traditional Tibetan social system with regard to the large private estates,

> on which the peasants worked for the profit of the
> aristocracy, under conditions on which the
> government had no direct influence. Moreover, in
> the field of justice, the country noblemen exercised
> feudal rights …[82]

Here we are neither running Tibet down nor directly or indirectly approving of the Chinese occupation. The voices of objective discussion

191. Tsewang Norbu pleaded for critical analysis on both sides: even if the Tibetan state had archaic legal standards and practices into the twentieth century, Western critics of this system ought first to take a glance at the history of the European Middle Ages.

cited here, which could be supplemented by those of Western authors,[83] in no way justify the 'reforms' of the Chinese in Tibet, which it is well known have turned out to be unjust and not at all selfless. The intention has simply been to demonstrate that there are indeed Tibetans who observe and describe their society and culture in a nuanced way, from a certain critical distance, although the Tibet dreamers seem not to notice this. The reasons for this must be sought primarily with the Westerners, with their selective perception and their almost exclusive interest in the Dharma, or in what they take to be the Dharma.

But the Tibetan side also contributes to the lack of open reflection on Tibetan society and culture. Basically, critical intention and critical faculty are little cultivated in Tibetan society—one submits to religious and political authorities whose decisions and power are scarcely analyzed. The exile situation moreover forces additional uniformity and the construction of a Tibetan identity on the basis of stereotyped ideas, which sometimes go back to Western models but are sometimes 'made up' by Tibetan exile circles. In the opinion of Toni Huber, these new notions of identity, such as Tibetan nationalism, environmental awareness, pacifism and feminism, are largely a creation of the Tibetan political and intellectual elite in exile. According to him, a small group of educated and cosmopolitan Tibetans have skilfully acquired, during their many years of enforced contact with the modern world, a wide repertoire of modern styles and strategies for self-representation.[84] The Tibetans thus shape the Tibet myths not only through their old legends of a mystical, sacred Tibet, but also, since living in the diaspora, increasingly by adopting social-political values that are dear to the West and skilfully transferring them to Tibet. They increasingly take part in the construction of Dreamworld Tibet, which—and here we refer once more to the aspect of criticism—it is not permitted to analyze. For criticism is interpreted as a sign of weakness, which will not and must not be allowed in view of the desperate refugee situation and the common enemy, China. So critics who differ from the opinion of the Tibetan government-in-exile are quickly branded pro-Chinese propagandists or—since the renewed outbreak of the Dorje Shugden affair in the mid-90s—labelled supporters of the renegade sect. This

renders open, unemotional engagement with controversial themes practically impossible.[85] It also has something to do with the fact that the Dorje Shugden adherents seize with relish on criticism of Tibet as evidence for their thesis of discontent with the Tibetan government-in-exile and the Dalai Lama. In other words, the adherents of the Dorje Shugden cult co-opt critics by making them out to be prime witnesses for their own theses. The result of that is understandably a still greater reluctance to engage in criticism.

An example of how critics are dealt with within Tibetan exile society is the newspaper *Mangtso* (*dMang-gtso*), published by the 'Amnye Machen Institute', which is active in Dharamsala and founded and run by Tibetan intellectuals. The editors of the open, independent, Tibetan-language newspaper incurred the anger of various interest groups and persons in positions of power, and came under so much pressure—one even received threats on his life—that in 1996 the widely-read paper was forced to close. The critical editors, who had not shrunk from publishing controversies dealt with in the parliament-in-exile, in which two high government officials were involved, and had even dared to criticize decisions of the parliament, were called militant, violent, extremist troublemakers. And a former minister accused them of destroying the Tibetan government-in-exile, discrediting the name of the Dalai Lama and serving Chinese interests. Yet the newspapermen had criticized the government for only one reason: because they were so concerned about Tibet and its affairs.[86] Even if a considerable number of new Tibetan-language books are censored or banned from publication,[87] there is one laudable exception: the monthly magazine *Tibetan Review*, published in New Delhi, has appeared despite constantly critical articles since as long ago as 1968.

Thus not all Tibetans try to preserve the Tibet dream image. There are in fact discriminating Tibetan voices, only they are scarcely noticed, either by the Western dreamers of Tibet or by the majority of Tibetans themselves. On the contrary, consternation and even hostility, on the Tibetan as well as the non-Tibetan side, are the usual reactions to attempts at portraying Tibet and its inhabitants objectively and discriminatingly. This is not really surprising, for as we have already mentioned, a principal characteristic of prejudices

—positive or negative—is their rigidity and unshakeability.

> A person in the grip of a prejudice defends it as a bird defends her chicks. He behaves as though he were in danger of losing something essential.[88]

On the preceding pages we have explained several possible reasons for the formation of Dreamworld Tibet: deep-seated hopes and theories (such as social evolution) that Western people's own longings and obsessions have fostered in certain periods of time; escapism; sympathy triggered by the David and Goliath myth; 'kernels of truth' anchored in Tibetan culture; circumstances that the formation of sterotypes encourages (such as the impossibility of proving absurdity, biased selection of sources, and other methodical tricks); and the need of Tibetans in exile, at least the Tibetan elite in exile, to give themselves an identity that can compete with Western professed values. In short, we can assume that there is not one single root of the Tibet dream, but that a complex, evolved network of roots underlies it, uncovering which has also been a goal of this book.

E. Postscript

In the introduction I pointed out that 'Tibetophiles' and 'Tibetomaniacs' might well ask themselves why, from novels, legends, stories, comics, films and the like, pieces of a jigsaw had been collected that in their entirety revealed a caricature of Tibet. I also mentioned that there are in fact Tibetans who have recently been wanting such a demystification of Tibet. They include, for example, Tsering Shakya, Dawa Norbu, Jamyang Norbu and Loden Sherap Dagyab.[89] Dagyab approves of critical investigation of the Tibet myth, since a look back over recent years tells us

> that the positive aspects of the traditional image of Tibet have had rather negative consequences for the long-term propagation of Buddhism, while the negative aspects of this image, at the very least, have stimulated Tibetan lamas and their students to evaluate themselves critically and, in the end, fruitfully.

Clinging to a romantic image of Tibet leads to superstitious ideas, sectarianism and dogmatism, which in turn activate the negative aspects of the Tibet myth among outside observers.[90]

Dawa Norbu was one of the first to point out the negative political consequences of the mysticizing portrayal of Tibet. He said that China was able to point out the unbelievability of the whitewashing statements and confront them with a counter-image, which was indeed just as one-sided, but in view of the shortcomings in the Tibetan image could not be refuted straight away.[91] According to Tsering Shakya too, Western mythologizing harms the political cause of Tibet, since because of it the true nature of Tibetan political aspiration becomes nebulous and hazy. In addition he points out another difficulty, little noticed up to now: as long as Tibet stirs the feelings only of whites, the Tibet question will be considered by the states of the so-called Third World as a concern of the West, and so will never make progress and will engage international interest only very peripherally. The Tibet question, Shakya says, will only be taken up in earnest when Tibet has been set free from Western fantasies and the myth of Shangri-La.[92] Losang Gyatso sets this out still more clearly, when he writes:

192. Jamyang Norbu: 'Tibet, however wonderful, is a dream; whether of a long-lost golden age or millenarian fantasy, it is still merely a dream.'

When someone continues to believe in the legend of Shangri La, he is denying the cultural devastation wrought on the land over the last 30 years. He is not believing the killings, the prison camps, nor the levelling of historical institutions.[93]

Jamyang Norbu also argues similarly,[94] as well as a Tibetan woman, who says:

I do not want Westerners to admire us and take care of us and expect us to solve their problems and satisfy their needs. I wish they would take us seriously as responsible human beings of equal birth, as people who have strengths, weaknesses and their own needs.[95]

Non-Tibetans also recognize dangers in the Western illusions about Tibet, for example, Donald Lopez, who writes:

Fantasies of Tibet have in the past three decades inspired much support for the cause of Tibetan independence. But those fantasies are ultimately a threat to the realization of that goal. It is not simply that learning that Tibet was not the place we dreamed it to be might result in some 'disillusionment'. It is rather that to allow Tibet to circulate as a constituent in a system of fantastic oppositions (even when Tibetans are the 'good' Orientals) is to deny Tibet its history, to exclude Tibet from a real world of which it has always been a part, and to deny Tibetans their role as agents participating in the creation of a contested quotidian reality.[96]

Tibetan artists portray dreams and illusions as a rule by painting the content of the dream floating in a cloud. And wisdom is often symbolized in Tibetan ritual art by a book and a sword—the sword of analytical discernment, which cuts through the (dream or illusion) clouds of ignorance. The present book has been about many such illusions and dreams: the Western dreams of Tibet in all their variants and ramifications—wishful dreams, dreams of hope, but also nightmares. And it has been about cutting through these dream-clouds of the West's, created principally by Westerners, with the sword of knowledge that we call reason. This plan was not meant to serve as an end in itself; rather, we have been pursuing the long overdue goal of finally perceiving the Tibetans, dispossessed of their individuality, as autonomous human beings, which allows their ability of action as real, live people, often denied them on the part of the West, to be restored to them.

I beg my friends, both Tibetan and non-Tibetan, to bear in mind when reading this book the Tibetan proverb: 'From the mouth of a true friend you hear no sweet words.'[97]

193. A new period in the Western reception of Tibet is announced. After sacred Tibet had seemed to be inhabited only by men for nearly four hundred years—first Aryans, then whites and eventually indigenous Tibetans—the world of Western commerce now appears to be discovering the sacred woman: an Asian woman in the robes of a Tibetan nun advertises a tourist place.

Notes

Although English-language editions of sources are listed in the Bibliography whenever possible, it has not been practicable to check all the references in them. Page references to German editions in such cases are marked with a dagger †.

Introduction

1. One of the few critical analyses examining publications on Tibetan art is found in Lopez 1998: 135ff.

2. On this, see Lopez 1998: 156ff and Kvaerne 2001. The orientalism debate launched by Edward Said also belongs here. The way in which Tibet is perceived by the Occident, however, does not appear to fit Said's theory—another possible counter-argument against Said's critique of orientalism, or evidence that Said's theory is applicable only to countries that the West oppressed in the course of colonialism and imperialism?

3. This explains why Alexandra David-Néel's work, for example, is not described. In her works, myth and reality are so cleverly interwoven that it is hardly possible to disentangle them any more.

4. Shakya 1992.

Part 1

1. Aschoff 1989: 35. De Andrade's original work is: *Novo descobrimento do Gram Cathayo, ou Reinos de Tibet, pello Padre Antonio de Andrade da Companhia de IESV, Portugez, no Anno de 1624*, Lisbon: Mattheus Pinheiro, 1626. Ital.: *Relatione del Novo scoprimento del gran Cataio, overo Regno di Tibet, fatto dal P. Antonio di Andrade, Portoghese della Compagnia di Giesú nell anno 1624*, Rome: Francesco Corbelletti, 1627. [German: 1627, see Fig.3.]

2. Journeys to China and Central Asia were already taking place in the 13th century, but they did not get to Tibet proper.

3. Didier 1989: 96.

4. The Christian proselytization of Central Asia started from Persia. In 635 Nestorians reached China, and in 639 India. In the 9th century the traces were fading, but in the 13th century there was a revitalization until Nestorianism was completely destroyed in the 14th century.

5. Since very early times, Paradise was supposed to lie somewhere in the East. Isidore of Seville (c. 560–636) 'cemented' this idea in his cosmography in the 6th century. The Venerable Bede (c. 673–735) and Aethicus of Istria also located the earthly Paradise in the East (Börner 1984: 54). In Graeco-Roman antiquity, the regions of the blest were sought in the West—Elysium, Arcadia, Atlantis, etc. But later, the East proved to be a more fascinating and promising direction again, although the Western theme did not disappear altogether (Börner 1984: 38).

6. Didier 1989: 89. Didier cites Isaiah 18.7 in this connection. This is in fact about Mount Zion, which can obviously be related to Israel; why this or indeed any other passage in Isaiah should be connected with the Himalaya, so far away from Israel, remains unclear.

7. Aschoff 1989: 16.

8. Aschoff 1989: 43.

9. Aschoff 1989: 76.

10. Aschoff 1989: 60.

11. Aschoff 1989: 66.

12. Aschoff 1989: 67.

13. Aschoff 1989: 71.

14. Aschoff 1989: 44, 64ff.

15. Aschoff 1989: 64.

16. Didier 1989: 101.

17. According to de Filippi 1932: 13.

18. Kaschewsky 1997: 29/2001: 15ff. Altogether there are four works of a similar title, of which the most extensive was published in 1762 or 1763. See Georgii 1987: Foreword XIII.

19. Taylor 1988: 103.

20. The correct transcriptions would be: *Sangs rgyas dkon mchog, Chos dkon mchog* and *dGe 'dun dkon mchog.*

21. de Filippi 1932: 305–6.

22. de Filippi 1932: 226.

23. de Filippi 1932: 245.

24. de Filippi 1932: 255, 301.

25. The title was: *Relazione e Notizie Istoriche del Thibet e Memorie de' Viaggi e Missioni ivi fatti dal P. Ippolito Desideri della Compagnia di Giesú*, see de Filippi 1932: 303.

26. de Filippi 1932: 197.

27. de Filippi 1932: 206.

28. de Filippi 1932: 295. Kircher had received this information from Grueber, whom Kircher had asked to report to him everything worth knowing. Five detailed letters from Grueber to Kircher form the foundation of Kircher's work *China Illustrata* (1667).

29. de Filippi 1932: 305.

30. de Filippi 1932: 175.

31. de Filippi 1932: 221ff.

32. Two more texts were found later, which Wessels 1924 and de Filippi 1932 analysed. Desideri's works written in Tibetan were also first discovered and published in the twentieth century, see Kaschewsky 1997/2001: n. 20.

33. On this see Wessels 1924.

34. The Theosophists gathered their knowledge about Tibet from the works of other missionaries, such as those of the Capuchin Orazio della Penna, who lived in Lhasa shortly after Desideri, and the accounts of Régis-Evariste Huc and Joseph Gabet, who entered Tibet from Outer Mongolia in 1846. As their knowledge did not come up to the standard of Desideri's, and also because the Theosophists used indiscriminately whatever sources suited them, the Theosophical references to Tibet are correspondingly vague and faulty.

35. From Grueber's letters, according to *Allgemeine Historie der Reisen zu Wasser und zu Lande*, Vol. 7: 218. Grueber expressed himself still more critically, speaking of 'bottomless stupidity' and 'abominable hideousness'.

36. Kant 1968: 405.

37. Kant, Gottholdsche Bibliothek Ms Ub 9 (fol.) (Adickes:T), p. 187a. Probably a copy of an exercise book from the Summer term 1793 (inscribed 'finitum 14.7.1793').

38. Markham 1879: 321.

39. Grueber 1985: 151.

40. *Allgemeine Historie der Reisen zu Wasser und zu Lande*, Vol. 16: 217.

41. Ibid.

42. Bishop 1989: 41.

43. Caroe 1960: 2.

44. *Allgemeine Historie der Reisen zu Wasser und zu Lande*, Vol. 16, Chap. IV, pp. 212–3.

45. Ibid., p. 213.

46. See Section 2.23, *Possible borrowings from critical philosophy*, pp. 73-75.

47. The fact that these similarities could also be interpreted negatively—for example, by certain Capuchins—has already been pointed out.

48. Manning, in Markham 1879: 256.

49. Manning, in Markham 1879: 266.

50. Bishop 1989: 98.

51. See for example Kaschewsky 1997: 29–30/2001: 19.

52. Kant's *Physische Geographie*, Vol. 2: 158–60, published in 1802; that Indians went on pilgrimage to Lhasa appears for example in *Allgemeine Historie der Reisen zu Wasser und zu Lande*, 7: 218; elsewhere Kant distances himself somewhat from this first statement. Accordingly Tibet might indeed be the ancestral seat of all cultures and sciences, the learning of the Indians stem with fair certainty from Tibet, but the arts seemed 'to have come from Hindustan, for example, agriculture, figures, chess and so on.' Such an original seat of the arts and sciences, indeed of humanity, surely deserved the effort of a more careful investigation (Kant 1968: 228).

53. According to Glasenapp 1954: 27ff; later, Karst 1931: 259, for example, was of the opinion that the mountainous region of Ararat, where Noachian humanity would have been cast up after the flood catastrophe, had probably been originally the Central Asian, Indo-Tibetan mountain massif.

54. Bishop 1989: 102.

55. Lindegger 1982.

56. Bishop 1989: 177.

57. Bray 2001: 41.

58. de Riencourt 1951, according to Bishop 1989: 205, 209, 212.

59. Govinda 1995: 11 (German edition).

60. Ibid.

61. McKay 2001: 71

62. McKay 2001: 74.

63. McKay 2001: 75.

64. McKay 2001: 84–85.

Part 2

1. Barker (1926) (all references to this source are to the online edition): Letter No. 98. The recipient of this letter was Alfred Percy Sinnett, a journalist. After initial scepticism, H.P. Blavatsky had found a 'Brother' in Tibet, who wrote Sinnett letters regularly from then on.

2. Constance Wachtmeister, *Reminiscences of H.P. Blavatsky and 'The Secret Doctrine'*; quoted in Barborka 1969: 17–18.

3. Blavatsky, *Collected Writings*, Vol. VII: 398; quoted in Barborka 1969: 242.

4. Barker (1926): Letter No. 26.

5. Blavatsky: 'Chelas and Lay Chelas', in *Collected Writings*, Vol. IV: 606; see <http://www.katinka hesselink.net/lay.htm>.

6. *Echoes from the Past*, in *The Theosophist*, October 1907: 77, according to Cranston 1995: 119 (German edition, quotations retranslated).

7. Lauppert 1954: 11 (quotation retranslated from German).

8. *An interview with Colonel Olcott*, in *The Daily Chronicle*, London, 14 September 1891.

9. Whether H.P. Blavatsky had in mind the Bhutanese or the members of the Ka-gyüd-pa sub-school called the Druk-pa, or both, is unclear.

10. Barker (1926): Letter No. 49.

11. Blavatsky, *Collected Writings*, Vol. IV: 15 note.

12. Barker (1926): Letter No. 49.

13. Barker (1926): Letter No. 66.

14. Pedersen 2001: 153.

15. Blavatsky, *Secret Doctrine*, Vol. I: 571 ff.

16. See Fuller 1988, Chap. 40.

17. Glasenapp 1960: 199.

18. See for example Glasenapp 1960.

19. Goodrick-Clarke 1985: 19; according to Frick 1978: 280, in a rock library that was chiselled into the wall of a ravine.

20. Frick 1978: 281 cites an author Hoffmann, who claims that *Dzyan* was of Taoist origin.

21. Blavatsky, *Collected Writings*, Vol. VI: 94–95.

22. Barborka 1969: 124.

23. Blavatsky, *Collected Writings*, Vol. III: 178, 180.

24. Probably Blavatsky only knew about the short report, which was printed in Markham 1879.

25. A.P. Sinnett, *Incidents in the Life of Mme. Blavatsky*, quoted in Barborka 1969: 351–2.

26. *The Complete Works of H.P. Blavatsky*, Vol. II: 46, quoted in Barborka 1969: 120.

27. Barborka 1969: Preface.

28. Lauppert 1977–82: Vol. 1: 166 (quotation retranslated from German).

29. Fuller 1988: 179.

30. H.P. Blavatsky in *The Theosophist*, Vol. V, December 1883/January 1884.

31. This 'thread' is probably the 'silver cord' that will be described more precisely in Section 3.2.2, *Rampa's Tibet image*, pp. 94-96.

32. *The Path*, Vol. IX, No. 9 (December 1894): 266, quoted in Barborka 1969: 357.

33. *H.P.B. Speaks*, Vol. I: 224-5, quoted in Barborka 1969: 365–7.

34. Neff 1937, pp.1-2, Chapter 1 (retranslated from the German version).

35. Washington 1993: 39.

36. Swedenborg n.d., Vol. 2, number 266.

37. William Emmette Coleman, 1895, *The Source of Madame Blavatsky's Writings*, in Vsevolod Soloviev, *A Modern Priestess of Isis*, London.

38. Blavatsky, *Isis Unveiled*, Vol. 2: 609.

39. Blavatsky, *Collected Writings*, Vol. IV: 347ff. [Huc's very detailed account (Huc 1982: 107-9) certainly reads like that of a sceptical eye-witness: 'We made every effort, until our brows were wet with sweat, to discover some evidence of fraud, but in vain.']

40. Blavatsky, *Isis Unveiled*, Vol. 2: 599–602.

41. Blavatsky, *Isis Unveiled*, Vol. 2: 620.

42. If 'Lamaism' is mentioned here and there in the present book, that is in full knowledge of the questionability of this term. As the authors cited frequently speak of 'Lamaism', the term cannot be completely avoided. On 'Lamaism', see Lopez 1998: 15ff.

43. Pedersen 2001: 157.

44. In Theosophical eyes, to describe Bailey as one of Blavatsky's female followers is not correct, as Bailey and her husband left the Theosophical Society in 1920 on account of disagreements, and founded the Lucis Trust, as well as the Theosophical Association (from 1923, the Arkan School).

45. Bailey 1994: 35–37.

46. Bailey 1994: 162–3.

47 Bailey 1994: 168.

48. Bailey 1994: 6.

49. Bailey 1994: 26.

50. Bailey 1994: 34–35.

51. Blavatsky, *Collected Writings*, Vol. VIII: 84.

52. Blavatsky, *Collected Writings*, Vol. IV: 11.

53. According to Barborka 1969: 116.

54. Blavatsky, *Collected Writings*, Vol. III: 268.

55. Blavatsky, *Collected Writings*, Vol. VIII: 84.

56. H.S. Hughes, *Consciousness and Society* (1958), quoted in Pedersen 2001: 152.

57. Bechert 1966, Vol. 1: 45.

58. Glasenapp 1960: 201–2.

59. Pedersen 2001: 158.

60. Goodrick-Clarke 1985 constitutes an exception: in several places he refers to the points of contact between Theosophical and nationalistic racial doctrine, for example that of Jörg Lanz von Liebenfels. See also Rose 1994.

61. Blavatsky, *The Secret Doctrine*, Vol. 2: 178.

62. Blavatsky, *The Secret Doctrine*, Vol. 2: 319.

63. Fuller 1988: 96ff.

64. G. de Purucker's *Encyclopedic Theosophical Glossary: A Resource on Theosophy* (Theosophical University Press online edition, 1999, <http://www.theosociety.org/pasadena/etgloss/etg-hp.htm>), under the headword 'Races'.

65. Barker (1926): Letter No. 23b.

66. Blavatsky, *The Secret Doctrine*, Vol. 2: 162.

67. Blavatsky, *The Secret Doctrine*, Vol. 2: 426.

68. Rose 1994: 87; Mosse 1978: 92 is of the opinion that Theosophy itself was not racist, based on the fact that Theosophy was the first European movement that showed the Indians that their religions were superior to Christianity. Eventually, however, says Mosse, racism did become allied to Theosophy.

69. Goodrick-Clarke 1985: 33ff. According to Mosse 1978: 94, List believed in the cycle of birth and rebirth. He maintained that future Aryan leaders would be rebirths of ancient dead heroes.

70. Daim 1958: 178; see also Goodrick-Clarke 1985: 101ff. According to Blavatsky, Verse 32 of the book *Dzyan* in fact states likewise (*Secret Doctrine*, Vol. 2: 184): 'And those [men] which had no spark [of intellectual capacity] took huge she-animals unto them. They begat upon them dumb races.'

71. Pennick 1981: 124ff (quotation retranslated from German).

72. How carelessly Pennick worked is shown for example by the facts that instead of Dr (Ernst) Schäfer he wrote Dr Scheffer; that he claimed Ferdinand Ossendowski had described the 'Vril' energy in his book *Tiere, Menschen und Götter*, and so on. In addition, Pennick disseminates the errors and half-truths put into the world by Pauwels & Bergier, without naming that source.

73. Washington 1993: 69.

74. Tingley 1992 (1921): 88†. The closeness of certain Theosophists to the Nazis could be further substantiated with additional examples. It is sufficient here to cite the president of the German Theosophical Society, who pronounced in 1933, after Hitler's seizure of power: 'The strongest and most influential powers that at present determine the life and development of the nations and that will always exist in future are the National Socialists and Theosophy.' (Schweidlenka 1989: 21).

75. On this, see for example Daim 1958.

76. Blavatsky, *The Secret Doctrine*, Vol. 2: 445.

77. These examples come from Tingley 1992.

78. Lopez 2001: 184.

79. *Theosophia*, Autumn 1974: 9–10, quoted in Cranston 1995: 641 (retranslated from German).

80. These statements are based principally on Meyer 1999.

81. Roerich 1988: 11†.

81. Roerich 1988: 64† (German edition).

83. Roerich 1988: 50ff†.

84. *The Ageless Wisdom teaching*: Interview with Benjamin Creme, by Rollin Olson, <http://www.lightinfo.org/maitreya/agleswis.htm>.

85. In this respect he is like his Mahatma Brother mentioned by Helena Blavatsky, who 'despite his comprehensive knowledge never uttered a word about these things in public and kept his knowledge carefully hidden except in front of a few friends.' See Frick 1978: 261.

86. This text is based mainly on documents from the Internet (e.g. <http://www.shareintl.org>,<http://www.shareinternational-de.org>) and Creme 1997.

87. The book was published in several languages, such as English, German, Swedish, etc. As his 'discovery' was already exposed as a swindle in his lifetime, the author disappeared into anonymity, so that the year of his death appears to be unknown.

88. According to Kersten, Jesus lived and worked in Kashmir not only as a young man, but again after the crucifixion, and even died there.

89. Douglas 1896: 673, as cited in Grönbold 1985: 25.

90. See Bray 1981.

91. For example, L. Huxley, in *The Life and Letters of Sir Joseph Dalton Hooker* (London, 1918), and Elizabeth Clare Prophet in *The Lost Years of Jesus* (Livingston, Montana, 1987), according to Lopez 1998: 233 n. 9. According to Grönbold 1985, similar claims were also made by Levi H. Dowling in *The Aquarian Gospel of Jesus the Christ* (first published 1908) and Paul Reboux: *La vie secrète et publique de Jésus-Christ: Son voyage au Tibet*, Paris: Niclaus, 1955.

92. Kersten 2001: 91–92.

93. In 1922 Gurdjieff founded an institute in Fontainebleau to the south of Paris, whose objectives are described by a good authority as follows: 'The first goal of the Institute is summarized thus: to break the artificial limits of the personality. Only through this does it become possible to develop the various mental and physical centres and put them in tune with one another. The methods used are: self-observation, a practical dance course, physical and mental exercises, psychic analyses and a series of mental and physical tests, which were applied differently by Gurdjieff in [each] individual case.' Pauwels 1974: 102 (retranslated from the German).

94. In one place it is stated that this lay somewhere in the centre of Asia.

95. Webb 1980: 80.

96. Gurdjieff (1963), e-book: 154 (Chap.VII).

97. Apart from an autobiographical booklet, none of Gurdjieff's works was published until after his death in 1949.

98. Gurdjieff's early years, especially his journey and his stay in the Sarmung monastery, are shown in the film *Meetings with Remarkable Men—Gurdjieff's Search for Hidden Knowledge*, by Peter Brook, 1978, Remar Productions Inc.

99. Moore 1992: 43 (German edition).

100. Ibid.

101. The 'malignant' kundabuffer, planted at the base of the spine, forces humanity to perceive reality in a confused way, so that objective understanding is not possible. Since man has had the kundabuffer organ, he has been caught in a daydream, is totally suggestible, and his energies are exhausted in egotism, self-love, vanity and pride. Moore 1992: 58ff†.

102. Gurdjieff (1950): 661 (Second Book, Chap. 35). The number seven plays a central role in Gurdjieff's teaching. Among other things, Gurdjieff builds his cosmology on the law of the number seven.

103. Gurdjieff (1950): 662–3.

104. Gurdjieff (1950): 666. This text employs a system of three 'being-bodies', of which the lowest is the planetary body, the second the kesdjan body (also known as the astral body), and the highest the soul, or 'body of the soul' (ibid, p. 704). Elsewhere Gurdjieff speaks of the four bodies of man: physical body, astral body, mental body and the true 'I', the soul. See Gurdjieff 1982: 242ff†.

105. Gurdjieff (1950): 241–2 (First Book, Chap. 22).

106. Gurdjieff (1950): 240.

107. Gurdjieff (1950): 661–2.

108. *God is my Adventure*, New York, 1936, according to Pauwels 1974: 46†; according to Webb 1980: 49, the book came out in 1935.

109. Suster 1981: 57; according to Bennett 1997: 88†, Gurdjieff was actually in contact with the Tsar's court. Apparently he tried to counteract Rasputin's influence on the Tsar.

110. Suster 1981: 122.

111. Bronder 1975: 247.

112. See Pauwels 1974: 24†.

113. Webb 1980: 52ff.

114. For Needleman & Baker 1996: 432, this chapter of Gurdjieff's life (allegedly a stay in Central Asia and the Middle East) remains largely a riddle. Others, however, are firmly convinced that Gurdjieff lived in Tibetan monasteries, and indeed became a Tibetan monk himself. See Webb 1980: 40–41.

115. Bennett 1997: 56† (retranslated from German).

116. Webb 1980: 41.

117. Carmin 1985: 43; Suster 1981: 57. Apparently this legend also goes back to Pauwels. See Webb 1980: 50; according to Bronder 1975, the two were in Tibet together at least three times.

118. Doucet 1979: 42.

119. Moore 1992: 361†.

120. Carmin 1985: 43.

121. Pauwels & Bergier 1974: 433.

122. McCloud 1996: 155.

123. Carmin 1985: 50. Neo-Nazi authors frequently speak of the Thule Order rather than the Thule Society. In quotations the style of the relevant author will be reproduced, otherwise we shall use the expression 'Thule Society'.

124. Ravenscroft 1974: 262†.

125. Ravenscroft 1974: 251–2†; see also Suster 1981: 121ff and Carmin 1985: 44, who gives the name of the Lodge as 'Lodge of the Brothers of the Light' and 'Vril Society', the foundation of which is supposed to have been the book *The Coming Race*, by Bulwer-Lytton, published in 1871.

126. See on this Grönbold 1985: 40ff, and further literature mentioned by Grönbold.

127. Bulwer-Lytton (1871): Chapter VII; it was probably not Bulwer-Lytton who invented the concept of 'vril' (see, e.g., *Encyclopedia of Occultism and Parapsychology*), but Jacolliot.

128. Bulwer-Lytton (1871): Chapters VII, IX.

129. Moon 1997: 164.

130. Carmin 1985: 49.

131. Pauwels & Bergier 1974: 440–441.

132. McCloud 1996: 154ff.

133. Rose 1994: 176.

134. Jacobsen 1979: 450. All the same, Jacobsen writes 'that Haushofer must rank as one of the intellectual powers in the Third Reich who by their writings fatefully contributed to a high degree towards the blindness of the German nation and the justification of the Nazi lebensraum programme up to the outbreak of war' (Jacobsen 1997 1: 257).

135. See Heller & Maegerle 1995: 43.

136. According to Jacobsen 1979; reader's letter from Heinz Haushofer in the *Frankfurter Allgemeine Zeitung*, 31st December 1956, p. 19.

137. Wasserstein 1988: 273ff; Hecker 1997: 364.

138. *Das Reich*, Berlin, 14th November 1943, p. 2.

139. Wasserstein 1988: 273ff.

140. According to Wasserstein 1988: 275.

141. Wasserstein 1988: 276ff; H.G. Stahmer, *Hitler und die drei Weisen Tibetaner*, in *Der Volkswille*, 11th November 1949.

142. Four years before, in 1937, the disbandment of organizations resembling Masonic lodges had already been ordered in a general edict (*Runderlass*). Masonic lodges, Theosophical groups and occult groups of the most varied kinds were affected. See Glowka 1981: 6; see also Cranston 1995: 673†, with an abridged copy of a document by Heydrich in which the disbandment of the Theosophical Society is announced, dated 23rd October 1937.

143. Carmin 1985: 89; Hecker 1997: 361. This is still not the complete list of names used by Trebitsch-Lincoln. See *Das Reich*, Berlin, 14th November 1943, p. 2.

144. Edward Alexander (Aleister) Crowley (1875–1947), well-known British magician, founder of the 'Argentum Astrum' society, and member of several secret societies (Golden Dawn, Ordo Templi Orientis/OTO), in which among other things sexual magic yoga practices were performed. Between 1902 and 1903, Crowley is supposed to have undertaken an expedition to Chogo Ri in the Himalaya. Crowley knew Gurdjieff, whom he visited in July 1926 at Fontainebleau near Paris.

145. Carmin 1985: 97.

146. Carmin 1985: 43.

147. Bronder 1975: 250.

148. *Das Reich*, Berlin, 14th November 1943, p. 2.

149. Wasserstein 1988: 271.

150. Pauwels & Bergier 1974: 439; Carmin 1985: 97 takes up this myth again. Dorji in place of Djordni (or Djordi in the German edition) would be more likely.

151. Wasserstein 1988: 290.

152. Heller & Maegerle 1995: 158.

153. McCloud 1996. Important pages on Tibet, pp. 144–73.

154. See also Heller & Maegerle 1995: 157.

155. Pauwels & Bergier 1974: 439.

156. Carmin 1985: 97.

157. Pauwels & Bergier 1974: 442; some of these claims were also taken up by Suster 1981: 122ff. See also Carmin 1985: 97, who, however, does not refer to Pauwels & Bergier.

158. Pauwels & Bergier 1974: 28.

159. Suster 1981: 191–2 (quotation retranslated from German).

160. Goodrick-Clarke 1985: 31–33.

161. Ravenscroft 1974: 263†.

162. Charroux 1970: 258.

163. Ravenscroft 1974: 243–4†.

164. Carmin 1985: 125.

165. Trimondi/Röttgen 1999: 652; see also Mila 1990: 122.

166. Most of the data on Serrano reproduced here come from Trimondi/Röttgen 1999: 651ff.

167. Goodrick-Clarke 1985: 201.

168. Rose 1994: 141ff. According to Rose 1994: 156ff, the Thule Society was certainly no 'political secret society'. Rather, the Thule Society was in the position of a temporary centre of crystallization for a political spectrum, the völkisch-nationalistic 'scene' of Munich and part of Bavaria. At all events, in the process of the emergence of National Socialism the Thule Society had a modest role, which did not go beyond some practical impulse; see also Goodrick-Clarke 1985: 220; Orzechowski 1988: 127 rightly asks how it came about that in 1925 the 'magic centre of National Socialism', the Thule Society, broke up for lack of financial means.

169. Heller & Maegerle 1995: 64.

170. Carmin 1985: 42. According to Rose 1994: 212, the Thule Society was not an occult group, which makes the supposed influence from the outset by secret Tibetan teachings look thoroughly improbable.

171. Sebottendorf 1933: 47. Thule is indeed clearly a land that lies somewhere in the north of Europe and not in Asia. Some authors (such as Mila 1990) are of the opinion that there were Theosophical ideas and activities in the Thule Society, which is at least a lot more likely than the assumption of a Tibetan influence.

172. Bronder 1975: 248.

173. Der Spiegel, 1996, No. 51: 73.

174. Van Helsing 1993: 116.

175. Van Helsing 1993: 117. According to van Helsing (van Helsing 1995: 232ff), the same Tibetan monks initiated the children of the 'Black Sun' in the Wefelsburg (Reichsführerschule of the SS) who were later to be taken to Tibet by Rudolf Steiner.

Eventually the Tibetan monks were supposed to have made contact with the Ariannis and Aldebaranians. The latter, it seems, are an extraterrestrial race who established the Aryan race on Earth. Remnants of this primeval race still live in the realm of Agarthi, which lies beneath Tibet and other regions.

176. Van Helsing 1995: 244.

177. Shambhala has been and is written by individual authors in very varied ways. Here we use the spelling Shambhala, but place the spelling preferred by a particular author in parentheses if it differs markedly from ours.

178. Carmin 1985: 45.

179. Ossendowski 1924: 345ff†.

180. Ossendowski 1924: 349†; Project Gutenberg English e-text, chap. XLVI.

181. Ossendowski 1924: 353†.

182. Guénon 1987: 42–43†.

183. According to Ekkehard Hieronimus: Okkultismus und phantastische Wissenschaft, in: Kursbuch der Weltanschauungen, 1981, 301-49; see Hedin 1925: Ossendowski und die Wahrheit, Leipzig, and Hedin 1924: Von Peking nach Moskau, Leipzig, p. 102ff.

184. Pallis 1983; see also Unkrig 1925: Zur Ossendowski-Frage, in Der Fels, 1925, p. 413ff.

185. How far d'Alveydre was inspired and influenced by Louis Jacolliot (1837–1890) can hardly be established now, as both lived at almost the same time.

186. d'Alveydre 1910: 30.

187. d'Alveydre 1910: 52.

188. d'Alveydre 1910: 178ff; see also Frick 1978: 401. Starting from d'Alveydre's ideas, between the two World Wars a strange secret society was formed, with the name 'Synarchy', which dreamed of an ideal system of government in which political power would lie with a 'college of the great initiates'.

189. It remains open how Roerich likewise came to claim that in many places in Asia 'Agarthi, the underground nation' was spoken of, when just a few lines further on he only speaks of the underground nation as the 'Chud'. Roerich 1988: 201†.

190. In one case—Ravenscroft—Anthroposophical influences can also be established.

191. There is no mention of Agarthi/Agarttha in Blavatsky. This can no doubt be put down to the fact that while d'Alveydre did indeed write his book La mission d'Inde by 1886, it was destroyed after printing except for one copy. Only after his death in 1910 did d'Alveydre's friends publish the book. In books by d'Alveydre published earlier, Agarttha does not appear.

192. Pauwels & Bergier 1974: 440–441. ('Shampullah' in the German edition.)

193. One notes the interchange of the hands with respect to Pauwels & Bergier, who had the right-hand path centred on Agarthi and the left-hand on Shambhala.

194. McCloud 1996: 156ff.

195. The Jews are in fact not mentioned in McCloud. The Freemasons, however, are often described in the National Socialist literature as a cover organization for the Jewish conspiracy.

196. Ravenscroft 1974: 249† (quotation retranslated from the German).

197. Ravenscroft 1974: 262–3†.

198. This book is subject to a sales ban in Switzerland.

199. One easily recognizes here the word Vril-ya, which goes back to Bulwer-Lytton, who referred to a certain kind of being by this term.

200. Van Helsing 1993: 109; most probably van Helsing got the name of the King of the World from Roerich 1988: 11ff†, who wrote 'Rigden-jyepo'. 'Rigden' is certainly *Rigs-ldan*, the Tibetan for 'Kalkî', the epithet of the rulers of Shambhala since the seventh ruler.

201. Stamm 1998: 89.

202. Van Helsing 1993: 110.

203. Van Helsing 1993: 116.

204. Moon is also present on the Internet, <http://www.crystalinks.com>, where he disseminates information on Agartha, the Nazis, the Montauk experiment, etc.

205. Moon 1997: 214.

206. Stamm 1998: 88.

207. For example, Hitler read no English literature, and Bulwer-Lytton's book was only published in German much later.

208. The Akashic or Akasha Chronicle is a term that is found among both the Theosophists and the Anthroposophists. According to Anthroposophical and Theosophical conceptions, nothing past is irretrievably lost. Every event makes an impression on the ground of the world (in Theosophy, the astral plane). This fine spiritual 'substance' is called 'Akasha', the 'notes' registered on it are the Akasha Chronicle (according to Adolf Baumann, *Wörterbuch der Antike*, Munich 1991: 6–7). Particularly gifted people can read in the Akasha Chronicle, either by clairvoyance or by leaving their bodies.

209. Suster 1981: 118.

210. Suster 1981: 118; reference in Carmin 1985: 135.

211. Blavatsky, *The Secret Doctrine*, Vol. 2: 294–5.

212. *3x3 Eyes*, see Comics Bibliography.

213. Rudolf Steiner, *Aus der Akasha-Chronik*, Dornach 1990; see Heller & Maegerle 1995: 101 and Ravenscroft 1974: 244†, who speaks of seven human sub-races.

214. *Le cerveau de glace; Le signe de Shiva; Le secret de l'espadon*, see Section 3.7.3, *Nazis, Agartha, theosophists and Rampa*, pp. 124-126.

215. See Goodrick-Clarke 1985: 223 and Rose 1994: 192ff.

216. Oral information from Harald Bechteler, August 1998. According to Greve 1995: 190, this Tibetan was Tafel's former interpreter, Herr Bordjal, who afterwards called himself August Langgo and lived in Asperg near Stuttgart. See also Captured German Records in the National Archives, Washington D.C., T 81 R129/162123; 162120; 164458

217. Burang, 1947: *Tibeter über das Abendland*, Salzburg; T. Illion, 1936: *Darkness over Tibet*, London: Rider (Ger. *Rätselhaftes Tibet*, Hamburg: Uranus Verlag, 1936).

218. Webb 1980, according to Rose 1994: 176 and n. 394.

219. It can often no longer be traced which author first put a given idea on paper. Guénon 1921: 84, for example, assumed that the Mahatmas were not an invention of Mme Blavatsky's but went back to M. Renan (*Dialogues Philosophiques*). The Agartha legend was not invented or 'discovered' by Ossendowski, but probably by Saint-Yves d'Alveydre (1842–1909), or else by Jacolliot. According to the present state of knowledge, the vril legend goes back to Jacolliot.

220. Hans Roth, Bad Münstereifel.

221. Rose 1994: 13.

222. Doucet 1979: 47.

223. Doucet 1979: 81.

224. Rose 1994.

225. Bronder 1975: 246, 251.

226. Greve 1995; Greve 1997; Bechteler 1999.

227. Ackermann 1970: 45.

228. Greve 1995: 168.

229. Goodrick-Clarke 1985: 178; Heller & Maegerle 1995: 70ff; see also Kater 1974. Neo-Nazi authors also turn the Ahnenerbe into a nest of occult secret research and make it out to be a further example of the work of Agarthi in Nazi Germany (Ravenscroft 1974: 263†; McCloud 1996: 155). Within the framework of the Ahnenerbe, Trebitsch-Lincoln and Ernst Schäfer are supposed to have maintained links with international esotericists (Carmin 1985: 215).

230. Bärsch 1998: 167.

231. Padfield 1990: 92, 401–3.

232. Ravenscroft 1974: 263† .

233. Ravenscroft 1974: 254†.

234. Mund 1982: 144.

235. Mund 1982: 145.

236. Mund 1982: 260ff.

237. Schäfer was not a member of the NSDAP when in 1934 he took part in the second expedition to East Tibet.

238. Istanbul–Berlin. According to a written statement by Bruno Beger (in the possession of the author): Vienna-Berlin.

239. Sievers to Wolff, 23rd January 1938, Captured German Records in the National Archives, Washington D.C., T-580R 204/686.

240. According to Meyer 1999.

241. According to Heller & Maegerle 1995: 97.

242. Landig: *Götzen gegen Thule*: 141.

243. Carmin 1985: 97.

244. Before travelling to Tibet, Schäfer sent two pack animals from Sikkim with gifts for the government in Lhasa, including a gramophone. This gift no doubt gave rise to the legend about radio equipment. Beger explained to Bechteler that both Eva Speimüller and Karo Nichi were completely unknown to him.

245. Bronder 1975: 250.

246. E. Schäfer, speech at the gift presentation, Bundesarchiv Berlin R 135/30, Nr. 23.

247. Funeral speech, p. 4, according to Bechteler 1999.

248. Ackermann 1970: 47. Schäfer appears not to have been interested in these objectives. He successfully fought against taking the world-ice-theory researcher E. Kiss on the Tibet expedition. Officially Schäfer put forward Kiss's age as a reason for his non-participation. See Interrogation Ernst Schäfer, 2.4.1947, Institut für Zeitgeschichte München, ZS 1405; Sünner 1999: 49.

249. See Ackermann 1970: 46.

250. Ackermann 1970: 45.

251. There is a single trustworthy source that indicates that Himmler may have seen Tibet as an area of retreat for former inhabitants of Atlantis. Schäfer writes in his book *Aus meinem Forscherleben* that Himmler once asked him whether he had not also encountered in Tibet people with blonde hair and blue eyes. For there were still numerous remnants of the Tertiary Moon people, last witnesses of the long-lost, formerly world-encompassing Atlantis culture, for example in Peru, on Easter Island and, as he supposed, in Tibet (cited after Bechteler 1999).

252. Beger 1998: 193 in fact writes of 'costly gifts for Chancellor Hitler'.

253. Captured German Records, Document T-81 R129/162385, National Archives, Washington D.C. Quoted after H. Hoffmann's translation. Beger also writes that the expedition had only a scientific and not a political mission (Beger 1998: 153).

254. Hans F.K. Günther: *Ritter, Tod und Teufel*, Munich 1928: 147, according to Becker 1990: 232.

255. Günther 1934: 33. In a statement on my book Bruno Beger wrote: 'Hans F.K. Günther was a writer and academic/scientist. In my student days in Berlin he several times invited a few students in … During the discussions carried on at these times, loud and bitter criticism of political measures took place again and again. H.F.K. Günther, who refused to join the NSDAP, … was unfortunately above whatever influence the racial politics office of the NSDAP exerted. The way the Jews were treated he found appalling. This was in the years 1936–37.' (Dated Königstein, 18 June 2000.)

256. Greve 1995: 187; Greve 1997: 111. In an article of 1955, Beger expresses himself significantly more vaguely, when he writes: 'Considered anthropologically, the Tibetans are one people, that is, a mixture of different races, principally of the Mongoloid racial family and to a limited extent also of the Caucasian.' (*Geographische Rundschau*, 7th Year, Issue 1, January 1955).

257. Greve 1995: 173.

258. Bechteler 1999; Beger 1998: 278.

259. Kater 1974: 215.

260. Greve 1995: 183.

261. Kater 1974: 245ff; Greve 1995: 189ff.

262. Secret Reich business (*Reichssache*), communication from the 'Ahnenerbe' to SS-Standartenführer Ministerialrat Dr Brandt, dated 5th September 1944.

263. Thus the Nazi race ideologist Hans F.K. Günther, who went on: 'Buddhism displays the hostility to life of a diseased nordic inner life … It amounts to a decay, but essentially still a decay of nordic nature.' (Günther 1934: 52, 53) Strangely enough, after the Second World War Günther was to take an interest in Buddhism, though it remains unclear to what extent Buddhism became Günther's own religion. See Becker 1990: 289ff.

264. Dauthendey 1958: 7.

265. Ipares 1937: 45, according to Müller 1982: 21.

266. In his 'first attempt at writing a history of the development of the secret world leadership', Strunk propagates a lot of nonsense about Tibetan Buddhism. For example, he claims that in the Lama monastery of Ram-Gelong in Tibet the new living Buddha is just now being born of a white maiden, whom the monks have brought up in their monastery (Strunk 1937: 14). Opposite p. 32 of the book a picture is reproduced, which shows a white woman with a prayer wheel and an Asiatic. The caption: 'The mother of the Living Buddha; the Russian maiden who is to bring into the world the new Buddha incarnation in the Nam-Galong monastery, with her teacher (Guru).'

267. Strunk 1937: 28.

268. Strunk 1937: 34.

269. Strunk 1937: 36.

270. Strunk 1937: 51.
271. Ludendorff & Ludendorff 1941.
272. Wilhelmy 1937: 14, 17.
273. Wilhelmy 1937: 39; the term *Afterwissenschaft* means false, bad science; cf. *Aftergott*, which means false god, or *Afterdienst* (false service), terms that Kant uses (see below).
274. Kissing the feet is not practised in Tibetan Buddhism. This myth certainly goes back to Grueber, who wrote: 'New arrivals, who cast themselves on the ground before him with lowered head, kiss his feet, not much different from Christians before the supreme priest ...' (Grueber 1985: 148).
275. Rosenberg 1941: 184ff.
276. *Der Spiegel* 1996, No. 51: 73.
277. Kant 1968: 404.
278. Kant 1990: 193ff.
279. Herder 1966: 288.
280. Herder 1966: 289.
281. Herder 1966: 290.
282. Rousseau (1762): livre IV, chap. VIII, *De la religion civile*.
283. Hegel 1972: 253.
284. Nietzsche 1973, *Die fröhliche Wissenschaft*, Book 3, Aphorisms 128: 161.
285. Meyrink, n.d. (1903?): 81ff. [Online edition <http://www.gutenberg2000.de/meyrink/wunderho/ violette.htm>. There exists an English translation of this story by Maurice Raraty in Gustav Meyrink: *The Opal and other stories*, Dedalus/Ariadne Press 1994 (not seen).]
286. According to Smit 1988: 135.
287. Markham 1879: 338.
288. Blavatsky, *Collected Writings*, Vol. IV: 15.
289. Frank 1957: 23ff.
290. van Rijkenborgh 1954: 10ff (German edition).
291. van Rijkenborgh 1954: 17 (German edition).
292. van Rijkenborgh 1954: 24 (German edition).
293. See for example Moon, Artaud, Trimondi.
294. Artaud 1925a (Corti translation).
295. Artaud 1925b.
296. Artaud 1925c.
297. Artaud 1946. [Artaud seems unaware that by 1946 the Thirteenth Dalai Lama had been succeeded by the Fourteenth, then eleven years old.]
298. Trimondi/Röttgen 1999: 746, 32, 674, 691, 746.
299. Trimondi/Röttgen 1999: 19, 670ff.
300. Trimondi/Röttgen 1999: 281.
301. Trimondi/Röttgen 1999. The examples mentioned are found on pages 470, 315, 326, 315, 87, 568.
302. Trimondi/Röttgen 1999. The examples mentioned are found on pages 422, 423, 319, 540, 326, 422, 423, 739–40 and 420.
303. All examples from Trimondi/Röttgen 1999: 69, 321, 94, 24, 120–121, 126, 371, 665, 650.
304. Trimondi/Röttgen 1999: 668.

Part 3
1. Hilton 1960: 128–9.
2. Hilton 1960: 159.
3. Hilton 1960: 178.
4. Hilton 1960: 78, 59.
5. Hilton 1960: 63.
6. Hilton 1960: 160.
7. In 1953, President Eisenhower renamed it Camp David.
8. On this, see Oppitz 1974 and Oppitz 2000.
9. Hilton 1960: 94, 88.
10. See for example Kelder 1988.
11. See for example the film *Emmanuelle in Tibet*.
12. Hilton 1960: 125.
13. Hilton 1960: 153, 125.
14. Cf. for example d'Alveydre with the twelve supreme Gurus, Blavatsky with the 'Lord of the World' and under him the helpers and the Masters, and Gurdjieff with the Seven Beings, one of who is supreme.
15. Hilton 1960: 93–95.
16. Hilton 1960: 115.
17. Hilton 1960: 94.
18. Hilton 1960: 165.
19. Hilton 1960: 169–70.
20. Hilton 1960: 180.
21. Hilton 1960: 83.
22. Rampa 1967: 86–87.
23. Rampa 1967: 105.
24. Rampa 1987: 31†.
25. Rampa 1967: 168.
26. Rampa 1967: 87.
27. Burgess gives the name as Hoskins in his account, but in other sources it is Hoskin.
28. Newby 1983: 179; in his book *The Rampa Story*, Lobsang Rampa describes the episode somewhat differently.
29. Rampa 1987: 188†.
30. Rampa 1987: 189†.
31. The spellings KuanSuo and Kuan Suo are also found. The shortening to Ku'an took place because people had trouble pronouncing the name KuonSuo correctly (Stanké 1980: 109).
32. Rampa 1987: 195†.
33. Stanké 1980: 109.
34. Baker 1977: 123.

35. Stanké 1980: 112ff prints copies of documents that prove that Carl KuonSuo deposed with a public notary in Montevideo, Uruguay a solemn declaration in which he recorded that from now on he would officially only bear the name Tuesday Lobsang Rampa. The correctness of the text was confirmed by the notary, who affixed to it his signature and various stamps. Evidently Hoskins sought to legalize his change of name in this way.

36. Stanké 1980: 50.

37. Stanké 1980: 149.

38. Stanké 1980: 65. Stanké reproduces many more examples of such positive letters.

39. Altogether 19 volumes. According to his wife there were 22 (see Rampa, Sarah, 1982: 41), probably because she counted three that were published under her name.

40. Rampa 1967: 13.

41. The German translation of *The Third Eye* was one of the best selling books in Germany in the second half of 1957; see *Der Spiegel*, 12th February 1958: 46. Lopez says that Rampa sold about four million of his books up to the time of his death.

42. Although such home pages sometimes disappear or change their address relatively quickly, three are mentioned here that deal with Lobsang Rampa:

 <http://users.uniserve.com/~dharris/Rampa/rampa.html>;

 <http://www.zetetique.ldh.org/rampa.html>;

 <http://www.serendipity.li/baba/rampa.html> (article by Agehananda Bharati (1974), also accessible from the other two pages mentioned).

43. Rampa 1967: 96.

44. Rampa 1967: 148.

45. Rampa 1967: 128ff.

46. Rampa 1967: 36–37.

47. Rampa 1967: 60.

48. Rampa 1967: 24.

49. Rampa 1967: 24.

50. Rampa 1967: 20–21.

51. Rampa 1967: 176.

52. Further examples of the numerous errors are mentioned by Lopez 2001: 193. Hoskins borrowed the name Rampa from the literature: it is the name of an influential Tibetan aristocratic family.

53. Rampa 1967: 50–51, 73, 95–96, 115.

54. Gareth Smith: *Tibetan Gung Fu—Tried and True*, internet article, October 1997 (retranslated from German).

55. Cranston 1995: 629–30†.

56. Rampa 1967: 167, 173, 175, 184.

57. Rampa 1967: 175.

58. Rampa 1967: 184.

59. Stanké 1980: 33.

60. 'It comes near to being a work of art,' and 'Even those who exclaim "magic, moonshine, or worse" are likely to be moved by the nobility of the ethical system which produces such beliefs and such men as the author,' *Times Literary Supplement*; 30 November 1956: 715, in Lopez 1998: 97ff. 'What fascinates the reader is not only a strange land—and what could be stranger than Tibet?—but [Rampa's] skill in interpreting the philosophy of the East,' *Miami Herald*, in Lopez 1998: 111. See also *Der Spiegel*, 12th February 1958.

61. Alan, 30 August 1996, e-mail.

62. Alain Stanké filmed an interview with Lobsang Rampa, which was shown on television. Stanké, however, declined to place this film material at the author's disposal.

63. Dalai Lama 1990: 209.

64. Bharati 1987: 39, 46.

65. Bharati 1974: 6–7.

66. Lopez 2001: 198.

67. Lopez 2001: 193.

68. Rampa 1987: 21, 160, 180 (retranslated from the German edition).

69. Quotations from Internet, Rampa (loc. cit. n. 68) and Blavatsky.

70. This will be recounted in Part 5.

71. A similar account, in which sexuality and horror are strangely combined, is found in an alleged travel report from the 1930s, written by Harrison Forman. In this, the abbess, a 'female Buddha', is revealed in her sanctuary, a horrific grotto, in the centre of which rise four pyramids of human bones. The abbess stands completely naked in front of Forman, surrounded by bats, which suddenly fall on the nun and sink their terrible, greedy teeth into her flesh. Forman starts shooting like mad at the vampires with his revolver, but the abbess encourages him to calm down. After the bats have flown away, not a wound is to be seen on her body. 'At that moment she was the loveliest woman in the whole world.' (Forman 1936: 183ff, quotation retranslated from German).

72. Podrug 1993: 364.

73. We shall show in Part 5 that this story, the union of a demoness with a monkey, goes back to an ancient Tibetan legend.

74. Podrug 1993: 307.

75. Podrug 1993: 413.

76. Text from the German version of Hausdorf 1995, cf. also Saitsew 1968. A popular English version is on the Internet at <http://www.crystalinks.com/dropa.html>, a page behind which clearly lies, among others, Peter Moon, whom we know already from his dubious book (Moon 1997).

77. Agamon 1978, also retold in Hausdorf 1995: 4ff.

78. von Däniken 1977; 1995.

79. von Däniken 1977; 1992; 1995; von Däniken took the original quotation from Albert Grünwedel's book *Mythologie des Buddhismus in Tibet und der Mongolei*, 1900: 55. [It translates a passage from Chapter 107 of the *Padma bka'-thang*.]

80. von Däniken (1985); see also 194ff.

81. Most of the following information comes from a correspondence with Glenn Steckling, Director of the George Adamski Foundation, Vista, USA, autumn 1998.

82. Zinsstag 1983: 5.

83. Sanders 1991: 184.

84. Sanders 1991: 52.

85. Sanders 1991: 74.

86. Kelder 1995: 25. Cited from the online edition at <http://www.twilightbridge.com/youth/returnyouth.htm>.

87. Norbu 1988: 44.

88. Norbu 1988: 8.

89. E.g. in *Lost Horizon* and *The Third Eye*, and also in other novels not retold here, such as *OM* by Talbot Mundy, *On the World's Roof* by Douglas V. Duff and the sequel to *Lost Horizon: Return to Shangri-La* by Leslie Halliwell.

90. On this, see Templeman 1996. In *OM* a Tibetan lama does indeed appear as well, but he is subject to strong Western influence—he has lived in Oxford, Paris, Vienna and Rome—and his explanations have something rather syncretic and not very Buddhist about them. In this novel moreover, a white woman is recognized as an incarnation. In *On the World's Roof*, a white man is abbot of a large monastery. In *Return to Shangri-La*, Conway has taken the place of the deceased Perrault. It could also have been Chang—an Asian after all …

91. We could not possibly take all novels with reference to Tibet into consideration for the present book. Over a hundred are known to us. We are aware that this list is far from complete. A decisive factor in selecting the novels referred to here was first of all how well-known the novel or the author was. We also took into consideration novels with recurrent, typical themes.

92. About forty titles are known to us, corresponding to some sixty volumes, as now and then several volumes come out under the same title (for example, nine volumes of the series *Jonathan*, six volumes of the series *Le lama blanc*, and so on). This number does not include those comics in which legendary or actual Tibetan stories are retold as true to the original as possible, as these comics give hardly any evidence on the nature of the Western image of Tibet. To this category belong, for example, Eva van Dam's masterly retelling of the life of Milarepa (Shambhala Publications, 1991), or the account of the Fourteenth Dalai Lama's younger years in a comic published in India (script: Vijay Kranti; artwork: Jugesh Narula; New Delhi: Gaurav Gatha, 1982).

93. *Der Dimensionssprung.*

94. *The Origin of Doctor Strange; Der Magier vom Dach der Welt; The Origin of an Avenger; Tintin in Tibet …*

95. Death sentence in *Mission vers la vallée perdue; Das Rätsel der Dämonenglocken; Die Spur des Gletscher-Dämons; Der Magier vom Dach der Welt.*

96. The cat myth, incidentally, is also taken up by the comic *Minuit à Rhodes.*

97. Obviously Tibet was already regarded at that time as a particularly peaceful country, which is also expressed, for example, in the comic *Trouble in Tibet* (1944).

98. *The Court of Crime; Dr Strange, Master of Black Magic.*

99. *Dr Strange, Master of Black Magic.*

100. *Tintin in Tibet; Mission vers la vallée perdue; Das Rätsel der Dämonenglocken; La rivière du grand détour.* In three comics people arrive in Tibet by parachute: *Jonathan; The Lost Crown of Genghis Khan; Uncle Scrooge in Tralla-La.* In some comics the heroes reach Tibet in aircraft or similar devices, as for example in *Treachery in Tibet.*

101. E.g. in *Le lama blanc.*

102. Different from *The Snowman!*, 1974.

103. In Rampa 1967: 54, Lobsang Rampa is named in full as Yza-mig-dmar Lah-lu. The first part is clearly a misspelling of *gZa'-mig-dmar*, the Tibetan for 'Tuesday'.

104. *L'uomo delle nevi; The Court of Crime …*

105. *Le lama blanc; Jonathan; Le secret de l'espadon …*

106. *Le signe de Shiva; Jonathan …*

107. *Das Rätsel der Dämonenglocken.*

108. *Minuit à Rhodes.*

109. *Le signe de Shiva; Le lama blanc; Tintin in Tibet; Jonathan; Le cerveau de glace; Le secret de l'espadon.*

110. *Abominable Snowman; Das Rätsel der Dämonenglocken; Tintin in Tibet; Le lama blanc; Le cerveau de glace …*

111. *Mission vers la vallée perdue; Jonathan; Le cargo sous la mer.*

112. *Mission vers la vallée perdue; Der Lama von Lhasa …*

113. Poelmeyer has demonstrated in a booklet what models were used by Hergé. An unfortunate scene is the one in which Captain Haddock wakes up in front of two wrathful deities: both statues are standing on the ground, and in front of them is an un-Tibetan little table with just two peculiar lamps on it, rather than a lot of offerings, etc.

114. [Cosey recently resumed this series after an eleven-year break, adding a twelfth volume in 1997 and a thirteenth in 2001.]

115. Hansen 2001: 92, 105–6.

116. Hansen 2001: 99.

117. Hansen 2001: 101–2.

118. Schaedler 1995: 24.

119. Schaedler 1995: 25.

120. Schaedler 1995: 26.

121. No Chinese films are dealt with here, on the one hand because they are scarcely accessible, on the other because the present book is mainly about the West's image and caricature of Tibet.

122. In the plane that crashes in Shangri-La there are five people instead of four, and—probably the biggest divergence—in the film Conway's brother is in love not with a Chinese woman but with the Russian, Maria, who—unlike in the novel—dies in the escape.

123. Translated from the German version of the film, which apparently differs somewhat from the English.

124. *Black Narcissus* is a film adaptation of the novel of the same name by Rumer Godden, of 1939. While the images of Tibet in the novel are not exactly flattering—Tibetan religion is characterized as 'a low form of Buddhism, that is in reality animism'—in the film the negative connotations entirely disappear. Cf. Bishop 2001: 209–210.

125. For this film, shots from the film *Der Dämon des Himalaya*, conceived by Prof. G.O. Dyhrenfurt (1935), were used. Both films are worth mentioning, inasmuch as they are among the very few feature films that were shot at the original locations. Thus they show original scenes from Kashmir and Ladakh (Lamayuru monastery) among others. In both films the main emphasis is on a mountaineering expedition, which turns out to be extremely dangerous, as a powerful demon, who is supposed to live on the mountain, tries to thwart the expedition. The film *Der Dämon des Himalaya* was for a long time thought to be lost, but there is now a copy in the Cinémathèque Suisse in Lausanne, and a video copy at the Völkerkundemuseum der Universität Zürich.

126. The name could not be caught exactly from the film copy available, Altenhoff or Almhof?

127. The outdoor shots were filmed in the Karakorum, during an expedition by Prof. G.O. Dyhrenfurt. The ritual dances were filmed in the Lamayuru monastery, Ladakh. See also n. 125.

128. Quotation retranslated from German.

129. In the film it is the Thiksey monastery in Ladakh, but its name and exact location are not mentioned.

130. This was the second film adaptation of the novel, the first having taken place in 1950.

131. 'The Shadow' is one of many American comic superheroes of the '30s and '40s. Typical of him are his unexpected, ghostlike emergence from night and fog and sudden disappearance. See Kagelmann

1997: 266ff [and <http://www.theshadowfan.com/faqontheshadow.htm>].

132. [A remake of a 1947 British film based on a novel by F. Anstey.]

133. *The Golden Child* and *Ace Ventura*.

134. In *The Shadow*, the evil Yin Po is transformed into Cranston/the Shadow in his lifetime; in *Vice Versa*, there is a 'transmogrification', a temporary exchange of 'souls' between two bodies.

135. Rainer Gansera in *epd Film, Evangelischer Presse Dienst*, No. 5, 1994.

136. *24. internationales forum des jungen films*, Berlin 1994: 1, text on *Ab nach Tibet!*

137. Achternbusch 1983.

138. Our quotations from *Emmanuelle in Tibet* are translated from the German version of the movie, as we did not have access to the English.

139. According to Lopez 1998: 1.

140. *Twin Peaks*, Episode 2, writer and director David Lynch, first transmission 19th April 1990. In the ninth episode (transmitted 6th October 1990) according to Lopez 1998: 209–210.

Part 4

1. *Tricycle, The Buddhist Review*, Fall 1994: 87.

2. An allusion to the film of this name.

3. *Neue Zürcher Zeitung*, 14th November 1997.

4. *Der Spiegel*, No. 45, 1997: 146.

5. David Roberts in *Postmagazine*, 19th October 1997.

6. The corpse dismemberment depicted in the film is in fact historically incorrect: the Dalai Lama's father—so the Dalai Lama's sister Jetsün Pema told me—was cremated. In *Seven Years in Tibet* also, Annaud had planned to let the body of the Dalai Lama's father be dismembered, but he refrained from this on the intervention of Jetsün Pema.

7. In the 1999 film *Himalaya: L'enfance d'un chef*, by Eric Valli (released in English in 2001 as *Himalaya* and as *Caravan*), the existence of Tibetan lay people is discovered. No further account could be taken of this film in the present book, for reasons of time. It seems, however, that it attempts to save Tibet, threatened with destruction, at the last minute as it were. Like *Der Dämon des Himalaya*, this latest feature film on Tibet also apparently comes down to a battle between man and mountain (god).

8. From a *Frontline* interview for 'Dreams of Tibet', <http://www.pbs.org/wgbh/pages/frontline/shows/tibet/interviews/scorsese.html>. Scorsese in the same interview also qualifies the romanticized Western picture of Tibet, saying: 'We even infer in the film that it (Tibet) wasn't Shangri-La. There were political problems, there was political corruption. ... I know that certain things weren't quite right, but that some were able to achieve a certain peace of mind, and

were able to fit themselves inside the universe rather than fight the universe.'

9. August 19–25, 1998.

10. Thurman 1992. Similar statements and sentiments were expressed by, for example, de Riencourt 1951, see Bishop 1989: 209.

11. R. Thurman made these statements in a talk at Sotheby's in Zürich, 16th June 1999.

12. All quotations from Robert Thurman from: Thurman 1992.

13. On this see also Thurman 1998.

14. Erik Davis, *The Village Voice*, August 19–25, 1998. David Jackson (quoted Lopez 1998: 258) also deals intensively with Thurman's Tibet image: 'To read Thurman's account, however, one gets the impression that Tibet was a sort of "zone of gentleness," and that its inhabitants also viewed it as some kind of blessed realm. But obviously such a picture is incomplete. Where in this portrayal do Tibet's nomads, for instance, fit in, a people who lived almost exclusively on animal products and on meat that they hunted, raided or slaughtered, and who out of a resultant sense of guilt were also great patrons of religious masters? And where are we to place the ruthless bandit chieftains who regularly terrorized Lama pilgrims and traders in desolated areas? And what would traditional life in the great monasteries have been like without the delinquent warrior monks (*ldob ldob*)? In Tibet as in many a country, in addition to genuine religious teachers there were also a host of dubious mendicants, madmen, and charlatans who plied their trade among the faithful, and life within the big monasteries witnessed the full range of human personalities, from saintly to coldly calculating.'

15. Commercials and advertising in general are an extremely fugitive medium, which is only collected selectively and hardly at all thematically. This is why the collection of advertising closely related to Tibet that is used here is certainly not complete. Despite the fleetingness of advertising we have succeeded in finding 16 commercials from Europe, the USA and Asia and more than 15 examples of advertising from printed media, all having some connection or other with Tibet. The commercials are: *Renault Clio* (car, 45 sec.); *Citroën Xsara* (car, 60 sec.); *Citroën AX* (car, 23 sec.); *Audi A8* (car, 1997?, 45 sec.); *Sampo* (TV, 60 sec.); *Thomson* (TV, 30 sec.); *IBM* (computer, 32 sec.); *Danka* (fax machine and office equipment, 1995, 30 sec.); *Electrolux Widetrack* (vacuum cleaner, 32 sec.); *Halls* 'pastilles, 45 sec.' (ie delete '?'); *Leerdammer* (cheese, 20 sec.); *Biogran* (pick-me-up, 30 sec.); Tibetan 'milk-tea' (Taiwanese tea, 1995?, 30 sec.); *Tchaé* (Lipton's green tea, 30 sec.); *Königspilsner* (beer, 20 sec.); *Baygon* (Bayer mosquito-killer, 30 sec.).

The printed advertisements are: *Macintosh* (Apple computer); *Un air de Samsara* (Guérlain, eau de toilette); *Condor* (holiday flights); *Beal* (climbing rope); *Apple* (computer); *Smirnov* (vodka); *JVC* (camcorder); *Stadtsparkasse Köln* (bank); *Diana* (commemoration of 1st anniversary of Diana's death, in Zürich); *Lotus Travel Service* (travel agents in Munich); *Silhouette* (range of spectacles); *Citroën Xsara* (car; Spanish newspaper advertisement); *Swissair* (Austria operational campaign); *Strellson Menswear*; *Shine* (Oregon Scientific, radio alarm); *Mephisto* (Tibet shoe range).

16. On the strategies of advertising, see Nerdinger 1996.

17. In one advertising film—*Audi A8*, Germany—there are in fact no Buddhist monks to be seen, but there is a reference to Tibetan religion inasmuch as—among other figures—an allegedly Tibetan (actually Nepalese) religious figure is shown.

18. *Leerdammer, Baygon, Königspilsner*.

19. In this commercial, two worlds are juxtaposed. Inside a house, spiritual relaxation is being practised (meditation by Westerners under the guidance of a Buddhist monk); outside on the terrace, a couple are relaxing physically on deck chairs. When the meditators inside 'open their minds', outside a beer bottle is opened; when inside 'golden light streams through the meditators', outside a glass is filled with golden-coloured beer; and when inside the monk announces: 'Right, now we repeat the exercise,' outside another tray of beer is served.

20. For the statement of the company Bayer S.A., France, I thank Françoise Pommaret, Paris.

21. Biogran is a pick-me-up manufactured by the Nutrilatina company in Curitiba, Brazil.

22. The other two 'levitation ads' are: (a) *Leerdammer*. In this ad, a monk offers to a large Buddha statue a rich, beautifully decorated offering of many fine foods and incense. The monk, who has sat down in meditation posture in front of the statue, rapidly floats up higher and higher until his head hits a ceiling beam. A voice, no doubt the Buddha's, says: 'Bring me some Leerdammer, or there'll be an accident!' Once again the monk places an offering in front of the Buddha, this time a round Leerdammer cheese. The Buddha's face is visibly more friendly. Now the Leerdammer levitates towards the Buddha's head, while the monk sits appreciatively in front of the Buddha with a piece of Leerdammer.

(b) *Baygon*: Along the corridor of an old, disused, Buddhist temple complex (probably in Thailand) run some young Buddhist monks. As they turn into the temple hall, they see in front of them an old, levitating monk. Then a loud buzzing of mosquitoes is heard. Irritated, the meditator opens his eyes—and falls on the floor. This happens once more, this time the novices laugh heartily. The old monk puts his hand into a bag and pulls out a Baygon aerosol can, sprays it into the air and floats up once again. Commentary: 'It doesn't take much to attain mental peace.' The questionability of this ad has already been pointed out.

23. In fact the connection with eastern religion is not just word play: according to the company history on <http://www.lotus.com>, the co-founder of Lotus Development Corporation, Mitch Kapor, 'borrowed the name Lotus from the language of Transcendental Meditation, a movement he was involved with at the time.'

24. [Translator's note: By my recollection, IT was not always so male-dominated—programming was reputedly invented by a woman, and when I first got involved with computing, at Cambridge in the 1960s, the programmers I encountered were predominantly women. Somehow, as business came to dominate the computing scene, women were (proportionally if not in absolute numbers) edged out. Likewise in Tantric Buddhism, women were once far more prominent than they are now (see Miranda Shaw: *Passionate Enlightenment*).]

25. In a variant of this TV commercial, the last scene takes place not with a call on the mobile, but with the following conversation. *Danka* man to Dali: 'Just tell me then, what is the true meaning of life?' The monk Dali: 'Give me your number and I'll fax you back.'

26. Barglow 1994: 195ff is of the opinion that this advertisement can be read in two ways: as a model of intercultural communication, but also as commercial exploitation, as the central placement of the white man and his technology, the computer, indicates.

27. Buddha is often treated by Western lay people as equivalent to God, for which reason this equation, intrinsically false, can stand here without further ado.

28. The advertiser makes this supposed inner connection between the Xsara Coupé and Tibetan spirituality in some printed advertising. In an advertisement that appeared in Spain (*La Vanguardia*, 8th March 1999), the text mentions Buddhist ideas of rebirth and claims of the Xsara Coupé that the car has something transcendental and unique about it.

29. Barglow 1994 likens the *Macintosh* advertisement to a Christian depiction of the Madonna and Child, in which men have taken the place of Mary and her worshippers, and a computer that of the Christchild sitting or lying on Mary's lap.

30. In the *Thomson* ad, as mentioned, it is not clear whether the novices that appear in it are nuns or monks.

31. Apart from the Dalai Lama, in the same advertising campaign by Apple there appear among others Muhammad Ali, Mohandas K. Gandhi, Alfred Hitchcock and Pablo Picasso.

32. In this book we deal with Western images of Tibet. A good article on Chinese clichés about Tibet is Heberer 2001. Heberer concludes on pp. 144–5 (original German: Heberer 1997: 144):

 'Representations of Tibetans in Chinese art and literature display a certain ambivalence toward their primitiveness and eroticism. Official Chinese propaganda characterizes Tibetan (and non-Han) society and culture as uncivilized, brutal, oppressive, and man-eating, even if there have been periodic oscillations between harsher and more generous images. ...

 '[Their] religion and traditions are seen as frightening and superstitious, their cuisine barbaric and unpalatable, their clothing colorful but disheveled, their lifestyles primitive.'

 Frequent themes in Chinese novels are the 'sexual permissiveness' of the women, sky burial, 'superstition' and the 'barbaric way of life' (oral information from Tsering Shakya, March 1998).

33. Swatch also produced a watch named 'Shangri-La' (Pop Swatch Collection 1991, no. PWB 156), but this does not display any Tibetan symbolism.

34. One such book, for example, talks about 'mandalaic sex meditation', which has not been properly discovered up till now because of the 'ancient defects of vision that always cling to Western psychology and sexual research'. Mandalaic sex, it says, is not mere sexuality. It turns into the flower of meditation, a flower that exudes floral fragrance. Günter Nitschke, 1995: *The Silent Orgasm. Liebe als Sprungbrett zur Selbsterkenntnis*. Cologne: 154–5. Many such books have been published on Tantrism, most of which are extremely dubious.

35. Andresen 1997: 238.

36. Sand mandalas sprinkled at both places, in 1991 and 1993 respectively.

Part 5

1. See for example Dodin & Räther 2001 (Ger. 1997); Korom 1997a–c, 2001; Bishop 1989, 1993; Feigon 1996. The last-mentioned book, however, shows how, under the guise of opening up the mysteries of Tibet, old myths are perpetuated. The author claims, for example, that Hitler and Himmler sent an expedition to Tibet (no doubt the Schäfer expedition) to establish that the Tibetans were not Jews but true Aryans. He even mentions, albeit sceptically, the claim that Hitler brought a group of Tibetan monks to Germany, who were to influence the weather favourably for his Russian invasion with special chants. (Feigon 1996: 15)

2. 'The Devil, says the Jesuit, has by his natural malice introduced into the worship of these people the veneration that is owed only to the Roman Pope, as Vicar of Christ, as he has done with all other mysteries of the Christian religion ...' From *Allgemeine Historie der Reisen zu Wasser und zu Lande*, Book XVI, Chapter IV, pp. 216–7, 218.

3. On this, see for example Waddell 1971 (1895): 129, etc. Many early authors evaluated Buddhism. They distinguished between early Buddhism, which they judged positively, and the relatively late form of

Tibetan Buddhism (which they called 'Lamaism'), which they described as a degeneration of Buddhism. Popular Buddhism and the Bön religion in particular were sometimes most severely criticized.

4. On Kailas, see Allen 1982 and Snelling 1990. On Tibetan mountain worship see Anne-Marie Blondeau & Ernst Steinkellner (ed.): *Reflections of the Mountain*, Vienna 1996.

5. The films *Der Dämon des Himalaya*, *Storm over Tibet*, *The Abominable Snowman*; yeti comics, etc.

6. Dürrenmatt 1981.

7. R. Thurman in Rhie & Thurman 1991: 312.

8. These 'power places' are a central concept in contemporary Western esoteric circles.

9. Blanche Merz: *Orte der Kraft*, Geneva, 1995.

10. Alexander Buschenreiter: *Unser Ende ist euer Untergang*, Econ 1983.

11. A certain Squadron Leader Peter Caddy of the British Royal Air Force is also supposed to have become interested in the power lines and places of Tibet. According to the legend, he wandered through Tibet in the Second World War, with the aim of reaching the 'Rarkor Choide' monastery. In the early 1960s he founded the Findhorn community, an important driving force for the New Age movement. See Schweidlenka 1989.

12. Lopez 1998: 46–85 shows convincingly how much the individual editors and translators of the *Tibetan Book of the Dead* display their own spiritual roots in each commentary and interpretation. The individual commentaries display different stages of the Western perception of Tibetan religiousness and the most varied borrowings and predispositions—Evans-Wentz: Theosophy; Govinda: Theosophy and Jungian psychology; Leary: LSD experiences; [Fremantle &] Trungpa: transpersonal psychology; Sogyal Rinpoche: New Age. It is interesting that so many spiritual movements are enthusiastic about Tibetan ideas of after death. [Translator's note: Lopez uses 'New Age' in the broadest sense, covering any currents of Western thought opposed to a materialistic outlook.]

On the reception of the *Tibetan Book of the Dead* see also Bishop 1997.

13. Doyle (1905): 'The Empty House'. There Sherlock Holmes tells Watson: 'I travelled for two years in Tibet, therefore, and amused myself by visiting Lhassa and spending some days with the head Lama.' Sherlock Holmes's stay in Tibet, mentioned only very briefly by Conan Doyle, inspired one author (Wincor 1968) to write a book entitled *Sherlock Holmes in Tibet*. This is primarily about the 'lectures' of the so-called 'leading metaphysician of Tibet, Lama Nordup', which Sherlock Holmes, also living in Tibet, is supposed to have attended. Of more recent date is Jamyang Norbu's novel *The Mandala of Sherlock Holmes. The Adventures of the Great Detective in India*

and Tibet, HarperCollins India, 1999.

14. Novels: Jones 1988; Podrug 1993; Kopacka 1997; Lawrence 1996; Bergius 1984; Higgins 1996; Davidson 1962.

15. Thus Tibet fascinated Ernst Schäfer above all as a place of origin of many genera and species of plant and animal life, and as an area of refuge for species extinct long ago.

16. See Huber 2001.

17. Marco Polo, *Il Milione*, <http://www.digilander. libero.it/bepi/biblio3a/indice3.html>, cap. 114; ed. Ronchi, CXV.12–19 (Latin tr.: Cologne 1671: p. 204 ff; Eng. tr. Latham: London: Folio Soc. 1968: p. 144).

18. Dauthendey 1958: 17.

19. Podrug 1993: 206. [Probably based on Alexandra David-Neel's classic traveller's tale of the *rolang* or corpse-raising spirit in *Magic and Mystery in Tibet*.]

20. Dickinson 1995: 270 ff; Jones 1989: 13ff†; Lawrence 1996: 351.

21. E.g. with Rijkenborgh and Blavatsky.

22. Moon 1997.

23. Marco Polo, *Il Milione*, <http://www.digilander. libero.it/bepi/biblio3a/indice3.html>, cap. 115; cf. also cap. 74 (Eng.: Folio Soc. edn, pp. 145, 90).

24. According to her own statements, Jetsunma Ahkön Lhamo was recognized in 1987 as an incarnation of a Tibetan saint from the seventeenth century, and in 1994 in addition as an incarnation of Lhacham Mandarawa, one of the female companions of Guru Padmasambhava. Steven Seagal was recognized in February 1997 as a reincarnation of the Tertön Chungdrag Dorje. See <http://www.palyul.org> [(especially <http://www.palyul.org/statement. html>)] and <http://www.tara.org>

25. Quotations from: *Facts*, No. 17, 1998; *Modeblatt*, No. 45, 1998.

26. Achternbusch 1983.

27. Novel: Higgins 1996: Chavasse helps the escape of the Fourteenth Dalai Lama. Film: *The Golden Child*: Chandler rescues (or at least helps to rescue) the young incarnation. Comic: *Manhunter—The Himalayan Incident*.

28. Norbu 1998: 20.

29. Börner 1984: 42, 45.

30. Grueber is supposed to have been eight years on the way from Europe to Tibet, Desideri 3 1/2.

31. Bharati 1987: 39.

32. Erdheim 1987: 48 ff.

33. Various investigations have shown that despite generations of secular education, even contemporary Americans do not behave or think rationally by a long way. See Edgerton 1994: 259†.

34. Edgerton 1994: 264 ff†. According to this legend, a primitive people's sense of community supposedly

involves emotional participation, personal closeness and intimacy, moral obligation, social cohesion and great temporal continuity.

35. The major in the film *Der Dämon des Himalaya*.

36. I owe this information to David Templeman, Melbourne. Govinda 1995: 12† also says that the Tibetans could be described as a people with high culture.

37. See for example Schmocker 1982. The example of the Tibetans shows that cultural distance, which is sometimes seen as a reason for problems of integration and xenophobia, is not a compelling reason for the tense relationship between the Swiss and certain groups of foreigners. When the foreigners share central values of the host society, they are tolerated and even highly regarded.

38. Others discover that their opposite number reacts with disbelief and uncertainty if they once swear or do anything else 'irreligious': a Tibetan wouldn't do that! (Information from Tibetans in the course of a conversation about the present book, July 1999.)

39. A study carried out by the Asia Society in New York in 1975 revealed that in American books, Filipinos and Thais are also portrayed as friendly, happy and nice. At all events, this chapter provides information on possible reasons why the Tibetans living in Switzerland are ranked more highly than other Asians.

40. An 'evolutionary' theory strongly shaped by Theosophy is also used by some to claim a particular closeness between Tibet and the Indians of South and Central America. One of these theories postulates a common origin of 'the three cultural provinces of Tibet, Rome and Mexico from a mother cult, which we can, without being forced, transfer to sunken Atlantis ... All three derive their origin from the original cult of the Aryan-Atlantean priesthood, which taught the protoreligion that, though its content is exceedingly diluted, is still effective in every nation of the Earth ... Crozier, bell, vespers, mass and keys also exist in Tibet, in Ljassa (*sic*) the Dalai Lama sits enthroned as God's deputy, infallible and unapproachable, like the Pope in Rome.' (Gorsleben 1981: 204)

41. See Kempf, n.d.: 131 ff.

42. Bishop 1993: 29 ff. gives some examples of enthusiastic descriptions of the mountains of Tibet.

43. Article in *Neue Zürcher Zeitung*, 22 October 1961, and reader's letter in *Neue Zürcher Zeitung*, 22 December 1961.

44. Orville Schell in conversation with Elizabeth Farnsworth in a TV broadcast on 3 December 1996.

45. Shakya 1992.

46. All these examples come from Dowman 1985.

47. See for example Chagdud Tulku 1992.

48. E.g. Loten Dahortsang (tr.): *Der geheime Kommentar*

zur Vajra Yogini Praxis, «*Herz-Essenz der Himmelswandlerin*» *genannt*, Rikon: p. 60, lines 4–5.

49. The capability of forcing one's way into the body of another person thanks to strong psychic powers (called *grong-'jug*), as is described in Lobsang Rampa's works and some comics, is also found in some Tibetan legends.

50. After the German translation by Loten Dahortsang, Rikon. It is said furthermore that the people living in Shambhala are rich, happy and healthy. The harvest is good and everyone spends their time practising the Dharma. As all the kings are religious, there is not even a sign of vice or depravity. Even the words 'war' and 'enmity' are unknown there. (Gar-je K'am-trül Rinpoche, in *A Geography and History of Shambhala*, in *The Tibet Journal*, Vol. 3, No. 3 (1978), 3–11)

51. The expression 'Lord of the World', used again and again by Western authors, is not found in this context in Tibetan texts, however.

52. Just when the Tulku system of Tibet originated is a subject of academic debate. Its roots probably lie in the Sakyapa school in the 12th century, but as a universally valid system the Tulku system was first introduced in the Karmapa school at the end of the 13th century. Many regard the Second Karmapa, Karma Pakshi, as the first true tulku. Right from the start the Tulku system was not just about the transmission of spiritual content with the least possible adulteration, but also—and especially—about the preservation of worldly and political power and the maintenance of stability.

53. Bishop 1993: 65.

54. On the subject of sex in Tibetan literature, see for example Dhondup 1995.

55. From the German translation by Loten Dahortsang, Rikon.

56. See for example Oppitz 1968: 136 ff; [Messner 2000 refers most often to chemo, chemong or dremo].

57. On the Tibetan ritual dagger, see Cantwell 1997; Marcotty 1987.

58. There was much debate about this question. In 1885, Hodgson claimed in a report commissioned by the Society for Psychical Research that, apart from a few exceptions, the letters allegedly written by Koot Hoomi had been written by Madame Blavatsky. A hundred years later, this report was called seriously into question by Vernon Harrison, on the basis of grave 'procedural errors'. Harrison said in the introduction to his article that he did not want to show that Mme Blavatsky was innocent, or even to demonstrate the true authorship of the Mahatma letters. His sole aim was to show that in the case of Hodgson versus Blavatsky the guilt of the 'accused' could not be proven. Harrison 1986: 287.

59. Mitscherlich 1964: 42.

60. Pauwels & Bergier 1974: 28.

61. Oppitz 1974 and 2000, for example, shows from the novel *Lost Horizon* that the function of real locations can be to make the fictitious ones believable.

62. Trungpa 1982: 113 (quotation retranslated from German).

63. Chagdud Tulku 1992: 87, 112–3, 116, 13.

64. Dawa Norbu 1974: 23, 221/ 1999: 224–5.

65. Pema 1997: 61 (German edition).

66. Pemba 1968: 126 (quotation retranslated from German).

67. Tsering 1997: 29, 187.

68. Dawa Norbu 1974: 80 ff.

69. *Wie weiter? Sechs Fragen an einen jungen, in der Schweiz geborenen Tibeter*, in DU 7/1995. On the use of force, among others by the Fifth Dalai Lama, see for example Sperling 2001.

70. Dawa Norbu 1999: 62.

71. Shuguba 1995: 66 ff; Goldstein 1989; see also Lindegger 1998; [Shakabpa 1984: 274–6. 'Tsipön' (*rtsis-dpon*) means 'Finance Minister', the title of four lay officials heading the finance department in the traditional Tibetan government.]

72. On Gendün Chöpel, see Lopez 1995a; Jeffrey Hopkins, *About Gendün Chöpel* in *Sex, Orgasm and the Mind of Clear Light*, Berkeley: North Atlantic Books, 1998; Stoddard 1985; Lindegger 1998.

73. Dawa Norbu 1974: 211 ff/ 1999: 215.

74. Shuguba 1995: 132 ff.

75. Dalai Lama 1990: 56.

76. Shuguba 1995: 67.

77. Dalai Lama 1990: 30.

78. Some Western authors have also been critical of the illusion of an always peaceful Tibet, e.g. Lopez. He points out that the Fifth Dalai Lama was able to gain worldly power only through military intervention by his Mongolian patron. Tibetan troops waged war against Ladakh (1681) and Dzungaria (1720), and invaded Bhutan several times in the 18th century. They fought against invading Nepalis (1788–1792 and 1854), and against the Dogras (1842) and the British (1904). Hopkins 2001 describes the great tensions between the individual colleges of the monasteries, which could result in such outbreaks as the Reting Disturbances.

79. Lecture by Tsewang Norbu on the occasion of the event 'Neues Feindbild Dalai Lama', Berlin, 26 March 1999.

80. Further critical remarks on the Tibetan judicial system and its methods of punishment are to be found in Tsering 1997, Dawa Norbu 1974/ 1999: 64 ff, and Pemba 1957: 85.

81. Losang Gyatso describes how an American woman was disappointed to discover in a book on Tibet a picture of a group of men posing proudly in front of the camera with swords and rifles, captioned 'Tibetan bandits'. She had hoped that Tibet was the place where there was nothing so worldly as crime. (Gyatso 1990)

82. Dalai Lama 1962: 44 ff†; the Dalai Lama's brother also makes similar statements, see Norbu & Turnbull 1972: 339, 347 ff.

83. E.g. Bishop 1993: 46ff, 73ff; Hopkins 2001; Sperling 2001; Clarke 2001.

84. Huber 2001: 358.

85. The Dorje Shugden adherents worship a manifestation that they themselves claim to be a Buddha. Their opponents, however, among whom is the Fourteenth Dalai Lama, take the view that it is a dangerous spirit. The dispute goes back to the Fifth Dalai Lama, has erupted repeatedly in the past three hundred years and came to a new climax both in India and in Europe in 1996 and the beginning of 1997. A good summary of the arguments can be found in: Stephen Batchelor & Donald S. Lopez, Jr.: *Deity or Demon? The 'Unmentionable' Feud over Tibet's Dorje Shugden*. In *Tricycle. The Buddhist Review*, Spring 1998.

86. Information from a letter from the Amnye Machen Institute to Swiss Tibet Aid (Schweizer Tibethilfe) dated 9 April 1996.

87. Huber 2001: 368.

88. Metzger 1976: 31.

89. At the *Mythos Tibet* symposium in Bonn (May 1996), however, Jigme Norbu, the Dalai Lama's eldest brother, felt uneasy about the 'iconoclastic will to destroy' (*Nordic Newsletter of Asian Studies*, No. 2, June 1996).

90. Dagyab 2001: 387–8.

91. Norbu 1974/ 1999: Preface.

92. Shakya 1992: 13 ff.

93. Gyatso 1990.

94. Jamyang Norbu 1998: 20.

95. Sonam Dölma Brauen, conversation in July 1999.

96. Donald Lopez, in *Tibetan Review*, May 1994: 20. Bharati also expresses himself similarly: 'an image of Tibet is created, and perpetuated, which cannot but be harmful to the future interface between Tibetan culture and the West.' (Bharati 1974: 9)

97. My attention was drawn to this proverb by my Tibetan acquaintance of many years' standing, Gyaltsen Gyaltag, in the course of a podium discussion on the subject *Tibet—Between Myth and Reality*, Zürich, 27 February–7 March 1998.

List of the literature, comics and films used

Literature

Achternbusch, Herbert, 1983 (1970): *Das Kamel.* Frankfurt: Suhrkamp.

Ackermann, Josef, 1970: *Heinrich Himmler als Ideologe.* Göttingen/Zürich: Musterschmidt.

Agamon, David (ed.), 1978: *Sungods in Exile, Secrets of the Dzopa of Tibet.* Sudbury: Neville Spearman

Allen, Charles, 1982: *A Mountain in Tibet—The Search for Mount Kailas and the Sources of the Great Rivers of India.* London: André Deutsch.

Allgemeine Historie der Reisen zu Wasser und zu Lande; oder Sammlung aller Reisebeschreibungen, welche bis itzo in verschiedenen Sprachen von allen Voelkern herausgegeben worden …, 21 vols, 1747–1774, Leipzig.

Allgöwer, Erik, 1995 (1991): *Le tigre et le lama.* Arles: Picquier poche.

Andresen, Jensine, 1997: *Kalacakra—Textual and Ritual Perspectives.* Thesis, Cambridge, MA: Harvard University.

Antweiler, Christoph, 1994: *Eigenbilder, Fremdbilder, Naturbilder. Anthropologischer Überblick und Auswahlbibliographie zur kognitiven Dimension interkulturellen Umganges*, in Anthropos, LXXXIX, 1–3, pp. 137–168.

Artaud, Antonin, 1925a: *Adresse au Dalaï-Lama*, in *La Révolution Surréaliste*, No. 3, 15.4.1925. Repr. in *Œuvres complètes*, Vol. I, Gallimard, 1970: 340–341. Eng., tr. Victor Corti: *Address to the Dalai Lama*, in *Collected Works*, Vol. I: 180–181.

Artaud, Antonin, 1925b: *Lettre aux Recteurs des Universités Européennes*, in *La Révolution Surréaliste*, No. 3, 15.4.1925. Repr. in *Œuvres complètes*, Vol. I, Gallimard, 1970: 335–336. Eng., tr. Victor Corti: *Letter to the Chancellors of the European Universities*, in *Collected Works*, Vol. I: 178–180.

Artaud, Antonin, 1925c: *L'Activité du Bureau de Recherches Surréalistes*, in *La Révolution Surréaliste*, No. 3, 15.4.1925. Repr. in *Œuvres complètes*, Vol. I, Gallimard, 1970: 344–347. Eng., tr. Victor Corti: *Activities of the Surrealist Research Bureau*, in *Collected Works*, Vol. I: 184–186.

Artaud, Antonin, 1946: *Adresse au Dalaï-Lama.* (Envoyé le 2.12.1946). Repr. in *Œuvres complètes*, Vol. I, Gallimard, 1970: 21–25.

Artaud, Antonin, 1968: *Collected Works*, Vol. I, tr. by Victor Corti. London: Calder & Boyars. Aschoff, Jürgen C., 1989: *Tsaparang—Königstadt in Westtibet, Die vollständigen Berichte des Jesuitenpaters António de Andrade und eine Beschreibung vom heutigen Zustand der Klöster.* Eching vor München: MC Verlag.

Bailey, Alice A., 1994: *The Unfinished Autobiography.* New York/London: Lucis. First published 1951.

Baker, Alan, 2000: *Invisible Eagle. The History of Nazi Occultism.* London: Virgin Publishing.

Baker, Douglas, 1977: *The Opening of the Third Eye.* Wellingborough: Aquarian Press.

Barborka, Geoffrey A., 1969: *H.P. Blavatsky, Tibet and Tulku.* Adyar/Wheaton: The Theosophical Publishing House.

Barglow, Raymond, 1994: *The Crisis of the Self in the Age of Information—Computers, dolphins, and dreams.* London/New York: Routledge.

Barker, A.T., (1926): *The Mahatma Letters to A.P. Sinnett, from the Mahatmas M. and K.H.* Transcribed, compiled and with an introduction by A.T. Barker. 1926. 2nd ed., London: Rider & Co., 1948. 3rd ed., revised, Adyar: Theosophical Publishing House, 1962. Online ed. (facsimile of 2nd ed.): Theosophical Univ. Press (<http://www.theosociety.org/pasadena/mahatma/ml-con.htm>).

Bärsch, Claus-E., 1998: *Die politische Religion des Nationalsozialismus, Die religiöse Dimension der NS-Ideologie in den Schriften von Dietrich Eckart, Joseph Goebbels, Alfred Rosenberg und Adolf Hitler.* Munich: Wilhelm Fink.

Bechert, Heinz, 1966: *Buddhismus, Staat und Gesellschaft in den Ländern des Theravâda-Buddhismus*, Vol. 1. Frankfurt.

Bechteler, Harald, 1999: *Die deutsche Tibetexpedition E. Schäfer 1938/39.* Unpublished lecture at Völkerkundemuseum der Universität Zürich.

Becker, Peter Emil, 1990: *Sozialdarwinismus, Rassismus, Antisemitismus und Völkischer Gedanke, Wege ins Dritte Reich*, Teil II. Stuttgart: Georg Thieme.

Beger, Bruno, 1998: *Mit der deutschen Tibetexpedition Ernst Schäfer 1938/39 nach Lhasa.* Wiesbaden: Dieter Schwarz.

Beligatti, Fra Cassiano da Macerata, *Relazione inediatta di un viaggio al Tibet.* Firenze.

Bennett, J.G., 1997: *Gurdjieff, Ursprung und Hintergrund seiner Lehre.* Munich: Wilhelm Heyne. Tr. of: *Gurdjieff—A Very Great Enigma.* Sherborne: Coombe Springs Press, 1981.

Bergius, C.C., 1984: *Endstation Tibet.* Munich: Goldmann.

Bernbaum, Edwin, 1980: *The Way to Shambhala. A Search for the Mythical Kingdom beyond the Himalayas.* Garden City, NY: Anchor Press/Doubleday.

Bharati, Agehananda, 1974: *Fictitious Tibet: The Origin and Persistence of Rampaism*, in *The Tibet Society Bulletin*, vol. VII, p. 1–11. Bloomington, Indiana. (Available on the Internet; see Part 3: n. 42.)

Bharati, Agehananda, 1987: *Mundus vult decipi: Falsche Lamas, ein Märchentibet und vermischte Esoterica*, in: Duerr, Hanspeter: *Authentizität und Betrug in der Ethnologie.* Frankfurt am Main: Edition Suhrkamp, Vol. 409 neue Folge, pp. 38–57.

Bishop, Peter, 1989: *The Myth of Shangri-La. Tibet, Travel Writing and the Western Creation of Sacred Landscape.* London: The Athlone Press.

Bishop, Peter, 1993: *Dreams of Power. Tibetan Buddhism and the Western Imagination.* London: The Athlone Press.

Bishop, Peter, 1997: *A Landscape for Dying: The Bardo Thodol and Western Fantasy,* in: Korom 1997 a, pp. 47–72.

Bishop, Peter, 2001: *Not only a Shangri-La: Images of Tibet in Western Literature,* in *Imagining Tibet:* 201-221.

Bitterli, Urs, 1976: *Die «Wilden» und die «Zivilisierten». Grundzüge einer Geistes- und Kulturgeschichte der europäisch-überseeischen Begegnung.* Munich.

Blavatsky, Helena Petrovna, 1877: *Isis Unveiled: A Masterkey to the Mysteries of Ancient and Modern Science and Theology.* 2 vols, New York: J.W. Bouton, 1877. Repr. Pasadena, CA: Theosophical Univ. Press, 1972, & online ed., n.d., <http://www.theosociety.org/pasadena/tup-onl.htm>

Blavatsky, Helena Petrovna, 1888: *The Secret Doctrine. The Synthesis of Science, Religion, and Philosophy.* London: Theosophical Publishing Co./New York: William Q. Judge /Madras: Adyar. Repr. Pasadena, CA: Theosophical Univ. Press, 1997, & online ed., n.d., <http://www.theosociety.org/pasadena/tup-onl.htm>

Blavatsky, Helena Petrovna, 1950–91: *Collected Writings,* 14 vol., Boris de Zirkoff (ed.). Madras, India/Wheaton: Theosophical Publishing House.

Bloch, Ernst, 1976: *Das Prinzip Hoffnung,* 3 vols. Frankfurt a.M.: Suhrkamp.

Börner, Klaus H., 1984: *Auf der Suche nach dem irdischen Paradies, Zur Ikonographie der geographischen Utopie.* Frankfurt: Wörner.

Bramley, William, 1990: *Die Götter von Eden. Eine neue Betrachtung der Menschheitsgeschichte.* Burggen: In-der-Tat-Verlag.

Brauen, Martin & Detlef Kantowsky, 1982: *Junge Tibeter in der Schweiz, Studien zum Prozess kultureller Identifikation.* Diessenhofen: Rüegger. Bray, John, 1981: *Nikolai Notovitch and the Tibetan Life of Christ,* in *Tibetan Review,* Vol. XVI, No. 5, May 1981, pp. 21–22.

Bray, John, 2001: *Nineteenth and Early Twentieth-Century Missionary Images of Tibet,* in *Imagining Tibet:* 21-45. (Ger. 1997: *Die Tibetbilder der Missionare im 19. und frühen 20. Jahrhundert,* in *Mythos Tibet:* 31–50.)

Bronder, Dietrich, 1975 (1964): *Bevor Hitler kam, Eine historische Studie.* Geneva: Marva.

Bulwer-Lytton, Lord Edward, (1871): 1st ed. *The Coming Race.* Published anonymously, London, 1871. Later Eng. title *Vril: The Power of The Coming Race.* Online ed., n.d., www.sacred-texts.com/atl/vril

Burang, 1947: *Tibeter über das Abendland.* Salzburg.

Cantwell, Cathy, 1997: *To Meditate upon Consciousness as Vajra: „Killing and Liberation" in the rNying-ma-pa Tradition,* in *Tibetan Studies,* Vol I. Vienna: Oester.

Akademie der Wissenschaften, 1997.

Carmin, E.R. (pseudonym), 1985: *„Guru" Hitler, Die Geburt des Nationalsozialismus aus dem Geiste von Mystik und Magie.* Zürich: SV International.

Caroe, Olaf, 1960: *Englishmen in Tibet, From Bogle to Gould,* in *The Tibet Society Publications,* London.

Chagdud Tulku 1992: *Lord of the Dance. The autobiography of a Tibetan lama.* Junction City, CA: Padma Publishing.

Charroux, Robert, 1970 (1965): *Verratene Geheimnisse, Atomsintflut und Raketenarche,* 3rd edn. Munich: Herbig.

Clarke, Graham E., 2001: *Tradition, Modernity and Environmental Change in Tibet,* in *Imagining Tibet:* 339-355. (Ger. 1997: *Tradition, Moderne und Umweltveränderungen in Tibet,* in *Mythos Tibet:* 281–299.)

Collected Writings, see Blavatsky 1950–91.

Combe, see: Sherap, Paul

Cooney, Eleanor & Daniel Altieri, 1996: *Shangri-La. The Return to the World of Lost Horizon.* New York.

Cranston, Sylvia, 1995: *HPB—Leben und Werk der Helena Blavatsky Begründerin der Modernen Theosophie.* Satteldorf: Adyar. Tr. of: *HPB: the extraordinary life and influence of Helena Blavatsky, founder of the modern Theosophical movement.* New York: Putnam,1993.

Creme, Benjamin, 1996: *The Ageless Wisdom Teaching. An introduction to humanity's spiritual legacy.* London: Share International Foundation. (Ger. 1997, *Lehren der zeitlosen Weisheit, Eine Einführung in das geistige Vermächtnis der Menschheit;* zusammengestellt von Share International Foundation. Munich: Edition Tetraeder.)

d'Alveydre, Joseph-Alexandre Saint-Yves, 1910 (1886 1st edn, all but one copy destroyed): *La Mission de l'Inde en Europe, Mission de l'Europe en Asie, la question du Mahatma et sa solution.* Paris: Librairie Dorbon Ainé.

Dagyab Kyabgön Rinpoche, Loden Sherab, 2001: *Buddhism in the West and the Image of Tibet,* in *Imagining Tibet:* 379-388. (Ger. 1997: *Die Problematik der Nutzung des Tibetbildes für die Verbreitung des Buddhismus im Westen,* in *Mythos Tibet:* 318-325.)

Daim, Wilfried, 1958: *Der Mann, der Hitler die Ideen gab, Von den religiösen Verirrungen eines Sektierers zum Rassenwahn des Diktators.* Munich: Isar.

Dalai Lama, 1962: *Mein Leben und mein Volk. Die Tragödie Tibets.* Munich/Zürich: Knaur. Tr. of: *My Land and My People.* 1962. Repr. New York: Potala, 1977.

Dalai Lama, 1990: *Freedom in Exile. The Autobiography of the Dalai Lama.* London: Hodder & Stoughton/New York: HarperCollins. (Pbk NY: HarperCollins, 1991)

Dauthendey, Max, 1958: *Himalayafinsternis.* In *Exotische Novellen,* ed. Herman Gerstner, Stuttgart: Reclam, 1958 (Reclams Universal-Bibliothek Nr. 8220).

Davidson, Lionel, 1962: *The Rose of Tibet.* Harper & Row, 1962; repr. New York: Avon Books, n.d.

de Andrade: see: Aschoff 1989; Part 1, n. 1.

de Filippi, Filippo (ed.), 1932: *An Account of Tibet. The Travels of Ippolito Desideri of Pistoia S.J., 1712–1727.* London: Routledge & Sons.

de Riencourt, Amaury, 1951: *Lost World: Tibet, Key to Asia.* London: Victor Gollancz.

della Penna, R.P. Francisco Horatio, 1740: *Missio Apostolica, Thibetano-Seraphica, Das ist: Neue durch Päbstlichen Gewalt in dem Grossen Thibetanischen Reich von denen P.P. Capucineren aufgerichtete Mission.* Munich.

Desideri, Ippolito: see: de Filippi 1932; Puini 1904; Wessels 1924.

Dhondup, K., 1995: *Sex in Tibetan literature,* in *Tibetan Review,* January 1995, pp. 11–17.

Dickinson, Peter, 1995 (1979): *Tulku.* London: Corgi Freeway Books.

Didier, Hugues, 1989: *Die Jesuiten-Mission in Tsaparang, kommentiert und interpretiert nach den Dokumenten in den römischen Archiven der Gesellschaft Jesu,* in: Aschoff 1989.

Dixit, Kanak Mani, 1996: *Welchen Himalaya hätten Sie gern? Sehnsucht verklärt—oder: Über die Schwierigkeit, sich vom Himalaja das richtige Bild zu machen,* in GEO Special, No. 3, June, pp. 24–28.

Dodin, Thierry, & Heinz Räther (ed.), 1997: *Mythos Tibet—Wahrnehmungen, Projektionen, Phantasien.* Cologne: Dumont. Eng.: 2001, *Imagining Tibet: Perceptions, Projections & Fantasies.* Boston, Mass.: Wisdom Publications.

Doucet, Friedrich W., 1979: *Im Banne des Mythos. Die Psychologie des Dritten Reiches.* Rastatt: Moewig.

Dowling, Levi H., 1908: *The Aquarian Gospel of Jesus the Christ.* Frequently reprinted.

Dowman, Keith, (tr.) 1985: *Masters of Mahamudra. Songs and histories of the eighty-four Buddhist Siddhas.* Albany: State Univ. of New York.

Doyle, Sir Arthur Conan, (1905): *The Return of Sherlock Holmes.* Repr. in *Sherlock Holmes: The Complete Short Stories.* London: John Murray, 1928.

Dürrenmatt, Friedrich, 1981: *Der Winterkrieg in Tibet,* in *Stoffe I–III,* Zürich: Diogenes, pp. 11–179.

Edgerton, Robert B., 1994: *Trügerische Paradiese. Der Mythos von den glücklichen Naturvölkern.* Hamburg: Ernst Kabel. Tr. of: *Sick Societies. Challenging the Myth of Primitive Harmony.* New York: Free Press, 1992.

Eich, Günter, 1970: *Ein Tibeter in meinem Büro.* Frankfurt a.M.: Suhrkamp.

Erdheim, Mario, 1987: *Zur Ethnopsychoanalyse von Exotismus und Xenophobie,* in *Exotische Welten, Europäische Phantasien.* Stuttgart: Edition Cantz, pp. 48–53.

Evans-Wentz, Walter Yeerling (ed.), 1957: *The Tibetan Book of the Dead.*

Evola, Julius, 1950: *What Tantrism means to Western Civilization,* in *East and West,* I, No. 1, April 1950, pp.28–32, Rome.

Exotische Welten. Europäische Phantasien, 1987. Institut für Auslandbeziehungen, Würtembergischer Kunstverein. Stuttgart: Edition Cantz.

Feigon, Lee, 1996: *Demystifying Tibet. Unlocking the Secrets of the Land of the Snows.* Chicago: Ivan R. Dee, 1996; London: Profile Books, 1999.

Forman, Harrison, 1936: *Through forbidden Tibet. An Adventure into the unknown.* London: Jarrolds.

Frank, Eduard, 1957: *Gustav Meyrink, Werk und Wirkung.* Büdingen-Gettenbach: Avalun.

Fremantle, Francesca, & Chögyam Trungpa, 1975: *The Tibetan Book of the Dead. The Great Liberation through Hearing in the Bardo.* Berkeley & London: Shambhala.

Frick, Karl R.H., 1978: *Licht und Finsternis – gnostisch-theosophische und freimaurerisch-okkulte Geheimgesellschaften bis an die Wende des 20. Jahrhunderts.* Graz: Akademische Druck- und Verlangsanstalt.

Fuller, Jean Overton, 1988: *Blavatsky and her teachers. An investigative biography.* London and The Hague: East-West Publications.

Ginsberg, Allen, (1976): *The Dream of Tibet,* in William S. Burroughs: *The Retreat Diaries.* New York: City Moon, 1976 (Ger. 1980, *Traum von Tibet,* in William S. Burroughs: *Zwischen Mitternacht und Morgen.* Basel: Sphinx Pocket, pp. 9–46.)

Giorgi (Georgii), António Agostino, 1987 (1762/63): *Alphabetum Tibetanum missionum apostolicarum commodo editum.* Rome 1762/63; facsimile reprint Cologne: Ed. Una Voce, 1987.

Glasenapp, Helmut von, 1954: *Kant und die Religionen des Ostens.* Kitzingen-Main: Holzner.

Glasenapp, Helmut von, 1960: *Das Indienbild deutscher Denker.* Stuttgart: Koehler.

Glowka, Hans-Jürgen, 1981: *Deutsche Okkultgruppen 1875–1937.* Munich: Arbeitsgemeinschaft für Religions- und Weltanschauungsfragen.

Goldstein, Melvyn C., 1989: *A History of Modern Tibet 1913–1951.* Berkeley/Los Angeles/London: University of California Press.

Goldstein 1997: see Tsering, Tashi

Goodrick-Clarke, Nicholas, 1985: *The Occult Roots of Nazism. The Ariosophists of Austria and Germany.* Wellingborough: The Aquarian Press.

Gorsleben, Rudolf John, 1981 (1930): *Hoch-Zeit der Menschheit. Das Welt-Gesetz der Drei, oder Entstehen—Sein—Vergehen in Ursprache—Urschrift—Urglaube, aus den Runen geschöpft.* Bremen: Faksimile-Verlag.

Govinda, Lama Anagarika, 1995 (1966): *Der Weg der Weissen Wolken.* Berne/Munich/Vienna: Scherz. Eng. tr.: *The Way of the White Clouds: a Buddhist pilgrim in Tibet.* London: Hutchinson, 1968; repr. Berkeley, CA: Shambhala, 1970.

Greve, Reinhard, 1995: *Tibetforschung im SS-Ahnenerbe,* in: Hauschild, Thomas (ed.), *Lebenslust und Fremdenfurcht, Ethnologie im Dritten Reich.* Frankfurt

a.M.: Suhrkamp, pp. 168–199.

Greve, Reinhard, 1997: *Das Tibet-Bild der Nationalsozialisten*, in *Mythos Tibet*: 104–113.

Grönbold, Günter, 1985: *Jesus in Indien. Das Ende einer Legende*. Munich: Kösel.

Grueber, Johannes, 1985: *Als Kundschafter des Papstes nach China, 1656–1664, Die erste Durchquerung Tibets*, ed. Franz Braumann. Stuttgart: Thienemann.

Grünfelder, Alice, 1997: *An den Lederriemen geknotete Seele. Erzähler aus Tibet: Tashi Dawa, Alai, Sebo*. Zürich: Unionsverlag.

Grünwedel, Albert, 1900: *Mythologie des Buddhismus in Tibet und der Mongolei*.

Grünwedel, Albert, 1915: *Der Weg nach Śambhala (Shambhalai lamyig) des dritten Großlama von bkra śis lhun po, Blo bzaṅdpal ldan ye śes*. Abhandlungen der königlich-bayerischen Akademie der Wissenschaften, philosophisch-philologische und historische Klasse, XXIX, Bd. 3,3. Abh., Munich.

Guénon, René, 1921: *Le Théosophisme. Histoire d'une pseudo-religion*. Paris: Nouvelle Librairie Nationale.

Guénon, René, 1987: *Der König der Welt*. Freiburg i.Br.: Aurum. Tr. of: *Le Roi du Monde*. (1958). Eng.: *The Lord of the World*. Ellingstring: Coombe Springs Press, 1983.

Günther, Hans F.K., 1928: *Ritter, Tod und Teufel*. Munich.

Günther, Hans F.K., 1934: *Die nordische Rasse bei den Indogermanen Asiens, zugleich ein Beitrag zur Frage nach der Urheimat und Rassenherkunft der Indogermanen*. Munich: J.F. Lehmanns.

Gurdjieff, Georgei Ivanovitch, (1950): *Beelzebub's Tales to his Grandson. An Objectively Impartial Criticism of the Life of Man*. (*All and Everything*, First Series.) New York: Harcourt Brace & London: Routledge & Kegan Paul, 1950. Repr. New York: Dutton, 1964, 1973, 1978 & London: Routledge, 1974. E-book edition: Fourth Way eBooks, n.d.

Gurdjieff, Georgei Ivanovitch, (1963): *Meetings with Remarkable Men*. (*All and Everything*, Second Series.) New York: Dutton & London: Routledge & Kegan Paul, 1963. Repr. New York: Dutton, 1969; London: Routledge, 1971; London: Pan Books (Picador), 1978. E-book edition: Fourth Way eBooks, n.d.

Gurdjieff, Georgei Ivanovitch, (1975): *Life is Real Only Then, When 'I Am'*. (*All and Everything*, Third Series.) New York: Triangle Editions, 1975. 2nd ed., ib., 1978. Repr. New York: Dutton & London: Routledge & Kegan Paul, 1982. E-book edition: Fourth Way eBooks, n.d.

Gurdjieff, Georgei Ivanovitch, 1982: *Aus der wirklichen Welt: Gurdjieffs Gespräche mit seinen Schülern*. Basel: Sphinx Verlag. (Eng.: *Views from the Real World. Early Talks in Moscow [etc.] … as recollected by his pupils*. New York: Dutton & London: Routledge & Kegan Paul, 1973. Repr., slightly abridged, 1975–6.)

Gyatso, Losang, 1990: *Tibet—A state or a State of Mind?*, in *Himal*, Jan/Feb 1990.

Hansen, Peter H., 1996: *The Dancing Lamas of Everest: Cinema, Orientalism and Anglo-Tibetan Relations in the 1920s*, in *American Historical Review*, Vol. 101, No. 3, June 1996.

Hansen, Peter H., 2001: *Tibetan Horizon: Tibet and the Cinema in the Early Twentieth Century*, in *Imagining Tibet*: 91-110. (Ger. 1997: *Der tibetische Horizont. Tibet im Kino des frühen 20. Jahrhunderts*, in *Mythos Tibet*: 87–103.)

Harrison, Vernon, 1986: *J'accuse. An Examination of the Hodgson Report of 1885*, in *Journal of the Society for Psychical Research*, vol. 53, no. 803 (1985–86), pp. 286–310, London.

Hausdorf, Hartwig, 1995: *Baian-Kara-Ula. Neue Erkenntnisse zum Jahrhunderträtsel*, in *Ancient Skies*, No. 6/1995, pp. 3–6.

Heberer, Thomas, 2001: *Old Tibet: A Hell on Earth? The Myth of Tibet and Tibetans in Chinese Art and Propaganda*, in *Imagining Tibet*: 111-150. (Ger.1997: *Das alte Tibet war eine Hölle auf Erden. Mythos Tibet in der chinesischen Kunst und Propaganda*, in *Mythos Tibet*: 114-149)

Hecker, Hellmuth, 1997: *Lebensbilder deutscher Buddhisten*. Constance: Universität Konstanz.

Hedin, Sven, 1924: *Von Peking nach Moskau*. Leipzig: Brockhaus.

Hedin, Sven, 1925: *Ossendowski und der Wahrheit*. Leipzig: Brockhaus.

Hegel, Georg Wilhelm Friedrich, 1972 (1840/1848): *Vorlesungen über die Philosophie der Geschichte*. Stuttgart: Philipp Reclam Jun.

Heller, Friedrich Paul, & Anton Maegerle, 1995: *Thule. Vom völkischen Okkultismus bis zum Neuen Reich*. Stuttgart: Schmetterling.

Herder, Johann Gottfried, 1966 (1784–1791): *Ideen zur Philosophie der Geschichte der Menschheit*. Darmstadt: Joseph Melzer.

Herrliberger, David, 1746: *Gottesdienstliche Ceremonien oder H. kirchen-Gebräuche und Religions-Pflichten der Christen … in schönen Kupfertalen*. Zürich.

Higgins, Jack, 1996: *Year of the Tiger*. London: Signet/ Penguin.

Hilton, James, (1933): *Lost Horizon*. London: Macmillan. Repr. London: Pan Books, 1947, 1960.

Hopkins, P. Jeffrey, 2001: *Tibetan Monastic Colleges: Rationality Versus the Demands of Allegiance*, in *Imagining Tibet*: 257-268. (Ger. 1997: *Tibetische Klosterkollegien: Die Spannung zwischen Rationalität und Gruppenzwang*, in *Mythos Tibet*: 254-263.)

Hopkirk, Peter, 1982: *Trespassers on the Roof of the World. The race for Lhasa*. London: Murray. (Ger. 1992, *Der Griff nach Lhasa. Die Erschliessung Tibets im 19. und 20. Jahrhundert*. Munich: Knaur.)

Huber, Toni, 2001: *Shangri-La in Exile: Representations of Tibetan Identity and Transnational Culture*, in *Imagining Tibet*: 357-371. (Ger. 1997: *Shangri-La im Exil:*

Darstellungen tibetischer Identität und transnationale Kultur, in *Mythos Tibet*: 300–312.)

Huc, Régis-Evariste, 1982 (1851): *Souvenirs d'un voyage dans la Tartarie et le Thibet*, 2 vols, 1851; 3rd vol. *L'Empire Chinois*, 1854. Eng.: (1) tr. W. Hazlitt, 1851; (2) tr. P. Sinnett, 1851: *Recollections of a Journey though Tartary, Tibet and China*; (3) tr. ? *Travels in Tartary, Tibet and China, 1844–5–6*. London: Routledge & Sons, 1928 (?=1); (4) tr. Charles de Salis, 1982: *Lamas of the Western Heavens*. London: Folio Society.

Huxley, L., 1918: *The Life and Letters of Sir Joseph Dalton Hooker*, 2 vols. London.

Illion, T., 1936: *Darkness Over Tibet*. London: Rider. (Ger.: 1936, *Rätselhaftes Tibet*. Hamburg: Uranus Verlag.)

Imagining Tibet, see: Dodin & Räther 2001.

Ipares, S., 1937: *Geheime Weltmächte*. Munich: Ludendorff.

Jacobsen, Hans-Adolf, 1979: *Karl Haushofer—Leben und Werk..* 2 vols. Boppard am Rhein: Boldt.

Jacolliot, Louis, 1869: *Vedisme, Brahmanisme et Christianisme. La Bible dans l'Inde et la vie de Jezeus Christina*. Paris.

Jetsün Pema, 1996: see Pema, Jetsün.

Jones, Alexandra, 1988: *Samsâra*. London: Macdonald. Ger.: *Samsara. Ein Roman aus dem geheimnisvollen Tibet*. Munich: Heyne, 1989.

Kagelmann, Jürgen, 1997: *Who's who im Comic*. Deutscher Taschenbuchverlag.

Kant, Immanuel, 1802: *Physische Geographie*, Vol. 2, Part 1, *welcher die allgemeine Beschreibung des Landes enthält*. Mainz and Hamburg: Gottfried Vollmer.

Kant, Immanuel, 1968 (1802): *Kants Werke, Akademie-Textausgabe*, Vol. IX (Logik, Physische Geographie, Pädagogik). Berlin: Walter de Gruyter.

Kant, Immanuel, 1990 (1869): *Die Religion innerhalb der Grenzen der blossen Vernunft*. Hamburg: Felix Meiner.

Karst, Joseph, 1931: *Die vorgeschichtlichen Mittelmeervölker ... mit Exkursen über Atlantis*. Heidelberg.

Kaschewsky, Rudolf, 1997: *Das Tibetbild im Westen vor dem 20. Jahrhundert*, in *Mythos Tibet*: 16–30. Eng. 2001, *The Image of Tibet in the West before the Nineteenth Century*, in *Imagining Tibet*: 3–20.

Kater, Michael, 1974: *Das „Ahnenerbe" der SS 1935–1945. Ein Beitrag zur Kulturpolitik des Dritten Reiches*. Stuttgart: Deutsche Verlags-Anstalt.

Kelder, Peter, 1988: *Ancient Secret of the Fountain of Youth*. New rev. ed., *Tibetan secrets of youth and vitality*. Aquarian Press, 1988. (Ger. 1995 (1989), *Die Fünf «Tibeter». Das alte Geheimnis aus den Hochtälern des Himalaya lässt Sie Berge versetzen*, Integral. Wessobrunn: Volkar-Magnum.) (So far as we can ascertain, the alleged first edition of 1939 never existed.)

Kempf, Franz R., n.d.: *Albrecht von Hallers Ruhm als Dichter, Eine Rezeptionsgeschichte*. American University Studies, Series I, German Language & Literaure, Vol. 52. Bern: Peter Lang Verlag.

Kersten, Holger, 2001: *Jesus lived in India. His Unknown Life Before and After the Crucifixion*. Shaftesbury: Element Books, 1986, 1994; repr. New Delhi: Penguin Books India, 2001. (First published Germany 1983: *Jesus lebte in Indien*.)

Kipling, Rudyard, (1898): *Kim*. Repr. London: Macmillan, 1908 etc.

Kircher, Athanasius, 1667: *China (Monumentis, qua Sacris qua Profanis) Illustrata*. (Used in a tr. by Charles D. Van Tuyl). Amsterdam.

Knefelkamp, Ulrich, 1986: *Die Suche nach dem Reich des Priesterkönigs Johannes. Dargestellt anhand von Reiseberichten und anderen ethnographischen Quellen des 12. bis 17. Jahrhunderts*. Dissertation, Univ. Freiburg.

Knigge, Andreas C., 1988: *Comic-Lexikon*. Frankfurt a.M.: Ullstein.

Kollmar-Paulenz, Karénina, 1993: *Utopian Thought in Tibetan Buddhism: A Survey of the Shambhala Concept and its Sources*. In *Studies in Central and East Asian Religions*, vol. 5–6 (1992/3): 78–96.

Kopacka, Werner, 1997: *Im Tal des Yeti*. Munich: Nymphenburger.

Korom, Frank J. (ed.), 1997a: *Constructing Tibetan Culture. Contemporary Perspectives*. Quebec: World Heritage Press.

Korom, Frank J., 1997b: *Old Age in New Age America*, in Korom 1997a.

Korom, Frank J., (ed.) 1997c: *Tibetan Culture in the Diaspora, Proceedings of the 7th Seminar of the International Association for Tibetan Studies, Graz 1995*, Vol. IV. Vienna: Verlag der Österreichischen Akademie der Wissenschaften.

Korom, Frank J., 2001: *The Role of Tibet in the New Age Movement*, in *Imagining Tibet*: 167–182. (Ger. 1997: *Tibet und die New-Age-Bewegung*, in *Mythos Tibet*: 178–192.)

Kvaerne, Per, 2001, *Tibet Images Among Researchers on Tibet*, in *Imagining Tibet*: 47-63. (Ger. 1997: *Die Tibetbilder der Tibetforscher*, in *Mythos Tibet*: 51–66.)

Landau, Rom, 1935: *God is my Adventure*. New York.

Landig, Wilhelm, n.d. [1971]: *Götzen gegen Thule. Ein Roman voller Wirklichkeit*. Hanover. Landig, Wilhelm, 1980: *Wolfszeit um Thule*. Vienna.

Landig, Wilhelm, 1991: *Rebellen für Thule. Das Erbe von Atlantis*. Vienna.

Langley, Bob, (1984): *East of Everest*. Repr. London: Sphere Books, 1987. (Ger. 1986, *Östlich des Everest*. Frankfurt a.M./Berlin: Ullstein.)

Lauppert, Norbert, 1954: *Briefe tibetanischer Weiser*. Graz: Adyar.

Lauppert, Norbert, 1977–82: *Die Mahatma-Briefe an A.P. Sinnett und A.O. Hume*, 3 vols. Graz: Adyar.

Lawrence, Leslie L., 1996 (1983): *Das Auge von Sindsche*. Bergisch Gladbach: Bastei Lübbe.

Le Page, Victoria, 1996: *Shambhala. The Fascinating Truth Behind the Myth of Shangri-La*. Wheaton: Quest Books.

Lindegger, Peter, 1982: *Griechische und römische Quellen zum peripheren Tibet*, Teil 2, Überlieferungen von Herodot bis zu den Alexanderhistorikern, Opuscula Tibetana, Fasc. 14. Rikon: Tibet-Institut.

Lindegger, Peter, 1996: *Zur frühen Erkundungsgeschichte Tibets. Kurzer historischer Überblick von der Antike bis zu den Missionsreisen der Jesuiten im 17./18. Jht.*, in *Schriften Nr. 7*. Rikon: Tibet-Institut.

Lindegger, Peter, 1997: *Die letzten 100 Jahre. Kurzer Abriss der Geschichte Tibets im 20. Jahrhundert*, in *Schriften Nr. 13*. Rikon: Tibet-Institut.

Lindegger, Peter, 1998: *Zwei politische Reformversuche im Tibet des 20. Jahrhunderts*, in *Schriften Nr. 14*. Rikon: Tibet-Institut.

Linton, George Edward, & Virginia Hanson (comp. & ed.), 1972: *Reader's Guide to the Mahatma Letters to A.P. Sinnett*. Adyar, etc.: Theosophical Publishing House.

Lopez, Donald S., Jr., 1995 a: *Madhyamika Meets Modernity: The Life and Works of Gendun Chopel*, in *Tricycle*, Spring 1995, pp. 42–51.

Lopez, Donald S., Jr., 1995 b: *Curators of the Buddha*. Chicago/London: Univ. of Chicago Press.

Lopez, Donald S., Jr., 1998: *Prisoners of Shangri-la. Tibetan Buddhism and the West*. Chicago/London: The University of Chicago Press.

Lopez, Donald S., Jr., 2001: *The Image of Tibet of the Great Mystifiers*, in *Imagining Tibet*: 183-200. (Ger. 1997: *Der merkwürdige Fall des Engländers mit den drei Augen*, in *Mythos Tibet*: 193–207.)

Ludendorff, E. & M., 1941: *Europa den Asiatenpriestern?*. Munich.

MacVicar, Angus, 1957: *The Atom Chasers in Tibet*. London: Burke.

Maréchal, Pierre Sylvain, 1788: *Costumes civils actuels de tous les peuples connus: dessinés d'après nature, gravés et coloriés*. Paris: Pavard.

Marcotty, Thomas, 1987: *Dagger Blessing. The Tibetan Phurpa Cult: Reflexions and Materials*. Delhi.

Markham, Clements R., 1879: *Narratives of the Mission of George Bogle to Tibet and of the Journey of Thomas Manning to Lhasa*. London: Trübner and Co.

Maugham, William Somerset, (1944): *The Razor's Edge*. Repr. London: Mandarin, 1990.

McCloud, Russell 1996: *Die schwarze Sonne von Tashi Lhunpo*: Engerda: Arun.

McKay, Alex C., 2001: *"Truth", Perception and Politics: The British Construction of an Image of Tibet*, in *Imagining Tibet*: 67-89. (Ger. 1997: *«Wahrheit», Wahrnehmung und Politik. Die britische Konstruktion eines Bildes von Tibet*, in *Mythos Tibet*: 68–86.)

McLagan, Meg, 1997: *Mystical Visions in Manhattan: Deploying culture in the Year of Tibet*, in Korom 1997 c, pp. 69–89.

Messner, Reinhold, 2000: *My Quest for the Yeti. Confronting the Himalayas' deepest mystery*. London: Macmillan. Tr. by Peter Constantine of: *Yeti. Legende und Wirklichkeit*. Frankfurt a.M.: S. Fischer, 1998.

Metzger, Wolfgang, 1976: *Vom Vorurteil zur Toleranz*. Darmstadt: Steinkopff.

Meyer, Karl Ernst & Shareen Blair Brysac, 1999: *Tournament of Shadows: The Great Game and Race for Empire in Central Asia*. Washington D.C.: Counterpoint.

Meyrink, Gustav, n.d. (1903?): *Der heisse Soldat und andere Geschichten*. Munich: Albert Langen.

Meyrink, Gustav, 1992 (1916): *Fledermäuse: Erzählungen, Fragmente, Aufsätze, herausgegeben von Eduard Frank*. Frankfurt am Main/Berlin: Ullstein.

Mila, Ernesto, 1990: *Nazisme et Esoterisme*. Puiseaux: Pardes.

Mitscherlich, Alexander, 1964: *Vorurteile. Ihre Erforschung und ihre Bekämpfung*, in *Politische Psychologie*, Vol. 3. Frankfurt: Europäische Verlagsanstalt.

Moon, Peter, 1997: *The black sun, Montauk's Nazi-Tibetan connection*. New York: Sky Books.

Moore, James, 1992: *Georg Iwanowitsch Gurdjieff. Magier, Mystiker, Menschenfänger, Eine Biographie*. Berne: Scherz. Tr. of: *Gurdjieff. The anatomy of a myth*. Element Books, 1991.

Morkowska, Marysia, 1997: *Vom Stiefkind zum Liebling. Die Entwicklung und Funktion des europäischen Schweizbildes zur Französischen Revolution*. Zürich: Chronos.

Mosse, George L., 1978: *Rassismus. Ein Krankheitssymptom in der europäischen Geschichte des 19. und 20. Jahrhunderts*. Königstein/Ts.: Athenäum.

Müller, Gerhard, 1982: *Überstaatliche Machtpolitik im XX. Jahrhundert. Hinter den Kulissen des Weltgeschehens*. Hohe Warte, 1982.

Mund, Rudolf J., 1982: *Der Rasputin Himmlers. Die Wiligut-Saga*. Vienna: Volkstum-Verlag.

Mundy, Talbot, (1924): *Om. The Secret of Ahbor Valley*. Repr. as online editions: <http://www.geocities.com/Athens/Forum/7656/om.html>, <http://www.blackmask.com/books32c/ommundy.htm>.

Mythos Tibet, see: Dodin & Räther 1997.

Needleman, Jacob, & George Baker (ed.), 1996: *Gurdjieff. Essays and Reflections on the Man and His Teaching*. New York: Continuum.

Neff, Mary K. (ed), 1937: *Personal Memoirs of H.P. Blavatsky*. London: Rider & Co., 1937. Repr. Wheaton, Ill.: Theosophical Publishing House, 1967. (Ger. 1994–?, *Persönliche Erinnerungen von H.P. Blavatsky*, in *Roerich Forum* (Zeitschrift der Roerich Gesellschaft Deutschland), from No. 3. Pfronstetten.)

Nerdinger, Friedemann W., 1996: *Strategien der Werbung. Vom Auftrag über die Gestaltung zur Entscheidung*, in Bäumler, Ursula (ed.), *Die Kunst zu Werben*, Cologne.

Newby, Eric, 1983 (1982): *A traveller's life*. London: Collins, reprint London: Pan Books.

Newman, John, 1985: *A Brief History of the Kalachakra*,

in *The Wheel of Time—The Kalachakra in Context*, by Geshe Lhundup Sopa, Roger Jackson & John Newman. Madison, Wisconsin: Deer Park Books, pp. 51–90.

Nietzsche, Friedrich, 1973 (1882): *Nietzsche Werke. Kritische Gesamtausgabe*, herausgegeben von Giorgio Colli und Mazzino Montinari, Fünfte Abteilung, Vol. 2. Berlin/New York: Walter de Gruyter.

Norbu, Dawa, 1974: *Red Star over Tibet*. London: Collins.

Norbu, Dawa, 1999: *Tibet. The Road Ahead*. New Delhi: HarperCollins India, 1997. Repr. London: Rider, 1998, 1999.

Norbu, Jamyang, 1998: *Dances with Yaks. Tibet in film, fiction and fantasy of the West*, in *Tibetan Review*, January 1998, pp. 18–23.

Norbu, Jamyang, 2001: *Behind the Lost Horizon: Demystifying Tibet*, in *Imagining Tibet*: 373-378. (Ger. 1997: *Hinter dem verlorenen Horizont. Zur Notwendigkeit eines Demystifizierung Tibets*, in *Mythos Tibet*: 313–317.)

Norbu, Namkhai, 1988: *Yantra Yoga. Yoga der Bewegungen*. Gleisdorf: Edition Tsaparang. Eng.: *Yantra Yoga: The Tibetan Yoga of Movement*. Snow Lion Publications, 2003.

Norbu, Thubten Jigme & Colin Turnbull, 1972 (1969): *Tibet: its history, religion and people*. Harmondsworth: Penguin.

Notovitch, Nicolas, 1894: *La vie inconnue de Jésus-Christ*. Eng., tr. V. Crispe: *The Unknown Life of Christ*. London: Hutchinson, 1895.

Oppitz, Michael, 1968: *Geschichte und Sozialordnung der Sherpa, Khumbu Himal*, Vol. 8. Innsbruck/Munich: Wagner.

Oppitz, Michael, 1974: *Shangri-La. Le panneau de marque d'un flipper, Analyse sémiologique d'un mythe visuel*, in *L'Homme*, XIV (3–4), pp. 59–83.

Oppitz, Michael, 2000: *Semiologie eines Bildmythos. Der Flipper Shangri-La*. Zürich: Völkerkundemuseum der Universität Zürich.

Orzechowski, Peter, 1988: *Schwarze Magie—Braune Magie*. Ravensburg: Peter Selinka.

Ossendowski, Ferdinand, 1922: *Beasts, Men and Gods*. New York: Dutton, 1922; London: E. Arnold, 1923. (Ger. 1924: *Tiere, Menschen und Götter*. Frankfurt a.M.: Frankfurter Societäts-Druckerei/Buchverlag.)

Padfield, Peter, 1990: *Himmler Reichsführer-SS*. London: Macmillan.

Pallas, M.P.S., 1788: *Voyage de M.P.S. Pallas [en Sibérie]*, 4 vols and supplement. Paris 1788.

Pallis, Marco, 1983: *Ossendowski's Sources*, in *Studies in Comparative Religion*, Vol. 15, Nos. 1 and 2, Winter–Spring 1983, pp. 30–41.

Pauwels, Louis, 1974: *Gurdjew der Magier*. Bern/Munich: Scherz. Tr. of: *Monsieur Gurdjieff*. (1971). First Eng. pubn: *Gurdjieff*. 1964.

Pauwels, Louis [François], & Jacques Bergier, 1974 (1960): *Le matin des magiciens. Introduction au réalisme fantastique*. Paris: Gallimard, 1960. Repr. ib., Collection Folio, 1974. Eng. tr. by Rollo Myers, UK: *The Dawn of Magic*. London: Anthony Gibbs & Phillips, 1963; repr. London: Panther Books, 1964. US: *The Morning of the Magicians*. New York: Stein & Day, 1964.

Pedersen, Poul, 2001: *Tibet, Theosophy and the Psychologization of Buddhism*, in *Imagining Tibet*: 151–166. 1st publ. 1997 as: *Tibet, die Theosophie und die Psychologisierung des Buddhismus*, in *Mythos Tibet*: 165–177.

Pema, Jetsün, 1997: *Zeit der Drachen. Die Autobiographie der Schwester des Dalai Lama*. Hamburg: Hoffmann und Campe. Tr. of: *Tibet, mon histoire*. (1996). Eng.: *Tibet, my story: an autobiography*. Shaftesbury: Element, 1997.

Pemba, Tsewang, 1957: *Young days in Tibet*. London: Cape.

Pemba, Tsewang, 1968: *Tibet im Jahr des Drachen. Ein Roman*. Freiburg: Herder. Original English ed. *Idols on the Path*. London: Cape, 1966.

Pennick, Nigel, 1981: *Hitler's Secret Sciences*. Sudbury/Suffolk: Neville Spearman.

Petech, Luciano, 1952–56: *I Missionari Italiani nel Tibet e nel Nepal*, 7 vol. Rome: Libreria dello Stato.

Picard (Picart), Bernard, 1988 (1741): *Cérémonies et coutumes religieuses de tous les peuples du monde, dessinées par Bernard Picart*. Paris: Herscher.

Podrug, Junius, 1993: *Frost of Heaven*. London: Headline Future.

Poelmeyer, Ronald H., 1985 (1979): *Tintin a-t-il été au Tibet?* Amsterdam: Edition Lambiek.

Polo, Marco, 1928: *Il Milione*, ed. L. Foscolo Benedetto: Florence (source for standard chapter numbering. Many MSS 14th–15th century, title variable. First printed edn was in German: Nuremberg, 1477, repr. Augsburg, 1481. Eng. tr. Ronald Latham: *The Travels of Marco Polo*, Harmondsworth: Penguin Books, 1958, repr. London: Folio Society, 1968.)

Prophet, Elizabeth Clare, 1987: *The Lost Years of Jesus*. Livingston, Montana.

Puini, Carlo, 1904: *Il Tibet (Geografia, Storia, Religione, Costumi) secondo la relazione del viaggio del P. Ippolito Desideri (1715–21)*, Vol. X. Rome: Memorie della Reale Società Geografica Italiana, X.

Rampa, T. Lobsang, 1960 (1959): *Doctor from Lhasa*. London: Corgi Books/Transworld Publishers.

Rampa, T. Lobsang, 1967 (1956): *The Third Eye*. London: Secker & Warburg, 1956; repr. London: Corgi, 1959, 1967; repr. Mandarin 1991.

Rampa, T. Lobsang, 1987: *Die Rampa-Story. Reise einer Seele*. Hamburg: Udo Polzer/Reidar. Tr. of: *The Rampa Story*. (1960), repr. London: Corgi, 1980.

Rampa, Sarah, 1982: *Rampa. Lumière et Sagesse*. Montreal: Stanké.

Ravenscroft, Trevor, 1974: *Der Speer des Schicksals. Das Symbol für dämonische Kräfte von Christus bis Hitler*. Zug: Edition Sven Erik Bergh. Tr. of: *The Spear of Destiny. The occult power behind the spear which pierced the side of Christ*. 1973; repr. London: Sphere, 1990.

Reboux, Paul, 1955: *La vie secrète et publique de Jésus-Christ: Son voyage au Tibet*. Paris: Niclaus.

Reigle, David, 1983: *The Books of Kiu-te, or The Tibetan Buddhist Tantras*. San Diego: Wizards Bookshelf.

Reigle, David, n.d.: *The Book of Dzyan Research Reports*. (Text from the Internet).

Rhie, Marylin M., & Robert A.F. Thurman, 1991: *Wisdom and Compassion. The Sacred Art of Tibet*. New York, Harry N. Abrams.

Robin-Evans, Karyl: see Agamon.

Roerich, Nicholas, 1988: *Shambhala. Das geheime Weltzentrum im Herzen Asiens*. Freiburg i.Br.: Aurum. Tr. of: *Shambhala*. (1930); repr. New Delhi: Aravali Books International, 1997.

Rose, Detlev, 1994: *Die Thule-Gesellschaft, Legende—Mythos—Wirklichkeit*. Tübingen: Grabert.

Rosenberg, Alfred, 1941: *Der Mythus des 20. Jahrhunderts. Eine Wertung der seelisch-geistigen Gestaltenkämpfe unserer Zeit*. Munich: Hoheneichen.

Rousseau, Jean-Jacques, (1762): *Du contrat social, ou Principes du droit politique*. Online editions, e.g. <http://www.pages.globetrotter.net/pcbcr/contrat. html> (Eng. tr. G.D.H. Cole: *The Social Contract or Principles of Political Right*, <http://www.constitution. org/jjr/socon.htm>).

Said, Edward William, 1978: *Orientalism*. London: Routledge & Kegan Paul. (Ger. 1981, *Orientalismus*. Frankfurt a.M./Berlin/Vienna.)

Saitsew, W., 1968: *Wissenschaft oder Phantasie?* in *Sputnik*, 1.

Sanders, Leonard, 1991: *The Eternal Enemies*. New York: Pocket Books.

Sarkisyanz, Emanuel, 1955: *Rußland und der Messianismus des Orients. Sendungsbewußtsein und politischer Chiliasmus des Ostens*, Tübingen.

Schaedler, Lorenz, 1995: *Tibet—ein Projektionsfeld westlicher Phantasien?* in *Tibet-Forum* 1/95: pp. 24–26.

Schmocker, Jürgen, 1982: *Vom „Tibeter" zum „Tibeter in der Schweiz", Zur Geschichte der Einpassung in eine Fremde Welt*, in: Brauen & Kantowsky 1982.

Schubert, Johannes, 1953: *Das Wunschgebet um Shambhala. Ein tibetischer Kalacakra-Text mit einer mongolischen Übertragung*. Fritz Hintze (ed.): *Mitteilungen des Instituts für Orientforschung*, Berlin, 424–473.

Schweidlenka, Roman, 1989: *Altes blüht aus den Ruinen, New Age und Neues Bewusstsein*. Vienna: Verlag für Gesellschaftskritik.

Scofield, Aislinn, 1993: *Tibet: Projections and Perception*, in *East-West Film Journal*, VII: pp. 106–136.

Sebottendorf, Rudolf von, 1933: *Bevor Hitler kam. Urkundliches aus der Frühzeit der nationalsozialistischen Bewegung*. Munich: Deukula.

Serrano, Miguel, n.d. [1984]: *Adolf Hitler el Ultimo Avatara*. Bogota.

Serrano, Miguel, 1987: *Das goldene Band. Esoterischer Hitlerismus*. Wetter. (Tr. of *El cordon dorado: Hitlerismo esoterico*. Santiago, 1978.)

Shakabpa, Wangchuk Deden, 1984: *Tibet. A Political History*. Yale University Press, 1967; repr. New York: Potala Publications.

Shakya, Tsering, 1992: *Tibet and the Occident. The Myth of Shangri-La*, in *Tibetan Review*, Vol. XXVII, No. 1, January 1992, pp. 13–16.

Sherap, Paul, (ed. by Combe, G.A.), 1975 (1926): *A Tibetan on Tibet. Being the travels and observations of Mr. Paul Sherap (Dorje Zödpa) of Tachienlu*. Kathmandu: Ratna Pustak Bhandar.

Shuguba, Tsipon, 1995: *In the presence of my enemies. Memoirs of Tibetan nobleman Tsipon Shuguba*. Santa Fe: Clear Light Publishers.

Silverberg, Robert, 1972: *The Realm of Prester John*. Athens: Ohio University Press.

Sinnett, A.P., 1886: *Incidents in the Life of Madame Blavatsky*. New York (repr. 1976)

Smit, Frans, 1988: *Gustav Meyrink. Auf der Suche nach dem Übersinnlichen*. Munich: Langen Müller.

Snelling, J., 1990 (1983): *The Sacred Mountain. Travellers and Pilgrims at Mount Kailas in Western Tibet and The Great Universal Symbol of The Sacred Mountain*. 1st edition 1983; revised & enlarged edn London/The Hague: East-West Publications, 1990.

Sogyal Rinpoche, 1992: *The Tibetan Book of Living and Dying*. London: Rider.

Solovjoff, Vsevolod, 1895: *A Modern Priestess of Isis*. London.

Soumois, Frederic, 1987: *Tintin au Tibet. Voyage au pays de l'Absolu*, in *Dossier Tintin—Sources, Versions, Thèmes, Structures* (Autor Soumois F.) Paris: Jacques Antoine?

Sparschuh, Jens, 1993: *Der Schneemensch*. Kiepenheuer & Witsch.

Sperling, Elliot, 2001: *'Orientalism' and Aspects of Violence in the Tibetan Tradition*, in *Imagining Tibet*: 317-329. (Ger. 1997: *«Orientalismus» und Aspekte der Gewalt in der tibetischen Tradition*, in: *Mythos Tibet*: 264–273.)

Stamm, Hugo 1998: *Im Bann der Apokalypse. Endzeitvorstellungen in Kirchen, Sekten und Kulten*. Zürich/Munich: Pendo.

Stanké, Alain, 1980: *Rampa—imposteur ou initié?* Montreal: Edition Alain Stanké. Steiner, Rudolf, 1990: *Aus der Akasha-Chronik*. Dornach.

Stoddard, Heather, 1985: *Le mendiant de l'Amdo*. Paris: Société d'Ethnographie.

Strunk, J., 1937: *Zu Juda und Rom. Tibet, Ihr Ringen um die Weltherrschaft*. Munich: Ludendorffs.

Sünner, Rüdiger, 1999: *Schwarze Sonne. Entfesselung und Missbrauch der Mythen in Nationalsozialismus und rechter Esoterik*. Freiburg: Herder.

Suster, Gerald, 1981: *Hitler and the Age of Horus*. London: Sphere Books.

Swedenborg, Emanuel, n.d.: *Die wahre christliche Religion*. Zürich: Swedenborg.

Taring, Rinchen Dölma, 1970: *Daughter of Tibet*. London: J. Murray. (Ger. 1996, *Ich bin eine Tochter Tibets. Lebenszeugnisse aus einer versunkenen Welt*, 2nd ed. Bergisch Gladbach: Bastei-LØbbe.)

Taylor, Michael, 1988: *Mythos Tibet. Entdeckungsreisen von Marco Polo bis Alexandra David-Neel*. Braunschweig: Westermann. (orig. *Le Tibet*, Fribourg 1985)

Taylor, Richard P., 1999: *Blavatsky and Buddhism*. Group in Buddhist Studies, UC Berkeley (Text from the Internet).

Templeman, David, 1996: *The White Lama*. Unpublished lecture given at the conference *Tibet in Context*, Australian National University, Canberra, 16–18 Feb. 1996.

Templeman, David, n.d.: *Tibet as Shangri-La? European Perceptions of Tibet*. Unpublished manuscript.

Thevenot, MelchisŒdech, 1672: *Voyage à la Chine des p‹res Grueber et d'Orville*. Paris.

Thurman, Robert, 1992: *Buddha's Mother Saving Tibet*, in *Turning Wheel, Journal of the Buddhist Peace Fellowship*, Winter 1992, pp. 10–15.

Thurman, Robert, 1998: *Inner Revolution. Life, Liberty, and the Pursuit of real Happiness*. New York: Riverhead.

Tingley, Katherine, 1992: *Helena Petrovna Blavatsky. Ein Genius verändert die Welt*. Hanover: Esoterische Philosophie. Tr. of: *Helena Petrovna Blavatsky: foundress of the original Theosophical Society in New York, 1875, the international headquarters of which are now at Point Loma, California*. Point Loma, CA: Women's International Theosophical League, 1921.

Trebitsch-Lincoln, Ignatz Timotheus, 1931: *Der grösste Abenteurer des XX. Jahrhunderts!? Die Wahrheit Øber mein Leben*. Leipzig/ZØrich/Vienna: Amalthea. Eng., tr. Emile Burns: *The Autobiography of an Adventurer*. London 1931.

Trimondi, Victor & Victoria (Röttgen, Herbert & Mariana), 1999: *Der Schatten des Dalai Lama*. DØsseldorf: Patmos. Eng., tr. Mark Penny: *The Shadow of the Dalai Lama: Sexuality, Magic and Politics in Tibetan Buddhism*. Online edn, 2003, <http://www.trimondi.de/SDLE/Index.htm>.

Trungpa, Chögyam, (1966): *Born in Tibet*. (Ger. 1970, *Ich komme aus Tibet. Mein Leben in der buddhistischen Mönchswelt und die Flucht Øber den Himalaja*. Olten/Freiburg i.Br.: Walter.)

Trungpa, Chögyam, 1982: *Feuer trinken, Erde atmen. Die Magie des Tantra*. Cologne: Diedrichs. Tr. of: *Journey without Goal: the Tantric Wisdom of the Buddha*. Random House, 1981; repr. London: Shambhala, 1985. Tsering, Tashi, (ed. by Goldstein, M.), 1997: *The struggle for modern Tibet*. Armonk/London: M.E. Sharpe.

TØting, Ludmilla, 1999: *Der Tibet-Mythos. Die okkulten Wurzeln der alten und neuen Nazis. Was fasziniert Rechte am Hinduismus und Buddhismus?*, in *Tourismwatch*, Informationsdienst Dritte Welt-Tourismus, No. 16,

October 1999.

van Helsing, Jan, 1993–5: *Geheimgesellschaften und ihre Macht im 20. Jahrhundert oder Wie man die Welt nicht regiert*, 2 vols. Rhede: Ewert, Vol. 1: 1993, Vol. 2: 1995.

van Heurck, Philippe, 1995: *Alexandra David-NŒel (1868–1969). Mythos und Wirklichkeit*. Ulm: Fabri.

van Rijckenborgh, Jan, [i.e. Jan Leene] (1951): *Licht over Tibet*. (Ger. 1954, *Licht Øber Tibet*. Haarlem: Rozekruis Pers.) Eng. tr. *Light over Tibet*. Haarlem: Rozekruis Pers, 1956.

van Rijckenborgh, Jan & Catharose de Petri, 1993 (1948): *Die Bruderschaft von Shamballa*. Haarlem: Rozekruis Pers.

von Däniken, Erich, 1977: *Beweise. Lokaltermin in fØnf Kontinenten*. DØsseldorf: Econ. Eng. tr. by Michael Heron: *According to the Evidence: my proof of man's extraterrestrial origins*. London: Souvenir Press, 1977.

von Däniken, Erich, (1985): *Habe ich mich geirrt? Neue Erinnerungen an die Zukunft*. Munich: Bertelsmann.

von Däniken, Erich, 1992: *Der Götter-Schock*. Munich: Bertelsmann.

von Däniken, Erich, 1995: *Der JØngste Tag hat längst begonnen. Die Messiaserwartungen und die Ausserirdischen*. Munich: Bertelsmann. Eng. tr.: *The Return of the Gods: evidence of extraterrestrial visitations*. Shaftesbury, Dorset/Boston, MA: Element, 1998.

Wachtmeister, Constance, 1893: *Reminiscences of H.P. Blavatsky and 'The Secret Doctrine'*. London (repr. Wheaton 1976)

Waddell, L. Augustine, 1971 (1895): *The Buddhism of Tibet, or Lamaism*. Cambridge.

Wallner, Albert, 1968: *Mönch-Story*. Horn: Ferdinand Berger.

Washington, Peter, 1993: *Madame Blavatsky's Baboon. Theosophy and the Emergence of the Western Guru*. London: Secker & Warburg.

Wasserstein, Bernard, 1988: *The secret lives of Trebitsch Lincoln*. New Haven: Yale University Press.

Webb, James, 1980: *The Harmonious Circle. The Lives and Work of G.I. Gurdjieff, P.D. Ouspensky, and Their Followers*. New York: G.P. Putnam's Sons.

Weber, Max, 1964: *Wirtschaft und Gesellschaft*, Vol.2. Cologne/Berlin: Kiepenheuer & Witsch.

Wessels, C., 1924: *Early Jesuit Travellers in Central Asia, 1603–1721*. The Hague: Martinus Nijhoff.

Wilhelmy, Fritz, 1937: *Asekha. Der ×Kreuzzug" der Bettelmönche*. DØsseldorf: Deutsche Revolution.

Wincor, Richard, 1968: *Sherlock Holmes in Tibet*. New York: Weybright and Talley.

Yuthok, Dorje Yudon, rev. ed. 1995 (1990): *House of the Turquoise Roof*, Ithaca NY: Snow Lion.

Zinnstag, Lou, & Timothy Good, 1983: *George Adamski. The Untold Story*. Beckenham: Ceti Publications.

Comics

(In some of the comics available to us, details of the publisher, date of publication and so forth are lacking; accordingly the bibliographic data are sometimes incomplete.)

3×3 Eyes, text and drawings: Yuzo Takada. Dark Horse Comics, 1995–2003. (Ger.: *3×3 Augen*, Hamburg: Carlsen, 1997–2003.) 1st Japanese ed. appeared 1983.

Abominable Snowman, Frank Robins, in *Johnny Hazard*, Papeete, Tahiti: Pacific Comic Pubns, 1980. 1st published as Sunday serial, King Features, 1954. (Ger.: *Die Spuren des Schneemenschen*, 1986, *Johnny Hazard*: Vol. 6, 45 pp. Reinbek bei Hamburg: Carlsen.)

(The) Abominable Snowman, writer: Jack Oleck, artist: Rico Rival, 7 pp., in *Secrets of Sinister House*, Vol. 3, No. 9, Feb. 1973. New York: National Periodical Publications.

(The) Black Lama (Iron Man), writer: Mike Friedrich, artist: George Tuska, 20 pp., in *Iron Man*, vol. 1, no. 53, Dec. 1972. New York: Magazine Management.

(The) Black Prize, Andru, 5 pp., in *Airboy Comics*, Vol. 9, No. 4, May 1952.

Bugs Bunny's Dangerous Venture, 31 pp., in *Bugs Bunny*, No. 123. New York: Dell Publishing, Warner Bros. Cartoons 1946.

(Le) Cargo sous la mer, Cothias & Sternis, colouring: Anna Aliberch. *Memory*, 2, Grenoble: Editions Glénat, 1987.

Le cerveau de glace, text: André Paul Duchateau & Daniel Hulet, drawings: Daniel Hulet, Brussels, 1988. (Ger.: *Tödliche Kälte*, in *Pharaon*, Vol. 3. Mannheim: Reiner-Feest, 1990.)

(The) Court of Crime (Green Lama), art: Mac Raboy; story: Richard Foster, 9 pp., in *Green Lama*, Vol. 1, No. 1, Dec. 1944. Springfield, Mass.: Spark Publications.

(Das) Dämonenpferd (Manos), Zeichung Goldenhorn, 4 pp. (only available as photocopy).

(Der) Dimensionssprung (Onkel Dagobert), Rudolfo Cimino & Giorgio Cavazzano, in: *Walt Disneys Lustiges Taschenbuch*, No. 151. Stuttgart: Ehapa, 1990. (Orig. *Zio Paperone e l'inafferrabile Trizompa*, in *Topolino*, No. 1775, Dec. 1989.)

Dr. Strange, Master of Black Magic, writer: Stan Lee, artist: Steve Ditko. 5 pp., in *Strange Tales*, No. 110, July 1963.

Hamilton's creature, in: *The Twilight Zone*, No. 8, August 1964.

(The) Himalayan incident (Manhunter), writer: Archie Goodwin, art: Walt Simon, 8 pp., in *Dynamic Classics*, No. 1, Sept/Oct. 1978. Orig. in *Detective Comics*, No. 437, Nov. 1973.

Ich fand den schrecklichen Schneemenschen, in: *Doktor Strange*. Hamburg: Williams, 1975. 6 pp. First Ger. publication in: *Dr. Strange*, Marvel-Comic, No. 2, 1968.

Jonathan, Cosey. Brussels: Le Lombard, Vols 1–11,

1977–1986. Ger.: Reinbeck bei Hamburg: Carlsen, 1985–1989.

Le lama blanc, text: Alexandro Jodorowsky, drawings: Georges Bess, 6 vols. Humanos, 1988–1992. Eng.: *The White Lama*, 6 vols, Humanoids Publishing, 2000–2001. (Ger.: *Der weiße Lama*, Zelhem, NL: Arboris, 1989–1994.)

(Der) Lama von Lhasa (Yinni und Yan), from *Yinni und Yan*, YPS series. Gruner und Jahr AG, 1979.

(The) Lost Crown of Genghis Khan (Uncle Scrooge), by Carl Barks, 19 pp., in *Walt Disney's Uncle Scrooge Adventures*, No.14, 1996. Gladstone, Arizona. First published in *Uncle Scrooge*, 14, June/Aug. 1956.

(Der) Magier vom Dach der Welt, drawings by Acciari, 7 pp., in *Gespenstergeschichten*, No. 265, Bergisch Gladbach: Bastei, 1979.

(The) Man who found Shangri-La, 1964; repr. in *Weird Wonder Tales*, Vol. 1, No. 11, August 1975.

Mickey Mouse in High Tibet, 22 pp., in *Dell Comic*, No. 387, Apr./May 1952.

Minuit à Rhodes, Eric Béhé & Joseph Boisset, Editions Vents d'Ouest, 1995. (Ger.: *Mitternacht in Rhodos*, 2 parts. Stuttgart: Ehapa, 1996.)

Mission vers la vallée perdue, drawings: Victor Hubinon, text: Jean-Michel Charlier, Brussels, 1960. (Ger.: *Notruf über Tibet: Rex Danny*, No. 22; also *Flucht aus Tibet: Buck Danny*, Vol. 17. Reinbeck bei Hamburg: Carlsen, 1994.)

(The) Origin of an Avenger (Peter Cannon/Thunderbolt), drawn by P.A.M., in *Thunderbolt*, Vol. 1, No. 1, Jan. 1966. Derby, Conn.: Charlton Comics Group.

(The) Origin of Doctor Strange, writer: Stan Lee, artist: Steve Ditko. 8 pp., in *Strange Tales*, No. 115, Dec. 1963.

Quisling Quest in Tibet (Commando Yank), art: Edd Ashe?, text: Otto Binder, 6 pp., in *Wow Comics*, No. 44, June 1946.

(Das) Rätsel der Dämonenglocken, 7 pp., in *Gespenstergeschichten*, No. 244, drawings: Ertugrul. Bergisch Gladbach: Bastei, 1978?

Return to Xanadu (Uncle Scrooge), Don Rosa, 1991. (Ger.: *Wiedersehen mit Tralla La (Onkel Dagobert)*, 30 pp., in *Onkel Dagobert*, Ehapa Comic Collection, 1996. Stuttgart: Ehapa.)

(La) Rivière du Grand Détour, drawings: E. Buche, text: C. Perrissin, Hélène Cartier; Geneva: Alpen Publishers, 1992.

Le secret de l'espadon, Edgar P. Jacobs, Brussels, 1946. (Ger.: *Der Kampf um die Welt (Blake und Mortimer)*, 3 vols, 3rd ed. 1988. 1st Ger. ed. 1986.) *Le signe de Shiva*, *Une aventure de Marc Mathieu*, Dominique Hé. Les Humanoïdes Associés, 1985. (Ger.: *Countdown des Wahnsinns, Ein Abenteuer des Marc Marell*, 50 pp. (??), Vol. 4. Reinbeck bei Hamburg: Carlsen, 1986.)

(The) Snowman! in *Dead of Night*, Vol.1, No. 6, Oct. 1974.

New York: Marvel Comics Group; reprinted from *Astonishing*, No. 36 , 1954?

(Die) Spur des Gletscher-Dämons, 12 pp., in *Gespenstergeschichten*, No. 76. Bergisch Gladbach: Bastei, 1976?

Ted Crane at the Top of the World (Ted Crane), 8 pp., in *Exciting Comics*, no. 22, Oct. 1942.

Tintin au Tibet, by Hergé. Tournai: Casterman, 1960. Eng., tr. Leslie Lonsdale-Cooper & Michael Turner: *Tintin in Tibet*. London: Methuen, 1962; repr. London: Egmont Books, 2002. (Ger.: *Tim in Tibet*. Hamburg 1995. 1st Ger. ed. 1967).

Top Secret (Buck (Rex) Danny), drawings: Victor Hubinon, text: Jean-Michel Charlier, *Buck Danny*, Vol. 16. Hamburg: Carlsen, 1993. Orig. French title: *Top secret*, Brussels, 1960. Previously published under the title: *Top secret*, in *Rex Danny*, No. 22.

Treachery in Tibet (Spy Smasher), 5 pp., in *Whiz Comics*, No. 72, March 1946.

Trouble in Tibet (Steve Conrad Adventurer), art and script: Jack Lehti, 6 pp., in *Adventure Comics*, No. 66, Sept. 1941.

Trouble in Tibet (Phantom Eagle), art: Charles Tomsey, text: Otto Binder, 7 pp., in *Wow Comics*, No. 28, Aug. 1944.

Uncle Scrooge in Tralla-La (Uncle Scrooge), written and drawn by Carl Barks, 22 pp., in *Disney Comics Album Series*, 6, 1991, Burbank, California: Walt Disney Publications. First published (without title) in *Uncle Scrooge*, No. 6, June/Aug. 1954. Also in *Uncle Scrooge Adventures*, No. 39, July 1996, Prescott, AZ: Bruce Hamilton Company (coloured reprint). (Ger. coloured reprint: *Uncle Scrooge. Onkel Dagobert und der verhängnisvolle Kronenkork*, in *Barks Library*, No. 6, 1998. Stuttgart: Ehapa.)

L'uomo delle nevi, drawings: Milo Manara, text: Alfredo Castelli, 1978. (Eng.: *The Snowman*, tr. Stefano Gaudiano. New York: Catalan Communications, 1990. Ger.: *Der Schneemensch*, in *Ein Mann—ein Abenteuer*; Vol. 1. Stuttgart: Feest-Comics, 1991.)

Films

Ab nach Tibet!, 1993, dir. Herbert Achternbusch. Germany: Herbert Achternbusch Produktion.

The Abominable Snowman, 1957, dir. Val Guest. G.B.: Warner/Hammer/Clarion/20th Century Fox. (U.S.: *The Abominable Snowman of the Himalayas*; Ger.: *Yeti, der Schneemensch*)

Ace Ventura. When Nature Calls, 1995, dir. Steve Oedekerk. U.S.A.: Morgan Creek Productions.

Alice, 1990, dir. Woody Allen. U.S.A.: Orion Pictures.

Black Narcissus, 1947, dir. Michael Powell & Emeric Pressburger. G.B.: The Archers/General Film.

Der Dämon des Himalaya, 1935, dir. Günter Oskar Dyhrenfurth & Andrew Marton. Switzerland: Tramontana Film.

Emmanuelle in Tibet, 1993, dir. Francis Leroi. France: Trinacre/Orphée.

The Golden Child, 1986, dir. Michael Ritchie. U.S.A.:Paramount.

Himalaya. L'enfance d'un chef, 1997 (Ger.: *Himalaya. Die Kindheit eines Karawanenführers*; Eng.: *Himalaya*, a.k.a. *Caravan*, 2001), dir. Eric Valli. France, Nepal, Switzerland, U.K.: Jacques Perrin.

Kim (Ger.: *Kim – Geheimdienst in Indien*), 1950, dir. Victor Saville. U.S.A.: Metro Goldwyn Mayer.

Kim, 1984, dir. John Davies. G.B.: CBS/London Films.

Kundun, 1997, dir. Martin Scorsese. U.S.A.: Cappa/De Fina Productions/Touchstone Pictures.

Little Buddha, 1993, dir. Bernardo Bertolucci. G.B./France: Buena Vista/Recorded Pictures/CIBY 2000.

Lost Horizon (Ger.: *In den Fesseln von Shangri-La*), 1937, dir. Frank Capra. U.S.A.: Columbia.

Lost Horizon (Ger. *Der verlorene Horizont*), 1973, dir. Charles Jarrott. U.S.A.: Columbia.

Meetings with Remarkable Men. Gurdjieff's Search for Hidden Knowledge, 1978, dir. Peter Brook. Remar Productions

The Millionairess, 1960, dir. Antony Asquith. G.B.: Anatole de Grunwald/20th Century Fox.

Phörpa/The Cup, 1999, dir. Khyentse Norbu (Dzongsar Khyentse Rinpoche)

Potomok Chingis-Khana (*Storm over Asia*, or *The Heir to Jenghis Khan*), 1928, dir. Vsevolod Pudovkin. USSR: Mechrapom.

Prince of the Sun, 1991, dir. Welson Chin. Hong Kong: Golden Flare Films.

The Quest, 1996, dir. Jean-Claude Van Damme. U.S.A.: Moshe Diamant Productions.

The Razor's Edge, 1946, dir. Edmund Goulding. U.S.A.: 20th Century Fox.

The Razor's Edge, 1984, dir. John Byrum, U.S.A.: Columbia.

Road to Hongkong, 1961, dir. Norman Panama. G.B./U.S.A.: Melnor/United Artists.

The Shadow (Ger.: *Shadow und der Fluch des Khan*), 1994, dir. Russell Mulcahy. U.S.A.: Universal.

Seven Years in Tibet, 1997, dir. Jean-Jacques Annaud. U.S.A.: Mandalay Entertainment/Reperage and Vanguard Films/Applecross.

Storm over Tibet, 1952, dir. Andrew Marton. U.S.A.: Summit/Columbia.

Twin Peaks, television series, 1990, dir. David Lynch. U.S.A.

Das verlorene Gesicht, 1948, dir. Kurt Hoffmann. West Germany: Neue Deutsche Filmgesellschaft.

Vice Versa, 1988, dir. Brian Gilbert. U.S.A.: Columbia.

Sources of illustrations

Zentralbibliothek Zürich, Graphische Sammlung.

55. Portrait of Friedrich Nietzsche: Zentralbibliothek Zürich, Graphische Sammlung.

56. Portrait of Gustav Meyrink: Österreichische Nationalbibliothek, Bildarchiv, Vienna.

57. Portrait of Antonin Artaud: Patrimoine Photographique, Paris.

Part 3

58. Portrait of James Hilton: photo VMZ.

59. Book cover, 37th impression of *Lost Horizon* by James Hilton, New York: Pocket Books, 1945: Martin Brauen, Bern.

60. Book cover, *Shangri-La: The Return to the World of 'Lost Horizon'*, by Eleanor Cooney & Daniel Alteri, illustration by Leland Klanderman.

61. 'Shangrila' cigarettes, Nepal.

62. Portrait of Lobsang Rampa: from the Internet.

63. Book cover, *The Third Eye* by Lobsang Rampa, London: Corgi Books.

64. a: Book cover, *Tibetan Sage* by Lobsang Rampa, London: Corgi Books.
b–g: Book covers, various novels by Lobsang Rampa published by Corgi Books, London: Hans Roth, Münstereifel.

65. Book cover, *Living with the Lama* by Lobsang Rampa, London: Corgi Books, 1964: Hans Roth, Münstereifel.

66. Rampa's 'coat of arms' from *Rampa—imposteur ou initié?* by Alain Stanké.

67. From the comic *Die drei Ohren* by Jodorowsky & Georges Bess, Vol.3 of *Der weiße Lama* (German edition of *Le lama blanc*): Arboris 1990. (Eng. title: *The Three Ears*).

68. From the comic *Die drei Ohren* by Jodorowsky & Georges Bess, Vol.3 of *Der weiße Lama* (German edition of *Le lama blanc*): Arboris 1990. (Eng. title: *The Three Ears*).

69. From the comic *Die vierte Stimme* by Jodorowsky & Georges Bess, Vol.4 of *Der weiße Lama* (German edition of *Le lama blanc*): Ehapa 1992. (Eng. title: *The Fourth Voice*).

70. Detail of illustration from the comic *Doktor Strange—Aufbruch nach Shamballa* by J.M. DeMatteis & Dan Green (*Marvel comic exklusiv*, No.7), Berlin: Condor, 1989/90 (German edition of *Doctor Strange: Into Shamballa*, New York: Marvel Comics Group, 1986).

71. Postcard of *Weird Tales* cover, artist Margaret Brundage, 1937: Jeffrey Luther, Palo Alto, CA, 1995.

72. Cover and illustrations from the comic *Twilight Zone*, No.8, 1964, New York: Cayuga Productions Inc.

73. From *Sungods in Exile, Secrets of the Dzopa of Tibet* by David Agamon.

74. From *Sungods in Exile, Secrets of the Dzopa of Tibet* by David Agamon.

75. Portrait of Erich von Däniken: photo VMZ.

76. Portrait of George Adamski: Adamski Foundation.

77. Book cover, *The Atom Chasers in Tibet* by Angus MacVicar.

78. 'Five Tibetans' perfume set, etheric oil blend, Primavera Life, Sulzburg.

79. Detail of book cover, *Yantra Yoga* by Namkhai Norbu.

80. Record sleeve, *Powerlight* by Earth, Wind and Fire: CBS Inc., 1983.

81. a and b: From *Die Offenbarung* by Jodorowsky &

Georges Bess, Vol.1 of *Der weiße Lama* (German edition of *Le lama blanc*): Arboris 1989. (Eng. title *The First Step*).
c: From *Le cargo sous la mer* by Cothias & Sternis, Vol.2 of *Memory*: Éditions Glénat, 1987.
d: From *Das zweite Gesicht* by Jodorowsky & Georges Bess, Vol.2 of *Der weiße Lama* (German edition of *Le lama blanc*): Arboris 1989. (Eng. title *Second Sight*).
e: From *Der Magier vom Dach der Welt*, drawings by Acciari, in *Gespenstergeschichten*, No.265, Bergisch Gladbach: Bastei, 1979.

82. a: From *Flucht aus Tibet* by Jean-Michel Charlier & Victor Hubinon (German edition of *Mission vers la vallée perdue*), *Buck Danny*, Vol.17: Carlsen, 1994.
b: From *Mitternacht in Rhodos*, Part 1 by Béhé & Boisset (German edition of *Minuit à Rhodes*): Ehapa, 1996.
c: From *Le cargo sous la mer* by Cothias & Sternis, Vol.2 of *Memory*: Éditions Glénat, 1987.
d: From *Ich fand den schrecklichen Schneemenschen* in *Doktor Strange Marvel comic*, No.2, Hamburg: Williams, 1975.
e: From *Der Schneemensch* by Milos Manara, in *Ein Mann—ein Abenteuer*, Vol.1 (German edition of *L'uomo delle nevi*), Stuttgart: Feest-Comics (© Ehapa), 1991.
f: From *Der Gesang des weißen Berges* by Cosey, Vol.2 of *Jonathan* (German edition of *Et la montagne chantera pour toi*, 1977). Carlsen, 1985.
g: From *El monasterio de la muerte* (*Capitan Trueno* series), Colección Dan: Editorial Bruguera.
h: From *Manhunter—The Himalayan Incident*, in *Dynamic Classics*, Vol.1, No.1: DC Comics, 1978.
i: From *The Black Lama*, Mike Friedrich & George Tuska, in *Iron Man*, Vol.1, No.53, New York: Magazine Management, 1972.
j: From *Dreieck aus Wasser, Dreieck aus Feuer* by Jodorowsky & Georges Bess, Vol.6 of *Der weiße Lama* (German edition of *Le lama blanc*): Arboris 1994. (Eng. title *Water Triangle, Fire Triangle*).

83. a: From *Der Schneemensch* by Milos Manara, in *Ein Mann—ein Abenteuer*, Vol.1 (German edition of *L'uomo delle nevi*), Stuttgart: Feest-Comics (© Ehapa), 1991.
b: From *Die vierte Stimme* by Jodorowsky & Georges Bess, Vol.4 of *Der weiße Lama* (German edition of *Le lama blanc*): Ehapa 1992. (Eng. title *The Fourth Voice*).
c: From *Dreieck aus Wasser, Dreieck aus Feuer* by Jodorowsky & Georges Bess, Vol.6 of *Der weiße Lama* (German edition of *Le lama blanc*): Arboris 1994. (Eng. title *Water Triangle, Fire Triangle*).
d: From *Ein Traum vielleicht vom Sterben*, in *Dr. Strange—Meister der mystischen Mächte*, artist Dan Adkins, writer Roy Thomas (German edition of *To Dream, Perchance to Die*, in *Doctor Strange*, No.170, July 1968): Williams, 1975.

84. a and b: From *The Court of Crime*, by Mac Raboy & Richard Foster, in *Green Lama*, Vol.1, No.1, December 1944, Springfield, Mass.: Spark Publications.

85. From *Bugs Bunny's Dangerous Venture*, in *Bugs Bunny*, No.123, New York: Dell Publishing, Warner Bros. Cartoons, 1946.

86. From *The Man who found Shangri-La*, in *Weird Wonder Tales*, Vol.1, No.11, August 1975 (orig. Hercules Publishing Corp. and Atlas Magazine, Inc., 1964): Marvel Comics Group, 1975.

87. a: From *Ich fand den schrecklichen Schneemenschen,* in

Doktor Strange Marvel comic, No.2, Hamburg: Williams, 1975.

b and c: From *Der Magier vom Dach der Welt*, in *Gespenstergeschichten*, No. 265. Bergisch Gladbach: Bastei, 1979.

88. a: From *Tim in Tibet* (German edition of *Tintin au Tibet*), © Hergé/Moulinsart 1999.

b: From *Die offene und die geschlossene Hand*, by Jodorowsky & Georges Bess, in Vol.5 of *Der weiße Lama* (German edition of *Le lama blanc*): Arboris 1994?. (Eng. title: *Open Hand, Closed Fist*).

89. From *Tödliche Kälte*, by D. Hulet & A.P. Duchateau (German edition of *Le cerveau de glace*), in Vol.3 of *Pharaon*, Feest 1990.

90. a–c: From *Countdown des Wahnsinns* by Dominique Hé (German edition of *Le signe de Shiva*): Carlsen, 1986.

91. From *Le secret de l'espadon*, Vol.3, by Edgar P. Jacobs (*Les aventures de Blake et Mortimer* series), Brussels: Éditions Blake et Mortimer, 1986.

92. a: From *Le secret de l'espadon*, Vol.3, by Edgar P. Jacobs (*Les aventures de Blake et Mortimer* series), Brussels: Éditions Blake et Mortimer, 1986.

b: From *Das Rätsel der Dämonenglocken*, in *Gespenstergeschichten*, No.244, drawings by Ertugrul, Bergisch Gladbach: Bastei, 1978?

93. a–c: From *Tim in Tibet* (German edition of *Tintin au Tibet*), © Hergé/Moulinsart 1999.

94. Title page of the comic book *Auf der Suche nach der Erinnerung* by Cosey, Vol.1 of German edition of *Jonathan*: Carlsen (© Ehapa), 1985?

95. a–d: Poster and stills, *Phörpa/The Cup*, 1999: Universal Pictures Switzerland/Esther Bühlmann, Zürich.

96. a–b: Film posters for *Storm over Asia* (*The Heir to Jenghis Khan*): Österreichische Nationalbibliothek, Handbills, Posters and Bookplates Collection, Vienna.

97. a: Still from *Lost Horizon*, USA 1937: VMZ.

b, d: Stills from *Lost Horizon*, USA 1937: VMZ.

c: Poster for *Lost Horizon*, USA 1937: VMZ.

98. a–c: Stills from *Lost Horizon*, USA 1972: VMZ.

99. Film poster for *Lost Horizon*, USA 1937: Cinema Bookshop, London.

100. a: Frames from *Das verlorene Gesicht*, Germany 1948.

b: Still, *Das verlorene Gesicht*, Germany 1948: VMZ.

101. Still from *Storm over Tibet*, USA 1952: VMZ.

102. Detail from leaflet on the film *Storm over Tibet*, USA 1952: Cinema Bookshop, London.

103. a–b: Booklet on *Der Dämon des Himalaya*, Filmkurier Deutschland, n.d.

104. Frame from *The Razor's Edge*, USA 1984.

105. Frame from *Kim*, GB 1984.

106. Still from *Kim*, USA 1950: VMZ.

107. Frames from *The Golden Child*, USA 1986.

108. a–b: Stills from *The Golden Child*, USA 1986: VMZ.

109. Still from *The Shadow*, USA 1994: VMZ.

110. Frame from *Vice Versa*, USA 1988.

111. a–c: Frames from *Prince of the Sun*, Hong Kong 1991.

112. Frames from *Ace Ventura—When Nature Calls*, USA 1995.

113. Frames from *The Shadow*, USA 1994.

114. Frames from *Ab nach Tibet!*, Germany 1993.

115. Frame from *Alice*, USA 1990.

116. Frames from *Emmanuelle in Tibet*, France 1993.

117. Still from TV film *Twin Peaks*, USA 1992: Zoom.

Part 4

118. Detail from film poster for *Little Buddha*, GB/France 1993.

119. Still from *Little Buddha*, GB/France 1993: VMZ.

120. Film poster for *Seven Years in Tibet*, USA 1997.

121. Advertising material for the film *Kundun*, USA 1997.

122. *Hollywood's love affair with Tibet* from *The Guardian*, Monday 2 June 1997, artist: Chris Garratt.

123. Printed advertisement for Citroën Xsara in *La Vanguardia*, Barcelona, 8 March 1999.

124. Frames from TV commercial for Baygon mosquito-killer from Bayer, France.

125. Frames from TV commercial for Tchaé green tea from Lipton, France (J. Walter Thompson, Paris).

126. Frames from TV commercial for Electrolux vacuum cleaner, UK.

127. Frame from TV commercial for IBM, USA.

128. Advertising for *Samsara* perfume, from Guerlain, Paris.

129. Frames from TV commercial for Sampo television, Taiwan.

130. Frames from TV commercial for Danka fax machine, USA (AFI filmworks).

131. Advertisement for Apple Notebook, USA 1992 (photo Nick Vedros, BBDO, Los Angeles, CA).

132. Frames from TV commercial for Renault Clio, France.

133. Frames from TV commercial for Citroën Xsara, France (IF Productions, Euro RSCG France).

134. Frames from TV commercial for Thomson television, USA.

135. From TV commercial for Tibetan 'milk-tea', Taiwan 1995.

136. Advertisement for JVC camcorder.

137. Advertisement for Beal climbing rope, ETS Vienne, France; photo Franck Charton, from *ROCnWall*, *L'esprit de la grimpe*, No.18, 1998.

138. a: Advertisement for Swissair Austria.

b: Advertisement for Condor Airline, Germany, in *Brigitte*, 24, 1998.

c: Advertising card for Lotus Travel Service, Munich.

139. Event poster for DIANA 98, Zürich.

140. Advertisement for a Zen cookbook in the magazine GQ, No.5, 1998.

141. Apple advertisement 'Think different', New York, 1998; photo Brad Doron, Mega Art New York.

142. *Prière au vent* scarf from Hermès, Paris; photo Völkerkundemuseum der Universität Zürich (VMZ).

143. Frame from *Tomb Raider II*.

144. Detail of the board for 'Samsara, the Wheel of Rebirth—a Tibetan Wisdom Game' from Michael Dörfler (Caraka); photo VMZ.

145. 'Shangri-La' pinball machine from W. Williams, 1967; photo VMZ.

146. 'Secret Dakini Oracle' game from U.S. Games Systems, New York, 1977; 'Mo' from Amrita Editions, France 1995; photo VMZ.

147. 'Tibetan love cushion' from Body Shop; 'Precious Gem Formulas' from Himalayas USA; 'Fit and young with the "Five Tibetans"' video, Videomotion on the instructions of Polyband, Munich. Photo VMZ.

148. 'Treasure vase' from Vajrayana Foundation, Corralitos, CA; photo VMZ.

149. Watches: 'Lama' from Swatch; 'Kalachakra' from Kalachakra Creations, Singapore; 'Tibetan Mandala—Jewel in the Lotus' from Original 2001 Design; photo VMZ.

150. *Aus dem Schatz des Dalai Lama* ('From the Treasures of the Dalai Lama') from *Ars Mundi* catalogue (n.d.).

151, 152 Advertising for 'Silhouette' spectacles, Switzerland.

153. 'The Shadow Phurba dagger' from United Cutlery, USA 1994 (Condé Nast Publications Inc.); photo VMZ.

154. Sand-mandala equipment from Mandala-Kit, Canandaigua, USA; photo VMZ.

155. a: Sleeveless T-shirt: no details; T-shirt with Tibetan deities: Cheap Thrill, USA; photo VMZ.
b: T-shirt with the Mighty Ten Syllables of Kalachakra; photo VMZ.
c: shoes; photo VMZ.

156. Doormat from Silly, Space Lab, Netherlands (made in China); photo VMZ.

157. Mandala jigsaw puzzle, 440 pieces, from Schmid, Prien, Germany; 'Kalachakra Mind Mandala' button from Samaya Foundation, 1997; Kalachakra wall clock: unknown manufacturer in India. Photo VMZ.

Part 5

158. Jigsaw card from the Royal Scottish Museum, Edinburgh (Manufacturer: Abydos, Yorkshire, England): Hans Roth, Münstereifel.

159. Detail from a Tibetan scroll painting (tangka, *thangka*) on which scenes from the life of Milarepa are depicted; photo Joss Bachhofer, Munich.

160. Engraving of Yama, the god of death, from *Voyage de M.P.S. Pallas en Sibérie* Vol.5, Paris 1788: Zentralbibliothek Zürich, Old Prints Collection.

161. Engraving from *Histoire générale des cérémonies, moeurs, et coutumes religieuses*, Tome 6, by Bernard Picard: Paola von Wyss-Giacosa.

162. From *Die Offenbarung* by Jodorowsky & Georges Bess, Vol.1 of *Der weiße Lama* (German edition of *Le lama blanc*): Arboris 1989. (Eng. title: *The First Step*).

163. From *Through the Heart of Tibet* by Alexander Macdonald, London 1910: Hans Roth, Münstereifel.

164. Poster advertising *Le temps*, bus shelter in Fribourg 1999; photo: Hansjörg Sahli, Solothurn.

165. From the comic *Bugs Bunny's Dangerous Venture*, in *Bugs Bunny*, No.123, New York: Dell Publishing, Warner Bros. Cartoons, 1946.

166. Film poster for *Lost Horizon*, USA 1937.

167. 'Tibet Snow' from Kohinoor Chemical Ltd, Karachi; UK distributor Golden Meadows Ltd, Wembley, Middlesex; photo VMZ.

168. a: Battery-driven prayer wheel, table model, from Mandallum Instruments, El Verano, CA, USA.
b: Earrings in the form of prayer wheels, from Dharmaware, Woodstock, USA. Photos VMZ.

169. Cover of *Notruf über Tibet* by Jean-Michel Charlier & Victor Hubinon: Bastei (n.d.) (1st German edition of *Mission vers la vallée perdue*, later reissued as *Flucht aus Tibet*, Carlsen).

170. a: 'Shambhala—Sky Dancing Boutique', Erlangen.
b: Back cover of *Queer Dharma—Voices of Gay Buddhists*, ed. Winston Leyland, San Francisco: Gay Sunshine Press, 1998.

171. Engraving (Plate LV, No.1) from *Histoire générale des cérémonies, moeurs, et coutumes religieuses* by Bernard Picard: Paola von Wyss-Giacosa.

172. a: Engraving from *China Illustrata* by Athanasius Kircher: Zentralbibliothek Zürich, Sammlung Alte Drucke/Old Prints Collection.
b: *The New York Review of Books*, drawing by David Levine.
c: Dalai Lama with sensors, from *Stern* 29/1998, illustration by Michelle Chang.
d: From *Le cargo sous la mer* by Cothias & Sternis, Vol.2 of *Memory*, Grenoble: Éditions Glénat, 1987.
e: Greetings card by Dick Chodkowski, Recycled Paper Greetings, Chicago.

173. From *Die Offenbarung* by Jodorowsky & Georges Bess, Vol.1 of *Der weiße Lama* (German edition of *Le lama blanc*): Arboris 1989. (Eng. title: *The First Step*).

174. Advertising poster for IBM.

175. Title page of the comic *Green Lama*, Vol.1, No.1, December 1944, Springfield, Mass.: Spark Publications.

176. Advertisement for 'Milkmaid' brand condensed milk, Anglo-Swiss Condensed Milk, Cham, Switzerland: Martin Weber, Bern.

177. Record sleeve, *Brown Rice* by Don Cherry, A & M Records, 1988.

178. 'Kohl threatens to be reborn!' postcard from *Titanic—Das endgültige Satiremagazin*, Berlin.

179. Coloured engraving, producer unknown: Wolfgang Hellrigl, Bozen.

180. Potala ('Bietala'), from *China Illustrata* by Athanasius Kircher: Zentralbibliothek Zürich, Sammlung Alte Drucke/Old Prints Collection.

181. a: Detail of tangka painting, Inv. No.13200, VMZ.
b and c: From *Buddhist Iconography of Tibet* by Lokesh Chandra, Kyoto: Rinsen Book Co., 1986.

182. Tangka painting, Inv. No.14122, VMZ.

183. Detail from a Tibetan tangka painting on which scenes from the life of Milarepa are depicted: photo Joss Bachhofer, Munich.

184 Tangka from the Dahortsang collection.

185. Detail from tangka painting, Inv. No.14475, VMZ.

186. Depictions of prayer wheels:
a: Book cover, *Through the heart of Tibet* by Alexander Macdonald, London 1910: Hans Roth, Münstereifel.
b: From *Top Secret* by Jean-Michel Charlier & Victor Hubinon (*Buck Danny* series, German edition), Hamburg: Carlsen.
c: Plate 3 from *Viaggio al Tibet* by Cassiano Beligatti: Biblioteca Comunale 'Mozzi-Borgetti', Macerata.
d: *Der Dimensionssprung*, in *Walt Disneys Lustiges Taschenbuch*, No.151 (German edition of *Zio Paperone e l'inafferrabile Trizompa*), Stuttgart: Ehapa, 1990.

187. So-called 'singing bowls', VMZ.

188. Ashtray from Silly, Space Lab, Netherlands (made in China): photo VMZ.

189. Detail from tangka painting, Inv. No.14379, VMZ.

190. Portrait of Gendün Chöpel, made by his brother Dondrup Tsering: coll. Heather Stoddard.

191. Portrait of Tsewang Norbu, Dondrup Tsering.

192. Portrait of Jamyang Norbu: Jan Andersson, Münster.

193. Advertising poster, Saas-Fee Tourist Office.

Index